Andy Warhol's
Art and Films

MANENTI

Studies in the Fine Arts: The Avant-Garde, No. 54

Stephen C. Foster, Series Editor

Associate Professor of Art History
University of Iowa

Other Titles in This Series

Andy Warhol's Art and Films

by
Patrick S. Smith

UMI Research Press
Ann Arbor, Michigan

Produced and distributed by
UMI Research Press
an imprint of
University Microfilms, Inc.
Ann Arbor, Michigan 48106

Library of Congress Cataloging in Publication Data

Smith, Patrick S., 1949-
Andy Warhol's art and films.

(Studies in the fine arts. The Avant-garde ; no. 54)
A revision of the author's thesis (Ph.D.)—
Northwestern University, 1981.
Bibliography: p.
Includes index.
1. Warhol, Andy, 1928- —Criticism and inter-
pretation. I. Title. II. Series: Studies in the fine
arts. Avant-garde ; no. 54.
NX512.W37S6 1986 700'.92'4 86-11400
ISBN 0-8357-1894-8 (pbk.)

Contents

Ronald Tavel, New York, 8 October 1978
Ronald Tavel, New York, 1 November 1978
Eleanor Ward, New York, 9 November 1978
Andy Warhol, New York, 6 November 1978
Holly Woodlawn, New York, 22 November 1978

List of Figures

Acknowledgments

I want to thank my family, especially my father and my late mother, for their love and support. My friend Bruce Litow followed the entire project and offered many suggestions. While I was in New York, I was assisted by the staffs at the Anthology Films Archive, the Archives of American Art, the Pierpont Morgan Library, and the Whitney Museum of American Art.

This study would not have been possible without the cooperation and expert testimony of the many people whom I interviewed. In particular, Nathan Gluck willingly answered hundreds of questions. Ivan Karp introduced me to Warhol, and Leo Castelli gave me access to his gallery's archive and photographs. The chapter on Warhol's films would have been impossible without Ronald Tavel's excellent memory. Gerard Malanga spent many hours describing in detail his association with Warhol. Lawrence Alloway opened many doors for me, and numerous collectors allowed me access to their works by Warhol. Finally, Warhol admitted me to his studio, where I spent many hours looking through his personal scrapbooks, interviewed and spoke to his staff, and observed his artistic means of production.

This book is dedicated to Bruce Litow.

Acknowledgments

1

Four Photographs

In 1929, when Greta Garbo was 23, Edward Steichen photographed her sensual yet spiritual face: flawless cheekbones, straight nose, wide and lipsticked lips, articulated nostrils, staring gaze, rounded and soft chin at the bottom of her abstracted face and, at the other side, glistening hair that is held back by her hands (fig. 1).[1] Steichen made this expressionless beauty unalterable and allowed Garbo to combine with her definitive silence and detachment the ideal of a romantic and glorified essence. Harmoniously pure, Garbo passed again beyond any dialectic of real and reel life into a mythic one. Her attractiveness that stirs the imagination was—is—enchantingly mysterious, at once distant and accessible. In her films she played the virtuous *femme fatale* (Marguerite Gauthier, Anna Karenina, Mata Hari), and her stunning face, captured in Steichen's publicity photo, nourished her glamorous legend. The photograph's mythic reality creates the ideal type of the exciting and illusory magic spell of Hollywood. Projected for daydreams this iconic photo is at once desire and fulfillment, yet also elusiveness and absence. Hollywood's commitment to such an ideal image of a glamorous and beautiful star evokes a ceaseless nostalgia because, as Andy Warhol wrote in 1975, "history will remember each person only for their beautiful moments on film—the rest is off the record."[2]

Garbo became a part of the apogee of Hollywood's star system, and she remained a living legend after her retirement at the age of 35 in 1941. As an archetype of attractiveness and fascination, Garbo retains her role as patron and model that affects her admirers. Her personality is a persona, a mask, which provides a tacit and silent eloquence. Edgar Morin observes, "In fact, the archetypal beauty of the star acquires the hieratic quality of the mask, but this mask has become perfectly adherent, identified with the face and dissolved within it."[3] Similarly, Morin notes, one who identifies with such a patron-model imitates such a personality. "The star provides the image and the model of this mask, this disguise; we assimilate it into our character, integrate it with ourselves."[4] Although unreachable in real life, the sheer presence of a star's image in a film or publicity photo, as well as mention in a magazine, is ceaselessly stimulated and nourished by and through the publicity apparatus of

+ disturbed + destroyed

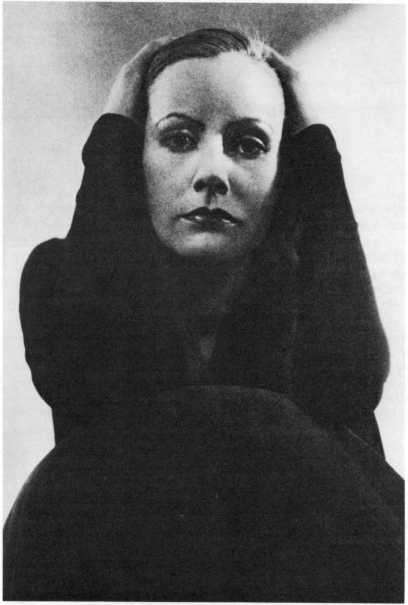

Figure 1. Edward Steichen, *Greta Garbo*, 1929
Publicity photograph.
(*Courtesy* Vanity Fair. *Copyright © 1929 by The Condé
Nast Publications Inc.*)

Hollywood and is provided an extremely powerful projection, reaffirming the provider of dreams and allowing the recipient's amorous identification. Garbo's "star quality" is the reciprocal correlation of a devoted fan's admiration and identification.

A star's existence is precarious and perpetually incomplete. Dependent upon an audience and composed as an impassive ideal, a star's private life becomes public and public life publicity. Yet, Garbo's ardent insistence to be left alone is a part of her legend. As a young Truman Capote observes in his collected travel essays in 1950:

> Surely it is enough that such a face could even exist, though Garbo herself must have come to regret the rather tragic responsibility of owning it. Nor is it any joke about her wanting to be alone; of course she does. I imagine it is the only time she does not feel alone: if you walk a singular path, you carry always a certain grief, and one does not mourn in public.[5]

Capote's encounter with Garbo in New York is situated in an earlier and interrupted devotion. Capote confesses:

> When I was twelve I had a tiresome series of mishaps, and so stayed a good deal in bed, spending most of my time in the writing of a play that was to star the most beautiful woman in the world, which is how I described Miss Garbo in the letter accompanying my script, but neither play nor letter were ever acknowledged, and for a long time I bore a desperate grudge, one which was indeed not dispelled until the other night when, with an absolute turning over of the heart, I identified the woman in the adjoining [theatre] seat.[6]

It is Garbo's screen presence that motivates Capote's inspiration, her silence that impels his chagrin, but her actuality that prompts his latent adoration. To be left alone is not to exist.

Capote's first novel, *Other Voices, Other Rooms,* aroused much comment in 1948.[7] The novel consists of a series of sketches centered on a rural youth named Joel:

> He was too pretty, too delicate and fair-skinned; each of his features was shaped with a sensitive accuracy, and a girlish tenderness softened his eyes, which were brown and very large. His brown hair cut short, was streaked with pure yellow strands. A kind of tired, imploring expression masked his thin face, and there was an unyouthful sag about his shoulders.[8]

The book included the portrayal of the boy's acquiescence to an older, homosexual artist named Randolph. Before Joel's encounter with Randolph, the boy's listless life is depicted:

> All Thursday night he'd left the electric light burning in the strange room, and read a movie magazine till he knew the latest doings of the Hollywood stars by heart, for if he let his attention turn inward even a second he would begin to tremble, and the mean tears would not stay back.[9]

Joel, whose empty and unformed character depends upon vicarious passion, soon meets his seducer:

> Randolph dipped his brush into a little water-filled vinegar jar, and tendrils of purple spread like some fast-growing vine. "Don't smile, my dear," he said [to Joel]. "I'm not a photographer. On the other hand, I could scarcely be called an artist; not, that is, if you define *artist* as one who sees, takes and purely transmits: always for me there is the problem of distortions, and I never paint so much what I see as what I think."[10]

Other Voices, Other Rooms is not so much a traditional novel but a series of vignettes, each one of which brings the seduction closer. With Capote's insight into human nature, as revealed in his characters and cloaked in their psychological disguises, the author achieved instant and widespread notoriety. A part of Capote's public personality related to the now famous publicity photo printed on the back of the novel's dust jacket: lying on a couch, Capote's small, compact body—dressed in an informal elegance (white shirt, bow tie, plaid vest, dark pants)—turns directly toward the viewer; short-cropped brown hair worn in bangs, large, gazing eyes, soft and fair-skinned flesh, slightly parted lips, open hands resting on his thigh and just above his belt, characterize his pose (fig. 2). Capote's publicity photo is an exquisite affectation. Impeccable and deliberately cultivated, the author's calm, horizontal deportment and dandified vanity may be seen as a deliberate, encouraged, and valued shock to the viewer, whose role becomes either that of a lover or voyeur. Capote's hypersensitivity to social nuance in his novel is allied to the eroticized reverie in his photograph.

Before Andy Warhol graduated from the Carnegie Institute of Technology, he was photographed during his senior year (fig. 3). Behind his glasses, Warhol looks toward the viewer. His long, blond hair is of the then-fashionable pompadour style, and his chin rests on his pale, delicate hands.

After his graduation in 1949, Warhol and his classmate Philip Pearlstein moved to New York, where they shared rented rooms in the apartment of the dance-therapist Francesca Boas.[11] After several months, Warhol moved to a basement apartment, which was subsequently demolished for a municipal housing project, at 103rd Street and Manhattan Avenue. Warhol shared this apartment with a group of aspiring young dancers, writers, and artists. Calvin Tomkins remarks:

> They all had a lot of fun, sharing food and money and clothes and being such good friends—there was no sex involved. They went to the movies a lot, and had a communal crush on Judy Garland. When one of her films played the neighborhood Loew's they all saw it six times.[12]

Within this "bohemian" atmosphere, reminiscent of the innocence portrayed in the Broadway play *My Sister Eileen*,[13] Elaine Baummann Finsilver, who was

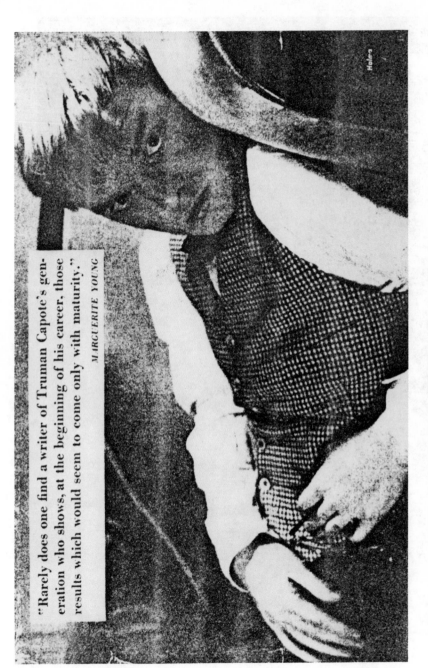

"Rarely does one find a writer of Truman Capote's generation who shows, at the beginning of his career, those results which would seem to come only with maturity."

MARGUERITE YOUNG

Figure 2. Henri Cartier-Bresson, *Truman Capote*
Photograph from the dust jacket of Truman Capote's *Other Voices, Other
Rooms*, New York, 1948.
(Copyright 1948, Magnum Photo)

Figure 3. Photograph of Andy Warhol, 1949
(*Courtesy of George Klauber*)

one of the dancers, characterized Warhol then as "an inarticulate, totally non-verbal young man."[14] While being shown photographs of Warhol during my interview with her, she described the artist's appearance:

> When I met Andy, I was shocked, absolutely shocked at this young man who was 19, 20. When I look at your pictures . . . And this is 1956! I mean, he has so much hair! When I knew him then, he was practically bald, and he had this bulbous nose and discolorations on his nose, face and chest. He also had very thick glasses and a whispery voice.[15]

This pale, balding, blond, reticent artist joined the group activities, which included viewing big Hollywood musicals, Garland, Frank Sinatra, and Jean Cocteau films, and attending a costume party at which he created a daisy chain. On weekends, communal parties would include such guests as the actor Hurd Hatfield, who played the dandified hero in the film version of Oscar Wilde's *The Picture of Dorian Grey.* According to his roommates, Warhol usually sat and observed during such gatherings.[16] One roommate remembers:

> I remember he always wrote fan letters. Probably to Truman Capote. I wouldn't be surprised to Judy Garland. He was a star-idolizer. He would just be breathless when he'd see Somebody or Someone. He did admire these people from afar. We were all star-crazy.[17]

Warhol's idolization of Hollywood's idealization, encouraged by the requirements of youth and beauty, as well as the artifices of photography, makeup, and plastic surgery, included a factor beyond a mere affective relation between hero and spectator.

This factor is grounded not in testimony, as much as such evidence elucidates, but in a photograph of Warhol (fig. 4). While visiting his former classmate George Klauber, who was living in Brooklyn Heights, Warhol asked Klauber to photograph him in Steichen's famous pose of Garbo.[18] Taken in 1951, Warhol's appearance in this photograph had changed from the one taken during his senior year in art school. Specifically, he changed the blond pompadour to straight brown (hairpiece?), which he cut short and wore in bangs that he pulled back with his hands. His bulbous nose is slightly more pronounced and red, but for now this is inconsequential to the import of Warhol's self-image-as-Capote-Garbo. Published here for the first time, the photograph reveals Warhol's private, photographic moment: one that is lighthearted and one that conveys an intense declaration of his self as these two personalities. For this moment, he has a romantic, exciting, and illusory attractiveness, alluring or fascinating to the viewer. Warhol's imitation of Garbo's pose and Capote's hairstyle is not intended for comic effect or in ridicule. This self-image is, in short, not a parody. Meant sincerely, it is a phenomenon common to fanatic adoration. Edgar Morin comments on such a fan:

Figure 4. George Klauber, Detail of a Photograph of Andy Warhol, 1951
(*Courtesy of George Klauber*)

But this dream borders on and even collides with reality. He becomes a worshiper of what he would like to be. [. . .] He may also wish to continue his dream, and thus seeks mythic aids to identification: autographs, photographs, fetishes, gossip columns, symbols of real presence—all are so many exterior means for living the life of the stars mystically and from within. The sympathetic magic functions either in a totally oneiric fashion or in an oneirical-practical way: in the latter case, the adorer comes to imitate unconsciously or consciously some aspect of the idol. . . .

The religion of the stars is precisely that imaginary practice which permits the identification-producing dialectic of fan and star. The same cult includes an adoring love of both heterosexual and homosexual characteristics. This is because both imply the same transformation of the star into the fan's alter ego and even of the fan into the star's alter ego. It is because, even as all self-love conquers love of others, in an individualistic civilization like ours in which love is also egoism, all love of others implies self-love.[19]

A devoted fan daydreams, and a glamorous model projects *mutatis mutandis*. The former may attempt to participate in the essence of the latter. In the case of Warhol, the artist's photograph depicts him living for a moment the elusive and mysteriously magic spell of two famous and intriguing celebrities.

Later, when he could afford the prices, Warhol attended auctions of the effects of celebrities and bought personal items, such as Carmen Miranda's platform shoes.[20] Warhol's infatuation with celebrities became evident to others from the time that he lived in the basement apartment, where, for instance, his friend and future model Robert Fleischer first met him. According to Fleischer, it was Truman Capote's publicity photograph on the dust jacket of *Other Voices, Other Rooms* that "sent him [Warhol] off provisionally" to be close to the author, on whom he had "a terrible crush."[21] During his interview of Capote in 1973, Warhol remarks: "I used to write to Truman every day for—years—until his mother told me to stop it."[22] Capote has recalled that Warhol sent him pictures and drawings.[23] In fact, 15 such drawings that were based on the writings of Capote were exhibited in 1952 at the Hugo Gallery.[24] As seen with Klauber's photo of Warhol, the artist identified himself with the author. Fritzie Wood, who was an associate and neighbor of Warhol, has commented that it gave Warhol much joy to be mistaken for Capote and that Warhol would sit under palm trees in the lobby of the exclusive hotel the Plaza *in order to be so mistaken*.[25] Famous at an early age, Capote held a special meaning for Warhol. Stephen Koch, the author of *Stargazer: Andy Warhol's World and His Films* (1973), speculates in my interview with him:

SK: [. . .] When he got to New York he wrote Truman Capote every day a letter, a fan letter, every day for a year [*sic*]. And . . . why would anyone do such a thing? Capote didn't answer. They finally did get to know each other. I would think to—in 1952, which is when he arrived. . . . Right? Something like that?

PS: He arrived in 1949.

SK: Forty-nine. Better yet. It was a moment when Truman Capote was extremely visible in a way that Andy probably admired and was very interested in, and the fact that he was also, from Andy's perspective, a very cultivated figure. That is to say, a major homosexual, literary figure, who was, at the same time, glamorous [. . .] absorbed Warhol. I would think that he would try to make that connection as quickly as possible.[26]

What Capote's allure for Warhol was based on remains moot, but nonetheless Capote's publicity photo, writings, and stature as a youthful and glamorous literary figure allowed Warhol to identify himself in an affective relation between devoted spectator and famed model.

The silent mystique of Garbo similarly, affected Warhol. Charles Lisanby, a scenic designer and former assistant to Cecil Beaton, was one of Warhol's closest friends. They met in the early 1950s and took a trip around the world together in 1956. They remained friends until the time of Warhol's infamous Pop Art persona. Regarding Lisanby's often quoted memory that Warhol once said to him, "I want to be Matisse," the scenic designer stressed in my interview that what Warhol *meant* was that he wanted to be as famous as the French artist and that everything, even a small collage, was to be regarded as a worthy item:

> You see, I turned [Rainer] Crone on to that Matisse thing, and, I think, he went off on a tangent. I realize, knowing Andy then, that if you ask him a direct question he will not answer it. He would rather let you go on, assuming something was true that was not true rather than to correct you. It was some kind of a mystique. Greta Garboesque kind of thing. He loved Garbo.[27]

Intertwined with distant admiration is the cultivation of a mystique of being alone and of being silent. In his collection of *pensées*, Warhol writes: "Fantasy love is much better than reality love. Never doing it is very exciting. The most exciting attractions are between two opposites that never meet."[28] It is the "aura"[29] of a distant, mythic reality, definitive in silence, that retains the daydream. To project that aura is to magnify and to focus the esthetics of an elusive and illusory glamour.[30] The fame of a celebrity (Capote, Garbo, Matisse) holds an important—in fact, crucial—allure for Warhol.

For Warhol, the romance dialectic of spectator and star subsumes a hypererotic, almost pathologically voyeuristic, urgency. Koch conjectures:

> [Warhol's] narcissistic vision of strength of the power to live and relate is replaced by a drifting self-protective reverie of self-sufficiency. The image in the mirror is eroticized but remote; beloved but unapproachable; needed but incapable of being possessed.[31]

This passionate, voyeuristic vision is fully announced publicly by Warhol in his

films, but as early as ca. 1951 Warhol was known to be ardently interested in pillow talk gossip, to be sketching highly erotic situations, and to be recognized for his series "Cock Drawings" (various private collections, whereabouts unknown).[32] "Sex is more exciting on the screen and between the pages," Warhol has written, "than between the sheets anyway."[33] Warhol's conscious identification with such a self-absorbed consciousness seems to have been especially fervent in terms of possession: autographs, publicity photographs, and other symbols of the presence of a celebrity. Another and highly personal incident clarifies these attitudes:

> I do remember Andy coming to the display department once, and he said, "I was just at *Harper's Bazaar*," and he gave me a picture of Marlon Brando. "Would you like to see it?" And I said, "Sure, Andy. Yeah." And he went into his pants, and he had it in here [i.e., his crotch], and he showed the photo to me. Then he put it back in. And he was walking around New York with Marlon Brando in there.[34]

Calvin Tomkins reports that Warhol

> had some wild idea about movie stars' underwear, that you could go into business selling underwear that had been worn by the stars, it would cost five dollars washed and fifty unwashed.[35]

The "unreachable" mysteries, the "elusive" enchantments, and the eroticized ideals of glamour are Warhol's tropes of style, and his entrepreneurial engagement with the economics of packaging the projections of celebrityhood range from extreme innocence (*Happy G. Garbo Day* flyers sent as promotion to art directors in the mid-1950s[36]) to extreme debasement (his later films *Suicide* and *Hedy the Shoplifter*).

To understand Warhol's work from the beginning of his commercial art career through the most recent silkscreened canvases is to deal with the notion of personality and its theatricality—the persona of a celebrity as it is projected as an iconic image. Capote's *Other Voices, Other Rooms* features an artist. This fictional and hypersensitive character, it will be remembered, defined his occupation "as one who sees, takes and purely transmits."[37] Warhol's commitment to an ideal image, which may be ordinary or marvelous, is his consignment to the viewer of the iconic power of the chosen person or object. In a sense, Warhol "sees," "takes," and "purely transmits" the elusiveness and unattainability of romantic, alluring, exciting, and fascinating attractions that are renowned.

Fame elevates; notoriety lessens. "We lose sight of the men and women who do not simply seem great because they are famous," Daniel Boorstin has noted, "but who are famous because they are great."[38] As one's publicity becomes contrived and as one's reputation lends itself not only to be widely and vividly reported but also to be incited into existence for the purpose of being

reported, someone who creates such attention may also create mere reputation. The difference depends not so much upon publicity as upon the personality of the celebrity: what one projects and externalizes. The sensibility of a celebrity, like that of a dandy, is a cult of the self that is dependent upon society. Living in the ideal moments of life, the impassive nature of a celebrity is a social style of an exclusive group (Hollywood stars, famous literary figures, notable café socialites, etc.). The ultimate expression of a dandy's refinement is his personal appearance; the declaration of a celebrity's fame is the crucial pose, the image, of well-knownness.[39] It is the celebrity's image that creates his "look" and hence, his style. Celebrityhood is not predicated on accomplishment but on fame alone—a simple and tautological state of being.

It is, precisely, such a state of being that Warhol attempts to achieve: one that is based on a combination of images of glamour, youthful notoriety, and mystery. As a commercial artist, his blotted-line style created a "look" that was fashionable. In order to understand Warhol's art and career, it is necessary, in my opinion, to deal with the ways that his personality and his art are theatricalized during his successful careers, first as a commercial artist and then as a Pop artist.

difference between being famous & being infamous – between fame & notoriety

2

Warhol's Formative Years
and Commercial Art

Warhol's Childhood and College Years

Andrew Warhola, Jr., was born on 28 October 1930, in Forest City, Pennsylvania.[1] Until recently, this fact has eluded everyone. Warhol celebrates his birthday on 6 August and claims to have been born in Pittsburgh (among other places) in 1928. Like some Hollywood movie star, Warhol has attempted, in Gerard Malanga's words, "a very Duchamp type of situation, to create a myth for oneself, an identity."[2] Yet, even this observation is not quite accurate however much it seems true in retrospect. His mother falsified his birthdate during his years in high school so that he could afford college tuition from his father's insurance policy.[3] Rainer Crone has pointed out that an atomic bomb was dropped on Hiroshima on Warhol's (pseudo-) birthday in 1945. In 1965 one of Warhol's documentary Pop Art paintings depicted an exploding atomic bomb.[4]

The artist's formative years before college suggest a disaffected youth, sick in bed with attacks of "St. Vitus's Dance," playing with an ersatz companion, a Charlie McCarthy doll, or doing paper cut-outs.[5] "My mother would read to me in her thick Czechoslovakian accent as best she could," Warhol has written, "and I would always say 'Thanks, Mom,' after she finished with Dick Tracy, even if I hadn't understood a word."[6] Later, one of his Pop Art canvases would be *Dick Tracy* (Private Collection), painted in 1960.[7] This painting was one of several depicting comic book heroes done in that year. Significantly, the speech-balloon in *Dick Tracy* is obscured.

Warhol enjoyed attending movies,[8] and he worked as a show window decorator and "idea" man in a Pittsburgh department store,[9] looking through copies of *Vogue* and *Harper's Bazaar*. Warhol's fascination with glamour, be it from Hollywood or from a fashion magazine, began in his youth. The notion of a faraway place seemed to him as exciting as a glamorous "idol."

During some initial art training in elementary school and high school,[11] the most formative influence on Warhol was his mother's "naive" sense of

drawing and use of color and line, as in decorating Easter eggs.[12] A hallmark of his personality throughout his life is an effortless intuition for something, a childlike naiveté that close friends have attributed to his mother's personality.[13]

At the extraordinary age of 15, Warhol attended the Carnegie Institute of Technology (now Carnegie-Mellon University). He majored in pictorial design at a time when returning GI's, such as realist artist Philip Pearlstein, were learning to become art directors or painters. Classmate Arthur Elias spoke to me about the irony of learning about contemporary artists and basic painting techniques outside the classroom.[14] As a student, Warhol has been characterized as being self-contained and shy, withdrawn and naive.[15] One classmate recalled that he was "closed-mouthed" during discussion sessions in a lecture class.[16]

Despite his fragile and shy mannerisms Warhol was admired by his classmates, and he had a penchant for being outrageous, claiming once to have a chess date with Marcel Duchamp during a summer trip to New York.[17] While he attended college, Warhol had a *coup de théâtre* that may be considered a parallel to Duchamp's scandalous success in the New York Armory exhibition of 1913 or his infamous and rejected submission of a urinal for exhibit at the Society of Independent Artists in New York in 1910.[18] During his senior year, Warhol submitted to the annual exhibition of the Associated Artists of Pittsburgh a painting entitled *The Broad Gave Me My Face, But I Can Pick My Own Nose*.[19] The jurors, which included George Grosz, were deadlocked on its merits and devised a *salon des refusés* for it and other submissions.[20] Warhol did not include his refused painting but exhibited it instead in a gallery in Pittsburgh where the public "just *flocked* to the Arts and Crafts Center just to see this painting that Andy Warhol did. . . . It was so controversial."[21]

While still in college, Warhol perfected a blotted-line technique and would use torn, colored construction paper for his student works.[22] Warhol combined such techniques, as will be seen, in his privately published promotional books during the 1950s. Also, contrary to what Warhol may claim, he was trained in the techniques of silkscreening and had used the medium in his Pittsburgh window displays.[23]

One of Warhol's teachers, Robert Lepper, wanted his students to be accurate observers. Lepper devised various mnemonic projects to capture urban life and to illustrate popular novels.[24] Consequently, Warhol and his classmates were trained to achieve effective graphic representations of subjects that would enframe an initial idea and its technical solution within a layout or a display.

"It Would Look Printed Somehow"

PS: Going back to the drawings, you said you got the idea of the blot-drawings from college. How did that happen?

AW: Well, it was just that I didn't like the the way I drew. I guess, we had
to do an ink blot and do that kind of look, and, then, it would look
printed somehow. Ah. And that's how, I guess, I did it.[25]

By 1953, Andy Warhol had changed his name from "Warhola" and had discon-
tinued an affected variant "André Warhola," though he acquired several
nicknames, including "Raggedy Andy" (because of his calculated appearance)
and "Andy Paperbag" (because of his practice of carrying a paperbag instead
of a portfolio).[26] In the mid-1950s, Warhol rented a split apartment whose par-
lor floor was glutted with enormous potted palm trees, a large round table, Tif-
fany lamps, twig furniture, Victorian antique toys, penny arcade devices, and
American Folk and Funk art objects.[27] The effect was a "stage set for a Ten-
nessee Williams . . . [or] Truman Capote play."[28] In such confected, scenic
surroundings Warhol entertained his close friends, silently sketching them as
they spoke, mostly about gossip.[29] Rarely would such visitors meet the artist's
mother, who had moved from Pittsburgh in order to take care of her son and
who lived in the top-floor apartment.[30] The top-floor apartment was also
Warhol's work area: a space crammed with drawings, tear sheets from
magazines, old picture books that were handcolored, and a desk. There were
Siamese cats everywhere.

 Warhol was living in this upstairs apartment when he was visited by
Robert Galster, the illustrator of books and posters. Galster, who was intrigued
by Warhol's dust jacket design that depicted a cupid, offers in my interview
with him one of the most thorough accounts of Warhol's working methods and
use of a stylized and blotted technique of drawing. The blotted-line technique
is considered Warhol's distinctive illustrative style, a style characteristic in the
artist's work in commercial art throughout the 1950s and into the 1960s.[31] Ac-
cording to Galster, Warhol used a door placed on two saw horses as a desk and
a typewriter case as a chair. Casual to the point of neglect of his top-floor sur-
roundings and their contents, as well as of his art supplies, Warhol would draw
and blot either on his lap or on his cluttered desk.

 Warhol's blot technique, including his casual and empirical approach to
pictorial source materials, features an acceptance of accidental happenings in
his intuitive drawing method. According to Galster and others,[32] the blot
technique is as follows: a completed drawing, which may have been traced,
was taped and hinged to a piece of Strathmore paper; the original artwork
would be inked and then blotted on to the finished work of Strathmore paper.
Often, the original drawing was discarded. Galster notes that Warhol blotted
only minute sections of the original:

> And he would simply draw on this, like masking tape it to the piece of . . . to the drawing
> surface so that you had this hinged like a door and then draw on the "door" a little short line
> and blot it on to the working surface and then lift it up and draw a little bit more and blot
> it again, and, ultimately, you would end up with an Andy Warhol drawing.[33]

The result, a highly decorative and calligraphic-like line, features accidental splotches which were carefully unplanned. The hesitant almost backed-up appearance of the technique appears at once naive yet sophisticated—reminiscent of the visual "noise" in the expressive graphic work of Paul Klee, whom Warhol much admired.[34] This blotted monoprint,[35] similar in appearance to the stylized ink drawings by David Stone Martin and Ben Shahn,[36] holds a particular fascination for Warhol.

Cage

This appeal of a blotted monoprint pertains to the artist's fascination with playful experimentation and a medium that allows both a stylized personal touch and a "trace" of its transmission. Although the effect of splotches seems to indicate an expressionistic unrestraint, perhaps gratuitousness, control is needed, as Galster explains:

> I tried it. It never worked for me, but one reason why I was interested in it is that I use a similar type of line in my work. That is, a rough, thick and thin . . . but I do mine with a brush, which gives sometimes almost a similar look, but, I knew, it was different, and, so, that's why I wanted to know how this guy could do this. Yes. After that, I tried it. I tried blotting a few lines, and it didn't work for me at all. [Laughs] Mine didn't look like fake Andy Warhols. They looked just like blotty lines. So he had it under control some way.[37]

Warhol's method, which included blotting on glass to keep the ink longer,[38] represents a specifically pictorial and graphic, hence printed, treatment of drawing: a means of giving *personality* to a medium. In fact it is Ben Shahn's work, which Warhol collected,[39] that may have inspired his continued use of this technique, not because of Shahn's graphic style alone but because of Shahn himself, who like Matisse, represented a famous artist-celebrity. Charles Lisanby clarifies this distinction:

> It was Ben Shahn's line, I think, that did inspire him in doing those blotted things. He *saw* the similarity, and Ben Shahn things were printed, and they were in the Museum of Modern Art. And he [Warhol] wanted his things to be printed in magazines, and he wanted them in the Museum [of Modern Art], too. *Very much.* And that's really why he started to do that blotted-line, which, as I said: it *looked* like a printed thing.[40]

Warhol's desire for a graphic style that appears printed—that is to say, public, or more precisely, publicized—is indicated in his continual interest in producing books, which began when he sketched his roommates in the basement apartment at 103rd Street and Manhattan Avenue. According to Margery Beddow, one of his dancer-roommates, he would "just catch you there, quickly, and you wouldn't even know he was doing it."[41] The sketches would be assembled into a loose-leaf notebook and then presented to the unaware model.[42] One of the attractions to Warhol of old books was the marbleized effect on the handmade endpapers. Warhol made marbleized papers after similar and earlier experiments by his associate Nathan Gluck,[43] and then exhibited them during the

early 1950s at the Loft Gallery, a cooperative exhibition space.[44] One of Warhol's one-man shows there consisted of large sheets of marbleized paper that he had crumbled and folded into various geometric solids. They were then either placed on the floor or mounted on the walls.[45] This exhibit reveals Warhol's preference to bemuse and shock spectators, and his inclination to experiment with materials. At the same gallery, Warhol showed erotic drawings that he had crumbled and exhibited in the same unconventional manner.[46]

Warhol is interested in the nature and use of art materials. He will often approach in a playful manner the means of producing and exhibiting art. Although all of the techniques that he will use are commonplace, it is the expressive effect of dramatizing them that engages and fascinates their viewers. On Warhol's blotted-line technique, Galster has commented, "I knew it was different, and so that's why I was fascinated by it, and I wanted to know how this guy could do this."[47] Warhol's generation of an image becomes a part of that image. The effectiveness of the artist's illustrative drawings depends, too, on the charming blotted-line.

Warhol's use of the blotted-line technique extended beyond the intimate scale of his fashion illustrations. Like Matisse and Jean Cocteau before him, Warhol did mural-sized drawings on walls. Unfortunately, without visual documentation it is necessary to depend upon testimony to provide evidence of at least one major, mural-sized project that was whitewashed and lost. Elaine Finsilver was one of the artist's roommates in the Uptown basement apartment. As a gift to her, Warhol decorated her bedroom wall in a mural using the blotted-line technique. During my interview with Mrs. Finsilver, she describes this mural, done about 1951:

EF: He did have a fey sense of humor. When he painted my bedroom, it was just a fantastic job. The patience! He had tremendous patience because his whole manner of painting, his illustration, was so painstaking, much more so than any other art or drawing form that I've ever seen. It would just take him hours to do half of a side of a body or one shoe.

PS: How large was the wall that he painted?

EF: At least 10 feet, and, I guess, it was eight feet high. And he painted circus people. I think, he painted people in tutus, kind of chubby, as you can see why. Chubby, round people in tutus, which were just hysterically funny. There would be the molding around the room. He would use the top of the molding as a trapeze. So, you would see the molding that goes around the door, and he would draw feet sticking up from that, and, somehow, he would have the person hanging from it so that the feet would be up there, and the body would be the full

length of the door, as if the person just had their feet hooked around. He did that on two closets, so that even when you open the door, the person was swinging. It was sensational! He drew a lot of his cherubs. . . . And [one] wall from floor to ceiling had people flying through the air and little ballerinas and little cherubs.[48]

Warhol's decorative depiction conceived as a delightful fantasy must have been more than whimsical caprice. From Mrs. Finsilver's description, his creation *was*—the mural was whitewashed by Mrs. Finsilver's mother—a highly inventive and animated visual charm. Warhol also decorated a bathroom (whereabouts unknown) using similar images,[49] and with Charles Lisanby, someone's kitchen wall.[50] According to Warhol's associate and model Robert Fleischer, "he used to paint on people's walls if they let him."[51] Fleischer continues, "And he did this line, this blotted-line of *Butterflies,* and he would write like a child writes in reverse and spell "butterfly" wrong. Something would be upside down."[52] Such atavism may indicate more precisely the artist's childlike fascination and delight in "playful" drawing: amusements, frivolous pleasures, and mischievous cherubs that are stripped of any allegory. In short, it is confection with its agreeable pleasantness.

What colors, if any, were used for these murals is unknown. In his illustrative art, Warhol used the saturated hues of Dr. Martin's dyes, which were diluted and then brushed over a completed ink drawing. One of the plates for the promotional book *Wild Raspberries* (1959), written by Suzi Frankfurt and conceived and illustrated by Warhol, is *Salade de Alf Landon,* a proposed mold of jelly bombe filled with slices of lobster tail and asparagus tips (fig. 5). The book, printed by offset lithography, was handcolored unevenly. Originally the page's coloration was vibrant, but the applied dyes have faded. The wit and whimsy of the recipe, combined with the charm of the blotted imagery, are visually animated by the intense, unevenly washed dyes coming into play with the variety of speckles and blots of the decorative line. The use of color—its uneven flow over a "printed" image—is again a carefully unplanned effect. Apparently, Warhol decided on an image and how to draw it before he considered the application of color. The artist's associate and friend Bert Greene recalls:

He used to carry around these little paint samples that you used to get: *House and Garden* colors, and, when he'd get a job, he used to fumble around with these little swatches of color until he found the colors that he felt would work, and, then, he would start to work. He never really conceptualized color until he started to work with anything, and he would think, "Now, where should the color go?" and that kind of thing.[53]

In Warhol's easel paintings of his commercial art period, patterns of color overlays were applied with an airbrush.[54]

Evidence of such paintings done between the time when he attended the

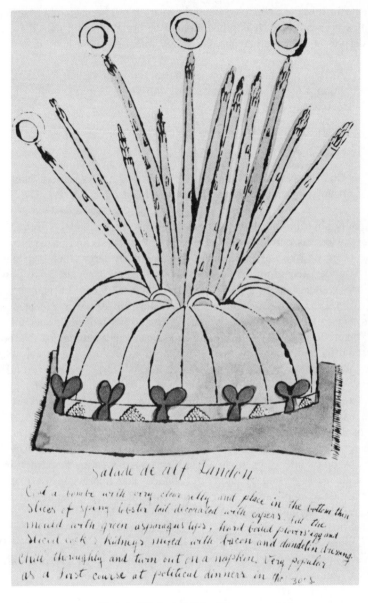

Salade de alf Landon

Line a tombe with very clear jelly and place in the bottom thin
slices of spring lobster tail decorated with capers, fill the
mould with green asparagus tips, hard boiled plovers' egg and
sliced cock's kidneys mixed with bacon and dandelion dressing.
Chill thoroughly and turn out on a napkin. Very popular
as a first course at political dinners in the 30's.

Figure 5. Andy Warhol, *Salade de Alf Landon*
Offset printed page with hand-colored wash, from Andy
Warhol and Suzi Frankfurt, *Wild Raspberries,* New York, 1959.
(*Collection of Ted Carey, New York;* © *A.D.A.G.P., Paris/*
V.A.G.A., New York, 1986)

Carnegie Institute of Technology and the year (1960) he made his first Pop Art canvases is incomplete. It is probable that the artist may still own these paintings despite his evasive manner during my interview:

PS: Anyway, getting back to the other question that I had was to this transition time. I understand you did large canvases with this blot technique.

AW: Yeah. Nothing ever arrived. I think, I threw them away.

PS: Do you still have them anywhere?

AW: Oh. No. No. Ah. I think, I don't know. I don't know. It might have been some things from school, that I did in school.[55]

Apparently almost all of the canvases featured Warhol's model Alfred Carleton Walters, who was a librarian in the picture collection section of the New York Public Library. Some of these paintings were fairly large: four feet high and five feet wide. According to Walters, one such painting featured two poses, in each one Walters was in a prone position. "Scores"[56] of such paintings were done from 1953 through 1956.[57] Each of the canvases was executed in oil paints that simulated Warhol's graphic style and his blotted-line technique.

Sometime in 1956 Warhol exhibited one of his paintings of this period. Sponsored by the Radio Advertising Bureau of New York, the exhibit "Art for Radio" included Warhol's painting *Rock & Roll* (fig. 6).[58] *Rock & Roll* depicts a young woman sitting back in a chair, next to which is a radio. Her eyes are closed and her mouth is open in a smile as she listens to the broadcast music which envelopes the shallow pictorial space and is suggested by zigzag and polygonal shapes airbrushed onto the canvas. The girl's body and the radio are suggested by short and slightly overlapping blotlike brush strokes. Any depth occurs by omission, for example a blank space representing the armchair. The radio's dial is suggested by short, unbounded, and impressionistic lines. The image is, then, implicative: the relaxing sonorities of popular music as produced by the medium of radio. Warhol situates rock and roll music as a visual presence that comes into play and provides dreams.

An unbroken euphony had a special consequence for Warhol. Stuart Davis listened to jazz and watched television as he painted,[59] and Warhol did, too. Alfred Carleton Walters comments:

> He loved to collect records, especially musical comedies, and he would play them constantly when working. I mean: I can remember hearing [the musical comedy] *The Golden Apple* a thousand times. He just played it over and over and over and over and over and over.[60]

Holly Neal, a friend of Charles Lisanby, installed a hi-fi which along with a

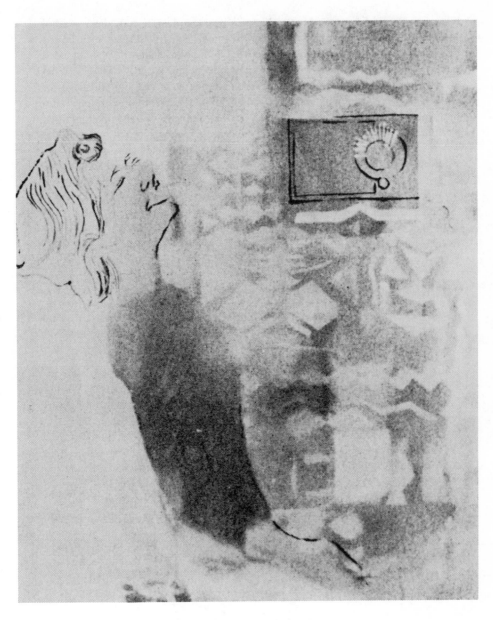

Figure 6. Andy Warhol, *Rock & Roll*, ca. 1956
Oil on canvas.
(*Present whereabouts unknown;* © *A.D.A.G.P., Paris/*
V.A.G.A., New York, 1986)

television would be set on high volume.[61] Besides musical comedies, Warhol listened to pop music, especially to favorite rock and roll singers such as Fabian, Frankie Avalon and Bobby Rydell.[62] On the other hand, he also attended operas, where he became transfixed or, as someone has put it, "numb."[63] What effect such auditory repetition and dissonance may have had and still have for Warhol may be described as another kind of blot: a means to obscure or to dim his real-life surroundings for another one of fantasy. In his book entitled *Philosophy,* Warhol describes his "affair" with his television that began in the 1950s. Warhol has written that he especially watched television when people would tell him their problems. He has commented that he found television "to be just diverting enough so the problems people told me didn't really affect me anymore," and he added that "it was like some kind of magic."[64]

Magic is a kind of enchantment, an artful and alluring influence that spellbinds. Warhol's drawings had such an attraction to the art directors of fashion magazines. For some of these art directors, Warhol was a dream. Joan Fenton, an art director then for *Seventeen* magazine, remarks:

> He had such a good eye, there was no reason to change anything. Obviously, if it involved merchandise where the heel had to be exactly right or the detail of a glove be exactly right, he *caught* it to begin with, so there was no reason for me to ask him to change. . . . There was little reason for me to ask him to change anything on which he worked because what I wanted was his original [blotted] line, not something scrubbed over.[65]

Unlike other artists who made their living by doing illustrative art and who, according to Fenton, "felt they should be doing something else greater," Warhol "gave it the same sensitivity and the same thought"[66] as he would to a fine art project.

Warhol's successful illustrative career, which began in 1949 with *Glamour Magazine* and continued through 1964, includes very prominent clients that deal with chic and fashionable commodities. A partial list would include the magazines *Seventeen, Vogue, The New Yorker, Harper's Bazaar,* and *Interiors,* and the stores Tiffany & Co., Bergdorf-Goodman, and Bonwit Teller.

Geraldine Stutz, who left *Glamour* to become head of the retail division of the fashionably exclusive shoe corporation I. Miller in 1955, hired Warhol to be the sole illustrator of the company's advertisements in the Sunday edition of *The New York Times* until I. Miller was bought in 1957 by Genesco, Inc., which changed I. Miller's personnel.[67] I. Miller's art director Peter Palazzo explains the procedure in producing such an advertisement:

> Andy and I would discuss the ideas to make sure that they were compatible. I would then make design and composition suggestions in rough form, and Andy would go off and interpret them in his blotting technique method with which he would blot each line on a second sheet of paper and use that as a finished product.[68]

The finished product combined a minimum of advertising copy and a maximum of space for Warhol's blotted shoe illustrations one of which won the 1957 Art Directors Club Medal (fig. 7).[69] Warhol's artwork for the I. Miller ad campaign was enormously successful. "What it was, everyone understood," Geraldine Stutz comments. "It was a breakthrough in advertising."[70] She continues:

> They had style and grace. They were not fey. They were full of fantasy, but they weren't fey. There was nothing coy or cutesy about them. Each one had a full life of its own. Andy would take an idea and do something. Shoe advertising, most advertising, was very literal up to that particular time.[71]

In fact, Warhol's expressive and glamourous illustrations developed a following, and the artist sold elaborate shoes-as-famous-personalities on consignment at the restaurant-boutique Serendipity. Among the frequent customers there were Mr. and Mrs. Walter Ress, who bought works by Warhol. In my interview with these early patrons of Warhol, it becomes clearer why Warhol's work attracted fashionable customers:

PS: What motivated you specifically?

MR: They were pretty, decorative. They would fill up the space on the wall. It's true.

PS: Do you remember how much they were at the time?

MR: Fifteen dollars. Maybe 35 dollars. One was 15 dollars. One was 35 dollars. We were buying things only because we liked the look of them. We had no idea of what anything was going to be worth or was worth. [. . .]

WR: When he stopped doing the ads—the I. Miller ads—I felt there was something missing in the Sunday paper.

PS: Really?

WR: Yeah.

MR: They had a charm to them.

WR: They were marvelous.

MR: And it was style. Nobody today has any style.[72]

Andy Warhol's illustrative style of this period held an enchantment and an alluring magic to his patrons, to the art directors of fashion magazines, and to people who bought his drawings.

What accounts for this charm? To return to Warhol's award-winning drawing for I. Miller is to notice Warhol's commitment to apply personality to an

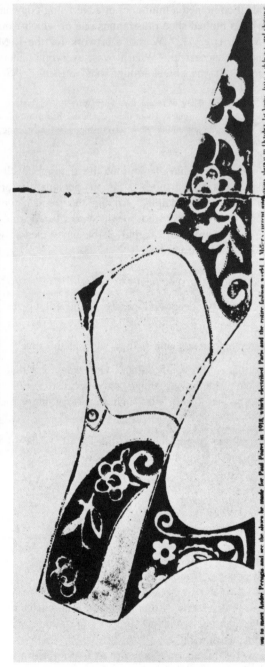

Figure 7. Andy Warhol, Newspaper Advertisement for I. Miller, 1957
(© *A.D.A.G.P., Paris/V.A.G.A., New York, 1986*)

ordinary object as a glamourous stylization: the shoe's vamp is elongated; the blotted-line not only delineates the seams but also literally characterizes the shoe's decorative additions. At first it appears that Warhol has shown the I. Miller shoe in a strict profile. In fact, it is in strict profile from the heel to the right side of the strap, but from the right end of the shoe's vamp to the toe, Warhol has "twisted" slightly the shoe's profile in order to show the decorative top of the toe. This rotation of the point of view seems natural because Warhol elongates the shoe and then flattens the appearance of the shoe by omitting any suggestion of depth by means of shading the contours. Rather, the decorative relief parts of the shoe are depicted by Warhol's flat, blotted additions, drawn to appear naive yet sophisticated. Such mannerist touches—to flatten, stretch, and twist a shoe's appearance—are evident in virtually all of Warhol's illustrations of shoes for I. Miller. He depicts an I. Miller shoe as an ideal, as a decorative and fascinating attraction and a chic, highly stylized commodity.

The weekly half-page illustrations appearing in *The New York Times* had deadlines that were usually only a few days. Just as Tina Fredericks at *Glamour* and Joan Fenton at *Seventeen* found Warhol a reliable and quick artist, Peter Palazzo, as art director of the I. Miller ad campaign, found Warhol "very good to work with, in the sense that the [blotted] technique was fast and that modifications were easy."[73] If Warhol had such a schedule for a single project and if he were a prolific artist who illustrated for a variety of magazines at the same time, how did he maintain his high quality and number of drawings?

This question becomes more intriguing in lieu of Alfred Carleton Walters's account of a "typical Andy day" at the time of the latter 1950s when Warhol was one of New York's most successful commercial artists:

> He would get up in the late morning, and his mother would make him some kind of breakfast. He would finish up some little thing that he was doing. He would put on his "Raggedy Andy" clothes, as you've heard people call them, with his shoelaces untied and things like that. His tie was all askew, and off he would go with his portfolio with his drawings up to I. Miller, let's say.
>
> Now, once he was there: they went over everything, and it was okay—the drawings—and they gave him another assignment. He might have had to go pick up another assignment from somewhere else, that he was working on.
>
> He would then, after that was finished, and, let's say, this was in the afternoon, he'd go to some very expensive pastry shop in New York, and he'd buy the most extravagant pastries or cakes possible, let's say.
>
> And then, he might buy a record, something that was on his mind, that he wanted, and, then, he would head back home. Sometimes he would eat all the stuff right away the minute he got home: eclairs and what have you. And, then, he would work in the evening. Again, his mother would make dinner. And that is really a typical day unless there was a party that he was going to, which, as I said, was quite often. He would work. . . . And he'd go to the theatre in the same way. It would be impulsive and at the very last minute.[74]

Walters depicts a man who is no recluse: going to parties (sometimes two in

one night), collecting, enjoying the theatre, the dance, and opera. Warhol is someone who loves pastry and who confects a deliberate, "Raggedy Andy" appearance, even at "a *very expensive* restaurant."[75] In short, Warhol became a society personality, and was a part of the café society of the restaurant-boutique Serendipity, as well as the creator of the "look" of a fashionable line of footwear: an observer of life and its dress, pose, and city life. Yet this does not answer the proposed question. What Walters describes is an artist-dandy who lives moment to moment. Society is his mirror, and he reflects it and is its reflection: an exquisite artificiality of style, as in the illustrative style of Warhol's shoe advertisements. Warhol *appears* in society. He *appears* as a naive "Raggedy Andy." And, as will become evident, his work *appears* to be eccentric, individual and, in fact, as deceiving to the uninitiated as is his appearance.

I. Miller's art director was one of the uninitiated. Embedded in my question to him is the answer:

PS: Did you find it unusual that he had assistants doing his work for him?

PP: [Sighs] I had seen that, but . . . I had heard that, I guess. I guess, shortly after this [I. Miller] period when he began to do more work. No. It didn't surprise me because I was familiar with the blotting technique, and it was easy to create.[76]

The answer also clarifies why Robert Fleischer, Warhol's friend and model, would characterize Warhol's work as "sloppy" and never on time. As head of the stationery department of Bergdorf-Goodman, Fleischer had Warhol design stationery and various kinds of seasonal greeting cards and notecards. Contrary to what the other quoted art directors have said about Warhol's work, Fleischer comments:

RF: He *hated* to do repairs. He *hated* to do, you know,—when you do a four-color process, you needed to do a black line drawing, after you do the original sketch and the final artwork, and you had to break it down by color separation. *He hated to do that!* You had to do your line drawing on one, and, then each color on a separate acetate, and then it was zeroed in on *exactly* the spot it had to hit to make the plates to run it. Well, his stuff was *so impossible.* It came in patched, torn, dirty, painted over in white where he had made a mistake. *Nothing* was zeroed in. Crosshatches never matched. I always used to have somebody redo all of that—the stationery line and the invitations and the Christmas cards—*completely* had to be reset up. They were on like scraps of paper. He *hated* to do anything like that. The things didn't register because he didn't know how to do it. He didn't have the patience. A lot of that stuff was accidental, and, then, he *used it,* and then that became his style.

PS: Do you think that was why he would employ someone like Nathan [Gluck] or Ted [Carey]?

RF: Oh, sure. I'm sure that was a part of it. Also, he *may* have had the eye problem, which healed eventually.[77]

Calvin Tomkins reports that Warhol went "to an oculist, who told him he had 'lazy eyes' and prescribed rather grotesque glasses to strengthen the muscles— the lenses were opaque with a tiny pinhole to see through."[78] Since at least the time that he attended art school, he has worn eyeglasses. During my interview with Bert Greene, Greene speculated that Warhol's interest, during the 1950s, in foreshortened photography is because of the idea that "Andy couldn't foreshorten in his mind."[79] Without medical records it remains an open question what, if any, optical condition(s) may bear on Warhol's art.

Fleischer's remarks concerning Warhol's difficulties in the preparation of color separation and his aversion to the repair of submitted artwork refer to his working methods, which are predisposed to expressive accident and to mannerist stylization. Warhol's blotted-line technique allows both to happen. Distinctive style in drawing and quickness in meeting deadlines are two reasons why Warhol's work was often used in fashion magazines.

In order to have as many illustrative commissions as possible, Warhol had employed assistants by 1955. His first assistant was Vitto Giallo, a freelance artist and coordinator of the Loft Gallery where Warhol showed his marbleized paper works and his crumbled drawings. According to Giallo, Warhol paid by the hour and would not indicate the circumstances of the drawings. During my interview with Giallo he commented, "Oh, gosh. He wouldn't say. All that he would say would be—just a lot of figures for the product or for the person for whom it was for . . . the client. I don't know."[80] Giallo would blot the "finished" drawing after Warhol's "original" one. He did this for several months and left Warhol's employment.[81]

Warhol's next commercial art assistant was his most important one. An associate of Warhol from 1955 until 1964–65, Nathan Gluck's work may be considered synonymous with his employer's commercial art. In fact, it is almost impossible to separate Nathan Gluck's "Warhols" from Warhol's "Warhols." A case in point is a 1959 *Wrapping Paper,* printed in offset and handpainted in Dr. Martin's dyes (fig. 8). The design consists of repeated images that were made by using carved art gum erasers. Since the images typify Warhol's winsome and enchanting illustrative style of this period, it would be otherwise assumed that all of the images were by the artist unless characterized by Gluck:

> This is Andy's *Wrapping Paper,* done with stamps carved out of a soap eraser, which is sometimes called "art gum." It's a brown kind of eraser, very easy to cut. Now, looking at it, I see. . . . Let's start from say, right to left. A man in the moon that I cut. A butterfly, I cut. [. . .] Andy did: the hearts, the stars, the black dots and maybe, the heavy sun face. And some of the others that I didn't name.[82]

Figure 8. Nathan Gluck and Andy Warhol, Wrapping Paper, ca. 1959
Stamped designs and hand-colored wash on paper.
(*Collection of Nathan Gluck, New York; © A.D.A.G.P.,
Paris/V.A.G.A., New York, 1986*)

This list of now-assignable attributions of this *one* work may be multiplied by the hundreds of works Gluck made for Warhol during the 10 years he spent with Warhol.

As with Giallo, Warhol paid Gluck $2.50 per working hour, and Gluck assisted Warhol from ten o'clock in the morning until two or three o'clock in the afternoon. He worked freelance during the rest of the day.[83] Gluck's importance to Warhol was apparently ironic. According to Warhol's then close friend Joseph Giordano, Gluck's work was considered by some as more Warholian than his employer's work:

> Nathan Gluck once had to do flowers, a sketch of flowers, for *Harper's* [*Bazaar*], I think. And he [Warhol] did several, and Nathan did several. And *Harper's* invariably, would pick Gluck's [drawings]. That used to upset Andy greatly, greatly.[84]

Warhol never told art directors that he had assistants, and only the rare visitor to Warhol's studio would have seen Gluck at work.[85] Warhol's admiration for Gluck may be gauged not only by how long he employed him but also by how he began to collect art and to fill his apartment with collectibles as did his assistant.[86] Among the techniques that Warhol borrowed from Gluck were the marbleized paper supplements painting on glass.

Among his commercial artwork, Warhol did freelance window displays for Gene Moore and then for Daniel Arje at Bonwit Teller. This exclusive department store's display department employed other artists, including Jasper Johns, Robert Rauschenberg, and James Rosenquist.[87] Unlike most of the store's displays which would feature a tableau of merchandise and mannequins, Warhol's work for Bonwit Teller involved painting on the window glass.[88] Nathan Gluck's friend Clint Hamilton worked for Bonwit Teller, and Hamilton asked Gluck sometime in the early 1950s, to decorate the store's outlet in White Plains, New York. Using poster paint, Gluck painted heart motifs for a St. Valentine's Day display on that store's windows; later, Gene Moore asked Gluck to decorate the New York outlet's windows.[89] After doing shoe and accessory ads for Bonwit Teller, Warhol did several window displays.[90]

One of Warhol's displays for Bonwit Teller consisted of dressmaker supplies painted in black poster paint on the inside of the windowpane, while the floor of the display was covered with brown marbleized paper over which sheets of glass had been placed. The wall was painted blue, and the display was flooded with blue lights from floor troughs. The mannequins were dressed in the store's copies of French and Italian original dress designs. A detail of this display, shown during October 1958, is published here for the first time (fig. 9).[91] This detail shows Warhol's continued interest in his earlier experiments in marbleized paper and his expressive combination of diagrammatic lines with simulated, blotted ones (depicting the contours of the dressmaker's dummy). Daniel Arje comments:

Figure 9. Andy Warhol, Window Display at Bonwit Teller, New York,
October 1958
(*Photograph courtesy of Gene Moore*)

The big impression I have of him [Warhol] was that when it came time to do the windows, he came in, actually, and did them on site. He did them right there: his drawings. It would be a verbal discussion [with Gene Moore], and, then, he would say, "Okay," and go and do it. I don't think in Andy's instance there was ever a sketch or any preparatory thing submitted to say, "This is the kind of thing that I can do or will do." It was all verbalized: "I'll go around the glass with tape measures and pin cushions." And, it seems to me, there's sometimes cherubs—his famous cherubs—holding something—a piece of fabric or something.[92]

Warhol relished any exposure of his commercial art, as opposed to Jasper Johns and Robert Rauschenberg, who signed their window display work with the pseudonym "Matson Jones" and who suppressed mention of their non-fine art.[93] Arje remarks:

Andy, of course, just adored the idea that he had the *whole notion* of what windows were about—here today, gone tomorrow, and the immediacy and the *reportage* and the journalism of it was, of course, right where his head was at.[94]

The transitory nature of fashion window display work is a part of Warhol's extensive commerical art career: a career that focuses an expressively linear stylization onto fashionable merchandise.

One of the most famous and distinguished names of New York's chic emporiums is Tiffany & Co. During the late 1950s, probably ca. 1959, Warhol did free-lance displays inside this store for Gene Moore, who was then the display manager of both Bonwit Teller and Tiffany & Co. One display campaign consisted of table settings of chinaware and silverware assembled by prominent socialites, celebrities, and artists. Eventually published in *Tiffany Table Settings*, Warhol's contribution was a children's birthday setting.[95]

In many of Warhol's endeavors he found people willing to donate assistance. Joseph Giordano, who worked at the agency Young and Rubicam during the late 1950s, became a close friend of Warhol and Mrs. Warhola. A daily visitor to the artist's studio-apartment, Giordano witnessed "coloring parties," in which Warhol had friends handcolor offset promotional books and brochures. An advocate for the tacit influence of Mrs. Warhola on her son, Giordano characterizes the artist's entrepreneurial enterprises:

It's a talent, and that's Andy's primary talent. It really is. He can get work. He can get the best, the best work that a person can do for nothing, and he learned that from his mother. . . . I know he used to have them coloring books night after night, day after day. Now, don't you think that's magic for him to get people to give up their time for nothing?[96]

One such "coloring party" assembled about half a dozen people to handcolor the pages for Warhol's book *Wild Raspberries*. For the page *Salade de Alf Landon* (fig. 5), Tom Lacy applied a wash of Dr. Martin's dyes over the offset-printed image. During my interview with Lacy, he provides an understanding of Warhol's working method and of his intention:

PS: Now, what was it, again, specifically, that he would say when you were coloring in the asparagus?

TL: Oh. I was doing them too carefully, and that's *not* a part of the way that he works. I was rather shocked even then, at least, that's the way my mind works—that he would have other people doing that . . . but I was having such a good time.[97]

Other "coloring parties" occurred at the restaurant-boutique Serendipity, whose co-owner Steven Bruce remembers:

> He would bring them in, and he would have five or six people with him. He would give them work, art work, to finish. Like: he was doing I. Miller ads and, then, weekly he would come in, and, I remember, one time he had a page of butterflies that he had printed or mimeographed, and he had all the people color in all of the butterflies with no direction or anything like that. . . . It was always different people, I think. People who were, you know, people who he was involved with, and a lot of them were very attractive, very nice people.[98]

Alfred Carleton Walters notes, "If you had helped him in some way, if you did an errand for him or if you helped him color something in, he'd call you up, and you'd have dinner at a really nice place. He *enjoyed* doing that."[99] Warhol's use of assistants, then, is either by employing someone full time or allowing friends to participate in an amusing pastime (such as Mark Twain's Tom Sawyer provided a "fun" time for his friends who painted a fence for him).

Tom Lacy mentions that Warhol wanted flowing, uneven washes of color over a printed image. Reminiscent of old handpainted books and prints, this kind of color overlay is a stylistic hallmark of Warhol's art. Gluck provides insight into Warhol's intention:

> That's the way Andy liked them, and that's the way Andy himself used to do it because if there's something that Andy didn't like was a complete, flat color wash, and I've since then done it, and, I think, it's a great effect. You put down the color very strong. You work at it. You let it fade out. If you bring it back, it gives an unevenness which gives it a richness and a depth to it.[100]

The flow of an application of color, by Warhol or by an assistant, parallels the expressiveness of his blotted-line technique and the distinctive, flowing script that accompanies an image by Warhol during this period.

The page of *Wild Raspberries* (fig. 10) exemplifies Warhol's printed— that is to say public—calligraphy. In fact, the handwriting is not by Warhol but by Mrs. Warhola, who formed each letter in script after her son supplied the text. Toward the later 1950s, Nathan Gluck would imitate her handwriting, and Warhol bought custom-made printed letters imitating her calligraphy.[101] Warhol's "real" signature (fig. 11) from this period is simple in comparison to

Figure 10. Andy Warhol, "Signature," 1954

Figure 11. Andy Warhol, Real Signature, 1954

the enchantingly animated and whimsical arabesques of his "public" signature:
a signature as a trademark similar to the logo used by Walt Disney and as a
sensibility corresponding to the expressive stylizations adopted by Warhol.
Warhol's published signature is a whimsical caprice just as the title of his
promotional recipe book is a gentle play on words. He combines the title of In-
gmar Bergman's film *Wild Strawberries* with the notion of a particular sound
of contempt—just as Suzi Frankfurt's recipes are delightful and topical
parodies of elaborate and contrived cuisine.[102]

If Warhol desired a technique that was associated with New York's fash-
ionable establishment, his success may be seen as credibly grounded by 1952
when he contributed diagrammatic illustrations to *Amy Vanderbilt's Complete
Book of Etiquette*.[103] Vanderbilt's book is a classic rulebook that proposes to
govern the nuances of modern American dress, poise, manners, and cere-
monies. Amenities and civilities stress common sense, simplicity, practicality,
and courtesy. Warhol and two other artists contribute simple, clear, and lucid
illustrations ranging from proper table settings, ceremonial arrangements, invi-
tations, and food preparation, to observances of social manners. Specific con-
tributions by Warhol are unknown.[104] However, he is credited for all of the
diagrammatic drawings for *Amy Vanderbilt's Complete Cookbook* (1961).[105]

Ten years after the *Complete Cookbook* appeared, Joseph Mascheck's *Art
in America* article, "Warhol as Illustrator," was the first consideration by an art
historian of Warhol's work of this pre-Pop Art period.[106] Mascheck's study
proposes that the Vanderbilt-Warhol

> collaboration was an event of a high order of importance in the social history of recent art,
> and a kind of microcosmic version of the readjustment of artistic and social relations which
> only now, a decade later is beginning to become clear. They [Warhol's drawings] are a real
> link between his merely commercial art infantilia and the fine art which came soon after, and
> they document his first [*sic*] tinkerings with the esthetic presuppositions of commercial
> graphics as material for his own play and workmanship.[107]

Warhol's drawings are characterized as being attuned to the "zeitgeist" of stan-
dardized illustration,[108] and especially as being influenced by French artist Fer-
nand Léger's still lifes of the mid-1920s and the 1930s:

> Warhol's row of glasses [. . .] presents a row of seven glasses in absolute profile. Three of
> them have the simple, *moderne* Duralex brand of fluting that Léger always admired, and in
> fact Andy's second vessel, a tall, conical soda glass, is the same—this time minus the flut-
> ing—as the beautiful glass Duralex example in Léger's *The Siphon* (1924).[109]

Such drawings by Warhol "were his rocket to stardom and the most vivid early
statement of his attitude toward the mundane.[110] Joseph Mascheck's basic as-
sumptions are: 1) Warhol's illustrative style before his Pop Art phase is dia-
grammatically lucid and explicit, 2) his drawings are "a foretaste of the paint-

ings that were to make Warhol famous,"[111] 3) Amy Vanderbilt and Andy Warhol closely collaborated on the *Cookbook*, and 4) the drawings in the book are all by Warhol.

Unfortunately, only one of Masheck's assumptions is grounded on fact. (The *Cookbook* drawings do provide a "foretaste" of Warhol's Pop Art paintings.) As characterized here, Warhol's illustrative style of his pre-Pop Art phase features an expressive, blotted-line technique with uneven color overlays and a flowing calligraphic "signature." Furthermore, though Warhol is credited for the diagrammatic drawings that "parallel" Léger's still lifes, he did not do all of the illustrations. Just as Robert Fleischer commented on Warhol's dislike of precise planning of illustrations and on the artist's hatred of corrections, Warhol began the drawings for the *Complete Cookbook* and then gave the commission and the entire fee to his friend Ted Carey, who was a free-lance commercial artist. During my interview with Carey, he mentions that the style of the *Cookbook* drawings was imposed by the publisher and that there was no "influence" or conscious "parallel" to Léger's style:

> There's an issue of, I think, . . . it is *Artforum* [sic] magazine, and it's an article on drawings, and there are some of Andy's drawings in there, and how they are influenced by Léger. And, I think, they're not influenced by him at all. . . . They are drawings that I did for the Amy Vanderbilt *Cookbook*. They're hand drawings. . . . *I did these drawings* [in Warhol's apartment-studio] over Florence's PinUp, and neither of us was anymore influenced by Léger. . . . He was having such trouble with the publisher, getting the things: if the hand wasn't exactly . . . , they were saying, "That's not the right way," . . . finally, he said, "If you finish the book for me," he said, "I will pay you the whole fee that I'm getting paid just to get rid of the book." I can't remember if we were given the dishes, and we worked from the dishes, or, whether we had photographs. I think, maybe, we had photographs.[112]

If the published drawings and rejects (fig. 12)[113] were based on samples or photographs, the stipulations of the commission were restrictive. Masheck speculates that "this project supplied an early occasion for Andy Warhol to show how he could make art by the gentlest esthetic tinkerings. [. . .]"[114] This characterization seems, in my opinion, to typify not the *Complete Cookbook* but the mannerist stylizations of Warhol's I. Miller advertisements in which Warhol *was allowed* to estheticize without restrictions commonplace but fashionable objects.[115] As a sponsored occasion in the fashionable world associated with Amy Vanderbilt, Warhol completed the *Cookbook* illustrations by means of a "ghost" artist. Warhol was willing to give Ted Carey the entire illustrator's fee because, one may suppose, he wanted to be credited and, therefore, associated with the project.

From all accounts, Warhol's artistic temperament accepts the possibilities of chance effects and the resulting change in the appearance of a drawing, even if such an alteration is made during the process of printing. Seymour Berlin, who printed many of Warhol's promotional books, comments:

Figure 12. Ted Carey, Reject Drawing for Amy Vanderbilt, *Amy Vanderbilt's Cookbook*,
ca. 1960
Ink and opaque correction fluid on paper.
(*Collection of Ted Carey, New York*)

If a job didn't come out right, Andy, maybe, even liked it better coming out differently than if he had made it. Sometimes he felt that it added different dimensions to something. So, he wasn't the type of customer that you had to duplicate *exactly* what he gave you.[116]

Another aspect of such chance effects concerns Warhol's blotted-line.

It is the stylistic variety of building up a residue of ink, speckles and blots that makes a line seem hesitant and backed up in Warhol's particular blotting technique. The expressive potential of accident and the nature of printing are two reasons why Warhol used this method which allowed fashionable looking stylizations. Why did he do blotted drawings? According to Fritzie Wood, who was an associate and neighbor of the artist, Warhol once said, "I like the style."[117] During my interview with Warhol, he remarked:

Well, it was just that I didn't like the way I drew. I guess, we had to do an ink blot or something [at college], and, then, I realized you can do an ink blot and do that kind of look, and, then, it would look printed somehow.[118]

According to Charles Lisanby, he and Warhol sketched flowers and other still life motifs during the 1950s and until the mid-1960s. During such sketching sessions Warhol never corrected or changed a drawing:

He would never apologize for something that didn't happen exactly as he intended. That's really the same characteristic of someone who assumes something that is incorrect, he won't correct their assumptions. He's very consistent. . . . It was that autographic handwriting . . . kind of *just* do it, and that's it. Whatever happens, that is what happens, and that is what is supposed to be.[119]

It is the transformation of an image—including visual "noise" and mistakes—that becomes a part of the process of producing art. From folded and marbleized paper experiments to autographed drawings with an expressive blotted-line and color overlay, Warhol explores multiple variants of the transmission of his images, their stylizations, and their distortions. Warhol's images are theatricalized ones in the sense that the presentation of a fashionable object becomes almost more important than the object itself, be it commonplace or marvelous. For Warhol, it is neither important nor to be asked if an image was by him or an assistant. To him, his images are studio products.

"Things the Mind Already Knows"

Using the design of the American flag took care of a great deal for me because I didn't have to design it. So I went on to similar things like the targets—things the mind already knows. That gave me room to work on other levels.

Jasper Johns in Steinberg, "Jasper Johns: The First
Seven Years of His Art," *Metro*, 1962

Comprehensive in its classified holdings, the New York Public Library Picture Collection subscribes to dozens of journals and other serials, and includes more than two million pictures depicting geographic views, flora and fauna, history, costume, design, etc., for public use. Large folders of pictures are filed under subject headings and subheadings. Alfred Carleton Walters was one of the librarians of the Picture Collection when he met Andy Warhol:

> Andy took out just hundreds of pictures. I don't know how he managed to do it, but he did and *very often* would lose them. And they were constantly sending him overdue notices, and he would finally end up paying for them rather than search for them because he knew he'd lose them. His—well, no doubt that you've heard from people who have visited his studio-apartments—there were just stacks full of things everywhere you looked. There was hardly any place for him to work.[120]

Walters also notes why Warhol used the Picture Collection:

> He would use them [pictures] for ideas. He would want a picture of such and such: like an old Victorian back porch because he needed to put it in an ad, to put a pair of shoes on it or something. And he'd go to the Picture Collection, and he'd get these out, and he used them *a lot* in his work. Sometimes he'd simply copy them.[121]

According to Bert Greene, Warhol's associate and friend, the artist copied photographs from newspapers:

> I remember Andy drawing. He was very tentative, but when he had an image he would take it. I mean, he would trace and, then, he would change it and redo it, and, then when he was doing those final inkings—at one point, he used to work on glass because it kept the ink longer. . . . He did something from *The New York Times* of a man hitting someone with an umbrella, I remember. He did it for *Seventeen* [*Magazine*].[122]

It is this wealth of pictorial source material and of the popular press that are the origins of many, if not most, of Warhol's pictorial art of this period.

From the time that Warhol was a youth, he read various illustrated magazines and comic books. He had access to fashion magazines when he was employed after school in the display department of the Joseph C. Horne Store in Pittsburgh.[123] In addition, his art school classmate Jack Wilson has recalled that Warhol read current and back issues of *Vogue* and *Life* magazines. In fact, Warhol ardently collected tear sheets from such periodicals. That is, he tore or cut out illustrations, ads, and photographs and kept them for ready reference. It remains an open question how often Warhol used photographic sources for his student artwork. But at least one of his paintings, done before 1950, was taken directly from a photograph.

Unfortunately the present whereabouts of this painting are unknown, but two facts about it are known. First, it was a large painting in the manner of the blotted ink drawings, and it was completed by 1949. Second, the painting's

subject matter was derived from one of the most famous photographs of violence and destruction in the twentieth century: H. S. Wong's 1937 photograph of a solitary Chinese baby in the just-bombed South Station of Shanghai (fig. 13).[124]

Warhol's (lost?) painted version of this photograph is significant because it is the earliest known work by him that was based directly on a photograph, and because it refers to an event which had saturated coverage by the world's mass media.

From Wong's newsreels of the Japanese bombings of the Chinese cities of Tsangchow and Shanghai during September 1937, the image of the solitary Chinese baby in the station's wreckage encapsulated the holocaust. Wong's picture was dispatched throughout the world and frequently reproduced. When *Life* magazine published the photo, the magazine's caption summarized its statistically iconic situation:

> He got this picture-of-the-week—a Chinese baby amid the wreckage. A print of it was sent through International News Service to all Hearst newspapers, totaling 25,000,000 readers, and to 35 non-Hearst papers totaling 1,750,000. It went in a mat reproduction to 800 other papers. International distributed the same picture, adding another estimated 25,000,000 readers. In the "News of the Day" newsreel, the sequence containing the baby was seen by some 25,000,000 movie-goers. Movietone News bought it and showed it to another 25,000,000. Together both newsreels are showing it to another 30,000,000 movie-goers abroad. This Chinese baby's potential audience: 136,000,000.[125]

The publicity and ubiquity of Wong's photograph and Warhol's choice of it for a painting, forecast one characteristic of his later documentary, Disaster Series, done throughout the 1960s. The presence and the shocking and haunting nature of Wong's photograph is a landmark of twentieth century photojournalism: the visual capture of a specific and historic event that is also a timeless subject.

Among the many illustrated periodicals of the twentieth century, it is *Life* that has had in America a significant, visual impact, only recently surpassed by film and television. From its debut issue of 23 November 1936, *Life* provided every week until 29 December 1972, an ambitious and innovative mixture of current events, history, the sciences, art and entertainment, and photographic features on almost every kind of activity. Its readers *saw* events from all parts of the globe. Moreover, the magazine's editors and art directors ingeniously refined and exploited the possibilities of photojournalism by means of careful and skillful pictorial layouts. *Life*'s photoessays supplied a readymade source of images.[126]

Warhol could have based his painting on Wong's photograph as it appeared in *Life*. When the artist was in art school, he would use photographic source material for accurate delineation of contours. His classmate Jack Wilson comments:

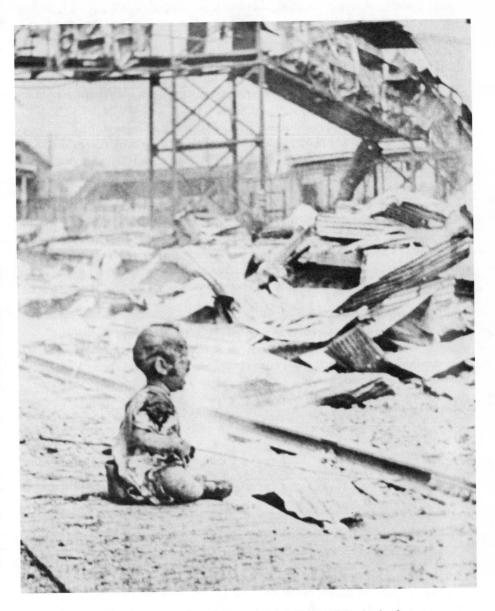

Figure 13. H. S. Wong, Photograph of Chinese Baby in the Just
Bombed South Station of Shanghai, 1947
(*Copyright © 1947 Estate of H. S. Wong*)

> Andy would go through *Life* magazine, and he would tear sheets. He was the only one [student] who did it. Andy's drawings are technically very correct because he used photographic copy. He used "scrap" intelligently.[127]

Warhol's use of such so-called "scrap" from *Life* forms one hallmark of his art: the use of the *photo trouvé*. Warhol was not, by any means, the first artist to use images based on photographs.[128] The use of imagery from *Life* may be noted in the work of many artists since the beginning of the 1940s.[129]

In fact, American commercial and illustrative artists throughout the twentieth century have utilized photographs as a basic tool. In his book *Forty Illustrators and How They Work* (1946), Ernest W. Watson regards this phenomenon and comments that photographic equipment may be found in the studio "of nearly every contemporary illustrator." Watson believes that such photographic equipment has revolutionized the profession of commercial art because it introduces "a new approach to illustration and substitutes new ideals for old."[130] Among Watson's profiles, there are several illustrators who extensively use photographic source material. For instance, magazine artist Roy Prohaska poses models for photos that are then reworked for his completed illustration.[131] Donald Teague projects photographs or photostatic sketches on his illustration board.[132]

In America, Norman Rockwell was one of the most well-known illustrators who has used photographs to supplement and complement preliminary sketches for a painting. In his 1946 book on Rockwell, Arthur Guptill shows how the illustrator completed a magazine cover, which included doing an initial sketch, assembling photographs of models and backgrounds, and tracing this photographic composite onto a canvas.[133] Guptill notes that Rockwell considered photographs as invaluable supplementary tools which are "especially helpful in recording transient effects, difficult poses, and subject matter far from the studio."[134]

The Picture Collection of the New York Public Library provides such artists an accessible source for a wide variety of pictorial and photographic material. Alfred Carleton Walters notes:

> And hundreds and hundreds and hundreds of people use that collection. It's a great resource file for a lot of people, and a lot of designers used it or artists used it. Television people used it if they were researching . . .[135]

Like the illustrators profiled by Watson and Guptill, Warhol used photographs as a basic pictorial resource. Warhol used a light box to trace pictures,[136] and by the late 1950s he was using an opaque projector for his drawings and early Pop Art paintings.[137] According to Charles Lisanby, Warhol often looked at photographs while he sketched.[138] One of Warhol's closest friends of this period was the photographer Edward Wallowitch, whose photos of children were the sources of many of Warhol's drawings.[139]

Not the least among the several attributed motives for Warhol's extensive use of photographic and other pictorial source material is convenience. With constant and short-term deadlines to meet, he would find a wealth of images at the Picture Collection. Once supplied with the art director's idea, Warhol would find its pictorial equivalent. In *Philosophy*, he writes:

> I loved working when I worked at commercial art and they told you what to do and how to do it and all you had to do was correct it and they'd say yes or no. The hard thing is when you have to dream up the tasteless things to do on your own. When I think about what sort of person I would most like to have on a retainer, I think it would be a boss. A boss who could tell me what to do, because that makes everything easy when you're working.[140]

Warhol's desire to make "everything easy" is his general attitude toward life: it should be effortless, simple, uninvolved, and practical.[141] He has had assistants since the early 1950s and has allowed his friends to participate in "coloring parties." He also used his mother's calligraphy as his "signature." When Mrs. Warhola was not available, Nathan Gluck imitated her handwriting. By the end of the 1950s, Warhol had bought custom-made printed type of the calligraphy.

One of Warhol's motives in buying an opaque projector was the ease it gave him in tracing an image onto a canvas.[142] In a sense, tracing a photograph is for Warhol one way to alleviate the "problem" of originality. Literally, Warhol takes "givens." Yet, does Warhol really only see, take, and transmit?

A crucial passage in Warhol's *Philosophy* answers this question. When working with an assistant or even choosing an associate, Warhol writes that there is a "certain amount of misunderstanding of what I'm trying to do"[143] on their part: recall that, during one of Warhol's "coloring parties," Tom Lacy did not understand the procedures of applying an overlay of color on an offset printed page. Warhol prefers that his associates misunderstand his work because:

> If people never misunderstand you, and if they do everything exactly the way you tell them to, they're just transmitters of your ideas, and you get bored with that. But when you work with people who misunderstand you, instead of getting *transmissions* you get *transmutations,* and that's much more interesting in the long run.[144]

Warhol not only allows chance and accidents to occur in his artistic process, but he also deliberately cultivates the changes of his original intentions by unwitting associates. The traditional esthetic distinction of a work of art as a final product and the artist as an author fades. Moreover, the Duchampian process of making art (by means of a profound Indifference) is redefined into an art game, in which there is a fascination and risk experienced while "playing" with possibilities of processes of making art. Warhol has no interest in fidelity to his interpretation when it is done by an associate. In short, to Warhol art is her-

meneutic transmutation: *any "meaning" occurs because of the transaction be-tween his creative consciousness and the (un)consciousness of his interpreter (assistant, viewer, or critic)*.

Warhol's repertory represents the remains of previous images which he de-constructs without any methodological eclecticism historicity. Rather, he deals with images—the debris or "scrap" from popular magazines, photographs, etc.,—so that he may put them into new contexts which are wholly his own. Any so-called "problem" of meaning is now no longer located exclusively in a preordained pictorial reality, but is subjugated—"signed"—by Warhol: a chosen image is displaced, and sometimes its origin is dispersed so that one has to reconstruct its context. In my opinion, Warhol's deconstructions are the in-stances of his accomplishment as an artist.

During his commercial art period, Warhol isolated an image from its con-text and would at times present it only in the simplicity of its outlined unit; at other times, he remodeled in a free play the nature—the "personality"—of an image.

Reconstructing this achievement is complicated because Warhol remains "silent" and because he has access to the "unclosed" inventories of this cen-tury's mass communications, press, and institutions (such as the Picture Col-lection of the New York Public Library). Yet, one may demonstrate Warhol's deconstructions of pictorial source material in works appearing as early as 1953.

In that year, Warhol wrote with "Corkie" (Ralph Thomas Ward) and pri-vately published his first promotional book, entitled, *a is an alphabet*.[145] Under Warhol's illustrations, which were drawn in his blotted-line technique, appear brief texts reminiscent of a child's ABC book. For instance, the U-page (fig. 14) has the following text: "U was an umbrella ant/who reminded this young man/of his favorite aunt." Warhol's blotted drawing depicts the outline of a fig-ure whose waist is bent and whose arms are stretched out. The figure's right leg appears to be in profile, while the left leg turns back as if to hold the body upright. At first Warhol appears to have taken a picture of a dancer who is per-forming a turn. The figure's left arm is foreshortened. Bert Greene has been quoted as saying that Warhol was fascinated by photographs featuring foreshor-tened figures because, Greene speculated, "Andy couldn't foreshorten in his mind."[146] Whether Greene's comment is or is not true, Warhol's drawing pre-sents an outlined, foreshortened figure that seems to be trying to keep balance.

In fact, the figure is doing just that. In the issue of *Life* magazine for 31 March 1952, there is a photograph of a teetering tightrope acrobat (fig. 15).[147] Warhol's blotted drawing omits most of the photograph's detail. Photographed from below, the tightrope supports the acrobat, who is wearing a striped shirt. Flags flap in the photograph's background, and there are a platform and trees. Warhol draws none of these details and includes only the outline of the ac-

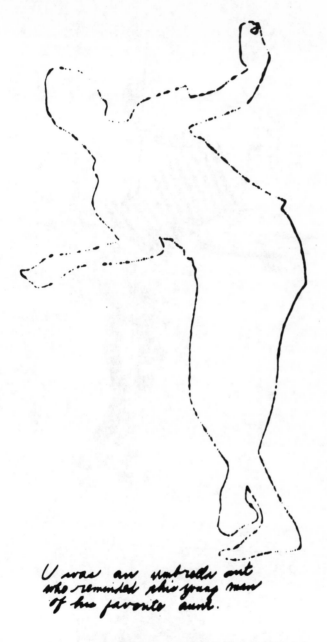

U was an umbrella ant
who reminded this young man
of his favorite aunt.

Figure 14. Andy Warhol, *U was an umbrella ant*
Illustration from Andy Warhol and "Corkie" (Ralph Thomas
Ward), *a is an alphabet*, New York, 1953.
(© *A.D.A.G.P., Paris/V.A.G.A., New York, 1986*)

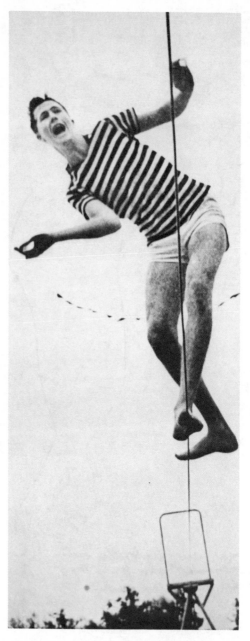

Figure 15. Photograph of a Teetering Tightrope Acrobat
(*Copyright © 1952 Time Inc. Reprinted
with permission*)

robat's figure and clothing. Taken out of context, the acrobat becomes the young man who sees an umbrella ant who reminds him "of his favorite aunt" in *a is an alphabet*.

The text for another page of this promotional book is: "C was a cricket/ who when chased by this young boy, hopped away and hid in a thicket." The drawing depicts a youth shown in three-quarter profile. Warhol omits contours except for those suggested by blotted hair and eyebrows. Curiously, Warhol omits any suggestion of a nose. The head is truncated on the viewer's right, leaving a blank margin. Why Warhol cut the figure is clearly understood when one sees the origin of the drawing: an ad for Curity first-aide dressings, which appeared in the 19 May 1952, issue of *Life*.[148] In this ad, a tearful, young boy watches a woman (off-camera), who is applying a Curity dressing to his hand. The boy's face is shown close-up, and the photograph's margin cuts off the back side of his head. Although Warhol omits the boy's nose, its tip almost breaks the outline of his face. Warhol does indicate his thick eyelashes, which protrude beyond the outline of the head. This drawing is of particular interest because it documents Warhol's use of advertisements as source material before any other American Pop artist (including Robert Rauschenberg and Jasper Johns) did.

Most of Warhol's drawings for *a is an alphabet* depict only the head of a figure. Four of these drawings indicate the different approaches that the artist uses to delineate traced photographs. The first approach is a simple, blotted outline of a head, with additional outlining of some facial feature. For the K page ("K was a Kala Azar/Who when caught by this young man/Was immediately made unhappy by being put in a jar."), Warhol's drawing outlines the head, neck, and eye of Franklin D. Roosevelt who appeared in a photograph in *Life* on 16 November 1953.[149]

The photograph shows the president "weak and tired,"[150] just a fortnight before his death, sitting at his desk in the White House. Warhol focuses only on Roosevelt's profiled, upturned head, while the text changes the context to a "young man." Another example of this approach is the drawing for the letter E, which depicts the horizontal outline of a male head in profile. Warhol includes a short blotted-line to denote a closed eye, above which is a thick eyebrow. It appears that the figure is sleeping and, in fact, the source of this drawing is a *Life* photo of a shirtless jockey (Tony De Spirito) who lies exhausted in a dressing room after a horse race.[151]

This first type of drawing features a profiled head with some denotation of facial features. A second type emphasizes hair curls within the outlined head. For the letter T, Warhol depicts such a strictly profiled woman. The facial feature here is a woman's eye, with the upper lid eyeliner extending well beyond the corner of the eye. The main emphasis of this drawing is curls of hair, those within the bounds of the outline and those which form the top of

the profile. The latter are curved and trail off to the right margin; the right side of the profile is unbounded and blank. Warhol's source for this drawing is a photograph that appeared in the magazine *Theatre Arts,* to which the artist was at the time a contributing illustrator. A photograph of actress Jane Cowl appeared in the September 1952 issue: the actress is in profile, and she holds a mirror.[152] Concentrating his drawing on only her head, Warhol includes the theatrical makeup of Cowl's eye and the curls of her frizzled, cottage-loaf hairstyle. Her hair bun is cut off by the photograph's margin, but Warhol retains the exact outline even though the final effect of the drawing remains curious.

A third type of drawing omits the nose unless the face is in profile, and it emphasizes the hair contours by denoting hair strands in the blotted-line technique. The young boy of letter C is an example of this type, as is the girl of letter F (which Warhol traced from a *Life* photo of a young girl hugging a doe).[153] Omitting the girl's barrette, the myriad of blots traverse and denote her curly hair.

A final type of drawing is either a full or three-quarter figure shown in outline, with additional features denoted within the outline, as in letter M. Traced from a *Life* photograph of Viscount Moore,[154] the drawing shows his upraised right hand, which holds a cigarette, within the outlined contour. Except for the nose, facial figures are indicated, and the viscount's mouth has been changed to a smile. Warhol clearly delineates each finger, the cigarette, the shirt cuff, and the bottom of the coat sleeve. The top of the sleeve is barely rendered in about a dozen small ink dots, as if to emphasize a continuous outline of the figure except for this upper part.

In the same year (1953), Ralph Thomas Ward supplied the text for Warhol's second promotional book, *There was snow on the street and rain in the sky.*[155] As in *a is an alphabet,* each of the 18 unbound pages has a blotted-line drawing above a text. The stylistic character of these drawings is also the same, featuring outlined full figures or heads in which facial characteristics are defined. The first drawing typifies these illustrations which were traced from some photographic or other pictorial source. In this case, Warhol chose a photograph from the 2 March 1953, issue of *Life* magazine: a close-up publicity photo of actress Geraldine Page, who appears in Vina Delmar's Broadway play *Mid-Summer.*[156]

Throughout the 1950s, Warhol employed such a blotted delineation as an abstracting process. For the February 1959 cover of *Dance Magazine,* Warhol drew a blotted-line portrait of the famous dancer-choreographer Doris Humphrey based on a publicity photo of her.[157] Unlike the drawings in his earlier promotional books, Warhol depicts all of Humphrey's facial features, and the seams of her blouse. The hair strands of the brows and the hair are emphasized. Despite delineation of her facial features, Humphrey's face appears *flat* because highlights that are seen in the photograph have been omitted.

One final effect these drawings have is an ambivalent discontinuity. Like Warhol's Oakland District project of his senior year (in which the viewer encounters collaged subject matter over which polychromed construction paper unifies and deflects the disparate images by means of a polychromed overlay), the artist's illustrative style of his commercial art combines color overlay with the visual "noise" of blots. The paper Warhol used for his promotional book *There was snow . . .* is a high-key, gold-leaf stock. In effect, the color of these pages is similar to the color overlays of Dr. Martin's dyes which were used in Warhol's promotional books such as *Wild Raspberries* (1959). An effect of discontinuity is also evident in his works that have no color overlays, as in his portrait of Doris Humphrey. Moreover, Warhol tends to "float" such drawings in blank space. He has transmuted his pictorial source material. Warhol's blotted drawings, with or without an overlay of color, deflect attention from the subject matter in that in the play of the possibilities of using various art processes, there is a disassociation between an image and its perceived presentation. Warhol deconstructs images. He does not structure lines and colors for coherence, but, for incoherence by means of distractions: omitting facial features; details depicting the contours of hair but not of the face; allowing assistants to misapply bright color overlays to printed images; abstracting images from their original contexts; and allowing chance and accident to supplement such artistic play. These deconstructions are evident in his work during art school, his commercial art career, and his Pop paintings and drawings.

To perceive such images is to construct them. The viewer, for example, fills in the missing contours, facial features, and other parts of a deconstructed picture. Warhol's friend and associate Bert Greene provides the artist's conscious intention:

> He also learned to leave out. I remember, Andy drawing these things from *The* [*New York*] *Times,* and, I remember he said, "The important thing is to leave out" " . . . which you leave out." And he said, "What you leave out, you can always put in later." I mean, add a little.[158]

Warhol's sense of omission begins with a pictorial source that provides a complete image, which he then deconstructs. For instance, the photographs from *Life* and *Theatre Arts,* which are the basis for his abstracted drawings in *a is an alphabet,* are the remains of his tear sheets from those magazines, and the dates of publication (14 January 1952 to 16 November 1953) denote, in part, Warhol's allowing an accumulated inventory of images to be used.

The date of the publication of an image denotes when Warhol did a drawing. For a commercial Christmas card, which Andreas Brown dates to 1954 without any documentation,[159] Warhol most likely traced from a reproduction of a woodcut of five medieval entertainers that appeared in the November 1955 issue of *Dance Magazine.*[160] Warhol could have traced the two figures from the woodcut before it was reproduced in *Dance Magazine.* A more certain date for

the Christmas card is, in my opinion, after the publication of the woodcut in this periodical, since Warhol used such popular mass-distributed magazines as pictorial source material.

In fact, Warhol's use of popular imagery includes tracing the handcolored lithographs and chromolithographs of Currier and Ives. Two such prints, from 1846, are entitled *The Lovers' Quarrel* and *The Lovers' Reconciliation* (figs. 16 and 17). Warhol traced these prints for two of the 24 unblotted drawings in his 1953 promotional book *Love Is a Pink Cake.*[161] This book was printed on light blue paper. Text by "Corkie" (Ralph Thomas Ward) is below each drawing of famous historical lovers. This unbound book of Warhol's drawings features his line illustrations from this period. In *Love Is a Pink Cake,* the drawing of Chopin and George Sand (fig. 18) is the result of Warhol's deconstruction of the Currier and Ives print *The Lovers' Reconciliation* (fig. 17). Warhol most likely did not trace this print but, rather, delineated it. One may note that the couple's clasped hands are slightly elevated in the artist's drawing. Like Warhol's other two promotional books printed during the same year, he omits all of the background. While the male figure in the print remains relatively unaltered, the woman's figure and accessories are simplified. Warhol leaves out her necklace and bracelet, simplifies her hat, and changes the Ingres-like rendering of her arms to simple, straight lines. Likewise, Warhol's drawing of Oscar Wilde (fig. 19) is a delineation of the male figure in the Currier and Ives lithograph *The Lovers' Quarrel* (fig. 16). The figure is still similar to the print, but becomes eroticized by Warhol, who adds an emphatic line at the crotch. The man in the print leans on a chair, but, when taken from its context, the figure's right hand appears in a limp-wristed, effeminate gesture that is, one may suppose, suitable to denote Warhol's depiction of Oscar Wilde. Both drawings also omit any shading. In the print the hair of the figures glistens with highlights, whereas Warhol depicts such highlights either not at all or as blank space. Similarly, flesh and clothing are rendered in simple, linear strokes that define contour but not depth, outline but not chiaroscuro.

Warhol transmutes his pictorial models. Although he may delineate or trace images, his completed work of art is a treatment, not a "copy" per se. His fascination with marbleized paper and handpainted color overlays on top of printed pictures, and his privately printed promotional books indicate, in part, his interest in old books. Alfred Carleton Walters, Warhol's close friend and model, tells of the artist's extensive collection of books:

AW: He [Warhol] would buy books if something struck his fancy or if some friend of his had been involved doing a book or designed it.

PS: Do you remember him collecting old books? For instance, Grandville?

AW: Yes. He would collect things like that because he enjoyed the drawings in them.

Figure 16. Currier & Ives, *The Lovers' Quarrel*, 1846
Lithograph.

Figure 17. Currier & Ives, *The Lovers' Reconciliation*, 1846
Lithograph.

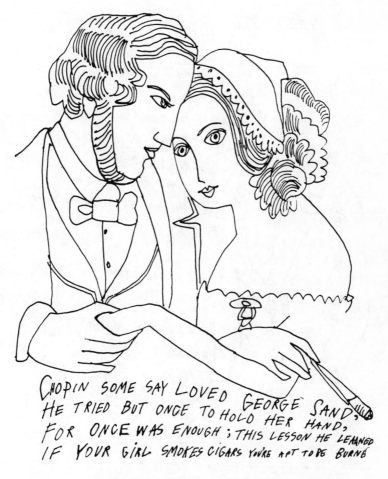

Figure 18. Andy Warhol, *Chopin Some Say Loved George Sand*
Illustration from Andy Warhol and "Corkie" (Ralph Thomas
Ward), *Love Is a Pink Cake*, New York, 1953.
(© *A.D.A.G.P., Paris/V.A.G.A., New York, 1986*)

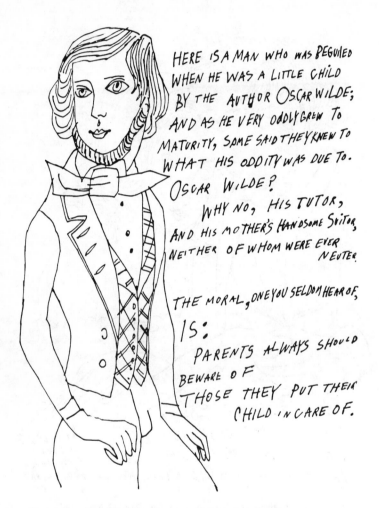

HERE IS A MAN WHO WAS BEGUILED
WHEN HE WAS A LITTLE CHILD
BY THE AUTHOR OSCAR WILDE;
AND AS HE VERY ODDLY GREW TO
MATURITY, SOME SAID THEY KNEW TO
WHAT HIS ODDITY WAS DUE TO.
OSCAR WILDE?
 WHY NO, HIS TUTOR,
AND HIS MOTHER'S HANDSOME SUITOR,
NEITHER OF WHOM WERE EVER
 NEUTER.

THE MORAL, ONE YOU SELDOM HEAR OF,
IS:
 PARENTS ALWAYS SHOULD
BEWARE OF
 THOSE THEY PUT THEIR
 CHILD IN CARE OF.

Figure 19. Andy Warhol, *Here Is a Man Who Was Beguiled*
Illustration of Oscar Wilde from Andy Warhol and "Corkie"
(Ralph Thomas Ward), *Love Is a Pink Cake*, New York, 1953.
(© *A.D.A.G.P., Paris/V.A.G.A., New York, 1986*)

PS: Do you remember anything else, specifically?

AW: Well, you can understand why he would like Grandville. It's so amus-
ing and beautiful. Yes. He would buy things, and sometimes they
were very expensive things. If something took his fancy, he'd just buy
it. It didn't matter what they cost. . . . In fact, I still have a Grandville
drawing of some flower that looks like a woman and she's walking
along this bank of a stream, and there's this beetle that accosted her,
and she, sort of, takes a start. And, occasionally, I would buy things
like that for Andy if I found an individual sheet. Books were often cut
apart for the illustrations, and on Fourth Avenue in those days, you
could sometimes, if you went through those bins of prints, you'd find
an old hand-colored Grandville or something.[162]

The Grandville print is one of the handcolored illustrations in *Les Fleurs
animées* (fig. 20).[163] The Grandville illustration is a delightful anthropomorphic
fantasy, in which two flowers discover two beetles among the reeds, one play-
ing a rattle and the other a violin. Another illustration from the same book fea-
tures a personified tulip (fig. 21). These two prints are among several pictorial
sources Warhol used for his promotional book *In the Bottom of My Garden*
(1956).[164]

 When Andy Warhol and Charles Lisanby were traveling around the world,
they bought in Amsterdam a series of illustrated children's books whose
chromolithographic illustrations featured a series of seasonal books of flower
personifications. According to Lisanby, these books inspired them to collabo-
rate on *In the Bottom of My Garden* when they returned to New York.[165] The
book's title refers to the Rose Fyleman and Liza Lehmann song *There Are
Fairies at the Bottom of Our Garden,*[166] made famous by Beatrice Lillie.[167]
(During the same year, Warhol constructed *Beatrice Lielie* [*sic*], one of his per-
sonality-shoes.[168]) In his blotted, and then handcolored drawings in *In the Bot-
tom of My Garden,*[169] Warhol depicts one of the song's beetles (fig. 22) from
Grandville's *Les Fleurs animées* (fig. 20). Grandville's personified tulip (fig.
21) is similar in costume to Warhol's rendition of the song's Fairy Queen (fig.
23).[170]

 Another pictorial source for Warhol's *In the Bottom of My Garden* is a
seventeenth-century illustrated book of children's games by Jacques Stella.[171]
Rainer Crone has shown that Warhol used two of the illustrations from Stella's
book.[172] One of Warhol's *Garden* drawings (fig. 24) omits the landscape but
adds wings to Stella's illustration *Le Jeu de pet en gueule* (fig. 25). In another
Garden drawing (fig. 26), Warhol adds wings to two background figures of
Stella's illustration *Le Batonet et la charrue* (fig. 27). In the latter, Stella depicts
two children playing a wheelbarrow game. Warhol has changed the children's
stance obliquely so that they seem to show one cupid held in flight by the prone
one: Warhol suggests, moreover, an "innocent" homoerotic sexual encounter.

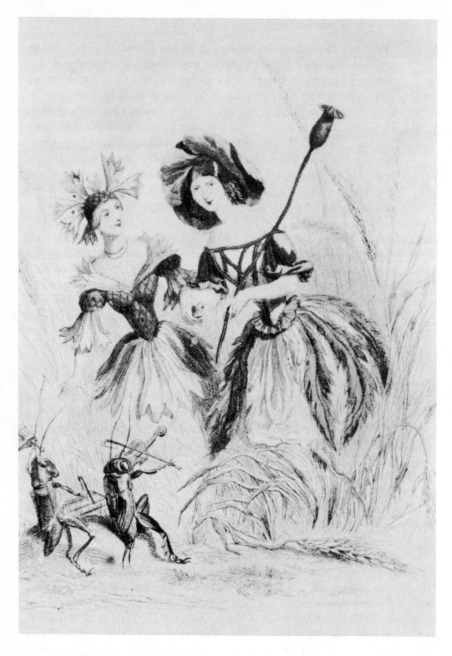

Figure 20. Grandville, Illustration of Two Personified Flowers and Two
Beetles from *Les Fleurs animées,* Paris, 1846

Figure 21. Grandville, Illustration of a Personified Tulip from *Les Fleurs animées*, Paris, 1846

Figure 22. Andy Warhol, Illustration of a Cricket and Fairy from *In the Bottom of My Garden*, New York, 1956 (© *A.D.A.G.P., Paris/V.A.G.A., New York, 1986*)

Figure 23. Andy Warhol, Illustration of Two Cupids and a Flower Fairy from *In the Bottom of My Garden*, New York, 1956
Additional hand-colored wash applied to page.
(© *A.D.A.G.P., Paris/V.A.G.A., New York, 1986*)

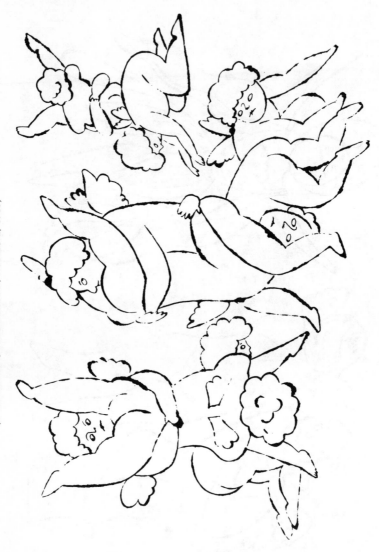

Figure 24. Andy Warhol, Illustration of Cupids from *In the Bottom of My Garden*, New York, 1956

(© *A.D.A.G.P., Paris/V.A.G.A., New York,* 1986)

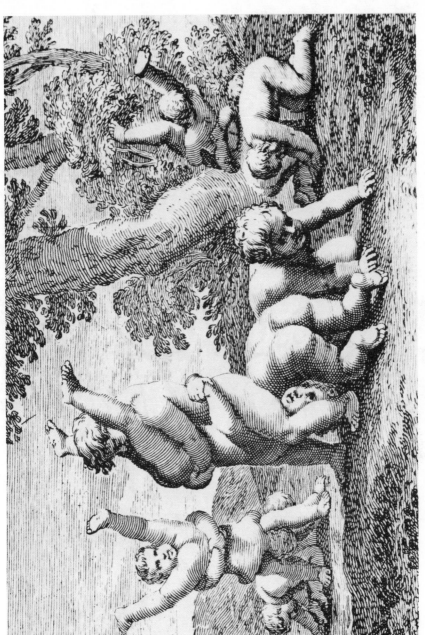

Figure 25. Jacques Stella, *Le Jeu de pet en gueule*
Illustration from *Les Jeux et plaisirs de l'enfance*, Paris, 1657.

Figure 26. Andy Warhol, Illustration of Two Flying Cupids from *In the Bottom of My Garden*, New York, 1956
Additional hand-colored wash applied to page.
(© *A.D.A.G.P., Paris/V.A.G.A., New York, 1986*)

Figure 27. Jacques Stella, *Le Batonet et la charrue*
Illustration from *Les Jeux et plaisirs de l'enfance*, Paris, 1657.

One effect of Warhol's whimsically ribald drawings in *Garden* is described by Charles Lisanby:

> And he [Warhol] was very fascinated by sexual things, such as that, and I don't know what the original artist [Stella] meant by this [print], but his [Warhol's] idea was that it was "naughty." But it is, really, so innocent and so naive, and that is the charm of it all.[173]

Such "naughty" cherubs were depicted by Warhol throughout the 1950s,[174] and these "innocent," childlike enchantments are a part of his eroticized ideal of glamour. "I don't know anybody who doesn't have a fantasy," Warhol has written, "Everybody must have a fantasy."[175] The artist has also commented, "Beauty doesn't have anything to do with sex. Beauty has to do with beauty and sex has to do with sex."[176] Evidence from at least 1951 suggests that Warhol has been ardently interested in sketching highly erotic situations.[177] In fact, Joseph Giordano's portrait by Warhol (fig. 28), was drawn while Giordano was reclining. My interview with Giordano clarifies this "corrected" viewpoint:

JG: Yeah, that's me. I have other things like this.

PS: Now, did he [Warhol] sketch you from life?

JG: Yes.

PS: What would he say? Would he say, "Would you model for me?" Or, would he just sketch?

JG: He wouldn't say, "Would you model for me?" Ah. He would just pick up the pen and do it. And you always had to be on the bed. That's another thing: he could only sketch in the bedroom. You know? [Giordano turns the drawing vertically, as opposed to the horizontal viewpoint in Rainer Crone's 1976 catalogue of Warhol's drawings.][178]

Similar drawings of Charles Lisanby and other young men were exhibited during 1956 at the Bodley Gallery.[179] One of these drawings was used to announce this show, and it depicts a young man's head (fig. 29). The man's eyes and lips are closed. The head is back slightly and the hair at the back of the head is cut off, leaving a marginal void. Lisanby was the model for this drawing. During my interview with Lisanby, he said that Warhol drew him during a nap.[180] Moreover, the back of Lisanby's head, sunk into an undrawn pillow, follows the contour of that headrest. As with his portrait of Giordano, Warhol signs the drawing as if Lisanby were sitting or standing. Warhol's drawing is shown here as it was sketched originally.

These so-called "Boy Portraits" were to be published, and the book was to be entitled *The Boy Book*.[181] Apparently, it was to feature similar young

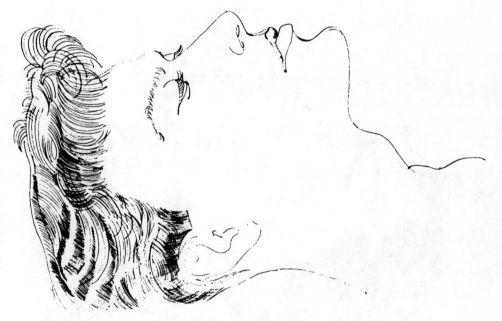

Figure 28. Andy Warhol, *"Boy Portrait": Joseph Giordano*, ca. 1959
Ballpoint pen on paper, 16½″ × 13¾″.
(© *A.D.A.G.P., Paris/V.A.G.A., New York, 1986*)

Figure 29. Andy Warhol, *"Boy Portrait": Charles Lisanby,* ca. 1956
Photograph taken from gallery announcement and positioned here as drawn.
Ballpoint pen on paper.
(*Present whereabouts of original unknown;* © *A.D.A.G.P., Paris/V.A.G.A.,
New York, 1986*)

men, in the manner of Jean Cocteau's homoerotic illustrations for Jean Genet's *Querelle de Brest* (1947), a copy of which was owned by Lisanby and admired by Warhol.[182]

Stylistically, Warhol's "Boy Portraits" are much more similar to Cocteau's drawings of Raymond Radiguet, which were published in Cocteau's *Dessins* (1923).[183] Warhol was familiar with these drawings because Gluck owned a copy of *Dessins*. According to Gluck, "Andy thought it was a great book and wanted to get a copy."[184] In fact, Warhol once claimed that he owned a privately printed book of Jean Cocteau's homoerotic drawings (*Querelle de Brest?*), and he met Cocteau at least twice during the 1950s in New York.[185]

Cocteau's ink sketches of Raymond Radiguet delineate his body, while short strokes and variegated lines form his hair. Undetailed, Cocteau's drawings tend to emphasize enlarged lips and the smooth plane of the side of the head. Similarly, Warhol's "Boy Portraits" emphasize the tenderness of young men, depicted as sensual ideals of the male body. As opposed to the vitality of Warhol's *putti* in *In the Bottom of My Garden,* his "Boy Portraits" are passive sex objects: recognizable and desirable "male odalisques" with narcissistic grace.[186] Warhol's idealized drawings of nude and clothed male bodies are a part of his association with "very attractive, very nice people."[187]

In 1957, Warhol printed the promotional suite of elegantly bound drawings of children and other "Boy Portraits." Entitled *A Gold Book,*[188] the 19 blotted drawings are printed on gold paper. Colored tissue papers are between the pages, and some of the drawings included handpainted overlays of Dr. Martin's dyes. The drawings are either traced from photographs by Edward Wallowitch or from Warhol's own sketches.[189] The title page includes a blotted drawing of a young street hustler. Similar to the publicity photos of James Dean from the 1955 film *Rebel without a Cause,* Warhol's virile youth wears blue jeans and a leather jacket and smokes a cigarette. Naive and gauche, this curly-haired young man confronts the viewer with the combative adolescence of a James Dean, yet also appears as a passive and narcissistic sex object.

Among the *Gold Book* drawings are male hands holding plucked flowers. One drawing depicts a handsome young man holding a cut rose sprig in his mouth (fig. 30). Another New York artist and window display designer, Dudley Hopler, represented the latter in a series of drawings done during the early 1950s. Reproduced here for the first time, one of his drawings, *Young Man with a Rose* (fig. 31), demonstrates the similarity between Warhol and Hopler: Hopler's pointilist ink drawing appears to parallel Warhol's refined blot technique, and the subject of both artists is a so-called "Boy Portrait." Hopler and Warhol were friends during this period, and Warhol collected Hopler's dot drawings of such sensuous young men holding flowers in their teeth.[190]

Another promotional book by Warhol during the 1950s is *25 Cats Named Sam and One Blue Pussy* (1954).[191] The "text" is written by Charles Lisanby—

Figure 30. Andy Warhol, *"Boy Portrait"*: *Boy with a Rose*
Illustration from Andy Warhol, *A Gold Book,* New York, 1957.
(© *A.D.A.G.P., Paris/V.A.G.A., New York, 1986*)

Figure 31. Dudley Hopler, *Young Man with a Rose*, ca. 1955
Ink on paper, 8″ × 10½″.
(*Collection of Jerry Lang, New York*)

every drawing but one is captioned "Sam," and the title page is followed by a colophon. According to Warhol's printer, Seymour Berlin, 150 copies were printed, but the colophon lists 190.[192] Part of the whimsey of Warhol's promotional books concerns the numbering of the copies. Nathan Gluck explains:

> Now, Andy got the idea that everybody wanted to have low numbers. So, he never kept track of the numbers. So, he would arbitrarily just write numbers: 190, 17, 16, and so on. He had all of these printed up, and then he had friends—whoever he could muster—watercolor with Dr. Martin's dyes these drawings of pussy cats.[193]

After the blotted drawings were printed, Warhol would have another "coloring party" at his apartment-studio on Lexington Avenue. On the top floor of Warhol's duplex, the artist kept seemingly innumerable Siamese cats, all named "Sam." Seymour Berlin remarks:

> Whatever Andy did, I personally felt, there was a purpose behind it. . . . Well, even the cats that he had in his house. The things that he did were to gigantic extremes, and, I think, there were purposes to these extremes. I think, they weren't just extremes because he was an extremist. I think, there were actually purposes to these extremes. In other words, *they were carefully planned effects* to be had for that and *not* just going in and seeing a million cats running around and saying, "Isn't he wild!" I think, this is what Andy looked for, this kind of response, "Isn't he wild, having 20 million cats running around!" That did not just happen like an eccentric.[194]

The exaggerated effect of having dozens of loose cats in his apartment was part of Warhol's notoriety during this period. In fact, in more than 50 of my interviews, Warhol's many cats were vividly remembered by his friends and professional associates.

To have a lot of cats gave Warhol a unique opportunity to draw his pets. His *25 Cats* has delightful and typical poses, attitudes, and activities of cats and kittens. One blotted drawing, depicting a close-up of one (fig. 32), may summarize Warhol's working methods and attitude toward his art of this period. The offset-printed drawing has an uneven wash of bright Dr. Martin's dyes which were applied during one of the artist's many "coloring parties." Moreover, despite the fact that Warhol continually sketched from life throughout this period, he has traced this feline image from a photograph from Charles Lisanby's copy of *All Kinds of Cats* (1952), a photobook by Walter Chandoha.[195]

As Nathan Gluck has remarked: "Andy was notorious for having things around and just drawing from photographs."[196] By tracing, Warhol could eliminate detail and take the photographic source material out of its original context. Like other commercial illustrators, Warhol used pictorial "scrap" for ideas. Taking images from *Life* magazine or from old handpainted prints, his pictorial repertory is the remains of such images which he then deconstructs and signs.

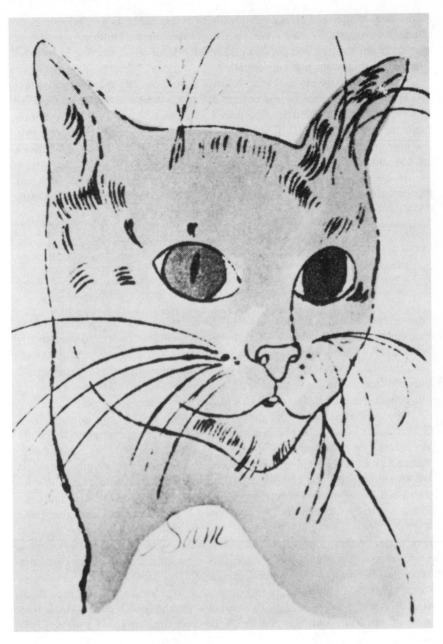

Figure 32. Andy Warhol, Illustration of a Cat from *25 Cats Named Sam
and One Blue Pussy*, New York, 1954
(© *A.D.A.G.P., Paris/V.A.G.A., New York, 1986*)

He isolates images and shows them in themselves, either as simple outlines or remodeled pictures. Warhol's having access to an almost limitless repertory of imagery from the past and present makes the task of reconstructing his playful approach difficult but not impossible.

The complexity of studying Warhol's commercial and illustrative art period may be indicated by the correct dating of Warhol's drawing *Mug with Flowers* (fig. 33), which is reproduced in Rainer Crone's 1976 exhibition catalogue *Andy Warhol: Das zeichnerische Werk, 1942–1975*.[197] Before discussing Crone's assignment of the drawing's date, Crone's critique of Warhol's art and career will be summarized.

In his book *Andy Warhol* (1970),[198] Crone argues that for the most part former critical commentary about Warhol has been concentrated on the (sensational) anecdotes of the artist's lifestyle in public during the 1960s:

> None of his [Warhol's] contemporaries has had his personality described to the extent that Warhol has, a fact that actually has little to do with Warhol the person, about whom we know little more than that he is shy and cool. But since his works do not conform to traditional ideas about art, the critics shift their emphasis to the individual, celebrating Warhol the singular and sensational person, rather than coming to terms with his works.[199]

Crone eschews such "misunderstanding" for an ideological interpretation based upon historical materialism,[200] Bertolt Brecht's conception of "Alienation Effects,"[201] and observations concerning techniques and media.[202] Crone's post-Hegelian and neo-Marxist attitudes necessitate suppositions that omit certain facts of Warhol's life and career, and the dating of Warhol's *Mug with Flowers* will demonstrate the different approaches by Crone and by myself.

One supposes that Crone dates this drawing on stylistic grounds from 1956. He assumes that Warhol jettisoned such a simple sketching style for the "documentary realism" during his Pop Art period, the Disaster Series being representative. With frivolous humor and fanciful serendipity, Warhol depicted various amusements and mannerist stylizations. At first, it would seem that he abandoned the expressionist realism of his student works and then abruptly resumed it with Pop Art. In turn, he abandoned Pop Art realism for an ultra-fashionable consciousness during the 1970s. He featured photographs of New York's café-society sophisticates in *Andy Warhol's Exposures* (1979), and a combination of stunning photographs but innocuous conversations with the "Beautiful People" in his monthly magazine *Interview* (1970–the present). These stylistic differences seem incongruous to Warhol during his career as an artist. However, what remains is Warhol's psychological absorption of the facets of modernity and its personalities, objects, situations, and projected fantasies.

Crone's analysis attempts to describe such stylistic differences and economic situations. He characterizes the stylistic changes as being some "confrontation" between opposing fantasy and realism.

Figure 33. Andy Warhol, *Mug with Flowers,* ca. 1965
Pencil on paper, 24″ × 18″.
(*Collection of Charles Lisanby, New York;* © *A.D.A.G.P.,
Paris/V.A.G.A., New York, 1986*)

However, Warhol's *Mug with Flowers* and its correctly assigned date may demonstrate that these presumptions are without foundation, because of the facts regarding this drawing (owned by Charles Lisanby). Warhol and Lisanby remained close friends from the 1950s until the mid-1960s. That is, they were friends until Warhol and his so-called "Superstars" achieved infamous repute. By the mid-1960s, Warhol's films were featuring amphetamine raptures, narcissistic eroticism, and outrageous and exhibitionistic behavior. In my interview with Lisanby, he said that one reason why he severed his friendship with Warhol was because of Warhol's public notoriety with the Underground, which dramatically changed when Warhol was alone with Lisanby. According to Lisanby, Warhol would leave his studio (called then "the Factory") and its subsumed Underworld at the end of a day and then visit Lisanby at his more sedate and tranquil apartment. Warhol and Lisanby would then sketch. Warhol would use his blotted-line technique and the "unmechanical" style of freehand sketching. Lisanby recalled that he and Warhol would sketch flowers during a typical evening in his apartment from the mid-1950s through the height of Warhol's "Pope of Pop" phase. By way of example, *Mug with Flowers* provides an insight into Warhol's art and career because, according to Lisanby, this drawing was sketched ca. 1965. Such a personal *aperçu* illustrates some of the contradictions and incongruities of Warhol's art and career.

Warhol's Involvement with Theatrical Productions

For two brief periods during his commercial art career, Warhol was directly involved in theatrical productions in New York. The first occurrence was during six months of 1953, when Warhol briefly joined a theatrical group formed by Bert Greene and Dennis Vaughan.[203] Greene was a playwright and an art director for an advertising agency.[204] Vaughan had acted and directed student productions at the University of Virginia, where he had majored in English literature and drama and where he became very interested in Jacobean Closet Drama and eighteenth-century British theatre.[205] Beginning in the summer of 1953, Greene and Vaughan had begun a weekly reading group in Greene's Greenwich Village apartment on West 12th Street. The group, which called itself "Theatre 12" (previously "The 12th Street Players"), included 15 to 30 volunteers who would read historical and contemporary plays on weekends. On the following Monday, the group discussed the form and content of the plays, chose a reading for the next weekend, and read another play.[206]

The weekend productions were "staged" in Greene's apartment with readymade props and sets, and the audience would contribute money for refreshments.[207] Situated in a large living room with doors to various rooms on each wall, the audience sat on rented chairs around the room's center, where the volunteers would read.[208] Works read by the group included William

Wycherley's *The Country Wife* and Dylan Thomas's *Under Milk Wood,* as well as works by Shakespeare, Chekhov, and Ibsen. In 1955, the group rented a Greenwich Village theatre and produced a reading of Sartre's *The Flies.* The same year they produced a dramatization of Kafka's *The Trial.*[209] By late 1955 the group had disbanded, but one of its original members, Fritzie Wood, revived the dramatic reading group at her apartment in Warhol's apartment building on Lexington Avenue.[210]

Two of the original members of Theatre 12 were Lois Elias and George Klauber. Mrs. Elias is an actress and married to Warhol's art school classmate, Arthur Elias. Klauber, another classmate, introduced Warhol to Theatre 12.[211] According to Bert Greene, Warhol's speaking manner was useless to the group, and the artist's "terrible reading manner"[212] contributed, at best, a very amateur performance:

> And then little by little it became . . . A certain professionalism came into it. People who weren't such good actors would drop out, or would just come and listen, and better people would come, and Andy was one of those people. And I remember Andy reading this play *The Way of the World* very badly. He was a very bad reader, and a very bad actor. He has no voice, and he has no ability to project at all. He was a very poor actor.[213]

In fact, Warhol was unwilling to take free speech lessons or undergo Vaughan's acting and improvisational exercises in order to improve any ability he may have had:

> But he [Warhol] said he felt it was getting too tough and it meant something that he would not be willing to do, to change or to have to develop his voice or use his body in a certain way. And that's when we lost him.[214]

While Warhol was with the group Greene characterized him as "just there" and "a voyeur,"[215] reading bit parts and listening to post-production discussions. To Greene, Warhol was "not valuable to us,"[216] and he was considered a "dilettante" by the group.[217] Warhol's participation in the group's readings was, then, minimal. When Mrs. Wood revived the dramatic reading group, Warhol never attended any of the sessions, even though he lived in the same brownstone apartment building.[218]

Why discuss Theatre 12 in relation to Warhol's art and career? First, Warhol designed sets for several of the group's productions in 1953. Second, the only significant commentary on Warhol's commercial art has been by Rainer Crone, and Crone's Marxist interpretation of Warhol's art and career is grounded in certain allegedly conclusive facts concerning Warhol and Theatre 12.

Warhol's sets for Theatre 12 were essentially only backdrops because no budget existed for any decor other than readymade material. Among the three productions that Warhol designed was William Clifford Larnur's *The Days of*

the Bronx, a play about an aging singer planning a comeback.[219] On the day of the first performance, Warhol quickly sketched famous theatrical personalities for a scene that took place in a nightclub similar to Sardi's, famous for its caricatures of celebrities. One such drawing (fig. 34) featured Sarah Bernhardt. Bert Greene comments:

> Andy did a free interpretation of all these caricatures, and he made a lot of them, and he pasted them on the wall. We made a wall, we took all the pictures off the wall, and we pasted these things. And he made a bar out of cardboard. And he drew on it, in a very free way.[220]

Using India ink, Warhol sketched these celebrities in a way that suggested the caricatures at Sardi's, including even an autograph in the lower right-hand side.[221] For another play by Larnur, Warhol sketched on a folding screen.[222] He did similar improvisational sketches for Aaron Fine's *My Blackmailer* on another folding screen, one side of which suggested a doctor's office and the other the doctor's living room.[223] Essentially, the time Warhol spent on such sets was the few hours before the first performance, and he worked with materials that he or someone else would volunteer since no money was available. Warhol's association with Theatre 12 was therefore very limited. He improvised sketches for backdrops and read small roles during the dramatic readings. The artist participated for only a few months during 1953.[224] He and Theatre 12 are at best footnotes to each other.

However, Rainer Crone has proposed[225] a relationship between Warhol and the theatrical group that suggests something more significant. Crone presented a summary of Theatre 12 that mentioned Dennis Vaughan's interest in German Expressionist drama. In translation Crone wrote:

> Denis Vaughan was a great connoisseur of German theatre, especially that of the twentieth century. Wedekind's *Death and the Devil*, Hauptmann's *Rats* and Sternheim's *Snob*, as well as, above all, Bertolt Brecht's *The Caucasian Chalk Circle* and *The Good Woman of Szechuan*, were done in collective readings. In these settings, Brecht's theory of Epic Theatre and the implications of his Alienation Effect were also discussed. That theatre was done from an understanding of these Brechtian theories and methods is evidenced not only by statements of former group members Bert Greene and Dennis Vaughan but equally from the method (group work) and manner (open stage, etc.) which the group used to put pieces on stage.[226]

Crone further proposed that Brecht's theories, and those of Piscator, were known to Warhol:

> The definiteness with which Warhol carried out in this way, the execution permits the conclusion that the form of the stage scenery arose not just from an intuition but, rather, from an historical knowledge of scenery, continually assessed by him of the '20s and '30s, over which Gorelik already in 1940 had published a thorough theatre book.[227]

Figure 34. Andy Warhol, *Divine Sarah*, 1953
India ink brushed on paper, 8¼″ × 8½″.
(*Collection of Bert Greene, New York;* © *A.D.A.G.P.,
Paris/V.A.G.A., New York, 1986*)

Without any evidence Crone mentioned other possible influences, including sets by George Grosz for Piscator's production of *Schweijk* (1928) and Dada collages. Then, Crone outlined how Brecht was known to Americans, especially his 1954 production of *The Three Penny Opera* and the 1955 "announcement" to Bert Greene by Brecht's translator, Eric Bentley: "You're doing Brecht before Brecht."[228] The illustrator-playwright Aaron Fine was described as a "Brechtophile," and Crone mentioned the Theatre 12 production of Kafka's *The Trial*, which included elements of Brecht's theoretical Epic Theatre.[229]

In Crone's discussion of Theatre 12, he proposed a connection with Brecht's notion of the Alienation Effect: a series of interruptions (announcements of the plot, interpolations of noises and dialogue, a stage set of a foreign locale in time past, projections of slides and films of domestic and contemporary events, etc.) that destroy traditional dramatic illusion so that the spectator may critically view a series of didactic episodes chosen to illustrate a political argument for social action. Crone's interpretation proposed that: 1) Warhol was aware of Brecht and Brecht's Alienation Effect because, 2) a part of Brecht's notion of an Epic Theatre was discussed and used by members of Theatre 12, as in the dramatization of Kafka's *The Trial* and, therefore, 3) Warhol subsequently and systematically used Brecht's ideas in such later paintings as *Electric Chair* (1963) and *Car Crash* (1963), in which a clash occurs between the "political" content and the "distancing" color overlay.[230] Consequently, Crone connects Warhol's art and Theatre 12 to demonstrate that the artist was inspired by Brecht's theories.

Unfortunately, the information concerning Warhol and Theatre 12 does not support this interpretation, even if one uses only the interviews of Dennis Vaughan and Bert Greene published in Crone's 1976 dissertation on Warhol's art. In the Greene interview, the codirector of Theatre 12 told Crone that Warhol participated in *1953* only. After an initial discussion of how productions were read in Greene's apartment, Crone asked whether anything by Brecht was produced. Greene then discussed their *1954* productions of *The Caucasian Chalk Circle* and *The Good Woman of Szechuan* and the impact of Brecht's Epic Theatre on him and Vaughan. Greene commented to Crone, "It wasn't this political aspect of Brecht that attracted us, it was his great theatrical vision."[231] And:

> I don't know that we analyzed the aspect of Brecht writing of alienation, or people separated from one another. . . . This was part of our theatrical trapping, we used that from Brecht when we . . . adapted *The Trial*—Aaron Fine and myself—we used this kind of technique.[232]

In the interview with Dennis Vaughan, Vaughan said that *The Trial* was produced in *1955,* and that Warhol not only had left the group by 1954 but did

not attend *any* performances thereafter, including *The Trial*.[233] Consequently, whatever discussions occurred about Brecht and his notions of the Alienation Effect and of an Epic Theatre did not take place in the discussion sessions of Theatre 12 until after Warhol had left the group. The connection between Warhol and Theatre 12 must be limited to the few months that he joined the group. Clearly Brecht and his notion of an Epic Theatre had an impact on Greene and Vaughan, but not on Warhol. Perhaps Crone's ideological interpretation of Warhol requires such a link, but the link is missing, even from Crone's own evidence. During my interview with Greene, I showed Greene Crone's discussion about Warhol and Theatre 12, and Greene commented:

> He [Crone] was very interested in the German Expressionists, and he felt, in your translation, that—you know—that the whole Brecht thing made such a profound influence on Andy: that Andy saw terms in a socioeconomic view that had altered his opinion only after his experience with Theatre 12. That's just balderdash! I mean I, . . . and, I think, Andy had no clue who Brecht was![234]

Throughout this period, Warhol attended Broadway plays by playwrights such as Truman Capote and Tennessee Williams. He met such theatrical personalities at parties and fashioned his parlor apartment as if it were a stage set for a Capote or Williams play.[235] The illusions of the Broadway stage fascinated Warhol, and he wanted to do designs, sets, and costumes for Broadway. Sometime in the late 1950s or early 1960s, Warhol did sets for a student production at Columbia University.[236] According to Nathan Gluck and Jerry Lang, Warhol did do the costumes and sets for a 1963 Broadway musical by James Thurber entitled *The Beast in Me,* which closed after four performances.[237] Warhol did not receive credit because he was not a union member. Kaye Ballard, who starred in the musical, is said to have commented to Lang that "the best thing of the whole show [was] his work."[238]

Warhol's interest and admiration for the theatre may indicate his commitment to the ideal images that are projected across the footlights. The glamour of a (theatrical) celebrity attracted Warhol. For instance, Warhol asked Robert Galster, who designed theatrical posters and knew actresses such as Julie Andrews, to introduce him to such personalities.[239] At the beginning of his commercial art career, Warhol illustrated theatrical production stills for *Theatre Arts* magazine. At the end of this career he began to assemble a portfolio of foot drawings, in the manner of his famous shoe drawings, of theatrical and other celebrities. Galster comments:

> Well, I was telling Shirley MacLaine about it, I guess,—it's all hard to remember now—but she said something: she admired his work or something. So, the next time I saw him, I told him that I saw Shirley MacLaine and that she admired his work. And he wrote . . . on one of those yellow pads . . . something like: "For Shirley/with love/Andy Paperbag."[240]

Warhol's whimsical autograph to the actress was one of several acquired nicknames that he used so people would remember him. Warhol's ardent interest in celebrities functioned as the inverse of his desire to be famous. The theatricality of his own personality became a part of his projection and promotion of himself and his art.

3

A Critical Analysis of Warhol's Pop Art

The Notion of "Art" and the Legacy of Marcel Duchamp's Silence

When traditional esthetics become anti-esthetics, then art becomes anti-art. Anti-art is a form of purification, and the anti-art stance is a pursuit of displacing the self from an older, no longer valued order. Hence, the anti-art artist becomes an *agent provocateur* who disregards the rational modes of traditional structure and composition: an art *saboteur* who goes "Underground." The contradiction of such traditional concepts as truth of characterization, the authenticity of language, and a verisimilitude of real objects and situations must not only be taken for granted but assumed to be the *raison d'être* of an anti-art. Logic becomes an internal "alogic" of a hypercritical urgency. It may result in a pure form in the sense that the process and structure of an anti-art piece becomes an end unto itself, outside traditionally held conventions of art.

The anti-art gesture is a sardonic blast against conventional modes. It is a sneering and mocking bitterness of an impotent *ressentiment*[1] that suddenly explodes in an indiscriminate and ironic sarcasm of illusionary devaluation, distortion, and even denial of the values and traditions of society. Traditional values and the notion of a cherished masterpiece are seen as bankrupt. They are falsified by being leveled in a "sublime revenge," to use Nietzsche's term. In short, the negative (anti-art) is asserted, and the positive (art) is negated.

The "first" anti-art work was Alfred Jarry's *King Ubu* (1896).[2] The premiere performance of this anti-play caused a riot.[3] A cynical farce, *King Ubu* takes place in Poland, a country that was then partitioned almost into nonexistence. Such a contradiction became, as Roger Shattuck has remarked, "the mode of its logic."[4] Language becomes devalued and scatalogical. (In fact, the first utterance is an ersatz expletive.) Also, stage directions indicate that costumes, masks, and scenery are to be militantly anti-realistic.

Alfred Jarry developed his own kind of metaphysics, which he termed "Pataphysics." Jarry wrote:

> Pataphysics is the science of the realm beyond metaphysics, the science of imaginary solutions, which symbolically attributes the properties of objects, described by their virtuality, to their lineaments.[5]

Jarry's attempt to attain an unobtainable new consciousness is a variant of the romantic Sublime,[6] and the genesis of *King Ubu* represents, in part, his resentment of early authority figures.[7] The play of a child becomes a deadpan pose of mockery. Violent shifts of mood, buffoon and puppet-like roles in absurd situations, and a devalued means of communication persist throughout *King Ubu* in a dreamlike atmosphere. Jarry's infantile anti-art stance later became the urgent cry of the Dadaists, whose works and performed *soirées* were deliberately outrageous, ironic, satirical, and animated by aggression toward Western art and culture.[8] It was Marcel Duchamp who regenerated and transformed the attitude of anti-art and who profoundly influenced Warhol.

In a frequently reprinted lecture (1956) entitled "The Creative Act," Duchamp remarked that there is a "chain of totally subjective reactions" from an artist's initial intention or conception to an artist's final realization. But there is too a tacit dimension of the spectator's involvement in that the viewer, in Duchamp's words, "brings the work in contact with the external world by deciphering and interpreting its inner qualifications."[9]

Duchamp's "creative act" is in part a means of presenting something to the spectator. Beginning in 1913, Duchamp began to present the Readymade: an ordinary, (manufactured) object that for Duchamp lacked uniqueness, was visually "indifferent," and considered to lack both good and bad taste. If a Readymade is *chosen* in "the creative act," the object, such as a bottlerack, is functionally displaced and rendered useless.[10] Ironically, such an object becomes elevated to the status of art by the mere gesture of the artist. A bottlerack or urinal[11] becomes as "worthy" as Leonardo's *Mona Lisa*. The latter becomes devalued when a lithographic copy is "rectified" with a beard and a moustache, and a hint of obscene sex is associated with it by an additional inscription. The ironically sinister dimension of anti-art in this Readymade, entitled *L.H.O.O.Q.,* is heightened by the provocative inscription, just as in *Fountain* by the virtual choice of a urinal. However, Duchamp's Readymades are not just Pataphysical works of anti-art. They form a vocabulary and a means of communicating an artist's ideas by objects and signs. For instance, the Readymade may be expanded to include a "found" environment[12] or a "canned-chance" (*hasard en conserve*) of a set of propositions.[13] Just as the Cubists experimented with the forms and means of Modernist art, Duchamp's works and his legacy offer something beyond anti-art: instances and acts of "art."

"Art" for Duchamp is no more than a legible yet effaced and unavoidable instrumentality, implying both presence and absence. In Freudian interpretation,[14] Duchamp's desire for all absences is grounded in Oedipal and incestuous fables that try to produce psychosexual, biographic meaning which inseminates iconographical resonance in his so-called "ambiguities."[15] On the contrary, Duchamp operates with the radical playfulness of dissemination: an

esthetic dispersal produced by various effects, propositions, or resemblances, such as the pluralization of his identity,[16] that can never be nor are meant to be completely controlled. Among Duchamp's use of these effects and propositions is his notion of "canned chance" (*hasard en conserve*) seen in *Three Standard Stoppages* (1913–14),[17] the esthetic portable property of *Box in a Valise* (1941) as a portable museum,[18] and the radicalized perspective of the uncompleted *Large Glass* (1915–23).[19] The observer's expectations of traditional stylistic or iconographic coherence are indiscriminately, cogently, and precisely dismantled. Duchamp's works after 1912 are "Pataphysical epiphenomena"[20] of esthetic deferment.

Duchamp's career suggests a strategy of using the language of art, but he stopped subscribing to its traditional premises when he no longer believed in the notion of the artist, but rather in the idea of the investigator who generated propositions (*Being Given: 1. The Waterfall 2. The Illuminating Gas* [1946–66])[21] of a class of presented objects, such as the various species of the Readymade.[22]

Duchamp's masterwork is *The Bride Stripped Bare by Her Bachelors, Even* (*The Large Glass*), a "painting" consisting of an unfinished mixed-media assemblage between plate glass. One of the "great truths" of *Le Grand Verre* is that it is not a construction but a deconstruction: a demonstration that traditional esthetic logic and perspective "undo" themselves; a central paradox is thus involved. This paradox is a self-contradiction in Duchamp's circuit of communication (artist, notes, object, observer), so that any attendant meaning of a creative act is securely uncertain in its open-ended conditionality. As Duchamp has said: "There is no solution because there is no problem. Problem is the invention of man—it is nonsensical."[23] No one meaning, even an interpretation by the artist, is to be approved at the expense of another.[24] There is no "uniqueness" in Duchamp's works in that *authority* is dispersed. As Duchamp remarks in his 1956 lecture, "The Creative Act," the viewers "bring the work in contact with the external world by deciphering and interpreting its inner qualifications."[25] That is, always different, always postponed meanings are deferred to the observer, who supplements Duchamp's open-ended creative acts in a field of free play.

In a sense, the observer is to deconstruct Duchamp's deconstruction of art. Such a supplementary creative act by the observer opens and exposes Duchamp's provisional and rigorous reopening of the interrelationship of "artist"-"art"-"observer." Duchamp offers not only a critique of traditional esthetics as anti-art but also a strategy to use the available language of art and then to erase it into "art." The observer is invited to contemplate Duchamp's chosen *exemplar,* such as one of the various Readymades. Duchamp's open-ended dissemination of esthetics and of esthetic meaning is in free play with the observer.

Duchamp is thus a *magister ludi*. Like any heretic or innovator, he spoils the traditional rules of an activity. He shatters the illusionistic tradition of easel painting and sculpture, and leaves (voluntarily) the community known for its artists to form his own activities and rules. A veil of occultism and multiple disguises supplement the secrecy and the license of Duchamp's heretical stance as an *agent provocateur* and *saboteur* of art. Duchamp's game, his playful ploys of "art," is highly inventive. It seems as allusive as his muse-cum-bride in the *Large Glass*—that shop window-like display. Just as the observer looks "through" the *Large Glass,* the observer looks through the open-ended world of Duchamp's highly nuanced amusements.[26] The amusements also include puns, double entendres, and chess.[27]

It is out of indifference that Duchamp claims to choose an object as a Readymade, to allow the observer to mediate a chosen *exemplar,* and to interpret it without interference. Duchamp's indifference, which is part of his chosen stance, is "meta-ironic." According to Duchamp: "Irony is a playful way of accepting something. Mine is the irony of indifference. It is a 'meta-irony.'"[28] Such an artificial and hidden self-as-persona is symptomatic of another form of ironic life-as-game: dandyism.[29] It is the attitude of self-control and steady calmness—the psychological coolness—that lacks ardor and excitement. With the precision and exactness of a surgeon, Duchamp examines and exhibits taxonomies of "art" and remains in a profoundly indifferent stance toward art and "art."[30]

Duchamp's attitude is to use chance. Another attitude entails entrepreneurial schemes that do not make a profit.[31] During Pierre Cabanne's interview, Duchamp remarks:

> but, fundamentally, I don't believe in the creative function of the artist. He's a man like any other. It's his job to do certain things, but the businessman does things also, you understand?[32]

Duchamp's indifference to being an artist is reflected in his own words: "mildly, lightly, unimportantly."[33] Such an ironic—meta-ironic—attitude is his *modus vivendi:* a sustained and delayed arrangement done in amusement and used to disperse notions of any personal touch. Duchamp remains present but absent in his "art."

Duchamp's legacy[34] implies a dialectic between art and "art." From the banality of an *objet trouvé* comes not only intrinsic poetics of the everyday, as opposed to an *objet d'art,* but such an object also becomes a cult. Similar to one Surrealist ideal (shared genius without loss of individuality), artists have subsequently claimed to be spectators to the generation of their imagery.[35] This impetus has led such artists not only to disestablish the artist as author by using techniques of chance and accident, but also to redefine the Duchampian process of making "art" into an art game in which public and private expression and

responsibility dissolve. By extension, this legacy has led to attempts to close the distinction between art and life. In 1959, Robert Rauschenberg stated, "Painting relates to both art and life. Neither can be made. (I try to act in that gap between the two.)"[36] Closing such a gap ultimately leads to the poetics of silence: either the esthetic and hermetic blank page of Stéphane Mallarmé or the "mute" stance of Arthur Rimbaud. Hence, Duchamp's dialectic (art-"art") has become another process (art/"art"-life).

The first direction of the esthetics of silence is an ironic, self-effacing gesture which aspires to Nothing. This is implied by Mallarmé's blank page: literature is led to its disappearance. Rauschenberg's all-white canvases, which were hung above the performance area in John Cage's 1952 Happening at Black Mountain College, similarly led art toward a hermetic blankness. Rauschenberg's *White Paintings* (1951) entail the literal change of their environment as light and shadows pass over their surfaces.[37] Moreover, these paintings involve the (unwitting) collaboration of an observer who approaches the canvases. Like the hermetic blank page of Mallarmé, Rauschenberg's canvases have a silence.

It is John Cage, who first met Duchamp in 1942 and composed *Music for Marcel Duchamp* in 1947, who has recurrently used Duchamp's aleatropic methods to compose his musical compositions, the most radical of which are his silent pieces. Cage's most famous silent piece is *4'33"* (1952), which in Cage's words consists of "sounds not intended."[39] This "music" is produced by a performer who sits at a piano and lifts the keyboard cover at the beginning of each movement and closes the cover after the designated time. "Music" and life are presented as one, but only for those "found" sounds bracketed by four minutes and 33 seconds of elapsed time.[40] The creative act is not determined by the artist's conscious or unconscious intentions,[41] and Cage's use of indeterminacy and chance to compose includes, as Michael Kirby remarks, an "acceptance of incidental aspects of audience reaction and environmental occurrences as *part* of the production."[42]

The purposeless play of an intricate "art" game of simultaneous events describes Cage's Black Mountain College Happening. It included Cage reading a book and/or lecturing, the poets Mary C. Richards and Charles Olsen reading their poetry, David Tudor playing a prepared piano[43] piece by Cage, and Merce Cunningham and others dancing in the aisles.[44] Regardless of where a spectator sat, there was no best viewing place since the simultaneous events occurred in places that could not always be seen. With the elimination of any centralized focus,[45] the acceptance of spontaneous chance events, and a method of indeterminacy, any notion of a framed stage-audience structure has been destroyed.[46]

Whereas the artist formerly imposed his intentions on the artwork and its elements in general, the validity of the randomized material may become the

license for both the aleatropic and the composition methods. For Cage, chance and change entail both a detachment, or nonintention, of the artist, and an indeterminacy for the artistic process.

Duchamp's legacy involves the tendency of the esthetics of silence: a new alliance with oneself in *la vie ardente* in which one may choose permanent silence, as did Rimbaud and Wittgenstein, or an aspiration toward a new wholeness of being, as did Jarry and Artaud. Susan Sontag remarks:

> Silence is the artist's ultimate other-worldly gesture: by silence, he frees himself from servile bondage to the world, which appears as patron, client, consumer, antagonist, arbiter and distorter of his work.[47]

Art or "art" becomes not an effort to indicate one's life but an attempt to *live* it repeatedly.[48] As in Action Painting, the artist's "performance" may be seen as a residual precipitation (an exhibited painting), which is, as Sontag remarks in a different context, "a part of a dialectical transaction with consciousness."[49] "Art" releases the artist's tension from a potential *ressentiment* toward the art establishment and elite norms of traditional art.

Concerning Robert Rauschenberg and Jasper Johns: The Threshold of American Pop Art

For the American Pop artist James Rosenquist, Jasper Johns "seemed to show the way"[50] in the use of imagery and color. In retrospect, Warhol has written:

> Johns and Bob Rauschenberg and others had begun to bring art back from abstraction and introspective stuff. Then Pop Art took the inside and put it outside, took the outside and put it inside.[51]

The works of Johns and Rauschenberg represent the threshold of American Pop Art at a time when Abstract Expressionism was still the most dominant force in the avant-garde art establishment.[52] Despite the importance of the "anti-drip" esthetic of such painters as Frank Stella,[53] for Warhol the examples of Rauschenberg and, in particular, of Johns provided the means and attitudes to formulate a "new" painting style that used Duchamp's notion of "art" to offer a critique of art and an esthetic silence.

For instance, Rauschenberg's *Factum I*[54] and *Factum II*[55] (both 1957) deconstruct the very question of *authenticity,* as advocated by the Abstract Expressionists: Rauschenberg's paintings are virtual duplicates, not just in images but also in paint drips. Are the twin paintings with the same images and drips as "spontaneous," as "accidental," as "authentic" as those in Abstract Expressionism? Clearly a critique of Action Painting and the "drip" esthetic, Rauschenberg's paintings are an "art" about art. Moreover, Rauschenberg's *Erased De Kooning Drawing* (1953)[56] may be considered a prime example of "art": no

more than a legible yet effaced and unavoidable instrumentality implying both presence and absence. In one interview, Rauschenberg remarked that he was using the eraser "as a drawing tool" and trying "to purge myself of my teaching and at the same time exercise the possibilities so I was doing monochrome no-image."[57] Significantly, Rauschenberg asked de Kooning for an important drawing that the Abstract Expressionist would miss.[58]

By means of such a deconstructive erasure of art, Rauschenberg began to explore the possibilities of "new" constructions, or, what he calls "Combine-paintings." His Combine-paintings present explorations into the conditions, limits, and adaptations that are to relate both to art and to life and art to "act in that gap between the two."[59] Rauschenberg takes on an open, radically playful, and experimental approach to the creative act. "Any incentive to paint is as good as any other," Rauschenberg has remarked. "There is no poor subject."[60] The possible means of such explorations have included nontraditional materials, including a pair of socks which, in the artist's words, "is no less suitable to make a painting with than wood, nails, turpentine, oil and fabric."[61] Rauschenberg's use of found and readymade material is dependent upon the examples set by Duchamp and Cage. In fact Rauchenberg and Johns made an esthetic pilgrimage in 1954 to visit the Louise and Walter Arensberg Collection of Duchamp's works at the Philadelphia Museum of Art. Rauschenberg stole (as a kind of relic?) the thermometer from Duchamp's Assisted Readymade *Why Not Sneeze—Rrose Selavy?* (1921), which was being displayed in an open case.[62] Another of Rauschenberg's gestures of disposal followed an exhibition during 1953 in Florence; the artist took the "advice" of a hostile critic and threw his exhibited works into the Arno.[63]

"I am trying to check my habits of seeing, to counter them for the sake of greater freshness," Rauschenberg once said to Cage. "I am trying to be unfamiliar with what I'm doing."[64] Like Cage's notion of aleatropic nonintention,[65] indeterminacy and chance may generate imagery in a Combine-painting, and a surrealistic juxtaposition of such imagery becomes a part of the creative process. Intact images become entrapped in a Combine-painting: each image forms an iconographic subset of a heterogenous whole.[66] Rauschenberg once remarked, "I had to make a surface which invited a constant change of focus and an examination of detail. Listening happens in time—looking also has to happen in time."[67] As an observer perceives Rauschenberg's critique of Abstract Expressionism in *Factum I* and *Factum II,* he becomes engaged with imagery and its means in Rauschenberg's later works with his use of functional instruments of time, such as the inclusion of two clocks in *Reservoir* (1961),[68] and with the creation of a sound environment, as in his use of radios in the five-part assemblage *Oracle* (1965).[69]

Moreover, Rauschenberg's Combine-paintings are part of one expansionist esthetic of Modernism: a continuation of the possibilities inherent in Cubist col-

lages, the *Merz* assemblages of Schwitters, the construction-boxes of Cornell, and the "junk" sculpture of Stankiewicz, Chamberlain, and di Suvero. In 1961, the Museum of Modern Art surveyed "The Art of Assemblage" and William C. Seitz wrote in the accompanying catalogue essay:

> The current wave of assemblage . . . marks a change from a subjective, fluidly abstract art toward a revised association with environment. The method of juxtaposition is an appropriate vehicle for feelings of disenchantment with the slick international idiom that loosely articulated abstraction has tended to become, and the social values that this situation reflects. . . . Wordlessly associative, it has added to abstract art the vernacular realism that both Ingres and Mondrian sought to exclude by the process of abstraction.[70]

This exhibition featured Schwitters and Duchamp, and it included works by Johns and Rauschenberg.[71] Just as everyday movements are incorporated in the dances of Merce Cunningham and "graffiti sounds" in John Cage's silent pieces, artists who use assemblage affirm, accept, and include popular culture. They pick its artifacts and refuse and collect its signs of modern (urban) life, all seen in their "vernacular glance."[72]

As Rauschenberg explored the "gap" between art and life, he also began to participate in its collaborative synthesis: Performance Art.[73] Just as Allan Kaprow and others (including the Pop artists Claes Oldenburg and Jim Dine) explored open-ended, discontinuous, "alogical" and "multi-focused" Happening,[74] Rauschenberg collaborated with Merce Cunningham to conceive and perform in his own autobiographical performances.[75] Comments Andrew Forge:

> The idea of collaboration with others has preoccupied him endlessly, both through the medium of his own work and in an open situation in which no single person dominates. In [the 1961 Combine-painting] *Black Market* he invited the onlooker to exchange small objects with the combine and to leave messages.[76]

And Forge has quoted the artist as saying:

> Ideally I would like to make a picture [such] that no two people would see the same thing, not only because they are different but because the picture is different.[77]

Rauschenberg's creative acts have at least a tacit dimension of participation in his vernacular visualizations, which combine the multiplicity of images and the means to formulate them.

Rauschenberg's works are perceptual educations. The artist's Combine-painting *Hymnal* (1955) includes various collage material placed on a paisley shawl acting as a stretched canvas.[78] A printed, cutout arrow points to a thick brushstroke, from which dried trails of drips descend to the right, lower corner. In the opposite corner, Rauschenberg includes an F.B.I. "Wanted" poster and toward the top of the work, a portion of the Manhattan telephone directory in a niche. The observer is struck by the resonances and possible associations that

could be brought to the work and by the use of unexpected materials as artistic media. Like Cornell's constructions, the open-ended, nostalgic uncertainty of the images becomes a poetics of detection.[79] In fact, one of his paintings is entitled *Rebus* (1955).[80] The suggestive bits of images, objects, and "tear sheets" from popular media, newspapers, illustrated magazines, and comic books are a part of the puzzles in his Combine-paintings, in which Rauschenberg allows the onlooker to provide "solutions."

Rauschenberg began his series *Red Painting* (1953)[81] "using comic strips as color ground."[82] Lawrence Alloway has observed:

He used comics and photographs, especially in the form of grainy photographic reproductions, which, first as collage elements and later as printing traces, were deposited on paper and canvas. All this material is identifiable in terms of its origins as well as becoming part of the cluster that constitutes Rauschenberg's composition.[83]

Works using such sources include *Gloria* (1956), *Mona Lisa* (1958), and *Hymnal* (1955).[84] *Gloria* refers to the socialite Gloria Vanderbilt, and Rauschenberg places sequentially four identical New York *Daily News* photos of her third wedding. He also includes a tabloid clipping that concerns a kidnapper. Implicitly, Rauschenberg refers here to the dramatic and highly publicized court battle of Gloria Vanderbilt, who was called by the press "The Poor Little Rich Girl," and her fear of being kidnapped, as Lindbergh's child was during the year of her custody trial (1934). In *Mona Lisa,* Rauschenberg "meditates" Leonardo's painting: a cheap postcard reproduction appears several times in a reversal of the iconic image.[85]

The multiple use of popular imagery also includes real American cultural icons, such as the four Coca-Cola bottles in *Curfew*.[86] During the same year (1958), Rauschenberg encases three Coca-Cola bottles in *Coca-Cola Plan;* eagle wings are painted on either side of the wooden supports. Thus *Coca-Cola Plan* represents, in part, an apotheosis of that popular beverage.[87] Rauschenberg's elevation of a common, manufactured item reiterates the artist's openness to the potentials of popular imagery. The addition of eagle wings signifies not only a common representational artifact of American society but also a direct relation to the tradition of the so-called "naive" images in Folk Art and to such "primitive" twentieth century artists as Florine Stettheimer.

Stettheimer, who was a wealthy New York socialite and friend of Duchamp, painted highly imaginative and fanciful portraits of New York's café society of the 1920s and 1930s. Stettheimer's *Cathedrals of Wall Street* of 1939, the last and unfinished painting of her *Cathedral* series, culminates her ironic celebrations of American life and customs, and features portraits of prominent Americans (Mayor La Guardia, Grace Moore and Eleanor Roosevelt), who appear in festive American costumes. The celebrities are in a setting of specific "and salient features of American life—from the glory of the

New York Stock Exchange to the Glory Hole."[88] Henry Geldzahler has characterized her paintings "that seemed merely eccentric during the artist's lifetime" as being "prophetic" of a concern with Folk Art that is "shared by a number of painters in the 1960s."[89] In fact, when Geldzahler was introduced by Ivan Karp to Andy Warhol at the artist's townhouse-studio in 1960, Stettheimer's work was mentioned:

> Almost as quickly as a computer could put the information together, he said, "We have paintings by Florine Stettheimer in storage at the Met. If you want to come over there tomorrow, I'll show them to you." I was thrilled. Anyone who'd know just from glancing around the room of mine that I love Florine Stettheimer had to be brilliant.[90]

For Warhol, her paintings set an important precedent in depicting specifically contemporary American images, places, celebrities, and symbols. Likewise, Jasper Johns considers Stettheimer one of his favorite American painters.[91]

In 1954, Rauschenberg and Johns went to see the Arensberg Collection of Duchamp's works at the Philadelphia Museum of Art.[92] Jasper Johns "began" his artistic career by painting five different series. Johns's choices of images were, in his words, "things the mind already knows,"[93] and they consisted of the American flag, a map of the United States, a bull's-eye target (with plaster casts), the alphabet, and the numerals zero through nine. Avoiding "formless" abstractions of Action Painting but using the gestural brushstrokes of it, Johns maintained the stylistic means of the then-current Modernist painting; he presented literal subjects that eliminated any illusionism and any notion of painting as a metaphoric subjectivism.[94] As a kind of estheticized nostalgia of learning (to situate states on a U.S. map, to recite a pledge, to learn to count and spell, and to hit a bull's-eye of a target), Johns reasserts the Duchampian metaquestion "What is art?" as a series of ironic contradictions. In *Flag above White with Collage* of 1955 and in *False Start* (1959)[95] the "messages" of collage material under the encaustic paint of *Flag above White with Collage* and the neatly stenciled lettering of *False Start* are denied by gestural brushstrokes, especially in the later work. Overlaid and dislocated, the representation becomes an "art" game of "hidden" esthetic indifference. In fact, some commentators have begun to notice that Johns's use of collaged clippings reflect the politicized moment following the McCarthy period (1950–54).[96] Just as Wittgenstein investigated the nature and foundations of language,[97] Johns's works offer commentaries not only on the nature of art but also on the communication network of the popular media and on elementary instruction. The viewer perceives that the collaged "messages" have been "erased" by the encaustic paint, and he must closely examine the painting for its subliminal "meanings." "If you have one thing and make another thing," Johns has said, "there is no transformation, but there are two things. I don't think you would mistake one for the other."[98] And:

I am concerned with a thing's not being what it was, with its becoming something other than what it is, with any moment in which one identifies a thing precisely and with the slipping away of that moment.[99]

Concisely, Johns's notion of "art" as an oblique and radical play concerns the problem of signification and transformation. What may be easily overlooked as "unimportant" becomes an esthetic preoccupation in Johns's ploys.

Perhaps, the most infamous instance of his mute strategy is *Painted Bronze (Ale Cans)* of 1960: two cylinders—*not* beer cans—are cast in bronze and then painted to simulate realistically the original Ballantine Ale label, but traces of the artist's *facture* are also included. According to Johns, this work was prompted by a remark by Willem de Kooning to Johns's dealer, Leo Castelli, in which the Abstract Expressionist said that "you could give him two beer cans and he could sell them."[100] Choosing his personal favorite brand of ale with its simple label design and bronze color, Johns changes the cans to represent a *"memento artes"* because "the cans are studio objects as well, since he used empty beer cans for mixing paint."[101] In fact, what at first appear to be identical cans are different. One is open (empty), the other is closed (full). Roberta Bernstein remarks, "When the cans are lifted off the base (each part is cast separately), one discovers that the open can is hollow and lightweight, the closed one solid bronze and therefore unexpectedly heavy."[102] As a self-conscious variant of Duchamp's Readymades, Johns's work is an "art" about Duchamp's "art" and a reference to Abstract Expressionism. Whereas Duchamp would have placed two *real* beer cans on a pedestal and included a provocative title, Johns set up two handmade objects on a base as his ironical variant and allowed the meaning of his gesture to be signified by the observer-critic. Just as his earlier paintings of flags and targets evoked an invitation to respond to the (politicized) American cultural experience as learned in school, *Painted Bronze* presents an essential and esthetic invitation to react to very common objects that are *made* but lack ordinary, artistic criteria.

The open-ended meaning in Johns's works parallels his stylistic tendencies of non-focused, random placements of imagery in his later works, as well as the equal intensity of brushstrokes. Even in works that have a predetermined design "of things the mind already knows," the perception of a work becomes diffused. In *Alley Oop* (1958),[103] Johns paints over the entitled comic strip. Although the observer still knows it is a comic strip, he has to read the captions through the dense impasto of paint. Johns uses the comic strip but then denies it by an overlay of visual "noise." Similarly, Johns's *Book* (1957)[104] includes an overlay of encaustic paint on a framed book, and *Canvas* (1956)[105] consists of a small canvas attached to another in such a way that the spectator cannot see what, if anything, is painted on the smaller canvas. Johns contrasts an activity (reading a book or viewing a painting) by its displacement (not being able to read a book or to view a painting). In essence, the proposed activity, which

is readymade and given, is "contaminated" by the artist-as-intermediary. A book or painting becomes hidden and made "silent." Just as Johns breaks away from illusionistic images, he also displaces an (esthetic) object or activity through conceptual "art" games that objectify "things the mind already knows."

The concept of "art" implies an ardent inquiry that uses the available language of art. It *provokes* fundamental questions about its nature and use in such a way that the viewer becomes a critic in his affective response. As the artist withdraws from a subjective mythos, the viewer overtakes the formerly sanctioned aura and provides a new focal forum.[106] The more seemingly familiar an objectified "art" work is—from Duchamp's *Bottlerack* to Johns's *Painted Bronze (Ale Cans)*—the greater the viewer's responsive dilemma becomes. Duchamp, Cage, Rauschenberg, and Johns present sweeping desublimations that subvert the functional credibility of traditional notions of creating art and being an artist. While the artist remains "silent," the onlooker brings the work, as Duchamp remarked, "in contact with the external world by deciphering and interpreting its inner qualifications."[107]

Warhol's Earliest Pop Art Works

During the summers of 1948 and of 1949, Warhol visited the Museum of Modern Art in New York City.[108] At that time, the museum owned Duchamp's *The Passage from Virgin to Bride* (1912), which was his first painting to be acquired by a museum, and his *Box in a Valise.*[109] Warhol probably was aware of Duchamp before he graduated in 1949. By the early 1950s, Warhol was definitely aware of Duchamp and even claimed that he not only knew the French artist but also played chess with him.[110] It was only during 1962–1963 that one may pinpoint Warhol's absorption with Duchamp's works and ideas. During that time, Warhol bought one of Duchamp's *Box in a Valise,* a leather valise containing miniature replicas, photographs, and color reproductions of works by Duchamp.[111] Also at that time Warhol bought a monograph on Duchamp by Robert Lebel[112] and various issues of *View,* including that magazine's special issue concerning Duchamp, from Nathan Gluck.[113] It is in this issue that there are important explications of Duchamp's notion of "canned chance"[114] and of the "gratuitous act,"[115] as well as his statement concerning the meta-ironic stance of indifference.[116] Moreover, Duchamp's lecture "The Creative Act" is reprinted in Lebel's book,[117] which examines all of Duchamp's known works through 1959 and contains a *catalogue raisonné,* reproductions of these works, and other documentation. In his chronological section of Duchamp's life, Lebel mentions that in 1926 the *Large Glass* was broken and that Duchamp began to repair it in 1936. "It was painstaking and difficult work," Lebel noted, "but today it is hard to imagine the *Glass* intact, without the filigree which time and fate have printed upon it."[118] Warhol's

Glass—Handle with Care of 1962 may well refer to Duchamp's *Large Glass* and its present fragile state.

In fact, Warhol saw the Duchamp retrospective at the Pasadena Art Museum in 1963, and he went to the opening night banquet which Duchamp attended.[119] Duchamp's poster design for this retrospective reproduced his Rectified Readymade *WANTED/$2,000 REWARD,* which consists of two mug shots of Duchamp pasted on a joke "Wanted" poster (fig. 35). On Warhol's return to New York, Philip Johnson commissioned him to produce a work for the New York World's Fair of 1964, and Warhol did *Thirteen Most Wanted Men* (fig. 36): pictures of real criminals that takes its cue from Duchamp's portrait-as-outlaw poster.[120] Likewise, Duchamp's *L.H.O.O.Q.* serves as the prototype for Warhol's comment on the exhibition of Leonardo's *Mona Lisa* in the United States the previous year:[121] *Thirty Are Better than One* (fig. 37).

In the November 1963 issue of *Art News,* Gene R. Swenson published the most famous and widely read interview with Warhol.[122] Ardently reticent to explain his work, Warhol was actually unaware that Swenson tape-recorded their conversation.[123] The published excerpts are Warhol's candid ideas, but any interpretation of the artist's edited remarks must be made with extreme caution because the tone may be at total variance with the content of the published interview. Nonetheless, in tone and content, Warhol acknowledges the influence of John Cage and Merce Cunningham, both of whom accepted everyday noises and gestures in their works which were composed, in part, using chance. In fact, Warhol even refers to an article in the *Hudson Review,* in which the author outlines the various means of random composition used by Cage and others, and the "antiteleological position" of such radical and "effortless" means of musical or artistic production.[124] Likewise, Warhol refers to Rauschenberg and Johns—"and everyone calling them derivative and unable to transform the things they use"[125]—and comments that they have been misunderstood by critics and the public. Clearly Warhol's earliest published interview indicates not only his awareness of the progenitors of his Pop Art but also his acquaintance with their critical reception and academic explications of their work.[126]

In fact, before Warhol began his career as a fine artist, he frequented galleries and museums in New York. In late 1959 or early 1960, Warhol and Ted Carey went to the art-lending department of the Museum of Modern Art. According to Carey, the following occurred:

> And there was a collage by Rauschenberg. And it was a shirt sleeve. It was like a shirt sleeve cut off and that was it. And I said, "Oh, that is fabulous." And Andy said . . . well, he said, "I think, that's awful." He said, "That's a piece of shit." And I said, "I think, it's really great." And he said, "I think it's awful." And he said, "I think anyone can do that. I can do that." And I said, "Well why don't you do it? If you really think it's all promotion. Anyone, you know, can do it. Do it!" And so he said, "Well, I've got to think of something different."[127]

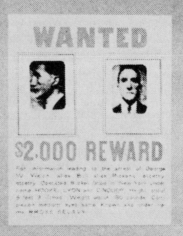

Figure 35. Marcel Duchamp, *Poster within a Poster*, 1963
Poster with reproduction of *WANTED/$2,000 REWARD*,
1923, Rectified Readymade.
(© *A.D.A.G.P., Paris/V.A.G.A., New York, 1986*)

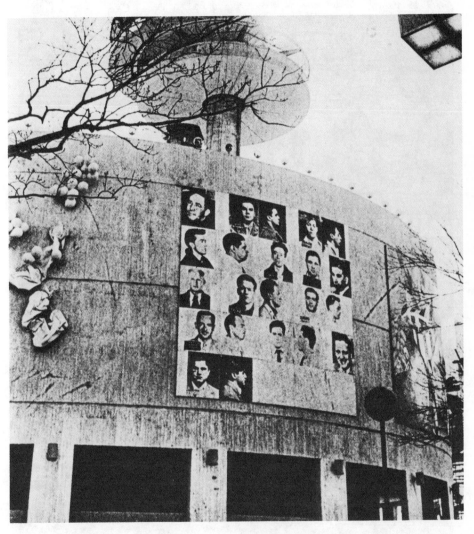

Figure 36. Andy Warhol, *Thirteen Most Wanted Men*, 1963
Synthetic polymer paint silkscreened on canvas. Twenty-five
panels, each panel 48″ × 48″. Photograph is of original con-
dition at the New York State Pavilion, New York World's
Fair, 1964.
(© *A.D.A.G.P., Paris/V.A.G.A., New York, 1986*)

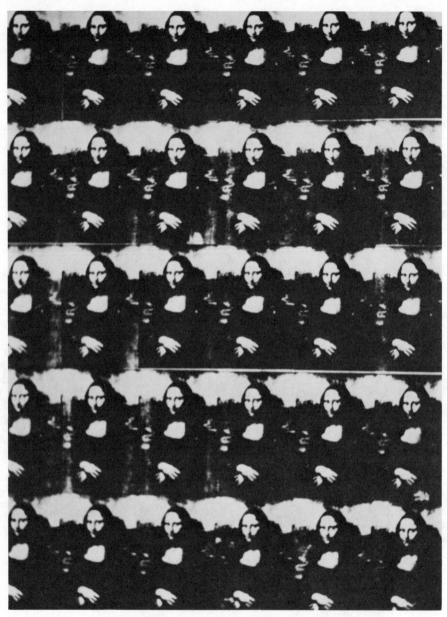

Figure 37. Andy Warhol, *Thirty Are Better than One*, 1963
Synthetic polymer paint silkscreen on canvas, 110″ × 82″.
(*Collection of Peter M. Brant, Greenwich, Connecticut;*
© *A.D.A.G.P., Paris/V.A.G.A., New York, 1986*)

Also at this time, Warhol attempted to befriend Rauschenberg and Johns, who would not associate with him because of his advocacy of commercial art as a valid career, his collections of Camp objects, Folk Art, and fine art (including a Magritte watercolor, a crushed car sculpture by Chamberlain, Warhol's portrait by Fairfield Porter, and paintings by Frank Stella)[128] and his openly theatricalized, effeminate demeanor.[129] According to Emile de Antonio, Warhol wanted to meet Rauschenberg and Johns in order to "latch on to the fine art sensibility."[130] In spite of his initial reaction to Rauschenberg's collage, Warhol apparently believed that the "art" of Rauschenberg and Johns had a viable esthetic style.

The beginning of Warhol's career as a professional fine artist was a period of decision and rejection. In 1960, Warhol decided to abandon paintings based on his successful blotted-line technique and the publication and exhibition of a drawing series of celebrities' feet. This series was to be used as a financial and promotional device in the manner of his Golden Shoe series and his *Wild Raspberries* recipe book.[131] Moreover, Warhol's definitive gesture in breaking away from his commercial art stylization occurred in 1960 when he and his curator-friend, Henry Geldzahler, destroyed hundreds of blotted-line drawings.[132] Warhol then attempted to find his own trope of style, but it was one that was based initially on Rauschenberg's combination of popular imagery and Abstract Expressionist drips, and John's use of visual "noise" and subject matter.

On the second floor of his studio-townhouse, Warhol set up his opaque projector and reproduced a monumentalized image of a Coca-Cola bottle on two canvases.[133] One version included drips of paint, and the other one omitted them (present whereabouts of both works unknown).[134] Apparently Warhol was uncertain which version he should pursue. Consequently, he showed both versions to his art dealer and friend, Emile de Antonio, who supported both Warhol's achievement as a successful commercial artist and his ardent·desire to achieve and promote a successful career as a professional fine artist. During my interview with de Antonio, the artist's friend recalled viewing the two versions:

> One day he put up two huge paintings of Coke bottles. Two different ones. One was, I would say, an early Pop Art piece of major importance. It was just a big black-and-white Coke bottle. The other was the same thing except it was surrounded by Abstract Expressionist hatches and crosses. And I said to Andy, "Why did you do two of these? One of them is so clearly your own. And the second is just kind of ridiculous because it's not anything. It's part Abstract Expressionism and part whatever you're doing." And the first one was one that was any good. The other thing—God only knows what it is. And, I think, that helped Andy make up his mind as to—you know: that was almost the birth of Pop. Andy did it.[135]

Using his favorite beverage,[136] Warhol set up two possibilities in the Pop Art visualization of Coca-Cola. His basic approach to the "problem" of a distinctive

trope of style is to allow permutations to occur and then to seek advice. In fact, Warhol's first Pop Art works were shown to many art dealers and gallery owners in order to solicit opinions on the suitability and "sale-ability" of the paintings.[137]

Warhol could not obtain a dealer, and his first Pop Art paintings were finally shown during April 1961 as a backdrop for the 57th Street side of the Bonwit Teller display windows where Johns, Rosenquist, and Rauschenberg first exhibited their Pop Art (fig. 38).[138] Despite De Antonio's advice, Warhol continued to use Rauschenberg's combination of a popular image and Abstract Expressionist drips. Warhol's images were based on comic strip cartoons (*Superman, Nancy, Dick Tracy*),[139] advertisements (*Before and After, $199 Television, Dr. Scholl's Corns*),[140] and consumer products (*Del Monte Peach Halves* and *Coca-Cola*).[141] These paintings of 1960 have several common stylistic characteristics and similar methods of producing them.

First, Warhol painted these 1960 canvases using acrylic paint. Second, all of these paintings were unsigned and large in size. Averaging $72'' \times 54''$ each, Warhol emphasized an almost billboard-like verticality.[142] Third, he used an opaque projector to trace an image.[143] Fourth, on top of the traced picture, Warhol added a series of incessant hatchings of paint, drip lines, and paint dabs that were infrequently applied.[144] Fifth, a centered image, such as a comic strip, had a large marginal area of blank canvas, usually at the bottom but also to one side or both sides.[145] Clearly, these earliest Pop Art paintings were experiments, the sixth in the monumentalization of images that were taken from American popular cultural sources, including a variant of the Abstract Expressionistic drip esthetic used by Rauschenberg and Johns.

A crucial example of these paintings is Warhol's *Superman* (fig. 39), taken from one of the comic strips of this very popular cartoon hero.[146] In this painting, the "super" hero extinguishes a forest fire by a stupendous breath ("PUFF!") that crosses the stylized smoke, in the conventional manner of comic strip art.[147] As the hovering hero exhales, he thinks, "Good! A Mighty Puff of my Superbreath Extinguished the Forest Fire!" This caption exemplifies two interdependent stylistic tropes of Warhol's earliest Pop Art. First, Warhol includes captions in his paintings based on comic strips. This text is obscured—but not totally concealed—by an application of white paint. This second characteristic is highly significant because it is a part of Warhol's use of visual "noise." Like Warhol's addition of paint drips and hatchings, this overlay interrupts the viewer's (literal or visual) perception of the pictorial text. Likewise, just as his commercial art drawings and promotional books of the 1950s feature a nonbounded use of color, the blue sky in *Superman* deliberately overlaps the upper section of the hero's white-colored breath. In the upper margin of blank canvas, Warhol includes a series of continuous red hatchings and inserts an overlay of dark-blue hatchings on the lighter blue of the sky. These

Figure 38. Installation of Andy Warhol's First One-Man Pop Art Exhibition in the Window Display of Bonwit Teller, New York, April, 1961
Left to right: Advertisement, 1960, acrylic on canvas, 72″ × 54″; *Superman,* original state, 1960 (was repainted in 1961), 67″ × 52″; *Saturday's Popeye,* 1960, acrylic on canvas, 48″ × 40″; *Little King,* 1960, acrylic on canvas, 54″ × 40″; *Advertisement,* 1960, acrylic on canvas, 72″ × 56″.
(Superman *in private collection, remainder from collection of artist;*
(© *A.D.A.G.P., Paris/V.A.G.A., New York, 1986)*

Figure 39. Andy Warhol, *Superman*, Repainted Version from 1961
Acrylic on canvas, 67″ × 52″.
(*Private collection; © A.D.A.G.P., Paris/V.A.G.A., New York, 1986*)

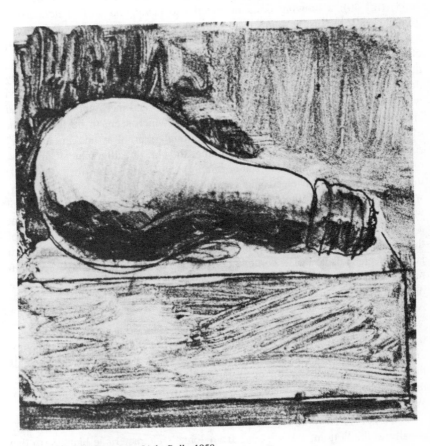

Figure 40. Jasper Johns, *Light Bulb*, 1958
Pencil and graphite wash on paper, 6½″ × 8½″.
(*Collection of Andy Warhol, New York;* © *A.D.A.G.P., Paris/V.A.G.A., New York, 1986*)

incessant but delicately rendered hatchings occur only in Warhol's paintings of 1960–61.[148]

Warhol's use of such visual "noise" is, in my opinion, directly dependent upon the drawings and paintings by Jasper Johns. In fact, after Warhol's paintings were shown at Bonwit Teller, he purchased Jasper Johns's *Light Bulb* of 1958 (fig. 40): a drawing done in pencil and having incessant hatchings of graphite wash.[149] Just as Johns used painterly, randomized, and "non-focused" brushstrokes to obscure the entitled comic strip in *Alley Oop* (1958),[150] the veil of hatchings in *Light Bulb* interrupts the viewer's reading of the object. During the period 1958–60, Johns did a series of drawings based on his five early themes (flags, targets, numerals, alphabets, and American maps) that included what Max Kozloff has described as "staccato lines and incessant scribbles that are free and wiry without being nervous, and which seem to be layered on, often in perceptible tactile screens."[151] Although Warhol avoids an "all-over" Abstract Expressionist use of such hatching, the almost calligraphic[152] and decorative use of it in the present state of *Superman* suggests, too, the occasional, unwanted signal in an electronic communication system, such as television, which is Warhol's favorite entertainment medium. As discussed earlier, Warhol watched television or listened to records as he painted. Visual "noise" is, then, a part of Warhol's signal of representation: he transmits a readymade object of the popular imagination and reminds the viewer that, like a televised image, it is a projected display of a contemporary icon. In a sense, Warhol "contaminates" such a pictorialization of a common image, and his paintings are demonstrations of an "art" that is legible yet effaced, and that subverts the viewer's perception of it.[153]

It is, in my opinion, Johns's use of visual "noise" that prompted Warhol's use of such "noise." Close examination of Warhol's *Superman* in the photograph of its exhibition at Bonwit Teller during April of 1961 (fig. 38), reveals that there is *no* visual "noise," as in the painting's present state (fig. 39). It was *after* Warhol's purchase of Jasper Johns's drawing *Light Bulb* (fig. 40) that Warhol added visual "noise."

Warhol's stylistic device of allowing large marginal areas of blank canvas, usually at the bottom, takes its cue from Johns's characteristic blank strip that appears at the bottom of his paintings (for example, *Flag above White with Collage,* of 1955). In this particular *Flag* the blank area plays an ambiguous role. Although on all of Johns's *Flag* paintings the edges of the flag do not match the edges of the painting, the repetitive pattern of the flag's stripes suddenly expands like the "field" paintings of Barnett Newman. This particular *Flag* is also a prototype of Warhol's use of images from a photomat machine: along the right edge of the flag is a vertical stripe of four photographs of a man taken in a photomat machine. The pose is frontal, like a mug shot of a "Wanted" poster. Although Johns's representational subject of a flag is clear

and factual, his obscured collage elements, visual "noise," and ambiguous margins disrupt the viewer's perception of "things the mind already knows."

According to Johns, his use of commonplace subjects makes it easier to concentrate on the dis*play* of an image:

> Using the design of the American flag took care of a great deal for me because I didn't have to design it. So I went on to similar things like the targets—things the mind already knows. That gave me room to work on other levels.[154]

Johns's game of "art" is of special significance for Warhol's Pop Art works. In fact, after his initial dislike of Warhol, Johns was to be in direct contact with him. It is unknown exactly what may have been discussed, but visual evidence suggests a scrutiny by Warhol of Johns's work, including the drawing *Light Bulb* which Warhol bought because he could not afford then to buy one of Johns's paintings.[155] Moreover, several works by both artists suggest a visual dialogue.

Johns's companion piece to *Painted Bronze* (*Ale Cans*) is *Painted Bronze* (*Paint Brushes*), also of 1960. Notes Roberta Bernstein:

> The Savarin coffee can in Johns's next *Painted Bronze* sculpture is like the Ballantine ale can, an object which made its way from Johns's kitchen to his studio, where it was used in this case to hold paint brushes. In a 1965 interview, he said that both his Painted Bronze sculptures were "right out of the studio. They'd been sitting there a couple of years before I noticed."[156]

Johns's use of a specific brand name specifies the *trompe l'oeil* realism of a commonplace object of his studio environment. Like a Synthetic Cubist work, Johns's sculpture evokes the enterprise of making an esthetic activity. Warhol similarly uses a brand name label which he stenciled and serially repeated in *Martinson Coffee* of 1962. In effect, like *Glass—Handle with Care,* Warhol's painting is an "art" about another "art." Carefully handpainted, Warhol's *Martinson Coffee* takes its cue from Johns's sculpture and it, like its prototype, refers to the American consumer society. Unlike the "uniqueness" of Johns's sculpture—a bronzed "*memento artes*"—Warhol's use of repeated images suggests shelves of the coffee product in a supermarket: multiple images of a mass-produced item.

Moreover, in *Glass—Handle with Care* and *Martinson Coffee* Warhol provides a variant to Johns's use of common, readymade patterns (targets, flags, etc.) and then acting upon them by means of various transformations (variant colors and brushwork, placement, etc.). For Johns, "things the mind already knows" are no more than convenient designs with which to play radical games of "art." For Johns, too, a series of such "art" games is a species of estheticized taxonomies, just as Duchamp's Readymades are. On the other hand, Warhol's two paintings attempt to display uniformity: first, to achieve formal

coherence and order and, second, to provide, as it were, "art" comments. Whereas Duchamp's *Large Glass* is a fragile and unique image which the viewer tries to understand, Warhol's *Glass* presents a ubiquitous image which the viewer can readily discern. Yet, Warhol's painting is an inexpressible something: why such a label? Duchamp and Warhol would answer, why not? The two questions cancel each other, just as Warhol works cancel Duchamp's *Large Glass* and Johns's *Painted Bronze* (*Paint Brushes*). Warhol's two paintings are examples of "art" about the "art" of Duchamp and Johns.

Jasper Johns has, in turn, acted upon Warhol's images in at least three instances. Johns borrowed Warhol's "GLASS" stencil and used it as an element in *Arrive/Depart* (1963–64) and in *Target* (1967–69).[157] In his *Map (Based on Buckminster Fuller's Dymaxion Airocean World)*,[158] Johns included in the polar region a winter scene from a comic strip with "BRRRR" in a speech-balloon: an allusion not only to the cold climate but also to Warhol's painting *Nancy* of 1960,[159] in which the speech-balloon begins "BRR"[160]

The "art" of Duchamp and Johns questions the notions of uniqueness, established esthetic values, and the assumptions of a viewer's act of perception. Whereas Duchamp radicalized the illusion of perspective in the *Large Glass* and Johns jettisoned illusionism for patterns of design with veiled collage material, Warhol provides solutions of "art," in which the cues are provided by Duchamp's legacy.

When Gene Swenson interviewed Warhol (1963), the Pop artist had settled upon his procedures in producing works of "art." For convenience, Warhol abandoned the tradition of a handpainted masterpiece for a mechanical-like master sequence. Like his own promotional work of the late 1950s and like Johns's use in some works,[161] Warhol used rubber stamps to produce an image, as in the 10 paintings of 1962 that represent serial presentations of airmail and trading stamps.[162] He also used stencils for *Glass* and *Martinson Coffee*. He began to use silkscreens, a medium he had used as an art student, in August 1962. In retrospect, Warhol remarks:

> The rubber-stamp method I'd been using to repeat images suddenly seemed too homemade; I wanted something stronger that gave more of an assembly-line effect.
>
> With silkscreening, you pick a photograph, blow it up, transfer it in glue onto silk, and then roll ink across it so the ink goes through the silk but not through the glue. That way you get the same image, slightly different each time. It was so simple—quick and chancy. I was thrilled with it. My first experiments with screens were heads of Troy Donahue and Warren Beatty, and then when Marilyn Monroe happened to die that month, I got the idea to make screens of her beautiful face—the first Marilyns.[163]

Warhol's trope of style—repeated images on a canvas by means of mechanical production—became his infamous device of transformations in a continuum as "homages to . . . :" celebrities, mass-produced consumer items, depersonalized portraits, and so on. Warhol's machine metaphor contradicts and denies the

subjectivism, anguished feelings, implied "heroism," and individuality of the Abstract Expressionists: Jackson Pollock's celebrated claim, "I am nature,"[164] in contrast to Warhol's statement, "I think everybody should be a machine."[165]

Warhol's Pop Art *in Extremis:* The Elements and Definition of His "Popism"

During Gene Swenson's interview with Warhol, the artist indicates his attitudes toward the creative process, the status of the artist, and the possibilities of technological connections with art.[166] The beginning of the published conversation deals with Warhol's indifferent stance toward (artistic) individuality, and it captures Warhol's controversially extreme position that opposes and violates the subjective expressiveness and *angstlich* temperament of Action Painting:

AW: Someone said that Brecht wanted everybody to think alike. I want everyone to think alike. . . . Everybody looks alike and acts alike, and we're getting more and more that way.
 I think everybody should be a machine. I think everybody should like everybody.

GS: Is that what Pop Art is all about?

AW: Yes. It's liking things.

GS: And liking things is like being a machine?

AW: Yes, because you do the same thing every time. You do it over and over again.

GS: And you approve of that?

AW: Yes, because it's all fantasy. It's hard to be creative and it's also hard to think what you do is creative or hard not to be called creative because everybody is always talking about that and individuality. Everybody's always being creative.[167]

In my opinion, it is Warhol's intuitive response to his interpersonal relationships that generates such statements. Why does Warhol remark that he wants everyone to be a "machine"? A possible answer may indicate why his personality is marked by a steady calmness and self-control and how he approaches the creative process in his Pop Art.

In *The Philosophy of Andy Warhol* (1975), the Pop artist portrays himself as a sickly, even bedridden, youth, a hapless teenager, and a young man who works long hours and becomes easily embarrassed by the emotional problems of his friends.[168] However, during the late 1950s, he buys a television set and

watches it continuously while working for his various commercial art clients. Warhol comments: "I stopped caring so much about having close relationships with other people."[169] Through a machine that projects two-dimensional images, Warhol claims that he becomes less involved with reality. In fact, Warhol's so-called "affair" with his television, he continues, has lasted "to the present, when I play around in my bedroom with as many as four at a time. But I didn't get married until 1964 when I got my first tape recorder. My wife."[170] Warhol also remarks:

> The acquisition of my tape recorder really finished whatever emotional life I might have had, but I was glad to see it go. Nothing was ever a problem again, because a problem just meant a good tape, and when a problem transforms itself into a good tape it's not a problem anymore. An interesting problem was an interesting tape. Everybody knew that and performed for the tape.[171]

By removing himself emotionally from the problems that he felt that he and others had, Warhol interposed some (technological or mechanical) instrumentality—telephone, tape or video recorder, television set, still or film camera, a silkscreen process—in order to allow a suspension and delayed representation of emotions, problems, or fantasies.

Warhol remains at a distance, but he is ever watchful. "I think that once you see emotions from a certain angle," he writes in *Philosophy,* "you can never think of them as real again. That's what more or less has happened to me."[172] Warhol has remarked, "I became what you might call *fascinated* by certain people."[173] This preoccupation with his entourage of "Superstars" is, also, his tacit possession of control, authority, or influence over them. A case in point is the dancer Freddy Herko whose ardent life suddenly ended during his last "performance": literally, by leaping through an apartment window. Fifteen years after Herko's death, Warhol reports in *POPism: The Warhol '60s* (1980) that many of the artist's entourage blamed him for Herko's death, as well as the tragic circumstances of Edie Sedgwick, Andrea Feldman, and others. Warhol concludes his assessment of such circumstances with the following crucial statement:

> Now and then someone would accuse me of being evil—of letting people destroy themselves while I watched, just so I could film them and tape record them. But I don't think of myself as evil—just realistic. I learned when I was little that whenever I got aggressive and tried to tell someone what to do, nothing happened—I just couldn't carry it off. *I learned that you actually have more power when you shut up, because at least that way people will start to maybe doubt themselves.* When people are ready to, they change.[174]

Warhol's psychological removal and silence are, then, his means to control or to reduce conflicts of interest by a stance that lacks ardor, excitement, or friendliness. With the relative coolness of a dandy, Warhol's admitted temper-

ament is one of deflection and diversion. As opposed to the *ressentiment* of an Alfred Jarry whose anti-art stance mocks sanctioned and traditional norms and conventions, Warhol tends to withdraw—more precisely, absent—himself and simultaneously presents an estheticized persona of passionless presence as a solution to approach life and art. Warhol's life, career, and art are projectional displays.

To be a "machine" is for Warhol not to have problems. His desire to have everyone be a "machine" is to indicate his preference for a world with people whose lives have happy endings, just as a Hollywood film may furnish proxies of luminous stars living theatricalizations of untroubled happiness. Yet Warhol's ideals are, also, the objectifications of his own engagement with life, seen again as a form of esthetic mediation. Moreover, Warhol doubts the attainment of such a fantasy and writes in his collected *pensées:*

> I think a lot about the people who are supposed to not have any problems, who get married and live and die and it's all been wonderful. I don't know anybody like that. They always have some problem, even if it's only that the toilet doesn't flush.[175]

With typical bathos, Warhol uses a sardonic but effectless humor to state his doubt about the American Dream, just as his silent stance reflects the doubt of others.[176]

In his intuitive effort to cope with life, he prefers to do what is easiest, such as finding convenient means of artistic production (photomechanical silkscreens), hiring assistants (Nathan Gluck and others for his commercial art and Gerard Malanga and others for his fine art), and being convivial. What Warhol calls "Popism" is as much a mental attitude to alleviate difficulties or embarrassment as a style of art that "impersonally" represents American mass cultural fantasies and icons. For instance, in *POPism* the artist remarks that his friendship with Henry Geldzahler was severely strained when Geldzahler chose Roy Lichtenstein's Pop works for the Venice Biennale in 1966, and that Geldzahler told him only at the last moment. In retrospect, Warhol sympathizes with Geldzahler for protecting his position at the Metropolitan Museum of Art by not bringing Warhol and his entourage, who were then at a peak of infamous repute, to Venice: "Well," remarks Warhol, "anyway, I thought, that was very Pop—doing the easiest thing."[177]

Another aspect of Warhol's Popism is the acceptance of American culture. Warhol states in *POPism:*

> The Pop artists did images that anybody walking down Broadway could recognize in a split second—comics, picnic tables, men's trousers, celebrities, shower curtains, refrigerators, Coke bottles—all the great modern things that the Abstract Expressionists tried so hard not to notice at all.[178]

Apparently, when Warhol in 1963 drove to Los Angeles with Wynn Chamberlain and Taylor Mead, the direct experience of popular culture across America reinforced his outlook:

> The farther west we drove, the more Pop everything looked on the highways. Suddenly we all felt like insiders because even though Pop was everywhere—that was the thing about it, most people still took it for granted, whereas we were dazzled by it—to us, it was the new Art. Once you "got" Pop, you could never see a sign the same way again. And once you thought Pop, you could never see America the same way again.[179]

To look at something afresh that has been taken for granted is a vividly raw and invigorating *experience:* millions of rock 'n roll records that teenagers would buy every year, publicity blow-ups of Hollywood celebrities, rows of canned goods at a supermarket: everything that Americans do, see, are. Warhol commented, "Pop references let people know that *they* were what was happening, that they didn't have to *read* a book to be part of culture—all they had to do was *buy* it (or a record or a T.V. set or a movie ticket.)"[180] Warhol remarks to Swenson in 1963, "Everybody's always being creative."[181] In *POPism,* Warhol reiterates this fundamental principle:

> As near as I could figure, why it was all happening was because we were really interested in everything that was going on. The Pop idea, after all, was that anybody could do anything, so naturally we were all trying to do it all.[182]

Because everyone experiences Pop phenomena and because everybody can do anything, then for Warhol the Pop philosophy is that everything is good. That is, everything becomes *equally* good. "I think the artists who aren't very good," Warhol said to Swenson, "should become like everybody else so that people would like things that aren't very good."[183] In *Philosophy,* Warhol applies this uniformity to several proposed Pop environments: "There should be supermarkets that sell things and supermarkets that buy things back, and until that equalizes, there'll be more waste than there should be."[184] In fact, Warhol equates waste with art:

> Wasted space is any space that has art in it. . . . So on the one hand I really believe in empty spaces, but on the other hand, because I'm still making some art, I'm still making junk for people to put in their spaces that I believe should be empty, i.e., I'm helping people *waste* their space when what I really want to do is help them *empty* their space.[185]

Warhol's Cagian space of art as emptiness has been a conscious consideration since the beginning of his Pop phase. Referring to Pop Art, Warhol said to the illustrator Aaron Fine sometime in the early 1960s: "It's the synthesis of nothingness."[186] That is, one Pop experience, atmosphere, or art is as good as any other. Ultimately, Popism is a kind of self-cancellation: an "art" that implies all absences and all presences, held in a suspension of contradiction.

If any one thing is as good as any other thing, then what makes something of higher quality? Warhol's answer: *Thirty Are Better than One* (fig. 37). In my opinion, Warhol's means of artistic production and his works offer similar kinds of solutions. By means of a profound, Duchampian indifference to the designation of what constitutes art or non-art, Warhol allows anything or any technique. For Warhol, there is no "problem" of what may constitute an activity, esthetic or otherwise, because he disregards any traditional notions of Fine Art or Culture. A Pop artist may produce or reproduce, at will, one masterpiece or a sequence of master sequences. Moreover, Warhol disregards the concept of an artist as someone who, by study and practice, crafts a work of fine art by the perfection of execution. In its place is the Duchampian idea of an art investigator who activates something or some activity by means of his "signature."

As opposed to Duchamp's cerebral "passage" to the experiences of esthetic creativity,[187] Warhol's sensibility is a quiet, intuitive approach. Warhol's classmate, Joseph Groell, characterizes the Pop artist succinctly:

> I think he always watched himself and always knew what he was doing. But whether it was a pose . . . [Groell shrugs] . . . or whether . . . he was always just aware. That's what he was doing, but he never commented on it. I mean, he never . . . he was always silent about himself and his motivations, and he was, you know, by no means a theoretical person. Other people superimposed that on top of him.[188]

That is, Warhol has never required any theoretical or formulaic program. His works are always so uncomplicated as to be *presque rien,* and his choice of Pop subjects is so common and so undistinctive as to trigger extreme responses to his telegraphic pictorializations of American icons and taboos: an esthetic solution to defuse what is "hidden" and "powerful." Warhol has, in turn, allowed the viewer to intellectualize verbally. In fact, a survey of art and film criticism concerning Warhol would demonstrate the almost obsessive desire by critics to explicate what the artist signified in his works by means of *their* responses to them. Joseph Groell, one of Warhol's roommates during the early 1950s, has noted that even the artist's commercial art associates and clients were similarly disposed: "And, you know, people write their fantasies and projected them on him . . . that he manifested . . . somehow was able to provide . . . make them visible in some way."[189] Warhol's choice of subjects is resonant, just as he is simply *dasein,* allowing any individual responses to his work or to him.

Warhol's *Thirty Are Better than One* consists of scattered and jumpy, photographically serigraphed images of Leonardo's masterpiece of ideal femininity, the *Mona Lisa.* Warhol's painting may be seen as a celebration and inventive comment on an ubiquitously mass-produced image of fine art. Thirty reproduced images of this popular esthetic icon are all equally valid and "better" because the now nonexclusive image has become a multiple icon. The im-

pressive possibility of conveying the changes in technological reproductions of such a masterpiece are fully exploited by Warhol.

In Swenson's interview, Warhol refers to his use of silkscreens as one means of creativity, just as the mechanical possibilities used in such a medium imply the employment of assistants to do the actual work for him. Just as there is no difference in style or technique—because his Pop attitude allows any means, all of which are equally valid—there is for Warhol an equally creative potential for anyone to use such media. Warhol's attitude is:

AW: If an artist can't do anymore, then he should just quit; and an artist ought to be able to change his style without feeling bad. . . . That's probably one reason why I'm using silkscreens now. I think somebody should be able to do all my paintings for me. I haven't been able to make every image clear and simple and the same as the first one. I think it would be so great if more people took up silkscreens so that no one would know whether my picture was mine or somebody else's.

GS: It would turn art history upside down?

AW: Yes.

GS: Is that your aim?

AW: No. The reason I'm painting this way is that I want to be a machine, and I feel that whatever I do and do machine-like is what I want to do.[190]

Warhol's notion of the possibilities of the artistic reproductive process redefines the ontological status of an art object and artist. For Warhol art no longer has a classic or individual condition. A master sequence is on a par with a masterpiece; an esthetic idea is as good as any other one; any individual is as creative as anyone else.

Warhol's notions concerning individuality and the creative process are not new, and, in fact, they reflect some of the inventive ideas of László Moholy-Nagy, whose writings include *The New Vision* and the autobiographical *Abstract of an Artist.*[191] Warhol was not only aware of these books, which were revised in 1947, but he enthusiastically discussed with his art school classmates Moholy-Nagy's esthetic tenets.[192]

In *The New Vision,* Moholy-Nagy introduces again the esthetics and practice of art and design as taught at the Bauhaus and later at the author's Institute of Design in Chicago.[193] The title refers to Moholy-Nagy's proposed utopia where mankind is psychically whole and has variety in education and professional pursuits, and exploits technical progress in advanced art, literature, theatre, window display, and motion pictures. Each individual has a potential

capacity for production in life, work, and art: *"Everyone is talented. If he is deeply interested in his work, every healthy man has a deep capacity for developing the creative energies in nature."*[194] By nature, anyone may be an artist, Moholy-Nagy contends, "just as when he speaks, he is 'a speaker.'"[195]

Moholy-Nagy's wholistic approach to esthetic production is based on one of the principles that dominated the pedagogy of the Bauhaus. Moholy-Nagy comments: *"Not the single piece of work, nor the highest individual attainment must be emphasized, but instead the creation of the commonly usable type, developed toward 'standards.'"*[196] It is the "possibilities of the machine—its abundant production, its ingenious complexity on the one hand, its simplifications on the other"[197] that for Moholy-Nagy promise to satisfy mass requirements, to provide improvements in esthetic production, and to allow invention within systematization. In his envisioned utopia, a creative individual becomes liberated by the advantages of technology, but such "technical progress should never be the goal, but instead the means" to a balanced life where the "focal point is man, not profit."[198] The discussion also includes the use of different media, sensory training, tactile and material experiences, and the application of the "commonly usable type" esthetically into everyday living spaces.[199] For Moholy-Nagy, the possible realizations in art, design, and space (i.e., architecture) were to create "new types of spatial relationships, new inventions of forms, new visual counterpart to a more purposeful, cooperative human society."[200]

In his autobiographical *Abstract of an Artist,* Moholy-Nagy notes that art students often presume that the artist's problem is something remote and beyond simple and everyday feelings, thoughts, or experiences. He remarks:

> In reality a problem, seen from the point of view of the worker, can be anything, from careful observation of an event, or of its smallest detail, to the deepest intellectual penetration of any subject. The task is to translate the "problem" into a "form" which can be comprehended and absorbed by the spectator.[201]

He believes that an artist's work is a kind of "trace" of the imagination, transformed into comprehensible and direct visual experiences. "The primary intention was to produce," he writes, "the visual fundamentals of picture making."[202] Consequently, the artist-as-agent produces a creation that critically admits the imagination by the acceptance and utilization of technological and industrial materials and techniques. Such an "anonymous agent"[203] serves the public:

> I was not at all afraid of losing the "personal touch," so highly valued in previous painting. On the contrary, I even gave up signing my paintings. I put numbers and letters with the necessary data on the back of the canvas, as if they were cars, airplanes, or other industrial products. I could not find any argument against the wide distribution of works of art, even if turned out by mass production.[204]

Thus, in an age of industry and democracy, there could be no absolute distinctions between mechanical technology and manual craftsmanship, or between art and non-art: painting, photography, window display, motion pictures, sculpture, etc., were to be considered equally valid and noninclusive.

An artist may use any medium and combine it in any way. The means of production (hardware) is not even considered by Moholy-Nagy to be unique and on a par with an artist's conception (software). In fact, Moholy-Nagy recounts the process of creating multiple works over a telephone: in 1922, he ordered pictures in various sizes from a sign factory's color chart.[205] For Moholy-Nagy, art is no longer an exclusive activity of someone who refines a precious object.

The ontological status of the art object, its maker, and its means of production are critically and systematically questioned by Moholy-Nagy. Art could no longer be secured de facto by a series of rules or an academic tradition. Rather, art is an open-ended and creative play that keeps alive the creativeness, the invention, and the scrutiny of a child. It also is an esthetic business that presents ideas and their reproduction for mass consumption.

Moreover, the notion of the masterpiece is equal to the master sequence: Multiple Art that may be repeated or multiplied in any amount.[206] The process of an artistic (re)production—what an image is made of—generates the possibility that such an image can be separated from its means of (re)production, as with Moholy-Nagy's ordering paintings made at a factory. Modernism includes master sequences such as Monet's *Rouen Cathedral* paintings, a series depicting how changes of light and atmosphere affected the perception of that cathedral facade. (It is possible that Warhol may have seen the Museum of Modern Art exhibition "Claude Monet: Seasons and Moments" in 1960.)[207] Yet, Moholy-Nagy's conception of a multiplied art is not dependent upon Modernist tenets but on the potentials of the anonymity of modern technology.

For Moholy-Nagy, the potentials of the machine include copious production, ingenious complexity, and simplifications. In his envisioned utopia, there are no profit motives and no loss of individuality. For Warhol the opposite is true:

> Business Art is a much better thing to be making than Art Art, because Art Art doesn't support the space it takes up, whereas Business Art does. (If Business Art doesn't support its own space it goes out-of-business.)[208]

During the 1950s, Warhol achieved an expressive linear technique with a blotted-line, resulting in a type of monoprint. He also used carved stamps to print wrapping paper designs. Being interested in a successful career, he issued various flyers and books to promote his work and obtained assistants and friends to produce his designs. By late 1962, when he started to use the silkscreen method for Pop Art images, Warhol began not only to experiment and exploit

mechanical artistic means of production but to have assistants do his work. In a former New York fire station and then in a large mid-town loft space (which he called the "Factory"), Warhol applied on a small scale the "manufacture" of esthetic works. Why?

First, he wanted to head a production firm. In a recent interview, Warhol remarked that if he had not become a professional fine artist, he would have begun an advertising agency.[209] For Warhol, a *signature* represents the prestige in the "name" of a production company founded by an entrepreneur.[210] The entire fifth chapter of this study investigates this issue. Second, Warhol wanted to use the easiest means possible, which included photographic silkscreens and the use of assistants. Third, Warhol's philosophy of Popism had by 1963 included Moholy-Nagy's notions concerning the potentials of the machine and the ontological status of an esthetic work as multiple art. Finally, Warhol has tended to deny individuality not only to the notion of "art" but to himself and to his subjects.

In his *Philosophy* book, Warhol remarks:

> In the '60s everybody got interested in everybody else. Drugs helped a little there. Everybody was equal suddenly—debutantes and chauffeurs, waitresses and governors. A friend of mine named Ingrid from New Jersey came up with a new last name, just right for her new, loosely defined show business career. She called herself "Ingrid Superstar."[211]

Beginning in 1963, Warhol—"The Tycoon of Passivity"[212]—fulfilled a deep fantasy[213] when he filmed Ingrid and other "Superstars." Like the Hollywood stars, Warhol's Superstars *exist:* they portray the transformation of individuals into roles in which their private lives become public, and their public lives become publicity. Although discussed at length in the following chapter, it is necessary here to say that Warhol's films display and project iconic images and taboos. He equalizes the ontological status of celebrities—from street hustlers to legitimate actors and even from people to the Empire State Building—so that everyone and everything may have its 15 minutes of fame. His filmic dreams deny individuality in order to achieve an alternative cult of the metamorphosis in Hollywood movies, in which stars are equated with merchandise. "That's the thing I'm always thinking about," Warhol once remarked, "Do you think the product is really more important than the star?"[214]

Like a transvestite, a Hollywood star or a Warhol Superstar is an envisioned persona. Warhol writes in his *Philosophy:*

> I'm fascinated by boys who spend their lives trying to be complete girls because they have to work so hard—double-time—getting rid of all the tell-tale male signs and drawing in all the female signs.[215]

Just as the proper makeup and clothes are vital to a transvestite, Hollywood makeup is crucial to the star's facial "mask," especially to the lips. With

makeup, a star's beauty becomes youthful and fresh. Fixed in the soft focus of a publicity still, the star remains radiant in his or her archetypal depersonalization. Warhol continues:

> Drags are ambulatory archives of ideal moviestar womanhood. They perform a documentary service, usually consecrating their lives to keeping the glittering alternative alive and available for (not-too-close) inspection.[216]

Warhol's adoration for such "inaccessible" Hollywood stars as Liz Taylor (fig. 41) and Marilyn Monroe (fig. 42) becomes an iconic Pop painting, and his love for his debutante Edie Sedgwick becomes a filmic icon.

Moreover, Warhol himself is an envisioned persona: Andrew Warhola, Jr. to "Raggedy Andy" to "Andy Warhol." His desire for fame transforms the shy art student from Pittsburgh to an estheticized and passionless presence. Warhol states in his collected *pensées:* "When you want to be like something, it means you really love it. When you want to be like a rock, you really love that rock. I love plastic idols."[217] His choices for subjects are personal annexations, as demonstrated later in this chapter. As Warhol ascertains and monitors *his* "plastic idols," he *appropriates* them: collecting movie magazines and reading gossip columns, writing fan letters (to Truman Capote and others), buying endorsed merchandise and mementos (such as Carmen Miranda's platform shoes). Warhol has remarked: "The best atmosphere I can think of is film because it's three-dimensional physically and two-dimensional emotionally."[218] In fact, Warhol has stated that his work deals with surfaces. Gretchen Berg quotes Warhol as saying: "If you want to know all about Andy Warhol, just look at the surface: of my paintings and films and me, and there I am. There's nothing behind it."[219] To study this "art" is to investigate an estheticized topology of the means and images of Warhol's "surface," as done recently by Lynn Thorpe.[220] In Thorpe's analysis of Warhol's radical play with accident and chance on photographic silkscreens, she compares the method to the taped dialogues in Warhol's *a, a novel* (1968):

> These mistakes are testimony to the subterfuge of the silk and also mark the hinge of the silkscreen each time it lifts up and closes down to make another print "run." The hidden movement of the hinge becomes analogous to the act of tape recording which has the potential simultaneously to erase as it records. As the silkscreen swings repetitively up and down, it marks the various color stages that bring about the metamorphosis of each individual print. As every new color is added it transforms the previous stage, simultaneously erasing it and extending it with an elaboration of forms, leaving only traces of its previous configurations. Every completed print carries within it the traces of its fetal stages. The hidden, moving hinge of the silkscreen marks the print's temporal and spatial passage, simultaneously recording and effacing its contours, as the ink passes through the resistant, or, alternately, pliant mediating silk.[221]

Thorpe's precise description of Warhol's use of the silkscreen process from

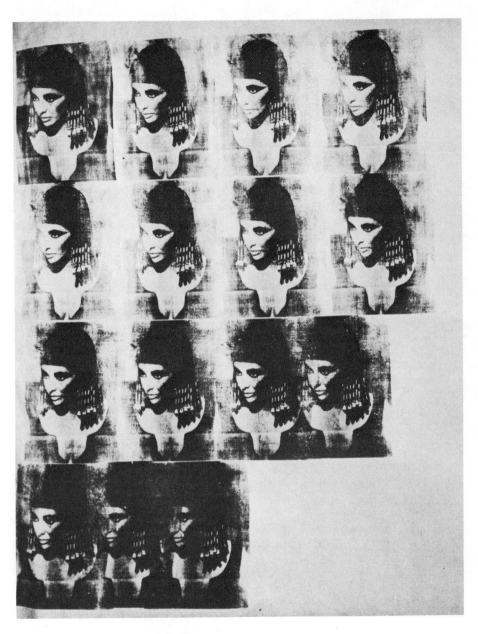

Figure 41. Andy Warhol, *Liz as Cleopatra*, 1963
Synthetic polymer paint silkscreened on canvas, 82″ × 65″.
(Private collection; © *A.D.A.G.P., Paris/V.A.G.A., New York, 1986)*

Figure 42. Andy Warhol, *Gold Marilyn*, 1962
Synthetic polymer paint silkscreened on canvas, 83″ × 57″.
(*Collection of the Museum of Modern Art, New York;*
© *A.D.A.G.P., Paris/V.A.G.A., New York, 1986*)

1962 through 1968 demonstrates how Warhol treats the surface application of paint as a Duchampian "art," in which an esthetic means is handled indifferently and implies both presence and absence. Warhol's "art" is a reification of the projected icons, his "plastic idols," of modern American culture.

Moreover, Warhol's *stare* at certain envisioned types is an intuitive and phenomenal attitude of perception: a commitment to the objectification of the *presence* of images. The ethos of this commitment is a theatricalized withdrawal, well-mannered and silent, resembling a devoted movie fan who stares at a movie screen. Warhol has written, "All my films are artificial, but then everything is sort of artificial. I don't know where the artificial stops and the real starts. The artificial fascinates me, the bright and shiny."[222] Warhol approves of his "plastic idols," accepts them, and withholds judgment: "The world fascinates me. It's so nice, whatever it is. I approve of what everybody does. It must be right because somebody said it was right, I wouldn't judge anybody."[223] The "somebody" may well be John Cage, whose life and work affirm the every day "graffiti sounds" of modern life and whose Zen-inspired use of chance and indeterminant nonintentionality has influenced Warhol.[224] Referring to his many performances with Merce Cunningham and Dance Company, Cage has stated:

> We are not, in these dances and music, saying something. We are simple-minded enough to think that if we were saying something we would use words. We are rather doing something. *The meaning of what we do is determined by each one who sees and hears it.*[225]

Cage provides here a cue for an esthetic silence in which the work is "determined" not by the artist but by the observer who completes the Duchampian game of "art."

Warhol's psychological acumen vis-à-vis American culture is his direct, uncomplicated, and uninhibited approbation of its icons and taboos. Warhol allows the spectator to be a mediator of his esthetic transactions. Therefore, in the case of Warhol, I offer the following definition of the boundary of *his* Pop Art and films: *By suspending his affective response as an observer, Warhol enables the viewer to experience directly the therapeutic resonance of an iconic image or a taboo of everyday life, as Warhol himself has experienced it or fantasized about it.*

The Death of Glamour and the Glamour of Death

Among the themes of Warhol's pictorial Pop Art works are glamour and death. Warhol combines them in such a way as to suggest the title of this section. Throughout this study, glamour and Warhol's fantasies about it have been emphasized. In my opinion, Warhol's representation of glamour, as well as of death, is of crucial significance. In chapter 2, it was remarked that Warhol's

mannerist stylizations of the chic consumer goods I. Miller sold made those products even more alluring and salable. With his success in this and other advertising campaigns, he began to produce a series of Golden Shoes that in some cases included the names of celebrities. Moreover, in Warhol's ardent desire to be employed, earn money, and be famous, he skillfully promoted his self-identifiable blotted-line technique and interest in visual "noise" in a series of promotional books, flyers, wrapping paper, etc. His clients would keep his promotional devices and hang their "Andy's" on a wall. They would recall him as a shy and whimsical "Andy Paperbag" or "Raggedy Andy." Notwithstanding the many cordial remembrances by his assistants and clients, Warhol was willing to pose as helpless in order to obtain such free assistance as with the many "coloring parties."

In spite of his deliberate and definitive break in 1960 with his commercial art stylizations, Warhol's work of the 1950s does have a "developmental" affinity with his Pop Art: from the use of an expressive blotted-line with additional visual "noise," to the accidental nuances of the (photographic) silkscreen process over a field of brilliant and "distancing" color. Moreover, Warhol's tracing or, at least, drawing from popular art sources can be discerned by at least the early 1950s, a time when he also employed assistants and used his mother's decorative calligraphy for his own "signature." Finally, Warhol's art and career represent the use of art to convey certain implicit or explicit extreme positions.

The dialectical extremes are glamour and death. In the next section, Warhol's ambivalent attitude toward glamour will be discussed in terms of the biographical elements in his pictorial Pop Art works. A survey of Warholian commentary suggests several responses to his depiction of glamour. One response is to combine the notion of theatricality and celebrityhood with Warhol's use of off-registration so that the cosmeticized appearance of a silkscreened personality is seen to be ironically turned upon itself. The second response deals with possible "psychological" overtones. Both responses are clearly evident as reactions to Warhol's images of Hollywood actresses Elizabeth Taylor and Marilyn Monroe.

For instance, Joanna Magloff has described *Liz as Cleopatra* of 1963 (fig. 41) as "gruesome" as "the photos of the dead reproduced on the tombstones seen in Italian cemeteries."[226] In Michael Fried's review of Warhol's one-man show at the Stable Gallery in 1962, Fried noted that Warhol's choice of subject matter, such as Monroe and Taylor, "is necessarily parasitic upon the myths of its time, and indirectly therefore upon the machinery of fame and publicity that market these myths. . . . Warhol's beautiful, vulgar, heart-breaking icons of Marilyn Monroe [reveals her as] one of the overriding myths of our time."[227] Yet, in Dore Ashton's review of the same one-man show, Ashton unfavorably compares Warhol's depiction of Monroe with de Kooning's version and re-

marks that "Warhol simply lifts the techniques of journalism and applies them witlessly to a flat surface."[228] Monographs on Warhol's images usually combine both responses. Peter Gidal refers to the *Marilyn* in terms of the formal repetition of a serialized image, the "distancing" effects of garish colors, and the implication that Warhol consciously emphasized Monroe's lips as a kind of *vagina dentata*.[229] The "distancing" effect of an image with Fauvist coloration is seen by Rainer Crone to be based consciously on Brecht's notion of the Alienation Effect, and Crone believes that Warhol's "impersonal" and radical approach to the tradition of easel painting "revolutionized" the concept of art.[230] Although the critical responses to Warhol's pictorial works are divergent in orientation, they all seem to suggest an approach based on formal, "psychological," or Marxist criteria.

Lynn Thorpe uses a structural approach. Thorpe's examination of the "signs" and "sign-systems" of religious, esthetic, and cultural images is used to interpret Warhol's *Gold Marilyn* of 1962 (fig. 42). This painting is, according to Thorpe, not just an isomorphic representation of Marilyn Monroe "presented to millions of fans through the commercial media."[231] Warhol's iconic image also entails "inherent" implications of a sexualized and unhumble Madonna; moreover, Warhol's use of gold is a visual pun in that the actress is a "gold mine" to Hollywood studios.[232] Silver variants of the *Marilyn*s (as well as of the *Brando*s and *Taylor*s) allude to the "silver screen" of a motion picture theatre.[233] Thorpe concludes:

> By placing in contestation the double meaning of the iconic sign, as both secular and religious signs that signify Marilyn and [the Virgin] Mary, Warhol effectively reduces both of them to products of collective cultural and religious myths that existed at different times but, more important, reveal man's need throughout historical time to set up systems of belief.[234]

In my opinion, Thorpe's concentration on one crucial aspect of Warhol's works—the radical play of the display of ironic images—is a significant contribution.

However, to my knowledge, no one has considered the contextual implications of Warhol's images of Monroe and Taylor. In fact, his choices and timing reflect, in my opinion, his iconological indication of the "death" of Hollywood glamour symbols and its star system. Like a child or a movie fan, Warhol was impressed by Hollywood stars. Not only did he read gossip magazines, tabloid newspapers, and biographies about Hollywood stars,[235] he often invited actors and actresses to his studio, the "Factory."[236] He met Marilyn Monroe twice.[237] The art critic Robert Pincus-Witten was a close friend, and Pincus-Witten recalled that the artist would say to him, "I'm interested in glamour."[238] Not only did Warhol write fan letters everyday for years to Truman Capote,[239] he collected autographs[240] and wrote fan letters to opera stars and other celebrities.[241] For Warhol, success *is* glamour.[242] In fact, he wanted

to illustrate Amy Vanderbilt's cookbook because she was glamorous and fa-
mous.[243] During my interviews with his associates and friends, virtually all of
them remarked that Warhol's conversations dealt with glamour and gossip.[244]
Warhol would call the gossip columnist Dorothy Kilgallen almost every day.[245]
Warhol was ardently interested in the minutiae surrounding the celebrities and
productions of Hollywood films, and of the entertainment industry at large.
Marilyn Monroe and Elizabeth Taylor are two of Hollywood's most famous
and glamorous products, and Warhol created the images of them at a very spe-
cific point in the history of Hollywood's star system, a scheme that Warhol
thoroughly and persistently appreciated, admired and, in his films, copied.

In addition to his depictions of Taylor's iconic publicity photo, Warhol
produced *The Men in Her Life* (*Mike Todd and Eddie Fisher*), *Eddie and Liz*,
and *Daily News* all of 1962.[246] The latter is a black-and-white painting of the
back and front pages of the 29 March 1962, issue of "New York's Picture
Newspaper," the *Daily News*. The front cover headline, "EDDIE FISHER
BREAKS DOWN—In Hospital Here; Liz in Rome" accompanies a photo of
the actress with her husband. In 1963, Warhol produced (at least) three paint-
ings entitled *Liz as Cleopatra*.[247] To understand why Warhol's choice of these
images of Taylor and Monroe represent his response to what he felt was the
"death" of glamour and Hollywood's star system, it is necessary to describe the
circumstances behind the movie *Cleopatra* and Taylor's scandalous publicity
during its filming.

Taylor's biographer, Dick Sheppard, succinctly characterizes the actress's
career when the shooting of *Cleopatra* began in Rome. Sheppard observes:

> The announcement by *Motion Picture Herald* on December 29 that Elizabeth was the Top
> Box Office Star of 1961 (thus out-ranking Rock Hudson, Doris Day, John Wayne, and Cary
> Grant) placed her at the very summit of her professional achievement. Now she had it all:
> an Oscar, box office supremacy, the title role [in *Cleopatra*] expressly conceived for her in
> what would doubtless be the most expensive film ever made, the adoring husband [Eddie
> Fisher], the solicitous studio [20th Century Fox], the feverish attentions of the world press,
> the love and adoration of millions.[248]

The filming of *Cleopatra* began in England, where Taylor came near death
with acute pneumonia and anemia; her life was saved only by a tracheotomy.[249]
After her long recovery, the studio began filming *Cleopatra* in Rome. While
in Italy, Taylor suffered from food poisoning.[250] The cost of the film escalated:
$6 million lost in the initial filming in London, and other expenses, the total
amounting to $39 million dollars.[251] Taylor's co-star, Richard Burton, fell in
love with the actress, and their affair during the production of the film became
the "media event" of the year.[252] In fact, columnist Art Buchwald mused that
the headlines concerning the actress's illnesses and love affair were taking
political events (nuclear testing, disarmament, Berlin, Vietnam, and Russo-
Chinese differences) off the front pages, and Buchwald asked for a worldwide
referendum concerning the actress because:

Elizabeth Taylor's problem has become the world's problem. Those who abstained from voting would be considered to have shirked their responsibility and would have no moral right after that to interfere in the personal life of Elizabeth Taylor—no matter how interested they might be.[253]

While *Cleopatra* was still in production in Rome and the Burton-Taylor affair was receiving worldwide publicity, 20th Century Fox studio was filming *Something's Got to Give,* starring Marilyn Monroe. Monroe was being paid $100,000 for this film (as opposed to Taylor's salary of $1.5 million for *Cleopatra*) and, according to Brenda Maddox, she deliberately swam in the nude for a swimming pool sequence:

She posed and frolicked for the delighted photographers, who were getting [in May of 1962] the first nude pictures of Marilyn Monroe in fourteen years. "I'll be happy," she said, "to see all those [magazine] covers with me on them and no Liz."[254]

Yet Monroe did not live to see the publicity that she received for the nude sequence. She died in August 1962, and 20th Century Fox suspended and then canceled the film. The same studio scheduled *Cleopatra's* filming to be completed by mid-May of that year, but the film's shooting was not completed until early March 1963.[255] The critical and public reaction to *Cleopatra* was mixed to scathingly negative.[256] Although the studio's production of *The Longest Day* salvaged its finances, there were widespread reports and speculation in the popular press that the cancellation of *Something's Got to Give* and the box-office failure of *Cleopatra* not only signaled the probable demise of a major Hollywood studio but also marked the end of both epic spectacles and the star system.[257]

According to David Bourdon, who was then art critic for *Life* magazine, Warhol asked him for photos of Elizabeth Taylor from that magazine's picture collection for *Liz* and *Liz as Cleopatra.*[258] When questioned about his choices in the depiction of Monroe and Taylor, Warhol has remarked:

I don't feel I'm representing the main sex symbols of our time in some of my pictures, such as Marilyn Monroe or Elizabeth Taylor; I just see Monroe as just another person. As for whether it's symbolical to paint Monroe in such violent colors: it's beauty, and she's beautiful and if something's beautiful it's pretty colors, that's all. Or something. The Monroe picture was part of a death series I was doing of people who had died by different ways.[259]

Concerning his *Liz* series, Warhol told Gene Swenson, "I started those a long time ago, when she was so sick and everybody said she was going to die. Now I'm doing them all over, putting bright colors on her lips and eyes."[260] Notwithstanding Warhol's curious mention of beginning the *Liz* series "a long time ago,"[261] Warhol associates the two glamorous actresses with death—*their* (possible) deaths. The instantaneous nostalgia evoked in the timing of his decision to depict the actresses must be considered, too, with Warhol's filmmak-

ing activities. It was during his *Kiss* films.[262] Moreover, Warhol also produced that year the silkscreened print *The Kiss:* a film still of Bela Lugosi as Count Dracula about to bite the neck of Helen Chandler as Mina in the 1931 film *Dracula.*[263] Just as the "kiss" of a vampire promises an eternal life in death, the *Kiss* series by Warhol contracts the artist's participants to a cinematic immortality. Warhol tends to suggest a metaphorical process of the notions of glamour and death. Moreover, his renderings of his beloved "plastic idols"[264] are the two-dimensional projections of his own fantasies concerning the secret of screen magic.[265]

For Warhol, the glittering alternative to real life—the projected enchantment of a Hollywood film—is a momentary cessation of the problems of life. Warhol wanted to "kill" his own emotional life by means of some mechanical device: his desire to be a "machine" is a manifestation of almost pathological necromancy. Stephen Koch observes:

> The old Factory [i.e., Warhol's studio, 1962–1968] was about decadence, about the wasted pallor on Warhol's boyish face, about his silence, his affectless gaze, the chic freakishness of his entourage, about all the things he was able to endow with the magic of his frame and transform into the image, par excellence, of a subterranean world of beautiful people and geniuses and poseurs, the obsessed and the bored, come at last into their glamorous own. To the people who gathered around him, Warhol *was* fame; . . . pale, soft-spoken young men with jobs sorting mail in the post office, who came out at night transformed by Marilyn Monroe wigs and make-up caked on their faces, . . . passing the drugs that would keep them awake during the next grim day when they showed up at work in Klein's dacron sport jackets and stringy worn-out ties.[266]

The fantasy netherworld of Warhol's "Factory," where his entourage and assistants would congregate, was the setting of his pictorial and filmic productions. The (almost) deceased glamour of the Hollywood studios would be recreated— *relived*—by his followers. Warhol remarks, "Drags are ambulatory archives of ideal moviestar womanhood. They perform a documentary service, usually consecrating their lives to keeping the glittering alternative alive and available for (not-too-close) inspection."[267] The key to understanding a female impersonator is the same as understanding a Hollywood personality: both are envisioned people—they (and others) picture themselves as a theatricalized image. Stardom is both fulfillment and desire, as well as unattainability. When a glamorous actress, such as Monroe or Taylor, ceases to exist literally, it becomes possible to envision her through the proxies of impersonators or of her own iconic image. Warhol's commitment to the ideals of glamour, stardom, fashion, and fame is expressed in his pictorial Pop Art works, which consign for preservation (such as iconic image), and in his films, which generate his own versions of the star-persona.

Warhol realizes that such illusions are manufactured deceptions, and he presents them *as such*. He is as open to the falsehood of others and himself as

he is to the artifices of a Max Factorized beauty. What Warhol does is to present portrayals of iconic and glamorous celebrities *at the extreme* of their own intentions. Warhol does not so much portray "sardonic" and "ironic" parodies as he uses the false art of Hollywood as an "art" about itself. Through the accidents of the serigraphic process, the repetition of the pictorial sources, and the "distancing" quality of off-registration, Warhol insists that the viewer encounters the doubt of "surfaces." That is, he deliberately and outrageously displays the externals of the otherworldly romance and theatricality of glamorous Hollywood personalities so that the viewer may be spared the latent terror of its—and our—passing. Warhol breaks the taboo, the prohibition, against the manufactured illusion of vigor, youthfulness, and beauty. Warhol's *Liz* and *Marilyn* series are the poignant reminders of Hollywood stardom. He estheticizes and anesthetizes the very materiality that the two actresses represent by depicting the publicity photos, the nostalgic regret of a "lost" star system, and his emphasis of off-registered surface makeup and silkscreen splotches. Warhol praises the cosmetics of such celebrities, just as he promotes and packages his own "Superstars" as his own stereotypes of glamour. In a sense, he rescues the notion of a chic and glamorous life by means of a mediation of that phenomenon.

Most commentators on Warhol's art have felt that his portrayal of such Hollywood stereotypes is meant to be essentially laden with irony.[268] They seem to suggest that Warhol employed a conscious strategy to present a critique of such an image and to indicate a "better" or more "truthful" version. An exception to this critical response is taken by Lynn Thorpe. Thorpe remarks:

> At the moment that we propose the image stands for something else we introduce hermeneutic devices that are supposed to lead us to the hidden truth of the work of art. In this way, irony becomes the ultimate form of recuperation and "naturalization." We reduce what is strange or incongruous by calling them ironic and making them confirm rather than deny our expectations. This [irony] has been the most dominant mode of interpretation of Warhol's art throughout his career.[269]

Rather, according to Thorpe, Warhol uses the radical playfulness of parody by mixing expectations of semiotic "codes":

> Warhol's movement away from ultimate meaning in art via parody is aided by his refusal to remember anything from one day to the next. This disavows any calculated aesthetic life style and casts him into the role of perpetual innocent. Thus he avoids any ironic Duchampian critique of society or art. By crossing indices of many semiotic systems in his art, Warhol raises the issue of the validity of the ordering system itself.[270]

A third and last known critical response to the *Liz* and *Marilyn* series is a Marxist one,[271] in which the notion of "irony" is used in a specifically Brechtian viewpoint. For instance, Rainer Crone proposes that Warhol's "distancing" ef-

fect of mass images leads to "the most topical, national product—the most precious goods of a nation whose ideology has led to the destruction of personality, of the individual."[272]

In my opinion, the key to Warhol's use of "glamour," just as in his use of "art," is the depiction of the demystified apotheosis of a Hollywood celebrity. Concerning his film *Chelsea Girls,* Warhol once remarked: "I use superstars in my movies so they can be superstars, portray their spontaneous— uh—talents on the screen."[273] In similar statements that have been published or that Warhol has made to me in conversation, the artist tends to be anti-analytical and to allow confusion concerning irony. Warhol forces viewers to see an image of Hollywoodized glamour *through* its own significance. His *Liz* and *Marilyn* series are difficult to explain precisely because they are easy to understand: anyone familiar with Hollywood glamour, fame, and publicity can understand depictions of it, but Warhol displays not the reality but the extreme irreality of such glamorous stars. Glamour is both present and absent in these paintings because he projects the cancellation of glamour by its own vulgarized extremity. By concentrating the viewer's attention on the arbitrarily "violent" and superfluous extremes of Hollywood makeup and an actress's perpetualized smile, Warhol deadens identification with and sympathy for a star. Consequently, the dilemma of a viewer's decision concerning irony is kept in suspension by Warhol. By concentrating attention upon Monroe's or Taylor's face, he focuses the viewer's consideration on the likeness used in traditional portraiture and on the likeness used in publicity photography.

Moreover, such glamorous and chic stars as Monroe and Taylor represent an idealized type. His series *Liz* and *Marilyn* are the almost taxidermic taxonomies of such images. Warhol's "naturalism" is the reification of mass media photographs that are retrospective in their nature. In this sense, one may return to Joanna Magloff's remark that *Liz as Cleopatra* reminds her of "the photos of the dead reproduced on the tombstones seen in Italian cemeteries."[274] Yet, Warhol leaves open-ended how one may respond to any of his works so that, as with *Thirty Are Better than One,* any response is as good as any other, and more responses generate for him more publicity and income. Notwithstanding the artist's attitude toward *Liz* and *Marilyn,* the two series to me suggest the artist's response to the "death" of glamour.

For Warhol, glamour and decay are parts of his own pose.[275] It is significant that the collected poems of Warhol's Pop Art assistant, Gerard Malanga, are entitled *Chic Death*. Malanga's literary efforts are responses to Warhol's *Disaster Series* and are printed opposite reproductions of that series.[276] In Malanga's heretofore unpublished manuscript concerning his first working day in June 1963 with Warhol, he writes:

> After printing four or five 40″ × 40″ canvases we went back to Andy's apartment [. . .]
> Andy was very pleasant; put on Sally Goes Round the Roses, offered me some Seven Up

and showed me his photograph collection which was given to him by his friend John Roblosky, the editor of the now defunct "girlie" magazine, *Scene*. The photos were of a very odd assortment: car crashes, people being tortured, and candid and posed photos of movie stars and nudes. It suddenly dawned on me that these photos were actual subject matter reproduced into silkscreens and that the carelessly placed canvases of *Campbell's Soup Cans* lying on the floor were actually paintings created by Andy, paintings I had seen all the time in magazines.[277]

Moreover, Warhol frequented bookstores that specialized in such sensational books,[278] and he asked many people to provide him with the most horrific and gruesome photos possible of natural disasters, traffic accidents, and suicides.[279] "Everybody knew what kinds of pictures he wanted," David Bourdon has remarked, and Bourdon, who worked at that time for *Life* magazine, supplied photographs of car crashes to Warhol.[280] The artist is still a regular reader of the tabloid newspaper, the *National Enquirer*.[281] In his memoir *POPism*, Warhol recalled one typical dinner during this period with Emile de Antonio: the two friends discussed art while Warhol "had the *National Enquirer* in my lap—I was fascinated by all the thalidomide stories"[282] about tragically deformed babies. Such "tabloid sensationalism" had a very strong appeal to Warhol.[283]

As with his paintings of Elizabeth Taylor, Warhol's Disaster Series begins with a black-and-white reproduction of the front page of the 4 June 1962, issue of the *New York Mirror* with the headline "129 DIE IN JET!"[284] In John Wilcock's interview with Henry Geldzahler, Geldzahler takes credit for the initiative to do the series:

> Great closeness was in the decisions about some of the paintings, too. I mean I bought him the first newspaper that he did, the "129 Die in Jet!" This was in June '62. We met at Serendipity for lunch one day and I brought him his headline and I said that's enough life . . . it's time for death. He said what do you mean? I said it's enough affirmation of soups and Coke bottles. This is what is really happening. . . . I never did anything literally to do with the paintings, I did help him decide what kind of thing to do.[285]

Warhol did ask for suggestions—as he did even with me—and ideas concerning his works, but, nonetheless, Geldzahler's proposal, in my opinion, only activated Warhol's own latent interest in depicting such disasters. As discussed earlier, the artist did a painting during the late 1940s that was directly based on a newsphoto of a Chinese baby during the bombing of the South Station of Shanghai (fig. 13).[286] Warhol's Disaster Series during the 1960s represents, then, an *explicit*[287] return to the depiction of highly publicized events recorded by photojournalists.

For instance, Warhol's *Race Riot* paintings of 1963–64 were taken from three photographs of a man being attacked by police dogs during the Birmingham riots. These photos by Charles Moore appeared first in the 17 May 1963 issue of *Life*.[288] Moore disapproved of Warhol's unauthorized use of the

photographs, and the artist settled the dispute by giving Moore a series of prints entitled *Flowers*.[289] Ironically, the *Flowers* series of paintings and prints[290] were taken from *Popular Photography*—a photo of Everglade flowers by Patricia Caulfield, who sued Warhol and thereafter received a royalty.[291] Because of such disputes, Warhol subsequently has used photographs taken by his assistants.[292]

The images for the Disaster Series are very unsettling: horrific car crashes,[293] an empty electric chair at Sing-Sing,[294] *Thirteen Most Wanted Men*,[295] race riot, suicides,[296] *Tunafish Disaster*,[297] a gangster funeral,[298] and photos of Jacqueline Kennedy at the time of the assassination of her husband.[299] In fact, the Castelli Gallery had great difficulty in selling these works, especially the *Electric Chair* paintings.[300] Critical reaction to the Disaster Series concentrated on the totally discomforting "hot" images that were silkscreened on top of a "cool" field of color.[301] The extreme of the possibilities of violence are presented by Warhol through the display of photojournalism. Warhol's use of violent images has been discussed by his critics. Yet, as far as I know, no one has associated Warhol's images of violent death with his sense of glamour except in the case of the *Jackie, Liz,* and *Marilyn* series.[302] Typically, critical reactions deal with formal aspects or with Warhol's use of the mass media.[303] A Marxist response, such as one by Rainer Crone, refers to Warhol's *Car Crash* works as pictures that "*become* criticism as soon as they are received into the machinery of the art market and thus accepted by society as viable artworks. Only a mirror held up without comment reflects society's ills—therein lies the criticism."[304] Warhol's "distancing" coloration has been seen as a kind of Brechtian "interference" with the imagery, which, according to Crone, generalizes "the subject, making it the basis for critical thought and reflection."[305]

Warhol's repeated use of violent images in the Disaster Series is another form of visual deployment. The individuality of a victim is cancelled by its splotched recapitulation, just as the idealized masterpiece *Mona Lisa* loses its traditional uniqueness in *Thirty Are Better than One*. Yet, Warhol's published statements reveal a profound preoccupation with the ultimate and unthinkable taboo: death. Moreover, he tends to associate death with its opposite: glamour. For instance, Warhol said to Gretchen Berg:

> All my films are artificial, but then everything is sort of artificial. I don't know where the artificial stops and the real starts. The artificial fascinates me, the bright and shiny . . . I still care about people but it would be so much easier not to care . . . it's too hard to care . . . I don't want to get too involved in other people's lives . . . I don't want to get too close . . . I don't like to touch things . . . that's why my work is so distant from myself . . .[306]

In order to understand Warhol's remarks concerning his fascination with "the artificial" and "the bright and shiny," the titles of his Disaster Series will reveal

his attitude toward the imagery: *Optical Car Crash, 5 Deaths 11 Times in Orange, Lavender Disaster, Mustard Race Riot,* and *Suicide (Purple Jumping Man).*[307] The descriptive titles further "deaden" the imagery, just as the very bright, saturated fields of color "distance" the images. Significantly, in response to Gene Swenson's question concerning why he did such violent images of death, Warhol replied: "I believe in it."[308] Just as Warhol believes in the "glittering alternative" of Hollywood's glamorous stars (his *Liz* and *Marilyn* series are *part of* these images of death), Warhol believes in the stillness and the silence of an untroubled, "machine"-like, or "deadened" existence: one that is forever carefree, exciting, attractive, fascinating, and hence, glamorous. The artist's *Philosophy* book includes a section about death. Warhol writes, "I'm so sorry to hear about it. I just thought that things were magic and that it would never happen."[309] Warhol denies death by living it. The dialectical extremes of death and glamour are cancelled in order to depict their silent synthesis, as most evident in his *Electric Chair* paintings (fig. 43). These paintings of a silkscreened photograph of an instrument of death (next to which is a sign marked "silence") are on a field of a bright, saturated color (usually yellow). Warhol's remark concerning the nature of his Pop Art—"It is the synthesis of nothingness"[310]—may now be considered crucial. Just as his work concerns "art," his pictorial Pop works are engaged in "glamour" and "death" by cancelling one extreme by the other and through his reifications of these themes.

Warhol deals with glamour and death in a profoundly direct and frontal way. The viewer may intellectualize at will about his images,[311] but Warhol's visualization is the externalized and basic "solution"—his "solution." By means of photographically silkscreened images that are produced by his many assistants, Warhol displays his fantasies concerning life.[312] Concerning pornographic images, Warhol said to Gene Swenson:

> When you read Genet you get all hot, and that makes some people say this is not art. The thing I like about it is that it makes you forget about style and that sort of thing; style isn't really important.[313]

One could substitute images of glamour and death, which are for Warhol almost interchangeable, and Warhol's sentiment would be the same. His technical "ineptitude" is not merely his acceptance of chance effects but, also, his deliberate renunciation of fine art. Moreover, the enigmas of death and glamour are displayed as being cancelled so that they may be reinstated directly into our consciousness. Just as television levels and disrupts any continuity of a dramatized plot,[314] Warhol's so-called "alienation effects" are both visual "noise" and equalizers.

Warhol referred to Monroe "as just another person."[315] Conversely, one of his most often quoted (and misquoted) statements is: "Everyone in the future will be famous for 15 minutes."[316] Just as everybody will encounter death,

Figure 43. Andy Warhol, *Electric Chair*, 1963
Synthetic polymer paint silkscreened on canvas, 22″ × 28″.
(*Private collection, New York; © A.D.A.G.P., Paris/V.A.G.A., New York, 1986*)

Warhol proposes that everyone can achieve the "glamour" or "fame" of a Hollywood star, as with his own stable of "Superstars." The mystique of glamour and of death is a "surface" issue. Warhol does not deal with hidden meanings. His displays of glamour and death are blatantly apparent, but he does "hide" himself in the "surfaces" of his works. The following section will explore autobiographical elements in the "surface" structures of his pictorial projections of glamorous and violent imagery, imagery that is consciously displayed as ambiguous in order to shock and to expose the extremes of life and to reflect it by deflecting it.

Autobiographical Elements in Warhol's Pop Art

Andy Warhol invites the viewer to experience a Pop Art image without his interference: "If you want to know about Andy Warhol, just look at the surface: of my paintings and films and me, and there I am."[317] He remains essentially "silent" so that he will not augment or diminish the effect of a painting. Perhaps the greatest open secret concerning his Pop Art paintings is that they do express autobiographical elements. Despite his disavowal of attachment, Warhol has left not just his self-proclaimed "surface" personality on the canvas, featuring surface textures of the silkscreen process, but also (very) personal references to his life and artistic career.

Since the time that his mother changed his birthdate from October 1930 to 6 August 1928,[318] Warhol has celebrated his birthday in August. On his fifteenth "birthday," the atomic bomb fell on Hiroshima: an event Warhol silkscreened in 1965 on the twentieth anniversary of the "Atomic Age."[319] In his youth, Warhol's mother used to read to her bedridden son: "My mother would read to me in her thick Czechoslovakian accent as best she could and I would always say 'Thanks, Mom,' after she finished with Dick Tracy, even if I hadn't understood a word."[320] In his early Pop Art canvas *Dick Tracy* of 1960, Warhol obscured the speech-balloon of the comic strip detective. Could the artist be referring implicitly to the memory of his mother's reading that comic strip?

In fact, just as in the works of Johns and Rauschenberg, other prominent American Pop artists have depicted memories of their lives in their "impersonal" paintings and Performance Art works. "Most of my work," Robert Indiana has said, "is very autobiographical in one way or another."[321] For instance, Indiana has explained the personal implications of his "sign" diptych painting *EAT-DIE* of 1962:

> *Eat* and *Die*, in particular, stem from the fact that "Eat" happened to be the very last word that my mother said to me before she died. That stuck very, very vividly in my mind, and I think that accounts for it. However, *Eat-Die* obviously has something to say about the consumers of America and maybe the destiny of all organisms.[322]

Other Pop artists combine similar tokens or "signs" that formulate and stereotype private happenings and meaning so that the viewer may become aware of *lived* daily life. Jim Dine's images of paint boxes, saw horse pieces, and bathroom fixtures refer to his uncle's hardware store, and to the Readymades by Duchamp.[323] Dine's Happening *Car Crash* is a literal "psychodrama" that enacts and "exorcises" the trauma of the artist's automobile accident.[324] Claes Oldenburg's works and performance pieces are the objectifications of his personal fantasies,[325] as are the paintings by James Rosenquist.[326] American Pop Art may be seen as being just as personal as Abstract Expressionism. But the Pop artists choose the ubiquitous "signs" of popular imagery and evoke the means of popular media: Pop Art transforms personally private moments into ones that the viewer may easily identify with. Lawrence Alloway remarks:

> Where process abbreviation is found in Pop Art, it reduces personal nuances of handling by the artist in favor of deadpan or passive images. This deceptive impersonality amounts to a game with anonymity, a minimizing of invention, so that the work is free to support its interconnections with popular culture and with the shared world of the spectator.[327]

In my opinion, Alloway is correct in the case of Warhol's Pop Art.

Warhol *felt* that Roy Lichtenstein had "stolen" his idea[328] for his comic strip after Lichtenstein had seen his comic strip paintings in the window display of Bonwit Teller during April 1961. Consequently, Warhol paid a friend, Muriel Latow, to give him a new idea. Warhol's close friend and associate Ted Carey was present during this "esthetic" transaction. Carey remembers:

> "So," he said, "Muriel, you got fabulous ideas. Can't you give me an idea?" And, so, Muriel said—she said, "Yes." "But," she said, "it's going to cost you money." So Andy said, "How much?" So she said, "Fifty dollars." She said, "Get your checkbook and write me a check for 50 dollars." And Andy ran and got his checkbook like, you know, he was really crazy, and he wrote out the check, and he said, "All right. Give me a fabulous idea." And, so, Muriel said, "What do you like more than anything else in the world?" So Andy said, "I don't know. What?" So she said, "Money. The thing that means more to you and that you like more than anything else in the world is money." And so Andy said, "Oh, that's wonderful." "So, then, either that or," she said, "you've got to find something that's recognizable to almost everybody. Something you see every day that everyone would recognize. Something like a can of Campbell's Soup." So Andy said, "Oh, that sounds fabulous." So, the next day Andy went out to the supermarket (because we went by the next day), and we came in and he had a case of every . . . of all the soups.[329]

Warhol used both ideas and especially capitalized on the Campbell Soup can (fig. 44).[330] The other image—money—was also used and also represents one of Warhol's preoccupations.

In his 1975 *Philosophy* book, Warhol equates the value of his commercial art with money[331] and provides one of his most famous pronouncements:

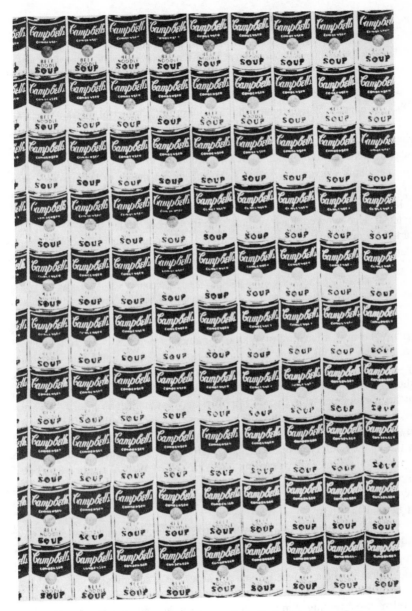

Figure 44. Andy Warhol, *One Hundred Campbell's Soup Cans*
(Detail), 1962
Acrylic paint stenciled on canvas, 72″ × 52″.
(*Collection of Albright-Knox Gallery, Buffalo, New York;*
© *A.D.A.G.P., Paris/V.A.G.A., New York, 1986*)

> Business art is the step that comes after Art. I started as a commercial artist, and I want to finish as a business artist. After I did the thing called "art" or whatever it's called, I went into business art. I wanted to be an Art Businessman or a Business Artist. Being good in business is the most fascinating kind of art. During the hippie era people put down the idea of business—they'd say, "Money is bad," and "Working is bad," but making money is art and working is art and good business is the best art.[332]

Although chapter 5 investigates the "Business Art" aspect of Warhol's career, it is necessary here to indicate that his esthetic sense entails entrepreneurial schemes. Moreover, Warhol's repetition of the same image is a Pop convenience to generate more income. In fact, according to Gerard Malanga, Warhol's use of a blank canvas that forms a diptych is not meant to "symbolize" anything; rather, for Warhol it was something (income) for nothing (blank canvas).[333] "Money is money," Warhol writes in his *Philosophy* book, "It doesn't matter if I've worked hard or easy for it. I spent it the same."[334] In fact, Warhol's Pop images of American currency are given their philosophical equivalent:

> I like money on the wall. Say you were going to buy a $200,000 painting. I think you should take that money, tie it up, and hang it on the wall. Then when someone visited you the first thing they would see is the money on the wall.[335]

Perhaps the most revealing of Warhol's monetary *pensées* is the following: "I have a Fantasy about Money: I'm walking down the street and I hear somebody say—in a whisper—'There goes the richest person in the world.'"[336] Warhol's esthetic "price"—the price of the highest bidder—can be gauged by the fact that he overcompensates for his impoverished youth. Yet Warhol's "art" and career are intertwined with his business sense. In fact, Warhol's first Pop Art show in New York was contingent in part upon depicting money. Eleanor Ward ran the Stable Gallery at the time, and Warhol was introduced to her by Emile De Antonio in 1962. After deciding over drinks that Warhol might be included in a vacant exhibition time, Ward took from her purse her lucky two dollar bill. If Warhol would paint the bill, she would give him a one-man show. He did, and he had his show.[337]

Warhol's *Campbell Soup Cans* refer to something he consumed every day, and his early Pop paintings of *S&H Green Stamps* of 1962 refer to his mother's shopping habits. According to Alfred Carleton Walters, Warhol's friend and model, Mrs. Warhola shopped every day at a nearby supermarket and would return home with S&H trading stamps. Apparently, Mrs. Warhola's ardent desire to collect these trading stamps included her son and anyone else she could get to lick and place rows of these stamps in redemption booklets.[338] The serial image or images of Warhol's paintings may well have been inspired in part by the seriality of these booklets.

Warhol once said to Gretchen Berg, "I never wanted to be a painter. I

wanted to be a tap dancer."[339] In my opinion, Warhol's Pop paintings *Dance Diagram (Fox Trot)* and *Dance Diagram (Tango),* both of 1962, may be seen as his objectifications of his interest in dance.[340] In art school he was a member of the dance society, and his first datable blotted-line drawing is a Christmas card depicting ballet dancers in various poses.[341] As a free-lance commercial artist, Warhol was a regular contributor to *Dance* magazine, and his first residence in New York was the apartment-studio of dance-therapist Francesca Boas.[342] Moreover, Warhol's *Merce Cunningham* pays homage to this choreographer and collaborator of John Cage.[343]

However, it is Warhol's series *Before and After* (fig. 45), taken from a plastic surgeon's advertisement in the *National Enquirer,*[344] that represents a very personal autobiographical element that has been "impersonally" depicted.[345] It may be recalled that several of Warhol's drawings of the 1950s curiously omitted the nose. Furthermore, Warhol's photograph, done at the artist's insistence by George Klauber in 1951, features Warhol imitating Steichen's photograph of Greta Garbo and the hairstyle of Truman Capote. In Klauber's photograph, one may discern Warhol's facial discolorations, or birthmarks, and his bulbous nose. Like the condition that afflicted comedian W. C. Fields, Warhol's bulbous nose would have become redder and larger had Warhol not undergone plastic surgery to correct his condition.[346] According to Charles Lisanby, Warhol's corrective surgery (performed sometime during the mid-1950s) had a great effect upon the artist:

> He *had* very definitely the idea that if he had an operation on his nose, which was, kind of, bulbous, then, suddenly, that would change his life. . . . But he *thought* that if he had his nose operated upon that he would become an Adonis and that I and other people would suddenly think that he is as physically attractive as many of the people that he admired because of their attractiveness. And when that didn't happen, I think, perhaps, that he became rather . . . he was very upset, and, perhaps, he was even angry because *suddenly* now things weren't different—as if an operation could remove or rearrange something is really going to change that person.[347]

If this is the case—and there is, in my opinion, no doubt—then Warhol's *Before and After* represents a caustic *ressentiment:*[348] in the painting, the woman is no more "glamorous" after her cosmetic change than before it. Yet Warhol insists upon glorifying blemishes,[349] and then contradicts himself.[350] "Andy the Red-Nosed Warhola,"[351] as the artist reports his family called him, did not become "glamorous" and "attractive." His ambivalent belief in the importance of cosmetic surgery and the artifice of an imposed fashionable and chic "look" may now give further resonance to his pronouncement:[352] "When you want to be like something, it means you really love it. When you want to be like a rock, you really love that rock. I love plastic idols."[353] For Warhol, it is the unattainability of an attractive and glamorous celebrity that represents an intense spectator's identity. Warhol also represents someone who not only covets

Figure 45. Andy Warhol, *Before and After* (Third Version), 1962
Synthetic polymer on canvas, 74″ × 100″.
(*Collection of the Whitney Museum of American Art, New York;*
© A.D.A.G.P., Paris/V.A.G.A., New York, 1986)

glamour but, like many other movie fans, brings his self-identification into the dress and mannerisms—the "look"—of a role model.

During the 1950s, one of Warhol's role models was Truman Capote, to whom he wrote fan letters every day for years and whom he imitated. During the 1960s, Warhol adopted another model—one that combined James Dean and Marlon Brando. It was Marlon Brando's picture that he once placed in his crotch.[354] In one Pop painting series, Warhol depicted Brando in the actor's role in the 1953 film *The Wild One* as a violent and marauding motorcyclist whose gang invades a small California town.[355]

Brando's defiant character and sadistic violence parallel the mythic rebels portrayed by James Dean,[356] and made concrete in the "So what?" demeanor of a leather-jacketed recalcitrant. From 1962 through 1968, Warhol and his entourage fashioned themselves as such rebels.[357] Even after Warhol was shot in 1968 and many of his former associates left his silver-foiled "Factory," new "Superstars," such as Jackie Curtis,[358] ardently admired and identified themselves with Brando or Dean. The "punk" quality of Warhol's activities may be seen as a definite esthetic attitude. This "underground" disposition is clearly evident in Warhol's films, and Warhol himself significantly characterizes it by mentioning another famous artist-as-outlaw:

> When people describe who I am, if they don't say, "Andy Warhol the Pop artist," they say, "Andy Warhol the underground filmmaker." Or at least they used to. But I don't even know what the term *underground* means, unless it means that you don't want anyone to find out about you or bother you, the way it did under Stalin and Hitler. But if that's the case, I can't see how I was even "underground," since I've always wanted people to notice me. Jonas [Mekas] says that the film critic Manny Farber was the first to use the word in the press, in an article in *Commentary* magazine about neglected low-budget Hollywood directors, and that Duchamp gave a speech at some Philadelphia opening and said that the only way artists could create anything significant was to "go underground."[359]

Warhol's esthetic attitude in his paintings and films combines both notions of this term. They are "low budget" works by someone who "goes Underground" to create something significant. In a sense, Warhol is as much below the surface of his works as he is on it.

4

Warhol's Films

Warhol's "Superstars" and the Possibilities of "Found" Personalities

*Anyone who cannot cope with life while he is alive needs one
hand to ward off a little of his despair over his fate—he has lit-
tle success in this—but with his other hand he can jot down
what he sees among the ruins, for he sees different (and more)
things than do the others; after all, dead as he is in his own
lifetime, he is the real survivor.*

Franz Kafka, diary entry for 19 October 1921,
in *The Diaries of Franz Kafka*

Warhol's persona of a passionless presence is the center of his own artificial
world, and it is a self-proclaimed "vacuum"[1] of emptiness. To his followers
during the 1960s, he epitomized an existence marked by steady calmness and
self-control and by a lack of ardor and excitement.[2] Such an illusion of a
friendly indifference and distant decorum is an attitude associated with the
dandy, as explained by Baudelaire.[3] Even in public, Warhol evokes a de facto
privacy. "The modes of his self-dramatization," Stephen Koch suggests, "are
really the result of solutions of the strategies for dealing with almost patholog-
ical shyness and timidity."[4] Such reticence is associated with an idolizer of
"star quality," and the "ever warm but slightly aloof benevolence when seen so-
cially or at public functions"[5] with such a celebrated star. Moreover, Warhol's
silent mystique has been a conscious imitation of that quality associated with
Greta Garbo.[6] The steady state of his stance is, then, both his ardent admiration
of famous and glamorous celebrities and his lifelong attempt to be such a per-
sonality.[7]

In part, Warhol's "Superstars" were entertaining personalities who were
anxiously eager to amuse and divert the artist from the "seriousness"[8] of art.
"I don't really feel these people with me every day at the Factory are just hang-
ing around me," Warhol once said, "I'm more hanging around *them*."[9] Yet,

Warhol's absorption of *la vie ardente* is, precisely, his creation of a *mise-en-scène* where he allowed narcissistic theatricalizations of "seedy glamour."[10] He tested *hundreds* of potential "Superstars" for their screen presence and magical allure.[11] How Warhol *used* such people suggests, moreover, that he was not just interested in an alternative to Hollywood stars but also in an exposure of such an illusory imposture.

A case in point is Warhol's "Superstar," the late Jackie Curtis. Throughout my interview with Curtis, the performer constantly spoke of the importance of Hollywood and of a fundamental identification with its mythology. "I was brought up, I was weaned by M.G.M.," Curtis said to me.[12] During the late 1960s and early 1970s, Curtis frequented Warhol's studio, the "Factory," where he often imitated two very different Hollywood types: James Dean and Joan Crawford. "I'm going to play females and males," Curtis remarked to me about future acting roles, ". . . and I've played females before, as well as males, and I'm very exciting as both."[13] As a performer and playwright, Curtis acted in Off Broadway theatres and produced and wrote reviews, but he has always hoped to be featured in a Hollywood motion picture. According to this "Superstar," the possibility of glamorous fame was conveniently closer:

> I thought M.G.M., Paramount and 20th Century-Fox and R.K.O., all those studios, were taking too long to get in touch with me. I just went over to the Factory and just decided to *get myself in film* before it ws too late because that seemed to me the thing to do. If you were a Warhol Superstar, you had it made, it seemed. I was right in the neighborhood.[14]

Curtis did appear in two films (*Flesh* and *Women in Revolt*) that were directed by Paul Morrissey and produced by Warhol. Yet, in the years that Curtis frequented the Factory (from 1965 until 1973), the performer's activities were, according to an unrecorded remark, other than being a filmed feature player: when someone new entered the artist's studio, Curtis was to "get to know" the person and then report back to Warhol. Curtis had potential acting ability, and, it seems, Warhol did not care for professionalism as much as for simple screen presence:

> My whole thing is to be a star. Always was. But Andy said, "You don't have to do anything." He said, "You can be a star." But I said, "But I want to be! I want to perform!" You know? You know?[15]

In a sense, Warhol has wanted to discover the possibilities of "found" personalities who live the esthetic of beauty on film. To be a "Superstar" is to be a given state of being. For people such as Curtis, it is an ardent desire and a possibility if they become a part of Warhol's entourage.

Warhol's "Factory" during the 1960s was a mecca not just for art students, who applied to Warhol's dealer to assist the artist,[16] but also for socialites to attend parties and film screenings, for people to be screen tested, and for any-

one to become a part of Warhol's totally permissive sanctuary.[17] In order to understand Warhol's creation of this "scene," it is necessary to identify some of Warhol's followers and paid assistants whose dealings with Warhol were both supportive and decisive in the creation of the "Factory."

Until 1963, Warhol apparently worked on his Pop Art paintings by himself. That year, Warhol met Gerard Malanga, a young poet, at a party given by filmmakers Willard Maas and Marie Menken.[18] Malanga had already worked as a silkscreen artisan, and he admired Warhol's Pop Art.[19] Warhol hired Malanga to assist him pulling silkscreens and paid him by the hour. (In fact, Malanga was paid a minimal wage and even was required to use a time clock.[20]) During his senior year in 1963 at Wagner Memorial Lutheran College, Staten Island, New York, Malanga edited the school's literary magazine, whose faculty adviser was then Maas. Other students who contributed articles and poems included Ted Berrigan, Ron Padgett, and John Palmer.[21] These students became professional writers and were involved in Warhol's films. Berrigan appeared in one of the hundreds of Warhol's portraits-as-screen tests, as did Padgett, and Palmer gave Warhol the idea for the film *Empire*.[22]

Malanga also introduced the writer Ronald Tavel to Warhol, and it was Tavel who wrote various filmscripts for the artist, including *Horse, Vinyl, Kitchen,* and segments of *Chelsea Girls*.[23] In 1965, Malanga brought Paul Morrissey to the "Factory," and Morrissey has directed all of Warhol's films since 1968.[24] During 1966, Malanga heard the musical group the Velvet Underground, and introduced its members (Lou Reed, Sterling Morrison, Maureen Tucker, and John Cale) to Warhol, who produced a multimedia presentation of the group. The Exploding Plastic Inevitable, which was the name of this musical and visual display, included the projection of Warhol's films, various slides and strobe light effects, and Malanga's famous "whip dance."[25] Nico, a beautiful German singer,[26] met Malanga in New York, and he brought her to Warhol's attention. She became the lead singer of this rock group and was featured in the films projected during the multimedia presentations.[27] Malanga's influence in the "Factory" was an essential one. Not only did he assist Warhol in the business of producing Pop Art works, he also introduced important members of Warhol's entourage. "And since he absolutely worshipped fame and beauty," Warhol has written about Malanga, "he made the celebs feel good, even if nobody else who was hanging around [the "Factory"] recognized them."[28]

During the early 1960s, Warhol frequented avant-garde theatre, dance performances, poetry readings, and Happenings.[29] At such centers as the Judson Memorial Church, the artist assembled people who supplemented assistant Gerard Malanga. The Judson "crowd" included the poet Billy Linich, the dancer Fred Herko, and the performer Ondine (Robert Olivio). Warhol has characterized these particular associates as his "a-men"[30] because they habitu-

ally took amphetamine ("speed"). These "fags on speed,"[31] to use Warhol's phrase, lived very intense and ardent lives. Warhol has evoked what he admired in such associates in his following comments on Herko:

> He was brilliant but not disciplined—the exact type of person I would become involved with over and over again during the 60s. You had to love these people more because they loved themselves less.[32]

The intensity generated by such associates at Warhol's studio—what Jackie Curtis has called "the desert of destroyed egos"[33]—became a silver-foiled arena, in which the atmosphere was completely permissive. In a sense, this loft space during the 1960s was a fashionable place of safety, where variations of narcissistic and streetwise hipsters could live out their communal fantasies, even in front of a camera. Gerard Malanga remarks:

> It was all fun and games, and we were all willing to participate. . . . Andy had this knack: he'd put you [snaps fingers] in this movie, and he'd make you a Superstar. It was hitting on people's vanities. People wanted to be in the movies and be a Superstar.[34]

The silver-foiled appearance of the "Factory" was due to Billy Linich, who also installed many mirrors and screens (behind which one could encounter casual sex or deals in drugs).[35] Linich also painted the windows black and installed a spinning, multifaceted ballroom globe, which reflected bits of light and cascaded them throughout the darkened loft space.[36] At the peak of Warhol's infamous repute, the silver-foiled environment attracted during the mid-1960s dozens of preening young men, who would often use the mirrors in order to see their reflected beauty. According to Ronald Tavel, many such "beauties," such as Philip Fagan and Tosh Carillo, frequented the "Factory," where they were featured in Warhol's films.[37]

Warhol has described his principal "a-men" as "leftovers of show business," people who "had star quality but no star ego," and who were too "unsure of themselves to ever become real professionals."[38] Yet Warhol has claimed to be "fascinated by the bizarre" and to be "open to involvements with crazy people."[39] Often, Warhol would just watch, utterly *absorbed,* his fascinating entourage who would match witty insults, change records on the phonograph—this included battles between those who wanted to hear rock music and those who listened to Maria Callas—and engage in sexual encounters.[40] Warhol allowed unseemly infighting and encouraged it by fabricating rumors concerning the private lives of his entourage.[41] At the same time, Warhol always kept a distance from even his closest associates. By absenting himself as a normal person for the persona of a passionless presence, Warhol emptied himself of individuality. In his *ethos* of withdrawal, he became a devoted fan of these individuals whose private lives became public and whose public lives became publicity.

The "Factory" was a sanctuary in which certain people took refuge and could be close to Warhol's famous aura. Warhol and his entourage would often annex locales which included hipster "coolness," a perpetual party atmosphere, and aspirants for his attention. One such locale during the mid-1960s was Max's Kansas City, a restaurant-bar which included a rear room where, as described by Danny Fields, a typical evening encounter would occur:

> It was an extremely permissive scene. . . . It was sexually permissive and socially permissive and artistically permissive so that the weirder you are or the more spectacular you are, the more fabulous you were, the more welcome you were. The point was to be fabulous and especially when Andy was there. He was like *I Am a Camera*. You, sort of, played to him. People from different parts of the room would be auditioning: getting up on tables and taking their clothes off or singing . . . [42]

"Fabulous" aptly describes the legendary creations of Hollywood, as well as the "flaming creatures"[43] that inhabited Max's Kansas City, Warhol's "Factory," and the artist's films. The desperate exhibitionism and outrageousness of those who vied for Warhol's attention demonstrated more their desperate need to exploit themselves at whatever cost than what Warhol may be accused of in his exhibitionism in his films. The actress Tally Brown, who was featured in several of Warhol's films, has commented that the artist's movies display *"their* need to be famous without taking the time or the trouble to develop the resources of, possibly, having the ability"[44] to act. Many of Warhol's entourage who became famous for 15 minutes were under pressure by the immense publicity that Warhol generated for himself and for them. Some could sustain such notorious repute, but most could not.

Tally Brown's role in the "Factory" is an exception to the demonstrative desire by Warhol's "Superstars" to be famous.[45] Trained as a professional singer and actress, Brown had appeared in nightclubs, plays On and Off Broadway, and in various independent films before she met Warhol. Her first appearance in one of Warhol's movies happened when she was virtually unconscious: asked to report to the "Factory" at a certain hour, Brown, who was exhausted and had asked to take a nap on a velvet-covered couch, was asleep when various "Superstars" began to "relate" to her. Although a film camera was present, Brown was totally unaware that her nap was being filmed. There were no traditional cues ("Lights! Camera! Action!"), and no discernible film crew to indicate that she was being filmed. Apparently, Warhol was fascinated by Brown enough to propose several tantalizing offers to "launch" her. One such proposal was that she be a lead singer in an all-female rock band, to be called Children, consisting of various feminine members of the artist's entourage. When Brown mentioned to Warhol that none of these women could play a musical instrument, Warhol responded by saying that they could hold transistor radios. Despite Brown's preference to remain her own person with her own goals, Warhol continued to offer allures of possible "Superstardom." Brown comments:

And I *looked at him* [Warhol], and he said, "Oh, right! I forgot. You can only do things that you believe in." And passed on to something else, which, to me, shows full cognition of where I was at. Andy regarded it as "What a drag! What a shame!" But *not* putting me down.[46]

Brown could have been a "Superstar" as Warhol would have fabricated it, but she refused to be so transformed. In fact, Warhol used her in his films as a "conscious anachronism."[47] Significantly, when the actress later appeared in Germany, it was her association with Warhol that was publicized—she was a "Superstar," nonetheless.

In addition to Warhol's "a-men" and other "found" personalities who had settled in New York, a group of people from Boston became associated with the "Factory." This "Cambridge set" included Gordon Baldwin, Dorothy Dean, Danny Fields, Tommy Goodwin, Donald Lyons, and, especially, Edie Sedgwick. These "glamorous young kids,"[48] as Warhol has called them, added a certain intellectual capacity to the "Factory." Baldwin and Dean had attended Harvard, and both were avid conversationalists.[49] Fields was associated with rock music periodicals, experimented with strobe light effects during performances of Warhol's Exploding Plastic Inevitable, and appeared in several of the artist's movies.[50] Goodwin and Lyons also appeared in the films, and Lyons was a classmate-friend of Paul Morrissey. Edie was a troubled and unstable socialite born in California and educated in New England and a chic and fashionable beauty. In Warhol's films, she was *The Poor Little Rich Girl*.[51] In *a, a novel* (1968) and *The Philosophy of Andy Warhol* (1975), she is thinly disguised and fictionalized as "Taxine."[52] Jean Stein's *Edie: An American Biography* documents in considerable detail Sedgwick's anorexia, breeding, drug addictions, ephemeral charm, mercurial personality, and vulnerability.[53] Her life story, from WASP family background to a highly publicized modeling career and "Superstar" to a death from a barbiturate overdose, makes grim reading.

While living in Boston, Sedgwick was known for her chic and very expensive dinner parties. When she moved to New York, Warhol often accompanied her and her Boston friends when they dined in expensive New York restaurants. In fact, Warhol's film *Restaurant* (1965) is based on these occasions: at the newly opened restaurant L'Avventura Warhol assembled Sedgwick, Ondine, Lyons, Dean, Sally Kirkland, and Baldwin to perform a series of cued tasks evoking a cinematic Happening, and to speak as themselves. Not only is *Restaurant* an open-ended and nondevelopmental film but it also functions as a document of its beautiful, young, and intellectual participants.

Warhol and Sedgwick became a "media couple," appearing together at innumerable social gatherings throughout the mid-1960s. Sedgwick even dyed her hair silver in order to match Warhol's silver wig. In Warhol's memoir of the 1960s, *POPism,* he quotes a New York journalist who remembers the celebrated couple:

You were *the* sensation from about August through December of '65. Nobody could figure you out, nobody could even tell you apart—and yet no event of any importance could go on in this town unless both of you were there. People gladly picked up your checks and sent cars for you—did anything and everything to get to entertain you.[55]

It was also at this time that Warhol and his entourage "were obsessed with the mystique of Hollywood, the camp of it all."[56] Precisely, it was the public notoriety—the "plastic" existence—of living a glamorous and artificial life that formed not only Warhol's public appearance in café society but also his fantasies in filming such a continuous party atmosphere.

Warhol's appreciative acceptance of his "Superstars," like his acceptance of popular artifacts and kitschy novels and movies, is a part of his "Popism."[57] Specifically, the shallowness and vainglorious ineptitudes of many of his "Superstars" are symptoms of real pretentiousness-as-seriousness. The more serious or desperate such a (potential) "Superstar" becomes, the more "worthy" that person becomes in Warhol's mordant sense of humor. That person becomes more "fun." Warhol has written:

The funny thing about all this was that the whole idea behind making those movies in the first place was to be ridiculous. I mean, Edie [Sedgwick] and I both knew they were a joke— that was why we were doing them![58]

Such a dubious ontological status of unprofessional "acting" is *displayed* in Warhol's films as an exposure of Warhol's perception of his "Superstars."

Warhol's attitude is one of appreciation and doubt. He is a connoisseur of Hollywood films, as well as of their glamour and chic illusions. He understands the seductive appeal of Hollywood, as well as its fakery, foolishness, and seriousness. In spite of it all, Warhol wants to become part of it. He realizes Hollywood's dishonesty. Warhol celebrates it. In fact, he embraces it: "But this made Hollywood *more* exciting to me, the idea that it was so vacant. Vacant, vacuous Hollywood was everything I ever wanted to mold my life into. Plastic. White-on-white."[59] In short, Warhol's sensibility is one that discovers the worthiness in someone, some place or object that seemingly is without any profound value. Warhol appreciates flops, and the fragility that just holds someone or something together. He takes a fresh look at something taken for granted. He includes outtakes. Warhol collects—reclaims—"beauty" in the bizarre or the strange or the ridiculous or the absurd. Carefully, Warhol is carefree in his canonizations of nostalgia or nonsense. Intuitiveness becomes a license to exhume the improbable and to exhibit the taxonomies of Camp. What amuses or diverts him, he enjoys. The so-called "boredom" of life becomes his pastime. Hence, foolishness and authenticity are equalized, as are fakery and seriousness: Warhol mixes metaphors as much as he mixes paints. He *lives* his "art" and his "films." His stance is a mirrored extreme of his own removal in silence, so as to solve the contradictions inherent in the daily dramas of his

proposals of comic existence and the unappeasable hunger of narcissism. Ul-
timately, Warhol is his own "Superstar," and his entourage is merely an in-
stance of its various possibilities.[60]

To return, then, to the very term "Superstar" is to return to Warhol's own
steady state of an infamous aura and awed idolizer. To reiterate: the notion of
Warhol's "Superstars" is a projected display of what Warhol himself fantasizes
about the chic, even "seedy," glamour of a screen presence and the individuals
who represent that quality to the artist. In 1963, Warhol felt the "death" of the
old Hollywood star system had occurred, and he preserved in his Pop Art many
of its representatives, including Marilyn Monroe and Elizabeth Taylor. In his
Jackie Kennedy series Warhol depicted what he believed to be the most
glamorous woman in the world, and he focused on her vulnerability, as seen
in close-ups of her face and in UPI photographs of the assassination of her hus-
band.[61] Warhol also took a publicity photograph of the rock 'n roll singer Elvis
Presley, because his image was *already* well known to the American public.[62]

Warhol's notion of depicting well-known personalities changes during the
first year of his film activities—that is, during 1963—in a manner reflecting
a change in his attitude toward what may or may not constitute a filmic pres-
ence. Warhol began to depict his own notion of instant celebrityhood at the
very time that he depicted in his Pop Art works representatives of "old" Hol-
lywood. In a very real sense, Warhol's movies depict his own alternative to
that star system.

After initial experiments,[63] Warhol chose "Underground" actor Taylor
Mead to be featured in *Tarzan and Jane Regained, Sort Of* (1963) precisely be-
cause the artist considered Mead already to be a "Superstar."[64] Warhol then
made a "newsreel," *Andy Warhol Films Jack Smith Filming "Normal Love"*
(1963), of a well-known "Underground" film director shooting scenes with that
filmmaker's infamous "flaming creatures."[65] At the same time, Warhol began
to film hundreds of small, usually three-minute reels ("100 footers")[66] of celeb-
rities who visited the "Factory." Visitors included well-known poets (Allen
Ginsburg, Peter Orlovski, Ted Berrigan), actors (Zachary Scott), art critics
(Barbara Rose, Gregory Battcock), artists (Roy Lichtenstein, James Rosen-
quist, Larry Rivers), and socialites ("Baby" Jane Holzer, Ethel Scull).[67]
Warhol could make frustrating demands on a (potential) celebrity. A case in
point involves Warhol's avoiding the rock star Bob Dylan, who waited hours
in Warhol's studio to be filmed.[68] A real or potential "Superstar" must submit
to the whims of the film producer. In fact, during the mid-1960s, Warhol al-
lowed infighting among his entourage, whose members desperately wanted to
be featured in his films.[69] Stephen Koch has shown that Warhol, who he aptly
described as a "tycoon of passivity," kept a stable of performers who *could* be
accorded "star treatment."[70] Warhol tested *potential* "Superstars" and filmed
them if they had a magical allure for him. In his *Philosophy,* Warhol writes:

Movies bring in another whole dimension. That screen magnetism is something secret—if you could only figure out what it is and how to make it, you'd have a good product to sell. But you can't even tell if someone has it until you actually see them there on the screen. You have to give screen tests to find out.[71]

During his "interview" with Gene Swenson in 1963, Warhol remarked that everyone is creative and that there were hundreds of good artists.[72] It was during that year that Warhol seriously began to produce his films and to paint his homages of the stars of "old" Hollywood, and to form an entourage of personalities whom he began to use in his films.

In short, he turned a fixed camera in the "Factory" onto all of his visitors whom already had evident quality of real talent. He then began to produce his own "names" who became "Superstars" because of the artist's choice. Warhol filmed these "found" personalities, and their stage names evoke a "seedy" glamour that seemed to suit well the artist's invented alternative to Hollywood: Vera Cruise, Candy Darling, Debbie Dropout, The Duchess, Ingrid Superstar, Rita Rotten, Silver George, The Sugar Plum Fairy, Ultra Violet, Viva!, Holly Woodlawn, etc.[73] These individuals are Warhol's own creations, his "plastic idols."[74] In fact, some of his "Superstars" were transvestites who symbolized glamorous women of "old" Hollywood. Warhol has written:

Among other things drag queens are living testimony to the way women used to be, the way some people still want them to be. Drags are ambulatory archives of ideal moviestar womanhood. They perform a documentary service, usually consecrating their lives to keeping the glittering alternative alive and available for (not-too-close) inspection.[75]

If Holly Woodlawn was Warhol's substitute for Hedy Lamarr, then Candy Darling was the Kim Novak "blonde" type, Jackie Curtis was the Joan Crawford "strong woman" type, and Joe Dallesandro was the Clark Gable "stud."[76] In *POPism*, Warhol refers to the height of his filming activities: "By now [1965] we were obsessed with the mystique of Hollywood, the camp of it all."[77] Holly Woodlawn—a stage name that combines glamour (Hollywood) and death (Forest Lawn Cemetery)—remarked to me that the artist led his "Superstars" to believe that he would help them.[78] In a sense, he did, as well as offer a unique alternative to fame.

Warhol assumed a certain persona in order to avoid taking risks, but he filmed those people who did. He provided a cinematic forum for their exhibitionist compulsions. "You're using me!" Warhol once said to Jackie Curtis, who replied, "No, you're using me!"[79] The claim and counterclaim remain moot. In fact, many of his entourage intensely identified themselves with him: Jackie Curtis's "ANDY" tattoo, Edie Sedgwick's silvered hair, the renamed associate "Andrea Whips Warhol," etc. During my interview with Curtis, I asked him about the tattoo. Curtis responded, "Well, Andy is like to me, you know . . . or, was like me when I saw his picture in the paper, it was just like

seeing a reflection. I already knew. I already knew we were kindred spirits."[80] The "spiritual" aspect of Warhol's "Factory" included astrology. When the "Superstar" Viva! had her nose cosmetically changed by surgery, Billy Linich first did "a nose job [astrological] chart for her."[81] In fact, Linich spent almost an entire year (1968–69) living in the photographic darkroom of the "Factory." He shaved his head completely, never appeared to anyone during the day, read occult books by Alice Bailey and other astrologers, and then suddenly left the "Factory," never to be seen by Warhol again.[82] According to Ondine, there was a *very* intense identification with Warhol by his "Superstars" who felt spiritually "akin" to the artist,[83] and Ondine has remarked that "you could *cling* to him in a way that you couldn't cling to anyone else."[84] Just as Warhol created a celebrated fame for himself, he allowed his adherents, who identified themselves with him, to project instances of the artist's notion of "Superstardom."

The possibilities of such "found" personalities particularly interested Warhol. The artist has written:

> I was reflecting that most people thought that the Factory was a place where everybody had the same attitudes about everything. The truth was, we were all odds-and-ends misfits, somehow misfitting together.[85]

But Warhol has also admitted that he does more than just allow such "misfits" to interact in their narcissistic theatricalizations of *la vie ardente*. Referring to his 1968 movie on surfing filmed in San Diego, Warhol writes: "From time to time I'd try to provoke a few fights so I could film them, but everybody was too relaxed even to fight."[86] Warhol's exhumations of Camp and Hollywood glamour are benign fantasies in comparison to his "setting up" demonstrations and deconstructions of narcissistic dysfunction and of latent exhibitionistic or sadistic tendencies in his "Superstars." The latter is fully discussed in the following sections, but it is crucial to point out here that some of his followers were very unstable. One such aspirant aimed a gun at Warhol sometime during 1964 and then shot bullets through a row of *Marilyn* canvases.[87] Another member of his entourage four years later actually did shoot Warhol in the chest.[88] After his recovery, Warhol was interviewed by Leticia Kent, who recorded the following crucial remarks by the artist:

> I'm trying to decide if I should pretend to be real or fake it. I had always thought everyone was kidding. But now I know they're not. I'm not sure if I should pretend that things are real or that they're fake. You see, to pretend something's real, I'd have to fake it. Then people would think I'm doing it real. [. . .] Well, I guess people thought we were so silly and we weren't. Now maybe we'll have to fake a little and be serious. But then, that would be faking seriousness which is sort of faking. But we were serious before so now we might have to fake a little just to make ourselves look serious.[89]

What is one to make out of such contradictions?

In these remarks, Warhol says that despite the foolish and unserious behavior of his activities, his films were serious. Yet he *puts into question* any resolution of what, if any, seriousness, fakery or foolishness there may be in his own films featuring his own "Superstars." Warhol is commenting upon doubt: his own doubt of what is real and what is not. The tone of his doubt is, moreover, the same attitude evoked in his films and his Pop Art. By presenting a certain presence, Warhol simultaneously acknowledges it without excuses and approves of it and recognizes it through its own theatricality. The presence of a Campbell Soup can or an actress or a trading stamp or money or a "Superstar" affects him, and he affects it. The contradictions of his statements concerning his films demonstrate Warhol's own imposture. He *lives* his "art," just as his "Superstars" live his "films."

Warhol begins with his notions concerning Hollywood glamour and fame with Garbo, Monroe, and Taylor, and then during the early part of his film activities—in fact, during 1963—he changes so that it is *he* who discovers an alternative form of glamour and fame. First, he features such "Underground" personalities as Taylor Mead, who have proven themselves as performers. Second, Warhol produced his own *equalizing* notion of glamorous celebrities: his "Superstars," whose cinematic lives cancel each other so that the final effect becomes not just a film by Andy Warhol but an "Andy Warhol film." And who is Warhol? The artist gives his own "scrapbook" answer:

> But I'm still obsessed with the idea of looking into the mirror and seeing no one, nothing. [. . .] The childlike, gum-chewing naivete, the glamour rooted in despair, the self-admiring carelessness, the perfected otherness, the wispiness, the shadowy, voyeuristic, vaguely sinister aura, the pale, soft-spoken magical presence, [. . .] The albino-chalk skin. [. . .] The graying lips. The shaggy silver-white hair, soft and metallic. The cords of the neck standing out around the big Adam's apple. It's all there, B. Nothing is missing. I'm everything my scrapbook says I am.[90]

In this passage from his *Philosophy,* Warhol is talking on the telephone with one of his "B's." Who are the "B's?" Warhol has written

> B is anybody who helps me kill time. B is anybody and I'm nobody. B and I.
>
> I need B because I can't be alone. Except when I sleep.
>
> Then I can't be with anybody.[91]

Beginning Again: Warhol's Cinematic Tropes and His Deconstruction of "Superstars"

The French playwright Jean Genet once wrote: "I exist only through them, who are nothing, existing only through me."[92] One could consider this quotation by Genet to be referring to Andy Warhol's participation in the production of films

and "Superstars," which did not begin in 1963 as has been generally supposed, but in 1948.[23] While still in art school, Warhol and his classmates made various films, including one that anticipated Warhol's *Chelsea Girls* (1966). Even though photography and film were not taught at his art school then, students made various kinds of experiments in both media. In 1948, Warhol made photograms, and one of his classmates experimented with overlapping of projected films and split-screen projection.[94]

Among the films that were shown at the Carnegie Institute, the artist saw or could have seen classics of avant-garde cinema such as *Un Chien andalou, L'Age d'or, Le Ballet mécanique, La Belle et la bête, The Cabinet of Dr. Caligari,* and animated short films by Norman McLaren.[95] In fact, McLaren's well-known techniques of applying color overlays on exposed film and of scratching the film's emulsion for abstract effects, directly influenced the production of a student movie made by Warhol and his classmates during their junior year. In lieu of a class play, the pictorial design majors that year (1948) codirected a movie that featured students and instructors. The film was in part a parody of Professor Lepper's coursework concerning the "social flux," as Lepper termed it, of the Pittsburgh area.[96] From the opening credits, which were written on pieces of toilet paper and then flushed down a toilet, to various sequences near a river that flows through Pittsburgh, the student film was a series of fast-paced comic encounters, mock murders, and chases through the city. Like *Chelsea Girls,* the student film was projected with various color filters, and like McLaren's cartoons, other types of visual "noise" (such as scratches on the film emulsion) enhanced the experimental qualities of the students' movie.[97]

Another film that Warhol participated in was an animated "moving collage."[98] By means of time-lapse photography, Jack Wilson, Warhol, and other students animated collage materials in such a way as to suggest one art game by the Surrealists: the "exquisite corpse," in which players were assigned to draw sections of a body on a successively folded piece of paper.[99] It is possible that the student-animators' contributions were done consciously after such a Surrealist parlor game, since there was an evocation of the personalities of each participant within the collective "moving collage."[100]

What influence these known cinematic experiments had on the artist's films of the 1960s may be only suggested by what little is now known about them: a collaborative exploration of the possibilities of film that may feature visual "noise."

In 1956, Warhol and Charles Lisanby took a trip around the world. Lisanby brought with them a film camera, and his "home movies" included sequences of Warhol sketching various foreign locales. When they returned to New York and watched the films, Warhol seemed to be as interested in the effect of a totally unedited presentation of the motion pictures as in their content. Lisanby comments:

In fact, he [Warhol] thought that the "Kodak" and all the dots and everything at the beginning or at the end of the [film's] leader, in other words, was as important as anything else. He felt that *all* of that was important to the total effect of the thing, . . . It's true that those early films [of 1963–64] that he did were completely artless and that he shot them. Nothing was done to them. He changed nothing, and he knew nothing about technique, nor did he think that it was important, and that's the important thing—that he didn't think it was important. . . . He was interested in all kinds of ways of expressing something other than through speech.[101]

Lisanby's remarks disclose several crucial aspects of Warhol's intentions concerning film. As someone who is "nonverbal," Warhol is extremely interested in the experimentation and visualization of the *presence*[102] of cinematic images. His films from 1963 to 1968 are made in such a way as to make the viewer consciously aware of such a presence, as well as of what constitutes a film.[103]

The filmmaker Emile de Antonio has described Warhol's cinematic experiments[104] as paradigmatic explorations of the medium. Ronald Tavel, whose career as a playwright began with writing scripts for Warhol, characterizes the artist's movies as exercises in "simplicity."[105]

Jonas Mekas, who is the founder and publisher of *Film Culture*, created a cooperative for avant-garde filmmakers in New York, and Mekas distributed "Underground" or Independent Films, including those by Warhol, as well as showed Warhol's films at the Filmmaker's Cinémathèque.[106] In 1964, Warhol received the sixth Independent Film Award for *Sleep* (1963), *Haircut* (1963), *Eat* (1963), the *Kiss* series (1963), and *Empire* (1964). His films were not only characterized as "a rejuvenation and a cleansing," but also as providing a "new way of looking at things" and a "new insight" into how film may give a viewer a new perception of daily activities: "The whole reality around us becomes *differently* interesting, and we feel like we have to begin filming everything anew."[107] When questioned why Warhol was given this award, Jonas Mekas remarked that the artist's films "stopped everything dead, like beginning from scratch and forcing us to reevaluate, to see to look at everything from the beginning."[108] What made Independent Film stop "dead" in Warhol's films?

Warhol uses very distinctive tropes in his films. A "trope" is a stylistic device that is tied to a specific medium and that constitutes a formal interruption of the normal "grammatical" flow of discourse for that medium. In essence, a trope halts that flow by calling attention to itself at the expense of the content, or generates the "meaning" of that content by its occurrence. For example, as a cinematic device a trope may be a form of editing which disrupts a narrative, or camera work that is noticeably discordant with other camera shots or placements. In his films Warhol makes use of an easily recognized set of tropes which bear little resemblance to those ordinarily employed in traditional Hollywood motion pictures[109] or even to those employed at that time in Independent or "Underground" films.[110] As used by Warhol, such distinctive tropes deconstruct the very nature of the cinematic medium.[111]

In part, Warhol's filmic tropes remove the viewer's psychological identification with the performers by means of various interruptions or sustained viewpoints, so that one may notice qualities normally obscured by the perceptions of everyday existence or by the traditional condensations of narrative form. Warhol's tropes are also a form of artistic "signature" reflecting his attitude of self-reflexivity that corresponds to his depictions of acute narcissism in his films. These films are in turn displayed as a form of voyeurism. In his projections of iconic images of "plastic idols"[112] and taboos, Warhol annexes and presents a cinematic version of his Pop Art: *a monitored stare*. Moreover, Warhol's own persona of a passionless presence entails the dispassionate vigil that is implied in his movies. In order to understand his films, it is necessary to specify his particular cinematic tropes and how they deconstruct the very nature of the medium.

The first such cinematic trope is *The Unmoving* or *"Static" Camera*. Warhol's films do not concern the development of characters played by professional actors, and they do not entail traditional dramatic narratives that are resolved. In part, they are merely static compositions of an image or of a situation *au tableau vivant*. After an initial experiment of hand holding an 8mm camera to film the heretofore unknown "portrait," *Henry Geldzahler*,[113] Warhol used a tripod throughout 1963 to hold a 16mm silent Bolex camera.[114] In 1964, Warhol began to film with an Auricon camera and shot the silent *Empire* and literally *hundreds* of "portrait" films.[115] In most of his films done between 1963 and 1968, Warhol deliberately kept the camera stationary and even excluded panning and tilting. Thus, a single point of view was established.

Exceptions to such an unmoving camera are notable. In *Space* (1965) isolated performers remain stationary and read from cue cards, but they are filmed by Warhol who continuously moves the camera. "Do a thing on space," Warhol told his scriptwriter, "I have this idea of, sort of, people just isolated. I want to use a moving camera."[116] As a conscious anomaly to his previous films, *Space* represents an evocation of *stasis* nonetheless: the performers, reading texts on various subjects, are seen as secluded beings disconnected in their thoughts. Another exception is actually motivated by an accident off the film set, when Warhol pans the camera to Buddy Wirtschafter, a technical assistant, who had just had a door crash down on his head during the shooting of *My Hustler* (1965).[117]

Another exception does not include moving the camera per se, but does break with a singular point of view. In *Soap Opera* (1964), socialite "Baby" Jane Holzer conducts a monologue, which is interrupted by actual television commercials. "So we spliced sales-pitch demonstrations of rotisserie broilers and dishware," Warhol has remarked, "in between the segments of *Soap Opera*."[118] As an evocation of an extremely popular form of daytime television programming, *Soap Opera* includes the incessant discontinuity of commercial

interruptions. Significantly, Warhol considers such disruptions as important as the televised melodrama. The artist has said:

> I like them cutting in every few minutes because it really makes everything more entertaining. I can't figure out what's happening in those shows anyway. They're so abstract. I can't understand how ordinary people like them.[119]

He continues: "They don't do anything. It's just a lot of pictures, cowboys, cops, cigarettes, kids, war, all cutting in and out of each other without stopping. *Like the pictures we make*."[120] Warhol's disruption of a fixed frame, either by a moving camera or by "found" footage, is rare in comparison to the hundreds of films that he made from 1963 to 1968 in which the camera remains "static."

In fact, Warhol once remarked to Ronald Tavel that one of Tavel's scripts was not suitable because the camera would have to move. Tavel recalls, "Because when we were discussing a new film at one point and I thought it would be suited to a moving camera, he [Warhol] said, "No, because that's what I *can't* do because my contribution is the static camera."[121] One aspect of Warhol's notion of "Popism" is to do the "easiest thing."[122] According to John Palmer, one of Warhol's assistants during 1963–64, "Andy never moves the camera because that's hard to do."[123] Notwithstanding this very probable explanation, Warhol's "static" camera is crucial to his displays of isolated images.

Moreover, where Warhol places the film camera is of importance. When Warhol uses a set, which is usually a portion of his studio, the camera is situated in such a way that what happens off camera can be a counterpoint to what is filmed. A significant example occurs in *Horse* (1965). Warhol places the camera facing the "Factory's" elevator. During the film, unsuspecting visitors to Warhol's studio walk literally into the center of the film set. Likewise, the studio's pay phone is next to this elevator, and, during the film, non-performers answer the telephone within the camera's range. By aiming the camera deliberately toward the studio's entrance, Warhol not only captures the planned events of the performers but the surprised reactions of people who, by chance, enter the "Factory." In my opinion, however, the most striking example of camera placement occurs in *The Life of Juanita Castro* (1965).[124] In this film, performers sit in bleacher chairs, repeating lines given by scriptwriter Ronald Tavel. At one point, Marie Menken, who plays the title character, delivers a harangue. Menken walks just past Tavel, who is seated facing the performers. During my interview with Tavel, the writer remarked:

RT: Also, Warhol had this idea. When we set up the camera, it was right dead on straight, and, I guess, he looked through it, and he said, "You know, that's not really interesting. You people all do this, you know,

screen job in this direction. Pretend the camera is here, but we will move it to the side and shoot it at an angle, but do not ever look toward it. Look . . . "—And they may have placed an object where it was—"Keep looking at that."

And that gives it *so* much interest because it's so bizarre that way. And, which, you don't realize 'cause a lot of the publicity stills—I see a lot of stills of that film reproduced in books and whatnot—and they're not taken from the film. Obviously, someone was shooting, and they were shooting straight on, giving the impression that it was shot straight on, and . . .

PS: And, so, it was shot obliquely.

RT: Right. . . . Then, I would say, "Okay, now, Juanita. Please stand up and come forward to the camera for a close-up and give us your big speech." And, of course, by doing that, she walked right out of the camera [range] and gave this big harangue off-camera, while all you saw was us. We're sitting and looking bored and waiting and falling asleep because she never ended.[125]

Like the reactions of unsuspecting visitors to Warhol's studio who entered the set of *Horse,* Warhol deliberately offsets an inflammatory political speech by its counterpoint: the bored reactions of the performers.

Perhaps the most infamous example of a crucial camera placement is Warhol's *Blow Job* (1963): an "apotheosis of the 'reaction shot.' "[126] Viewers, who would expect by its title an explicit pornographic film, would have been disappointed, because the entire movie consists not of the homosexual act performed off camera but of the sustained image of a young man's facial expressions during fellatio.[127] In a sense, Warhol allows viewers to feel like frustrated voyeurs because the real focus of attention is excluded from the camera's point of view.

Warhol's use of an unmoving or "static" camera implies various states or givens: *Kiss, Eat, Drunk, Blow Job, Shoulder,* etc. By means of a very carefully placed viewpoint, Warhol directs an absolute attention to an object (Lucinda Childs's shoulder, the Empire State Building, etc.) or to a situation (a screen test, an erotic encounter, a courtroom, etc.). Either the viewer chooses to contemplate it or to turn away from the movie screen. Such isolated and monumentalized "plastic idols," like the iconic images of Warhol's Pop Art, are sustained by means of his second cinematic trope: *The Long Take.*

In Warhol's films, as well as in his *a, a novel,*[128] reel time is real time. In a traditional Hollywood film, the director films usually more than one shot, and only one of each group of takes will appear in the completed film. Moreover, Hollywood films usually feature condensed narratives. On the other hand, Warhol consciously films only one (long) take so that the effect of one

of his films is an incessant stare at his beloved "plastic idols." More precisely, his films exhibit the tireless power of a voyeur's scrutiny. A case in point is *Couch* (1964).[129] This film represents one of his most pornographic series: dozens of reels that focus on the couch in Warhol's studio. With absolute total permissiveness, Warhol allowed his stable of performers to exhibit themselves on it. Emile de Antonio has recalled viewing one reel in Warhol's studio in which a prominent socialite freely fornicated.[130] Tavel has commented on how such a film was seen at Warhol's "Factory":

> A lot of people would come up to see it, you know, but they would, as it's said, was meant with these films [by Warhol]: you debauch, you walk out and have coffee and then come back and watch the movie, which everyone did—because how much could you watch these people on a couch.
>
> But he [Warhol] would sit wrapped up with his legs crossed. And just like a little child: just perfectly content. It wasn't a look of rapture so much as a perfect contentment that could just go on, and, I realized, could go on for hours and hours like that unless he was interrupted.[131]

Warhol's use of a cinematic long take is in part his way of not obstructing his own obsessive breaking of erotic taboos. To experience a film like *Couch* is to submit oneself to passive inaction and to endure with great patience the unfolding of anonymous, erotic encounters. Koch writes on *Blow Job:*

> We wait through it hoping for the arrival of those few moments which actually touch the nerve of some private fantasy, game, need. We laboriously wait through its *otherness* until it at last gets to *us.* [. . .] In this vague state [of dissociated sexual awareness], the [viewer's] personality becomes diffuse, lax, attentive, merely open, waiting for that sharp singular instant (that may or may not come) when authentic desire will leap at the screen like a dog snarling for its gratification.[132]

The sensibility of the long take is a measure not of a viewer's endurance but of a voyeur's vigil. The viewer bears witness to Warhol's erotic exhibitions, which are immediate yet apart from one. Several films clarify Koch's exact observations.

Empire is an eight-hour film of the Empire State Building, seen from the forty-fourth floor of the Time-Life Building from late dusk until early morning.[133] Jonas Mekas, who assisted Warhol, recorded three crucial remarks by the artist during the filming: (1) "The Empire State Building is a star!" (2) "An eight-hour hard-on!" (3) "Henry, what is the meaning of action?"[134] These self-apparent statements refer not only to Warhol's explicit pornographic voyeurism but also to the objectification of such a sensibility. To equate a well-known building to one of his male "Superstars," who may be viewed in *13 Most Beautiful Boys* (1964–65), *50 Fantastics* (1964–65), or *My Hustler* (1965), is to treat both a person and an object as conceptualized personalities. The implicit eroticism of *Empire,*[135] whose subject was a featured "player" in another erotic

masterpiece (*King Kong*), has not gone unnoticed. Implicitly or explicitly, Warhol considers objects or persons as equally good presences. Significantly, one of Warhol's unrealized films (with an anticipated running time of six months) was to be entitled *Building,* showing the destruction of an old building and the construction of a new one.[136] It is the conceptualization of a temporal "portrait" that Warhol concentrates on in his movies. Not only does the viewer endure such (erotic) portraiture, but so does the performer.

In his two series, *Kiss* (1963) and portraits of visitors (1964–66),[137] Warhol filmed sustained close-ups of various "glamorous" personalities and celebrities. For three-minute reel "portraits," the performer was asked to stare into the camera and not to blink, or to kiss someone without moving. According to James Rosenquist, Warhol also took still photographs before he began taking film portraits.[138] As with a photograph that is a publicity still, Warhol's filmed portraiture requires endurance. One participant, Danny Fields, describes it:

> [. . .] so that they would start to cry because if you keep your eyes open for three minutes, they'll start to water. So, you had these close-ups of these very beautiful people, and you're just looking at their faces, and little by little they start to twitch, and, then, their eyes would fill with tears and, then, they'd start to cry.[139]

When the art dealer Irving Blum watched the *Kiss* series at Warhol's studio, he recalled to me that he was startled when someone blinked.[140] Those commentators who refer to these films of kissing as simply films of kissing, in my opinion, miss Warhol's intention.[141] Significantly, Warhol filmed both the *Kiss* series and the portraits-as-films at 24 frames per second and then projected them at 16 frames per second (the speed of old silent films):[142] the screen presence of the participants is extended for a maximal duration. The temporal portraits are symbols that signify Hollywood glamour. After the poet Ted Berrigan was filmed for a portrait, he said, "It was all really wonderful; I just loved myself every second."[143] The art critic Robert Pincus-Witten was similarly disposed:

> I remember Gerry Malanga and Andy were there, and Andy would say things like, "Isn't this wonderful! Isn't he terrific! He's doing it!" as if one is really doing something wonderful by simply remaining static and unmoving before the lens, but the *hype* was very, very exciting. It's a tremendous kind of adrenaline-hype . . . [144]

The inducement to become fulfilled as a screen presence did not necessarily have to be heightened by the artist, whose own fantasy is to become a "plastic idol."[145] In fact, when the *Kiss* series or the filmed portraits-as-screen-tests were shown at Warhol's studio or in public, each reel was shown as a separate and complete entity: from the white film leader to the close-up to the final leader.[146] Such entities are for Warhol either readymade or discoverable.[147]

He isolated his "Superstars," just as he isolated himself in public, especially during the peak of his infamous notoriety during the mid-1960s.[148] Warhol's fantasy of "plastic idols" is, in my opinion, a means to please himself. He sets down on film or tape cassettes everything they do, and then he selects some images or conversations in which (erotic) power is at a height. Yet such a fantasy may be quickly exhausted. Hence, Warhol films *hundreds* of such screen portraits-as-tests. The value of a "Superstar" is transitory.[149] A performer may derealize himself and be replaced by a younger, fresher, and more alluring "Superstar."

The *Kiss* series and *Sleep* were both done in 1963. How they were filmed and presented offers a significant insight into Warhol's use of the long take and the general misconceptions of critics who have commented on them. To reiterate: each reel of *Kiss* is a conceptual entity that is displayed separately and shown at the speed of an old silent movie. On the other hand, Warhol filmed the poet John Giorno sleeping over a period of several weeks and then edited or "faked,"[150] as the artist has put it, film "loops"[151] of 100-foot reels into a six-hour movie.[152] *Sleep* is *not* the equivalent of *Empire*. The Empire State Building seen from a distance is documented as a continuous and temporal presence, but *Sleep* includes variously held views (the stomach slowly breathing, the sleeper's eyes moving with his dreams, etc.) so that the state of slumber may be experienced as a disassociated "design." The patterns of the surfaces of a sleeping nude are "cut up," in the sense used by William S. Burroughs.[153] The film becomes a cinematic "topology" that concentrates on the fragments given. Like the *Kiss* series, *Sleep* is to be projected at 16 frames per second.[154] As a slowly paced discontinuity of incidents of slumber, the slightest variation of Giorno's "performance" becomes, as Henry Geldzahler has commented, "an event, something on which we can focus our attention."[155]

Perhaps the closest equivalent to viewing *Sleep* would be attending a performance of Erik Satie's *Vexations:* a short melody repeated 840 times, performed in New York for the first time under John Cage's direction in 1963, the year Warhol filmed *Sleep*.[156] In fact, Warhol attended this particular performance.[157] Although *Vexations* is not a movie, there is a comparable effect on the audience. During such a performance, the possibility of a musician making a mistake during the 18 hours and 40 minutes is, to say the least, high, and such an accident would not only be noticeable but a part of and perhaps, an unexpected climax in the musical marathon. Likewise, when a viewer experiences *Sleep,* the incidents of the sleeping variations concentrate the attention of the viewer. When I first saw the film, I was literally mesmerized, and I can still remember that when Giorno made even a slight movement, I was startled. In *Vexations,* mistakes become conspicuous; in *Sleep,* already filmed moments of sudden and unexpected movements are featured.

A common overview[158] of Warhol's *Sleep, Empire, Eat,* and the *Kiss* series implies that all of these films feature the same use of the long take; but

they do not. Essentially, *Eat* (a half-hour reel of Robert Indiana eating mushrooms and playing with a cat[159]) and *Empire* are sustained portraits, in which the particular "personality" "behaves" "normally." In the former, the Pop artist engages in a favorite activity; in the latter, the Empire State Building is a Pop icon. The *Kiss* series forms a part of Warhol's testing of the endurance and the presence of (potential) "Superstars." Finally, *Sleep* is an experiment in the display of a common state of unconsciousness. Whereas all of the films represent instances of the long take, Warhol's intentions vary. The ontological status of a depersonalized "Superstar" becomes equated with that of an inanimate object, and the surface "design" of a nude is varied.

Warhol's films, to use Koch's phrase, "touch the nerve." However, his use of the long take not only suggests a voyeur's vigil of a highly charged sexual encounter, or a dedicated fan's adoration of a cinematic icon, but also a visualized third degree interrogation or a sustained investigation of "set-ups." Just as Warhol allows members of his entourage to expose themselves literally before the camera, he also allows performers to unmask themselves psychologically. In a sense, the long take becomes a form of a temporal tabloid effect of sensational and pathetic events: a perception of the phenomenon of *la vie ardente*, preserved in his films. Just as in an opera in which dialogue and action of any practical nature frequently come to a standstill for an aria, Warhol's films include unedited moments of truly human intensity. Warhol has written:

> Of course the movies became part of their lives; they'd get so into them that pretty soon you couldn't really separate the two, you couldn't tell the difference—and sometimes neither could they.[160]

He also notes: "Everybody went right on doing what they'd always done—being themselves (or doing one of their routines, which was usually the same thing) in front of the camera."[161] By means of the long take, Warhol could "get it *all* down on film."[162]

The culmination of many hours of filming long takes and then carefully planning an orchestration of such monitored behavior occurs in *Chelsea Girls* (1966): 12 reels of unedited long takes that record 12 separate set pieces, projected two at a time.[163] "Each performer is set in front of the camera and told to stay there playing until the reel runs out," Koch remarks.[164] Black-and-white and color sequences would be projected on split or dual screens with or without sound, and color gels were sometimes placed over the lenses of the projectors.[165] When asked about the long take in reference to *Chelsea Girls*, Warhol stated:

> Well, this way I can catch people being themselves instead of setting up a scene and shooting it and letting people act out parts that were written because it's better to act naturally than act like someone else because you really get a better picture of people being themselves instead of trying to act like they're themselves.[166]

In fact, parts of the film were scripted by Ronald Tavel,[167] and Warhol did "set up" all of the circumstances that were filmed. For instance, he told Eric Emerson to do an autobiographic monologue and then to strip sometime during the long take.[168] Emerson does precisely this. In another sequence, Warhol told Marie Menken before filming that she was "to play" the mother of Gerard Malanga.[169] In this reel, Menken delivers an ardent reprimand to her "son." The starting point is chosen in accordance with *the possibilities* of *"found" personalities*. They may clash. They may evoke an introspective narcissism. In a very real sense, Warhol allows such people to display their open psychic wounds. Like his Disaster Series, a horrific document is consciously "distanced."[170] By means of the long take, Warhol ensures that somewhere on a reel something will strike a nerve.

In one sequence, Warhol's long take captures a particularly significant devastation of someone who is "trying to act" like himself. This reel concerns Ondine, who was—is—one of the wittiest, incessant humorists, all the more beloved because he also stutters, of Warhol's "Superstars." One of Ondine's routines is to pretend that he is the Pope, hearing confessions. This particular persona was begun by him before he knew Warhol.[171] (Ondine met Warhol at an orgy, to which the artist came to watch the homoerotic encounters, and from which the artist was asked to leave by Ondine because he only stood in a corner.[172]) In *Chelsea Girls,* there are two segments based upon "Pope" Ondine, who hears confessions.[173] "I didn't proclaim myself Pope," Ondine says during one of the long takes, "I was elected. My parishioners are addicts, homosexuals, thieves." Like a situation from a work by Genet, a main character bears witness to vainglorious creatures whose "beautiful" lifestyles are contaminated by filth. "Saintliness" is defiled. "Popesi-Cola" is dispensed. The resonance of Ondine's persona entails a subtle contradiction—as if, like Genet, one were to say, "For I hate you, lovingly."[174]

Ondine summons a parade of victims to his drugged presence. Obscene penitential duties are prescribed ("Just go up to the Crucifix, lower His cloth, and go about your business."). Throughout the segments, up to one point, Ondine remains buoyantly assured of his authority as a mock anti-Pope. A young woman enters as a new petitioner. With a new shot of methadrine, Ondine is prepared for another confession, but she refuses to comply. "I can't confess to you because you're such a phony," she remarks, "*I'm* not trying to be anyone." Ondine mocks her by repeating her words. "I'm a phony, am I?!" he shouts. She counters by saying, "That's right." By questioning Ondine's authority and the very premise of *inauthenticity,* the woman has broken the fantasy. Ondine is stunned, and in a rage throws "Popesi-Cola" in her face. Yet, she remains steadfast. He slaps her. He slaps her again and again until she runs off the set. Ondine shouts to Warhol to turn the camera off. Warhol continues the long take. The "Pope" leaves the set, and the scene blurs: as the camera operator,

Warhol breaks his rule of a "static" camera in order to document Ondine's rage. Finally, Ondine returns to the set and apologizes to the camera. Still the reel is not over. He tries to assume his presence as "Pope," tries to remain calm, and even tries to smile. But he is now emptied of wit. "Dear God," Ondine says, "how much longer do I have to go?" He is now unmasked, and all he can do is wait until the long take is over. From a hysterical explosion of anger, Ondine's persona implodes. What happened?

"She failed to realize," Koch has commented, "that, once you've stumbled out of the cool, vibrant life of inauthenticity, mockery is absolutely forbidden."[175] But like laughter that would kill any suspended fantasy, a magical spell has not just merely been broken. Ondine's intense outrage is an authentic one against the indignation of the unknown woman. In fact, it was precisely this "death" of Ondine's self-control and hipster caution that was "set up" so that, somewhere in one of the reels featuring "Pope" Ondine, Ondine would lose control, lose his "cool." In retrospect, Ondine remarked to me:

> And *to this day* [in 1978] *I don't know* what happened. I know what I did. I know what she did. But when it was being filmed, I had no idea that Paul Morrissey had rehearsed her to the point of that. And when she left there . . . she screamed, "Why did you send me in there!" . . . *I knew none of this!* And I think that all of the people who appeared in the Warhol films—they didn't know half of the stuff that was going on around them. He had them *respond* to a certain set of circumstances.[176]

Warhol's films not only deny individuality in order to achieve an alternative cult of Hollywood stars, they allow the disintegration of it in order to investigate such an imposture. His films are scintillating reductions of not just the form of the medium but of the participants. "Slowly but surely I want to strip her," writes Genet, "of every vestige of happiness so as to make a saint of her."[177] Slowly but surely Warhol strips his "Superstars" of their humanity so as to form "plastic idols" of them. Warhol does not so much "exploit" them as *"explicare"* them.

"Because the more you look at the same exact thing," the artist has written, "the more the meaning goes away, and the better and emptier you feel."[178] He has also written: "The great stars are the ones who are doing something you can watch every second, even if it's just a movement inside their eye."[179] Either through the pressure of becoming a glamorous and temporal presence in his *Kiss* or portrait-as-screen-test series, or by the tension of performing a certain given activity as a test of such presence, Warhol empties his performers of their individuality so that they may (possibly) become symbols of his fantasies.

Warhol's *My Hustler* (1965) was filmed on Fire Island. This two-reel movie is, according to Warhol, "the story of an old fag who brings a butch blond hustler to Fire Island for the weekend and his neighbors all try to lure

the hustler away."[180] The first reel consists of an actual plot, perhaps due to Paul Morrissey, who would subsequently direct narrative films that are produced by Warhol.[181] Moreover, this first reel includes edited cuts and pan shots that follow the hustler on the beach. However, the second reel consists of a single long take, in which the blond hustler (Paul America) and the older man (John MacDermott) are alone in the bathroom of a beach house. In contrast to the "narrative" of the first reel, the second reel concerns the "theatricalization of masculinity." [182] Specifically, the long take in *My Hustler* is a trope signifying the unappeasable hunger of narcissism and its deconstruction. Stephen Koch explains:

> The reel is a document in masculine coquetry without parallel. MacDermott stands before the mirror, shaving, combing his hair, washing his separate fingers one by meticulous one, performing any other act he possibly can arrange rather than leave his carefully chosen forced proximity to the blonde bruiser, who is likewise arranging to shower, rinse his suit, urinate, lean against the wall to pass the time, casually "waiting" to take MacDermott's place before the all-beloved mirror. The atmosphere is electric with the tension of pretending not to notice, of two large bodies near each other, and the potentiality of flesh brushing — accidentally — flesh. The action is tense with its obvious little truth, that this sequence is about two men's bodies, that they have become, in this situation, sexual objects, without admitting that simple fact or rather only admitting it on two different levels: MacDermott on the level of seduction, America in the realm of a certain coy evasion.[183]

The theme of masculine indulgence and of homoerotic desire becomes inverted by an accident. While the hustler preens before the mirror and the older man combs his hair, the hustler's towel slips. For now, the fantasy of desire halts: the hustler must divert his attention from his auto-erotic gaze in the mirror, and the older man, living through the youth and physicality of the hustler, diverts his glances into the mirror, where he sees the young man's reflection. As in a performance of Satie's *Vexations,* the high point of this long take is thus an accident which disrupts the continuity of the narcissistic absorption of the two men. This accident deconstructs the filmed situation of imposture and its heightened self-reflexivity.

During 1965, Warhol filmed *My Hustler,* and he used the long take for several films entitled *Screen Test.*[184] Before each screen test, Ronald Tavel interviewed the featured performer, who was filmed in a sustained close-up. During the long take, Tavel grilled the participant quickly so that he would react spontaneously.[185] These several *Screen Test* movies represent Warhol's attempt — his obsessive attempt — to capture either the Camp mystique of Hollywood,[186] or the raw exposure of an unstable mind by means of a sustained tension: cinematic equivalents to the tabloid *True Confessions.*[187]

Warhol's directions to Tavel were explicit. The first *Screen Test* was of Philip Fagan, one of the "beauties" of the artist's entourage. Warhol told Tavel:

Sit and ask him questions which will make him perform in some way before the camera. You will not be on camera, but we'll hear you talk. The questions should be in such a way that they will elicit, you know, things from his face, because that's what I'm more interested in rather than in what he says in response.[188]

This unreleased *Screen Test* was apparently unsuccessful because, according to Tavel, the performer could not cinematically *express* a glamorous and mysterious beauty, and he would not respond openly to the questions about his personal life.[189]

Hence, a second *Screen Test* used Mario Montez, who could project a particular beauty—that of his beloved actress Maria Montez. In fact, Tavel recalls that Warhol said to him:

So, we're going to do this same thing because I love this idea of *Screen Test*, and it has to work, and the problem here has been the subject. So, we'll get Mario Montez, who thinks of himself as a star. All of these things. *He thinks he is, and he wants to be, and he is.*[190]

In *Screen Test #2*, Mario Montez perpetuates the legendary myth of Maria Montez and, as the filmmaker Jack Smith remarks, her "ravishing beauty."[191] The young transvestite gave a remarkable imitation of the Hollywood actress to the extent that, according to Tavel, "what you saw was the genuine belief on his part that this was all so, his willingness to cooperate during it."[192] What was recorded consisted of two long takes of extreme intensity in reliving Hollywood glamour. In retrospect, Tavel comments:

But if you know what to choose in film their goodness or envy, it was just them under that pressure. It was their *worst* qualities often, having to behave under tension. You see, with a model you can relax in a studio. There's no way to relax people in front of a [film] camera.[193] . . .

I felt humiliated in this way. I felt also part and parcel of a system that was doing something as *insane* as thinking of people as "Superstars." Human beings are commodities as the human being as "Superstar." I couldn't live with it. And it finally gets to you, you know. Just working: all that publicity under the strain . . .[194]

More shocking and chilling is, however, *Screen Test #3*—the Technicolor close-up of a young man's wrists that have been slashed many times, and the youth's monologue concerning each of his 19 attempts at suicide.[195] Unreleased, this film-as-testimony was shot the same year (1965) as *Drunk*, in which Emile de Antonio decided to risk his life by consuming an entire bottle of Scotch.[196]

It is by means of the long take that Warhol attempts to record variants of mystery and even of survival. Warhol allows his "Superstars" to create themselves as "mythic" personalities who are disconnected from "reality." In fact, for these "Superstars," the self-created illusion of glamour and chic celebrityhood or of heightened self-reflexivity is "reality." Warhol's use of the long take

is a demonstration of such delusions, as well as their deconstruction. However, not all of his hundreds of films include this trope. At certain points, Warhol would turn the film camera off as a form of editing and thus, would use *The Strobe Cut.*

An Auricon camera synchronizes images with an optical soundtrack. As it is used by documentary and newsreel filmmakers, the camera may be simply turned off to edit the film. When such "in-camera" editing is done, the projected image appears completely white for a few frames and a loud "bloop" sound occurs on the optical soundtrack. If kept in a completed movie, this form of editing is known as a "strobe cut," something that usually "is the first thing every technician would cut out."[197]

Warhol retains the strobe cut not only as a form of visual and aural noise that punctuates a sequence of events, like the static on a television screen during the changing of channels, but also as a conscious means to punctuate the long take. Warhol once said, "Since everyone says I never stop the camera, I stop it now, start and stop, and that makes it look cut."[198] During an interview, the artist was asked if he experimented with projected images. "Well, you get used to cutting off things," he replied, "It makes the movie more mysterious and glamorous."[199]

Almost equivalent to the strobe cut as used by Warhol, is the projection of reels from the initial white leader to the final one ("white out"): an effect that the artist found to be as important as the content in Lisanby's "home movies,"[200] and which he used in the *Kiss* series. Warhol told Howard Junker "that seeing the leader run by in the midst of such boring other material was in itself quite a dramatic event."[201] The strobe cut serves the same function in the structure of a Warhol film. Since most of the hundreds of films that Warhol produced featured the long take, an experienced viewer, expecting a sustained image or an unedited sequence throughout a reel, would be shocked by such an abrupt interruption.

Warhol used the strobe cut only in his later films, such as *Lonesome Cowboys* (1968) and *Imitation of Christ* (1967). The latter film contains excerpts, dealing with "Superstar" Patrick Tilden, from Warhol's 25-hour film *Four Stars* (1966–67): the strobe cuts are simply the seams of the condensed version.[202] Beginning with *Flesh* (1968), Paul Morrissey became Warhol's main film associate. During the time of his influence on Warhol the use of an unedited long cut to an edited one began. According to Morrissey, the strobe cut eliminates "boring" material and concentrates on more "entertaining" content.[203] For *Lonesome Cowboys,* a "sex" Western filmed in and around an "Old West" film set in Arizona during 1967, the strobe cut is used as simply an easy way to edit, as Morrissey has explained:

> We don't move the camera in, and we don't zoom in, in the shot. We stop the camera, zoom into the close-up, maybe pan to the second actor, turn the camera off, zoom back, to a two-shot, then start the camera again.[204]

Morrissey's film esthetic is different from Warhol's use of the long take. Whereas Warhol simultaneously deconstructs the nature of the medium and the content of traditional cinema, Morrissey and his films seem to seek an approach based on a narrative structure that is meant to be entertaining. The strobe cut is a trope used in Warhol's later films, and it occurs with and is structurally similar to *Zooming as Zooming*.

In his films, Warhol may zoom into a close-up of an object or a performer, and such a zoom will have no narrative or "meaningful" basis. That is, he will not zoom to a performer's face for a close-up reaction or to an object that may be referred to in the dialogue. Rather, Warhol slowly or quickly zooms in and out of a scene merely for the sake of zooming. In *The Velvet Underground and Nico* (1966), the lead singer of Warhol's rock band sits on a stool and the musicians form a semicircle behind her. During the two reels of long takes, the band performs ear-splitting musical numbers, which are all the more irritating because of the bad sound recording. (In fact, the end of the film features actual police officers who had arrived in response to complaints about the noise level.)[205] On occasion, members of the band or of Warhol's entourage stand in front of Nico, mugging into the camera. As a counterpoint, Warhol zooms in on a close-up of Nico. At other times, Warhol's zooming quickly back and forth creates a visual "noise" factor. In *Restaurant* (1965), two tables of performers perform various activities, and Warhol arbitrarily zooms to either table without any particular "narrative" motivation. David Bourdon has noted that in *Lonesome Cowboys* Warhol often missed "significant moments" during the filming:

> Viva was nearly urinated upon by her antagonist's horse and then, losing her footing in the mud and falling against the hind legs of her horse, nearly trampled upon. Warhol missed both events because he was zooming in on a storefront sign across the street.[206]

However, in my opinion, Warhol's use of zooming parallels his use of the continuously moving camera in *Space* and *Hedy* (1966).[207] It was also during this time that Warhol's productions of simultaneous light shows, film projections, etc., accompanied presentations of his rock band,[208] with no central focal point of attention. In fact, during the filming of *Hedy*, Warhol deliberately aimed the camera away from depictions of the debasement of a famous Hollywood actress who was caught shoplifting. Tavel comments during my interview:

RT: And Warhol got behind the camera, and he did the camera-work, which is incredible and unbelievable. It moves constantly from the high point of the action. It's very strange.

PS: As if he's deliberately trying . . . ?

RT: *Deliberately*. Yes. It's beautiful. As the script starts to build toward a

climax, the camera leaves it and goes up to the ceiling and begins to examine furniture, also. As a *film*, that's an incredible thing. Again, it was shitting on the script because it was falling together marvelously.[209]

The use of the moving camera is, like zooming, the long take, and the fixed camera, an insistent vision of another reality. Warhol imposes his means and his self-referential tropes.

Through such cinematic tropes, Warhol's films simultaneously set certain limits on the medium and reveal it. Warhol consciously used such devices to form a filmic "signature." Without complete control during the actual filming of a personality or a situation, the artist allows accidents to form the very fabric of his enterprise. Although his films are studio productions, like his hundreds of silkscreened canvases and prints, they are all distinctly *his* works. They include his "aura" and his fantasies. In a sense, Warhol's "aura" denotes a crisis and the uniquely "Andy Warhol" nimbus that *is* his art works, career, and entourage. In my opinion, his films do display puerile thrills as much as his self-referential passion for depersonalizing objects and personalities in order to give them a mythic status. The voyeuristic element—*the monitored stare*—in his films characterizes him as a kind of inert and ambivalent fan of his beloved "plastic idols." Warhol does not so much seek out and hide but seek out and remain visible in his quiescent response of the flesh. Like Duchamp, the artist-as-investigator acts as an observer to his own creations. He is as much a spectator of his films as we are, either accepting or rejecting the filmed presences. By means of cinematic tropes and simultaneous projections of filmic images,[210] Warhol allows the flotation of meaning: the spectators "create" the works as they observe the free play of form and content.

In Genet's *Our Lady of the Flowers*, the author is the narrator. He presents his fantasies of certain beloved prison inmates. In essence, these inmates are the phantoms of his stream-of-consciousness. The reader knows them only as images in his mind. In a sense, Warhol's films present displays of personalities in such a way that the viewer only knows them through the artist's fantasies. The real character of Genet's novel is Genet, just as the real presence of Warhol's films is Warhol. "I exist only through them," wrote Genet, "who are nothing, existing only through me."[211]

Toward a Cinema of "Cruelty"

Surrealist playwright Antonin Artaud once wrote: "Everything that acts is a cruelty. It is upon this idea of extreme action, pushed to its limits, that the theatre must be built."[212] During 1964, dancer Fred Herko, one of Warhol's close associates, suddenly completed his final "performance." Artaud's notion of a "Theatre of Cruelty" may provide an understanding of Warhol's films. Warhol has written about Herko's death:

He said he had a new ballet to do and he needed to be alone. He herded the people there out of the room. As the record got to the "Sanctus," he danced out the open window with a leap so huge he was carried halfway down the block onto Cornelia Street five stories below.[213]

When Warhol first heard about Herko's death, the artist is reported to have remarked, "What a shame that we didn't run down there with a camera and film it."[214]

Stephen Koch has called several of Warhol's later films, including *Imitation of Christ* (1966–67), *The Loves of Ondine* (1967) and *Lonesome Cowboys* (1967–68), films of "degradation."[215] One could also add Warhol's *Hedy* (1965), a tabloid-like exposé based on the real circumstances of a Hollywood star who was caught shoplifting; *Suicide* (1965), the third in a series of extended screen tests; and *Drunk* (1965) in which Emile de Antonio risks his life by consuming an entire bottle of Scotch. Warhol's steady state of a passionless presence is an adopted persona that avoids risks and psychological pain, but he films people who seem to be willing to submit to both. Moreover, Warhol's stance is a mirrored extreme of his own removal in silence, so as to solve the contradictions inherent in the daily dramas of his proposals of comic existence. Several films clarify this duality.

Kitchen was filmed during June 1965 at the apartment of Buddy Wirtschafter, Warhol's technical assistant.[216] Warhol told his scriptwriter, Ronald Tavel, "I want it simple and plastic and white."[217] That is, he wanted to film a proxy of daily life, as he associated such qualities with Hollywood.[218] This film was to be a "vehicle" for Warhol's "Superstar" Edie Sedgwick, whose social life with the artist was then highly publicized.[219] *Kitchen* was the second film by Warhol to be rehearsed, but during these rehearsals Sedgwick had difficulties memorizing the lines and various situations (as opposed to plot developments), because Chuck Wein, one of Warhol's assistants, deliberately kept her out late.[220] (Apparently, Wein was "sabotaging" the film in order to discredit Tavel.[221]) Scripts were provided for Sedgwick throughout the set during the actual filming. Sedgwick sneezed to indicate that she needed a cue, and the film features constant sneezing.[222] The Absurdist "kitchen drama" also included much improvisation. Even though Warhol realized that the rehearsals and the chaotic filming were not going well, he allowed the movie to be completed. In fact, he included a fashion photographer, who was visiting the set to take photographs.[223] Despite the fate of a ruined script, Warhol deliberately added to the chaos instead of stopping the film or rescheduling it. The "accidents" in *Kitchen* deconstructed the film and dehumanized the performers.

Sedgwick's first film for Warhol was *Vinyl* (1965), the first film adaptation of Anthony Burgess's novel *A Clockwork Orange*. In this film (which concentrates on the first half of the novel), the main character, played by Gerard Malanga, is being tortured. In the back of the set, actual experts in

sadomasochism are performing real sexual tortures. Warhol places the camera in such a way as to include Sedgwick, whom Warhol asked to visit the set. Warhol placed her on a trunk, and she was apparently unaware that she too was being filmed. *Vinyl* becomes a visual counterpoint between Sedgwick smoking a cigarette and her disdainful reactions to the homoerotic tortures, and between Malanga trying to portray his character but realizing his "vehicle" is being sabotaged.[224]

In my opinion, one film in particular epitomizes Warhol's "Cinema of Cruelty." That film is *Horse* (1965): Warhol's first "sex" Western, in which a real horse is featured as a part of the film, which was shot in Warhol's "Factory."[225] This film consists of three reels, each of which is a long take. The second reel is a close-up of the horse's head, and it was filmed after the first and third reels.

As with Tavel's previous scripts or improvised questions to Warhol's performers, the scriptwriter interviewed the film's featured players, including Larry Latreille as the "Kid," Gregory Battcock as the "Sheriff," Tosh Carillo as "Mex," and Daniel Cassidy as "Tex." Tavel was interested in these performers because they were articulate sadomasochists. In fact, during Tavel's interview with Carillo, that performer demonstrated his "game room."[226]

During the filming, cue cards were held by Tavel and Gerard Malanga. Consequently, the script features simple and rhythmic lines, such as these: "I'm the Kid from Laramie/Hang me on yonder tree/I come ridin' off the plain/A-seeking just one friend/But, friend, this here's the end."[227] The performers were not aware of their lines until the actual filming took place, and a part of the performance value—more precisely, the shock value—of *Horse* occurs in the improvisations by the performers. A part of the script includes the "educated toes" of Carillo, and this detail of the script was incorporated by Tavel from his pre-production interview with that "Superstar."

An analysis of Tavel's script, as opposed to the actual filmed performance, reveals a rather tame "sex" Western. After the credits are read, the Kid is to perform as many tricks with the horse as he is capable, while the other performers ("instructors") stare at him. The Sheriff insists that Tex or the Kid is a murderer, while the Kid, who is on horseback, "makes love to it." Following the amorous advances to his equine companion, the Kid "from Laramie" admits that he is indeed a murderer and demands to be hanged from a nearby tree. But the dim-witted Sheriff still asks which one of the young men is the murderer, and he and they "proceed to make love to the horse, rubbing its mane . . ." After disparate claims of being celibates and onanists, the performers proceed to preen their theatricalized masculinity and then to engage in combative games of bondage and domination around the horse. They also make sexual appraisals of the animal. The third reel includes shooting the Sheriff, obscenely drinking milk (as a metaphor of consummated sex), a parody of the

final duet of *Faust,* and playing strip poker. During the last activity, the wounded Sheriff is bound and beaten with the cowboys' belts while the finale of *Faust* is heard.

Tavel had expected a pony to serve as the entitled animal, but Warhol rented an enormous stallion, which was extremely nervous. According to Tavel's understanding of the Old West, cowboys were celibates, asexuals, or homosexuals and loved their horses, which were their "sex objects." The theme was the cowboys' sexual encounters with horses, but the display of a "genuine" Western coexisted with Tavel's interest in sadism:

> But though what I *really* wanted to say was how easily would a group of people under pressure be moved to sadistic acts—to genuinely inhuman acts toward each other and perhaps the horse—under pressure. And I had this very consciously in mind.[228]

The theme of sexual aggression becomes the mode of examining the particular performers. Tavel comments:

> I had this *unique* opportunity to demonstrate for myself, to experiment for myself, how quickly would people be moved to do *extremely* hostile acts under pressure, inhuman acts toward their best friends (in long range) merely by telling them to do so.[229]

The answer was an astonishing four minutes. Influenced by various drugs, the performers apparently not only felt no pain (such as being kicked by the horse) but were totally oblivious to any sense of danger from the horse or the inflicted beatings. Warhol allowed the deliberate and genuine "acting out" of the sadistic tendencies of the performers. At one point, the Kid's head is rammed against the "Factory's" concrete floor. Despite Tavel's screams to stop the action, Warhol continued the long take of the growing chaos of inflicted pain. Tavel recalls Warhol saying to him during the shooting, "Gee. It looks so real. Like a Western. Like a real Western. I don't know if I like that."[230] What Warhol would have preferred is unknown.

Like *Vinyl,* Warhol's *Horse* presents actual incidents of sadistic behavior as interplay between the performers. The viewed visceral experience parallels Warhol's voyeuristic sensibility in which he allows performers to fornicate before a camera. The extremes of behavior are pushed to their limits so that a "Superstar" reveals himself in a situation, just as a critic "reveals" himself in his response to a Pop Art canvas. In part, a performer is allowed to create himself and to respond to various sets of circumstances.

As an artist-investigator, Warhol monitors his own creations in his films. He tests his "Superstars" not just for their screen presence and magical allure but for their impostures, exhibitionistic and sadistic compulsions, and their narcissistic self-reflexivity: *la vie ardente* that is presented and exposed. Warhol has remarked, "Their lives became part of my movies, and of course, the movies became part of their lives; they'd get so into them that pretty soon you couldn't separate the two, you couldn't tell the difference—and sometimes neither could they."[231] In the case of Herko, one should include "death."

5

Warhol as Entrepreneur

Entrepreneurship and Star Merchandise

I'll endorse with my name any of the following: clothing, AC-DC, cigarettes, small tapes, sound equipment, Rock 'N Roll records, anything, film, and film equipment, Food, Helium, WHIPS, Money; love and kisses Andy Warhol. EL 5-9941.
Andy Warhol, advertisement in the *Village Voice*, 1966

A novelty book entitled *1000 Names and Where to Drop Them*, was published in 1958, and it included such categories as "Nescafé Society," "Theatre," "Artists," and "Fashion."[1] In *POPism*, Warhol has written: "I got a real kick out of seeing my name listed under 'Fashion.'"[2] However, his name was neither listed under "Fashion" nor under "Artists." It was listed under "Big Business."[3]

When Warhol began in 1960 to produce a new marketable style—Pop Art—to launch his career as a fine artist, he could not find a gallery to exhibit his esthetic products. Warhol considered even a "vanity" exhibition.[4] During April 1961, Gene Moore, the director of display of Bonwit Teller, gave Warhol his first one-man "exhibition": for one week, Warhol's Pop Art canvases were backdrops of that store's show windows. According to Ted Carey, Warhol felt that Roy Lichtenstein "took" his comic strip subject matter,[5] especially since gallery owner Leo Castelli had taken Lichtenstein on and had considered Warhol's paintings too similar to Lichtenstein's.[6] Desperate to be included among the Pop artists, Warhol gladly accepted a one-man show at the Ferus Gallery in Los Angeles,[7] and he even accepted the terms offered by Eleanor Ward to have a one-man show in her New York gallery in 1962: Warhol was to paint her lucky two-dollar bill.[8]

Warhol's Pop Art career was launched by 1963. During that year, Warhol adopted the appearance of an 'Underground" punk in the manner of James Dean and Marlon Brando (black leather jacket, sun glasses and a silver-sprayed wig).[9] Moreover, Warhol's persona of a silent and self-contained artist included

his lifelong tendency to speak in "telegraphic" remarks that would involve "uhs," "oh, wows," and many pauses. Yet, Gene Swenson's interview[10] with Warhol during that year demonstrated mordant humor and epigrammatic wit.[11]

It was also in 1963 that Warhol hired Malanga to help him silkscreen images, and he also brought certain associates to the "Factory," including Billy Linich who silver-foiled the loft.[12] This was the time during which Warhol produced paintings, objects, and films, and formed an alternative to Hollywood glamour and fame by featuring "Superstars" in his films. By 1963, the popular image of his studio and his activities was infamous.[13]

During 1964, Warhol was represented by Leo Castelli, who showed that year a sold-out exhibition of *Flowers*.[14] The following year, during a showing of the same series at the Galerie Ileana Sonnabend in Paris, Warhol announced, as did Duchamp in a similar gesture, his "retirement" as an artist to become a filmmaker. "Art just wasn't fun for me anymore," Warhol has written about his decision. "It was people who were fascinating and I wanted to spend all my time being around them, listening to them, and making movies of them."[15] It was also during that year that he experimented with audio and videotape—an expensive hobby then and one for which Warhol used his income from painting to record his "Superstars."[16] Through the remainder of the 1960s until he was shot in 1968, Warhol accelerated his publicity stunts: allowing spokesmen to answer interview questions, producing multimedia presentations of his rock band the Velvet Underground, designing "do-it-yourself" paper dresses, giving away a bride during a ceremony at the Detroit State Fairgrounds Coliseum, allowing the poet Allen Midgette to pose as him in lectures at several universities, and appearing at the opening of a one-man show in Philadelphia where, because of an expectant throng, the paintings were taken off the gallery's walls and Warhol and his entourage "became" the show.[17]

Since 1968 Warhol has produced various publications and commissioned portraits. These activities are in the following sections. He also has produced commercial films directed by Paul Morrissey.[18] In short, Warhol's career since 1960 includes diversified and mercantile ventures that expand the possibilities of studio products and that involve assistants who execute such works. Like his use of friends to apply overlays of color on offset promotional books and flyers during the 1950s, Warhol's "Factory" consisted of people who were willing to assist the artist without pay. If Nathan Gluck was Warhol's paid "ghost" assistant for commercial art commissions, then Gerard Malanga and Billy Linich were Warhol's "ghost" assistants for his Pop Art and films. Warhol's esthetic productions have usually been easy ones: tracing images that are readymade and implicitly or explicitly from popular sources, and using techniques (offset lithography, stamps, silkscreens, film, and audio tape, etc.) that may yield multiple works.[19]

A case in point during Warhol's Pop Art phase is his series of object-mul-

tiples of unnumbered editions of *Brillo Boxes, Kellogg's Cornflakes Boxes, Heinz Boxes, Del Monte Boxes, Mott's Apple Juice Boxes,* and *Campbell's Soup Boxes,* all of which were produced during 1963 and 1964.[20] Warhol asked Nathan Gluck to go to a grocery store and to pick out various "boxes." Because Warhol did not specify what kinds of boxes to obtain, Gluck returned with fruit crates bearing labels with pink flamingos, palm trees, etc. According to Gluck, these Campy labels appealed to him but were not what he wanted. In fact, Warhol told Gluck that he wanted something that was more "everyday." During that time Warhol used the term "Commonist Art" (which he soon discarded because it sounded too much like "Communist Art" and because "Pop Art" became the designation most critics used).[21]

Instead of Campy boxes, Warhol picked well-known grocery product cartons, then he sent specifications of the cartons' dimensions to a professional carpenter, who fabricated the plywood boxes. When these boxes were delivered to his studio, Warhol instructed Billy Linich to paint the background colors. Warhol then photographed the "original" cartons and sent the photographs to be processed into photographic silkscreens. Finally, Warhol and Gerard Malanga silkscreened the labels onto the painted plywood boxes.[22]

Warhol's boxes-as-multiples were shown in 1963 in his last one-man exhibition at the Stable Gallery, which was piled with the works. Having great expectations of selling them, the small number of initial purchases disappointed both Warhol and Eleanor Ward, the gallery owner.[23] One of the publicity stunts was to include the original designer of the Brillo shipping carton—abstract painter James Harvey—to autograph the commercially available product, but Harvey died soon after the opening and had signed only one box (Collection Irving Sandler, New York).[24] Because the *Brillo Boxes,* et al., did not sell, Warhol gave dozens away to friends and commercial art clients, just as though they were promotional works that he had done during the 1950s.[25] Sometime during the late 1960s, plastic covers were placed over the *Brillo Boxes.*[26] These covered *Boxes* sold for $1,800 each, instead of the original price of $300 apiece.[27] The majority of the *Brillo Boxes* were unsigned, but according to Ronald Tavel, Warhol did allow assistants to sign them with his name.[28]

Like Duchamp, Warhol is an estheticized *bricoleur* who works with material that he has not produced and that is not used for its original intention. Such a *bricoleur's* repertory consists of the remains of constructions, acting as readymade "pre-constraints," that are taken out of context. The function of the original is canceled or deconstructed. Moreover, any "message" from the original, though it is still being transmitted, is remodeled by the esthetic gesture of displacement. (In my opinion, if there is irony involved, it is the *ironia* of "dissimulation."[29]) For Warhol, there is no necessary methodological eclecticism or historicity involved. As opposed to the signed and limited editions of Duchamp's Readymades,[30] Warhol uses unlimited editions and "unclosed" in-

ventories of imagery and objects. Such inventories are the intermediary links between Warhol's readymade materials and the resulting paintings, multiples, and films that put into play the possibilities of how Warhol displays them. It was during 1963 (when Warhol began his *Brillo Boxes*), that he bought literature concerning Duchamp from Nathan Gluck. He also attended the opening of Duchamp's Pasadena retrospective.[31] In my opinion, Warhol's *Brillo Boxes* do not represent a Duchampian *épater du bourgeois*. Rather, it is precisely that class that he wants to purchase his specimens of Popism:

> So you need a good gallery so the "ruling class" will notice you and spread enough confidence in your future so collectors will buy you, whether for five hundred dollars or fifty thousand. No matter how good you are, if you're not promoted right, you won't be one of those remembered names.[32]

Moreover, unlike Duchamp, Warhol is not concerned with the "problem" of meaning or of intentionality, but with the "solution" of minimizing risk and of maximizing return.[33]

Warhol's Popism includes his notion that "anybody could do anything"[34]—a variant of Moholy-Nagy's esthetics.[35] Such possibilities for creativity are "surface"[36] concerns so "that you just had to spread yourself very thin and that then maybe *some* of the things you did would catch on."[37] Warhol's diversification of his esthetic production is, moreover, one of the artist's fundamental principles: "My style was always to spread out, anyway, rather than move up. To me, the ladder of success was much more sideways than vertical."[38] Consequently, Warhol's motive of being a successful and famous artist involves the production of numerous works in various fields, and such works are to be made with as little effort as possible. In fact, his admiration for Matisse is not based on any stylistic grounds but, rather, on the nature of the celebrated French artist's output: everything Matisse did, even a simple cut-out collage, was considered to be valuable.[39] Likewise, his appreciation for Picasso concerned a nonesthetic appraisal. "Picasso was the artist I admired most in all of history," Warhol has stated, "because he was so prolific."[40] Value entails for Warhol the quantity and quality of marketable commodities. Hence, he will add a blank panel to a portrait or another form of painting in order to double its monetary worth,[41] and he will leave any overtones of a religious diptych to the critics.[42] Blankness is precisely at the center of Warhol and his notion of Popism: (1) entailing his self-proclaimed inner "vacuum,"[43] (2) depicting unqualified surfaces of American cultural and social life, as he has experienced it, (3) idealizing the "plastic" or "white-on-white" proxies of the American Dream in a Hollywood film,[44] (4) accepting boredom that empties meaning and feeling,[45] (5) being a persona of mysterious silence. Warhol's "art" is the display of deconstructed star and "Superstar" merchandise that is drained of "meaning" and subjugated by his "signature."

Warhol depicts dreams and nightmares. His esthetic accomplishments are in part the isolation of an image or a situation from an original context and from unique cultural and social parameters, and the presentation of such icons or taboos as both themselves and "defamiliarized" commodities. (Such is the legacy of Duchamp.[46]) Images (publicity photos, documentary *reportage* in the Disaster Series, and reproductions of art masterpieces) are "erased." While the autonomous iconology of such images is clearly evident, there is a displacement or dispersal—more precisely, a disposal—of meaning, which becomes no longer located exclusively in a preordained pictorial reality. Warhol has remarked:

> Everybody does the same thing over and over again. I like to do the same thing every day. Well, I'm different. I like to paint the same painting. If I had my way I'd paint Campbell Soup cans every day. It's just so easy and you don't have to think. It's just too hard to think.[47]

Warhol's intuitive estheticized *bricolage* is an "art" that devises stratagems of entrepreneurship.

A crucial case in point is one of Warhol's paintings in his 1963 series depicting Leonardo's *Mona Lisa*. This particular Warhol *Mona Lisa* (formerly in the collection of Eleanor Ward and Andy Warhol, New York) *puts into question* the very apparatus of the contemporary art market, and its support system of museum exhibitions and art criticism. It demonstrates Warhol's "silent" *modus operandi* (fig. 46). The painting has been discussed by prominent art critics and has been included in important exhibitions.[48] Lawrence Alloway's catalogue essay for the major exhibition of American Pop Art in 1974 at the Whitney Museum of American Art, New York, reads:

> As usual with him [Warhol], each image is a whole; yet each one is subject to gradual or abrupt variation. In a curious way, the shift from image to image constitutes a kind of covert return to the characteristics of autographic touch, one of the traditional functions of which was to provide just this kind of unpredictable sensuous departure from a norm. . . . in *Mona Lisa*, 1963, the images are scattered, not serial, with complete color change; some images are tilted, and in addition, two details of the painting are added. The result is a jumpy and restless composition, in which the Mona Lisa's status as a cliché of twentieth century art is celebrated.[49]

The multicolored variations of the image and the eccentric, almost Rauschenbergian dispersal[50] constitute an exciting visual dynamism and its consequently expressive "noise." In fact, this painting is unique in Warhol's Pop Art because (1) it does not feature autonomous serialty, (2) it includes details of the image, unlike his other paintings which feature either close-ups or the entire image, (3) although many of his Pop paintings include slight displacements in the alignment of serialized images, no other Pop canvas by him includes rotated orientations from the vertical, (4) when Warhol does use multiple variations of col-

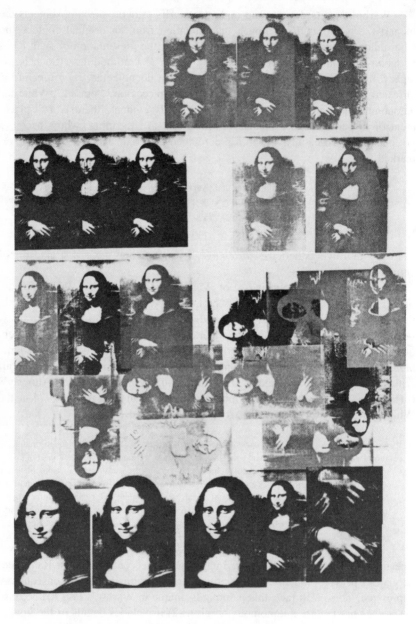

Figure 46. Andy Warhol, *Multi-Colored Mona Lisa*, 1963
Synthetic polymer paint silkscreened on canvas, 128″ × 82″.
(*Formerly collection of Eleanor Ward and Andy Warhol,
New York;* © *A.D.A.G.P., Paris/V.A.G.A., New York, 1986*)

ors in silkscreened paintings, he does not otherwise superimpose such vari-egated repetitions of the exact *same* image.[51] What may account for this not-able exception to Warhol's Pop Art style?

When Warhol used[52] photographed serigraphy to produce his Pop Art im-ages, the artist followed a regular procedure.[53] In his studio, there would be a large roll of unprimed canvas. Warhol and Malanga would unroll the canvas and then prime either canvas still on its roll or canvas that had been cut from it. Any paint that is not applied serigraphically would *first* be applied, including the details of a portrait. Second, the serigraphed image would be placed over the "background" of the field of color. Third, after the painting has dried, it would be cut and then stretched onto a canvas support. (If an image appeared on unprimed or "raw" canvas, the first step would be omitted.) It would not be unusual for Warhol to send a roll of painted canvas to a gallery for the gallery owner to cut, stretch, and mount, as with the *Elvis* and *Liz* shows at the Ferus Gallery in Los Angeles during 1963.[54] Often clogging would occur during the second step of producing a Pop painting. Consequently, Warhol and Malanga would clean a silkscreen on an extra section of unrolled canvas. Warhol used four colors (black, blue, red, and yellow) for his *Mona Lisa* series. After he used one color, such as blue, he would clean off the excess blue paint onto such a roll of scrap canvas before he would use the same silkscreen for another color. As Malanga told me, the particular *Mona Lisa* discussed here is in fact just such an extra sheet of canvas for cleaning the several colors used in that series.[55] What heretofore has been critically discussed and generally accepted as a unique variant of Warhol's Pop Art is not the case. Apparently, even Warhol himself did not originally intend this *Mona Lisa* to be a "work" of "art." What may account for its present canonical position within Pop Art?

During the year (1963) of this *Mona Lisa,* Warhol had his "Factory" op-eration in full production, with various series (the Disaster paintings, the *Mari-lyns,* the *Liz*s, the *Elvise*s, etc.) being produced in an attempt to be recognized as an important Pop artist. The following year, Warhol had his second and last one-man show at Eleanor Ward's Stable Gallery before he was permanently ac-cepted as one of the artists represented by Leo Castelli, whom Warhol ardently wanted as his dealer.[56] Sometime during this period (1963–64), Warhol "pre-sented"—as a parting gift?—this *Mona Lisa* to Eleanor Ward. During my in-terview with her, she remarked to me that sometime later there was a "dis-agreement" over the ownership of it.[57] There was a lawsuit over the possession of it, the result of which was joint ownership.[58] It is unclear exactly when Warhol decided to "recall" this *Mona Lisa,* and it remains an open question what may have motivated Warhol to want to retrieve it. In any case, what *may* have been a silent joke now had a different, perhaps a solely monetary, signifi-cance to him.

There is, moreover, no evidence that Warhol has ever revealed the original circumstances of this *Mona Lisa*. Unlike Duchamp, he has never disclaimed it

as not being a work of art and, therefore, an exemplification of the suggestive power of an artist's "gesture" and of the investigation of the equivocal status of "art."[59] Likewise, this *Mona Lisa* is not an instance in Warhol's Pop Art of the repeating mechanism of a serialized icon. Rather, it implies the interchangeability of objects, people, and situations (and the inherent absurdity of such an "art" game), that simply and effectively make known the intrinsic "comedy" of well-established and readymade sources for an "original" painting, sculpture, or film. In effect, this *Mona Lisa* represents an unadulterated accident. It is independent from Duchampian or even Cagian esthetic happenstance, in which there is a programmed change in the esthetic situation, but it is a truly "found" object.[60] By removing the actual status of it *through silence,* by taking it for granted as lacking any esthetic or monetary value until it is conferred by legal proceedings, and by remaining silent about its real circumstances after such a lawsuit, Warhol has, in effect, held his *own* notion of Popism in a suspension of contradiction. This *Mona Lisa* is Warhol's self-cancellation. It is not only *presque rien,* it is a silent implosion of any significance of the artist-as-agent who activates something by means of his "signature."[61] Precisely, it is the confirmation of outside authority (the legal system, the art market, the museum, the critic, and the spectator) that confers status to this *Mona Lisa,* and it is only through such authority that it has become perhaps the most extreme case of Warhol's Pop "art."

This *Mona Lisa* does not represent the only paradox of Warhol's inversion of Walter Benjamin's notion of "the work of art in the age of mechanical reproduction."[62] According to Benjamin, such mechanical reproduction of art (including the fine arts, music, etc.) represents an "accelerated intensity" in the "challenge" against the "uniqueness" and the "aura" of the original by its reproduction, which may now be viewed or heard at anyone's convenience. Benjamin remarks that such "rapid dissemination" of reproductions changes expectations of "the masses" toward art, a change most notable in viewing motion pictures. The "cult of the movie star" does not, consequently, preserve that person's unique "aura," but rather what Benjamin has called, "the 'spell of the personality,' the phony spell of a commodity." Such an "uncritical" regard by the public represents the two aspects which Benjamin believes result: the "growing proletarianization of modern man" and the "increasing formation of [the] masses." For Benjamin, it is a unique work of art which may provide an authentic "aura," and the notion of authenticity is grounded in the singular absorption and critical evaluation by a spectator. With the advent of such mechanical reproduction, one may imply from Benjamin's remarks that the "cult value" of a work of art is replaced by its exhibition value, and this is best exemplified in the medium of film.

Warhol's own film activity is concentrated in a period from 1963 until he was shot in 1968. After 1968, Warhol produced films that were primarily di-

rected by Paul Morrissey:[63] entertaining, feature-length motion pictures that did not feature Warhol's use of cinematic "tropes."[64] According to Jonas Mekas and Stephen Koch, the Morrissey films were distributed on a more commercial basis than Warhol's, and the commercial distributors requested Warhol to take out of circulation the pre-1968 films.[65] The earlier films were taken off the market and have gained both a "mythological" status and an increased monetary value. Several people who have spoken to me off-the-record have indicated that a more probable explanation exists: because the participants signed releases and received a token payment (such as one dollar), the probability of lawsuits over residual rights motivated Warhol to produce a new and more commercially acceptable product.[66] Moreover, the negligent preservation of the early films led to loss of many unique film prints.[67] Apparently, Warhol has prints of the pre-1968 films in storage somewhere. (The artist would not tell me anything about the whereabouts or the number of films he may still possess.) Therefore, Warhol has reversed the implications of Benjamin's remarks concerning the uniqueness and "aura" of a work of art in a period of mechanical reproduction: Warhol "manufactures" his own form of "uniqueness" and establishes a unique "aura" for his works in that he produces unlimited works of art. They lose their "aura" while his films gain it, based upon Warhol's notion concerning the commodity value of multiples wherein his originals are on a par with reproductions, and his film prints are now virtually unique (or lost) by means of isolation.

Warhol orchestrates networks of disseminated products, which he may also use as investments or means of exchange. Apparently, he barters his unlimited supply of "art" for various collectibles. He frequents auction houses, galleries, and shops.[68] He has supported his various activities, such as filmmaking, by means of his commissioned portraits and Pop Art paintings and multiples, just as he supported his painting initially by continuing to do freelance commercial art. Like any entrepreneur, Warhol possesses "a rare combination of traits: high physical energy, confidence to act on new opportunities, adaptability to altered conditions," and the ability "to work within the cultural system while consciously upsetting its state of equilibrium to his advantage."[69] Warhol's works and "Superstars" are his instruments and commodities. They are diverse, disturbing, mobile. One "psychological" factor of his entrepreneurial behavior is, in my opinion, what Everett Hagen has called the "withdrawal of status respect":[70] some initial condition, such as the depression or the "low" status of being a commercial artist, may generate eventual entrepreneurial behavior (as in Warhol's case). In fact, another artist-entrepreneur has been a conscious role model to Warhol: Walt Disney, whose Disneyland was a "must" when Warhol and Malanga visited Los Angeles, and whose "signature" (in itself not Disney's) represents an enterprise of anonymous artisans.[71] The products of Disney and Warhol are studio productions. Both men "present"; "Walt Disney Presents . . ." and *Andy Warhol's Dracula, Andy Warhol's Interview*

Magazine, and Andy Warhol's Enterprises, Inc. In fact, Warhol's (unrealized, planned, executed) projects during the 1970s include: a videotaped soap opera,[72] a glass car for Bavarian Motor Works,[73] sequels to his *a, a novel* every five years,[74] Andymats (a restaurant chain "for the Lonely Person," having individual booths with pay television sets),[75] Rent-a-Superstar,[76] and the artist's own appearances in advertisements.[77]

In his *Philosophy* book, Warhol remarks that he would someday produce a television program entitled *Nothing Special.*[78] Concerning his Pop Art, he has remarked, "I made nothing happen." Warhol's notion of nothingness or blankness is not only the central theme of his Popism, it is interchangeable with money, art objects, or "Superstars" as commodities, as well as the "erasure" of feelings: Warhol has stated that his "mind is like a tape recorder with one button—Erase" and that he is "always trying to buy things and people." For Warhol, the "best time" is when he can pay his way out of something. He cannot understand anything but money, with which he may "purchase" prestige, friends, status, as well as some mood. Being an artist is "just another job."[79] Any publicity is good publicity.[80] The worst review is one that is middle-of-the-road, and any review is a good one, but the best one is anything "as long as it's extreme."[81] Warhol will endorse anything,[82] and he particularly enjoys doing "no-fault put-ons."[83] He will not even give away money when he has enough to "hand out."[84] Warhol is a mythmaker whose "esthetics" are a Pop state of being: a phenomenon of seeing and displaying something or someone *sub specie theatri,* a steady state persona of a passionless presence and actual products of "art" that are incidental to a self-consciously narcissistic artist whose success is measured in his assimilation into high society. Warhol's generating motivations of glamour and fame are dialectically synthesized with his entrepreneurial schemes. One such unrealized devised scheme may further illustrate this fusion. Craig Unger and Sharon Churcher reported in the May 1981, issue of *New York* magazine:

> After making a lucrative hobby out of photographing glamorous people, Andy Warhol is now going into the business for real. He and Peruvian socialite Carmen D'Alessio are planning to set up their own model agency, tentatively named Twinkies.[85]

If such a venture is realized, then Warhol will have devised another and more glamorous group of "Superstars." In short, Warhol is a realist: he realizes very shrewdly the power and "aura" of an activity known as "art" and its marketability. Nothingness or blankness is at the calm or "cool" center of his Popism, and it is surrounded by his very real fantasies, which are merely instances of his "art" that are at an extreme, taken at a price—the price of the highest bidder:

> *I really believe in empty spaces,* although, as an artist, I make a lot of junk. . . .

An artist is somebody who produces things that people don't need to have but that he—for *some reason*—thinks it would be a good idea to give them.

Business Art is a much better thing to be making than Art Art, because Art Art doesn't support the space it takes up, whereas Business Art does. (If Business Art doesn't support its own space it goes out-of-business.)[86]

Warhol's Publications, Play, and Soap Opera

> *I felt so good about things then [in 1967], like we could do any-thing, everything. I wanted to have a movie playing at Radio City [Music Hall], a show on at the Winter Garden [Theatre], the cover of* Life, *a book on the best-seller list, a record on the charts. . . . And it all seemed feasible for the first time.*
>
> Andy Warhol, *POPism: The Warhol '60s*

In 1965, Warhol "announced" that he was giving up "repainting successful themes"[87] in order to record and to package his "Superstar" merchandise.[88] In addition to his films,[89] he used audio and videotape. Under his "signature," he produced various studio publications, a play, and a video soap opera. The diversity and range of these activities are variants of his Popism.

Warhol proposed publishing a series of novels to appear every five years,[90] but only the first such work has appeared. Eventually entitled *a, a novel*, Grove Press printed the 451-page "novel" in 1968. It sold for the then expensive price of $10.[91] It was conceived originally by Malanga, who suggested to Warhol that he do a novel entirely from audio tape cassettes, which were being tested by Warhol in 1965 for the manufacturer.[92] Billy Linich was responsible for its appearance as it was printed, including typing of the transcription, little drawings (such as the head of the god Mercury) through-out the text, and the division not of chapters but of the duration of the half-hour tapes.[93] The premise of the novel was the audio recording of 24 hours in the life of Warhol's "Superstar" Ondine (Robert Olivio), in which the artist accom-panied Ondine, who constantly rambled on diverse and profanely witty topics at Warhol's "Factory" and at various locales in New York. Throughout *a*, On-dine is referred to as being "O," and in a sense, *a* is a homoerotic *Story of O*. During my interview with Ondine, the "Superstar" describes both the beginning and the *modus operandi* of the "taped novel."[94]

At the start of *a*, Andy and I are having a *snecken* in a restaurant called Starkee's on Lexington Avenue (in the '50s). But who walks in but David Whitney, and the conversation is that: who David Whitney is, what he does, why does he act the way he does. . . . And Andy hands me four pills immediately. He takes them from his bottle of speed, and he said, "How many do you want?" And I said, "Oh, I'll take them all." . . . He [Warhol] said, "Well, here we go." And that's how the book started.[95]

Throughout the rest of the novel, Ondine and Warhol meet various "Superstars" in encounters that included visiting "The Duchess," who has escaped from a hospital and who has stolen 3,000 pills and a blood-pressure machine; listening to "Taxine" confess to "Pope Ondine" that she has attempted suicide, and to "Irving du Ball" who has people talk about their sex lives; and following On-dine into a bathroom where he defecates, takes a bath, and then dresses in drag for an evening at the "teenage whorehouse." By using amphetamine ("speed"), Ondine stutters through a virtual logorrhea of alliterations and tries to visit everyone and everywhere that means something to him.[96]

A textual analysis alone cannot reveal where the characters are at any given point or even who they are. Like any *roman à clef,* the names are altered but do reflect "in" nicknames: "Bobby Cool" (Bobby Schwartz), "The Sugar-Plum Fairy" (Joseph Campbell), "The Duchess" (Brigid Berlin), and "Drella" (Warhol).[97] The text's style resembles stage directions, in which in the doz-ens[98] of references to the microphone and the tape recorder there are Pop cues, such as "(*Click. Pause. Zap. Static and voices.*)"[99] and "(*blip/censor*)."[100] Background noises are usually specified, and allusions to Maria Callas records playing indicate Ondine's favorite diva.[101]

Despite the almost exasperating opinions, debates, sarcasms, and verbal posturings of the recorded participants, it is possible to gain insight into Warhol and his entourage. At the beginning of the novel, Ondine asks "Drella" who Robert Rauschenberg is, and his response is, "I wouldn't be able to do the kind of work I do"[102] without Rauschenberg, who is *"the father of art."*[103] At one point, Ondine remarks that "the only way to talk is to talk in games, it's just fabulous."[104] "I hope I don't suffer from overexposure," Ondine wonders aloud while taking a bath, "—cut right off in the butt of my career wouldn't that be a terrifying feeling."[105] However, the most revealing episode concerning Warhol takes place when Ondine is momentarily at another part of the "Fac-tory." In the background, as indicated in the text,[106] loud opera music is being played. "The Sugar Plum Fairy" (Joseph Campbell) has his words indicated by "SPF," and those by "Drella" (Warhol) are indicated by "[blank]." Throughout his recorded conversation with Campbell, Warhol attempts to pry out Campbell's secrets (especially details of obscene sexual escapades done in pub-lic) by two strategies: carefully listening in silence, and asking leading ques-tions. Yet during the dialogue, Campbell asks Warhol questions—a confron-tation that Warhol tries to dodge. For instance, Warhol denies taking drugs, en-joying meals, etc. Yet, Campbell continues to press questions ("Do you devel-op?" and "Why do you avoid yourself?") that Warhol answers with his stock replies and hesitations ("Well . . ." and "Uh—it's just easier."):

SPF: Why do you avoid yourself?

Warhol: What?

SPF: I mean you . . . you almost refuse your own existence. You
 know —

Warhol: Uh — it's just easier.

SPF: No, I mean I like, I like to know you (*talking very quietly*) I al-
 ways think of you being hurt.

Warhol: Well, I've [been] hurt so often so I don't even care anymore.

SPF: Oh sure your care.

Warhol: Huh.

SPF: Sure you care.

Warhol: Well, uh, I don't get hurt anymore.

SPF: Well[,] maybe, of course, you get hurt. Everybody gets hurt
 everyday.

Warhol: Yeah, but uh I can just turn it off and on.[107]

Being "turned off" to feelings is further described by Warhol as being "sorta
dead" and "a nice feeling," and he remarks that he likes everything and that he
does "nothing" by himself. Doing silkscreens and photographs is "not really
work," and doing anything else "means you can do anything whenever you
want to or if somebody calls you up and says, 'Do you want to go out for a
ride?' then you can do it." Warhol guesses that he does not know what he
really wants to do in life except "to get to the point where somebody will tell
me what to do."[108] The final effect of the encounter between Warhol and
Campbell, as well as all of *a,* is of an unedited long take. Unlike his films,
where he is always offscreen, Warhol is a participant. In a sense, the reader be-
comes a voyeur of Warhol's verbal withdrawal.

 According to Warhol's own admission, he "faked" *a, a novel* because sev-
eral cassette reels at the end of the book were recorded on different days.[109]
The effect of Warhol's book has been described by one reviewer as "a total en-
vironment of typos and sputterings, hellish hymns from Amphetamine Heaven,
the vox populi"[110] of Warhol's "Superstars," especially Ondine. Yet however
much one may speculate about the overtones of Performance Art and in par-
ticular of Happenings, Warhol's novel represents, too, his ardent obsession to
record and to package his own version of "instant" fame and "seedy" glamour:
a strikes one as the published version of his unscripted films. The notion of
Performance Art enters as a side issue since, by nature, Performance Art usu-
ally involves open-ended formats within which performers (not actors) do des-
ignated tasks. Rather, it is Warhol's conscious use of a stable of "found" per-
sonalities, who are unstable and highly volatile, that differs: Warhol seems to
be interested in probable acts of "cruelty."

Warhol was especially interested in *a* as a project. Ondine has recalled that Warhol could be seen alone during one of the multimedia events of the Velvet Underground: he would be reading and rereading the publisher's proof-sheets.[111] Five years later, Warhol began *b* as the projected second of multiple sequels, but *b* was cancelled after only five or six hours of recording Ondine at Judy Garland's funeral, Ultra Violet's apartment, and the Russian Tea Room.[112] At this time, Ondine no longer was regularly taking "speed," and according to Warhol he "was like being with a normal person."[113] Warhol's remark may imply that Ondine had become "stale" without his drug-induced wit. That is, Ondine was no longer a fabulous "flaming creature."[114] When Ondine was asked during my interview why Warhol chose him as the centerpiece of *a*, Ondine replied: "I was simply the most interesting person that he had ever met in his life at that point."[115] Indeed, it is his unpredictable and manic behavior that lends much of the fascination to the novel. Having met Ondine, this "Superstar," in my opinion, was—*is*—one of the most entertaining, profanely witty, honest, and exasperatingly intense persons that one could wish to encounter. (Warhol was wrong.)

Another experimental publication by Warhol is *Andy Warhol's Index (Book)*. Published in 1967 by Random House, the *Index (Book)* is a Pop work in which there is an evocation of a studio effort under Warhol's "signature."[116] Like his promotional books of the 1950s,[117] each page is a whimsical visual surprise. The book includes photographs printed in dark contrasts of black and silver inks of the "Factory" and its silver-foiled walls and ceiling, and of Warhol and his associates. The reader "participates" in this published form of Warhol's "Factory"-world with the surprise and wit associated with a child's wonderment: as a part of the book, various objects are to be taken out and used. These objects include a balloon, eight labels, a record, and a plastic bag. In between the pages, there are paper constructions which literally pop up to form various fanciful objects. Such pop ups include an old-fashioned aeroplane, a multicolored fantasy castle with images of Warhol and his entourage, a brightly tinted accordion, and a Hunt's tomato paste can. The *Index (Book)* is a playful "art" game, and the work's images and objects, as well as the interplay between them, demonstrate Warhol's wit and self-image.

There are three taped interviews in the *Index (Book)*. In one interview, someone (Warhol?) asks Ingrid Superstar to describe the "Factory." She does so for two pages of transcript, but she complains that she has nothing else to say. The interviewer demands that she continue because she is supposed to speak for 30 minutes (the length of one side of the audio cassettes that Warhol was using then). Ingrid Superstar's audio "long take" is printed throughout the book. After the first part of the interview's text, the castle pop up appears with the caption "We're attacked constantly": an allusion to the "Factory" as Warhol's own castle and the adverse critical reception to him and his works at a time (1967) when the artist had achieved an insidious reputation.

The second interview is with Warhol. The interviewer's questions are printed in Gothic print and Warhol's replies are in simple and plain type. The interviewer, identified only as a "German Reporter," becomes an anonymous, almost Nazi-like interrogator, while Warhol's responses reflect his "simple," "homespun," and "unassuming" persona. Interspersed among the pages of this text are photographs of Warhol, including one in which Warhol impersonates Albrecht Dürer. In this photograph Warhol is dressed in a Germanic costume, and he uses the Old Master's monogram. He establishes an interplay between the interview and the photograph in a way that suggests a literally oblique game of self-ridicule. Lynn Thorpe comments:

> Here Warhol impersonates a "German Hamlet." His pose recalls the many frontally posed, Northern Renaissance portrait busts, with his arms folded across the back of a chair, and his solid, triangular form framed by the window-like square that illuminates the background. In this photograph Warhol fools the Renaissance portrait tradition and compounds the joke with Dürer's mark. The jester continues his play by putting his portrait at an extreme right angle on the page. This makes the photograph appear as if it is in imminent danger of slipping off the page. This placement disturbs the formal stability of the Renaissance portrait [type] and underscores Warhol's game.[118]

This game lends doubt to Warhol's own self-image as a "great" artist.

The third interview may only be known if the reader listens to a plastic record in the book. The record label features a photograph of Lou Reed, one of the principle performers in the rock band the Velvet Underground (which Warhol included in his multimedia event known as the Exploding Plastic Inevitable). Without having listened to the record, a reader might expect a recording of one of the rock band's musical pieces, such as *Walk on the Wild Side* which concerns a certain "Drella" (Warhol). However, on the record the listener hears someone asking questions of Nico, the German-born singer of Warhol's rock band. The expectancy of something is playfully countered by Warhol throughout the reader's experiencing the *Index* (*Book*).

Warhol has been associated with Campbell's Soup Cans since 1962 and cartons since 1965. One of the book's paper pop-ups is an image of a Hunt's tomato paste can: a popular brand-name product and a competitor to Campbell's tomato products. In order to understand Warhol's joke, the reader would, of course, have to be familiar with his Pop Art images of *Campbell's Soup Cans*.

There are other references to Warhol's self-image and art. One of the attached objects is a plastic bag with the quotation "'. . . Warhol's bag is the neatly packaged, Saran-Wrap society.'—Richard Goldstein." Warhol refers to Goldstein's review of *Chelsea Girls* (1966), which the artist had read and clipped.[119] Goldstein's comment refers to a popular brand of plastic wrap, and Warhol literally makes what Goldstein said about the artist's film. Another attached object is a piece of paper with instructions ("FOR A BIG SURPRISE!!!

Tear out and place in a container of warm water."), and the paper consists of eight labels. Four of the labels are blank, and the other four have the artist's name on them. If the reader follows the instructions, the inscription simply disappears: an "erasure" of Warhol as a process into nothingness. That four of the labels are blank suggests that Warhol equates himself with emptiness. As has been discussed, Warhol's basic descriptive qualities for himself and his art are vacuity, plasticity, and surfaces. His allusions are as transparent as Goldstein's quoted comment, which, in turn, becomes the reader's "bag."

Throughout the *Index* (*Book*) there are metaphoric references to Warhol's self-image. In addition to the dissolving paper with Warhol's name on it, he includes another paper pop-up: a double-page foldout of a profiled rose-colored nose. This nose, like his painting series *Before and After* (1960–61), refers, in my opinion, to "Andy the Red-Nosed Warhola"[120]—the particular physical denial to Warhol's fantasy of being a handsome and glamorous presence.[121] Another page includes the phrase "Notes on Myepic": a reference to Warhol's own life-saga ("my epic"), to his myopia and, perhaps, to the consciously nearsighted vision of his "surface"-oriented notion of Popism.

If one may infer that Warhol *feels* abused, as in his interview, Goldstein's comment and the inscription ("We're attacked constantly") of the pop-up fortress with photos of Warhol and his associates, then one may further presume the *Index* (*Book*) represents Warhol's attitude toward the reader. Often this attitude is laden with sexuality. For instance, one paper pop-up is a brightly colored accordion. If a (male) reader flaps the pages back and forth, then he silently "plays with" (masturbates) the book. There is a polygonal cardboard object on a string lying between two pages. On one side of the object is a closeup of a nude male torso, and on the other side is a male nude aiming a camera at the reader. When the reader holds the object, the unassembled tips of the first photograph are centered on the navel of the male torso: a presumed reference to Warhol's self-centered and self-conscious world, dominated by young male "beauties." In the second photograph, one such "beauty" holds his "camera" (genitalia) and "shoots" it (reaches a sexual climax). Moreover, the camera, like a pistol, "shoots" (kills) the reader; this particular metaphor of violence may be a further self-image of the artist, because in one photograph in the book someone aims a gun at Warhol.

Just as Warhol deconstructs his own self-image, the reader who fully participates in the "reading" of the *Index* (*Book*) metaphorically and literally "violates" it. Lynn Thorpe comments:

> In effect, the reader metaphorically rapes the book by tearing out the record and the paper with Warhol's name on it. The reader, in the act of reading, ruins the book. In turn, Warhol's book ruins the modes of communication established and acknowledged in traditional books.[122]

In addition, the reader must unseal two of the pages in order to view their contents (photographs of the "Factory"). The "index" of *Andy Warhol's Index (Book)* puts the concept of a "book" at a distance. Like Warhol's cinematic "tropes,"[123] the artist ruptures normal associations that are traditionally given and then "puts into play" a more extreme and personal use of such stylistic devices. Finally, like Mallarmé, Warhol's "literature" concludes in a silence in that the last two pages are a white background with the word "blank" written on each page—a final reference to the central theme of Warhol's notion of Popism and of himself.

Constant reference has been made to *The Philosophy of Andy Warhol (From A to B and Back Again)*, the artist's collection of Pop *pensées*. What may be noted here is his reliance on audio tape. In fact, the *Philosophy* begins with a transcription of Warhol's first daily event: speaking to one of his long-winded "B's."[124] The remainder of it consists of his comments about his central concerns, which are suggested by the chapter titles: "How Andy *Puts* His Warhol *On*,"[125] "Love," "Beauty," "Fame," "Work," "Economics," "Atmosphere," "Success," through to the final bathos of "Underwear Power." What appears to be a simple prose style is, in fact, heavily dependent not upon the author but on the several editors (his secretary Pat Hackett, his associates Brigid Berlin and Bob Colacello, and the publisher's own editor Steven M. L. Aronson).[126] Pat Hackett told me that she redacted tapes Warhol had given to her. In addition, she used passages from Warhol's personal scrapbooks of past interviews and criticism.[127] Warhol's *Philosophy* represents, then, a careful assemblage of his own "readymade" and "found" material.

Similarly, *POPism: The Warhol '60s* is a redacted collection of taped remarks by Warhol or by Warhol's friends and associates. During my interview with Emile de Antonio, the filmmaker stated that Warhol and Hackett tape recorded a conversation. During this conversation, Warhol started his tape recorder and then three minutes later Hackett started hers so that nothing would be missed.[128] Fred Hughes, Warhol's current manager, offers an "official" explanation of the *Philosophy* and the *POPism:*

PS: I understand that one of Andy's new projects is a book about the '60s.

FH: Yeah.

PS: How did that come about?

FH: Ah. With his partners. They got several ideas. Besides, he had the material. It [?] was particularly able to do a thing on the '60s.

PS: And why did Andy publish *The Philosophy* . . . ?

FH: The same sort of idea that evolved out of the discussion with the publishing company.[129]

Hughes's responses indicate a more monetary than purely "esthetic" or "philosophic" viewpoint. Ondine has suggested that Warhol published the *Philosophy* book because *a, a novel* was not a success.[130] Since Warhol wants to have a best-seller,[131] it is possible that *Philosophy, POPism,* and his other books are simply literary variants of his Popism and star merchandise.

Andy Warhol's Pork is a play that was presented Off Broadway in New York and in London during the spring and winter of 1971.[132] Apparently, *Pork* is a theatrical version of a typical Warhol film, in which a voyeur (Warhol?) watches disinterested various incidents in the life of Amanda Pork (Brigid Polk?) set in the voyeur's studio and in Max's Kansas City.[133] The voyeur records on audio tape and with photographs the encounters between Pork and Vulva (Viva!?), the Pepsodent Twins, and others. Like *a, a novel* and his films, the incidents of the play are vulgar and obscene (including douching, masturbation, and intercourse), as is the dialogue (discussions about flatulence and feces). According to Leonard Leff:

> The work's comic climax is, in retrospect, its most affecting scene. When a scratchy record is heard in the middle of the second act, all take partners—Pork takes B.; Vulva, her lover; a bald-headed woman, a slovenly man; a Pepsodent twin, his counterpart—and dance to Elvis Presley's "Treat me like a fool . . ."[134]

As with his other literary efforts, *Pork* is based on taped conversations.[135]

For a one-year period at the same time that Warhol produced *Pork,* the artist videotaped *Vivian's Girls.* Similar in spirit to his film *Chelsea Girls,* this television program, which has never been released, is a series of encounters by Warhol's associates. *Vivian's Girls* is a soap opera that was taped twice a week in Warhol's studio. It concerns a boarding house owned by the title character. From what little is known about it, Warhol used stock characters, improvised dialogue, and a single set.[136]

Andy Warhol's Exposures (1979) depicts the artist's "Social Disease" through his photographs and profiles of members of café society, such as Bianca Jagger, Halston, Steve Rubell, Diana Vreeland, Truman Capote, Paulette Goddard, Liza Minnelli, and Marisa Berenson. "Social Disease" is for Warhol when you "judge a party by how many celebrities are there," or "the first thing you do is read the society columns," or *"go to the opening of anything, including a toilet seat."*[137] "Publicity is," Warhol remarks, "the ultimate symptom of Social Disease."[138] If Max's Kansas City was Warhol's "watering hole" during the mid-1960s, Studio 54 took its place during the late 1970s (until it was closed). "At 54, the stars are nobody because everybody is a star," Warhol states.[139] If this is the case, then *Exposures* represents, like his films, the deconstruction or "exposure" of this collection of glamorous "Beautiful People." In fact, Warhol's photographs of the celebrities are less than flattering, and include such unlikely poses as Bianca Jagger shaving her armpit, the

fashion designer Halston placing "falsies" on his chest, and the disco-restaurant entrepreneur Regine sticking her tongue out at Warhol's camera. Moreover, Warhol's profiles include confessions. Margaret Trudeau, who was once married to the Prime Minister of Canada, admits, for instance, that she dyes her eyebrows.[140] Even Warhol admits lying to Salvador Dali that he did his *Oxidation* paintings (1978) before Pasolini's depiction of the same kind of "Process Art" in the film *Theorema* (1970).[141] Yet, such admissions are trivial and bathetic when compared to the open psychic wounds displayed in Warhol's films from 1963 through 1968. *Exposures* represents Warhol assimilated into his self-elevated position in the glamorous and chic High Society of contemporary New York. When referring to Jade Jagger (the daughter of rock star Mick Jagger), Warhol summarizes his attitude as an artist-entrepreneur: "She never calls me Andy, always Andywarhol, as if it were one word—or a brand name, which I wish it were."[142]

In 1969, Warhol began his (now monthly) tabloid magazine about celebrities of the arts, movies, fashion, and business world. Warhol started the magazine originally to exploit the possibilities of audio tape-recording, to allow Gerard Malanga to edit an illustrated magazine, and to permit his associates access to various functions by means of press passes.[143] Pat Hackett told me that *Interview* was to be similar to the then "Underground" tabloid *Rolling Stone* and to the pornographic tabloid *Screw*.[144] However, within two years (after Gerard Malanga left Warhol's employment), Warhol changed the appearance of the magazine to one that featured chic celebrityhood and his own "Superstars." For instance, the March 1972 issue included interviews with actor Michael York, actress Marisa Berenson, and director Bob Fosse, as well as Bob Colacello's feature "At Home with: Candy Darling." In this article, the Warhol "Superstar" states that "the great movie stars were *ideal* people."[145] Rose Hartman has aptly described Warhol's magazine "as a trendsetting bible for those who want to be in the know."[146] In addition, its "documenting the frenetic pace of international do-ers," according to Hartman, stresses "only flawless, sylphlike, ultra-fashion conscious personalities."[147] *Interview* includes photographs of fashion models wearing the most recent *haute couture*, publicity photos of Hollywood stars of the 1930s and 1940s, a rock music column by Glenn O'Brien, as well as Warhol's own interviews with celebrities.

In 1967, Warhol commissioned an (expensive) subscriber survey of *Interview* by Mark Clements Research, Inc., in New York.[148] Two mailings (with autographed publicity photographs of Warhol) were sent to 1,000 subscribers, to which a large number (619, or 64.6 percent) responded. According to the survey, the average age of a reader was 27.1; 46.8 percent were female and 52.7 percent were male; the average income was $32,177; and 71.1 percent were single. According to the survey, 58.8 percent invested in original art; 53.8 percent in antiques; 51.9 percent in jewelry; and 48.8 percent in real estate.

The survey found that *Interview*'s readers were young, fashion conscious, rich, and independent—qualities that Warhol has always admired. Warhol told me that *Interview* became profitable in 1978 and that his commissioned portraits had been financially supporting the magazine until that year. Recent copies have been filled with advertisements for fashionable and chic perfumes, designers' clothes, discos, and restaurants. As of August 1, 1978, the advertising rates were $1,200 for a full-page black-and-white ad, and $1,600 for a four-color inside ad.[149] In short, Warhol packages his magazine in the image of its readership and in the creation of his own fantasies concerning glamorous and famous personalities.

Warhol's Commissioned Portraits

From 1976 through 1978, Warhol produced almost 1,000 commissioned portraits.[150] During the three months (October–December of 1978) that I spent at Warhol's studio, I personally observed American, European (mostly German), and Japanese businessmen and socialites visiting every day to purchase paintings and to commission portraits. During one of Warhol's catered luncheons for such clients, I met a cousin of Queen Elizabeth, Regine Choukroun (an internationally known owner of restaurants and discos), several fashion models, and a group of Japanese businessmen. In fact, one day I was not allowed access to Warhol's studio for security reasons, because Warhol was photographing Princess Ashraf of Iran. As was his practice during the 1960s,[151] Warhol will photograph virtually all of the visitors to his studio. (On the first day I visited his studio, Warhol spent several minutes photographing me as he was showing me one of his new painting series. He also asked me for suggestions for future projects.) According to his current painting assistant, Ronnie Cutrone, Warhol files all such photographs for future use.[152]. He may include them in *Interview* magazine, or publications such as *Andy Warhol's Exposures* (1979), or he may sell them.[153]

Warhol's working method since 1969 for each commissioned portrait is virtually the same unless the sitter is a famous celebrity, in which case he may include a session of taped conversations for *Interview*. These commissioned portraits are the basic sources for Warhol's present income, and they have financed such projects as his monthly tabloid and collecting works of art. Warhol's current studio is called his "office."[154] A potential client will make an appointment to see Fred Hughes, Warhol's associate since 1967 and the president of Andy Warhol Enterprises, Inc. During the time I frequented Warhol's studio, Hughes would show such a customer Warhol's current works and samples of commissioned portraits. After the initial tour and a possible brief conversation with Warhol, the client and Hughes would then discuss the price of the portrait and the number of portrait panels to be done.[155] After a

contract has been signed or after an oral agreement, the client will be photographed by Warhol and will later pick up the finished portrait(s).[156]

A case in point is Warhol's *Liza Minnelli* (fig. 47), which was commissioned and executed in 1978.[157] As well as being the daughter of Judy Garland (one of Warhol's favorite entertainers),[158] Liza Minnelli is one of America's most prominent actress-entertainers. While she was appearing in the Broadway musical *The Act,* she spent one afternoon at Warhol's studio. Wearing her red-sequined costume for that show, she had lunch with Warhol, who taped their conversation for possible future use.[159] After lunch Warhol photographed Minnelli. For a commissioned portrait, Warhol may make from 10 to 200 Polaroid photographs. In this case, he took about 100 photos, most of which were close-ups of Minnelli's face. It is possible to examine Warhol's procedure for this specific portrait and to demonstrate his esthetic process and thematic concern with iconic imagery.

First, Warhol chooses a photographic image. He has always preferred to choose from a large pictorial archive. Depending upon what use he may have for such photographic source material, he usually chooses images that depict a subject from the front and at close range (as in a publicity photograph). For his commissioned portraits, he will photograph a sitter so that usually only the head and neck are within the camera frame. If Warhol includes more than this, it is to emphasize a sitter's hand gesture, as in *David Hockney* (1974), or he wants to photograph a provocative pose, as in *Jane Holzer* (1975).[160]

Because of at least two lawsuits against his "unauthorized" use of photographs from periodicals,[161] Warhol or one of his staff takes the photographs that he uses for images.[162] When I visited his studio, Warhol was often looking through contact sheets of his studio photographs ("Factory Fotos") for use in *Interview* magazine or for various commissioned painting series. Warhol takes all of the photographs for the commissioned portraits. These are Polaroids of the client sitting in front of a neutral background. The square format of a Polaroid photo is an "easy" and "same-size picture,"[163] which Warhol prefers to use as source material.

After Warhol selects several possible photographs of a client, his printer, Rupert Smith, prints the photos on sheets of clear acetate, making halftone positives of the photos.[164] The dimensions are $10'' \times 20''$. These initial acetates are trial proofs. Warhol then selects one or several final images. Most of the commissioned portraits are generated from one image. The printer makes another halftone positive from the original Polaroid. For *Liza Minnelli,* Warhol's standard 40″ square format was used, and the dimensions of the final halftone positive image are also this size.

When the large halftone positive is completed, the printer brings it to Warhol's studio. It is at this point *and at no other time* that Warhol applies paint to a primed canvas. The artist places the clear sheet of acetate on a stretch

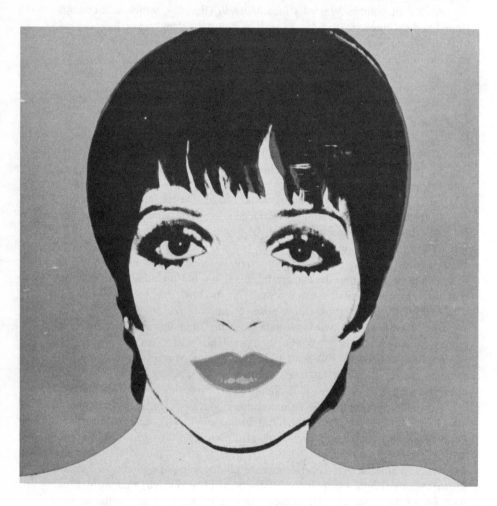

Figure 47. Andy Warhol, *Liza Minnelli*, 1978
Acrylic and silkscreened enamel on canvas. One of two
panels, each panel 40″ × 40″.
*(Collection of Halston, New York; © A.D.A.G.P., Paris/
V.A.G.A., New York, 1986)*

of canvas on the studio floor: Warhol has abandoned the notion of traditional easel painting. He marks the outlines of the head and facial features. Because the acetate's image is printed in high contrasts, the various facial points are easily marked on the canvas. First Warhol will paint the "background." That is, he paints the canvas which lies outside of the client's head.[165] Second, he paints local colors of the facial features (flesh, hair, eyeshadows, brows, etc.). He may often include eye shadow on a client's face, as is the case with many of his portraits of men.[166] In all of his commissioned portraits that I have seen, some kind of "cosmetic" addition is added to evoke a Hollywood publicity photograph.[167] A hallmark of his portraits is an extreme emphasis on the lips and eyes of the sitter and an "elimination" of the nose: an "erasure" perhaps of autobiographical implications that is also evident in Warhol's drawings from the 1950s.[168] Contrary to published remarks concerning his portraits,[169] Warhol does *not* apply any painted "touch ups."[170]

After the canvas has dried, the printer silkscreens the photographed image in black acrylic paint. Sometimes he may print additional colors for hair stubble and for collars. With *Liza Minnelli,* highlights are added. Specifically, Warhol had Smith print a lavender highlight on the ridge of Minnelli's head, producing a halo. Smith prints the lips of all the female clients. Their lips are bright red and deliberately off register, as in the manner of Warhol's *Liz* and *Marilyn.* Smith then stretches the completed silkscreened painting and returns it to Warhol's studio, where the client may pick it up. If additional panels of the portrait are requested, then each panel is produced simultaneously. In fact, Warhol has followed the same procedure since 1969. If he decides to make drawings from a painting series, he traces the halftone positive image at the time that he paints.[171]

As was his practice during the 1950s, Warhol produces "promotional" works that are given to steady clients. Smith comments about such a series for 1978:

> We're doing his Christmas present: a painting which is duplicating *Studio 54 Complementary Drink Invitation,* which will be turned into paintings, which will be given to his dear best friends and good clients, from [fashion designer] Halston to people who buy a lot of art. Well, they'll probably be twelve by fourteen inches, but I'm getting them together. So, I can produce a painting that's around twenty-eight or thirty-six by . . . I haven't decided. It will be twenty-eight inches or thirty-two inches by like, about thirty inches. Depending [upon] who you are will depend on how big a painting you'll get.[172]

The disco Studio 54 was one of Warhol's favorite haunts. Warhol has characterized it as a privileged equalizer:

> The key to the success of Studio 54 is that it's a dictatorship at the door and a democracy on the floor. It's hard to get in, but once you're in you could end up dancing with Liza Minnelli.[173]

Like Max's Kansas City during the 1960s, Studio 54 was where Warhol found volunteers and employees for his studio in the late 1970s. One such person was his receptionist, Robyn Geddes.[174] The artist has commented:

> At [Studio] 54, the stars are nobody because everybody is a star. It's the place where my prediction from the sixties finally came true: "In the future everyone will be famous for fifteen minutes." I'm bored with that line. I never use it anymore. My new line is, "In fifteen minutes everybody will be famous."[175]

The snobbery of Studio 54 is an appetite-seeking satisfaction of glamour and fame, and it represents a self-centered, sensationalized, and seductive style of life—dead to those who do not enter it and deadened unless constantly renewed by scandal, gossip, or some extreme action. The physicality of youthful glamour and the emotionality of "surface" triviality combine into the "best" atmosphere for Warhol.[176] Moreover, such a mode of living provides for Warhol the selective uniformity, sanctioned nonsensitivity, and acquired taste for such an experience—an experience that customers may purchase, situating them in a fashionable elite.

Such was the case when Ethel Scull, who was the wife of one of the prominent collectors of Pop Art,[177] had Warhol do her portrait in 1963. *Ethel Scull 36 Times* (Collection of the Metropolitan Museum of Art, New York) consists of 36 panels of Mrs. Scull (fig. 48). According to David Bourdon, Warhol had her enter a photo-automat booth:

> "Now start smiling and talking, this is costing me money," he [Warhol] told her, as he started dropping quarters into the machine. With and without her sunglasses, Ethel preened, mugged and clutched her hands to her chin, hair and throat.[178]

Warhol then used the automated photograph strips to make the silkscreened images of Mrs. Scull in the painting. It was also at this time (1963) that Warhol used similarly derived photographs for his commercial art.[179] Warhol often used such photo-automatic images as personal keepsakes of his friends and associates. For instance, Gerard Malanga still keeps the original format of such contiguous strips in his scrapbook.[180] According to Nathan Gluck, Warhol used such derived photographs for commissioned portraits during the 1960s.[181]

Ethel Scull 36 Times represents the chance capturing of the sitter's continuous series of poses. To ask "Who is the real Ethel Scull?" is to miss Warhol's point: none of the poses is any more "real" or "character penetrating" than the others because all of the photographs are "merely" her "surface"— hence, Pop—gestures, signifying that she is on par with celebrities who "improvise" glamorous poses for publicity photographs.

Warhol's Pop Art involves not only chance effects and a deliberate renunciation of fine art but also a conscious equalization of the notion of a celebrity. Anonymous victims depicted in his Disaster Series are on par with Hollywood

Figure 48. Andy Warhol, *Ethel Scull 36 Times*, 1963
Synthetic polymer paint silkscreened on canvas. Thirty-six panels, each panel
20″×16″.
(*Collection of the Metropolitan Museum of Art, New York; © A.D.A.G.P.,
Paris/V.A.G.A., New York, 1986*)

stars and his own "Superstars." In order to expose the extremes of death and glamour, Warhol makes them ambiguous through a dialectic that fuses them.[182] "People with pretty smiles fascinate me," the artist has remarked, "You have to wonder what makes them smile so pretty." He has said that he admires beautiful people because they are *being* something, just as good conversationalists "do something." Such glamorous or talkative people are his "plastic idols,"[183] who are ridiculed through his mordant sense of humor.[184] Warhol is a poseur who puts his "plastic idols" into question. He has stated "But beauty and riches couldn't have anything to do with how good you are because think of all the beauties who get cancer. And a lot of murderers are good-looking, so that settles that."[185] Criminals are considered equal to other kinds of celebrities. Andrew Kagan comments on Warhol's *Most Wanted Man* series:

> The Most Wanted Men had all attained the pinnacle of their dubious trades, and they had achieved unintentional media celebrity by excelling in deeds which our society professes to abhor. While condemning them we reward them with fame for their success.[186]

Warhol "equalizes" a mug shot of a criminal with a publicity photo of a celebrity and with an accident victim: the infamous, famous, and anonymous are displayed in his Pop icons.

Equalized "plastic idols" are also featured in Warhol's films, in which he monitors and documents the essential and extreme nature and the abnormalities and the open psychic wounds of his "Superstars." They become mere specimens of "seedy" glamour, infamous repute, and Camp mystique. Warhol has stated:

> Those movies showed you how some people act and react with other people. They were like actual sociological "For instances." They were like documentaries, and if you thought it could apply to you, it was an example, and if it didn't apply to you, at least it was a documentary, it would apply to somebody you knew and it could clear up questions you had about them.[187]

Warhol blunts his own feelings and possibly those of a viewer toward such subjects by "distanced" and "mechanical" means, such as a fixed or "static" film camera. To survive Warhol's documentation is to remain transfixed as an idealized "plastic idol": an envisioned persona. Transvestites are nostalgic symbols for Warhol, and they are "ambulatory archives of ideal moviestar womanhood." In Warhol's words, they "perform a documentary service."[188] In a sense, they transform themselves into leftovers of Hollywood glamour. During the 1960s, Warhol's "Factory" was a construct—a closed world and an internally coherent "machine"—that became a forum for analysis of the significance of star presence of such transvestites as Mario Montez and of young male "beauties" such as Philip Fagan.

Warhol's notion of leftovers is integral to Popism. Warhol characterized Fred Herko, Billy Linich, and Ondine as being "leftovers of show business." Warhol has commented that such "discarded" people or objects are "inherently funny," and that he does not want to become a leftover.[189] He avoids being threatened by such remnants which he is willing to expose either literally[190] or figuratively.[191] He finds these audited creations, and they represent his fantasies concerning contemporary iconic images and society's (sexual) taboos. "I usually accept people on the basis of their self-images," he has written, "because their self-images have more to do with the way they think than their objective-images do."[192] If one were to "judge" such self-images, which Warhol claims not to do,[193] then one would not accept Warhol's idealized notion of Popism with its "no-fault put-ons," horizontal success ladder, "seedy glamour," and "plastic idols" who can "do anything."[194]

The success and the "glamour" of Warhol may be indicated by the thousands of commissioned portraits and unlimited editions of his Pop works. Warhol is persistently appreciated and admired by his clients—at least those whom I met during 1978. During 1978, Warhol's clients included King Gustav of Sweden, Princess Ashraf of Iran, and prominent members of café society such as Regine Choukroun and Liza Minnelli. Such a star persona is promoted and packaged for others who wish to become an estheticized apotheosis of celebrative illusion. Even though his printer may execute most of the work, it is Warhol's "signature" product that a client purchases. It is an *image* not a penetrating psychological portrait that is commissioned.

6

"Warholism"

Warhol wants to remain a mystery through silence so that he may become a glamorous and famous celebrity who creates "art" games by eliminating traditional esthetic concerns and techniques. Warhol remains at a calculated distance for reasons of self-preservation, and his retreats into a persona of a passionless presence became a cult to his entourage. With the exception of *a, a novel,* in which he becomes "Drella" and participates directly in 24 hours of "Superstar" Ondine's activities, Warhol remains offstage from his proposed situations and images that are seen entirely as "surface" or exterior conditions that are *being given.*

By suspending his affective response as an observer, Warhol enables the viewer to experience the resonance of an iconic image of contemporary American culture or a taboo of everyday life as Warhol has experienced it or fantasized about it. Moreover, he not only allows chance and accidents as part of the process of displaying such images, but he also deliberately cultivates the changes of his original intentions by unwitting associates. Warhol has remarked:

> If people never misunderstand you, and if they do everything exactly the way you tell them to, they're just transmitters of your ideas, and you get bored with that. But when you work with people who misunderstand you, instead of getting *transmissions* you get *transmutations,* and that's much more interesting in the long run.[1]

Warhol is fascinated by the risk experienced while "playing" with the possibilities of the processes of making "art." Warhol seems to have no interest in fidelity to his original intention when an associate executes a work. That is, Warhol situates art as a hermeneutic transmutation, in which any "meaning" occurs because of the transaction between his creative consciousness and the unconsciousness of his interpreter (assistant, viewer, or critic). This is "Warholism."

Art critic Max Kozloff coined this neologism in a 1965 lecture entitled "Critical Schizophrenia, Intentionalist Method." Kozloff complained in this lecture that the art critic "becomes a man alone" because Pop Art challenged the

critic with imagery "that was very unsettling and within a field of inquiry that was opaque and alien."[2] For Kozloff such art "blurred the categories of good and bad, the indifferent and the committed."[3] According to Kozloff, the art critic confronts with discomfort "immeasurable" and "intangible" aspects of art. Contemporary artists such as Warhol have a conscious "aggression" of denying what exactly may be meant or intended by an art work, continued Kozloff. For Kozloff, this "problem" is a "moral issue" because there exists a systematic doubt about self-evident imagery and a (proposed) reduction that such art leads to nothingness: such an art is an "antihumanist development" that the critic must morally combat. Kozloff writes:

> Not for nothing are we in the midst, at the moment, of an accelerating cult of enthusiasm, a movement of the sensibility that might be called "Warholism," in which nothing has to be proved or justified, and that is designed to invalidate, as one writer put it, "the critic, with his baggage of lunatic distinctions, judgments, significant and insignificant forms, 'second guesses,' killing doubts, museum mentality—pack him off to look for 'motifs' in comic strips and half the battle is won."[4]

For Kozloff, "Warholism" is an artist's strategy in which there is not only nothing to prove or to justify, but there is also a deliberate attempt to invalidate any critical or conceptual approach to an artist's works.

In 1974, Donald B. Kuspit wrote an essay entitled "A Phenomenological Approach to Artistic Intention." Kuspit argued that Kozloff's notion of

> Warholism wishes to mute the full experimental implications of artistic experience, to prevent the uncovering or at least neutralize any deeper implications, any implications beyond the art itself.[5]

Although "the Warhol artist" avoids any confrontation with his own sensibility, intentionality, and perhaps his own uncertainty, such an artist, according to Kuspit, reduces through esthetic radicality works and methods to such an extreme degree that he forces a critic to question the presumed self-evident objectivity of the art and his own sensibility. For Kuspit, "Warholism" places

> the spectator in the most "moral" position imaginable for him, one in which he can no longer take for granted that he is seeing and attending to "art" let alone that there is a unique logic— an unequivocal "organizing concept"—to its [a work's] execution.[6]

As a corrective, Kuspit proposes an intentionalist method in which the critic may "transcend" his doubt through doubt: the critic is to intuit that anything given is consciously intended, to doubt naive and unquestioning proposals of such givens, and to uncover the ontological and existential import of the works.

As has been shown in this study, Warhol's relative "silence" concerning his esthetic intentions is an ironic and self-effacing gesture aspiring to nothing. The hermetic aspect of "Warholism" is a part of Warhol's creation of a pass-

ionless presence. It is a strategy that jettisons traditional norms of fine art (especially of easel painting) based in part on Duchampian and Cagian notions, and on a preoccupation with a dialectic of glamour and death. Warhol's notion of Popism has led Kozloff to a critical numbness: Warhol's Pop Art filters through the spectator's memory, and the viewer may become confused in the subtle tension of what Warhol displays and how he presents something.

One of Warhol's earliest *coups de théâtre* took its cue from Duchamp. Warhol induced spectators to look at comic strips and banal advertisements as if they had a special modality of esthetic perception. Warhol then took the Duchampian game of "art" on a new turn in which works of art, objects, and people are all equal. Moreover, Warhol's "art" concerns a Camp sensibility in which there is a delight in neglected leftovers. Warhol's Popism is as much a temperament as an art style, and as much a series of entrepreneurial schemes as a (one-man) cult of American icons and taboos. Since at least the early 1950s, Warhol has projected a persona of an inarticulate and shy naif whose ever-innocent "eye" looks upon everything with wonderment and remains silent to evoke a mystique.

Warhol's relative "silence" is the result of his equivocal responses to questions or of his own redirected questions. During my conversations with him, Warhol was always evasive about his esthetic intentions or he feigned a loss of memory about particular works (especially his commercial work), but he could remember in detail events of his life that had happened decades ago. Typically, Warhol will take a long pause before speaking. One will begin to speak during such a pause, and Warhol will lapse into an absorbed silence. While I was frequenting his studio during the fall of 1978, a one-sided "conversation" took place between us. In fact, since the early 1960s, he has allowed various "spokesmen" to answer questions, and he has asked members of his entourage to lie about his art and biography.[7] In my opinion, in order to investigate Warhol's "art" and career it is necessary to use authoritative evidence. *As much as the notion of "Warholism" may perplex a critic, it is possible to leave one's personal response and to examine Warhol and his art by means of his working methods and by compilation of testimonies by his friends and associates.*

In order to demonstrate "Warholism," a reconstruction of Warhol's intention of a work, and the process and context of it, one last series will be discussed: Warhol's *Shadow* series of 1978 (fig. 49). At the Heimer Friedrich Gallery in New York during the spring of 1969, 67 paintings of this series were displayed around the gallery.[8] For the opening, one of the most expensive white wines available (Perrier-Jouet Fleur de Champagne) was served to guests who could take away autographed copies of the latest issue of *Andy Warhol's Interview Magazine.* Gregory Battcock covered the opening for *Domus,* and he recorded frivolous remarks by guests. "I'm glad the paintings are all alike," Robert Rosenblum is reported to have said, "It makes them much easier to remember." Philip Johnson remarked that the paintings represented pilot lights.

Figure 49. Andy Warhol, *Shadow*, 1978
Acrylic and silkscreened enamel on canvas. Four panels, each panel 76″ × 52″.
Installation photograph from the Heimer Friedrich Gallery, New York.
(© *A.D.A.G.P., Paris/V.A.G.A., New York, 1986*)

Elizabeth Baker, the editor of *Art in America,* observed that "the paintings will be here forever but the champagne might run out." Similarly, the art critic David Bourdon said at one point: "Thank God for the champagne. Seeing these pictures once is bad enough. Just think how often they'll keep popping up." "Everybody wants my autograph," Truman Capote said to Battcock, "When fame is the game you can't complain, can you?" Mike Robinson, the editor of *Art-Rite,* commented that "Duccio painted a dozen crucifixions. So why shouldn't Warhol paint 200 bunny rabbits?"[9] Following the opening, five critiques appeared in art magazines.

For *Art News,* Jane Bell remarked that curators, critics, and artists had a "passive attitude"[10] toward the *Shadow* series. Presumably, she is referring to the opening and is characterizing comments that were similar to those Battcock recorded. Bell considers the series as being "provocative and engaging," "visually stunning," and even "unearthly." Bell writes:

> The shadow was silkscreened onto a painted background which itself negates the cool smooth surface associated with almost all Pop art. The hand is everywhere in these paintings—a generously sensuous hand that is clearly Warhol's, although, as always, the artist accepted a little help from his friends at the Factory.[11]

Although Bell comments that the "gestural tapestries of color" may be "merely monumental homages to the legacy of the New York school, prettied up for a new, possibly less demanding generation," she considers them "problematic" because the paintings indicate to her "a strange departure in content"[12] from the rest of Warhol's Pop Art. Finally, Bell asserts that the series blatantly refers "to pre-Pop Abstract Expressionist 'push and pull' painterly techniques à la Hans Hofmann."[13]

Two reviews of the series appeared in *Arts.* The first review, written by Thomas McGonigle, says that Warhol "creates a terrible dilemma for the viewer of his paintings."[14] The artist's promotional appearance at the opening is described, as is the varied repetition of colors in the *Shadow* series. McGonigle considers the title important, and he interprets it in terms of Warhol's personality by quoting a phrase ("the shadows of existence") from a Joseph Conrad biography: shadows represent Warhol's proposed "marginality" in life as a person.

The second review in *Arts* was written by Valentin Tatransky, who considers the *Shadow* series to represent a commentary on the formal qualities of the handpainted canvas and of the silkscreened image. According to Tatransky, *Shadow* is Warhol's abstracted self-portrait because the "ominous, huge, blank-ink strokes" signify Warhol's "other side."[15] "Think of the satisfaction he [Warhol] might be experiencing in the presentation of his multi-purpose, screamingly powerful *Shadows,*" Tatransky concludes.[16]

In Carrie Richey's review for *Artforum,* she describes the *Shadow* series

as being "brooding" and "riddling" because "there are no answers, just mystery."[17] Richey notes that a press release at the opening "assures [one] that each of the canvases bears the same image, so if I detect two, could this mean there's a positive and negative version of the same image?"[18] For Richey, a critic is a detective who discovers clues about the mystery of the series. In fact, according to her, the paintings evoke a "criminality" because "each canvas looks like an over-enlarged photograph of some unmentionable event,"[19] as in Michelangelo Antonioni's film *Blow-Up* (1966).

Finally, Thomas Lawson's response to the *Shadow* series appeared in the Milanese art magazine, *Flash Art*. Lawson remarks that "the shadows [are] cast by the props [in Warhol's studio] as used as a formal device to undermine the symbolism of the emblem by concentrating attention on the deployment of shape and color."[20] Lawson is not sure what the "emblem" may be except that shadows are themselves mysterious and may have some possible signification in Warhol's paintings. Lawson concludes, "Free of the old Pop references, the work becomes more concise [than other paintings done in the 1970s] because the conventions used are more directly related to the concerns of art."[21]

These five reviews imply that there is a confrontation between the critic and the series, works that represent, in Kozloff's words, "immeasurable, intangible aspects of art."[22] Warhol's series is seen as "mysterious." Each critic's attempt to understand *Shadow* becomes an occasion to embark on associative evocations in which there is in each case a speculative response: each critic guesses what the series is supposed to mean. There was one reference to a press release, and all of the reviews mentioned the contiguous display of the paintings, their "decorative" qualities, and evocative reference to Abstract Expressionism. As if to suggest further that the critics had little to say, most of them used up to one-third of their reviews describing the opening as a "media event." McGonigle writes: "A long line forms to receive a copy of the magazine [*Interview*]. . . . A public knows so much about a famous person that there is just nothing to say."[23] If these reviewers are uncertain of what to say, then how can one clarify what Richey describes as "a brooding, riddling exhibition to which there are no answers?"[24] As much as Warhol's *Shadow* series may perplex these critics, it is possible to understand the series, as well as Warhol's intention and the context of *Shadow* in his other works, by means of testimonies by his associates and by direct observation.

During the early 1960s, Warhol was influenced by the style and especially the visual "noise" used by Jasper Johns.[25] Warhol was, moreover, interested in the creative potentials of producing works that were formed by chance. In fact, Warhol conducted several esthetic experiments during the early 1960s that were never exhibited and that heretofore have never been publicly discussed. Sometime during 1961 or 1962, Warhol "recorded" tracks left by pedestrians by placing unprimed canvas on the sidewalk in front of his townhouse.[26] Warhol

conducted another experiment during the same period, in which he urinated on canvases,[27] thus anticipating his later series of *Oxidation* paintings (1978): Warhol's canvas had wet copper paint which turned green when it oxidized (by his urinating on it).[28] Warhol never exhibited these early experiments in personal and impersonal methods of producing art-as-process. According to Ronnie Cutrone, in 1978, Warhol decided, "Gee, I wonder if that would work now."[29]

After 1963, the year that Warhol began to use silkscreens, the artist often included splotches as a part of the expression of his "surface"-oriented Popism.[30] Such abstractions were part of the expression. During the 1970s, Warhol did several series of paintings concerning "political"[31] still lifes, including *Hammer and Sickle* of 1973 and *Skull* of 1976, based on photographs by Ronnie Cutrone, Warhol's current painting assistant. During my interview with Cutrone, he discussed his photographic images and mentioned that Warhol deliberately chose the photograph with the most shadow. Cutrone added:

> But because he [Warhol] had always admired the corners of his paintings, which is where the [silk]screen falls off and becomes just broken dots, like there might be a definite image in the center of a painting, but around the edges there's always this, this scattering of dots. He would always say, "Oh, that looks so pretty. It looks so pretty. What can we do to abstract?" So, I don't paint, I haven't painted since 1968. So, I had always been thinking of about photographing shadows. So, I just decided to try that and see what they looked like, and it worked. So, that's how that came about. It was just an idea of trying to make something abstract, yet, have it really be something instead of just what comes out of the artist's mind.[32]

The choice of *Shadow* lies, then, in Warhol's previous use of shadows, the effect of abstraction in the visual "noise" of the silkscreen process, and in the ambiguity of what a shadow is (a "surface"-abstraction). A shadow is an everyday phenomenon, and the subject aligns with his displays of common objects in his Pop Art. When I visited Warhol's studio in the Fall of 1978, the *Shadow* series was one of several painting series Warhol was doing simultaneously, including his commissioned portraits. One series, which has neither been shown publicly nor photographed, is *Abstract Paintings:* paintings that consist of only swirls of paint that were *mopped* onto a roll of canvas, which is then cut into individual works. Apparently Warhol uses such paintings as gifts. Warhol's interest in abstraction is also indicated in some of his commissioned portraits.[33] Contextually, Warhol's *Shadow* series is one of several concurrent series that exploit Process Art and abstraction.

Production methods used in the *Shadow* series are the same for all of his works since 1969. Warhol's printer, Rupert Smith, briefly outlines the process:

> the small negative, which was blown back up into a very gigantic fifty-two inch by seventy-six inch positive. It's, like, a "big" piece of film: "a lot of Tri-X [film]" I always say. . . . Andy mixes the paint, and it's mopped on the canvas, and its . . . We separate

them. We cut them up and print them on top with the screen: print the screen on top of the . . . You know, the screen is made from the large positive. It's a photo-process . . . I cut them to the size that I want, and it's printed on top of them.[34]

The canvases were then returned to Warhol's studio. Smith neglects to mention—perhaps the following were produced after I spoke with him—that the negative image of the photograph was also silkscreened. When I was in Warhol's studio, I noticed several concurrent works that also used negative reversals of a photographic image: *Negative Reversal Self-Portrait's, Negative Reversal Marilyn's,* and *Negative Reversal Mona Lisa's.* The *Shadow* paintings were created using the same technique.

All of the *Shadow* canvases were, presumably, kept in Warhol's studio until the exhibition at the Heiner Friedrich Gallery to benefit the Lone Star Foundation.[35] The series was reviewed after the exhibition. What effect did the reviews have on the sale of the painting series? None. The show was sold out before it opened.[36] Consequently, "Warholism," as evident in the criticism of the *Shadow* series, may be seen only as a critic's personal response to a work by an artist who remains relatively "silent" about his intention. It is possible to reconstruct and to demonstrate Warhol's intention, his artistic means of production, and the context of a particular series in the artist's other works by ignoring one's personal response and finding authoritative evidence concerning such a series.

"I'd prefer to remain a mystery," Warhol once said, "I never like to give my background and, anyway, I make it all different every time I'm asked."[37] Warhol may prefer to remain a mystery in order to achieve a glamorous and passionless presence, but he is not as mysterious as he and his critics make him out to be. Warhol's calculated distance may be seen as his personal solution to the problem of art and life. His career is built upon a contrived series of schemes by means of various "dodges" in order to achieve fame and glamour. By remaining relatively silent—"My friends know it better than me."[38]—and by proposing a series of playful "art" games, Warhol allows someone (an associate, viewer, or critic) to transmute "meaning." "Warholism" becomes not so much a "moral issue," as Max Kozloff would have it, but an esthetic radicality that allows one to enter into Warhol's transactions of "art." Warhol carries on his esthetic business, performs as a passionless presence, and conducts investigations of "comic" existence. The means of his esthetic productions have been usually easy ones: tracing images that are readymade and implicitly or explicitly from popular sources, and using techniques (offset, lithography, silkscreening, film and audio tape, etc.) that may yield multiple works. By presenting a certain presence, Warhol simultaneously acknowledges it without excuses and recognizes it through its own theatricality. His "art" reciprocally affects one and is dependent upon responses by his audience. In order to achieve his ardent desire to be famous and successful, he has established a mythic legend in his own time: a legend perpetuated by means of "Warholism."

7

Conclusion

In many ways, Andy Warhol was—is—a profoundly withdrawn man who envisions himself through glamorous fantasies of life: wealth, beauty, power, security, and especially fame. Warhol's pictorial and cinematic projections of glamorous and violent, even cruel, imagery are consciously displayed as ambiguous in order to expose the extremes of life and to reflect it by deflecting it. In a playful process that combines such imagery with various "distancing" techniques, Warhol simultaneously allows the viewer to "see" the medium, from which visual attention is usually diverted. The artist not only allows chance and accidents to become part of his means of production, but he also deliberately cultivates the changes—transmutations—of his original intentions by unwitting associates and by the spectator. The traditional esthetic distinction of a work of art as a final product and the notion of an artist as the author of a work are replaced by open-ended and playful investigations and games of "art."

"Art" is for Warhol no more than a legible, perhaps effaced by visual "noise," and unavoidable, instrumentality implying both presence and absence. That is, Warhol's repertory is the remains of previous images which he deconstructs without any methodological eclecticism or historicity. Rather, he playfully puts images—the debris or "scrap" from popular magazines, newspaper, publicity photographs, etc.—into new contexts. Any so-called "problem" of meaning is now no longer located exclusively in a preordained pictorial reality, but is subjugated—"signed"—by Warhol: a chosen image or a *photo trouvé* is displaced from an original context, and sometimes its origin is dispersed so that one has to reconstruct its context.

By presenting a certain presence from a common consumer product to the "seedy" glamour of a so-called "Superstar," Warhol simultaneously acknowledges it without excuses, approves of it, and recognizes it through its own possible theatricality. By suspending his affective response as an observer, he enables the viewer to experience directly the resonance of the display of a contemporary iconic image or taboo of everyday life, as Warhol himself has experienced it or fantasized about it. In a sense, he "hides" himself in the "sur-

face" of his works, which have autobiographical elements; Warhol formulates and stereotypes private happenings, meanings, and fantasies so that the viewer may become aware of lived daily life and put into question the artist's proposals of comic and tragic existences and givens. Moreover, his desire to "kill" his own emotional life through some mechanical device (tape recorder, television set, etc.) becomes a voyeuristic element in his monitored stare at the possibilities of equalized "found" objects, images, and even personalities.

In his *ethos* of withdrawal, Warhol became a devoted fan of celebrities (from the actress Greta Garbo to the writer Truman Capote) and of his own alternative "Superstars," whose private lives become public and whose public lives become publicity. In his films (1963–68), Warhol allowed narcissistic theatricalizations of "seedy" glamour to be presented by his "Superstars." The value of their beauty or wit is *en passant*. The shallowness and vainglorious ineptitudes of *la vie ardente* of such personalities are displayed also in a novel, a play, a videotaped soap opera, and in the artist's monthly tabloid magazine. To become a "Superstar" is to be denied individuality, yet to be presented as a "plastic idol." Warhol exhumes the improbable, exhibits taxonomies of Camp, and is carefree in his canonizations of nostalgia and nonsense. His quiescent response of the flesh and of the apotheosis of the banal is presented by various "tropes."

In his hundreds of films from 1963 through 1968, Warhol used four cinematic "tropes." They are the unmoving or "static" camera, the long take, the "strobe cut," and zooming. Such stylistic devices in his pictorial works constitute Warhol's evocations of visual "noise," and such "noise" may be traced back at least to a project done during 1949, when the artist attended the Carnegie Institute of Technology (now Carnegie-Mellon University).

Warhol's trope of style in his Pop Art—repeated images on a canvas by means of a mechanical production—became his infamous device of transformations—more precisely, transmutations—in a continuum of "homages to . . .": celebrities, mass-produced consumer items, depersonalized portraits, and so on. Moreover, Warhol has claimed that his images of unqualified depictions of American cultural and social life are "emptied" of meaning and feeling. Consequently, the still center of Warhol's notion of Popism—which is as much an attitude toward life as it is a style of art—is Nothingness. Warhol dulls significance and kills emotion by means of some mechanical or stylistic device.

Warhol's acceptance of a profound alienation from "comic" existence is especially evident in his dialectic of the "death" of glamour and of the "glamour" of death in his Pop Art and films. He investigates and puts into question the ontological status of "plastic" idols and taboos, and he allows the spectator to resolve any "meaning," while he remains a persona of mysterious silence or as some whimsical self-image ("André Warhola," "Raggedy Andy," "John Doe").

Yet, it was precisely the *personal touch* of various books and flyers during the 1950s that promoted his commercial and illustrative art based on a fashionable and decorative blotted-line technique. Warhol made a definitive break with his commercial art by destroying (at least) hundreds of his blotted-line drawings when he began his Pop Art works. In retrospect, it is possible to discover, however, certain common features to his works during the various phases of his career as an artist.

The assumption that Warhol used assistants only during his Pop Art phase is incorrect. Rather, their use was a continuation of Warhol's studio practices going back to the 1950s, when he employed assistants (especially Nathan Gluck who worked for Warhol from ca. 1954 to 1964–65). Moreover, Warhol allowed his friends to work unpaid: "coloring parties" included his friends working on hundreds of promotional books and flyers.

Second, Warhol used "unclosed" inventories of pictorial source material, including the Picture Collection of the New York Public Library, popular magazines (especially *Life*), popular prints (such as Currier & Ives), old books, advertisements, and so on. Such use of "found" pictorial source material may be traced to 1953 by direct evidence and to ca. 1949 by authoritative testimony as first shown here.

Third, Warhol's studio products are "signature" works even though someone else may have executed them. During the 1950s, Warhol used his mother's decorative calligraphy; when she was unavailable, Nathan Gluck imitated it. During Warhol's Pop Art period, his studio produced multiples of (photographic) silkscreened paintings, prints, and objects that were executed by others but were nonetheless "Warhols." Similarly, Warhol's films were scripted and, in part, filmed by associates; yet, such cinematic works are examples of his "signature" films.

Finally, Warhol's entrepreneurship that became his notion of "Business Art" appeared as early as the early 1950s, in which promotional products were produced to generate interest in his work, art, and career. Warhol's schemes of packaging his projections of idealized images (including "male odalisques") denote his desire to become a glamorous and famous personality: his "plastic idols" are his means of achieving his goal, and they represent various aspects of his fantasies.

To conclude a study on a living artist is to reiterate and to analyze his accomplishments. In Warhol's case, such an analysis necessitates authoritative evidence from his friends and associates, because he remains "silent" in order to achieve his life's goal: a glamorous and famous presence, which is flawed and displayed as such.

Appendix

Interviews

In the interviews, bracketed ellipsis points indicate that text has been dropped from the transcription. When appropriate, bracketed text summarizes what has been discarded.

Lawrence Alloway, New York, 9 November 1978

Alloway is a well-known art critic.

PS: Could we go back to what you were saying about the blotted line, so I have that for the record?

LA: Yes. I'm interested in [Rainer] Crone's idea about the blotted line, but it is nonetheless, a line imitated by Warhol. Although what we see may be blotted, and, hence, at a remove, it's still following Warhol's line: his crinkly, crisp early line. He became an artist, I think, when he began to use *not* his manual procedures but his stencils, stamps and, then silkscreen. So, he begins in a way as an artist with this gesture of denial: self-denial. He turned away from the thing that he had become celebrated for: his touch. Although I think that Crone's point is interesting, he is almost unifying the two phases of Warhol. Whereas, I think, there is more of a jump between what he did for I. Miller and what he did for himself subsequently.

PS: When I was talking with Duane Michaels, I asked him, "Was there a difference between his commercial work and his work of the 1960s?" and he said that there was a tremendous difference for him. Not only with the people that Warhol associated with but the "look" of his art. What do you think—when we were talking about before—about the denial of the commercial [art] "look?" What do you think prompted Warhol?

LA: I don't have the least idea. I hope that's something you'll find out. [Laughter] There is something that is awfully nice about being an art-

ist. I think, one of the great satisfactions of being an artist is being in a situation of total control of a work. Whereas, if you were a commercial artist or a designer, no matter how well you are thought of, you're always working toward a target that someone has set for you. You're always subject to editing—to veto—by somebody or other. Whereas, when you work for yourself, there's the risk of starvation and nobody knowing about you, and so forth, but you have the satisfaction of total personal control. And, maybe, Andy knew artists. He had the example of [Philip] Pearlstein—a man of exceptional autonomy. Maybe he wanted to have that kind of control himself, but that's a guess. When he decided to produce his own work outside of a proscribed channel, it wasn't especially well received at first. So, he went from being the obedient designer to being [an] avant-garde outsider, and that's a tremendous switch in social-psychological worlds.

PS: How did you see it when you first came upon Warhol before the switch?

LA: I didn't know him *before* he was doing silkscreens, but I found out *later* about his earlier work; and, maybe, that is why I attach importance to the *difference,* whereas, [Rainer] Crone, working chronologically along, sees one leading into the other. I started with the silkscreens, and, then, I had to discover by surprise that he had also done these other things, and, then, I thought—and, perhaps, I still think— but here are these works of pre-existing photographs turned into works of art, being called "commercial" by everybody. (Nobody noticed them at all.) Whereas, in fact, when he was a commercial artist, it had been his manual skill, upon which he relied. So, there is a kind of double-take in those later works, which I find attractive. One has to be aware of over-interpreting Andy, I think.

PS: Do you think there is such a thing as under-interpreting Warhol?

LA: Good point. Yes. I think, there is such a thing as under-interpreting. I think, the early literature on him, which saw just "mindless repetition" (the supermarket phase as a source of his imagery), I think that was under-interpreted because that was going by the associations of the subject matter, which were being put upon works which had [inaudible words] autonomous in origin. I think that the early Andy criticism is under-interpreted.

PS: What do you think contributes to that? The fact that nobody knew very much about him at the time?

LA: Well, I think, it's part of the thing that has troubled early [Roy]

Lichtenstein criticism. Everybody thought that what he was doing was copying comic strips because they didn't know enough about comic strips to see the ways in which Lichtenstein *departed* from comic strips. He had the *style* of comic strips but not the substance or the detail and, therefore, the recognition-source overlayed the uses that the artists were making of the comic material so that our recognition—people's recognition—of the sources wiped out recognition of the artistry and the autonomy of the artist in doing it. I think, it's fairly common in early Pop criticism. This was a mistake that was made.

PS: Now, your idea of Pop Art from the [1974] Whitney catalogue [*American Pop Art*] is that Pop Art is the art of "sign systems," and, I think, one of the reasons why you may have done this—correct me if I'm wrong—was, perhaps, to include [Robert] Rauschenberg and [Jasper] Johns in a more rigorous way of saying that Rauschenberg and Johns have some commonality with the other so-called "Pop artists."

LA: Right.

PS: I've always tried to explain "sign systems." Do you think of it as a kind of sociological approach? Do you think of it as a, shall I say, artistic-linguistic approach? In the sense of Roland Barthes? When I see the word "sign," I think of semiotics.

LA: Yes, to some extent, but let me put it the other way around: what is the alternative of looking at Pop Art without Rauschenberg and Johns? What you get is a one generational group of people which plays down—Jim Dine gets shuffled to the margins, and it becomes Roy Lichtenstein and Andy Warhol and Tom Wesselmann and, I suppose, [James] Rosenquist. It becomes a stylistic unit of some narrowness, and it's that aspect of Pop Art which then gets affiliated to Ellsworth Kelly and Frank Stella and the idea being: art of the '60s is "cool," "compact," "polished," "impersonal." Now, it seems to me that that is an impoverished view of the scope of Pop Art because you also have to include I consider [Claes] Oldenburg and [Jim] Dine, who were expressionistic in their tendencies, and, it seems to me, that Johns and Rauschenberg come in in the same way. So, you either get a tight generational unit, which minimizes the subject matter of Pop Art but [which has] its affiliation with Hard Edge Painting and Minimal Sculpture, or one gets something which I prefer, which is a suggestion of the expansion of collage—into seeing society as a sign system. So that is the rationale, really. It is, also, an opposition to a narrow stylistic meaning.

PS: Why did you pick the term "sign system?" Were you reading semiotic works at the time?

LA: Yes. I had been interested in the word "signs." I think, the word "signs" . . . I don't know quite when the word starts. I think, you can find it in my criticism all over. I think, it has been there a long time.

PS: When you were talking about equating Pop Art with Hard Edge Painting, I think immediately of Irving Sandler and Barbara Rose, who in their mid-'60s criticism . . .

LA: Right.

PS: . . . For instance when she compared and contrasted Warhol and [Frank] Stella, trying to think of something that puts them together. And you said that was rather "impoverished." Do you think it was, shall I say, a sign of the times in art criticism of the mid-'60s?

LA: I think, it was a sign of the way in which we tend to recognize very fast whether we are in the present moment. That is to say, we organize our "present" as we go along, and, sometimes, this can be very fruitfully done, and, sometimes, it can be very narrowly done. I think, by equating Stella and Warhol, one of the things you do is you dry out Warhol's subject matter. You just get his repetitiveness, his seriality, whatever it may be, and, so, you are dealing with technical and stylistic factors, and you have to give up with coping with subject matter. And that has been the tendency of American art criticism in the last 15 years or so: to be iconographically rather unresourceful but highly sophisticated in formal terms. So, it's in opposition to the formalism implicit in that position that I stress signs.

PS: Do you think that the idea of formalism in art criticism still infuses the art scene and the art critics?

LA: I don't think much has been added to the idea any longer, but I don't think that it has been successfully replaced. So, it's going on by inertia, and it seems to me that curatorial taste in museums seems to rest on that pretty much, though, I think, New York critics aren't bound by it any longer, but it's certainly very influential in museums.
 [Alloway discusses Minimal Art and art critics.]

PS: Could we go back again to Pop Art. Do you think that the style of Pop Art has changed differently with different artists? For instance, I'm thinking of Jim Dine's recent paintings. Or, do you think that is historically interesting and has stopped? Or is it something ongoing?

LA: Well, it was never a movement with a manifesto and an agreed upon program, and, I remember, at one point Rauschenberg . . . There was an interview with Rauschenberg and that he was quite happy to be a

Pop artist, and he said, "I hope that I am a member of the next move-
ment that comes along." And then, later, he changed his mind and
said, "I hate this Pop Art. I have nothing to do with it." And in a way,
I think, it has always been kind of loose, but it does seem to me that
it represented a convergence of interests of the flatness of Abstract Ex-
pressionism combined with an interest in signs of contemporary life.
A number of artists had these interests, and they converged, and,
while they were in convergence, it was something like a movement.
It was something like a tendency, and we called it "Pop Art." I think,
they have now opened out and have gone their different ways; but, on
the other hand, it seems to me that this combination of formality and
signification has supported artists in a lot of different directions, and,
I don't think, any of the Pop artists have departed from that premise
of the interplay of significance and of formal order. So, it's not a
movement any longer, but I don't think that Oldenburg or Rauschen-
berg or Wesselmann have departed from the premises which the theory
of Pop Art was based on.

PS: Now, of course, we are speaking specifically of American Pop Art.

LA: Yes.

PS: Now, of course, everyone knows that you were back in England when
English Pop Art began. Do you think there was much influence of the
English Pop artists on American Pop Art?

LA: I'm not aware of any, and, equally, I don't think, English Pop Art
turned out to have much future, one of the reasons being the compara-
tive weakness of the formal traditions of painting and collage in Eng-
land. English art is frequently more graphic than painterly. There is a
great separation among the generations. Whereas, it is quite clear that
even when the Pop artists, just as the Minimal artists, were rejecting
Abstract Expressionism, they were benefiting from its formal perfor-
mance, and, so, you have got a high level of execution combined with
this quoted subject matter. In England the quotidian subject matter was
not reinforced by a similar pictorial sophistication so that it seems to
me that American Pop artists went ahead and diversified, whereas the
English equivalent—although *early*—had no future: it aborted it.

PS: When I was talking to you earlier at Northwestern [University], I
asked you if you were the one who, *indeed,* coined the term "Pop
Art," and you are often credited with the coinage. Do you think, in
fact, you are the one who coined the term?

LA: Yes. I believe, I was. [Laughter] But what I meant by it originally was

not quite what is meant by it now. That is to say, I meant by it the mass media and the products of the mass media.

PS: For instance, in Richard Hamilton.

LA: And Richard is one of the people who altered—who kind of steered— it towards the fine art sense which, more or less, it has now. There's an article in *Architectural Design,* I think. [See Lawrence Alloway, "The Arts and the Mass Media," *Architectural Design,* vol. 28, no. 2, Feb. 1958, p. 84f.]

PS: Yes.

LA: That's where it showed up, but we had used it in conversation around the I.C.A. [Institute of Contemporary Arts, London] for a while be- fore.

 [Alloway describes his first encounter with the works by Jasper Johns and Robert Rauschenberg.]

PS: When was your first encounter with Warhol?

LA: I don't remember except for certain silkscreens. Now, what kind of silkscreens? I think, it was about the time of the *Marilyn Diptych* [of 1962] and *The Men in Her Life* [also of 1962]. I was around about that time, and I went to his studio, I remember. He had a studio Uptown in a place, which was also called the Fertility Institute. It was quite near the Guggenheim [Museum], where I worked at the time. So, I used to go every now and then and just walked around Andy's studio when he was doing his early silkscreens. I think that was 1962.

PS: Did he ask you to help out?

LA: No. I think at that time he was mostly doing them by himself. This is pre-Factory.

PS: Yes.

LA: It was on Madison and in the 80s. [Actually, Warhol's studio-apart- ment was on upper Lexington Avenue.] So, I remember, he always had music playing louder than was really comfortable for me. I can vaguely remember that, but I liked the work immediately, I think, partly because at the time Pop Art, having meant originally to refer af- fectionately to the mass media itself, I was very predisposed towards works which quoted the media. So, the pleasure of the recognition of those things made it easy for me to like them.

[Alloway and P.S. discuss Happenings and the influence of John Cage on Allan Kaprow, Robert Rauschenberg and Jasper Johns, as well as

a general discussion on social connections in New York's art world. Alloway also comments on Marshal McLuhen, Tom Wolfe's *The Painted Word* (New York, 1977), *Artforum* magazine, Robert Smithson's *Site-Nonsite*, Eva Hesse's works and art works by women during the 1960s and 1970s, as well as realist trends in painting during the 1970s (including Photo-Realism and Perceptual-Realism)].

Gregory Battcock, New York, 15 October 1978

The late art critic and anthologist appeared in several of Andy Warhol's films.

GB: Some of the films that I was in, I never saw afterwards, which struck me as somewhat interesting about them. Usually, when you're in a film, you can look at it later. That's the reason, but you'd never see any film later. [Laughs] It just vanished. Warhol would say, "Oh, yes. Well, it's around some place." [Laughs] And the next thing you know, it would never be screened. Most of the screenings were in his studio. And people would come by, and as soon as there was a crowd, he or somebody would put on a movie and screen it. So, maybe, if you happened to be there at the one time that the film was screened, fine; but if you missed that one screening, the film was never retrieved, and God knows what happened to it.

Filming always, struck me, was that you knew what you were doing was amusing and interesting and, certainly, different and not too serious. We were not professionals, and that was that. It was always very chaotic. You never knew what was going on. People were given instructions and contradicted the instructions, and you had the feeling that whoever it was directing or organizing that particular film didn't really know what to make of it because they were really designed as they went along rather than sticking to any kind of serious script. They were occasionally. Someone would have big cards made with instructions on them, which they would hold up so you could see them from behind the lights, but if you didn't happen to see those instructions, it didn't matter too much. The film wouldn't stop. It would just keep on going.

Dracula was filmed in various places, and it went on for weeks. Jack Smith was occasionally there, working in the film. I didn't see any of the footage, but I recall that I saw stills of myself in a sailor's uniform lying on a couch, and you also didn't know that once you were on the set whether it was being filmed. I mean, the camera may have been going.

PS: You were in *13 Most Beautiful Boys*.

GB: Yes. I only saw stills or snapshots of it.

PS: I understand that the sound version of *Blow Job* was filmed in your apartment. What happened during the filming of it?

GB: That was my apartment when I lived in the Village. Lou Reed was there, and Andy was there. I saw it in the Film-Maker's Co-Operative catalogue and rented it. There wasn't any written dialogue. They would just have the sounds, as so often in the experimental early films. The dialogue was just whatever happened to come up. You know? Sometimes Warhol or somebody would set up provocations, which *might* stimulate dialogue in one way or another but not really direct it.

PS: Do you remember what he would say?

GB: Yeah. He might ask a question: "Tell the story about such-and-such," or something like that.

PS: Were you in *Chelsea Girls* at all? One of the segments?

GB: Well, you never knew because *Chelsea Girls* wasn't really made to be *Chelsea Girls,* as you know. *Chelsea Girls* is an idea that he got much later and decided it would be one way to use up a lot of his films which, otherwise, didn't seem to have any use at all, but he would take many of these reels of films, that seemed to have no point what-soever, and to put them, screen them, and each time the *Chelsea Girls* was screened—I think, it was only screened once or twice; two times maybe—and it was never screened the same way. It was just using up the reels. It was just showing all the films, and, then, he titled it the *Chelsea Girls.* He didn't have much organization. The projectionist didn't know what order to put all of those films. I remember, they were *there* in the basement of the 42nd Street Theatre. In the back room, there were just piles and piles of film. And the guy really didn't know what to do with those films—just keep them going, keep the projectors at the same time, one next to each other. No, it was shown more than two times, it was shown several times, but each time you went to the studio for a while, watching it, it didn't come on the same way.

PS: How were Andy's films shown at the Factory? What were the cir-cumstances? Would he say, "Oh, we're going to see a film today," or . . . ?

GB: It seemed, mainly, you were hanging around, and, for some reason, after a while the crowd would swell, and either some group would ar-

rive from Paris or somewhere—like [Michelangelo] Antonioni would come in with people, and Warhol would say, "Oh, I promised to show Antonioni such-and-such films, and we're all going to watch such-and-such." So, sooner or later, with much confusion, Warhol would get the film on the machine, and everyone would sit or stand around, and the film would go. In the beginning everyone would stand around, but, later, when he moved to Union Square, there were couches and things to sit on, but when it was at 47th Street, there would be usually no place to sit. So, everyone would stand around. The screenings were very informal. People were coming and going. The elevator was coming up with people getting in and out. You could never understand the dialogue. The sound was always a disaster. It just didn't come off, but it was quite interesting. It was really very amusing, and everyone would applaud very enthusiastically after these things.

PS: When was the first time that you met Andy?

GB: Maybe at a show at the Stable Gallery around '61 or '62, and he invited me up to his studio.

PS: What was the Factory like?

GB: It was usually dull with people wandering in and out. Sam Wagstaff was there often, and Robert Indiana was there. Usually, New York flashy types would drop by. [. . .] Some of the people there were clearly because of connections. It was a social business for them. A lot of them were there for just that reason. There were a great many else because it was really just a kick, and it was certainly the most interesting thing that you could think of that was going on. I found it all rather boring. I would never stay there for more than 15 minutes. I would go and just see what's going on or something. I would quickly, instantly, get bored, as a matter of fact, then leave, and Warhol would say, "Oh, come back on Thursday afternoon when we're doing such-and-such." And I would pop in again for a few minutes and watch and, then, go out. So, I never got to know anybody too well except for a few of the people, naturally.

PS: What were the kinds of things that Andy was interested in back then?

GB: Basically, he was rather quiet, and he was much more interested in being amused than amusing other people. And, I think, he just picked people because they amused him, and he very rarely contributed anything, but this didn't bother us [Battcock and Tosh Carillo, who would occasionally prepare dinners for Warhol]. We would just drink and carry on, and each person tried to be more outrageous than the next,

and Warhol was very entertained by this, and he was a satisfying person to have around, but he rarely contributed anything specifically in a social situation. Occasionally, he would make a comment, or he would direct again, introduce something which one would take about or act upon or something, but he didn't. . . . He wasn't very entertaining. [Laughs] No. But he was very unobstructive and never asserted himself.

PS: Would you then characterize him as a kind of shy person, as you knew him?

GB: Shyish but not really shy. Maybe he had some of the characteristics of being shy, but he wasn't *really* basically shy.

PS: What's the difference then between someone who *is* shy?

GB: Someone who would be hesitant to talk with strangers, I suppose, and things like that, but Warhol was never in the slightest bit hesitant or nervous in large groups or anything like that. Those are some of the things that I would think, and, because he was always sort of quiet and wide-eyed, you'd think, "Oh, this is a little bushy tailed boy from Pittsburgh." But it was just this performance that Mid-Westerners always try to calculate: the little lost boy in the city of business. He wasn't.

PS: Do you think this was a front, or do you think . . . ?

GB: It was a device.

PS: A device?

GB: Yeah. Up to a point, Yes . . . I think, it became clear to many people that Warhol was really becoming famous and that he was available, and many famous people aren't available. You can't get their telephone numbers, and they don't leave their door open all the time, but Warhol did. . . . Security was more tight after he was shot and somewhat before that happened, but anyone could still go there with an appointment to be let in. . . . When I first met him, I was allowed to silkscreen boxes, and he said that if I helped, then I'd be given a box, but he forgot, and I didn't care. Several times I signed his name.

People just feel that he is just playing a high society game, which obviously—certainly—he is, but it's obvious that he is, and he is not disguising it in any way. There's no hypocrisy about it, as there isn't in almost everybody else's case. So, that's fine. I've said in articles time and time again that his art is no longer valid and that it's just junk, [laughing] and I bring him the article, and he reads it and says,

"Oh, yes. It's a very good article." At first, I thought that he must not have understood it, then I realized, "Oh, yes. He understands it perfectly." Like, the last thing I did on his big *Hammer and Sickle* paintings, and I did something in *Domus* magazine, and there was a big, almost a full page, reproduction of one of his paintings. In my text, I said, this whole procedure, this whole thing, is totally irrelevant and that it's just cheap sensationalist shots. And I'd say, "Oh, that's disinteresting." Blah-blah-blah. And I went, and Warhol was tickled to death and showed everybody the article. [Laughs]

PS: Would he be tickled to death because someone wrote an article about him?

GB: Probably. Yeah. That always seemed to please him to no end.

PS: So, in the various articles that you have written about Andy's art and his movies, you have been somewhat critical, to my recollection.

GB: Yeah.

PS: But, at the same time, you like him as a person.

GB: Oh, yeah. I like him as an artist too.

PS: No one seems to have a middle ground toward Andy. Why do you think that is true?

GB: Well, that seems to be true of anybody who is doing important things. It always provokes that kind of . . . anytime that kind of response, there must be something of value by the person who is doing it to provoke it, it seems to me.

PS: What do you think is Andy's most important film or films, or what do you think is his contribution to film?

GB: Well, I suppose that we can't really say what that is until he becomes a part of film history, I guess. But, in general, if you consider the context in which he is making the films and what was happening at American filmmaking at the time, I think, I would consider his films specifically were designed as a provocation or an alternative, in a sense, to commercial Hollywood, commercial American entertainment films. He always tried to do the opposite of what was being done, which if you defined, basically, the characteristics of his movies, and, then, you would see that he seemed to show in many ways and to point out many ways what should have been obvious anyway: the routine and the dullness, stupifying sort of idiocy of mainstream, commercial filmmaking by being more extreme and more idiotic and more appal-

ling than they were. All of his films were references to commercial cinema in one way or another. They are just full of references. They're almost all metaphors, in a sense, of what is wrong with commercial entertainment cinema. . . . You see, what was wrong then, isn't necessarily what's wrong today. The situation has changed, and it's because of Warhol on that—not entirely because of Warhol but at least partially. [Battcock describes the public screening of Warhol's *Empire,* in which there was at first a rather crowded theatre, but, by the end of the film, there were less than a dozen in the audience.] . . . Warhol asked me to write some scripts, but I only wanted to help in general—superficially. Maybe, he didn't even think that I would do it. I was never sure if Warhol was really seriously, considered me as a scriptwriter. It was very casual.

Irving Blum, New York, 20 October 1978

Irving Blum gave Andy Warhol his first one-man gallery show in Los Angeles in 1962: 32 *Campbell Soup Cans,* all of which Blum now owns.

IB: Andy seemed a bit shy, very shy, very charming, very gracious, and he was delighted in showing me six or seven paintings which were all unfinished cartoon-like pictures. I was absolutely mystified by them, coming from an orientation of first and second generation Abstract Expressionism and being very involved with that style. These seemed to me . . . oh . . . very strange . . . ah . . . too strange, somehow and simple-minded. And, so, I stayed for a while, chatted with him for a while, liked him very much, but left [Warhol's studio apartment]without making any commitment to anything, put the experience very much out of my mind and went back to California.

Several months after having this experience with Andy, I had the opportunity to return to New York—there was a collector by the name of Edwin Jans in California that I was selling paintings to, and he said, "Look, I'm looking at some things at the Pierre Matisse Gallery. Will you come back and give me your opinion?" And I said, "I would be very happy to." And he paid for my trip, and, therefore, I came back more quickly than I would have ordinarily. And while I was here, I was looking at this painting that this man was considering and I thought, it was very good. He bought it and then went on to Europe. I stayed in New York. I went to visit Ivan Karp at Leo Castelli's gallery. I was doing business with Leo—we were showing . . . I was showing at that time—in 1961—Jasper Johns, and I was very interested in Frank Stella, having been made aware of Frank by his in-

clusion in the *16 Americans* show — that was at the Museum of Modern Art in '59, put together by Dorothy Miller and two or three other people that Leo was showing. . . . In any case, I spoke to Ivan, and he was very glad to see me. And I was talking with him for a while, and he said, "Irving, I have some transparencies of some work that I think might interest you." And I said, "I would be thrilled to look at them." And he showed me some cartoon paintings, and I said, "I know that I've seen these — Warhol." And Ivan said, "No." He said, "A guy by the name of Lichtenstein — Lives in New Jersey — brought these in." And I said, "Let me look at them again." So I made that connection between what I had seen several months earlier in Andy's studio and these paintings which I thought were beautifully done, really marvelously crafted. They reminded me of Leger. I made several connections very quickly in terms of Roy's work, and I agreed at that very moment to have an exhibit on the West Coast, somewhere down the line, when it was comfortable for both Leo and Ivan to organize. And I left and called Andy on the telephone and asked if I might go back to his studio and visit with him again. And he said, "Please do." And I went and there was a whole series of small soup can paintings leaning up against the wall, and he was into — this was 1961 — he was into the *Soup Can* series. And I said to him, "Andy, what happened to the big cartoon paintings you showed me?" — which I understand later were shown at Bonwit's —

PS: Yes, on the 57th Street site.

IB: On the 57th Street site. Right. I missed that experience. As I say, I did see them at Andy's studio. He said that he had wanted into Leo's gallery, and Ivan had shown him slides by an artist that he couldn't recall, who was also working in this format, and that he was doing them much better than he was doing. And, so, he kind of stopped them, and, so, he was doing the *Soup Cans* instead. That seemed to me *extremely* curious. Really interesting. I spent quite a time looking at the *Soup Cans* paintings. Liked them. And there and then, organized an exhibit on the West Coast of all the *Soup Can* paintings, which turned out to be 32 varieties at that time. So, consequently, Andy painted 32 paintings of them, and I showed in my gallery in July of 1962 the 32 paintings. I sold a half-dozen. One to Don Factor. One to Betty Astor. One to Ed Jans. One to Bob Brown. A half-dozen people in California. And, through the experience of living with these pictures in the gallery, living with that *set* of 32 paintings, it occurred to me that I might really want to keep them together as a group. They were extremely provocative to me, and so I called Andy and said,

"Look, this is my plan . . ." He agreed. He said they were conceived as a series and that it would be wonderful if they could be kept together. And I said, "Would you give me a price?" And he said, "Absolutely." And I said, "All right." I said, "Let me get back to you." And so I called a few of the people that I had sold individual paintings to. And they all agreed to relinquish their painting. So, I had the set intact, and I called Andy up, and Andy said that he would sell them for a thousand dollars for the group. And I asked him if he could give me a bit of time. And he said, "How much time do you want?" And I said, "About a year." And he said that he'd give me about a year and I sent him one hundred dollars a month until the amount was paid. And I kept the set intact and still have them intact. And that was my beginning experience.

PS: Could you explain to me the reaction of the people walking into the gallery?

IB: Extremely mystified. The artists, who were very hostile—the artists in California were very hostile to *any* work that was not locally made. They were provoked by these paintings. Not in a hostile way necessarily. They were curious. They tended to shrug but not really condemn. It was very peculiar. There was a lot of amusement. People felt that they were somehow slightly ridiculous. A gallery dealer up the road, I remember, did something that was very well publicized at the time. He bought dozens and dozens and dozens of cans of Campbell Soup cans at the supermarket, put them in his window, and said, "Buy them cheaper here—60 cents for three cans." Or, something like that. And, so, there was a lot of hilarity regarding them. *Not* a great deal of serious interest. *Not* a great deal of . . . In fact, hardly any *serious* speculation. But a lot of carnival-like activity regarding the exhibition.

PS: Did Andy ever come to Los Angeles?

IB: Not at that time. No. He never came. He came later. He was to come several times. So, we did a big show of *Elvis Presley* paintings that ringed the walls of the gallery. And he was out for that. And he was out in California with his Exploding Plastic Inevitable nightclub situation, which coincided with the *Elvis* show, and that was a very, very peak Warhol moment in Los Angeles. He had his show going on Sunset Strip, and we had the *Elvis*es. But that was two years subsequent to the *Campbell Soup* exhibition.

PS: Now, also, at that time in 1963, was a Marcel Duchamp retrospective . . .

IB: Yes.

PS: . . . in Los Angeles.

IB: Yes. There was. Yeah.

PS: Did Andy ever go to the retrospective?

IB: Yes, he was there. He was there. He went and was, I think, enormously impressed by the exhibit. The exhibit was brilliantly done. It was done . . . it started as a dialogue between Walter Hopps whom I had started the gallery with, who moved on as the curator of the Pasadena Art Museum. And he and Marcel had a very lengthy dialogue together. The result of that dialogue was the Duchamp exhibition that Walter did at the Pasadena Art Museum and did very brilliantly. Andy was in California—I can't recall exactly why. Whether it coincided with an exhibit or whether movie activity or whatever. I can't remember why.

PS: His movie activity . . .

IB: I think it was his movie activity, yes, brought him to California, and as the result of that trip he was able to meet Marcel Duchamp, and he certainly saw the exhibit. He was there as a matter of fact on the opening night. I recall that we all went. He and I and Dennis Hopper. I have a photograph at home of that event.

PS: May I see that sometime?

IB: Yeah. Of course.

PS: Do you remember what Andy's reactions were to you about Marcel Duchamp?

IB: Ah. Not specifically. They were private and very contained and other than the fact that he was very moved by what he saw. And somewhat dazzled. I can't tell you specifically.

PS: In the *Elvis Presley* show that you had in '63 . . .

IB: Yes.

PS: How many sets were there?

IB: Ah. That's funny. Andy sent a *roll* of printed Presley images, an enormous roll, and sent a box of assorted size stretched bars, and I called him and said, "Will you come?" And he said, "I can't. I'm very busy. Will you do it?" I said, "You mean, you want me to cut them? Virtually as I think they should be cut and placed around the wall?"

And he said, "Yes, cut them any way that you think should . . . they should be cut. I leave it to you. The only thing I really want is that they should be hung edge to edge, densely—around the gallery. So long as you can manage that, do the best you can." And I said, "Well, if you're sure if that's what you want." And he said, "Yes. Absolutely." And that's exactly what I did. Well, with the help of one or two people, I assembled the wooden bars. They were in various sizes. Sometimes the images were superimposed one over the next. Sometimes they sat side-by-side. They were of varying sizes, as I said. All the same height—roughly six-and-a-half feet, as I recall. Really, life size. The image was life-size. And I got up as many stretched up as required to fill—densely—the gallery, as per Andy's instructions. And I sent what was left on the roll back to Andy and opened the exhibit.

PS: Did he ever tell you why he ever painted the *Elvis Presley* series? Or, did you ever ask him why *Elvis* at this time?

IB: Ah, no. I never did. I simply assumed that the people he selected to paint—well, he had done *Marilyn*, he had done *Liz Taylor*, *Elvis*— were kind of quintessential public people that engaged his interest in some specific way. I always felt that his selection was always something private, somehow, and I never, never queried him about it. No. But accepted it. Always thought that his choice of imagery was *extremely* appropriate, and I was, enormously impressed by his work.

PS: What was the reaction to the *Elvis Presley* show?

IB: Ah. About the same as it was to the *Soup Can* show. By then he was a bit more in the limelight. He was, certainly better known. Many more people came and saw the *Campbell Soup* show in my gallery. But there was *very* little activity, in terms of sales.

PS: Did they sell well?

IB: No. They sold subsequent to the show but not during the show at all.

PS: From the time of the show of the *Campbell Soup Cans* in 1961 to the *Elvis* show in 1963, did you ever meet Andy again in New York?

IB: Yes. Yes. But since I came so seldom, it may, it may have been only a single time. And there was never a time of a really lengthy, elaborate dialogue between us. Just a real, a real passion that I developed myself for his activity, and a real regard, a real respect in every way. That's about as much as I can say, I think.

PS: What happened then, after the *Elvis* show?

IB: After the *Elvis* show? Let me think. What did I do? Oh! I exhibited
 his work. I must have done a group show of various images at one
 point. Ah. I showed the, the big *Brillo Boxes* at one point. I main-
 tained my interest and continued to show him right on through the
 years of my gallery activity, at least, different aspects of his work. I
 had a show much later of his portraits. He did a portrait of myself,
 Brooke Hayward, Marsha Wiseman. I combined them and did a por-
 trait show, and I got Andy a couple of commissions on the West
 Coast, as a result of that. I maintained my interest in his work through-
 out my time in California.

PS: How was the *Brillo Boxes?* How was it mounted? And, do you recall,
 how was the reaction to that show?

IB: Ah. The reaction was, the reaction was always, always a scandalous
 reaction, and there was hardly time for it to evolve into something
 more serious. Even now, it seems to me, Andy is very hard to *grasp*
 in that way. So much of what he does is so sensational, and somehow
 it seems to smother the high seriousness, and the high purpose of his
 work. But I think all of that is there. I mean if I didn't think it was
 there, I certainly wouldn't be as involved as I am, I think. I think he
 is extremely intuitive, extremely poetic—very, very serious as an art-
 ist and highly competent.

PS: Did you ever see any of his films when they were released?

IB: Yes. Almost from the beginning I did. I did. I saw them here. Some
 in Los Angeles but really in New York. I thought that the film activity
 was really extraordinary because at that time many, many artists were
 focused on making movies. They all talked in a regular way about
 their desires to make movies, and the only artist *in* my orbit, who was
 actually doing them, however, however you like, but *doing* them, was
 Andy, and he was doing them in a regular way. And then he was test-
 ing the limits of cinema, I felt, in a kind of extraordinary and curious
 sort of way, and, I found them, always, provocative.

PS: Which ones stick out in your mind, of the early movies?

IB: Well, *Kiss,* the first one I ever saw. A movie with Robert Indiana and
 Marisol. It was a simple movie with two people with their lips pressed
 together. It came on the screen, and there were several people watch-
 ing it. It may have been my first film experience of Andy's and I
 looked and looked and looked and looked and looked and I said, "It's
 a still. It's not a motion picture at all." And I looked and looked and
 looked and looked and *looked* and at one moment I remember Marisol

blinking and the *shocked* response of everybody in the audience. It was something I don't think I'll ever forget. It was just simply extraordinary. I don't think anybody was prepared, and it was a *brilliant* and *memorial* event for me.

PS: When was that movie shown?

IB: In Andy's studio, where most of the Andy movies that I saw were screened at various times in the studio.

PS: Do you remember other memorial points when seeing his movies?

IB: Yeah. I saw *Sleep.* I saw *Empire.*

PS: You saw the whole *Empire?*

IB: No. No. No. I saw as much of it as I could possibly take, which was about two hours worth. [Laughs] And then was forced to give up the ghost. But I adored the idea.

PS: When you saw *Empire,* it was in the theatre?

IB: Ah. It was really Andy's screening it in the studio for people who came and went.

PS: Oh. I see.

IB: . . . but he was wanting, he was wanting the movie to be essentially background. That was really an ideal of Andy's—that it could just *be there* always, and that you could come and go, and you could have lunch or do whatever, you could make an appointment, you could go to a department store, but you could come back and that film would still be there always, ever-present.

PS: How did he show it at the Factory?

IB: Ah. Well, in a projection room with the door wide open so that people were *absolutely* free to come and go. He didn't mind that at all, as a matter of fact, he encouraged people to getting up and leaving. [Laughs]

PS: Were there any other activities involved with the film? That is, for instance, in this film or any of the other films that you saw? Would they still be in that same projection room in the Factory at that time?

IB: Yes, very much.

PS: And would the door be open and people come and go . . .

IB: Ah. Sometimes a bit more formal, sometimes not.

David Bourdon, New York, 16 October 1978

Bourdon is an art critic.

PS: You were just saying that Andy used to play records in his apartment.

DB: I got to like it: hearing this same little, dumb tune on a two and one-half minute record over and over again. It really got to be hypnotic. "Little Eva," I remember. "Little Eva." But, at that point, some . . . Oh, that was it. Yeah. I was still at *Time-Life,* and there was this woman named Ann Halster, who was the music researcher, and at some point . . . The *Time-Life* record people got complementary records of *everything* that was ever produced. So, anyway, they used to have this box where they would throw all the 45s. They would throw all these 45s in this box, and one day she said, "Do you think that Andy would like a collection of these pop records?" And I'm sure that's where they came from. No, I'm not sure, but, I think, it was Ann Halster at *Time,* who just gave Andy this box filled with 45s. And he just kept them by the door, and he would play [them] or give them out as favors (you know: as people were leaving, he'd say, "Here, don't you want a record?" and hand them a record). And, so, anyway, he became identified with pop music, but, also, he went to live concerts.

There were two, about two, live concerts every year that were at the Brooklyn Fox, the Manhattan Paramount, the Brooklyn Paramount (I think), and I would often go with him, with him to those things, and there would be Murray the K or some—Murray the K was one, was our favorite, and the other one was the Good Guys or some other station. And they would get up. They would just get all the top talent, and all of these people would come, and they would sing, you know, their songs live, and we would go, and it would be great fun.

PS: Did he ever listen to jazz, to your recollection?

DB: I've never known Andy to listen to jazz. It means nothing.

PS: Did he ever talk to you about the kinds of books that he was reading?

DB: He does more so although I talk to him much less frequently now. He mentions books now more than he did then. In fact, I was surprised— for years I used to think that he never read anything except his own press and the kinds of magazines and newspapers that would be likely to write about him, but, at some point, I became aware that—gee— he was really reading a lot of books, and, you know, I had got the impression that he read, you know, a book or two a week. And he reads

mainly, as far as I can tell, biographies of movie stars. It's all sort of movie-show business type biographies, but he also has read . . . I think, he reads novels. But he's very much interested in people, and, so, I think it's mainly biography and autobiography.

PS: Do you remember what kinds of magazines he would look at or show you?

DB: Oh, he looked at everything. You know. It was just . . . He, Andy . . . Andy covered newsstands like a brush fire. He'd just— gossip . . . you know: the movie star magazines, the fashion magazines, news magazines. He wouldn't pick up *Field and Stream,* but he would pick up *Playboy* and anything that had pictures, anything that was in any way covering culture with pictures.

PS: It has been often said by him and by others that he is a kind of syn- thesizer, and people posit a part of his genius—someone once de- scribed him as a "sponge of ideas," and some other people have said that Andy, when he wasn't sure what to paint, would ask people, and, for instance, there are stories about Ivan Karp giving him suggestions and Henry Geldzahler . . .

DB: Everyone did.

PS: Did you ever give him a suggestion that turned out to be a series?

DB: It wasn't so much. . . . I used to provide him with photographs. There were lots of people, who would go through and if they . . . they find, you know, a photograph of a particularly wretchy car crash, and they would send it to Andy. But it was mainly the, ah, the Disaster Series, where people sent him pictures. I mean, everybody was scouting. Everybody knew what kinds of pictures he wanted. And, ah, I think, as far as an idea for a series goes, I think, that Henry Geldzahler did give him or encouraged him to do the *Flower* series. But, you know, you're on very risky ground when you start crediting people with giv- ing Andy ideas because it's true—I agree with everything that you've said about all those people, whoever they are, about Andy being a syn- thesizer and a "sponge" and constantly asking [for] ideas—I think, "sponge" really gets to the complex cellular core because he wants other people to come up with ideas. I mean, everytime . . . I mean, whenever Andy calls me, even now, he's still asking do I have any ideas for him, but the fact is, you know, he'll only . . . I mean, he doesn't . . . he accepts some ideas and rejects most.

PS: In other words, he's extremely discriminating?

DB: Yeah. I mean, he's not . . . I mean, it would be all wrong to say that . . . that Henry Geldzahler gave him all of his ideas or something like that is much, much . . . not true. Ah. But, ah, Andy is receptive . . . and he does have all of his sensors out, and if he gets enough feeling, if enough people tell him, "You should be doing car crashes," or something like that, or, also, Andy will try out ideas on people who . . . He'll say, you know, "Henry says that I should do flowers," or . . . and, then, he would sort of . . . He gets an initial reading on it to find out how likely it is to go over before he does it. I don't know if that is so unusual. I mean, is it?

PS: Now, you mentioned that people would send in pictures: various kinds of disasters, car crashes, and such.

DB: Well, of course, at the time that Andy was doing those paintings, he was buying—regularly buying—copies of *National Enquirer,* which was different then as it is today. It was very, very sensational.

PS: Like the *Police Gazette.*

DB: Pictures of two-headed monsters. It was a real tabloid with a lot of grizzly pictures and very, very lurid stories. It was all about being buried away and being attacked, you know. And he got a lot of pictures—one of his grizzlier *Car Crashes*—came from there, but exceptional car crashes, you know, could be from anywhere. One was from *Newsweek.* It was the famous picture of a man who was thrown out of his car, and he got impaled on a telephone pole. Well, that was such a freak accident that, I remember, that was *Newsweek,* and it was also in every other paper. I don't know which particular source that it came from, but, I think, in that case that Andy, you know had maybe 24 pen pals who clipped out that photograph and mailed it to him or presented it to him.

 But some of the *Liz's* are very beautiful, and a lot of them are from *Life* magazine—pictures that I sent from *Life* at the time when I was still working there.

 And one of the famous ones of *Liz* is from a *Life* cover: one of her wearing the Cleopatra tiara or headdress. So. Well, I'm not sure. One is from the cover, or if it's not . . . Actually, I'm not sure. Yeah. One is from the cover. I remember seeing one.

 And, then, he graduated to painting society people who liked to think of themselves as being little stars.

PS: Has he ever painted you in one of those portraits?

DB: Oh, no. I can't afford one. Those are 25,000 dollar portraits and

up. . . . No, he's offered to do a drawing of me for 10,000 dollars, but, ah, and, then, he offered to do one of Topper [Bourdon's dog].

PS: During the time that you knew him, did he ever give you one of his recipe books, or did he ever talk to you about his earlier drawings that he would make—his illustrations?

DB: No, he never talked about them and never gave me any of those books. You see, I wasn't interested in that stuff. His recipe book was being remaindered at Brentano's once, and I remember walking by and looking at it, and it was reduced to five, 15 dollars. And I just thought, "Oh." I said, "Oh, that's Andy's book." And I knew it was his book, and it never would occur to me in those days to have bought that book.

PS: That now would be worth 2,000 dollars.

DB: Oh, yeah. It's worth a lot of money. You know, you didn't know it then. It seemed like just a Campy little thing. It wasn't serious. You see, I was involved in serious art, and Andy wasn't serious. And, then, you know, his friends all have little, you know, shoe drawings or cats, and I had a friend who had a couple of the cat things, and she would always try to get me to commit myself. She said, "Oh, aren't these nice? Aren't these sweet, little things by Andy? I just love them so much." And I would have to, sort of, put on a smile and say, "Yes, they're nice. They look good here in your kitchen." But, you know, I never took that stuff seriously. I'm not sure how serious Andy would take them now. And I can see the correspond . . . I can see a very strong connection between early and late work, but I'm not sure if I can take the early work in all serious[ness], you know, it's still not serious. I think, it's a serious interest to art historians. I'm interested in it now, but, ah, you know, it would never occur to me even now to, ah, put one on the wall next to, ah, [laughs], something that is "serious."

PS: Do you remember anything that Andy said to you that you found particularly startling or very phrased by . . . ?

DB: [Laughs] Andy has startled me so many times over the years. He's just full of provocative remarks, and I never have kept a record of them, and there has been so many of them. It would be hard to. . . . I probably would . . . I'd just . . . I'd just never . . . I can't say anything. But that's one of his best tricks. He's just so shrewd, and he's so quick to size things up and to say what nobody else has been able to deduce or have the nerve to say, and Andy will come out with an absolutely brilliant, completely on target . . . [Laughs]

PS: Would you be talking with him, did he ever talk about his own art?

DB: No, I don't remember him talking about his art. I can't say that he never did, but, you know, certainly, he would never talk about anything . . . well, of course, he would talk about his art in terms of what should he do next and did anyone have ideas for him? And, you know, send him newspaper clippings of car crashes and things like that, but he certainly, you know, he never talked about technical things.

PS: How about esthetic considerations?

DB: No, I've never, ah . . . No. He would talk about that. He would ask, you know, if you would like the images lined up evenly, or did you like them more staggered, or did you like them with more splotches, or less, or what did you think of this blank panel with no images, or should it be a panel that was only part blank, or was it better by itself without the blank panel? So, I would say that he did talk about esthetic questions.

PS: Did he ever talk about what he intended or what he meant by a particular image?

DB: Oh, no. Never. No, if he did, it was always in terms of shock, like: wouldn't it be exciting or shocking or provocative if he did this kind of image? I mean, that was an important consideration. He would always try to second guess the audience reaction, and there would be an intent very often to shock or to startle, but things . . . I never heard him talk about, you know, what he thinks those things were supposed to signify anything or have any heavy or ulterior meaning.

PS: Have you read the Rainer Crone catalogue on his graphic works?

DB: No, I wasn't aware . . . You mean the drawing catalogue? The one that is in German?

PS: Yes.

DB: No, I can't read German. Can you?

PS: I have a translation of it.

DB: Oh. . . . Did you get it from him?

PS: No, I did it for myself. . . . One thing that Crone likes to talk about is the blotted-line technique. I was wondering what thoughts you may have.

DB: That's been written about a lot, and Nathan Gluck is the one who knows the most about it. That's a very important part of Andy. You

see, there are these stylistic parallels. You know, the blotted-line leads right into the smudged silkscreen, and in his early work where things were stamped and the color didn't follow the contours—it leads right into the latter work like the *Flowers* over there [Bourdon points to his wall], where the color, where the contours no longer describe the color area. So, that's a consistent thing, and it's very interesting to see how from the '50s, they carry over to a lot of his Pop Art "look," and that it's all there in the '50s. I think that a lot of Andy's traits follow through. . . . Even, there's a predilection for certain kinds of forms, you know, his kind of very floppy, curved forms, as in the *Flowers*. . . . I think that Rainer Crone's probably has done all the homework on those, and picked it up. . . . A lot of it comes from Ben Shahn, and, I suspect, a lot of it comes from [Jean] Cocteau.

PS: Do you think that Salvador Dali had any influence on Andy, as either an artist or as a lifestyle?

DB: I don't know. I have no idea. It's conceivable that he had a big influence as a model, you know, as a life . . . as a model for what a successful publicity-oriented artist could be.

PS: Did Andy ever mention Matisse to you, to your recollection?

DB: No, he never did. I have to say that when I read the Calvin Tomkins' profile on Andy [in John Coplands, *Andy Warhol,* exhibition catalogue (New York: Whitney Museum of American Art, 1971)], which read to me like sheer fiction, though I recognize that many segments of it were, in fact, based on fact, but, somehow, as it got filtered through the whole Calvin Tomkins' writing apparatus, even the stories that were grounded on fact came out sounding legendary, and, by the time he got to the end about how Andy always wanted to paint like Matisse, or whatever that was, I mean, it sounded absolutely apocryphal. I have no idea. I have never heard Andy mention Matisse so that I can't say. . . . I thought it was sheer legend.

PS: Legend?

DB: Yeah. It was a very pleasant make-believe story, but, I think that . . . See, Calvin Tomkins but apparently never could get any, quite grasp of Warhol, and, so, where he really erred was in accepting other people's accounts and taking, you know, when people gave . . . when people gave credit or when people took credit like Henry Geldzahler and somebody else . . . that woman in the French shop [*sic*] who supposedly told Andy to paint *Dollar Bills.* Calvin Tomkins just wrote it down piously as fact, and . . . No, I think, it's

one of Tomkins' lesser efforts. I'm sure that he worked very, very hard on that piece, probably harder than he did on his other profiles because the subject was so elusive and slippery and . . . but the result, you know, just didn't turn out to be one of his better profiles. It was one of his weakest.

PS: Do you think there has been something written so far about Andy that you find particularly appealing, as far as capturing Andy's personality, style, and such?

DB: Oh, there have been so many things. You know, I think, that most of the journalistic stuff has been very, very good. You know: John Wilcock, Gregory Battcock, Howard Smith, Grace Glyck. It seems that whenever I pick up something that just is sort of reporting it . . . I mean, things that are not trying to be comprehensive but just sort of *reportage*, that it's very good and very accurate. But when people, you know, sit down and try to do a heavy number [laughs] it gets, you know, they sort of lose touch with reality.

PS: What was your reaction to Stephen Koch's *Stargazer?*

DB: Ah, I don't know. I just don't know. You know, I read it with great interest, and, you know, I can't even remember . . . I mean, it kept my interest going. I mean, his . . . his thing is more of a meditative speculation on Warhol, and, so, there is very little that one can argue with because it's Stephen Koch's meditations on Warhol, and, you know, some of it was interesting, I thought. . . . I thought it was an interesting book, a book that certainly didn't seem to be about my Andy, but, ah, I can see it was a very legitimate and compelling viewpoint—whatever it was.

 John Perreault [. . .] made one remark once that how Andy was a mirror, and you could read anything you want into him, and, I think, there is a certain amount of truth to that. . . . Any time that you get a compilation—a kind of *Rashomon* kind of view—it's very helpful because it does show this. . . . I mean, it somehow conveys a little bit of this very great elusive character because Andy . . . I don't know. . . . Like Andy has yet . . . I mean, he's extremely predictable. . . . I mean, I can feel that I can feel how he is going to react a lot of the time, and, yet, he is one of the least predictable people that I know. I mean, there's an inconsistency right there, you know. So, I would hesitate to ever second-guess him except that I'm reasonably sure of how he is going to respond on most things but on a lower level. Well, I guess, anyway, that surely must help account for Andy's fascination for a great many people that he is just so open and recep-

tive to ideas, and he listens. And he's just a very alive, vital person. He's not closed off. A lot of artists get . . . They reach a point when they just sort of get closed off in their studio. I mean, they no longer want to know what's happening, and they just cease to see new people and cease to have new ideas, and, whereas Andy is and still is a living "sponge," he never becomes "coral."

Tally Brown, New York, 11 November 1978

Tally Brown, who is a professional singer and actress, appeared in several of Andy Warhol's films, including *Batman/Dracula* (1964) and *Four Stars* (1966–67), as well as Warhol's *The Exploding Plastic Inevitable* (1966).

TB: When did I first meet Andy? There was, what we called a launching benefit for the Living Theatre, when they went into exile in the summer of 1964. And I did not know the Underground filmmakers at that point, but I was performing with the Living Theatre. The play that they were doing was *The Brig,* so there were 13 men. So, I sang, and I remember, a lot of people coming up at the end of it and asking me to make movies. And Julien, who, of course, did know them and knew about them—Julien Beck—would say to me, "Do that one." "Don't bother with that." "Do that." And after they left—they left in stages: in other words, a group of the Living Theatre first and then another group and then another group—this was going on all during this very hot summer. And, I remember, it was —I was at a showing of Underground films on the top floor of a museum on West Broadway—a gallery with many, many levels and many flights of stairs, and on the top they showed Underground films that summer. And I was watching [Stan] Brakage and, I remember, that I got very nauseous—it was very humid (you know how I feel about humidity) and the heat with no ventilation and also, as Jonas [Mekas] told me, I was watching Brakage wrong. I was trying to follow it with my eyes, and *you don't.* You let the images happen. You just sit there and let it happen. Anyway, I went downstairs outside in the air on some kind of camp chair, I guess. And Andy, who [had] first heard me, I guess, at this Happening of the Living Theatre's—handed me this little piece of paper that had the address of the Factory that was then (the original Factory, which was on West 47th). Put the piece of paper in my hand and it had a time, and I said, "Okay." And, then—I don't know if this was July or August—but, I remember that the man in the Living Theatre who had been my lover left with a big boat full of—and that was a lovely, lovely launching because we had a big ship launching

party and Tiny Tim brought his cute guitar and sang "On the Good Ship Lollipop" and it was very touching. And I had been adventuring for four days without sleep and with about six people staying here. And I left straight from the boat—with another man from the Living Theatre. The boat hadn't left yet. He drove me to the Factory. And I went upstairs and I saw this sofa in the middle of the Factory, which was one open space there: a huge loft completely open. There was this nice comfortable Victorian sofa which looked like me. It was curvy and round and fat. And I asked somebody, whom I assumed was the director because he was behind the camera—he looked authoritative to me—and you're used to asking when you're a stage actress, the stage manager, whether you can do something. He's the authority figure. So I figured he must be the stage manager. What did I know? I was stoned, and I had been stoned for four days and I hadn't slept for four days. And I said, "May I lay down and take a nap on that sofa?" And he said, "Certainly." And for the whole afternoon, I was trying to sleep. And various strange people kept gathering and attempting to relate to me in one way or another. [Laughing]

And when I saw the footage, I thought that I looked like a very petulant baby whale, sort of thrashing around and trying desperately to sleep and all of these gadflies poking me and demanding things of me. And one of them was Taylor Mead. Now, you have to understand that what makes this funny is that at least half a dozen of them became— well, they *all*—became colleagues of mine, when I became conscious. And at least half a dozen are still close friends, who mean a great deal to me. For example, Taylor Mead sat down on the sofa. And it just looks like a dragonfly gadding about and goading this creature that's just trying to sleep.

The reason why I did not know that they were making a movie was that where I came from when you were making a movie somebody said, "Lights! Camera! Action!" and they told you what to do and, furthermore, you'd usually learned lines for the occasion and there was somebody behind the camera. *None of these things, none of these factors were present.* Nobody was behind the camera. The camera was just *on.* So, I had no way of knowing, and I was too tired.

Normally, I'm very aware, and I'll understand what's happening. I just wanted to sleep. And that man, who turned out to be Sam Green, who you should also talk to, he was then the curator of the Barnes' Institute in Philadelphia and was a very strong advocate of Andy's work. The man who I thought was the stage manager was Sam Green. Anyway, it wasn't until I saw the footage that I realized that it was filmed.

PS: Was that the movie *Couch?*

TB: Oh! Is that now called *Couch?* (Laughs) *How would I know!?* When
I saw it, it was either *Batman* or *Dracula,* which I remember because
Jack Smith was made up as a kind of combination of Batman and
Dracula. [. . .] That was Jack Smith and Taylor Mead, Sally Kirk-
land and a lot of other people: Jane Holzer. And Beverly Grant.
Beverly Grant is a beautiful, extraordinary, intelligent woman. How-
ever, on that day, she kept leaning over the sofa and running her hands
down my bare flesh. I used to wear bras in décolletage. And, I re-
member calling Mr. Green, who I still thought was the stage manager,
and (laughing) saying to him—this is so unbelievable—I must have
been very out of it: "Would you kindly tell that woman: I will not re-
late to her in this film." *I can't* . . . you know: when I hear myself say
that I crack up! I should tell you that Beverly is at Antioch now. She
has a son who is my godchild. (Laughs) Theodore. Teddy. She mar-
ried another Underground filmmaker named Tonnie Conrad. And they
became—are—close friends. Even though I haven't seen them since
they were last here, sometimes she writes, sometimes she calls me.
Teddy gets on the phone: the godchild. Ah. His baptism was at St. —
——'s, . . . or was it Judson? And I was the godmother, and Frankie
Francine was the godfather. Fortunately, Al Carmines was the minis-
ter! (Laughs) But that's how my Underground career started. That day.
And I was unconscious for it.

PS: (Laughing) Marvelous!

TB: All of these close friends. I did *Roofs* in New York. It was Sam
Green's roof, by the way. I was, obviously, not present at the part on
the beach.

PS: Could you describe the film, as you've seen it? Because I've never
seen it and I can't find it.

TB: Well, not easily. I told you what my reaction was. I remember that
Sally Kirkland . . .

PS: . . . Viewing the movie later . . .

TB: Yeah. But I viewed it last summer. I had as yet no perspective on Un-
derground films. It was just beginning to . . . which I got into—
hugely—as a body of frames of references of experiences. I thought
that Jack [Smith] was fascinating. I remember him with a cape, flung
over this roof, caddying a skull. Oh, he wanted to do—he didn't
know that I was afraid of heights—all he wanted me to do was leap
from one parapet to another with him. That's all! As I went toward the

edge, I turned green. On that day, I remember meeting Wynn Chamberlain, who I subsequently made a film for called *Brand X,* which . . .

PS: Yes. I've seen it.

TB: . . . is a very popular Underground film.

PS: What happened after *Batman-Dracula* in your recollections of Andy and the Factory?

TB: In that period, I started to hang out with them. One of the things that I *always* appreciated from Andy was that his attitude was totally permissive, which is: you could partake as much or as little either as you wanted to or, in the cases of most of the people, needed to. So that there were only periods where I could allow myself the luxury of the all night hangout with the gang wandering around New York, going to events, ending up at Bickford's at oh seven in the morning (on Park or Lex? Somewhere in the 20s)—that kind of hanging out. Because most of the time, I was doing eight shows a week. And I couldn't do it. But Andy never . . . Andy did not, as one whole school of thought has it, *exploit people*. He never coerced you to do anything you didn't want to do.

What it was was a conviction of his vision, his permissiveness, where he *allowed* people to do as much as their compulsions made them do. In other words: he created a perfect outlet for people who were exhibitionistic or needed some *wild* outlet, which they didn't—couldn't—weren't skilled—you know—weren't taught to perform in other ways, were interesting enough to look at, to become Superstars (without having bothered to become actors first). That was true for quite a few of them. And it was made them to be very touching, very—in the end—very heartbreaking because most of them led this *insane* life, where we were the focus of a few hundred cameras and all eyes, and then couldn't follow it. Those are the ones who are dead, who O.D.'d, who committed suicide in other ways. And that's my book. That's what I'm going to write about when I get around to it having the time and the mobility, to write. Those people. That hanging out period would have been '65, '66, '67, as my geography (whatever my work schedule was) permitted.

PS: Tell me about Max's.

TB: Max's Kansas City was run by a man by the name of Mickie Ruskin. It was the only real—*real*—hangout, public place hangout: the way public places are in Paris like the Cafe Fleur—for the Underground.

Filmmakers and the Underground rock movement. Still a hangout for Punk Rock. But it's no longer Mickie's. And no longer "Max's." And the action . . . all of us were in the back room. *Many* of the most insightful and devastating scenes of the movement took place there in the back room of Max's at four in the morning with people wiped out on all sorts of things. There are things that I will never forget. And you can't possibly write anything meaningful without that.

PS: You were also with the Exploding Plastic Inevitable.

TB: He wanted to do a show there—at the Filmore Theatre, a former movie house in New York's Lower East Side—with film. He always had a lot of things going simultaneously. Mixed-media was his invention. The first ones that we ever did: the first Happenings with film, slides, projections, live performance and rock group were Andy's, for example. That's very important in the history of not just graphic art but art. And he wanted Ondine on one side of the stage and me on the other side of the stage, both preaching sermons: me for heterosexuality and Ondine for homosexuality, simultaneously. That was one of the little numbers that I remember. I thought it was a very interesting thing to pursue but at that time I didn't have the time to pursue. I had to do a run of something else.

PS: You were going to mention what else happened.

TB: Yes. This is what became the Electric Circus afterward on St. Mark's Place. It was then called the Dome, and it had been built as a Polish dance hall. That area there was populated—St. Mark's Place is the Village side of Eighth Street and it had been populated by Ukrainians and Poles in the immigrant wave. So, it was a fascinating cultural *milieu* there because there were a lot of old Polish gentlemen and Ukrainian gentlemen, their baths and in the middle of this Andy did a production called the Exploding Plastic Inevitable, which was the first very mixed-media event that I am aware of and, at which at my own whim, what I did was use a projector.

I was flashing slides around: standing and holding a projector. I think that there were six projections, but it wasn't just in the performing area but all around—ceiling, walls . . . there was a balcony there. So, he could walk from the balcony.

And the Velvet Underground. [. . .] It was the first by many years Punk Rock group. I would say that they created the *milieu* but with a lot of differences from their hundreds of imitators. One is that Lou Reed is a brilliant lyricist, an imagist, really. And John Cale (one of the four musicians) is a very, very good musician, he played elec-

trified (or whatever you call that) viola (viola?). I think so. He was an instrument player. It may have been violin, but I think viola. And John [Cale] was a superb musician. And Lou is one of the most interesting lyricists of urban life, in the world. He also is one of the best theoreticians about rock and roll. I mean, he can write about it and talk about it. He's very verbal. Besides that he's a very fascinating, fucked-up guy.

Anyway, the Velvets were performing, and Gerry Malanga was doing a whip dance on the platform with the Velvets. And that was accompanied by Nico on her numbers. A wonderful close-up in a film about the Velvets and Nico simultaneously and all of these projections of other images all over the place. I would say that was a very successful mixed-media event.

And I don't remember being a part of any before that. Happenings, yes. But something that used split screen plus slides plus projections plus music (rock group) plus live [performance]. Photo projections became a part of the way rock music was presented always in an indoor situation. In a theatre situation there were projections on the back wall. That's the first place that I ever saw it, when we did those. And it was *very* exciting. It was the kind of place where your blood pressure jumped 30 points when you entered the door. It was that kind of exciting [situation]. And I remember Danny Fields was experimenting with strobe lights and with strobe light reflection from tin foil, which was literally hypnotic. Literally. You could trance-out on it. It was on the tempo: the light, as well as what the silver did. Many fascinating things about that. The evolution of things.

I suppose the reason why Andy is so significant in twentieth century art is that these things, that I would encounter first by coming in to the Factory one day, were emulated and created cultures around the world. But one day I came in and he was on the floor doing the *Flower* paintings, and I looked. I thought that they were very pretty because I'm sure they reminded everybody of the ———— that their grandmother had, and they reminded me of a platter that I had that had been my grandmother's. And he just looked up and said, "Back to flower painting." I didn't know if they were going to appear in dishes and postcards and every other possible medium. I felt that that was one of the ways that Andy functioned. He would make an object, which was a comment on society: a Campbell Soup can, the helium balloons, the banana. I would then ultimately, you could go into the five and ten [cent store] and buy it: a copy of Andy Warhol's creation, which was his vision of the reality of our culture. So, it was inter-reflected over and over and to my intense surprise, he was recognized seriously as

a person of overwhelming influence, culturally in Europe before here [the United States]. When I went there—to Germany—to sing which was '74, I had done a lot of other things: the film that was known that I was in in Europe was the work of Gregory Marcoppolis. It's called the *Idyllic Passion* and many of the German avant-garde filmmakers of the present day, Rassa for example, were all students of Marcoppolis. And, yet, the way I was billed, the way I was known, was a Warhol Superstar because Andy was so famous that if you had been any part of that that was the identity that was given to you. Although it was a very minor part of what I was and I would realize it because there were festivals of his work in Berlin. Berlin was *always* behind by virtue of its cultural isolation, by virtue of its political isolation. And when I got there in '74, "Warhol" was the single most recognizable word about me, which gave me a very accurate indication. And there was all of these young filmmakers imitating him.

PS: Do you remember any by name?

TB: Well, I just made a movie for one. That's Rossa von Brownheim. And I would say they were quite numerous. I know a *lot of* German filmmakers. Most of the ones that I work with or know or am going to make films with *weren't* imitating him. Jonathan Brill, Lola Lampart, . . . definitely not, but many of them are: Schroetens, Werner Fassbinder . . . but Pop Art certainly has influenced them. And to most people in Europe, Pop Art is synonymous with Andy Warhol.

PS: The *only* filmmaker that I can think of off-hand—it seems to me—to be influenced by Andy is Michael Snow.

TB: Um-hum.

PS: Can you think of any others, off-hand? Americans . . . Germans . . .

TB: Technically or conceptually?

PS: Both.

TB: Technically: virtually everybody up to and including the way commercials are made. Because jump-cutting—the technique of zooming in and zooming out at high speed—was first an Underground [film] phenomenon. And *then* absorbed into the culture. Now, in Hollywood, they jump-cut in films. They use telescopic lens. But it was done in the Underground first.

 I think that most people misinterpret about Andy is that whatever he says is absolutely direct, is exactly what he means, and people interpret it as a put-on and start looking for ironic meanings, cynical

meanings to it and *it meant exactly what he said*. Once I came in and he and Lou [Reed] were weaving very ugly plastic crosses (plastic is what reminded me of this); white, plastic crosses. And he said, "Isn't it terrific?" And somebody who didn't know him would have thought that it was a put-on, but it wasn't. He meant that he thought it was terrific. Just that. And I think that the most interesting recognition that he ever made in my basic esthetics and the anachronism of my presence in the Factory was in the frame of reference [of the following]. He kept . . . he could not forget having heard me sing and he kept coming up with ideas for making me very rich and very famous as a singer. The first, rather logical, was that I was to be the singer with the Velvets. That's another story.

I was used to professional . . . I could improvise in movies easily. I could not improvise a performance as a singer. I had no desire to because my phase of jamming blues—jamming sessions, singing blues—had been, oh maybe, 10 years worth with very good jazz musicians far preceding the Factory. In the '50s, I was doing that wherever I happened to be singing or . . . and they were very good musicians. There would be sessions afterwards which were jam sessions. And if you know a lot of jazz musicians, they go to a lot of jam sessions. But I was no longer interested in jamming, and I was no longer interested in a performance that was haphazard. And because they were living in a loft on Grand.

To them, time didn't mean very much. A rehearsal was called, I think, at three o'clock. I had to go on that night, naturally. And at three o'clock, Lou started playing me rock 'n roll 'cause he realized that I didn't know any. It turned out that I didn't—did because some of it was blues, which I had been singing for 15 years. And, I remember, one was Tina Turner (whom I *adored*), Little Richard . . . , and I said, "They're blues singers." And I was so dumb that I couldn't tell the difference as to what made it rock 'n roll. What made it rock 'n roll was the amplification and the use of the triplet, which when rock 'n roll was relatively primitive was the predominant form figure. And I was used to the blues beat—the beat of New Orleans' blues. And I really didn't like the triplet. You see, my first—before Lou [Reed]—reaction to rock 'n roll was antipathetic 'cause it always seemed to me that it was raping my mother, the blues. And he really taught me what rock 'n roll meant, the first sense of it. I think, that he thought it was necessary 'cause he was up here one night, and he didn't find anything that he wanted to in my whole record collection, which is an excellent one. It did not have any rock 'n roll. It had a lot of blues, but they were Bessie Smith and Billie Holiday and

Thelonius Monk and Charlie Parker and *nothing* that I would apologize for: *fine* music, but they weren't rock 'n roll. And they didn't interest Lou. So, when I got to the loft, he played me rock 'n roll. And at about four o'clock someone else came, stoned on something else, and about five o'clock somebody else came, stoned on something else. And when it came to work on the key, it was about an hour before I had to leave for the theatre, and they did that—all except John [Cale] by running those things, those arbitrary things that establish the key on the frets of the guitar. And, I thought it was all very unprofessional, which it was but which certainly didn't mitigate the power, its driving force, during a performance. It was just that the method of preparation was something that where I could adjust to it very easily in movies—I could just go with it—when singing, when music was involved, I really could only function with a more structured rehearsal atmosphere. Basically, I would have enjoyed adjusting to it, but, I knew, that I didn't have the time; I knew that I had to be at the theatre and ready to perform. So, I told Andy that that would not work. I could not sing with them.

Andy's next idea was that he decided that I should have my own group. This is after the Velvets were launched in triumph. And it would be called "Children."

Now, we had been through a lot together by then, in terms of both our full knowledge of the difference in my esthetics and the esthetics of the Factory. I would say that our relationship was never exploitation but his conscious use of the anachronism of my presence in his films and his *total* knowledge of the basic, underlying purpose, being that in order to do something well, had to believe in what I was doing, which is directly counter to nihilism, which is the predominant philosophy which he does superbly. And, he'd hate me for saying so, but constructively. And this only came in conflict in terms of music.

So, the next group idea that he brought up was to be called "Children." (That's what I think I remember to consist of all females behind me.) I was to be the lead singer. And he named five or six women, who were Underground filmmakers. And I said, "Yeah. But they don't play instruments." And he said, "It doesn't matter. They can play transistor radios." And I *looked at him,* and he said (just like this), "Oh, right! I forgot. You can only do things that you believe in." And passed on to something else, which, to me, shows full cognition of where the work was at, where I was at. Andy regarded it as just, "Damn! What an imitation . . . ," 'cause he felt . . . he said to me, "You can make a million dollars." And the fact that that was not what I was interested in—doing something bizarre because it would make

a million dollars—was a sort of obstacle that had to be gotten over, *but he did not tamper with it*. He realized that it was, in my case, in relationship to singing, serious. And, indeed, I just kept rejecting them when they didn't suit *my* purpose, which was basically sort of Aristotelian. And you've got to respect and to like someone for that, and that's why I've always felt, no, he's not exploitative. He's the idea man. Yes, he *really* thought he was without question, right. It would have become very famous. It would have become very "in" (a word I hate), but I would not have become very comfortable with it, which he accepted in each case where he would set them up and I'd bat them down. Not "bat them down": it's a lousy idea. They weren't. They were damn good ideas, but I'm not capable of that. Just that. I thought that was an interesting one-liner. Isn't it? Like, "Right. I have to remember to ask Tally to do something that if she doesn't believe in it, she can't do it. What a drag! What a shame!" But *not* putting me down.

PS: Just the realization of . . .

TB: Right! I became very fond of Andy. I truly respect him, and I always felt this hot resentment when he was described as having led people to their deaths 'cause he didn't. *He never pushed anybody into anything that they didn't need and want to do*. And he never *stopped* anybody. That's what I meant when I said [earlier] "permissive."

Ondine—I don't know about now—but at the phase where we were working on *Four Stars* of which Ondine was the star. That was the 24-hour film. Ondine played the president of the United States. He interviewed a lot of people, sitting on the toilet. They *actually* built a set, which is to say: they had a toilet and built a sort of, what I only say: a shack around it. And people came to see the president. And my lover and I were a typical American couple. I sang, "God Bless America" *a capella* with rolls of toilet paper. *That* did not go counter to my principles one little bit. It seemed quite an adequate political statement. [Laughs]

Ondine was on speed, and he was enthralling when he rapped. He never bored me. He never irritated me, *but* there was—seeing as how I elected to do this interview in front of this sort of outhouse—a small problem in that the entire floor outside the door was littered with broken ampules. So, I was lying on crushed glass, which is *not* the most comfortable way to film the scene. [Laughs] But Andy never said, "You have to work here stoned," or "You can't work here stoned." Either one. Just do what you do.

PS: When I was speaking on the phone to Ondine, he felt that one person
 who I should speak to or contact is, unfortunately in California. I don't
 remember her name. She was the first one to ask Andy for a contract
 in a movie, and he said, "No." I assume, then, that the question of
 money never came up during the movies.

TB: In that phase. In the beginning it didn't even come up. I wasn't in-
 terested. You know, it shows. I was doing that because it was fun: the
 Factory. It was fun. In *Four Stars,* I remember that somebody handed
 me—not Andy—a release and a dollar. In other words, you signed a
 release for a token (it's pretty token) payment. Then, when there were
 so many Underground films happening—it was a formidable force—
 my Union . . . I put off joining SAG [Screen Actors Guild] as long
 as I could for the freedom to do Underground films. Eventually SAG
 had to create an Underground film contract at lower rates. Of course,
 it could not ignore the existence of the Underground, nor could it
 capitulate, nor could it permit its members to work for free. Now,
 knowing that, when I began there was no SAG Underground film con-
 tract. I just put off joining. I turned down quite a few what I call
 "Overground" films because I didn't want to give up that freedom. I
 enjoyed making them so much. [. . .] And this whole [loft] area was
 used for filming. And when I came in and saw the *Flower* paintings
 the first time, there were big things on the floor, and Andy was kneel-
 ing on the floor, working on one. Over here [diagramming the loft
 space] is where I approached. Whereas, when I came in and saw the
 helium balloons, which was the set for *Camp:* the whole silver set, the
 set was here and the balloons were on the ceiling.

PS: Do you know why he did, specifically, the helium balloons? What
 they symbolized?

TB: Yeah. Because they would float. They'd stick to the ceiling.

PS: I don't understand. Why helium balloons?

TB: Well, because everything was silver that season, and they were cov-
 ered with silver. [. . .] They were the decoration of the ceiling.

PS: Do you remember nicknames?

TB: These were all, almost all, made up names, *not* nicknames, but
 Superstar names. Ingrid Superstar was not born Ingrid Superstar.

PS: But born . . . ?

TB: I would never have been rude enough to ask.

PS: What else was it like at the Factory?

TB: I told you: seductive. It was that feeling of being really where the action was and of constant activity.

PS: For instance?

TB: Filming. First, very . . . no sound and then very primitive sound (you had to be on the microphone to be heard). Then, as he got more money from selling more issues of things, fairly sophisticated sound. First, there was one camera that couldn't move, then there were more and more. Projectors. Projectors. People. Lovely old furniture: couches, places to be comfortable. Lots of floor. But sometimes the floor, you had to pick your way around the *Flower* or *Jackies* or *Marilyns*. It was a trip.

PS: How did Taylor [Mead] meet Andy?

TB: Oh, my God. I'll ask him. It never occurred to me to ask him since I met Taylor, as I told you, when he kept trying to wake me up in that first movie. I didn't even know who Taylor *was* when I met him. And in all these ensuing years, because I've now known Taylor for 14 years. I've never thought of asking him how he met Andy. [. . .]

 Those things don't occur to me. I think it would have been considered tacitly a breach of taste—one prevailing taste—to ask anyone how they happened to get into that scene or what their real name was or what their relationship with anybody was. There was no sense of documentation. You accepted. You walked in and accepted. I think if you didn't, you wouldn't have fit. You wouldn't have been comfortable. And I could accept it all with enormous interest always and with what turned into genuine affection for a lot of the people. But would not have dreamed of asking Ondine what was his real name. [. . .]

 I would say that the fact of some people did a great deal more [than me] was because they had the money (some means of support to have the time to do more) or the need (the compulsive need in some cases to exhibit themselves or to immortalize themselves). Andy coined the term "Superstar," [. . .] for all of us. We were Superstars. As for somebody who had been a mere feature player working with (you'll pardon the expression) people who are only stars, I found it very amusing and a kind of the essence of what it was about. It was creating a Hollywood outside Hollywood, where you don't have to bother with learning to act, making the rounds, going to agents, getting your 8×10 glossy [photo], doing small parts, being an extra, and gradually working up to becoming a star. You just got on camera and were a Superstar. I thought it was brilliant as a concept! It sure as hell

worked! Now, breakfast cereals are superstars, athletes are superstars, but Andy coined it to embrace this incredible distance between being "a Hollywood star" and a Superstar.

I really couldn't myself see myself as a Superstar because all of the time that I was being a Superstar, I was being a featured player, a principal player or someone in a nightclub or a member of a repertory company. When *Batman/Dracula* (as you've just informed me it was called) came out, I was in McCanter at Princeton. The way I found out was that *Life* magazine had a fashion spread. The fashions were small figures against a backdrop of huge blow-ups of frames from that movie, and the way they found out that I was a Superstar was that there was one of me with very sinister dark glasses in a cape on the roof with Jack Smith. And they said, "Do you do *that?!*" I said, "Oh yes, I've been doing it all alone. I've been going back weekends and doing it, and I was doing it on a dark day." (That's the day you're off in the theatre).

PS: Apparently, there were—I've had personal, on- and off-the-record, chronicles of politicking in the Factory.

TB: Yes. Any place where it's the center of the universe and where the people feel that there are great gains to be had from prominence in jockeying in position in, I guess, closeness to Andy, to be the center of the center—there's bound to be that, particularly if a lot of the people are insecure or don't clearly understand why they are there. So, I'm sure there was. But was I aware of it? No. Was I a part of it? Absolutely not. Any power I wanted, any greater eminence that I wanted, was offered me.

I explained why I couldn't accept those various offers. Nevertheless, I *always* recognized there was, absolutely right: I could have made a million dollars. Yes, I could have gotten famous. But what he didn't know was that I could have also made a million dollars by becoming a female Jackie Gleason 10 years before when I was on the road with *Pajama Game,* and the star's husband heard me sing and said to me, "You can sign with me. You can be a female Jackie Gleason and have your own show." And I knew that wasn't what I wanted to be. I also had been offered a recording contract with Columbia but with someone else choosing the repertory and telling me how to sing it. I wasn't interested. I always had been very clear about what *I* needed creatively. That was always more important to me, which is something that most people in America cannot understand, can truly be more important to you than money and fame. It's what *I* needed to do.

PS: Do you think that those two characteristics are infamous?

TB: Not at all.

PS: With Warhol? Money and Fame.

TB: Absolutely not. There is no quality alive—judgment. I told you that. It's just acceptance.

PS: The reason why I ask you that, some people have claimed that I have spoken with, that Andy was interested in money, and he was always interested in becoming famous.

TB: He did that very well. Don't you think?

PS: Yes. That was my question about Andy.

TB: He did it very well, but as I feel that I've explained, I don't feel that he did it by exploiting other people but by intelligently using their needs to exploit themselves. And *always* other's concepts were his.

PS: Would you like to tell . . .

TB: So I can attach no negative judgment to this. I think he became rich and famous very intelligently, myself. All I'm saying is that in the basic anachronism of my presence there was the fact that I was not interested in money and fame. I was making a small but adequate amount doing my eight shows a week or singing in my club or playing in my repertory company. It was enough for me.

PS: Here I'm thinking of some of the people who wanted fame.

TB: Yes?

PS: Perhaps, for some, desperately.

TB: Yes. Some inner compulsion. Of course, I've said that very clearly.

PS: Yes, and I was . . .

TB: *Their* need to be famous *without* taking the time or the trouble to develop the resources or possibly, having the ability.

PS: You've mentioned this in general. Are there any people specifically that you're thinking . . . ?

TB: Mostly, they're dead because they could not sustain the fame because they didn't know where to go from there. I'd rather talk about the exception: Holly [Woodlawn] is a notable exception. Holly could not only sustain the fame. She could grow. Anybody who had talent could take it from there. Holly can do now a very good live nightclub act.

When Holly started to, she couldn't. She couldn't work live without a script, without a frame of reference, without being told what to do because she was too wiped out. I know this because I was unfortunately there at her first performance. She was the warm-up act for me at the Baths. I had to go out and pick up the pieces.

PS: This was at the Continental Baths?

TB: Yes. And I was so torn because Holly was taking Valiums and got bombed out, and got out there in front of a live audience and didn't—couldn't—do anything at all, literally *but* determined to do it. And Holly's thng that she had to overcome was that the need to be stoned, and, boy!—my admiration of Holly—beside for my love, which is quite separate—is the fact that Holly became this beautifully functioned, disciplined creature who gets out and does her 12 shows a week with *total* control. What a trip that was!! What an exercise in self-discipline and desire to grow! And the talent was there. With the real talent comes the need to do more than that, other than that, use more of yourself or use yourself in more disciplined ways. The ones who are dead couldn't. Holly could follow it up.

PS: Who were some of the other people like Holly?

TB: Candy Darling. Candy Darling before her death was playing in a Tennessee Williams play [*Small Craft Warnings*], doing runs, had genuine talent and total commitment, and that's why Candy's death is so different in that it was not remotely self-inflicted. I talked to Candy who was living then at her parents' home. I had gone to see her at the hospital and Candy never said, "It's hopeless. I'm going to die." Candy said, "I'm getting better. I want to go back to work." I admired Candy enormously. One last thing I did in America on my way to the airport to go to Berlin was attend Candy's funeral.

PS: I don't know anything about Candy except that she appears in *Women in Revolt*.

TB: Oh, my. There's quite a lot to know. Candy is the one who lived most completely the illusion of being a woman. I have the feeling that Candy alone in an apartment or a loft would *never* have done anything that wasn't elegantly feminine, but Candy did get beyond the star bullshit and determined to become an actress and, by gum, did it.

Ted Carey, New York, 16 October 1978

The late Carey, who was a free-lance artist, was one of Andy Warhol's commercial art assistants from 1957 through the early 1960s.

PS: When did you first meet Andy Warhol?

TC: I think, I met Andy in the late '50s. It was around 1957. I think, it was around 1957.

PS: And what happened?

TC: Well, I think, as I remember, I met Andy at an exhibition of drawings that he had done. And the exhibition was at Serendipity, which is a . . . do you know Serendipity?

PS: I know the name.

TC: It's a combination restaurant-boutique. And this was the original one. They started out very small, and it was downstairs in the cellar of a brownstone. And this particular exhibition was an exhibition of drawings of cats. And I think that the title of the show was "Cats with Hats." And Andy at that time had several cats. And, so, he had the idea of drawing the cats, and that was the show. And that was the first time I had met him, and then I saw him shortly after that in the zoo . . . in the cafeteria of the zoo. And he had remembered meeting me. And he said he would like me to pose for him. So, at that meeting we made a date, and he came by and did one or two drawings of me. So, that's how we met. And, then, after that we became friendly, and, this is where I tend to forget dates and events. At that time, I think I was working for N.B.C. And shortly after that I lost my job at N.B.C. I was unemployed.

PS: Now, was this in the design department?

TC: In the graphic arts department. And, so I can remember during this period that one of the things they asked me to do was to do drawings for movies . . . stills for programs . . . old movies that they were going to do on television. And rather than to show an actual photograph from the movie, they wanted graphic art: "Tonight at nine o'clock we will show Marlon Brando in *The Men.*" And that was one of the things I had to do: to illustrate this movie. And I was not able to draw very realistically, and I had to do a drawing of Marlon Brando. So, at this time I was seeing a great deal of Andy. And I can remember telling him how frustrated I was. So, I can remember that Andy helped me with this drawing of Marlon Brando. But that has nothing to do with the drawing that Andy gave me of Marlon Brando. That's just a coincidence that this drawing [Carrey points to Warhol's blotted-line drawing of Marlon Brando on his wall] was done before the incidents of my having to do this drawing of Marlon Brando.

PS: Did Andy do any other free-lance work for N.B.C., besides helping
 you with the [Brando] drawing?

TC: As far as I know, I don't think he did anything for N.B.C. I don't
 think . . . He may have done some television work, not that I knew
 of or at the time that I knew him well. I know that shortly after I left
 N.B.C., for a short time I was working for Andy on a free-lance basis.
 And at that time, Andy was doing a lot of advertising art. And one of
 his biggest accounts at this particular time was the I. Miller shoe ac-
 count, and I used to do the drawings of the shoes, and, then, Andy had
 this rather ingenious technique of doing a very blotted, uneven type
 line.

PS: The blotted-line?

TC: That's right. And the blotted-line he discovered by accident. He said
 that one day he was doing a drawing, and he just, for some reason,
 blotted it, and he saw, when he took the blot off, this interesting line.
 And he thought that this would be an interesting technique. So,
 he . . . he had already discovered this before I met him, so, he
 showed me how he did it. And I would do the actual shoe drawings,
 and, then, Andy, who for years technically just knew how to control
 it because to get the blot . . . it looks like it was all done by accident,
 but to get it interesting, there is a certain control, which after doing it
 for several, you know, years, you can do it very, very *technically*.
 You can control it to a certain amount. So, Andy had this unique con-
 trol of the blotted-line. So, I would never do the actual blot, but I
 would do the drawing. And on a tracing paper. Then, the tracing paper
 would be rubbed-down on a white piece of paper. Then he would take
 his pen and draw on it, and then flip that down on another piece of
 paper. And that was the blotted-line.

PS: As far as you know, was Andy the only one who did that technique?

TC: I cannot believe that no one else ever did it. The only person at that
 time who had a line, that looked like that was it, was not done that
 way. It was Ben Shahn. And Ben Shahn and Andy . . . their work had
 a strong similarity, and, in a way, they were very competitive. And I
 think at that time . . . I can remember once Andy was doing some
 theatre work—and I don't remember if it was a poster or some cos-
 tume design—and, if I can remember, it was for the Spoleto Festival,
 but I'm not absolutely sure. And in some way, Ben Shahn was in-
 volved, whether it was a judge or he had some sort of influence de-
 ciding whether his [Warhol's] work would be used or not. And, as I
 can remember, he more-or-less put Andy down because he was more

of a "commercial artist" rather than a "fine artist," which is kind of interesting now because I think Andy is much more recognized and more famous than Ben Shahn. So, I think that is rather ironical. But anyway, Andy . . . I don't think the work was used. But as far as the blotted-line, I cannot believe that nobody else ever did it, but I don't think that anyone else ever commercialized it as successfully as Andy did.

PS: This brings me to a couple of avenues. One is Ben Shahn. I know that Ben Shahn worked for C.B.S. graphics.

TC: Yes.

PS: As Andy did previously.

TC: Yes. Yes. That was for . . . but that was for "graphics" . . . that was for newspaper and illustration rather than for actual work done on the television screen. And that was what I was doing. And when you asked me if Andy had ever done anything for television that was what I thought you meant. And I'm sure he did a lot of promotion—advertising promotion work—for television. I think, he did more. I think he did something for N.B.C., but I think he did more for C.B.S. because at that time there was an art director whose name was Lou [Dorfsmann], who, I think, Andy did some work for him.

PS: To the best of your knowledge, do you think that Andy met Ben Shahn, or, talked about Ben Shahn?

TC: He talked about him because the work was very similar, and they were competitive. But at that time Ben Shahn had been around longer than Andy. And, I think, [he was] more successful. So, Andy was very aware of him. Whether they actually met, I don't remember, but I'm pretty sure they probably did. Well, there was a similarity in the work. And Shahn was certainly doing it first because he was older, and he was around longer. Now, whether Andy unconsciously developed his more personal version of the Ben Shahn line, or, whether it was calculated, I don't know. But as Andy, as I remember, Andy told me that he really discovered it [the blotted-line] by accident. The other thing that was very unique about Andy's advertising work . . . all the lettering, or most all of the lettering, was done by his mother. Did you know that?

PS: I had heard [of] that in passing.

TC: Yeah. And that was, as I remember him telling me, happened one day . . . he was rushing to do a job, which had lettering, script in-

volved. He was late, and he was hurried, so he thought well, his mother could help him. But his mother could not write . . . read or write English. So, what he would do . . . He would print it, and then she would sit down and copy what he had written, not, I think, knowing very much what she was writing. And, then, from that time, he was so pleased, and apparently the client was so pleased with the result, that from then on, she did all the writing. Even, she would sign his work. That's a Julia Warhola signature. [Carrey points to Warhol's drawing of *Marlon Brando* on his wall.] And his mother was very artistic herself. She also drew, and the two things that she drew were the cats and angels. She was a very religious woman. And, in fact, Andy had a book printed of his mother's [drawings of] cats.

PS: I have seen that book.

TC: And she did beautiful angel drawings. I have some of them, but they're out in East Hampton. And they're charming. They are really fabulous.

PS: How would you characterize Mrs. Warhola?

TC: She was almost like a child. She was rather naive, and being Czechoslovakian, and raised in Czechoslovakia, and being brought here as an adult, her English was a little crude, and, therefore, particularly when she came to New York [City], she was an adult and had very few friends. And she came, apparently, according to Andy, for a visit. And I don't remember the year that she came, but she came for a visit, and she never left. And at the time I met Andy, he was living on Lexington Avenue, between 34th and 35th Streets. And he had two apartments. It was an old brownstone building. And it was over a bar called Florence's Pin-Up. And he had the one apartment right over the "Pin-Up" room, and then he had another apartment on the top floor. And there were, I think, two floors in between the two apartments. Now, that was the time I met him. He had the one downstairs apartment. He began to fix up, I guess you could call it, the "normal" apartment. And the top floor was a studio. This top floor was a mess. I mean, I just cannot describe it. It was piled from floor to ceiling with magazines, old tracing papers, old drawings, a lot of canvases. At that time, Andy, although he was very successful as a commercial artist, he aspired to be recognized as a more serious painter. And I can remember he had stacks of very large paintings done in this style, of this drawing. But they were done on canvas, very, very large, the blot technique, the painted backgrounds, and so there were a lot of those in the apartment.

PS: What ever became of all these paintings?

TC: I have no idea. I have no idea of what happened to those paintings be-
cause he was there until he moved up to Lexington Avenue, in the
90s. He bought a house up there. Now, I can remember being in that
house Uptown several times after he had moved. But I really don't re-
member seeing those paintings on canvases. But he must have moved
them with him. Now, whether they're still someplace in the warehouse
or whether they have been destroyed, I don't know. But they were
very much like this drawing but done on a very, very large scale.

PS: And for the record, this drawing is about three feet high?

TC: This drawing is, I would say, about three feet by a foot and a half,
something like that. Then the other drawing that I have, in the closet
is a shoe drawing. And I think that one is a little bit later. And that
was a part of a group of drawings that he did at a show that was also
at Serendipity. This was after they moved to where they are now on,
I think they are on, 59th Street or 60th Street or something like that.
And these were shoes that he did and dedicated them to a personal-
ity—a *Kate Smith Shoe,* the shoe that I have: *Maria Dora,* who is an
opera singer. But to get back to the apartment, it was a terrible mess.
Plus, he had the cats upstairs. And at this time, I think he only had
two cats left. And he always had Siamese. And I think at one time,
as I remember, he had something like nine cats. And the cats were
only partially housebroken. So the smell was horrendous. And all the
cats he called "Sam." They were all called "Sam." And the one at this
time was cross-eyed, "Cross-Eyed Sam" because this cat he had had
the longest of any of his cats. And he claimed that when he got him,
he was living next to a firehouse. And the cat was sort of crazy every
time the fire engine would go out, it was so neurotic. Now, whether
that was true or not, I don't know, but that is why he claimed the cat
was cross-eyed. But this was his studio. And this is where I worked
for him. I used to go up everyday. And down the stairs. And at this
point of his life, he was beginning to make money. He was concerned
about . . . He should enjoy a little bit, and he should fix-up a home
for himself. Because I think prior to this time, he had not made very
much money. And at this point, he was just beginning to make money.
So, he decided that it was time for him to acquire some nice things and
to have nice clothes, and at this time he was interested in having
clothes made for him. Just the opposite to what he was later, in the
other extreme. And he started to fix-up the apartment downstairs, and
he was very friendly with the boys at Serendipity. And they were fix-
ing-up their shop, and they found all of these wonderful things, and

they would bring them to the shop. They, in a way, were Andy's dec-
orators. And they would get a lot of things in on consignment. And
if Andy liked it, then he would buy it. And, I can remember at that
time, they had brought him a beautiful Tiffany lamp. In the front room
he had a big round table . . . chairs around it. A magnificent hanging
Tiffany lamp. And Andy had the lamp for many months. And, I can
remember, one day they called him. I came over one day, and he was
very upset because he said, "The boys from Serendipity called today,
and they said to me I've got to make up my mind whether I want to
buy the Tiffany lamp or not." So, I said, "Well, are you going to buy
it?" And he said, "No. They just want too much money for it." And
I said, "One thousand two hundred dollars." So, the Tiffany lamp
went back. And I still think it's hanging in the shop.

PS: Could you tell me something about Serendipity? What kind of shop
 was it? What did they specialize in?

TC: It is really much the same now, as it was then. Everything
 is. . . . They went to a larger space, and, I think, now it has become
 very commercial whereas at this time it was more special. And it
 really didn't attract the general public as it does now. Also, now it is
 a restaurant. And now, I think, it is filled with people from the sub-
 urbs who, when it first opened, would, you know, never would have
 come to New York for a place like this. I think at that time it was very
 special, and they went out into the country and bought sort of off-beat
 things. They were, really, the first ones to popularize the Country
 Look. You know, going out and finding old wicker chairs and starting
 that kind of look.

PS: So, essentially, then, it was a kind of antique-curio shop?

TC: Yes. But they were also very good friends with Andy. And they would
 be someone very interesting for you to talk to, because they knew
 Andy earlier than I did. And they helped Andy with his, you
 know . . . They liked his work. They knew him personally. And he
 had several shows with them. He had the *Cats with Hats*. That was the
 show I met him at. . . . Andy was always a little ashamed of his
 mother.

PS: Why was that?

TC: Well, because she had a very strong accent, and Andy, I think, would
 have liked to have thought of his mother was very glamorous. And
 Mrs. Warhola was not glamorous, and I think he felt a little bit
 ashamed of her. In fact, Andy was very timid about people coming to

his house, unless he knew you very well. And even more timid about letting you meet his mother. If you got to meet Andy's mother, then you knew that Andy liked you very much. And I can remember Andy taking his mother to the show at Serendipity. And I remember that he was so nervous. He was afraid to take her. Should he take her? She wanted to go. And, finally, I think she did go to the show, and Andy was, I think, very uncomfortable about it. But then, I think, Andy was very interesting because to me a part of Andy's . . . intrigue. . . . There was something about . . . people just sort of liked Andy. And I think Andy had a lot of insecurities, but he learned to sort of capitalize on them into . . . not be . . . you know, people thought he was peculiar. And most people would feel very inferior. He sort of learned how to capitalize on it. I can remember like when he first went around to a friend who was in advertising. And I can remember, we went out one afternoon to visit Andy, and he said, "Oh, I have to write something about what my art is about." And he said, "I don't know what to say." So, my friend sat down and wrote what it was about. I can't remember whether it was a specific painting. . . . It was the early comic paintings.

To skip some time now, to get on to the fine art painting, which is probably the most interesting to you: Andy finally came about the idea of the Pop Art paintings. He was very much influenced at that time by a woman with whom I became very friendly with, and her name was Muriel Latow. And Muriel had an art gallery called the Latow Gallery in the East 60s, and Muriel was a decorator from someplace in Massachusetts. And she was frustrated because she was not really interested in interior decorating at all; she was really interested in paintings, and Muriel wanted to have an art gallery. . . . Muriel was a sort of overwhelming personality. She was very strong, overwhelming personality, very charming. . . . And we became very, very good friends. And, so, at that time, being friendly with Andy, eventually, Andy and Muriel met. Well, during that year, Muriel's gallery. . . . She was sinking more and more money into it, and it was not paying off, and she was having financial difficulties.

And, at the same time, Andy was pursuing his fine art career. And Andy first, I think, became very interested in pursuing it because I can remember that Andy was spending Saturday afternoons going to the art galleries. And I can remember one day we were in the Museum of Modern Art, and we went to the art-lending service in the Museum of Modern Art. And there was a collage by [Robert] Rauschenberg. And it was a shirt sleeve. It was a small collage. It was like a shirt sleeve cut off and that was it. And I said, "Oh, that is fabulous." And

Andy said . . . well, he said, "I think that's awful." He said, "That's a piece of shit." And I said, "I think, it's really great." And he said, "I think, it's awful." And he said, "I think, anyone can do that. I can do that." And I said, "Well, why don't you do it? If you really think it's all promotion. Anyone, you know, can do it!" And so he said, "Well, I've got to think of something different." So, anyhow, Andy got the idea of doing the cartoon paintings. Now, it was around about this time that I was very friendly at that time, but I could not remember *exactly* of how he got the idea to do the cartoon paintings. As I remember, I think, there was someone in Europe who had been doing it, and there were some publications of his things. Whether Andy had seen those or not and that triggered off the idea or not, I don't know. But I can remember the . . . He started to do the cartoon paintings, and he went out, and he spent a lot of money, stretched these canvases . . . He was doing these paintings. And, so, he was . . . but, then, he didn't know how to get a gallery, who would think him serious enough, who would show him.

 And, so, I can remember, one Saturday afternoon going into Castelli [Gallery], and I was in looking at a show, and Ivan [Karp] said, "Oh, I've got something to show you." So, I said, "What is it?" He said, "Come to the backroom." So, we went into the closet, and he pulled out this big Pop Art painting, and I can't remember what it was, but it was a cartoon-type painting. And I said, "It looks like Andy Warhol." And he said, "No, it's Roy Lichtenstein." And I said, "Well, it looks very much like some paintings that Andy is doing." "Yes, we've heard that Andy is doing some paintings like this," he said, "Leo [Castelli] would like to see them. So, tell Andy to give us a call." So, I went home and called Andy—no, I think, I went right over to Andy's house (he was now living up on Second [*sic*] Avenue in the 90s), and, so, I said, "Prepare yourself for a shock." And he said, "What?" I said, "Castelli has a closet full of comic paintings." And he said, "Yóu're kidding?!" And he said, "Who did them?" And I said, "Somebody by the name of Lichtenstein." Well, Andy turned white.

 He said, "Roy Lichtenstein." He said, "Roy Lichtenstein used to . . . "—as, I remember, he used to be a sign painter for Bonwit Teller, and here's where I'm a little bit confused because Andy I think, . . . this was *before* I saw the paintings at Leo's: Andy couldn't get anybody to show his early cartoon paintings, so, he went to Gene Moore, and Gene Moore said, "Well, I can put the paintings in the windows."

PS: These are Andy's paintings?

TC: Andy's cartoon paintings. But he did put them in the windows, but also at that time Gene Moore was not only doing Bonwit's, he was doing a store on 57th Street around the corner, where I think, it was called Gunther . . . something like that. It doesn't exist any more. I think, it's where the Bonwit's Men Store is now [*sic*]. . . . So, he didn't even put the pictures in the Bonwit's window [*sic*]. He put them in the 57th Street window, and they were there like in August, when everybody was away. [Actually, it was on the 57th Street side of Bonwit Teller during April of 1961 — P.S.] Now. I can't remember. I think, this was done before that, and, as I remember, the implication was: Andy felt that Lichtenstein had seen the paintings in the window and gave them the idea to do his paintings. Now, whether this is true or not, I don't know, but at this time, this is what Andy had felt. So, I said, "Well, Ivan said that Leo would like to see your paintings." So, Andy arranged for Leo to look at his paintings, and, I remember, seeing Leo shortly after he had seen the paintings, and, I remember, his saying — he really felt of all the artists at that time, — which at that time was: Andy, Lichtenstein and Rosenquist — that Lichtenstein was the strongest. And that was the one that he was going to show. But, eventually, he ended up showing *all* of them.

 But, anyway, at that time, Leo was not interested in taking Andy on; so, Andy didn't get in there. Lichtenstein was being shown by Castelli, which was, like, the Pop gallery — Lichtenstein was going to get the credit. So, all of these paintings that Andy had done, even if they had been done and had been recognized as being done before Lichtenstein were, really, going to be anti-climactic. And, I remember, that right about this time that [Claes] Oldenburg, was having an exhibition Downtown in the Store — it was a fabulous store. He just rented a store and just did the whole store in cakes, pies, . . . I mean: it was incredible. And going down there with Andy, and it was just overwhelming and so fabulous that Andy was so depressed. He said, "I'm so depressed." And, I can remember, right about this same time, going to the Green Gallery, and, I remember, I went to the Green Gallery, and I called Andy. I said, "There's somebody at the Green Gallery called [James] Rosenquist, who's doing paintings, like of a bottle of 7-Up," and I said, "They're fabulous," I can remember saying; I said, "I think they're really wonderful. I think, I'd like to buy one." And Andy said, "Oh." He said, "If you buy one of those paintings, I'll never speak to you again." I mean, he was just so depressed that it was *all* happening and he was not getting any recognition. And he was so depressed that he was thinking of showing at a gallery called the Bodley Gallery, which, then, was, I think, near Serendipity: on that same

street; they're now on Madison Avenue. But, it's not a gallery that would have really helped Andy prestige-wise, but he was so desperate, and he knew the man who ran that gallery, and, I think, that he would have even *paid* the gallery to have shown them. But, I think, he may have had second thoughts that this would not have been a good idea, but, anyway, I can remember him saying in desperation, "Maybe, I should have a show at the Bodley Gallery."

PS: Now, who was the manager of the Bodley Gallery at the time?

TC: His name is David Mann, and I don't know if Andy showed any of his early things there or not. He may have. Because I remember, I used to go to the Bodley Gallery, and the Bodley Gallery. . . . They were showing . . . He had a beautiful collage show of Max Ernst. I remember he had a [Saul] Steinberg show. I remember one year Andy bought me a Steinberg drawing from that show. So, I can remember that it was a nice gallery, but not the thing that they show. . . . As I think of the Bodley Gallery today, it's hard for me to conceive of Andy could have seriously thought of showing there at that time with the way the gallery is today, but, anyway, he didn't show there, and, so, in the meantime, this particular day, after going to the Oldenburg Store, I called him when I got home, and I said that . . . I said, "John, Muriel and I are having dinner tonight. Do you want to have dinner with us?" And he said, "No, I'm just too depressed." So, I said, "Maybe we'll come by afterwards." So, he said, "All right. Why don't you come by afterwards." So, after dinner we went to Andy's, and he was very depressed. And Muriel was depressed because she was either, at this time, declaring bankruptcy or was about to declare bankruptcy. And, so, she was more desperate than . . . she was financially desperate. And, so, Andy said, "I've got to do something." He said, "The cartoon paintings . . . it's too late. I've got to do something that really will have a lot of impact that will be different enough from Lichtenstein and Rosenquist, that will be very personal, that won't look like I'm doing *exactly* what they're doing." And he said, "I don't know what to do." "So," he said, "Muriel, you've got fabulous ideas. Can't you give me an idea?" And, so, Muriel said—she said, "Yes." "But," she said, "it's going to cost you money." So Andy said, "How much?" So she said, "Fifty dollars." She said, "Get your checkbook and write me a check for fifty dollars." And Andy ran and got his checkbook, like, you know, he was really crazy, and he wrote out the check, and he said, "All right. Give me a fabulous idea." And, so, Muriel said, "What do you like more than anything else in the world?" So Andy said, "I don't know. What?" So she said, "Money. The thing

that means more to you and that you like more than anything else in the world is money. You should paint pictures of money." And so Andy said, "Oh, that's wonderful." "So, then, either that, or," she said, "you've got to find something that's recognizable to almost everybody. Something you see everyday that everybody would recognize. Something like a can of Campbell's Soup." So, Andy said, "Oh, that sounds fabulous." So, the next day Andy went out to the supermarket (because we went by the next day), and we came in, and he had a case of every. . . . Of all the soups. So, that's, that's how the idea of the *Money* paintings because he did . . . he did *Money* paintings and soup paintings. I don't remember which he did first, but, I think, they were done at the same time. And the first ones were done by hand; they were hand-stenciled. And, then, in order to do them faster, then, he started the . . .

PS: Silkscreens.

TC: . . . The screen, but the early ones were all done by hand. . . . The early—the very first ones, he did by his own hand. Then, later, I think, he . . . particularly when he started the screen, he started having people help him.

PS: Where do you think Andy got the idea of using serigraphy? To do something more quickly?

TC: I think that has always been a thing that Andy has been concerned with: doing everything fast. He's very fast even when he was doing his commercial work although he had to do a lot of the work over again because the customers would always . . . particularly when he was doing the commercial work . . . if he was doing a shoe, and the shoe was not . . . the proportion was not right, that they thought was not right, he would have to do it over. But as the actual work was done very fast, and that was the thing that was so fabulous about the blot technique—very often you could disguise a mediocre drawing by the charm of that line, which had a tendency to make it look very naive. And it was a very fast way of working. But the . . . But it was only natural for him to develop the screen technique because even before that in his commercial work, he often used rubber stamps, which is, in a way, related to screen printing. You know: it's a print technique. So for him to think of the screen particularly with the cans of Campbell's Soup and the money: they were so graphic to begin with, it was just a natural way for him, to think. And he was always concerned (you know) doing things fast because the faster he could do it, the faster he could sell it. And, also, going back to his commercial

work, Andy worked so hard, so hard socializing, so hard making con-
tacts—Andy used to work all night long. Andy used to spend his days
taking little secretaries from [*Harper's*] *Bazaar* to lunch: making con-
tacts, working at it, taking art directors here and there, and when you
work that hard all day, you don't get any work done. That's the reason
why he usually had somebody helping him. The other person who
you . . . who knows him as well as anybody, particularly his early
commercial work, is somebody named Nathan Gluck.

PS: Yes. I'm going to see him tomorrow.

TC: And Nathan . . . prior to when I met him, will be as helpful as any-
body you'll meet. And, yet, I've never met Nathan, but I've heard so
much from Andy about Nathan, and I know that he thinks very highly
about Nathan's work, and I think that Nathan influenced Andy's think-
ing a great deal. The other person who was early . . . was . . . Ed-
ward Wallowitch . . . who was a photographer and who was a very
close friend of Andy during the early '50s. . . . [Carey remarks that
Alex Katz was to have a show at Eleanor Ward's Stable Gallery and
that Ward canceled it and, consequently, had an opening in her 1962
gallery schedule. Warhol's first one-man show in New York of his
Pop Art paintings was then scheduled for that opening.]
 There's an issue of, I think, it is *Artforum* magazine [*sic*], and it's
an article on drawings, and there are some of Andy's drawings in
there, and how they are influenced by [Fernand] Léger. And, I think,
they're not influenced by him at all, and what they are, and unfortu-
nately I have lost the magazine, they are drawings that I did for the
Vanderbilt Cookbook. They're hand drawings. As a matter of fact, I
have in my closet, some rejects of those drawings, and I don't re-
member who the critic is, but they're reproducing these drawings: say-
ing that Andy was tremendously influenced by these drawings by
Léger. *I did these drawings* [in Warhol's apartment-studio] over Flor-
ence's Pin-Up, and neither of us were any more influenced by Léger,
and I have often thought of asking Andy if he'd sign them for me,
and, unfortunately, I have lost that magazine, and if I ever come
across it . . .

PS: It's *Art in America* . . .

TC: You know it?

PS: Yes, It's an article in *Art in America* . . .

TC: Yes.

PS: . . . In the special Andy Warhol issue . . . [see Joseph Masheck,

"Warhol as Illustrator: Early Manipulations of the Mundane," *Art in America,* vol. 59, no. 3, May-June 1971, pp. 54–59.]

TC: Right. Well, I'd love to see it. I guess, you could get it at an old bookstore. Well, I had a copy, and somebody took it. And I've always thought about that, and I have the drawings—the rejects; I don't have the ones in that book—because Andy was working on that book. I remember that he worked like two years on that book, and he was having such trouble with the publisher, getting the things: if the hand wasn't exactly . . . , they were saying, "That's not the right way," or, if the teapot, the handle wasn't this way, . . . and he was working and rejecting and, so, finally, he said, "If you finish the book for me," he said, "I will pay you the whole fee that I'm getting paid just to get rid of that book."

PS: How much, may I ask, was the fee for the book?

TC: . . . And I can't remember. Maybe, it was like a few hundred dollars or like four or five hundred dollars or something like that. I can't remember.

PS: So, you were the ghost illustrator for the first edition because Andy is credited for the illustrations?

TC: Right. . . . He had done part of the book already. I could probably tell [who did what] because the rejects had to be done over; so, in the book, there would have to be something very similar to what I have, to which . . . was changed a bit, but I think it's a lot of nonsense . . .

PS: Do you remember the origins of the illustrations? Where would you and Andy have gotten the ideas for the illustrations in the book?

TC: Well, the ones that I worked on, where as I remember, they were ones demonstrating: like how to roll a cookie, or the way to pour tea. So, they were I can't remember if we were given the dishes, or, whether we had photographs. I think, maybe, we had photographs. . . .

[Carey remarks that, according to what Warhol told him, because of a phone bill, he changed his name from "Warhola" to "Warhol." Carey then describes Warhol's duplex apartment on Lexington Avenue.]

At the time I met him [in 1957], he didn't have any American things. His tastes were more Serendipity: with Tiffany lamp, the [stuffed] peacock, more of the sort of bizarre and of the unusual. And *I* was very much interested in Americana, and, I think, that Andy got triggered off a little bit—not totally—by me because I had a lot of

Americana. And we went to the country a lot, and we went to antique shops, and, so, Andy started collecting. And I would see things and tell him, you know, "You should buy this," and Andy has an incredible Punch cigar store [figure] . . . that we found in Pennsylvania. . . . And at the time that I met Muriel, and Andy and I had started collecting contemporary paintings; so, when I started collecting contemporary paintings, for some reason, I had decided that I was no longer interested in Americana, particularly because of Muriel's influence. So, I got rid of everything, and Andy liked most of the things that I had, and he particularly wanted . . . a marvelous French iron bed. . . . And I had a corner cupboard, a pine corner cupboard and several other things, and so I said, "Well, if you buy everything, I'll sell you everything for what I paid for it." . . . [Carey describes his portrait of Warhol.]

At this time, he did an awful lot of tracings. He would take photographs and blow them up, and, then, simply pencil-trace the drawing then rub it down on a piece of paper and then do his blot drawing. Which is interesting because his later work—the paintings—were so much involved with photographs, which, in a way, there is a relation to the early blot drawings for photographs that were blown up, traced and then blotted. Now, he just does photographs, blows them up and silkscreens. . . . He relies a lot on tracing from photographs which implies, I think, that one cannot draw. But I think in Andy's case, a lot of it is laziness or a way of getting something done quickly because Andy can draw beautifully. . . .

I can remember earlier things. Andy was working on two projects in the late '50s. One was, that he was planning to do, a book. And this was stopped because he started to get involved in the important, in what he considered fine art painting and to have continued with something like this would have, as far as the project, would have seemed too, probably, not serious enough. And this was a book he was doing on feet. And I think that the original connection was because he was associated with I. Miller [shoes]; that people think of Andy in his association with I. Miller: feet. So, he started doing drawings of celebrity's feet. And he would put an object in with the . . . I remember, one weekend we were in Philadelphia at a friend's, and Cecil Beaton was there, and Andy did Cecil Beaton with a rose between his toes. . . . The other things that he started to do a whole group of *Cock Drawings*. Beautiful cock-penis drawings.

PS: I don't think, I have ever seen those illustrated.

TC: They were . . . They've never been shown, and they're fabulous! He

was going to do a book of those. So, somewhere there's hordes of much more interesting work, much more interesting work than what's being shown. And that's the reason, that's the one thing that I feel kind of sad from a personal standpoint—and this is, I guess, my own personal feelings and tastes about Andy—that he is so much concerned with sensationalizing that he's afraid to be himself and to do something personal at the risk of losing universal audience. And, yet, to me he is so successful now that he could do almost anything. But I don't understand, you know, why he is constantly thinking of something new to do, something interesting to do [. . .] But he's constantly obsessed with sensationalization. . . . [In 1964] Andy was saying, "Give me some ideas for some new paintings." And I said, "Why don't you do just some beautiful, romantic paintings in your screen technique. Just do beautiful, romantic flowers, something beautiful." "Rather," I said, "everyone expects you to do something decadent or something shocking or something new . . . why don't you just shock them," I said, "by doing the other extreme . . . something so beautiful and something . . . very romantic." "And," he said, "ah, well, maybe that's a good idea." But, I thought, he wasn't really excited by it, I don't think. . . .

The *Cock Drawings* were never reproduced, and I don't have any. They were done mostly through friends . . . like if he met somebody . . . at a party or something . . . and he thought they were fascinating or interesting . . . he'd say, "Oh, ah, let me draw your cock; I'm doing a cock book." And, surprising enough, most people were flattered, asked to be drawn. So, he had no trouble getting people to draw, and he did a lot of beautiful drawings. . . .

After Andy did a book, he would usually have little evening parties, where he would usually invite about half a dozen people in that [Lexington Avenue apartment's living] room and sit around the table, and everybody would be given a color, and somebody would put down the pink, and the next person would put down the yellow. Or he would do some all by himself. But very often, he would have parties and have friends help to color. . . .

He always wanted to be glamorous. We used to say, "pencil-thin," and so I don't know if he really works at it now or . . . I think, he's going through a period where he's taking care of himself much more than he used to. He used to love sweets and ate a lot at night— to keep himself going. . . .

Mrs. Warhola was very lovely. Her whole social life was at a New York Czech church. Whenever I was over, she loved to talk. . . . Andy didn't like me talking to her because I wouldn't work

fast enough, and, when he'd come back and felt I hadn't accomplished enough, he'd yell at his mother, "Say, you've been talking to Ted." But as soon as Andy would go out she would come up [to the upper level apartment], and we would just talk. And she loved television, and she loved programs like *I Love Lucy*. And she would laugh. She was like a child. She had a wonderful sense of humor. And, so most of my memories working there are about his mother, sitting there talking to me. And he had the most awful equipment: he had brushes that were so old they'd have three hairs, but he didn't want to get new brushes. It was a *mess,* but it was so intriguing. It was really like fun not work; it was really like fun.

PS: Did Andy speak Czechoslovakian to his mother?

TC: Yes. . . . Julia Warhola went to a nursing home in Pittsburgh and died about five years ago [in ca. 1973]. . . . He was a sickly child. I think, he had rheumatic fever or something. . . . He never talked about it, as if it was serious, solemn, or . . . I think, he was very lonely. . . . He was always, *always, always* secretive about the year and month of his birth. . . . Andy has always been very much *influenced* by other people, and, so, to say what he was interested in music-wise at this period, it would have to be which people he was with at this period, . . . and what they did at the time. . . . I mean, some people might think, you know, the fact that I did the book and those drawings and get no credit for it. But, I mean it . . . it doesn't mean anything to me. At the time I did it, Andy was paying me, and if he's getting the credit for it . . . it's like—do you think Walt Disney designed Donald Duck? . . . What does it matter? And, if it hadn't been for Andy, I wouldn't have the drawings in the book for someone to enjoy. . . . Andy was always impressed and excited by famous people . . . all the fashion work: he got into contact with famous people. I think, he always had a great desire to be famous. He wanted it very badly. . . . I always felt that he had a wonderful sense of humor. I always felt that he was a lot of fun. . . . He had a Toulouse-Lautrec poster of a bicycle. A Magritte lithograph with a tree, and a little door open in the tree. . . . He bought a drawing of Larry Rivers' son by Larry Rivers. He bought it for about 20 dollars. . . . He had things by Ray Johnson and . . . several drawings by Dudley Hopler. Dudley didn't like Andy very much. He did on commission several portraits of Andy and me. . . . He [Warhol] used to spend a lot of money buying books. . . . Andy and I used to go around the galleries and decided to buy art, and Andy had these few others, and he had this Larry Rivers [drawing], so he hadn't this interest before I knew him.

The fact that I was interested and would go around to the galleries . . . and, so, we began to go around the galleries together . . . stimulated his interest [in collecting art] and stimulated mine, so we got very keyed up on it. So, we decided to buy a Jasper Johns' *Flag*. So, we both wanted a Jasper Johns' *Flag*. So . . . I can remember that we decided to call up Jasper Johns, and so we looked up his number in the phone book, and I can't remember if we called him or couldn't get the number. . . . So, in the meantime, we learned that he had exhibited at the Stable Gallery, but, then, or . . . no, he had left the Stable Gallery and was in the Castelli Gallery, and, of course, we found out what the prices were, so we realized it was out of the question buying a Jasper Johns. . . . I think, the paintings were several thousand . . . because, eventually, we did buy drawings . . . his drawings. [Carey and Warhol also bought one work each by Robert Goodnough and Grace Hartigan.] We had gotten friendly with Ivan, and I bought a *Numbers* drawing for about 400 dollars, and Andy bought a *Light Bulb* drawing for about 350 dollars at Castelli's. I bought a CyTwombly drawing . . . but Andy didn't . . . Andy also bought some early lithographs by Johns: the *Flags* and *Targets*. He loved the *Flags*. . . . The *Light Bulb* drawing by Johns at his retrospective at the Whitney last year [1977] is the one that Andy bought. . . . I think, Andy was definitely influenced by Johns and Rauschenberg, not so much by their produced work but by their personality and their success and their glamour and the fact that they were in the Castelli Gallery, and that's what Andy would most like to be. So, I think, he was more influenced by that, that they were "stars" rather than he was influenced by the work, but he probably studied the work and thought, you know, "Well, what have they done that has gotten them there?" . . . I can't imagine that Andy is doing a serious autobiography.

PS: Did you read his philosophy book?

TC: No, I'm sure it's all nonsense. I can't believe he's writing a autobiography because I don't believe that he has the time, the patience or, really, the desire to do something that demanding and that serious. I think, he would be better off, if he were really interested, to have somebody do it for him, but I can't believe that he can devote that much time to do something like this. An autobiography is a hell of a lot of work. Andy could never do it. I don't think, he's capable. *If* such a thing were done, then, I believe, it would be ghost-written. And I don't think he has the patience or the seriousness to sit down and do it as a serious thing. I'm sure it's nonsense. . . .

PS: What do you think is the genius of Andy Warhol?

TC: I think, it's a combination of things. I don't think you can say it's one
thing. I think, it's, one, talent, two, timing, three, tremendous amount
of energy and a tremendous determination and to have a very thick
skin, and that's it.

PS: Do you think that Andy's really thick-skinned?

TC: I think, he's extremely sensitive. I think, he's learned by just being
hurt and disappointed so much to overcome it. I think, he's very sen-
sitive. I think, the genius of Andy Warhol is a little like Truman Ca-
pote. They both have talent, but there are other people who have just as
much talent or more talent. [Both made it because of] the fact that they are
ambitious.

Ted Carey, New York, 13 November 1978

Carey continues in the second interview his recollections of Andy Warhol.

TC: Andy was invited, as I remember, to five or six parties a week, and
he was very curious about people. And he would be invited to two or
three parties a night. . . . He was very curious. [Carey mentions that
for Warhol's projected promotional book of celebrity's feet, Warhol
did draw the feet of Leontyne Price, Tallulah Bankhead and Cecil
Beaton.]

PS: Do you remember Andy writing fan letters, when you knew him?

TC: I'm sure he fantasized writing fan letters, but as far as the discipline
of sitting down and writing a fan letter every day at the time that I knew
Andy, I can't think of him doing it. When I knew him, he worked
very hard and went to parties. . . . Somewhere in the East 60s be-
tween Park and Lexington Avenues, Andy did blotted drawings on the
wall of a photographer's bathroom. I remember, Andy showed me
sketches and tracings for the project. . . . Andy did a table setting for
Tiffany's, and I bought candles and cookies. We used Andy's round
table with the high-back bentwood chairs and bought blue and white
cabbage roses on the slipcovers. Nothing matched. It was my idea to
put a cat on the table, and we put a stuffed cat on the table . . . but
a customer complained. There was a screen behind it. . . .
 Andy *very* much liked money. Andy was very much fascinated
and thought about elegant people, elegant restaurants and all the things
that money can buy. Andy, I think, did want to be a fine artist. He
did want to do something but not in a living style *less* than to what he
had gravitated to, and I think, Andy had gotten to the point where he

had reached a success in his commercial work. I mean, he was a nationally known artist. His work was in publications that were all over the country, so he was . . . so he had received a status as a commercial artist. He had made a great deal of money. So, for the first time in his life he had some financial security, and this was probably the first time in his life that he had anything like this. He had had financial security. He had bought a house. He had money in the bank. He had, of course, big expenses, but he, I think, just felt that he wanted to do something more now, and a lot of it was the timing. He was interested in fine art. He had seen people like Rauschenberg and Johns, who were . . . suddenly becoming bigger names than he was and making bigger money, and, so, he began to think, "I can do it, too." And, then, when the Pop thing happened to come along, he sensed the direction, and he had just happened to feel that this was the right direction. . . . It was the right timing for him. . . . [Carey mentions that toward the end of Warhol's commercial art career, imitations of his blotted-line technique appeared and that probably Warhol was unaware of the "cheaper" Warholian blot-like drawings.] Most people, if they're very insecure or if there is something peculiar about them. . . . I think that Andy was very insecure and shy, but he was aggressive in what he had to do, but, I think, he was very shy. . . .

[Carey remarks, again, that most of the work that he did for Warhol concerned the I. Miller shoe advertisements and that he did some drawings for Andy that appeared in *Glamour, Harper's Bazaar* and *Vogue*. Carey also mentions ideas for Hanes stockings, a dishware account and theatre posters. Warhol had an opaque projector, according to Carey, and Warhol often used pictures that appeared in *Life* magazine. Warhol is said to have frequented a used bookstore on 34th Street and to have purchased many old books, using pictures for his commercial artwork in such a way that the tracings were "brilliantly transformed into his own style." Complaining that he had no money, Warhol paid Carey minimal amounts of money for his assistance. Having an assured hand at his blot technique, Warhol would rework tracings or throw such tracings away in most cases instead of beginning again. Warhol used Higgin's or Pelican's India ink.]

He [Warhol] realized certain characteristics that he had that were sort of unusual, and, rather trying to be the way people [were] expecting him to be, he would turn his particularities into . . . rather than trying to hide it, he would flaunt it. And the fact that he was sort of inarticulate: he just wouldn't say anything, or he would be very vague, or he would talk nonsense, and, by not expressing very much of anything, people think there is more. . . . But he had a quality that there was something very sympathetic about him.

Leo Castelli, New York, 8 November 1978

Andy Warhol has been represented by Leo Castelli since 1964.

LC: [Castelli describes Warhol viewing a show of works by Jasper Johns and then purchasing from Castelli one of Johns' drawings of a *Light Bulb* during 1961.]

I had seen [Roy] Lichtenstein just a few weeks before, and he came with those images of consumer products and also comic strips and things of that type. And I liked his work very much and, actually, had taken him on right away. So, a few weeks later, I went to Andy, and it seemed to me that Andy was doing exactly the same thing: the same imagery. So, I said to Andy, "Well, I like very much what you do, and I do understand it, but, unfortunately, another painter (who you probably don't know) called Lichtenstein came and showed me things, and I liked them very much and took him on. But it seems to me now that this would be too close to it for me to take another one on who does this kind of imagery." So, he says, "Well, I'd like to see what Lichtenstein does." And he came to the gallery—I don't know if he had seen Lichtenstein's work before or not—anyway, he saw his work and then he told me, "No. I'm not doing the same thing at all. You are mistaken. This is an entirely different kind of idea that I have." And I said, "Well, I do understand. Probably it is a different kind of image, but, for the moment, they are hardly indistinguishable from each other." At the time, you know, we didn't know. It was entirely new. This kind of thing happened, and what seemed to count more than the way it was done was just the imagery, which was the imagery of the consumer product or newspapers or ads, and so on. So, I said, "No. No. I couldn't take you on because of that." And he was very sad and depressed about it. . . . So, he said, "Well, you'll be sorry because you really don't know what I'm doing." And, then, I asked him, "Well, is there any other gallery that you have showed your work to?" And he said, "Yes. It's the Stable Gallery. Eleanor Ward. And she liked what I am doing very much indeed and would like to have me on." So, I said, "Look. Then you go to the gallery that you want, that wants you, and let's see." And then he had two shows, fantastic ones, in fact, at the Stable [Gallery] which convinced me right away of what he was doing was entirely different from what Lichtenstein had, also, of course, I had more experience then [with] Lichtenstein's work, and what it meant that it was all quite fresh and not easy to understand what he was about. And, so, he had two shows at Eleanor Ward's, two very important shows: one that he had all of those *Brillo*

Boxes and one with *Marilyn Monroe*s and with *Elvis Presley*—you know: the '62 shows. And, then, he said, "Well, you see that it was different, and I still want to come to your gallery." So, that was a rather delicate question, you know: to take someone from another friendly gallery, but, somehow, it was managed, and he came over to my gallery and had his first show in '64. It was a show . . .

PS: That was the *Flowers*?

LC: The *Flowers* show. Yeah.

PS: How was the *Flowers* show received?

LC: Ah. It was well received. Very well received. Quite a few were bought by important collectors. You know, we had a whole group of collectors who were used to buying his stuff and others who started buying. Ah. Jasper Johns and Robert Rauschenberg and then Lichtenstein and [Claes] Oldenburg and all of this was, sort of, familiar, and it was easy for various collectors, who were involved in contemporary American art, and, by and by, and . . . So. That show was all sold out. It was very easy. And they were very expensive, too. And, so, that was my first show of Andy's and my first experience with Andy—meeting him. And, of course, there were all of those other experiences that I had of seeing his films.

PS: Is that a subject you feel a bit touchy to talk about? His films?

LC: Touchy? In what sense?

PS: "Touchy": something you'd rather not talk about.

LC: Well, no. I have nothing . . .

PS: The reason why I ask you is that someone asked me to ask you—in fact, it was Stephen Koch, who wrote the book *Stargazer* [(New York, 1973)] about Andy's movies. *He* believes that you had some trepidation, some misgivings, when Andy began to make films because he was so successful in doing his paintings. That is his supposition.

LC: Well, that's a little ridiculous. I mean, obviously I felt that that was probably the end of Andy doing paintings—being involved with painting—as he was. . . . He would get more and more involved with films, where, especially starting with *The Chelsea Girls*. . . . In the beginning, when he did those portraits of Henry Geldzahler, sitting there smoking a cigar, or the Empire State Building, and so on, it seemed to go very, very well with what original point of . . . departure—not "departure" but . . . original approach to what he was doing

anyway other than painting. So, I liked those very much although I didn't really know at the time how to handle a thing like that. Now, of course, I'm used to showing things in all kinds of media. [Laughs] And it would have been a sin for me then to understand how to handle those particular films, but, in the meantime, I have a whole outfit of videotape and film, and so on, but at that time, it seemed sort of odd and difficult to handle. And then came the more important films, and he did less and less, ah, less and less paintings. Well, obviously, then he became so involved so many people, other people, that it was not like having a regular artist like the other ones in the gallery. He became so involved in many things, being around . . . that, ah, you had to, sort of, approach him—approach his work—whether he wants to do it and if he wants to do it, in an entirely different way.

PS: What would that different way be?

LC: Well, just to hope for the best, really, and take on things if they were there . . . ah . . . not expect him to concentrate on gallery shows at all . . . to do whatever he wanted, whatever was doing at any given time and if then . . . if then something came along—has been done since—came along, it was . . . of something he wanted to show, do it for many years that he didn't want to show at all at the gallery; he felt that he hadn't done anything that was really good enough to show at the gallery. . . . And I had a show after many years: the *Maos* then the *Hammer and Sickle*.

PS: Did you ever sell his paintings during the long stretch of . . . ?

LC: Oh, yes! I always had something around that came up. I always had *access* to his paintings. So, there was no problem. . . . So, he was always with the gallery in one way or another but more with graphics— the silkscreens than with paintings, which he didn't do many—not doing all the time. So. Well, you have to take him, you have to take everybody, as . . . as they are. You cannot or, at least, I would never impose on any artist or anyone to work according to my specifications because, ah, that's not the way, ah, artists like to be treated. And, at first—well, of course, you have to . . . express certain wishes but that even seems to me a little bit too much, so, I always let them do what they want. Always. [Laughs]

[Castelli describes the *Flowers* show as a profusion of flowers. Fifty percent of the price went to Castelli, and Warhol received the other 50 percent. Warhol's *Cow Wallpaper* show "seemed terribly extravagant" with the *Cow Wallpaper* on the walls and *Cow Paintings* hung over the

papered images. Warhol's *Silver Pillows* were devised by Billy Kluever; however, they still rapidly lost helium.]

PS: Did Andy ever tell you why he did the *Pillows*?

LC: Well, Andy never says anything. If you ask him, he will just have a . . . an evasive or no answer at all—just look at you uncomprehending and asking himself, "Why do you ask a question like that?" [Laughs] They are there, aren't they?

Jackie Curtis, New York, 21 November 1978

Curtis, an actor and playwright, was actively associated with Andy Warhol from 1965 through 1973 and has appeared in Warhol's films *Flesh* (1968) and *Women in Revolt* (1970–72).

PS: Thanks for allowing me to talk with you.

JC: Jerry [Lang] said—because I trust Jerry. I adore Jerry. He knows and I know. We know from Hollywood Hall of Fame. We know from June Allyson and all of them. You know? I'm not a hundred years old. I was brought up, I was weaned by M.G.M. And I said so in an article. I said, "When the Loews (theatre chain) went out and M.G.M. died. I had to go." So, I went around like a wreck for centuries. And they said, "If you sleep with everyone here, you can do the Audrey Hepburn Story." I was so stupid? That's how they got me. Okay? You know?

But I think you're very smart to do a historical thing on it because there have been a lot of books . . . okay? There's been a lot of picture books, a lot of word books but a real . . . you know what I mean? Chronological. Accurate. Everything's going. I've got the archives. I can get in touch with people. You know? And I love it when people want to do stuff historically. . . .

And I was going over my thing [i.e., night club act]. . . . And it will be something to see. *How* a person who got hooked up with Warhol . . . who had *talent* (you understand) . . . got hooked up . . . and that's why he always mentioned me in everything he ever does. That's why he rhapsodizes. He says, "Remember Jackie Curtis. Jackie Curtis is one of the most (you know) brilliant young men (you know) in America." No.—"One of the most amazing children in America." You know? . . .

My whole thing is to be a star. Always was. But Andy said, "You don't have to do anything." He said, "You can be a star." But I said, "But I want to be! I want to perform!" You know? You know? But he

did help out a lot. You know? He helped. You know? They all did. I mean: number one, but charity begins at home.

. . . to see talent that you only see once in a lifetime. That's my other self speaking. Not as a performer but as an agent. So, you just won't believe why a person—a lot of people—said, "Why the fuck do you want to get mixed up with Andy Warhol?" I said, "Media." Media. Media. You know? "The happy media." It helps. But, also, I was on the staff, and I was writing other things. And I was very social. I mean: I went out with . . .

I'm going to play females and males because it is now no longer . . . and I've played females before, as well as males, and I'm very exciting as both.

I love James Dean. I used to wear James Dean stuff. I imitated him. . . .

PS: When you were at the Factory? . . .

JC: The desert of destroyed egos . . . you mean?

PS: [Laughs] Did people read anything?

JC: "I read *Interview*," they said. "Oh, really?" I said, "There's a story about me this month." . . .

PS: Some people have described Andy's movies as exploiting the people. Some others have said that he doesn't exploit people: people go there to . . . present themselves, and it's a convenient forum. What do you think?

JC: What do I think? I thought M.G.M., Paramount and 20th Century-Fox and R.K.O., all those studios, were taking too long to get in touch with me. I just went over to the Factory and just decided to *get myself in film* before it was too late because that seemed to me the thing to do. If you were a Warhol superstar, you had it made, it seemed. I was right in the neighborhood.

Everything that he does, 'cause he used to say it to me but he wasn't saying that's what I was doing, it was like cryptology, but I didn't understand. I'd show him a collage that I made. He'd go, "Oooh! That's the new art." And so, everytime I'd show him something I did, you know, like this thing over here [Curtis points], that thing there, he'd say, "Oooh! That's the new art" when I'd show him something. But what he was *really* saying was, "Well, that was the new art, but . . . " You see, you have to keep something new [Curtis snaps fingers]. That's what he's been doing all these years.

PS: One step ahead?

JC: He's just, you know, you know, doing everything, you know, everything that he does is different. Each time it's a new trip. Like when he changed his name.

PS: From Andy Warhola to "Andy Warhol"?

JC: No. I mean from Andy Warhol to "John Doe." And where do you think he got "John Doe" from?

PS: I didn't know he called himself "John Doe."

JC: Because we were watching *Meet John Doe* on T.V. . . . That's my favorite movie. Not to mention Gary Cooper is in it. You know? And we went on the radio. We went on Howard Smith's radio show, and he said, "Oh. I'm changing my name to John Doe."

PS: I didn't know about this.

JC: Well, it didn't catch on, but, I mean, he was changing his art. . . . Everything that he's done has been different.

PS: Yes?

JC: When I got back [to New York City] just last November [of 1977], he invited me to his *Sport* series—silkscreens of sports stars. I didn't know Tom Seger was there. He was all around us there. I was standing with Andy in front of a CBS T.V. camera. Just standing there. You know, waiting for them to set up. And what do you think he was talking about? "We were thinking of doing a movie of my life story. And this is Jackie Curtis. He's one of our biggest stars. Jackie's playing . . . " And then he said, "What are you going to do next?" What is he going to do next? He meant it all. It's always going to be something new, otherwise it's boring.

PS: Some people have described his movies as boring.

JC: Well, that was just like that was all . . . You see, he was just making . . . like . . . Do you know magazines and *True Confessions* and books that you read? That's what that was, only it was film. People doing it. Actually doing it! It was art. It was living art. It was the most . . . It was like *primo*. It was people really . . . That's why they call them "Superstars." They were not acting. That was really happening! See, what I did in the two films that I did for Andy was acting. You know? I was, sort of, trying to get my feet wet.

 You know what they used to say? It was Paul's [i.e., Paul Morrissey] business and Andy's art." You know what I used to say? "How can this be when it's Andy's business and Andy's art?" Andy is only

using Paul just like he's used everybody else. You know? You know? Andy once said to me, "You're using me." I said, "You're using me." It's a moot point, and, besides, he told me, "Nothing lasts forever."

PS: Did he say anything after that?

JC: No. I mean, we were the only ones . . . I'm on the level of Henry Geldzahler or David Whitney or anybody up there. You know? I mean, during the screening of *Women in Revolt,* after the screening. Andy had a little special office that we'd use to sit in, and David Whitney and I were sitting in there. And I'm in some old army raincoat with a snoot on and broken down heels and a knapsack over my back. It looked like, like I was about to sing *My Forgotten Man.* And Candy [Darling] comes traipsing in and said, "I was the best one in that movie. Wasn't I?" And we all looked at her. It was like . . . I don't know what we were talking about. We were talking about something. You know? Something and this . . . *thing* walks in and says, "*I* was the best one. *I* was the best one in that movie. Wasn't I?" And we all looked at her, and David Whitney said, "I was the best one. Admit it." So, we all—the three of us—said, "Yes, Candy, you were the best one in the film." And she looked at me and said, "See." Then, she walked out, and I closed the door, and we roared with laughter. I mean, it was so ridiculous because nobody in the movie relates to nobody. I'm the only one trying to relate to anybody in that movie. They're all doing singles. That's a tortured soul. You don't ask a question like that if you know you're good. Why would I be there, sitting with David Whitney (one of the biggest art dealers in New York or the world) and with Andy in the little private office after the screening while they all are out there bitching and killing themselves? . . .

PS: Tell me about *Women in Revolt.*

JC: It would have been better if Paul Morrissey left his two fucking cents out. And I kept telling Andy. . . . I gave a consistent performance despite my hair color change and my weight change.

PS: How long did it take to make it?

JC: Two-and-a-half years! I was in the editing room, too. My big scene was when I was painting my toenails, and Paul Morrissey wanted that scene out, but I wanted it, and Andy said, "I want the scene in." That's it. I told Andy that I'd be in it only if he'd be behind the camera, and all the scenes that I'm in, Andy shot them. At least, I could say, "I did the movie for Andy." . . .
 I decided as a child to be a star and not to marry or have children.

I sought out stars. I'm always trying to go to the next level. . . .

PS:　You have a tatoo on your arm that says "ANDY." Could you tell me about your feelings and such about Andy?

JC:　Well, Andy is like to me, you know . . . or, was like me when I saw his picture in the paper, it was just like seeing a reflection. I already knew. I already knew we were kindred spirits. There was a picture of him and Gerard Malanga. What is he doing with this person? You know, trying to show the world that he could be photographed with a very attractive boy? Well, that's very . . . I knew he was too great, and, already, I knew that about him—that he was too great. . . .

PS:　What year did you meet Andy?

JC:　1965. On 42nd Street and 2nd Avenue. There I was surrounded by pumpkins on the back of a big green truck. I was staying at the YMCA, which was across from where the old Factory was.

PS:　This is the one with the tin foil?

JC:　Yes. There are photographs of that. In the toilet, all covered with tin foil. Nobody in their right mind would go to the bathroom there. You know? Because there was no paper there except the foil. Oh, it was wonderful and very scary. I mean, everybody wore glass butterflies, heavy clothing, . . . I was scared. I just wanted to go to an East Side school. Irving Berlin was writing his last story, and I knew Andy knew people. And, so, I tried to get Irving Berlin on the phone? You know? And, you know, one thing led to another.

He couldn't understand why I wanted to be a Broadway star. He just thought that I was cute enough to live on my looks: to be one of the great courtesans or something, sit on somebody's lap under a light and sing and that would be it. No. I'm not just some cheap chorus girl who yearns for a star on a door and a dressing room full of flowers. I mean, what makes a person want to work. I don't know. I mean, I don't know. It's what I enjoy doing. I know that's the way it is, and that's the way it will always be.

PS:　You must have had great affection for Andy when you . . .

JC:　Oh, I did! Well, it was like looking through a . . . I mean, the two of our faces were like the faces behind the silver screen door. It was just . . . Well, I mean, he always called me his "roommate," and he wants me to do his life story, says he. I wouldn't mind doing it. It's like two peas in a pod. He's a Leo, and I'm an Aquarius. He says, "You're a Pisces," to me because I'm never an antique [?] on the cusp.

But, I mean, we get along very well.

Andy said to me that I'll have a career and he'll support me, but, after *Women in Revolt,* I got a small Christmas card. As Andy's said, "Nothing lasts forever."

Ronnie Cutrone, New York, 13 December 1978

Ronnie Cutrone, who has known Andy Warhol since the mid-1960s, is at present the artist's painting assistant.

PS: When did you first meet Andy?

RC: I guess, 1965. I wasn't in art school yet. I was interested in being an artist. I was just running around meeting people. I got involved with what was then the Underground Theatre, and I just knew a lot of people, I guess. I guess, the first time I met him was at the Cafe Cino, and I was pretty slicked up. I was wearing a raincoat, and my hair was longer, and it was combed up. And I said to [. . .], "Is that another one of your amphetamine queens?" And [. . .] said, "No, that's [an] amphetamine glory." [Laughs] That was the first meeting, which did not amount to much.

PS: And did you just drop by the Factory after that?

RC: Yeah. I was going to The School of Visual Arts then, and I was studying art, which wasn't getting me any place because I never got to see anybody during the week actually working. Everybody would theorize and talk about art and ways of doing art, and it all seemed like bullshit to me, because nobody was really doing it.

A friend of mind brought me up one day, and I just saw that they were actually working up there and doing things. And so, I went up with him a few times, and, then, I just sort of went on my own, and, so, I would go after school, and I would learn there more about art than I had all day. . . .

PS: What did you learn from Andy?

RC: Just to actually do something than to think about it. Just sort of stop theorizing, which is what we do now in a sort of a way a bit, but at least there is still work being done. . . . But from watching Andy (you know), I just learned firsthand, and just the people were fun. I was pretty young then.

Basically, I got involved because of the Velvet Underground 'cause I was real still in art school and not in the career stage yet. So, I was a good dancer, and I would dance when he had the Velvet Un-

derground play. And then one day, they asked me to dance with them, and I just started touring with them on the Eastern Coast, and I would mostly do it on weekends. I mean, Saturdays. We would do a weekend tour.

And, then . . . ah . . . I was just sort of around. Everybody used to hang out more then, than they do now. Now, it's more of a business situation. There was like a movie every day, and people would hang out.

PS: You mentioned [before taping], when I spoke with you last . . . you were in a movie that was never released on the assassination of President Kennedy. Could you describe the movie? What was it like? And the screening that you saw?

RC: Oh, yeah. As I remember it, it was very loose, naturally. There was a whole bunch of us together one day, and we started. We loaded the camera, and we decided that each character would be played by two people. And I played Oswald with Gerard [Malanga]. Gerard and I were Oswald. For weapons we had bananas. Andy was doing the big, long bananas then. So, that fit in. And our other weapons were giant, inflated Baby Ruths that were about six feet tall. So, we killed Kennedy. I can't remember who played Kennedy. I think, Mary Woronov was one of the people who played Kennedy. So. I don't know. I guess, it went on for about half an hour or 45 minutes.

PS: Were you in any other of Andy's other movies?

RC: Yeah. I was in, I think, one thing that was *Chelsea Girls,* that was mostly edited. It was a version of *Our Town* that, I think, Ronnie Tavel had put together, and it was a very static situation. There was sort of a little wooden theatre box with about four or five people just standing behind it like a counter, and we all had lines that we read very sort of wooden-like. It was, again, like a parody of *Our Town.* I played Bad Butch, who wanted to take someone to the pizzeria. I don't exactly remember exactly. And, so, he sort of left a part of that without the dialogue in the movie *Chelsea Girls.*

I did a couple of others, too. But I don't remember. You see, we used to do about three movies a week, and I was there from '65 to '68. So, that was a three year period.

PS: Here's a filmography.

RC: Well, that wouldn't help me. You see, I never wanted to be a Superstar. That's what would set me apart from people, too. I never really particularly cared. It was great, but I never cared for vying for

Andy's attention: to be as outrageous as possible, to be as "high" as possible, to be as outrageous as possible. And people have looked at me and say, "Oh, you're an Andy Warhol Superstar." I *really* didn't care. I was much more interested in the art and the films in those days, anyway.

PS: Could you tell me, then, about what you liked about . . . what it was like working with Andy on a daily basis then and, say, today?

RC: Well, I wasn't employed by him then. I was there primarily to watch. I really was. I was a teenager—just a young teenager and a middle teenager. I was there basically hanging-out. I was in art school, and a lot of the people there were my friends. So, I wasn't there all day long. I was in school all day long, and I would come in at five or six o'clock and stay until eight or nine. And we would then go to a party and come back there or just go home. I lived in Brooklyn then. So, I would go home and go out. It was always a frantic atmosphere. It was like having cocktails after school or something . . . just to see the people, and, basically, it was just a hanging-out situation. There was a good friend of mine, Eric Emerson, who I used to stay with then, and he was invited to these movies, and I would just go along [with] Eric sometimes. And, then, Andy asked us both if we wanted to do a series of movies together, but I was never that much interested because I was, as I said, acting was not my forte. And I never really cared to be a Superstar because I didn't think it would help my career much any. . . . This was, again, '65 and '66. . . .

Then, by chance, I started working for him in '72 doing soap operas. Vincent [Freemont] was shooting soap operas, and I was doing stills for them that pertained to my own work. These were black-and-white photographs . . .

PS: This was a series that Andy was doing?

RC: Andy was doing the videotape of soap operas, and for my own project from these tapes (not directly from the tapes themselves but from the situations), I was shooting photographs. In other words, they were stills in a way.

PS: I'm not familiar with these at all. Were they ever released?

RC: No. We have archives filled with tapes. They're never shown. Anywhere.

PS: And Andy decided just not to show them or what?

RC: Well, we don't want to be on cable [television] necessarily 'cause the

audience just isn't that big, and the budget would then completely
have to come out of our own pockets, I guess. It would be more work
that it would be worth.

PS: How long did he do the soap opera series?

RC: He did it for about a solid year. Maybe, shooting once or twice a
week. That's what I remember. Anyway, it was about a year.

PS: What kind of . . . Was it a real parody of a soap opera?

RC: Yeah. We used to get groups of people. The main theme was a board-
ing house where all these crazy people lived—and how they as-
sociated with one another, whether it was mentally or sexually or
whatever. Just how they got along in this boarding house. And we
were going to call it *Vivian's Girls* 'cause the lead character was
named Vivian. It was Maxine McKendrick and Paul Pamaro . . . just
a group of nice looking people who were also funny. Oh, Candy Dar-
ling was around then, too, for a couple. It was an automatic set-up for
me taking photographs because all these people were here. . . .

 And, then, Fred [Hughes] asked me if I were interested in work-
ing for *Interview* at all, and since I didn't know anything about edit-
ing, I thought that this was the chance to learn. So, I said, "Yes."
Plus, I was getting tired staying home during the day . . . So, I did
that for a year. Then, I decided I really didn't like being an editor.
Deadlines are just too frazzling all the time. . . . And, then, Fred
asked me if I wanted to work with Andy, which was much more my
field—the art field. So, I said, "Yeah. That's perfect."

PS: And what did you do for Andy at that time?

RC: For Andy? Well, in the beginning . . . He hadn't had an assistant for
a long time—since Gerard [Malanga]. So, he was pretty used to work-
ing on his own, but he knew he should be getting more work out. For
that he needed an assistant.

 So, it took him a while to figure it out and for me to figure out
exactly what I was doing there as his art assistant. And then gradually
different things, different situations, new ideas came popping up and
I started helping him out with the prints mostly, not the paintings. I
usually don't work on the paintings that much. What I do basically is:
I do all the graphs for . . . —not the portraits, not the people, not the
still-lifes like the *Skulls, Hammers and Sickles, Cats* and *Dogs,* the
Shadows . . . the print and the photographs for the prints, *The
Gems.* . . . So, basically what I do is photograph anything that's not
people, and in this way, he doesn't get *sued* from magazines if he cuts
pictures out and things like that.

PS: Like the Patricia Caulfield thing?

RC: Yeah. The *Flowers?*

PS: The *Flowers.*

RC: The *Flowers.* So, that's basically what I do. When I first started, I used to answer telephones for a while, and then it just developed. It worked out.

PS: Does Andy have an idea and tell you to photograph such-and-such? Or, is it a two-way street?

RC: Ah, sometimes it's a two-way street. Mostly . . . he'll just hand me something and say, "See what you can do with it." Like with the *Skull.* It had to be a human skull. Andy said, "Ah, I was thinking of doing these." Sometimes I don't understand what he means, sometimes I do. The *Skulls* I didn't know at first. I just shot. I knew what he wanted, but I didn't know as an image. So, I took the photos, and then we went over the contact sheets and decided it did look good and blew them up.

PS: What did he want for the *Skulls?* What was his idea?

RC: Well, just to have different angles of a human skull with as much shadow . . .

PS: Why? Why a skull?

RC: I don't know why. We never talked about that. So, I get along with him because I don't really ask him. It just sinks in, or, it doesn't. But, for example, the *Hammers and Sickles* were done just because he was in Italy then. He had just come back from Italy, and he said, "Gee, when you walk around Italy, all over the walls no matter where you go, there's in chalk or paint, there's all these images scribbled on everything with hammers and sickles." So, in a way, that sort of makes it Pop, in a funny way. It sort of loses its political meaning, when you see so many of them. It becomes like graffiti or decoration. So, it's just sort of a different way of looking at it. Plus, it's a nice shape. There are nice shapes in a hammer and sickles. So, then, when he came back, he said, "Well, maybe can find, ah, three-dimensional pictures of hammers and sickles." Well, for a couple of weeks—three weeks, actually—I was going to all the Communist stores in New York trying to find something that was three-dimensional, and there just wasn't anything. Most of the symbols I found were just flat. So, we decided to use the real objects. So, I went to a hardware store, a number of them, and picked out the best hammers and sickles that I

could find and brought them back and shot them with three or four rolls of film, all different ways, using different lighting and *that* came about.

PS: How did the *Mao Tse-tung* come about?

RC: That was right before I started working. I think those were the last paintings he did before I came along. I guess because Mao was such an icon. I don't like that word, but, anyway. I guess that's what it is.

PS: So, the first series you really started with was the *Hammers and Sickles?*

RC: No. No. The first one was hand-tinted *Flowers.* I didn't photograph them. I went out and got all sorts of books on Japanese flower arranging and every different kind of flower arrangement. And then, well, he did drawings from those. So, that was basically the first big project that I worked on. And, I guess that was in '73 or '74.

PS: And then what happened after that? Chronologically.

RC: In terms of projects?

PS: In terms of projects.

RC: I don't really remember.

PS: How about the *Shadow* series?

RC: Well, Andy wanted to do something abstract, and he didn't know what. I sort of felt that it wouldn't be too healthy for him to do something abstract, unless it was really something. I mean a shadow *is* something, and it isn't, which is sort of what Andy is noted for in a way. Something, you know, whether it is a definition of an image or an opinion on an image. There's always a double edge to it. So, I thought we should try a shadow because it was actually something physically. We could entitle them easily enough, because all they are are shadows. But he had always admired the corners of his paintings, which is where the screen falls off and becomes just broken dots. Like there may be a definite image in the center of a painting, but around there was always this scattering of dots, and he would always say, "Oh, that looks so pretty! It looks so pretty! What can we do that's abstract?" So, I don't paint. I haven't painted since 1968.

PS: Now, you mentioned the *Gem* series. Has that come out yet?

RC: Well, that's published by us. So, that, in other words, it's not, it wasn't a commission from any gallery or any private service or what-

ever. So, that just comes out by us. Yeah, there's an edition of 20 of those.

PS: And . . . ?

RC: And Andy had bought some big gems and gave them to me, and I photographed them, and, then, we worked on the prints together.

PS: Has all that been printed?

RC: Yeah, that's all printed.

PS: Okay. Because I haven't seen that and that's the reason why I mentioned it.

RC: Well, they haven't been shown anywhere. Again, the *Hammers and Sickles,* I think, have been shown only once. We had prints of those. And we have the *Skull* prints.

PS: How about the *Still Lifes* that I saw recently?

RC: I would go out to the fruit stores and look for the prettiest fruit and then just photograph them.

PS: Why?

RC: Why?

PS: Yeah. I have these Columbo-type questions. Why? . . .

RC: Well, somebody . . . somebody wanted something that, that wasn't too controversial, but that the stuff still had his look about it and his ideas. I don't necessarily know why the fruit, but it's just an academically popular theme. And, also, I mean, I always joke about it. And I like to think that he used to peddle fruit when he was very young that that had something to do with it, but I don't know. I never ask. It just seems so obvious because it was—it's such an academic subject. You know? There's *millions* of paintings of cantaloupes cut in half and things like that, but they're not done with that crisp Warhol style. You know: the shadow, the break off of dots and the cold photograph.

PS: Is the main series of paintings being done now mostly portraits?

RC: No, we're doing the *Piss,* and we're doing, we're doing the *Shadows.*

PS: The *Torso* series. What about . . . ?

RC: Oh, the *Torso.* That was . . .

PS: Now Victor Hugo was the guy?

RC: Well, he brought up a lot . . . we had, I don't know, hundreds of
 photo sessions. Victor would find people in bars and in the street and
 his friends and ask them if they wanted to pose for something that
 would be turned into prints and paintings. So, we did Polaroids of
 that. And Andy would shoot those. Those were the people and he
 would just shoot them and collect all different sizes and shapes and
 positions and, then, just work them into paintings. Again, it's a sort
 of classical theme. I mean, we have hundreds and hundreds and hun-
 dreds of photographs. The ones that actually got done were mostly
 cocks and asses and things. But, I mean: we would photograph pieces
 of arms and arm pits and, maybe, like, whether it was male or female,
 one breast and a shoulder, and, so, it was a way of cutting-up the
 body, and getting nice shapes and shadows again. And just, I guess,
 just another approach to an academic problem. So . . . but only with
 a little flair to it. [Laughs]

PS: What's coming up with Andy besides the book project that he's in-
 terested in?

RC: Well, I don't know what happened to the restaurant. I guess that it just
 fizzled out.

PS: You mean the Andymat?

RC: Yeah. We're always interested in T.V. but that doesn't seem to be
 working right now anyway. Now, it's basically the paintings and the
 book and the prints. We're trying to do more prints. Small editions
 and keep them and have them published by ourselves, and that keeps
 us pretty busy.

PS: What do you think is important about Andy that you've never been
 asked or don't remember seeing discussed?

RC: Well, the way I feel about Andy *really* has . . . it doesn't answer any
 questions but it just holds to that same idea that everything he is, he
 isn't at the same time. And everything he sort of does, sort of
 isn't . . . I mean: it really is sort of a paradox in a way, which I guess,
 is a common theme. It's that whole mystique thing, but that there isn't
 any great secret with underlying myth—but there is because it is
 pretty superficial in a way—so, it's very surface. I mean, we think
 about everything we do but, not aloud. So that, so that the art itself
 is aloud—to take on any variety of meanings, and it's not a cop-out
 to say: ah, it is what it is or, you know, or, it means nothing more than
 that because it really doesn't, and art critics always make me laugh.
 They make me laugh hysterically at times. I mean, because their prem-

ise is that in order to get the particular job at writing in an art magazine—like the *Hammer and Sickle* review . . . I don't remember what it said in general, but it was just so funny . . .

PS: Was that the one in . . .

RC: Yeah. Probably.

PS: Okay.

RC: It just seemed—it all seems so funny to me because I'm so closely involved with it. I mean, what *really* happened is what I told you. We went to Italy and saw that they were just all over the walls. There's no deep connotation except . . . I mean, there is obviously 'cause it's a social symbol. Other than that there's really not much thought given to it except of how it really breaks up into shapes and forms. And that's basically what I really like about Andy's . . . because, basically, he's not pretentious that way. And he doesn't . . . And that's why I get along so well with Andy while we work. I don't badger him with questions. I might ask him once or twice, "Why are you doing the *Hammer and Sickle?*" Or, "Why are you doing the *Skull?*" Andy works on many things at one time sometimes, and that takes all the pressure off of one thing and concentrating on it on and on. So, that's just why I enjoy working for him. He almost dismisses a lot of things so that you don't, you don't have to be weighed down by their presence.

PS: What is it like working for Andy? What is a typical work day like?

RC: They vary. That's why I'm still here. If there was such a thing as a "typical work day," I wouldn't be here. I'd be bored stiff. And I always thought that was impossible, but there is no "typical work day." A typical *slow* day might mean that I'd go to the photo lab and pick up the pictures that we've done the day before or whatever. We all just work together here and try to keep things going, if it's *slow*. But everything is broken down. We all know what we're supposed to do. What we're working on. That's why when you ask me about the book, I really don't know much about the book.

PS: Because you're not working on it. It's not your division.

RC: Right. If I had to work on everything at once, I'd . . . it would sort of dissipate my ideas about the paintings and the prints and take away from that. But we have somebody who is *better* at working on books than I am 'cause I don't know that much about it.

PS: Now after you take the photograph, could you tell me about the pro-

cess of a completed package? How that would go about? Let's take a recent one like the *Shadows*.

RC: Okay. Well, there's the idea. Then, well, in the case of the *Shadows* I just got matte boards and pieces of cardboard, ah, arranged them and tone them up and photographed them. And, then, we get the photographs back, pick the photographs that we like the best, usually more than we're actually going to do so we have a choice. Then, they're matted, ah, into acetates or positives. Depending upon what size we see the images at . . . in other words: if it's a print, the photograph will be blown up on an acetate approximately—almost all the time— 30 by 40. But there are variations. And if it's a painting, larger. And then we just lay it down on white paper and see how it looks blown up. If it holds up, or, if it breaks down. Then, in the case of a painting, it would be mopped out on to the canvas.

PS: . . . You use . . . ?

RC: Just the loose outline of the image, and, then, contrary to popular belief, it's painted *first,* not after the screen is put on. Everybody thinks that—that first we silkscreen the photo image and then he paints around it. But that would be impossible if anybody *looked* because, ah, you'd be painting over the photograph. Where, as you've noticed, the photograph is always intact and it lays on top of the painting. The only reason why it doesn't look that way sometimes is because the paint varies in thickness, so, you have different planes. So, ah, whether it's on paper or on canvas, it gets printed that way. Then we always have the flukey projects. Like, ah, doing a car—the BMW— for the BMW Company, a group of artists including Lichtenstein and Frank Stella and a few others were invited to do—to redesign a car: the outside of it at least. And there's projects like that. Let's see what other ones? There's been a few throughout the years.

PS: The ones that I remember are the Rothschild's wine . . .

RC: Oh, yeah. But that basically is done the same way as a regular silkscreen, whereas the car is different. I mean at one point, we were thinking of maybe making a glass car. You know—so you could see *absolutely* everything. It was totally transparent. So, that, in a way, has nothing to do with the silkscreen but we're still working on that, actually, so I don't know what we're doing yet. And there's a few other flukey projects. I can't think of . . . there are some that drive you crazy.

PS: Like what?

RC: I can't . . . what was . . . oh, I'm trying to think of . . . the car was one of them that really drove us nuts for a while. Let me ask Vincent [Freemont]. Just something not much to do with painting or prints necessarily.

PS: Now, are these projects usually brought to Andy's attention or . . . ?

RC: Yeah, or it's sometimes something that he's been thinking about—that he might use if he's asked to do something for a show . . .

PS: Is there any other thing that bugs you about art criticism about Andy, technically or . . . that you'd like to clear up?

RC: Well, there's the general assumption that other people do his paintings, of course, which is bullshit. I like to make that clear right now. I don't really touch the paintings at all. That's . . . you know . . . we work on it together, we talk about it, you know, and things like that, but nobody really, ah, touches the work except Andy. And, ah, art criticism, in general, just bugs me. I think, I think it's, I guess, it's necessary if you have to . . .

PS: . . . they have to make a living, too . . . [Laughs]

RC: Well, you see, I used to write about art. I wrote about art in *Interview* for years, but I don't believe in writing anything negative. If you see a show and don't like it, why fill up space on a page with something that you don't like when you can be using that same space to the advantage on writing about something that you do like and that you would suggest to other people to see. So, most of the time, it becomes either a problem of not saying anything, or having to write something just to fill up the paper or some ego problem or some personal problem or personal grudge against the artist or whatever. And I always hated the idea of being called an "art critic" even though that's what some people thought I did. Because I'm an artist, and I would never write anything about another artist. It would be foolish. Not only because you'd appear, you know, or whatever—why fill up space with negative things when you can say something that is really good and that you should see.

PS: What should I see in Andy Warhol?

RC: In him?

PS: Yeah. Or about his work?

RC: [Pause] I guess just the energy that is involved—whether if it's enough. If you see nothing else, that's just, ah, . . .

PS: How would you define the energy?

RC: Just the constant . . . ah . . . the old work ethic is what it is. Just the old American work ethic. [Pause] It keeps you out of trouble. [Laughter] It pays the bills and keeps you out of trouble.

PS: Now, who's the people that blows up the . . . is that Kodak?

RC: No. We have our own printer: Rupert [Smith]. He usually has them done . . .

PS: Who?

RC: Rupert Smith. He's our printer. He's our silkscreen printer. So, he takes them to a lab, a lab with special facilities . . . with a big, 60-inch camera, and they blow them up. And this way, we can, you know, even after the painting is done, we can lay down the acetate on top and see what it looks like before its printed. Move it around. That's the advantage of that. Or, just lay it down on white paper and see if it's a strong photograph to begin with. So, it works . . . [Interruption]

PS: Now, I'm going to ask you that "dreadful" question. Has Andy ever said anything to you in general about art that you felt, that made a big impression on you? [Pause] I'm not saying: pronouncements. Something that pleased you very much, even something that esthetically shocked you? [Pause] You know, like, "Oh, that's so different. I've never thought of that."

RC: Oh, yeah. He's very funny that way because he does . . . he sees something and reacts to it immediately. I work with him so well on one level. I mean: on "one level" because, because, for example, I'm not impressed by stars ever. I mean: Bob Marley impresses me somehow. You know, people who usually, more or less are unknown basically. He's like a child that way. He goes, "Oh . . . " And the same way if someone has a great idea or does a show. Even if most people consider him better, he'll still say, "Oh, we should have done that better." "We should have done that." But what I get from Andy about art is mainly because he says, he says it's been done and that's important because he's older than I am and that he's seen more because he's been actively involved with art longer than I have, so, he's, he's, he's really a key for me on what's been done and what's not been done or even if it's worth my effort putting it into—you know—he never discourages me from doing anything personally. But, ah, one time we were trying to think of jewelry ideas and I thought of, ah, casting the rim of somebody's ear or like: one of their fingers, and they would just

slip on this solid gold or solid silver cap over their fingernail. If it was a woman, it could be a long, beautiful fingernail with, maybe, the finger down to there [Cutrone demonstrates]; or, maybe, it would be just the top rim of their ear and lobe cast in gold—very light Italian gold or something in silver, but he said somebody had done that. He saved me a lot of time doing studies and drawings. So, I got a lot that way.

I get a lot of inspiration from just the work: the actual involvement. It's a . . . it's a different approach to art than simply sitting in your studio and staring at a blank wall. There's a lot of people who like to work like that. Or, you know, just the long contemplation process. I mean, it's actually doing the work that is more important than thinking about it, sometimes. . . .

And he is . . . he is really positive about other's work, too. He encourages them, and he'd rather see somebody working on something that is not so great rather than running out in the street, hanging out or whatever. So, just for that alone. . . . I mean, there are moments of grandeur [that] appear, and things we say that you're really overwhelmed by something [that] has just come back from the printers or something. I mean, sure, I think about a lot that we do. It's just not . . . Sometimes, it's just not audible, and that's nice because when you work closely with somebody, you know how you feel about what you're doing towards each other so that there's . . . Sometimes, words just aren't necessary, and that's why criticism and people coming up here [to Warhol's studio at 860 Broadway], trying to find some deep hidden meaning—by the time [that] they find the hidden meaning, we've done something else. So, you know, an artist is always bored with what he's just done—not with what's just done, but, I mean, . . .

PS: But is enthused about his newest project.

RC: Right. You could put it that way. That's a good way.

PS: Because I remember when I walked in the first time, Andy had just finished the *Piss* paintings and was about to go off to France. "Oh, look at these. These are great," [he said to me].

RC: Oh, yeah. Well, they were fun doing. That was the night that was one of the more active projects because of all the experiments [that] we had.

PS: Could you tell me all about the evolution of that particular series? How did that begin?

RC: Well, actually in about 1961 or '62. He had, ah, peed on some white canvases, and he had always saved it, rolled up. And, also, one of the things that he did in the very early '60s, I believe, he put some canvas outside of his [town]house—in front of his brownstone, and the people who would walk to and from work walked over the canvas, and he kept it, and, then, he would unroll it after a period of time. And that was very early to do things like that, actually. I mean, there were Happenings: Allan Kaprow and all that, but this was just, ah, methodical. He . . . he would just do it, and, so, they have been put away for more than a decade now, and he unrolled one and looked at it and said "Gee, I wonder if that would work now."

They were sort of, you know, I guess, ideas about the process of painting or whatever, which is still going on pretty strong, I guess. And they sort of look . . . they sort of look flat on just white canvas. So, he started experimenting with the metallic pigments because the urine oxidizes on—against—the metal and turns it green, and, then, you have . . . you have something else. And, again, it fits in with the idea of an abstraction towards something that is . . . but it is, also, . . . abstract. That is urine, and it is something that is, also, comes out to be an abstract painting. So, that fit in very nicely with the *Shadows* in that sense. So, we just started doing them.

PS: When I spoke with Andy after he came back from Paris, he thought it was . . . great that the French would walk up and sniff the canvases.

RC: Oh, yeah. Right. They do smell.

PS: When we were in the back for the one potential customer, you were showing the new *Mona Lisa,* and you mentioned that they were done this year [1978]. Another "why": why did he happen to do the *Mona Lisa* series again in the style that he is doing now—the painting style?

RC: I think, somebody wanted one, and that's the way he's painting now. So, he did one.

PS: Initially as a commission and then . . . ?

RC: I don't know. I really don't know the story on that, to tell you the truth. It's just . . . I'm not sure if somebody took one or not or, maybe, it's just a suggestion, but, ah, since that's the way he was painting now, it just developed that way.

PS: What else has he done besides the *Piss* series and the *Mona Lisa,* the *Gems* and the *Fruit* still lifes?

RC: Well, we've been working on other things. Ah. Again, we're working

on some abstract prints. Some are *Triangles* or *Pyramids* and others are of *Building Blocks* of different shapes. They're laying out on the front table. You can look at them later. It was, ah, . . . so, yeah, we do a lot of photographs and things and pick the ones that we like. Well, the *Fruit* kept me busy for a while: at least about a month and a half or two months.

PS: Just getting the photographs right?

RC: Well, just waiting for the fruit markets to have the best passable fruit, actually. It was a problem 'cause there are horrible looking oranges and [laughing] great looking oranges. So, I mean, I would have to wait a week sometimes for the produce to change in order to get the best possible shapes.

PS: Andy must take absolutely *hundreds* of pictures within a week. Does he keep all of them?

RC: Yeah. They just get stored away. Filed.

PS: You mentioned that he keeps the videotapes in storage. I'm sure that he keeps his films in storage, and I've heard of all sorts of speculation of why he just, sort of, stores these things that he did years ago, and, all of a sudden, here they are.

RC: I think it's a disease. He just, ah, . . .

PS: You mean, the idea of Andy liking to collect?

RC: Yeah. We keep everything here. Abso[lutely] . . . we have the *Time Capsules* in the back. That whole wall of boxes.

PS: What are the *Time Capsules?*

RC: The *Time Capsules* range from, ah, silverware from an airline, letters, ah, announcements, ah, . . .

PS: Whose idea was that?

RC: It's Andy's [idea] because he saves everything. So, we thought [that] we might as well keep them in boxes. We call them *Time Capsules,* and I have this idea that . . . He always said it would look nice as a show: just to have the boxes. And I was trying to think of a sales point for them and thought, maybe, you know, each box or any box could be bought sight-unseen, but just to make sure that there was really something worth the money in it, there would be a drawing in each of the boxes; and, then, you'd get the box and whatever was in it was in it. It might contain a rubber doll or something, but, as I say, he doesn't throw anything out, which is a problem here.

PS: How far back does the Factory go?

RC: You saw the whole thing. It's twelve thousand square feet, and we've filled it up already.

PS: Now, when did Andy move in here at 860 Broadway?

RC: Seventy-four.

PS: Why did he decide to move?

RC: We needed more space. It's as simple as that. We really . . . There was no room to do anything. Then, we got more people working with us. So, ah, . . . and *Interview* got a bigger staff. *Interview* used to be one tiny little room, and now it's like a whole regular office. I mean, it used to be, really, one little cubby-hole. It was just Glenn [O'Brien] and I running the paper. Glenn O'Brien. And for two people that was fine.

PS: He's now in California?

RC: No, Glenn is still here. He's writing. He's working on books. He has his own cable TV show that he just started. He might be working on a film.

PS: Is he here today?

RC: No. It was great. It was just he and I running the entire paper then. Whereas now, there's about eight people or nine.

PS: I understand that they're making *money* now.

RC: I don't know. It's been a while since I . . .

PS: . . . That's good.

RC: Yeah. It took a long time. It's been going since 1969, which not too many people realize. So, that's almost 10 years.

PS: Have you ever been to his house?

RC: Yeah.

PS: What is it like?

RC: It's, ah, again, it's sort of made up of the choicest pieces that he's collected, whether it be art or furniture or whatever, and there's some very beautiful. . . . Like, there's one room that's all French and looks like that nobody should ever sit there. And, uh, a very comfortable living room with shark-skin furniture and a Jasper Johns painting.

PS: Which one?

RC: Which one? I think, it's the one with the spoon and the fork that hangs [i.e., Jasper Johns, *Screen Piece,* 1967, oil on canvas, 72 × 50 in.].

PS: Okay.

RC: And, ah, it's just very beautiful furniture. It's not unlike many other houses, but it's very comfortable, and he has his two dogs.

PS: Oh. The dachshunds.

RC: Yeah. And, ah, he almost doesn't spend too much time there. So, in a way, it seems to me, like, it's where he keeps . . . oh . . . like, all the furniture you see here, he just keeps things that would go there. It's just like . . . a house . . . it's a beautiful house.

PS: Was it last year [1977] that Andy did the series on the *Athletes?*

RC: Yeah.

PS: What prompted that?

RC: Well, that was through Richard Wiseman. I mean, Andy liked the idea of doing it, and Richard wanted some paintings, and he thought sports stars would be good to do—of athletes—because he was very involved with sports, and he knew some of the athletes. And that just became an ongoing project, much as the *Drag Queens* [or, *Ladies and Gentlemen*] were, for example. It was just shortly before *Torsos.* It was a certain type of activity.

PS: When did the *Drag Queens* series occur?

RC: When? I think, that was '75 or '76. I get fuzzy on my dates. In '75 or '76. . . . And, ah, so Bob [Colacello] and I just went out at night and collected drag queens. As many as we could find. Bob got most of them, actually. I found one or two. And, ah, we just asked them if they were interested in posing, and they got paid for a session; and, then, ah, that was it.

PS: How about—what was it?—the *Cat* and *Dog* series?

RC: That was for a show in London, ah, and, again, I used a lot of my friends' pets. And it just went around. Basically, I didn't use anybody that I didn't know. I just . . . just a lot of my friends did have nice dogs and cats. So, I would just photograph them at night. Go and visit them and photograph them at night and bring the pictures back and look at them, much like *Fruit* or anything else at the time.

PS: How about the *American Indian* series? Was that any particular American Indian?

RC: Yeah. That was Russell Means. He was involved with the Wounded Knee Massacre, which I don't really know too much about (to tell you the truth), but, I think, he's still in court. I don't know. Something like that?

PS: So, it was only that one particular Indian?

RC: Yeah.

PS: And was that for a commission?

RC: That was, I believe, through Doug Christmas.

PS: Who is . . . ?

RC: Who is working in some aspect with Russell Means.

PS: Did Andy do anything in particular for the Bicentennial?

RC: No. Just passed over that. Was . . . ? I can't . . .

PS: I think that the *Skull* series began then. Didn't it? Or . . . ?

RC: Yeah. Around that time. Yeah, we just skipped that over. It was too much like jumping on a bandwagon. It's like with the King Tut exhibition. You know? We're almost afraid. . . . We wanted to do *Pyramids* and *Triangles,* but . . . we probably will do them, but not really relating to the King Tut exhibition. It's just like . . . I mean, it's just too much of a bandwagon thing. I did a Bicentennial piece.

PS: What did you do?

RC: I raised 60 giant moths behind this scrim. [Cutrone describes his project.]

PS: Has Andy done any projects for theatre? Theatre design? Recently?

RC: Not recently at all. I can't think of anything.

PS: How did the Richard Nixon—*Vote for McGovern*—poster come about?

RC: Again, that was a little before my time. That's when he was doing the *Mao*s and *Nixon* and this and that. I guess . . . I don't know who asked him to do it, but, I know, it had something to do with the McGovern campaign, but I don't know exactly who. . . . I guess, it was the [Democratic] Party.

PS: Now, what is the set-up for a commissioned portrait? How does that work?

RC: Well, if somebody is interested, they come and talk to Fred [Hughes] [and] get a price. And if they're really interested in the painting or two or three or whatever, we do a photo session of Polaroids and, then, follow the same process as the paintings.

PS: Hi, Andy.

RC: [To Warhol] I cut up those chartreuse ones, Andy.

PS: And are they like with the white screen behind them, or is it just like around the Factory in general?

RC: It's always just behind a white surface. Yeah. It just, you know, so you can put whatever color background.

PS: So, the process of the painting is that the background is applied first and then the black silkscreen?

RC: The screen. Yeah.

PS: And then touches [of paint] on top of the . . . ?

RC: No.

PS: Never? Okay. I remember at the Art Institute in Chicago there is a huge *Mao Tse-tung,* and it seemed as if there were touches of paint applied after the silkscreen was . . .

RC: No. I don't think so. I came in after the *Mao's,* and it's never been done that way.

PS: Is there anything else that I won't find written down anywhere that will help me to understand?

RC: No, not really. Just, ah, I *can't* think of what hasn't been brought up. It's just wild theories . . . one of [the] things that Andy . . . Instead of . . . He thinks that, ah, the Prince in [Walt Disney's] *Snow White* is the most handsome man in the whole world.

PS: When I was just talking to Andy, I forgot to ask about the canvases with the solar burns.

RC: Those are by a teacher of mine at art school—Charles Ross. We also have one of his *Prisms* outside, also. So, that's Andy's birthday month. Andy was born in August [*sic*]. That's his astrological birthday month: from July 23rd to August 23rd. In other words, it's the month of Leo for 1978.

Emile de Antonio, New York, 14 November 1978

De Antonio is a filmmaker.

ED: And Andy became privately rich and a collector, and I knew him as
a collector. I met him through Tina [Fredericks]. He was then a com-
mercial artist. I introduced him to Frank Stella. He bought at that mo-
ment six little Stellas. Andy has a substantial collection of paintings.
This is '60, maybe. Andy was just beginning to paint. There are two
people who take credit for the forming of Andy's . . . Nobody formed
Andy. Andy himself formed himself. There are two people who take
some credit for helping Andy in his early days. One is Henry
Geldzahler, and the other is myself. In my own film *Painters Paint-
ing,* I asked Andy, "How did you get started painting?" And he said,
"Because of you, De." And what that really means is that: I mean this
is a fairly precise . . . this is a precise recollection. I used to live Up-
town near Andy, when he lived on 89th [Street] and Lex[ington Ave-
nue]. I used to live on Park and 86th. And Andy said . . . I used
to . . . I'm a tremendous drinker, and Andy used to invite me over for
a drink and pick my brains. And we'd chat. We were good gossips:
both of us. And we knew a great many people in common. One day
he put up two huge paintings of *Coke Bottles.* Two different ones. One
was, I would say, an early Pop Art piece of major importance. It was
just a big black-and-white Coke bottle. The other was the same thing
except it was surrounded by Abstract Expressionist hatches and cross-
es. And I said to Andy, "Why did you do two of these? One of them
is so clearly your own. And the second is just kind of ridiculous be-
cause it's not anything. It's part Abstract Expressionism and part what-
ever you're doing." And the first one was the one that was any good.
The only thing—God only knows what it is. And, I think, that helped
Andy make up his mind as to—you know: that was almost the birth
of pop. Andy did it. But he was a little, I think, in a moment of par-
tition there is sometimes a moment of confusion, and, maybe, Andy
was a tiny bit confused as to which way he would go. But I knew him,
say, '59. Sometime in 1959 with Tina [Fredericks].

[De Antonio discusses at great length his friendships with John
Cage, Merce Cunningham, Jasper Johns and Robert Rauschenberg.
Johns and Rauschenberg used the name "Matson Jones" when they did
commercial artwork, assisted by Paul Taylor.]

Once and for all, I think, that the myth of Paul Morrissey and all
of the other people doing the paintings—all of that has to be put aside,
laid to rest and buried because without Andy none of it would have
existed. Andy was the *prima mobela.* He was the . . . the. . . . He
was the spirit of it: without him, none of his work. . . .

When I introduced him [Warhol] to Stella, at that time he owned, to my knowledge, a lot—Fairfield Porter, two Magrittes, seven Stellas, a Jasper Johns. . . . He was very *helpful* to those people, although Jasper was already successful, but Andy had that big townhouse. . . . As you enter from a little stoop, on Lexington Avenue, there is a tiny vestibule—a tiny entry way—and in the entry way there were things like "Test Your Strength" machine, you know: from a fair or a circus or a carnival and an early pinball machine—that kind of thing, and the place was . . . you went up a little flight of stairs and into this one room that was totally paneled. I think, the building had belonged to a psychiatrist and had that soothing psychiatrist kind of effect—of paneling the room that faced Lexington Avenue—that room was like an art director's room. It had a big pivoted drawingboard on a swivel. And sketches: commercial sketches and stuff out of magazines and pin-ups. It looked like a very . . . It looked like a desk of the art director of *Harper's Bazaar,* rather than of a painter. Nobody ever got upstairs. Andy had his paintings up there and his mother, and she was a fairly heavy drinker [and] cleaned the house for Andy [and] made sure that he went to church. . . .

He got rid of people. Andy is to me, essentially, a phenomenon of capitalism: upward and onward and to hell with the people who were there before. That's fine. That's the way life is. But he, ah . . . I once tried to get [. . .] to invite Andy to a party, and she said, "I wouldn't invite someone like that in my house." And then she fawned on him once he became famous. Andy understood the nature of that, better than anybody I have ever known: the nature to exploit everyone and everything while seeming totally passive and doing nothing. When he first moved into his studio on 47th Street, he said, "Oh, De, what's the matter with these girls who have written to me from Parson's School of Design? Look at the letter these girls have written to me." And I looked at it, and it looked like something out of early masochism, you know: these girls wanted to come everyday and just clean Andy's studio, and they were teenagers. And, so, he let them do it. And they used to come and to mop the place and to clean it all up and then be very thankful and then to go home. [De Antonio describes his friendship with Frank Stella.]

It's funny. They—Bob [Rauschenberg] and Jap [Jasper Johns]— didn't want to meet Andy at the beginning. They absolutely . . . ah. I tried to bring them together, and they . . . Andy was too effeminate for Bob and Jap. Ah. I think, his openly commercial work made them nervous because they really had their commercial work. As I say, the rubric of "Matson Jones." Ah. They also, I think, were suspicious of

what Andy was doing—his serious work—because it had obvious debts to both of them in a funny way. And. Ah. That has since passed. But, at the time that Andy was trying to break through and out, ah, Jasper and Rauschenberg were already well-known and successful and making money and not keen to align themselves with Andy.

PS: What was Andy's attitude toward them?

ED: Andy was always a master. He would always say how wonderful they were. But he was always a master of disguise and of commitment. You know, no matter what people said, he always said how wonderful they were. . . .

PS: What is the origin of the *Two-Dollar* painting?

ED: Andy wanted to get into the Castelli Gallery and could not. Leo [Castelli] was very funny about all of those things at the beginning. [Castelli's Gallery is discussed.] And, so, I thought of my own . . . friend Eleanor Ward, who had the most beautiful gallery in New York—the old Stable Gallery—And Rauschenberg worked there as a janitor. Cy Twombly, with whom Rauschenberg was living before he met Jasper, had a show there, but . . . I decided that Eleanor needed Andy. So, Eleanor came over to Andy's place, and I was there with Andy, and I was drinking Scotch out of a Danish white cup, and Eleanor came in, and we started to drink great big quadruple whiskeys in the white Danish cups. . . . Andy was dragging out these pictures, and she said, "Well, I'll give you a show, but you've got to paint me a two dollar bill." She said, "I always carry my lucky two dollar bill with me." And, so, she whipped out a two dollar bill, and Andy made a painting out of it, and that was the first *Two-Dollar Bill*. He then had a show, and, then, they got into a huge argument because Andy insisted on doing the *Brillo Boxes*. [De Antonio describes earlier and unsuccessful attempts to find Warhol a gallery.]

PS: You were good friends from 1959 through today?

ED: No. No. We see each other infrequently. I would say that he and I are still well disposed with one another without being friends. I think the last time I spent any time with Andy was just like this. . . . Ah, Andy in a tape which he did with me last year [1977]. . . . And he arrived with Pat Hackett. Each of them had a tape recorder. And Pat started hers, and three minutes later Andy started his, so that there would never be a run out. And his first questions would begin with a statement, which, you know, would be the second time it was on the record. This time we started talking about film. He said, "You know,

you started me out in film." And I said, "That's not true, Andy. I think that I had a good deal to do with your painting, but film: no." He said, "Yes." He said, "I remember that you used to go out with us when you had a hangover to look at double bills on 42nd Street with David Wynn, and I would come with you." And this is true. . . . David and I and Andy and sometimes with my to-be-wife, who was a fashion model, used to go to 42nd Street with the double bills of the worst films made, and then we'd go somewhere and ah, ah, talk about them. Talk about movies and about what movies should be and, ah, what was wrong with Hollywood and what was wrong with [unintelligible word]. Andy *claimed* on his own tape this is what influenced him in film. I see Andy in a much more . . . a much more different light in films. And he, like everything else, found it for himself. Ah. And I also think—and I don't know if anybody has written this or not because I can't bear to read what most people write about film—that Andy is, surely, a paradigm of the whole history of film. And I think that he meant it to be that way. He began by knowing nothing, and he did very simple badly lit films without sound—which, I think, are among his better films—and, gradually, just as Hollywood evolved—Andy evolved to the point where he had fairly awful sound. Some of those pictures that Gerry Malanga is involved in—about sadism and masochism—I forget the names of them—I'd like to see *The Life of Juanita Castro*—but, ah, until, finally, he got up to slick failures like *Bad,* which he spent a lot of money and had actors and actresses and all that. . . .

Andy had been after me to do a film with him, and I said, "Come on, Andy. You know. Our work is so different in every way. Its politics. Its form." Ah. Call it "Camp" versus something else, but . . . But I hadn't seen him at this point [1965] as often as I had seen him. He would say, "Why don't we do a film?" So, I said, "Okay, I'll do a film which, I think, is an ultimate gesture. I'll drink a quart of whiskey in 20 minutes. Now, Marine Corps sergeants die doing this, and, I think, if you're going to do a gesture, you might as well risk your life on it. So, he got very excited because Andy is to me the ultimate voyeur. He's the prince of voyeur[ism] because he, finally, doesn't have to go to his window. He doesn't have to peek into windows. He makes people come to him and do their thing while he deigns or deigns not to look. And that's what an ultimate voyeur is: he doesn't have to peek. He makes people come, and he chooses to peek. But, ah, he, ah got ecstatic about this idea. Ah. He shot, ah, 1200 magazines. That's why the film is 70 minutes long: because in a 1200 magazine, each magazine, each roll of film, is 35 minutes. In

the first roll I'm not at all drunk. I drink the whole bottle in the first 35 minutes, but Andy was still an amateur with that equipment because it took him 20 minutes for him to unload it and load it so that by the second time the roll of film is underway, I was *totally* drunk because in that period the whiskey had taken its effect. Ah. I was able to walk out of there. I think that most people would have died. . . . I told my lawyer what I did on the next day, who said, you know, "Did you sign a release?" And I said, "No. I never get releases from people. You know, the fact that I did it." And he said, "Well, you agreed to it. You did not get a release to be paid for it." So, I think, he made some noises in Andy's direction, and that's why there is nothing but an original. . . .

What I mean by ultimate voyeur, ah, he got a woman who was well-known socially in New York to be filmed . . . with two black guys on a couch: she's going down on one of them and being buttered by another one. . . . I have a feeling that people would get very upset by that film, but this was not the kind of thing that [. . .] did ordinarily, and, yet, I don't think, Andy first suggested it to her either.

PS: Could you tell me your ideas on Andy and Marxism?

ED: Yes. . . . To me, Andy is quintessentially American because he was the upward bound boy. He's the son of the immigrant, whose name was Warhola, from Pittsburgh. You don't catch Andy lying too much. He ignores things. Well, he lied when I first met him because he told me that he never had any education. [Laughter] And, ah, he had just gone to high school. And, ah, I then met a friend, a guy I knew—I forgot his name even, I just knew him peripherally, who had been up to Carnegie Tech with him. And, ah, as a matter of fact, the first thing Andy said to me—the very first thing when Tina [Fredericks] introduced us—he said, "Oh, De, I hear you write everything. How did the First World War begin?" And I looked at him, and I was about to step into an enormous trap—about talking about Lord Grey and all the rest of it—and I just said, "I think, you know more about that than I do." And, ah, he smiled, and that was the end of that. Ah. But he would always ask me questions—sometimes I thought he knew the answer, sometimes not—about that kind of thing.

PS: Politics?

ED: Yeah. And about historical events and . . . who was sleeping with whom in the groups of people that we knew in common, about which I knew a lot. . . . For one thing, he was Horatio Alger. You know. Except that he is the melting pot Horatio Alger. Here he comes out of

nowhere, and, ah, ends up: there is no fancy party in New York that is successful without the appearance of Andy. . . . At the same time, he changed the means of production in painting. He created an act of total Marxist alienation by withdrawing himself from the process of [painting] entirely except to—by saying, "This is a nice painting" or something like that. And, then, the people—his people—would do the whole thing. It was his painting, just as Titian's paintings were painted by Titian. But, I mean, he would simply suggest the photograph that would then be silkscreened. . . . He literally changed the means of production. . . . Even the old studio system of the Renaissance: the master would paint all of the key parts, and the people would paint in the draperies. . . . But in Andy's case: the painting is mass-produced. It was literally mass-produced. And any . . . you can't imitate it. I mean, in a funny way, Andy has it both ways. He also shows us what is unique in mass production, which Ford and General Motors can't do.

PS: What is the uniqueness for you?

ED: The uniqueness is for me is that other people can't do it. I mean, the people who have imitated Andy are failures. Andy's have always looked like Andy's, and the ideas are like Andy's. [De Antonio discusses Warhol's drawings of *Mao Tse-tung* using a copy machine for Experiments in Art and Technology, Warhol's association with Henry Geldzahler, Warhol's advice to a theatre-owner and his film segment of Warhol in *Painters Painting*.]

[De Antonio reads from his transcript for *Painters Painting* the following by Ruth Ansell, an art director of *Harper's Bazaar*.]

RA: And we got personalities in theatre, art, music and dance. When we were discussing how to do it in the office, I think, that happened when I was telling how terrific the photomat machine was, and he naturally said, being so graceful about picking up, said, "Yeah. Gee. That's terrific." We just looked at one another, and that would be a funny way of doing portraits of these people. [End of script excerpt.]

And, I think, they came in that way. And this is really what happened is that—I've seen the layout of the pages, and Andy—Andy did magazine work, as well as windows. . . . They were all in what she called "Photomat Art." . . . And Andy took all of their pictures [for *Harper's Bazaar*]. . . . I did not use this in the film. [De Antonio describes his 1970 filmed interview with Warhol and Brigid Berlin, who taped what was filmed.]

PS: [Reading from the script.]

De: When I first knew you, you weren't painting, and then, you did become a painter. I wonder if you can tell me why that happened and when it happened and . . . ?
Andy: Well, you made me a painter.
De: Let's have the truth.
Andy: That is the truth. Isn't it? You used to gossip about the art people, and that's how I found out about art. [End of script excerpt.]

And I was wondering about . . . when you say, "Let's have the truth."

ED: Well, nobody ever made anybody into a painter, and only a maniac or an ego-maniac would. . . . I mean, nobody ever made anybody into a good painter, and Andy's a very good painter. Ah. No. I mean, I think, I gave Andy some ideas at the beginning. As I said earlier, the critique of the *Coke Bottle,* but he goes on to say that I told him all the gossip. And I . . . Two things. . . . That's important. Ah. And I'm never sure Andy says anything except what he means; so, I don't mind explicating it. . . . I used to tell him about Bob [Rauschenberg] and Jap [Jasper Johns], and he wanted to be like them and to know them, as I said earlier, and he was just too fruity for them, you know. I mean, he was. . . . And, I think, more than anything else in the world, he did come. . . . And this is what I meant earlier when I was talking about his Horatio Alger aspect . . . that he was rising through the American art world. I mean, who could dream of a steel worker's son going to be in *Glamour.* But, then, who would dream that the steel worker's son in *Glamour* was dissatisfied with that. That it was boring. You know: that there was a higher level, and that's where Rauschenberg and Johns were. And, ah, I think, my telling him about that world which he could not enter at that point made him very ambitious and angry. And Andy never shows anger, of course. But made him angry internally and absolutely determined to get that place. I think, that's what he meant. I think, it's probably correct. . . . You can repeat almost anything. . . . I mean, Bob and Jap, although they both were close to Abstract Expressionism . . . But, I think, that, ah, they opened up another world and a different sensibility which Warhol thought he could latch on to or identify with. And this is not only why he wanted to meet them but be like them because they were about to make more money as fine artists than he did as a commercial artist plus getting all the *kudos,* plus getting trips and all the rest of it. And, I think, that gross considerations like that sometimes lie behind, ah, not esthetic movements but the lives of artists. [De Antonio describes

works by Jasper Johns before 1955.] And Bob [Rauschenberg] said,
"These are my favorite Jap's. These are the best pictures he ever did.
It's too bad that he didn't continue this way." And then I mentioned
what I said what he said about [Marcel] Duchamp and he [Rauschen-
berg] said, "Well, Jap lied to you because I took him down to the Ar-
ensberg Collection when I first met him [in 1954], and, so, he knew
all about that Duchamp." . . . Rauschenberg maintained, of course,
that they went down and looked at the Arensberg Collection before
Jasper painted a picture, when he was doing just basically, ah, finish-
ing school work. [De Antonio describes Rauschenberg's marriage,
John Cage on an artist's personality and Rauschenberg and Cy Twom-
bly.] There's a lot of chance in Rauschenberg and a lot of . . . not
"chance" in the [John] Cagian sense but . . . I mean, Johns' chance is
plain chance. Rauschenberg's chance is: he really paints [while]
drunk. Ah. Bob goes through about a quart of Jack Daniel's a day. He
does a lot of work when smashed. And . . . Ah . . . I think that, ah,
he doesn't have that self-critical sense. [De Antonio describes Raus-
chenberg's works, Abstract Expressionism and criticism by Clement
Greenberg.] Andy is a superlative gossip, but, I think, he's too old for
it, and he has no reason to trust you, perhaps. I don't know. Or if not,
he has more sense. He has no reason to trust anybody. Ah . . .

PS: [Reads from filmscript.]
Andy: But Brigid does all of my paintings, but she doesn't know
anything about them.
Brigid: I know, what's good.
De: What do you mean Brigid does all your paintings?
Andy: Well, Brigid has been doing all of my paintings for the last
three years [1967–70].
De: How does she do them?
Andy: Well, I haven't done any work in the last three years.
Brigid: Well, you see. I just call Mr. Goldman, and I just tell him
the colors, or I just go down there and choose them from anything
that's just lying around: a [Frank] Stella poster, . . . you know, and I
just pull off a piece and say, "That color." "That color." I take
Polaroids of the *Four Flowers,* and I switch the colors around and
superimpose for the cut-out one on the top of it. Take a picture and
have Mr. Goldman do it.
Andy: But Mr. Goldman's dead.
Brigid: No, his son.
Andy: Oh.
De: But the paintings that you first did, Andy, as you know, there's
a German critic writing a book about you, who regards this as one of

the main contributions, and he [Rainer Crone] attributes this to the things [Gene] Swenson wrote about, too: that you said, "All people are the same," and that you wanted to be a machine. Is that true?

Andy: Is it true, Brigid?

Brigid: No, he just wishes it was all easier. He said to me last week on the phone. He said, "Brigid, wouldn't it be nice in the mornings we could get up, and at 10 o'clock go to all the movies and to all the galleries? And just think, it would be like Teeny and Marcel [Duchamp] used to do." You know? Then how would you get any artwork done then? Andy could do that. [. . .]

Andy: Well, that was the time that they stopped killing people in the electric chair, or was it before? So, I thought it was an old image, and it would be nice to do. [End of script excerpt.]

ED: [Describes Rauschenberg and Johns, how Rauschenberg stole a thermometer from Duchamp's *Why Not Sneeze, Rrose Selvay?* and John Cage's friendship during the 1950s.]

Robert Galster, New York, 25 October 1978

Galster is a prominent graphic artist and illustrator.

RG: I was vaguely aware of him [Warhol] myself [during the early 1950s] because I was a designer myself: book jackets and record cover albums and posters and things. And, once in a while, I would see his little dotted line, and I was always intrigued by it. I had admired Andy's book jacket design for Ronald Firbank's *Three More Novels,* and Gilbert [Ireland] called up the publisher [New Directions] and said, "Who did that book jacket?" because he wanted to see if he could get a Valentine's Day drawing with these little cupids, and it turned out that the artist was Andy Warhol. Andy lived, it turned out, nearby, and we both met him. Andy charged about 20 dollars for the drawing.

PS: What was his apartment like?

RG: I was expecting to find something—I don't know what I was expecting—but you have preconceived ideas that you don't even know about, and I turned up on the top floor of this brownstone, above a restaurant [Florence's Pin-Up at 242 Lexington Avenue]. As I recall, it was funny. It was like a bat cave: funny room just filled with things like boxes and things, and not a stick of furniture. And for a desk, he used a door: a door taken off a wall and on two saw horses. He was also working while we were there, and he was sitting on a typewriter case, which was funny. He was sitting on this typewriter case, which

is so high off the ground, and working . . . his nose on this door off the bathroom or whatever. And I said something about that I liked the little cupid drawing, and he started drawing me more cupids. Just drawing away, and he gave me three or four drawings then, and then we started seeing each other a lot. It turned out that we had a lot of mutual friends in common, of course . . .

PS: As a person in design and in drawing, had you ever come across this blotted-line process before?

RG: No. To me, it was absolutely new. In fact, the first thing I wanted to ask him when I met him was, "How do you make this line?" That was one reason why I wanted to meet him. As an artist, I was interested in how do you make this curious line? I couldn't imagine how he did that. I was so dumb; I couldn't envision it, but, of course, I saw him doing it then.

PS: Could you explain how he did it, as you saw it?

RG: Yes. He had a piece of drawing paper, just as you would normally do a drawing, and, then, he would cut out a piece of cardboard that was much smaller and was more like the size that he was doing the drawing on. And, then he . . . I never actually saw him do a drawing. He took the ink and started going, you know, like Picasso. [Laughter] I mean, there was no thought about doing a drawing first and then turning it into anything. And, in my experience watching him work . . . and he would simply draw on this, like masking tape it to the piece of . . . to the drawing surface so that you had this hinged like a door and then draw on the "door" a little short line and blot it onto the working surface and then lift it up and draw a little bit more and blot it again and, ultimately, you would end up with an Andy Warhol drawing.

PS: Have you come across people who have tried that technique subsequently?

RG: I tried it. It never worked for me, but one reason why I was interested in it is that I use a similar type of line in my work. That is, a rough, thick and thin . . . but I do mine with a brush, and I do it with a dry and erratic brush, which gives sometimes almost a similar look, but, I know, it was different, and, so, that's why I was fascinated by it, and I wanted to know how this guy could do this. Yes. After that, I tried it. I tried blotting a few lines, and it didn't work for me at all. [Laughs] Mine didn't look like fake Andy Warhol's. They looked just like blotty lines. So, he had it under control someway.

PS: Now, Ben Shahn would have, what I would call, a "telegraphic line."

RG: Yeah. Yeah.

PS: Did Andy ever talk about Ben Shahn with you?

RG: I didn't hear him mention Ben Shahn? No.

PS: Okay.

RG: As a matter of fact, I don't think, we ever talked about artists or anything. I think, we talked about . . . I don't know. Of course, Andy never talked about anything. That's one of the interesting things about Andy Warhol. My recollection of him is never hearing him say anything. You'd ask him a question, and you'd probably get the minimal answer whispered, but he was always surrounded by others who were talking, but he didn't talk a great deal. He didn't communicate well, I would say, at all. You say, "Did he ever talk about Ben Shahn?" And, I recall, I can't remember. I can't tell you really anything. Andy never said much.

PS: Going back to his work method, was there anything else that you noticed about how he worked when he was drawing?

RG: No. The only thing to me that was incredible about him was his curious working conditions: that he could sit near the floor and could work on just any old surface, apparently, and turn out these drawings.

Then, of course, everything that he was doing for a commercial purpose. I had forgotten one thing: we didn't exactly see him after he had given Gilbert [Ireland] the Valentine drawings. It was sometime after that. I was a freelance book illustrator. One day, I was up at Doubleday, and . . . What I mean to say is that we did not become friends immediately in that first meeting, but I met him. He was up at Doubleday. There was a wonderful woman there named B. G. Schuller, who, I understand, gave Andy one of his first jobs. He walked into Doubleday with some samples of his work and, I guess, showed them to B. G., and she was a sweet woman and impressed by his work and not put off by his physical appearance or in his strange, fey mannerisms. In those days, we were dressed differently from how we do today. I would go to Doubleday with my little work job—what I was doing for them—and I would get—not "dressed up" but be sort of "conventional" with my shirt, pants and something. And I remember seeing Andy there for the first time and thinking, "Isn't it amazing! I wonder how he ever gets a job!?" I wondered how he ever got his first job in a commercial establishment, but B. G. Schuller, of course, through . . . he would get a job because she would recognize his tal-

ent. He had a thing. He used to sign his name: "Andy Paperbag." . . .

I know Shirley MacLaine slightly, and he wanted to do people's feet. He was going to do a *Foot Book,* and he wanted to draw the feet of celebrities. He had heard me talk about various people like Shirley MacLaine, Janice Groel . . . anyway, he wanted to draw her feet, and he . . . I knew Lena Horne, and he wanted to know if I could arrange for him to meet Lena Horne and to draw her feet. Well, it's very hard to go to Lena Horne and say, "I've got this kookie friend who wants to draw your feet." [Laughs] You know, it's kind of strange. . . . I mean, I never put him together with anybody to draw feet. At the time, I was a friend of Kim Stanley, and he wanted to draw Kim's feet. . . . Well, I was telling Shirley MacLaine about it, I guess. It's hard to remember now, but she said something: she admired his work or something. So, the next time I saw him, I told him that I saw Shirley MacLaine and that she admired his work, and he wrote on a yellow . . . I still have it because I never gave it to Shirley . . . on one of those yellow pads with red lines like secretaries use, and it says something like, "For Shirley / With Love / Andy Paperbag." That's how I remember. I had forgotten all about that.

[Galster shows P.S. two drawings by Warhol: *Two Cupids* (*Valentine*) and the portrait *You-Me.*]

Many times that I was there, Nathan [Gluck] was sitting in the corner doing "Andy Warhol" drawings, and I always thought that it was funny that Andy was getting paid for those drawings that Nathan was doing. Because . . . I think that was when they were doing shoes or, maybe, that was even the time when the [Museum of] Modern Art had discovered Andy, and he did, at least, a Christmas card for them. . . . And I was always—being a hard-working artist myself— couldn't imagine finding anybody doing my work for me. I thought that it was absolutely remarkable that Andy had found Nathan who could do his Andy Warhol "originals."

[Galster remarks that Warhol's close friend during the 1950s-early 1960s, Charles Lisanby, lives in the same apartment building, and he describes Lisanby's designs for theatre and television.]

He [Andy] did a whole book of Charles Lisanby. It's called the *Boy Book.* . . . As he [Warhol] started to be known and started to get fame and success and all this, nobody ever saw him again. Charles Lisanby never saw him again. I never saw him again. Jerry [Lang], I think, never saw him any more. And it's just that he had a whole new world built around him. Ted Carey probably did. . . . As I started to say, after he became renowned, I just lost touch and never saw him again. I mean, *for years.* And I would be at parties that I was apt to

go to, and Andy wouldn't be there. But there would be three or four very strange people [who] would arrive at this party, and nobody would know who they were or what they were doing there. And they would say, "We're Andy Warhol's friends." And I was talking with one of them one night at a party—we all were getting drunk—and they had come to check out the party. They would come and check out the party, and to see if it was a party that Andy should come to, and they would telephone him and tell him to come to the party. [Laughs] And he had this whole coterie.

PS: Going back to his appearance at Doubleday, did she ever use any of his drawings?

RG: She said that she couldn't use him since he couldn't adapt to various cover styles, but she did like his work, but he couldn't adapt. I had no personal style, so I could.

[Galster comments on commercial art illustration during the 1950s, especially on innovations by Milton Glaser and his Push-Pin Studios.]

Henry Geldzahler, New York, 17 November 1978

Formerly a curator at the Metropolitan Museum of Art, New York, Geldzahler is currently a free-lance art consultant.

HG: . . . She [Florine Stettheimer] was a wealthy society lady, ah, in New York in the 1910s, '20s and '30s, who was a very good primitive painter. And there was a very good show over at the Museum of Modern Art in 1936. There's a book by Parker Tyler, devoted to her work. And the Metropolitan has her four major pictures of cathedrals: *The Cathedral of Art, The Cathedral of Broadway, The Cathedral of Fifth Avenue* and *The Cathedral of Wall Street*. And, ah, the day [August of 1960] I met Andy, I mentioned that these were pictures that would interest him, and he said that he would like to come and to see them, and the next day he came to the Met, and I showed them to him. . . . Florine Stettheimer. She was a protegée of Marcel Duchamp and that sort of New York City avant-garde culture — Virgil Thomson.

I think that Andy's first attempt at a movie was an 8-mm. job when I lived on 84th Street and Central Part West. He just rented a little camera and came in and did a three minute movie where I was smoking a cigar, and, then, I threw the cigar in the toilet, and I brushed my teeth, and, then, I flushed the toilet. For all I know, it was never printed. He was just trying to see what it looks like through a camera.

PS: This was around '64?

HG: Yeah, '64.

PS: Didn't he make one where you sat on a stool and smoked a cigar?

HG: Yeah. Andy wasn't *behind* the camera. He was walking on the other side of his studio, making phone calls and silkscreening. And it was very weird sitting there. The subject was having nobody watching. And, ah, I thought that was very Andy-like.

PS: What was it like at the Factory: in the tin-foil Factory?

HG: That was a Billy Linich environment. And . . . Ah. Billy Name . . . Ah . . . Which *thrived* in . . . More interesting than that was what it was like in the firehouse [studio] before Billy . . . and before that what was it like in the former psychiatrist's wood-paneled, ah, first floor of the 89th Street townhouse, which was where Andy was playing phonographic records and was having T.V. sets running while people were sitting on the couch, talking to him while he was making a painting. That was back in '60. . . . His mother was living in the basement. And, ah, . . . every once in a while she would emerge up the stairs, and, I remember, one time when she forbad Andy to take planes because she said, "Many big-shot guy in the sky might die." And she already had a vision of Andy as some kind of big-shot, which was really quite marvelous. So, in a way, Andy fulfilled her invention of him.

 He was still doing commercial work for the first couple of years that I knew him. I met him in July or August of '60, and he really didn't start selling paintings until two years after that. So, he was completely supporting himself with his I. Miller shoe ads and the rest. There is a story that in the early '50s that he was the weatherman on the early morning news, and he had to get there at five o'clock because his hand was so colorless that they had to make-up his hand, and they would say, "It's going to rain today," and he would paint the clouds and the rain, or, "It's going to be sunny," and he'd do a sun. Ah. That was one of his earliest commercial jobs.

PS: What did Andy collect at the time?

HG: It was very crowded. We were never allowed off the first floor. The living quarters were upstairs; his mother was downstairs. I never went anywhere but upstairs in the big room where he was painting, and he had a collection of some Surrealist stuff . . . Frank Stella—small paintings of squares . . . a John Chamberlain crushed car sculpture . . . Carmen Miranda's shoes, which were four inch shoes

and three inch room for feet. . . . The amount of information that he was taking in at the time that he was painting I found amazing. There were stories that Stuart Davis used to paint with jazz records going in the background, and that was the situation like that. I knew of . . . And Andy was actually painting with television sets going, and the contents of the pictures and the formal qualities—the black-and-white and the idea of repetition came, I think, as much from watching television as much as anything else.

The work of the '50s has a . . . I make a joke about it, but I used to tell Andy [that] it looks like Jean Cocteau had been gay, he might have worked something like that. And they were very fourth-generation Picasso by way of Cocteau. That's the way it looks to me.

PS: I was just going to ask you about Cocteau.

HG: And I had the delicious pleasure . . . around 1962 . . . Andy brought a pile of drawings over to my house, and, then, we looked through them, and I tore up about 80 percent of them as just not being worthy of going out into the world and picked 15 or 20 or 30 that I thought he might keep and let go. But, ah, it was, ah, very light-headed kind of . . . illustration. And there was very little—you know the German catalogue of the drawings? And there was a little bit of Ben Shahn. There was a little bit of Paul Klee (as there is in Ben Shahn). There was a little bit of Cocteau. Ah. I think, I can probably recognize something as a Warhol drawing now, if I saw something from the '50s—the elements are quite clear.

The last hand-painted painting was *129 Die in Jet!*. Ah. The silkscreen was well in place by the time that the *Mona Lisa* was at the Metropolitan Museum, and, I guess, it's easy enough to date 'cause there was a lot of publicity about it in the papers, and that's when all those *Mona Lisa* paintings came about.

PS: Why did he do the *Mona Lisa* series?

HG: Oh, I think, the same reason that [Marcel] Duchamp and Man Ray [unintelligible word] with the *Mona Lisa*. It was the image of art in the public mind. And he felt that the *Mona Lisa* was being seen so often and being seen in so many reproductions that his serial way of silk-screening it was—he had another way of doing it. I . . . I . . . he gave me one of the *Mona Lisa* paintings which I gave to the Met almost immediately, and it's one of the most borrowed twentieth-century pictures that the Met has, actually. . . . I brought Dennis Hopper to his studio. One of the first things that he did was to buy one of the *Mona Lisa* paintings. I think, it was '62, actually.

PS: One of the major questions that I have in the back of my mind is why did he leave commercial art into fine art?

HG: I think that his ambition always was from the time before he went to Carnegie Tech was to start off by beginning to support his mother and himself, but the ambition was always to be world-famous, very secure and have a lot of money coming in. And whether it's making society portraits or whether it's making Pop Art in the '60s—they all have in common a need to build security. There was aching poverty early on, which hit him like a ton of bricks, and he just has never been on to, ah, experiencing that again. Even now he doesn't judge his success by the amount of money that is in various bank accounts or by the total value of his collection. He judges his success each year on how much money is coming in that year because underneath is always the image of total starvation and poverty and being evicted. There's no way he's ever going to get over that because that's the plot. That's the under. . . . That's the armature of his view of the world. And what looks like cynicism to us is really panic, I think.

 I mean, Andy made the joke. I said to him—with the *Liz Taylor's,* there was a *Liz Taylor* and a black-silver canvas next to it, and the joke was—he could charge twice as much because it's twice as big. You know, it seems to mean something—the idea of getting twice as much money.

PS: Why do you think he wanted to become a full-time moviemaker?

HG: Well, I think, that the idea of the Hollywood star, the great American [unintelligible word] expression that was most popular and that was most income-producing: being the film. That was something that was always in the back of his mind. And it went rather naturally from the illustration—I think, *Troy Donahue* was one of the first silkscreens, and the illustration of the movie star to the [unintelligible word] of the movie star to the making of movies and to the producing of the movies. And Andy himself doesn't have that strong a physical [unintelligible word], as that he would want to be a star himself. But there is a would-be [Louis B.] Mayer quality which also made it possible for him to play people off of each other. The big studios in the '20s and the '30s always had a few more stars on their books than they could use. And the producer-entrepreneur was in the position of punishing or awarding them. And unconsciously—I don't think, Andy had any idea of this—he always had a few more people who wanted to be in the films and who had a legitimate reason to be in the films than he could accommodate with—he was able, therefore, to play—I mean, I don't [unintelligible word] Andy that he's, ah, that he was a sadist and,

therefore, [unintelligible word] people who were around him as being somewhat masochistic. And he's a bit of a voyeur. And, therefore, he belonged necessarily with [unintelligible word] exhibitionists. And that adds up being a film-entrepreneur, a sadist-voyeur is exactly the right consolidation of psychological qualities. I mean, he doesn't go around hurting people, but they do get hurt.

Henry Geldzahler, New York, 28 November 1978

This interview with Geldzahler was done at his office; after a series of constant disruptions, the interview was abruptly concluded.

PS: I was asking you last time about the time from 1960 to 1962 (that is, the time you arrived in New York and began work at the Met[ropolitan Museum of Art] until Andy's big success in Los Angeles and then in New York—both came in 1962) with the Pop Art phase. And I was wondering . . . to your . . .

HG: Everyday. . . . Leo Castelli turned his work down. Robert Alcott turned his work down, and [Sidney] Janis turned his work down, and, finally, Eleanor Ward gave him a show. It was really quite amazing. I don't remember the exact time of the Sidney Janis Pop Art show. Was that 1962?

PS: That was 1963.

HG: Nineteen-sixty-three. That . . . that put the *seal* on the whole thing. It made it clear that there was Warhol, there was [James] Rosenquist, there was [Roy] Lichtenstein. But in '62 there—'60—'61—nothing was clear, and Castelli didn't want to show him because he felt that he would be confused with Roy, and today Lichtenstein and Warhol look very different to us. In 1961–62, Leo Castelli didn't know the difference—ah, you know, the very king-maker now, ah, historically. Ah, Alcott had, believe it or not, Jack Lesley. You know what I mean? And he didn't want to take Andy because he had Jack Lesley. That . . . that was the thinking that was going on at the time. I was horrified because I could see from the beginning that what Andy was doing was startling, and, I think, my background as an art historian made . . . I think, as a trained art historian, I think, I had . . . less trouble justifying Andy because I didn't see anything to justify. He clearly had formal qualities that were shocking, in the sense, that they were being new subject matter. There had been new subject matter entering art every decade in the last hundred years. So, it didn't seem that interesting. It just . . . It just stood or fell in terms of itself,

whereas the . . . the Alcotts and the Castellis or even the Janises were looking at them in terms of merchandise. And . . . But what they were really reacting to was the other. Differentiate between Andy was doing or Jack Lesley was doing or Lichtenstein or whoever was doing. They couldn't justify it.

PS: What things will I not find in art history books that you think I should be aware of?

HG: You have to look at the history of ways in which, especially in the last hundred years, of artistic expressions extraneous to mainline Western art came in, like [André] Derain introducing Picasso to African art, [Jean] Dubuffet and the art of the insane and making it a part of his vocabulary, bringing in dreams and theories of the Freudians into the Surrealists—becoming a *single* concern of artists—[Robert] Rauschenberg taking comic strips and putting them into his work in 1954, which is a lead in. . . . The art of the insane, of children, of the Primitives. . . . To take the next step and take commercial art is simple. It's that it's not a very good step after the other steps have been taken.

PS: And with Andy specifically?

HG: With Andy it's taking the road of the "Arts Review" section of the newspaper—the Sunday section of the newspaper—and making it the subject of art. A part of everyday life that had never been made permanent—what Andy did and, by silkscreening on canvas was to take something ephemeral and given it a chance to.

PS: Of all the times that you've been asked about Andy—different questions. What's the question you've never been asked . . . ?

HG: I've never answered before as frankly about how angry I was about those dealers not taking him. I'm not going to do your interview for you.

PS: I usually ask that question to whatever . . .

HG: That's all right . . . let me get back to work.

Nathan Gluck, New York, 17 October 1978

Nathan Gluck met Andy Warhol in 1950–51, and he was his commercial art assistant from the early 1950s through 1964–65.

NG: [Gluck describes his first meeting with Warhol at an ad agency during the early 1950s. He found Warhol's commercial artwork as being

"very amusing, whimsical work, very fresh, too." At that time, Warhol's work appeared in *Charm* and *Mademoiselle* magazines. For a few months previous to his employment, Vitto Giallo had been Warhol's full-time assistant. When Gluck began working for Warhol and subsequently throughout his employment, he worked for a few hours at Warhol's apartment-studio, where Mrs. Warhola would serve him lunch. During the rest of his working day, Gluck was a free-lance artist, working for various magazines and department stores.]

The *reason* he needed someone was the fact that he got busier and busier. And carrying around the work and doing it had gotten just too much. . . . I would draw I. Miller shoes on tracing paper, and Andy made corrections. Andy then made a drawing from that and blotted it. . . . Over the years, he got so busy that he didn't have time to blot it, so I would blot it. . . . Andy's mother signed his handwriting, so she had over the years become tired of that, and I would fake it. . . . Another reason why he liked it [the blotted-line technique] so much: by having your master drawing with which you made your blot, you could keep blotting it and redrawing it and reblotting it each time and make duplicate images. . . . The basic way of doing it was, simply, to draw on a sheet of paper, usually Andy used charcoal paper which had a little tooth to it, and you traced your pencil drawing down, and, then, you would ink down a couple of lines and flip it over a piece of Strathmore paper and lift it up again. And, then, each time you did that, your drawing progressed, and by the time you had finished, you got this wonderful drawing of little speckles and dots.

PS: How many images could come off the original?

NG: Five to ten maybe, but each one would vary because you would be building up a residue of ink in the original thing, and the paper would be getting heavy with ink and blotted with everything else.

PS: How many, then, would he usually make?

NG: I think, one or two images.

PS: What would he do with the original image?

NG: I think, he kept them. He may have filed them away somewhere, or, maybe, when we were housecleaning, he may have tossed them out because when he was doing an ad for shoes or something that had no life or use after that, so he probably may have just dumped them.

PS: The reason why I asked that: because he was interested in the *effect* of the blotted-line instead of the original.

NG: Right. Right.

PS: Is there anything else about that technique that was important for Andy? Did other people pick it up after him?

NG: I'm not sure if anyone picked it up after him, but a lot of people tried to imitate it because I would see things, and I even sometimes see things today when someone has tried to draw in that technique, but either they didn't know how it was done and just sort of take a pen and make little dots, but the beauty of Andy's thing was that *so* much was left to chance.

I had done some drawings once where I had drawn on wax paper and when you flip it over and make the blot from it, you get a *myriad* of dots like bubbles . . . like the bubbles you get in soda water. But it's not the same as Andy's because you got, you got a lot of variety in the blot: sometimes it was heavy; sometimes it was thin; sometimes it was a line; sometimes it was a broken line. But, I don't think, it really caught on, and a lot of people thought he was imitating Ben Shahn, and he wasn't.

PS: Let's talk about Ben Shahn for a minute. To my understanding, Ben Shahn did a number of freelance work for a number of ad agencies . . . for C.B.S. and, I believe for N.B.C. . . . and I know that Andy worked at one firm that was advertising for a pharmaceutical industry and also for C.B.S., on a freelance basis.

NG: Right.

PS: Did Andy ever meet Ben Shahn?

NG: Not to my knowledge. I don't think so.

PS: Did he ever say anything about Ben Shahn?

NG: No, I don't think he ever did.

PS: Did you know Ben Shahn yourself?

NG: No. His work was around; you couldn't miss it because at that time, he was one of the better artists who was doing commercial work, and I know that his philosophy was that whatever he did commercially was as good as his fine art. That's how he looked at it. That's why, of course, he also didn't do a *great* deal of commercial work because it was always a high level where the drawing made the ad.

PS: Did Andy, to your recollection, ever say anything about Matisse?

NG: Nope.

PS: Did he like Matisse?

NG: I have no idea.

PS: According to Rainer Crone in his essay for the drawing show, Andy was influenced by Matisse. [See Rainer Crone, *Andy Warhol: Das zeichnerische Werk, 1942–1975,* exhibition catalogue (Stuttgart: Wuerttembergischer Kunstverein, 1976).] Moreover, Andy is supposed to have gone to the Matisse retrospective at the Museum of Modern Art.

NG: Yeah, I saw a reference to Matisse, and I couldn't understand why. Andy never really said anything about painting or artists *until* maybe the late '50s or the '60s when he started to collect and *then,* well, let's put it this way: I can't remember how he started to collect. *I* had been collecting. He may have seen the things that I had bought. And, I know, at one point we had seen a Paul Klee in a window of a shop. It was a little picture called *Young Park.* And somehow or other, I had always thought, it was a lithograph, but, I think, it was a lithographic reproduction. But anyway . . . he bought that. *Then.* [Gluck recalls that during the time that he knew Warhol, Warhol had bought on his own a Toulouse-Lautrec poster of a bicyclist, a portrait by Pavel Tchelitchew, a wash of a tree against a blue sky by Magritte, a drawing *Light Bulb* by Jasper Johns, a drawing by Saul Steinberg, a crushed automobile sculpture by John Chamberlain, an etching by Picasso and a sand sculpture by Constantino Nivola.] But, anyway, to get back to Matisse. I don't *ever* recall Andy getting excited by Matisse, and I can't ever recall Andy going to gallery shows. [Gluck discusses forms of entertainment for Warhol that included listening to popular songs on the radio. At one time, Warhol had an opera subscription. Gluck would have to explain to him the plot. Because he was not adept at foreign languages, Warhol would "come up with some stunning malaprops of an opera title."] There was a *naivete* about Andy that was *incredible,* and here he was going off to the opera—and he bought good seats, and it was in the old house—and it was in the dress circle, which was a decent location, as opposed to the balcony or the family circle. And I think that Paul Cadmus would go to the opera; I'm not sure, but he must have met somebody, and he went off to the opera. . . . I don't know about Andy's social life.

PS: Did Andy ever like to read?

NG: I don't know even if Andy was a big reader.

PS: Did he read magazines? Art magazines?

NG: He would look at fashion magazines and look at the ads to keep abreast, but I don't recall that he subscribed to any art magazines. . . . Did anyone else know? Did they come up with the same answer: bewilderment?

PS: When I spoke to Ted Carey yesterday, he mentioned that Andy would go to the newsstand, when Ted knew Andy.

NG: Well, if that's the case, then it would be gossip and fan magazines that he bought because that always intrigued him. Andy was *really* not an intellectual. This, in a sense, is what is so phenomenal about him because he is *today meeting* all these intellectuals, and I'm always flabbergasted because I'm always thinking, "What on earth is he talking to them about because, *unless* since the '60s Andy has developed an intellectual curiosity and background, he would rather be a rather naive kind of person," and, I think this is what grabbed everyone— here is this sort of person—his *appearance* was incredible.

PS: Tell me what his appearance was like when you first met him.

NG: Well, he would walk around in blue jeans that had paint spattered on them, and, if he had a pair of shoes that didn't quite fit him, the backs of them were scrunched, and he would wear a tee-shirt or a sweat shirt or something or an odd jacket or what and a necktie poorly knotted and everything. And everybody thought this was just an incredible appearance.

PS: Did he ever read?

NG: Andy didn't read or get excited about reading, to my recollection. Maybe he read fiction and fantasy. [Gluck describes Warhol's duplex apartment on Lexington Avenue and his townhouse Uptown on Lexington Avenue. Gluck remarks that he worked for Warhol until late 1964.] On the top floor [of the townhouse], in the back, there were two small rooms for storage—where he would put his antiques, weather vanes, Bentwood twig furniture, and his artwork was stored there. In the front room, he installed a big projector. So, he would place a drawing on the wall or a canvas and draw on that. . . . The first things he did was the comic book things and the *Dance Steps*. He would put them in the projector and project it on the wall, and, then, he would either draw, if it was a drawing, he would draw, or, if it was a painting, he would trace it off on canvas and then fill it in.

PS: Such as the *Dick Tracy?*

NG: Right. [Gluck mentions that his roommate during the 1950s worked at

Bonwit Teller, before this time, Warhol did a window display there of a wooden fence. Gluck remembers that Warhol also did blotted-line drawings of ice cream sodas on panels. Using Alfred Carleton Walters as a model, Warhol painted, with very delicate oranges, pinks and yellows, paintings that imitated the blotted-line technique. Such paintings averaged three feet by two feet. Warhol also painted portraits and children in the same format and style. Such paintings were done from the time Gluck knew Warhol through the 1950s.]

PS: I noticed that in one of his *Paint-By-Numbers* paintings, that he used press-type for the numbers.

NG: And he probably did it because he realized it was just too much trouble to paint the numbers because Andy has *always* said over and over, "It's too much trouble to paint." And that's one of the reasons why he silkscreened. And I always said to him, "Hell, why even the silkscreen, let someone else do the silkscreen, and just call up and say, 'Run me off this much.'" . . . We started at some point, I don't know how it happened, but Andy wanted to reproduce things, and, rather than have rubber stamps made, he thought maybe we could carve things in balsa wood. Well, that was too much of a chore. I think maybe we did a *Coke Bottle* with balsa wood, and we discovered soap erasers. You know: art gum . . . an eraser that comes in a cubular form. It's brown like octagon soap, like laundry soap, and it usually comes in two by two by three. We discovered one place once that had it in flat surfaces with four inch square and about an inch and a half thick. So, we could carve apples, squirrels, peanuts, etc. Here is an example—the wrapping paper. And just between you and me, I carved most of them. All the stamps were made from soap eraser. . . . My line was a little more sensuous, a little more "romantic" while Andy's was a little more "primitive" and direct, in a way. So, we had *boxes* of these. . . . I think, he had decided to paint *Money*. And he was *not* about to draw rows and rows of money. And he couldn't think of what to do, and, then, he remembered the fellows who were doing the Christmas cards at the Tibor Press—Richard Miller, who was in an automobile accident a long time ago and Florio Weckee, who may still be running the company—so, he called them up and asked them if they would make up a silkscreen of money. And, I think, they said, "No," but if Andy made a drawing, they would make a silkscreen of the drawing. So, I think, they made a screen of money—of the drawing. And, so, Andy ran it off and made it serially like that [points]. And from there on, I think, he realized that he could use the silkscreen.

As the work got bigger, he needed a place to work. So, a block or two from where he was living, there was an old firehouse—and Andy, by this time, had a whole bunch of people that he knew and somebody—I don't know how they worked it—found out that the city would rent it to him for something like a hundred dollars a month. It had no heat. It was ice cold. But it was big. So, Andy got canvas, and he got paint, and he got silkscreens, and he would work on the second floor of the firehouse, and he would unroll canvas on the floor, and take the silkscreens and start screening. And I told Andy, I said, "Now, when you start silkscreening, you put little marks here, and you line up the screens with the marks, so, you know, when you screen, everything is exact." And Andy couldn't be bothered with this. So, when he got through, the lips [of a *Liz*] were a little askew, the eyeshadow went a little high, or the hair went a little over to the left, and Andy would look at it, and you'd look at it, and it was all a little off-register. And you'd say to Andy, "Andy, it's a little off-register." And Andy would say, "I like it that way." And that's how it went.

[Gluck mentions that Warhol's promotional books were hand-colored, just like pre-Currier & Ives prints or hand-tinted children's books. Such previous works, according to Gluck, may have been an unconscious influence.]

One thing that Andy loved to do was put down a wash of color *very* unevenly, so that you could almost see where the water flowed. In other words, he'd put it on very heavily, and, then, it would sort of thin out, and sometimes you'd get these blotty effects, as if you'd put some watercolor, and it would sort of flow. And he liked that sort of unevenness.

PS: Do you remember, during the time you worked for him his ideas about art or his intention?

NG: No.

PS: What kinds of things would he say when he would be making works of art or illustrations?

NG: Paintings, do you mean?

PS: Paintings and . . .

NG: Well, he would come up with very astounding things sometimes and say things like, "What should I paint next?" And, of course, that's why I can believe the story about Muriel Latow and the *Soup Cans*. And I remember him getting excited about Wayne Thiebaud painting ice cream and cake. . . . He really never talked about what he was

doing or what he was trying to do. [Gluck mentions that Warhol's earliest Pop Art works, which were done on the second floor of his townhouse, were done by Warhol, usually on weekends.]

PS: Why did he paint cupids [during the 1950s]?

NG: I don't know. Maybe because it was "fun." Andy was one of the first who worshipped "fun." And it was just "fun."

PS: What do you mean by, "He was one of the first people who worshipped 'fun'?"

NG: Well, later on, it became fashionable to use the word "fun." There's that wonderful story about somebody at *Vogue* magazine who was going to have a baby, and somebody asked the person, "What do you hope it will be?" And the person replied, "Oh, I hope it will be a 'fun' baby." But Andy did things because they were fun—they amused him, and he got delight out of them. And, I think, that is why one of the reasons he did cupids.

PS: Why did Andy do the Amy Vanderbilt books?

NG: I don't know why he did them. Maybe he needed the money or the time. He had no "fun" doing them. And there were endless changes. [Gluck shows P.S. one of Warhol's *Happy Butterfly Day* promotional flyers that would be sent to art directors. Other such flyers are also shown: *Happy December* and *Happy G. Garbo Day.* About 1954, Gluck introduced Warhol to the photographer Edward Wallowitch and his brother John Wallowitch. Edward Wallowitch had just graduated from high school and had some photographs chosen and bought by Edward Steichen to be in the permanent collection of the Museum of Modern Art. Wallowitch often photographed children in his neighborhood in Philadelphia. Such a photograph was traced by Warhol and used as a promotional flyer. Gluck points to his wall, where one is framed. According to Gluck, the photographer and Warhol became very close friends, and Warhol often used Wallowitch's photographs as the basis of drawings, such as some in Warhol's so-called *Boy Book,* as well as at least Campbell's Soup cans for Warhol's *Campbell's Soup Can* Pop Art paintings. The photographer lived *in cognito* in Florida and sold photographs to religious organizations: photos of underprivileged children for promotional material. Original photographs by Wallowitch are, according to Gluck, very difficult to obtain.]

Andy had this great passion for drawing people's cocks, and he had pads and pads and pads of drawings of people's lower regions:

they're drawings of the penis, the balls and everything, and there'd be a little heart on them or tied with a little ribbon. And they're. If he still has them, they're in pads just sitting around. I used to wonder what his mother would do if she saw them. But, I guess, she never saw them or didn't recognize them. But, everytime, he got to know somebody, even as a friend sometimes, he'd say, "Let me draw your cock."

PS: And then they would volunteer?

NG: Yeah. They'd drop their pants, and Andy would make a drawing. That was it. And then he'd say, "Thank you." Sometimes three or four drawings. [Gluck looks through Warhol's *Gold Book,* and he points out a drawing based on a photograph of Edward Wallowitch's sister. Gluck believes that the cover drawing is based on a Wallowitch photograph. For the *Cat Book,* Mrs. Warhola did all the calligraphy, and Warhol would leave in her mistakes, such as "Name" instead of "Named" on the title page.] Now, Andy got the idea that everybody wanted to have low numbers. So, he never kept track of the numbers. So, he would arbitrarily just write numbers: 190, 17, 16, and so on. [P.S. laughs] He had all of these printed up, and, then, he had friends—whoever he could muster—watercolor with Dr. Martin's dyes these drawings of pussy cats. Then all of these pages were dragged down to some bindery on Canal Street where it was bound. Oh! The interesting thing is that, I think, almost *all* of these pictures were taken from *cat* photographs done by a man named Walter Chandoha, a photographer who specialized in taking cat photographs. And I wouldn't be surprised if somebody ever went through all of his photographs and relate some of these to some of these he did because I don't believe that Andy drew from his own cats. I wouldn't swear to it, but Andy was notorious for having things around and just drawing from photographs.

 Dudley Hopler used to draw with little dots, and he had windows at Tiffany's once with trees. He was forever drawing pictures of sensual men with very large lips, holding roses in the teeth. Ah, ha! This is a recollection: *The Boy Book*—the one with the boy with the flowers in his mouth. That! . . . The idea, I think, with the flower in the mouth was subconsciously suggested by Dudley's things because we once had a drawing like that—my roommate had. . . . I *think,* Ralph Pomeroy was a friend of Dudley's, but, you know, there's not really a text except for the title. . . . Most of these [shoe drawings] are lifted, in a sense, from plates of old shoes. . . . Andy didn't really use gold leaf. Actually, it was bronze leaf, called "Dutch metal." He would use sobo—a glue, an adhesive from milk products, bought in

an art supply store. There was an exhibition of them [*Gold Shoes*] and a spread in *Life* magazine, then someone gave him a bunch of wooden lasts to which we would glue wooden heels and decorate them. And sometimes I'd throw down some fake blotted drawings on them and put tinsel on them.

PS: Why did he use rubber stamps? Because it was quick?

NG: Yep.

PS: Did he ever talk about Kurt Schwitters and rubber stamps?

NG: No. . . . This is Andy's *In the Bottom of My Garden,* sometimes called *The Fairy Book.* . . . Andy, at some point, began to buy some books. There was a dealer, I think, on 34th Street or so: Cane. And Andy bought some books. And one of them was a French book: *Les fleurs animée* by Grandville—with flowers who are little people and things. He also bought a few books on elaborate French cooking— where you have these tremendous and elaborate dishes, which the French all *"presamment"* and where you have cakes that are built like grottos or huge roasts that are all decorated with things. And those, in a sense, prompted his other book called *Wild Raspberries:* which was a play on words of the Ingmar Bergman movie which was current at the time, which was called *Wild Strawberries.* And a lot of these drawings were really adapted from them. [Ted Carey did all of the drawings, from which Warhol blotted. Gluck did another separate drawing, *Knight-Cornucopia with Swan.* Mrs. Warhola is described, as is the time when she would sing folk songs in a tape-recorder and then sing duets with the recordings.] Never talked about his father. His whole family were simple, plain and hard-working and are, I'm sure, are dazzled by his fame. . . . [Mrs. Warhola was] a very sweet woman, a very sweet woman, a very naive woman: she thought every girl who came [to the studio-apartment] was Andy's fiancé. She had no concept of art or anything. She was very religious. She used to make me lunch. . . . She was always writing and sending books to Czechoslovakia. . . . Most of the the time, when I was with her, Andy spoke in English to her.

 Andy used to lie about his age. During the last year I was work-ing for him, somebody from Europe was doing a biographical thing on him, and Andy handed me a form. And I asked Andy: what should I put down? And he said, "Just put down *anything*." And I said, "Well, what about the year you were born?" And he said, "Oh, I don't know. Just put down *anything:* any month, any day, or any place practi-cally." So, all of this, you know, has led to an ultimate of confusion.

It's like numbering all the books with low numbers: so everybody could have a low number of the edition. But I really can't see why.

Andy used to go there [the restaurant-boutique Serendipity] so much that people used to think that he owned it or had an interest in it. Truman Capote and Greta Garbo and others would go there. They sell there precious fans . . . ditsy display of such things. . . . This folding screen, *Pin-the-Tail on the Donkey* was for a birthday party display at Tiffany's . . . I did all of that [screen]. . . . I think, there are on the other side stamped butterflies, maybe. . . . All of these [blotted-line drawings] were done by tracing. He would put something in an opaque projector. Andy stood at the wall, drew and filled it in.

These headlines [in Warhol's Pop Art paintings] *thrown* at you is what appealed to Andy. I don't think, he had this fascination with death. I think, the same thing with this one: *Eddie Fisher Breaks Down, Liz in Rome, Eddie Fisher in the Hospital* and all of this tabloid sensationalism and gossip kind of thing. *That's* what appealed to him. And, I don't think, for instance, the fact when he did the *Electric Chair*. . . . I think, he did the *Electric Chair* because it was an American kind of symbol. But I don't think that he feels strongly about morbidity or death. . . . Andy just loves to shock. . . . It's part of our hype . . . like *A Boy for Meg. The Dance Steps* when shown at Janis' [Gallery] were on the floor. . . . And, as you said, he used press-type numbers in *Do-It-Yourself.* . . . I can't see Andy painting these things. He would have either stamped or press-typed them. Knowing Andy's philosophy of painting—that it's just too hard to paint—he would have found a way. . . . I made the S&H stamps out of a soap eraser [for Warhol's *S&H Stamps*].

The Amy Vanderbilt [book project] was something out of his field. Most people who hired Andy wanted an "Andy." It seems in this case, they didn't. Maybe he did it for the money or maybe because he felt it was "Amy Vanderbilt" and did it. . . . With the art directors, he did changes and corrections. . . . One of the funniest things that happened was that he did some work for some particular director, and, *then,* he was getting involved [with Pop Art] and going out to California for one of the first films. They all piled into the car and drove to California. . . . Andy asked me to do the job and to take it over. Well, the art director fussed and wanted a lot of changes, and I realized this was happening only because Andy wasn't there to do it, and if Andy was there, he would have accepted it, but, because he knew Andy didn't do it, . . . and what he didn't know was the job I did for him the previous year . . . but because Andy had brought it in, he thought it was Andy's. . . . Most of the time there were not too

many corrections, and a lot of times there was complete freedom in il-
lustrating something.

PS: What about Andy and Capote?

NG: I know that Andy wrote to him, and he never answered his letters, and
Andy was very hurt. And then, later, he got to know him.

[Gluck recalls that Warhol used a balsa wood stamp for the earliest se-
rial images in *Coca-Cola Bottles*. During the *Brillo Box* show at the
Stable Gallery, the *Boxes* were in rows and that someone was asleep
behind one such row. Edward Wallowitch took photographs of Warhol
when the artist rented a firehouse station for a studio, but the present
whereabouts of the photographs is unknown. Warhol owned a
Japanese-made pornographic book. Gluck shows P.S. receipts for bills
at various hotels (Glouster Hotel in Dublin, Imperial Hotel in Tokyo,
the Bali Hotel and Raffel Hotel in Singapore) that Warhol and Charles
Lisanby had for their 1956 trip around the world; Gluck was going to
use the receipts for an unrealized collage. Gluck suggests that
Warhol's use of serial images may have subconsciously been taken
from the repeated pictures used in billboards or handbills pasted on
outside walls or from advertising storyboards or patterns used in Slavic
Folk Art or Czech dress patterns. According to Gluck, Warhol "didn't
care" how images were repeated in Pop Art works. Until Warhol's
career was launched as a commercial art illustrator, Warhol lived very
frugally. By the end of the 1950s, Warhol became extravagant in his
entertaining friends, and he had an accountant who may have
suggested various investments to Warhol. "As he became more
affluent, he indulged in collecting." Yet, Warhol's "naive" nature
could also suggest that Warhol would choose very expensive items be-
fore he would ask the price of such items. Once, Warhol bought one
to two dozen goblets from Tiffany and Company, and he collected ob-
jects made in the 1930s.]

Andy picked up on the idea of Camp but not Erte. It was his own idea
of Camp. Just like the glasses—the black glasses with the pin-holes—
I'm sure just as much as they were beneficial to Andy, he also enjoyed
wearing them as Camp, in the same way that he went around with his
shoes scrunched down on the heels.

There was an element of liking to shock . . . sort of like a bad
boy. So, that's why he would have outrageous subject mat-
ter. . . . Andy once wanted to have this exhibition with live people
hung on the wall as works of art.

PS: When was that?

NG: Oh, it must have been '65 because he kept asking, "How can I do it?" Nothing came of that.

PS: Do you ever remember him talking about Marcel Duchamp, or Duchamp ever meeting Andy?

NG: I don't remember him ever talking about Duchamp until about '64 or '65. When he met Gerard Malanga, I think, it was through Gerard that he met some of the younger poets of the time. . . . At one point, I was trying to weed out my library so that I wouldn't have too many books then. And I had a book on Duchamp by Robert Lebel, which I sold to Andy. And I had quite a long run of the magazine *View* that Charles Henry Ford and Parker Tyler and those people put out, and at one point, I decided I was only going to keep certain numbers—one that had an English translation of de Chirico's book. . . . And I sold the balance to Andy. [Gluck remarks that Warhol paid him by the hour, usually two dollars and fifty cents per hour during the 1950s. Gluck demonstrates how Mrs. Warhola formed letter-by-letter the script used by Warhol for the text of his promotional books and for his signature. Gluck describes various people ("hangers-on") who were associated with Warhol's Pop Art phase.]

PS: Did you have anything to do with the *Brillo Boxes?*

NG: Andy told me "to go to the supermarket and find me some boxes." So, I went to the supermarket and—dumb me!—picked out *very nice* boxes. You know: for grapefruit with maybe palm trees or crazy flamingos or . . . some kind of oranges—maybe, they would be called Blue Orchid Oranges, and the box would have a blue orchid on them. And I brought them back. And Andy said, "No. No. No. Not like these." And then he did *Brillo, Kellogg's Corn Flakes* and *Mott's Apple Juice.* And I thought, "Oh, gosh! They're. They're . . ." You know. But I could see his point was: to get something that was basically everyday, dull, that you've seen over and over again, is not romantic, is not esthetically. . . . Whatever you want to say. . . . You know, at one time, when the movement first got started, he wanted to call his stuff "Commonist Painting." Meaning: it was common.

PS: This is something *he* said?

NG: Yeah. . . . I know there was this plug about "Commonist Art" because they were going to paint common things, but "Pop" stuck and it never got off the ground, and, of course, it sounded like "Communist." But here I was with all this exotic kind of cartons but not in

the sense they were foreign but the names of the things and the emblems and the logos that they had were so much more romantic and atmospheric than Brillo.

When Andy told me he had to do something for the World's Fair, and he was going to do the *Ten Most . . .* , do you know what he wanted to do first?

PS: No.

NG: A Heinz pickle! [Laughter] Now, do you know why he was going to do the Heinz pickle?

PS: No.

NG: Because this Fair was in . . . 1964. . . . in 1935 or 1936, when we had the first World's Fair in New York, there was a Heinz Pickle Pavilion, and they gave everybody little pins that were Heinz pickles, and everybody wore them. And Andy had, evidently seen these or heard about it or something and thought, "Wouldn't that be great: for this year's World's Fair to do a Heinz pickle." *Then* he thought of the *Ten Most Wanted Criminals.* And I thought, "Andy, you are out of your mind!" And he went ahead and did it, and the story I heard— whether it was Andy or what—was that either [. . .] and this was very bad for the Italian vote, and, so, they were painted out.

What I think is so fascinating was that Mrs. Warhola never knew how famous he was. [Gluck suggests about 20 people that P.S. should interview and gives his permission to reprint his manuscript *About Andy, His Mother and 3 Cats Named Sam and Hester.* P.S. explains to Gluck Rainer Crone's interpretation of a proposed influence of Bertolt Brecht's notion of Epic Theatre and the Alienation Effect on Warhol's art, as in Crone (1976).] Well, here was Andy living down there, and he thought it was fun, and I think that Andy didn't give peanuts for Brecht, but I just remembered something: Andy's costumes for a Thurber play. They wanted Andy to do the costumes but credited to somebody else because of unions. . . . [Gluck mentions that Warhol did costume designs for a ballet for the 1964 Spoleto Festival. Gluck comments that Warhol was not interested in politics and probably never voted. Warhol did have a "sweet tooth" and bought an exercise machine around 1960; the machine was used only a few times.]

PS: What about *Wild Raspberries,* if Andy didn't cook?

NG: Oh, that was a joke thing, a Camp thing, because those recipes were all either fantastic or absurd.

Nathan Gluck, New York, 25 October 1978

During the second interview with Nathan Gluck, he discusses a variety of topics.

NG: One thing that I forgot: Andy was going to change his name. He was going to call himself "Andy Paperbag." . . . Andy used to go around and used to give people little packets of birdseed with instructions to plant it and a bird would grow.

PS: And Robert [Galster] found it extraordinary that you and Ted [Carey] had never met because, he said, "Well, everytime I went there, Nathan was always there."

NG: Well, Ted Carey never came to the house during working hours, and Ted Carey was, more or less, someone whom Andy would see socially or however after the day. See, I would be there from 10 o'clock to about two or three, and, I'm sure, anytime that he saw Ted was after that or if they went out to lunch, but I don't ever recall Ted coming to the house. I'm sure I had seen Ted, like walking down the street, and Ted went by with Andy, or if Andy was walking with me, and Ted went by. Well, you know, Andy could have come in contact with a lot of people socially at a party or something like that.

PS: Did you ever see any of the other Pop artists, such as James Rosenquist or Robert Indiana?

NG: I never saw them at Andy's house. . . . If they did, it was, as I said, after I had left. . . . But Andy was never a party-giving sort of person, to come over to the house type. I mean, a *friend,* yes, but to have maybe five or six for an evening party kind of thing—I can only recall one party at Andy's when he was living down at 34th Street, and I can't remember what the occasion was or when. . . . Did anyone ever show you the pin button? The *Campbell Soup Pin Button?*

PS: No.

NG: [Leaves and then returns.]

PS: Did Andy have these made?

NG: Yes. I think, it was for the *Campbell Soup* show, and he had these pin buttons made. . . . He was just giving them out to everybody. There may have been a basket of them for people to take. . . . But they're collector's items.

PS: Sure. Someone gave me a button with his picture on it that they had found in a flea market.

NG: Oh, really? How funny. . . . Oh, yeah. Andy used to do . . . occasionally, he had a lot of the drawings around the house that had been tinted with watercolor and there was a lady on Madison Avenue. . . . Her name was Joan Morse, and she ran a little shop called the Gilded Lily. So, very often, we used to refer to her as "The Gilded Lily Lady," and Andy would sometimes take these drawings down to her and stick them in the window and try to sell them in her shop, and it had all sorts of little chic things, boutique-type things, and, of course, at that time it was quite an innovation. And she had some of Andy's things on consignment.

PS: Now, what year would that be? About . . . ?

NG: Well, that would be the early '60s, I guess. The late '50s.

PS: Did Andy ever do any of his films at his house?

NG: Andy had a projector, and he would run them out at his house. If there was any filming there, it was done when I wasn't there. . . . Andy was, you know, always fascinated by movie stars. Even when he started to become a celebrity himself, he would say, you know, something like [imitates Warhol], "Oh, I met so many poets last night." . . . I don't think he has any close friends but knows various groups of people. I once saw him at a Guggenheim exhibition of [Joan] Miró, and he said, "Oh, I knew you'd be here 'cause, I know, you like Miró so much."

I remember the time I had to go up and wrap, upstairs in one of the rooms, and wrap all of Andy's [*Brillo*] *Soap Boxes* in plastic because he didn't want them chipped. They *all* came back. He maybe sold two out of all that bunch. Maybe three? He was *so* upset and depressed, and these bunches were just lying from floor to ceiling, practically. I wonder if he still has them? Or if they sold them all eventually? . . . He just bought plastic and wrapped them all to keep them from getting dusty and chipped. . . . Do you want to photograph *Happy G. Garbo Day?* It would be nice if you could talk to Garbo if she remembers meeting Andy, but I don't think she would talk to you. First of all, I don't think she would talk, and secondly, Andy met her through Mercedes Decostella, and Mercedes Decostella had written a book, and Garbo didn't like the things she said, so, she dropped Mercedes Decostella. Now, how Andy met Mercedes Decostella, I don't know.

PS: Tell me about the nature of the canvases. Were they stretched?

NG: No. No. They were just rolled out on the floor. He didn't have anything stretched, I think, until they were done. They were just unrolled

in the firehouse. And Andy would sit down and screen them. I don't think, he'd done the serial ones. I think, he sort of did a *Liz Taylor* and then unroll a little more canvas and then do another *Elizabeth Taylor,* and the idea was that he'd just cut them out individually, and somewhere along the line it occurred to him to just do them bum-bum-bum-bum—you know, serially.

Okay. This is Andy's *Wrapping Paper,* done with stamps carved out of a soap eraser, which is sometimes called "art gum." It's a brown kind of eraser, very easy to cut. Now, looking at it, I see. . . . Let's start from, say, right to left. A man in the moon—that I cut. A butterfly, I cut. A fern frond, I cut. A bird, I cut. Another little bird, I cut. A star face, I cut. I'm not sure. That might be Andy's. A dragonfly, I cut. A butterfly, I cut.

And, then, in the next row there's a fly that I cut. Andy may have cut these leaves and this sunflower. Down around the center, there are repeats of the previous. Oh, a shooting star, I cut. A butterfly, in profile, I cut. And another funny kind of beetle, I cut. Oh, a bird with little wings and with little feathers on the wings, I cut. Two walnuts. Actually, it's a repeat of the same walnut that I cut. And a bug. Andy may have done the cherry. I think, I did these two and, possibly, the almond. And butterfly-bird-butterfly, I cut. A lily of the valley. A ribbon bow. Another butterfly. And, then, there are some repeats below here.

Andy did: the hearts, the stars, the black dots and, maybe, the heavy sun face. And some of the others that I didn't name.

PS: Now, how was this printed?

NG: Seymour. Seymour Berlin, Record Offset, printed it.

PS: And the applied color?

NG: Same thing. Dr. Martin's dye, which are little inks that come in a bottle, and you dilute them with water, or you could use them very strong. And Andy would just brush color or have somebody do it. . . . And it was a kind of a give-away, and, I guess, he gave somebody a sheet of it. As a matter of fact, I once saw it in a window on Madison Avenue in an art gallery, where all the things had been colored all different colors, but the only two sheets that I have, have only these colors. So, evidently, he had some that he colored most of them. . . . It must have been done about 1959.

I was never with him socially. [Gluck describes some of Warhol's social friends.]

I think that the *Ethel Scull* thing is a kind of pretty thing. The col-

ors are nice and pleasant, and the juxtaposition of all these various poses. . . . They went out and just dropped nickels and took all of these pictures [in a photo automat booth]. In fact, that's what Andy always did until he got a camera. So.

PS: And when did he get the camera? About . . . ?

NG: Gee. I don't know.

PS: Oh. This reminds me of something—when I was talking to Irving Blum. When the second show that Andy had in California, simultaneously, there was a Marcel Duchamp retrospective, and I asked Blum if Andy had seen the show. "Yes," he said, "he went with me." And I said, "Do you remember him saying anything to Duchamp? His reaction?" And Irving Blum said, "No." And, I think, I've neglected to ask you about Duchamp. Did Andy say anything about Duchamp?

NG: I met Duchamp. I not only met Duchamp, but I met him at an evening of a small group at Richard Huelbeck, formerly Huelsenbeck, the Dadaist. [Gluck describes the evening.] That was my one time that I met Duchamp. But he was probably a very easy person to see because he was in New York during all this time playing chess. . . . Andy—I don't know, maybe someone could prove me wrong, but I've never known how much Andy knew about art history or contemporary art history—that is, modern art history—the School of Paris art history.

PS: Do you remember him liking to play games like card or board games?

NG: No. I don't know. I never saw him socially in that respect. We'd have a Christmas party, and he'd come over, and once, I think, he had a party, and, I think, that's where I met David Bourdon, and another person who was a part of that circle was Ivan Davis, the pianist. [. . .]

PS: Are there stories about Warhol that you have heard or read that you think to be totally untrue?

NG: [Pause] No. [Pause] I don't read the columns. . . . I don't read the gossip columns or anything, and, so, I don't know what, you know. . . . I just feel that if somebody said that Andy was a great admirer of Delacroix, I'd be a sort of a little . . . [P.S. laughs] . . . You know? *It's possible!* You see, I'd love to be proven wrong because I have this conception of this *terribly naive* person. Now, unless someone else has said something to substantiate it and that I'd be the only one thinking along those lines. That's why I'm so intrigued about what questions you have asked and what answers you've gotten. You might

want to throw out to somebody: who do you think were Andy's favorite painters? And see if they can name any. I really don't know.

Nathan Gluck, New York, 20 November 1978

During the third interview with Andy Warhol's commercial art assistant, Nathan Gluck comments and clarifies various aspects of Warhol's art.

NG: We were talking about Rainer Crone's theorizing about Andy's relation to Matisse and your [Patrick Smith's] feeling that it's closer to Cocteau. I think it's much closer to Cocteau not only in resemblance, but, I think, more in spirit because Cocteau's whole lifestyle was, certainly, a lot closer in a way to Andy's and Andy's to his in a way. But when you mention this, it made me think that there was a book by Cocteau of drawings that came out in the '20s . . . and Andy, I think, saw a reprint of it somewhere and thought it was a great book and wanted to get a copy. I don't know. But it had all of Cocteau's drawings of people at the piano and people in bars and things like that. Do you want to see it? . . . The title of the book is: Jean Cocteau, *Dessins* (Paris: Stock, 1924). But to say that Andy was influenced by Cocteau would be not entirely fair.

PS: I would say, it's *an* influence. I'm not saying there is any "*the* influence."

NG: I think, maybe, it's basic things that motivated Cocteau motivating Andy [and] motivating a lot of other people. Like, for instance: the artist drawing his hand . . . which we just saw [in the Cocteau book]. This looks a lot like one of Andy's *Boy Drawings,* but, I think, it's purely coincidence in the sense that they both were using a fine line. And, I think, this happens to be a guy who was Cocteau's lover. And whoever Andy was drawing, he considered pretty people, too. So, I think that the motivation rather than saying that Andy had looked at Cocteau and had been influenced because I'm not sure that at the time that Andy mentioned this about the Cocteau book, he had been, you know, drawing like this for quite a while. It's just like when people tie it into Ben Shahn and think that Shahn was an influence. And I don't think it was. I think that it's just that if you're going to look for an influence, you might go back to Picasso's Blue Period and Picasso's Classic Period when he was drawing in a fine line which, then, you could say was an influence on Shahn and an influence on Andy. And, of course, Picasso wasn't the first person to invent drawing in line. You can go back to Ingres. I think it's interesting because

sometimes there are deliberate influences. I mean, when someone who is very heavily influenced and you know then that they have *seen* the other person's work and drunk it in.

PS: Okay. And this [other] book?

NG: [Laughing] This book I bought on Lexington Avenue once because there was a print store called Pageant. They sell prints, and they had this notebook that somebody had made in the 1880s, which I thought was just incredible, and I bought it at a ridiculously cheap price. But it's so hysterical because it's all muscle builders. But whoever did it must have had a foot fetish because you find all these little feet through the whole thing. [Gluck turns the pages of the scrapbook.] Also, they drew in a lot of mustaches. See? I think, there was a mustache there which I must have erased, and, I think, there was one once there. I don't know who drew in the mustaches. After I erased them, somebody said that I shouldn't have dared that because, maybe, the person who did the book had put the mustaches on the men. And somebody said once, when I showed him this book, "Oh. That must have been where Andy got his idea for the shoe book." [Pause] It's just insane: it goes on and on with. . . . I think, those are little tights. Then he had this great fetish for drawing in the rest of the leg, and, then, these are thrown in. Someone once insisted that these were somebody in drag, but they're crazy. It's so obviously looking like a woman. "This is Sandow—Sandow the Strong Man." This was Jim Jefferies. Well.

Well, the Loft Gallery was a big loft, and, I think, it was used by Jack Beck for his advertising studio, and he had a gallery for exhibitions. And Andy had at least two shows there. I remember one show that [was] just crumpled paper. And, I think, there was another show of drawings. And part of the floor [of the gallery] was shared by a Japanese picture framer named Louie Shima . . . it was off Second Avenue, and it . . . must be 46th Street . . . something like that.

PS: Now, you mentioned a crumpled picture exhibition.

NG: Yes. Andy had taken paper. I can't remember if he drew on it or what, and, then, he would fold it every which way, and they were just stuck around on the floor. . . . I remember just: "Oh, crumpled paper! God! Andy, do you think anybody will buy that?" And when you stop and think about it today, it's like Carl Andre and the Earth [Art] people and the Minimalists and everything.

PS: Do you remember when the exhibition was? Approximately? . . .

NG: Fifty-four, fifty-five.

PS: And he just drew on the paper, crumpled it and threw it on the floor?

NG: I don't know if he "threw" them.

PS: Placed?

NG: Sort of placed them around. Yeah. You sort of walked up and said, "Where's the show?"

PS: And what was the second show?

NG: I think, maybe, that was the second show. The first show may have been just his drawings, again. . . . There were never any catalogues for them.

PS: Now, I went to George Klauber's [home] yesterday. He has a drawing, a pencil drawing, that is crumpled. I was wondering what it was. And it's an erotic drawing of people with clothes, but it's a man holding another man, like around the shoulders and the other with his legs up. . . . And I was wondering why it was crumpled.

NG: Well, I don't know if that was one of the crumpled ones. Was it on good white paper?

PS: White paper.

NG: Not newspaper stock?

PS: White paper.

NG: It might have been.

PS: When I was speaking with Gene Moore and with Bob Fleischer, both mentioned to me that Andy, of course, did paintings on windows. Now, do you remember, Nathan, did you paint on windows first or did Andy paint . . . ? And did you ever do windows for Andy in his style?

NG: No, I don't think, I never did windows for Andy in his style. But whether *I* did them first or Andy, I don't know. It *may* have been me because the first time, I think, I did them. . . . My roommate worked for Bonwit's, and, I think, the first time that I painted on the glass was in White Plains [New York] for Valentine's Day. We painted big hearts on the window, and, then, I got this fabulous idea of an arrow that ran across the whole outside, over the stone work, of the window to the hearts and, then, continued on, which we did. And, then, they had the damndest time getting the paint off the stone work, and they ended up sandblasting it. And it may have been after that that I *then*

painted them on the Bonwit windows. So, whether I did them before Andy, I don't know. I do remember once painting on the glass at Bonwit's and looking up, and there was this woman watching me, and she smiled, and it was Garbo. [Laughs] . . . Bonwit's always took the things out of the window at four o'clock, and you had to start them around five, and you had to be finished by eight or nine because that's when they were finished with their windows and wanted to go home. So, you would start like mad painting, you know, and at five o'clock or five-thirty, everyone was leaving their offices and going home. And there would always be somebody going by who would know you and would tap on the window and say things to you or make faces.

PS: Do you remember what kinds of windows that you did? Painting on the glass.

NG: Oh, yeah. Gene [Moore] would suggest painting palm trees, or, I remember, even after Gene had left, I did them for one of his successors. I painted big white doorways. But you always used—you usually used—poster paint, which could be either washed off, or they could just take a razor and rub it up and down the window, and you'd have a pile of paint dust.

PS: And that was for Danny Arje?

NG: For Danny Arje, I did them. I did them for Charles Stevens, who came in after Danny. I did them when Gene [Moore] was there.

PS: Now, the one that I have seen by Andy—painted on glass—was a dressmaker's dummy . . .

NG: . . . A dressmaker's dummy and with little pin cushions with little cupids sitting on them.

PS: Right. And that was by Andy.

NG: Andy did those by himself. . . . He'd have to. . . . People would be seeing him. I mean, I couldn't *look* like Andy and do them too! [Laughter]

PS: Okay. I just wanted that for the record. [. . .] But he never discussed his father, or did he?

NG: No. No, it was Mrs. Warhola that mentioned that he had died of some sort of lung problem, working in mines or something like that. . . . Somewhere, it says that his father died from drinking bad water or something, but the impression that I got from Mrs. Warhola was that it was a lung thing. [Gluck describes Mrs. Warhola as a re-

ligious woman, who would go to Mass every Sunday with a woman.
She liked to watch television. She could not read English well. Usu-
ally, she darned, watched television, cooked and kept house, and she
was a "very naive woman."]

PS: Do you remember Andy writing fan letters when you worked for him?

NG: No. . . . But I *do* know that he wrote to Truman Capote.

PS: Now, how do you know that?

NG: Because he mentioned it, I think, once to me when he had the Capote
show, and he was very upset because Capote never came to see the
drawings. . . . I don't think that anything sold from that show.

PS: Now, did you know Andy when he lived with this bohemian dance
group?

NG: No.

PS: So . . . that was from 1949 to 1951.

NG: Oh! Well, I may have known about it, but I didn't know where he was
living. I had met him. . . . What did we figure out? . . . In 1948 or
1949.

PS: He arrived in '49.

NG: He arrived in New York in '49? . . . Then, I must have met him in
1950 or 1951. . . . Well, I only remember that at one point he was in
the 70s, and, then, he moved to 34th Street and Lexington Avenue. I
never saw the one in the 70s, 75th Street or so. Well, the bathtub with
paper [as described in Robert Fleischer's interview] sounds interesting
because I'm beginning to think that the exhibition of crumpled paper was
dyed paper, marbleized, which Andy may have learned from me.

PS: How so?

NG: Well, when I was a little kid in grade school, we marbleized paper,
and many, many years later, I suddenly remember this technique. You
fill the basin or bathtub (however big you wanted to dye a piece of
paper) with water; then, you thin out oil paint with turpentine or oil,
sprinkle it out on the surface of the water, dip the paper into it, pull
it out, and you have all this configuration like, you know, like oil on
water. So, I suddenly remembered this in . . . 1947? Forty-eight?
Forty-seven because I was still doing it in Jersey. Forty-seven or '46.
And I would marbleize envelopes. And I discovered that when you put
the paper into . . . with the paint floating on the water, you wiggle

this way. [Demonstrates] You got a wavy, marbleized line like this. I also discovered that if you plop it on the surface like this [demonstrates] and lifted it up quickly, you got *exactly* what you saw on the surface of the water. So, I was using oil paint thinned out with oil, thinned out with turpentine. Then I started experimenting around by throwing in some varnish. Sometimes with the oil paint, you'd get even stranger configurations. You'd get reds of varnish—colored varnish on it. If I can get my hands on them, I can show you some of the old envelopes, but I won't bother. . . . And I may have told Andy about it, or I may have given him a marbleized envelope, and he may have said, "Oh, gee! That's beautiful! How did you do it?" So, that's why I'd be fascinated to find out what he [Robert Fleischer] saw in the bathtub when he [Warhol] was dying them. Was he marbleizing them, or was he dying them, just a solid color?

PS: I think, it was marbleizing . . .

NG: Because if it was marbleized, then, I think that's what the [Loft Gallery] show was because, I think, the show was just these sheets of paper, and it was poor marbleizing. Do you know what I mean? A big sheet of white paper that he had just a little bit of marbleizing towards the bottom of it, and Andy folded it every which way and unfolded it and just stuffed it there. That was one of the exhibitions.

PS: Now, Andy in the recipe book [*Wild Raspberries*] would have that pink paper inbetween the pages, and he would have these precious, very limited editions of the books. You have mentioned and [Charles] Lisanby has mentioned Andy's liking of old books.

NG: Ah! Do you know that sometimes the old books would have steel engravings in them, and, then, sometimes over the steel engravings, you'd have a piece of tissue?

PS: Well, that's what I was thinking of, and I was hoping to trigger your memory: Andy, and you and Andy, collecting books and what kinds of books . . .

NG: Andy went down to this place to buy some, and that's where he got the Grandville: the flowers dressed as people, stuff like that. And it's possible that one or two of those books may have had tissues between the illustrations in the text.

PS: Do you remember any others—other books?

NG: Oh. He had Grandville, and then he had two big books. . . . There was another one which was called *Le Patissier pittoresque* [by Grand-

ville]. . . . [And] by Antonin Careme, and it was a very old book: 1800s. In fact, I once tracked down a copy of it, and it was selling for 125 dollars. And what it was, was a picture of all of these crazy cakes. You know: that are built up like Greek temples and things like that. Andy had a copy of that. Then he had . . .

PS: So, he had a lot of recipe books?

NG: [Gluck finds his copy of *Larousse Gastronomique*.] Now, you see, this kind of thing. That inspired the pictures in the recipe book. Now, this one happens to be Careme. But he had a two volume set. . . I think it was a book called Urban Dubois, *La Cuisine classique* — the second edition of 1864. You might want to try to look these up. . . . Let's see. It doesn't say two volumes. So, anything without two volumes, forget about, *or* it could have been Dubois and Bernard, which is also *La Cuisine classique*. That's . . . 1856. And these are three books that I remember Andy having, with old engravings.

PS: How many books—old books—do you remember Andy having?

NG: Not very many.

PS: Do you remember any classic children's books?

NG: No. I don't remember those little things — ABC books — at all. But they're all so helter-skelter that it wouldn't matter anyway.

He bought a Japanese pornographic book, but I could never find it after he had been back [from his trip around the world in 1956] a year. . . . It was something he had bought in Japan, and it had these little flaps which you lifted, and there was the pornography. But, you know, he had all kinds of things. For instance, I told you—remember: I told you — that about the rolltop desk.

PS: No.

NG: Yes. He bought this beautiful Herman-Miller desk with rosewood rolltop and with a beautiful white metal base and then hated it because it was so modern. And, what he used to do, whenever he got bills or letters or anything, he'd just shove them into the furniture. The rolltop may have been a little open, but he'd just shove them in like that. [Demonstrates] There were things all over the house. It was higgledly-piggledy.

PS: Now, the rare books that you have mentioned so far—two or three of them—are cooking books.

NG: He bought them, I think, for the pictures. Yes! Because they were in

French, but the pictures were so gorgeous. . . . But I just remember the Grandville, which was such a source for all of those things.

And, of course, too, once Andy "got a motif," you might say, say: a lady with a tulip skirt and tulip head, then it was no problem to blow it up big and use it on a screen or make it small or make it this way or make it that way.

PS: I was wondering if Andy ever mentioned to you when he began to get the idea of the cupids.

NG: No. [Gluck argues that Rainer Crone does not mention whimsy, "which is at the bottom of Andy's early graphics." Gluck "cannot believe the Brecht business" in which Crone posits that Bertolt Brecht's notions of Epic Theatre and the Alienation Effect influenced Warhol. Gluck also remarks that Crone's Freudian interpretation of Warhol's *Golden Shoes*-as-sexual fetishes ignores the fact that Warhol capitalized on his association with I. Miller shoe advertisements.] Tina Fredericks told Andy to lengthen the shoe and twist the toe. Now, for instance, when you draw a shoe [demonstrates] in profile you see it in profile. Now, if you get to see a lot of the shoe ads, you will notice that you're seeing this: the shoe is twisted. In other words, if you draw them in profile you can't see what's on here.

PS: So, it's turned on its axis.

NG: . . . It's turned on its axis, but the heel stays where it is. This part stays where it is, but this is turned in three-quarter view. So that when you see the shoe, you see the what-ya'-call-it. . . . Now, when I look at your shoe, I see all of this but not the heel. Right? So, the way you draw it is, is that you have this . . . this way and that . . . that way, and, then, you draw the heel. You have this distorted view, and, yet, it looks very natural. It looks very right, but what you have done is to flip it over a little bit this way to show a little more of the detail on the surface that you wouldn't see.

And, the vamp, you sort of lengthen it a little bit to make it look glamorous. It's just like fashion drawing because if you did a fashion drawing of a real human person, it wouldn't look very glamorous, so they used to stretch the neck a little bit and make the arms a little longer. Of course, what else you find, too, is such a horrible drawing like the one that [Yves] St. Laurent with his own fashion where the head—the pin-head—with huge neck and huge shoulders. It looks ridiculous. But in real, glamorous fashion drawing, arms are lengthened, hands are lengthened, proportions are changed so that if you ever try to translate this into a real person, it would be somebody

eight or nine feet tall or whose torso is only that big and whose legs
are like that. These are things that you do to make the drawings
glamorous.

PS: [P.S. discusses Rainer Crone's interpretation of Warhol's *James Dean
 Boot.*]

NG: Yes, and they [pictorial sources] could have been there [the Picture
 Collection of the New York Public Library] and also Bonwit Teller's
 in their shoe salon, had these things hanging around, framed. Little
 clusters of engravings of shoes and stuff.

 But, also, an interesting point is the *names* that were given to
 these things were, more or less, arbitrary. I mean, the *James Dean*
 was given to a boot because it was the only male shoe. The only male
 shoes that Andy did were boots. I mean, he never did a moccasin or
 a slip-on or a tie men's shoe. But if he had done that, he could have
 called it the *Cary Grant Shoe* or *A Shoe for Cary Grant.* But, instead,
 they were boots. Who would you name the boots for? The two big
 idols at the time: Jimmy Dean and Marlon Brando. All the rest of the
 shoes were ladies' shoes. So, the obvious thing was to name them for
 the ladies. But if he [Rainer Crone] is trying to make inferences that
 because of the rose on a particular *Gold Shoe* that's what gave it such-
 and-such's name, that's just hogwash, putting the cart before the
 horse. [Gluck discusses Crone's interpretation of Warhol's *Shoe
 Book.*]

PS: Then he [Rainer Crone] talks about James Dean, etc., as providing the
 "iconography" for the *Shoes.*

NG: Well, that's such a pile of shit because they were all drawn and were
 given names afterwards! They were never given names before they
 were drawn.

PS: Who gave them the names?

NG: I don't know. Andy or Ralph Pomeroy or somebody.

PS: Did you know Ralph Pomeroy?

NG: Nope. Never saw him.

PS: And did Andy ever himself do the drawings or did someone else do
 them?

NG: The drawings?

PS: . . . Of the shoes.

NG: I may have helped him, but *never*. . . . They were all drawn, and, then, Andy may have given them names before he decided to put them in a book. Oh, I know how it went. I think, what happened was: they were drawn; Andy was just making shoe drawings and gold-leafing them, and, then, I guess, some people wanted them. This person would want some; so, he would say, "To so-and-so." Then, I think, he must have decided to have an exhibition and maybe that's when he gave them the name *A Shoe for Judy Garland* or *Any One for Shoes?* But he [Rainer Crone] almost implies that the feather was put on this *Shoe for Judy Garland* and a feather and little rosettes that are symbolic for this, that and the other thing. Isn't that the impression you get?

PS: Yeah.

NG: Which isn't so at all. . . . He did a shoe, and, then, somebody said, "Let's call this shoe *Judy Garland,* and let's call this *A Shoe for Zsa Zsa Gabor.*" I don't think, Andy ever said, "Let's make a shoe for Mae West." If he did—I know, there was a *Mae West Shoe*—but if he did, then we made it big and fat and, you know, breasty like Mae West. *But* I don't know where he [Crone] gets the feather for *Judy Garland* as being significant or something. I don't know. . . . I just think that Crone has gone off the deep end and made it all very deep and ponderous, and that a lot of this stuff was "fun": fun for Andy, fun for people to look at, just like the cook book. I don't think, it was meant to caricaturize or satirize American recipes or anything like that. *It was just fun* because, first of all, there was much more interest in this country in cooking *today* and in recipes than there was then. Today, it's big stuff. Back in those days, it wasn't that big a thing. And this was done as a "fun" thing. I think that he [Crone] has lost sight of all the wit and the whimsy and the fun that went into Andy's things, and he's trying to formulate a theory to prove it.

 I think, for the most part, it's cheap gold metal. It's called "Dutch metal," and it's like gold leaf. The only trouble, I think, is that it tarnishes.

 He used colors with these flowing, uneven washes, but that's the way Andy liked them, and that's the way Andy himself used to do it because if there's something that Andy didn't like was a complete, flat color wash, and I've seen Andy apply the color, and, at times, I've done it since then, and, I think, it's a great effect. You put down the color very strong. You work at it. You let it fade out. If you bring it back, it gives it an unevenness which gives it a richness and a depth to it. But to apply it flat, I mean: you can see it on the leaf of this rose.

See. The darkest black is what would have been the darkest green and, then, you lighten it, and it gives it a vibrancy.

PS: Would you also blot the dyes?

NG: Oh, no. No. Those went on with a brush. . . . You brushed it in. So, like in those little fairy wings here. And what happens is, you put it down dark, you know, and, then, you thin it out with a little water, and, then, you make it dark enough, and, then, it flows on, you know, and it gets a vibrancy that way whereas if you just apply it flat, it looks like it was silkscreened.

PS: What do you think of Crone's characteristic of people who participated in the coloring as "dilettantish?"

NG: Well, I think it's an unnecessary adjective.

Bert Greene, New York, 3 December 1978

Formerly the co-founder and producer of Theatre 12 and the art director of *Esquire,* Bert Greene is at present a free-lance writer.

BG: Theatre 12 was begun by me and Dennis Vaughan (who now lives in Petersburg, Virginia). Dennis was an actor who wanted to direct, and I was in advertising, wrote some short stories and wanted to direct. We began it here in my apartment [on West 12th Street] and, hence, "Theatre 12." I'd known George [Klauber] from Pratt, and he brought Andy in. What happened was, we'd meet here on Mondays and read plays. We started reading American plays and then more profound plays, such as [Bertolt] Brecht, George Kaiser and became interested in German Expressionism.

The first time that Andy came here, as I remember, we did *The Way of the World* by [William] Congreve. He was a dreadful reader. I mean, he's hopeless. Hopeless actor. I mean, he has no talent at all in this direction. I, of course, knew who he was because even then in 1953, he had a small reputation in advertising. And I don't know if I told you this, but I was an art director all the while I was trying to be a writer. I don't do that now at all. That's all forgotten and over, but I was always an art director—usually advertising agencies and the last job I had I was at a magazine—at *Esquire.* But I knew Andy from that because of my interest in graphics, and I was impressed with his reputation. It certainly was not his *persona.* He was always strange. He was shy and very different looking. [Greene mentions Warhol's facial surgery.]

[Greene describes Dennis Vaughan's interest in Jacobean Closet Drama.]

I don't know why Andy wasn't a part of us when we moved to a real theatre. He offered to do sets when we were still in my apartment. One set had black-and-white drawings for a Sardi's Restaurant set and a cardboard bar. He did sets for three plays. The Sardi's set was for a play by William Larner. He also did sets for [James M.] Barrie's *The Twelve Pound Look.* There's something I wanted to tell you, and I was telling George [Klauber] this: I don't think, much as we read the great classics, and we read the German Expressionists, I don't think we had any influence on Andy at all. Andy is an *auteur* person. He's absolutely his own man. I mean, he's original. He fits into nothing. He's affected by nothing. He always did what he was going to do. And there's a man who was in the group, who's now dead, named Aaron Fine. I don't know if you know anything about him. He was a poster artist. He did collage. He did a lot. He was very successful. He worked for Pan American Airways. All those great posters—that great era of great posters in the early 1950s. I think, 10 years he did them, and he wrote a couple of children's books, and he was a playwright. And it was his play, *My Blackmailer,* that Andy did his best set for. And it was very original. It was based on a set of screens, and Andy decorated them, and, then, the screens were folded, and they became other things. They were turned around, and they were still other things. They were just, really, folding screens. But he did . . . I have photographs of them somewhere here. I mean, they're in a scrapbook on Theatre 12. I think, it was called: The 12th Street Players.

After Andy began his Pop Art, Aaron [Fine] asked him why he was doing it, and Andy said, "It's the synthesis of nothingness," which is, of course, the Dada reply.

PS: [P.S. reads his translation of Rainer Crone's commentary concerning Theatre 12 in *Andy Warhol: Das zeichnerische Werk, 1942–1975,* exhibition catalogue (Stuttgart: Wuerttembergischer Kunstverein, 1976).]

BG: It's amusing that Andy Warhol "lived" at Theatre 12. That's an absolutely ridiculous idea. . . . When we had the group, we never felt that Andy was valuable to us. We thought Andy was valuable to do sets. We thought that it was great for him to do it, but, I thought, he never did his greatest work for us. But, ah, I just didn't have the foresight that he was going to become a Superstar. [Laughs] I would have . . . [laughing] . . . "clung" to him a bit longer, if I had the

good sense to know it. I always thought that Andy was a "light-weight," and I still do. I think that he is a talented man, and he has certainly found his place, but, ah, I can't take him very seriously even now.

PS: What kinds of things did [Rainer] Crone ask you?

BG: Well, he wanted to know. . . . He was very interested in the German Expressionists, and he felt, in your translation, that—you know—that the whole [Bertolt] Brecht thing made such a profound influence on Andy: that Andy saw terms in a socio-economic view that had altered his opinion only after his experience with Theatre 12. That's just balderdash! I mean, Andy had no clue who Brecht was. And, don't think that he was—I remember we read a play—it's called *The Rats* and it's by Gerald Hopman. It's a German Expressionist play written, I guess, about 1911. And Denis Vaughan was very interested in the German Expressionists, and that was his field. I mean, he studied that, and he was also a wonderful director for German Expressionism, but, ah, I don't think that Andy was much influenced at all by . . . did Andy understand it? He was just *there*. He was there as a . . . , as I said, he was a voyeur. Crone was very interested in what might have triggered Andy into film. And I have no clue. I mean, he was certain that it was the theatre, and he was certain that it was this little familial atmosphere that kept us all together. I think, it was another opportunist moment. . . . Something happened. Whatever it is, whatever happened to Andy pushed him into what? Well, lots of things in all our lives—the forces—and you meet someone and something happens and . . .

PS: It's the throw of the dice . . .

BG: Yeah. It sure is!

PS: Did you ever observe him drawing?

BG: Oh, yeah. Yeah.

PS: What do you remember?

BG: Well, I remember that he was very dependent upon tracing paper. I mean, he usually would trace an image from something. I mean, he would find an image. Or: in his free-hand drawing was always very shaky in those days. It wasn't the firm stroke that it is now. Certainly, those pencil drawings in the catalogue are nothing like the way I remember Andy drawing. He was very tentative, but when he had an image he would take it. I mean, he would change it and redo it and,

then, when he was doing those final inkings—at one point, he used to work on glass because it kept the ink longer. He would press blotter paper against it. I remember watching him: he would put the glass over an image—he did something from the *New York Times:* of a man hitting somebody with an umbrella, I remember. He did it for *Seventeen Magazine.* And he was doing this drawing quickly: so quickly, that he could blot it and once he blotted it then he realized that he didn't like it. Then he would do another drawing and change it and vary it. But it was always a reverse image of what he was doing. He found that the glass didn't soak up as fast as the other medium (as paper would, as a matter of fact).

He used to go to the New York Public Library's print collection. Andy said, "Oh, you just go to the Public Library and take out as much as you want, and you just say that you lost them, or they were burned. And you only have to pay two cents a picture." And, so, you would really get valuable things, and you would collect them from the library and just give them back this small token thing. But, I think, his name became so well known for losing so much that they . . .

PS: He had to pay large fines. In fact, I talked to the guy who was in charge of the library . . .

BG: And he did have to pay large fines?

PS: Yeah.

BG: But they were all stolen. I mean, *Life* was his favorite source. It really was. And the *New York Times.* And he used. . . . And he was always interested in photography that was foreshortened. You know. Andy couldn't foreshorten in his mind. I mean, he couldn't let his eyes in a . . . He couldn't get the perspective. So, he would usually do it as a . . . by using a photograph. And, so, because that always looked strange, when it's rough, you know: when it's done—it would work when he would blot it because certain lines would elapse. I mean, so every detail wasn't there so that your eye would fill in.

PS: Right.

BG: He also learned to leave out. I remember, Andy drawing these things from the [*New York*] *Times,* and, I remember, he said, "The important thing is to leave out." And he said, "What you leave out, you can always put in later." I mean: add a little. So, he was a master of his own technique. He always was. He was technically perfect. He knew what to do.

PS: Do you remember anything else [that] he told you or recommended to you when he drew?

BG: No. Not really. I don't remember too much. I do know. . . . I always thought that he had a weak sense of color. I mean, his color thing has evolved. He's learned a lot from his silkscreening and with matching colors together. He had a little thing that he used to carry around, these little paint samples that you'd used to get: *House and Garden* colors, and when he'd get a job, he used to fumble around with these little swatches of color until he found the colors that he felt would work, and, then, he would start to work. He never really conceptualized color until he started to work with anything, and he would think, "Now, where should the color go?" and that kind of thing. He was very interested in working in collage because, I think, then, he didn't have to put down something directly. I mean, he could switch and change. And, of course, his *Campbell Soup* things—the most interesting ones are the silkscreened things, where the colors are quite bizarre and strange, and, then, he had the option of changing it. I think, even now, when I was in his studio, he was just finishing his portrait of *Russell Means*. . . . That was a commissioned portrait. And, I thought, they were very strange colors and I said, "Are those the colors?" And he said, "No, those are tests." Because they were silkscreening it, printing it. . . . It wasn't really a painting, he was going to finish it after he had found the silkscreened colors that he had liked. And, certainly, the *Jimmy Carter* portrait—he had just done that one, too—I guess, Carter had just been elected when I saw him, so, I don't know: that was two years ago [in 1976]. It was right after Carter's election that he had done that painting. Maybe before. Because I remember saying to him, "Are you going to vote for Carter?" and he said, "Well, I really like the [Gerald] Ford children. I really like the Ford children. I might. I don't know. But I'm . . . " and, obviously, he didn't vote for Carter, I think. Who knows who he voted for. But he was very attracted to the Ford children: Susan, Jack, . . . he liked them.

PS: Do you remember when you went to his studio that he actually participated in the work, or, mostly was it that you talked to him in that dining room?

BG: I talked to him in his private office. We were, at first, in the dining room, but that was too noisy or something, and we . . . But people were working on his work. It was . . . I accept, he has a large crew.

PS: Did Andy ever mention [Jean] Cocteau to you?

BG: Yeah.

PS: In what way?

BG: Well, I think, we both saw Cocteau on the street together. I saw Cocteau in 1952 or something. He was coming out of the St. Regis [Hotel], and I was walking and saw Cocteau. . . . Andy was like a groupie. He had a fix on Cocteau.

PS: Can you specify in any way?

BG: Gee, it was so long ago [that] I really don't remember, but I know that we talked about it once. . . . And I knew that he [Cocteau] was looking at me as if I was an object, and Andy said that he does that to everybody: you ought to have felt flattered.

I have something that I remember, and it's so funny. *Andy gave me pornography* which he said was done by Cocteau. And he said, "They're by Cocteau." And I said, "They're not Cocteau. Cocteau wouldn't draw like this." They were kind of, like husky, husky drawings like Tom of Finland. Right? Sort of brawny. And I said, "This couldn't be Cocteau because Cocteau's style is so apparent, and his line is always . . . " And Warhol said, "I guarantee you those are Cocteau's." They were photographs. And he gave me these drawings, or he showed me these drawings. I think, he just *gave* them to me. I don't know if. . . . I may have them somewhere. He *insisted* that these were drawings by Cocteau, but Cocteau had an entirely different. . . . And I never believed it.

You know, the screens [by Warhol for Theatre 12] that I had had marbleized paper. Black-and-white marbleized paper that he crumbled and cut up. He used them as collage. He messed around with them and placed them on the thing.

[Greene describes the productions of Theatre 12 at his apartment as similar to Jacobian Closet Drama. In 1953 or 1954, they produced Jean-Paul Sartre's *The Flies* Off-Broadway, in which they rented a theatre for 100 dollars for weekend shows. Professional actors began to join the workshop-oriented group. They also did a series of play-readings at the Providence Town Players Playhouse in Greenwich Village. Usually, plays that had not been seen in New York or plays that a member wanted read were chosen to be read at Bert Greene's apartment. The readings evolved with productions with costumes.]

PS: Did Andy ever pick a play to read?

BG: No.

PS: And you said that he read once?

BG: He read several. . . . He used to be given small parts. I think, when we read [Anton Chekhov's] *The Cherry Orchard,* he played the butler because it was the easiest thing to read. He was a *very* poor sight-reader, and he mispronounced words very badly. And he was a "downer" in a performance. I mean, he wasn't very good, and he didn't have a very strong voice anyway and made no pretense to project. I remember well Dennis [Vaughan] saying to him, "Andy, if you're going to stay in the group, you *must* project. You *must* talk loud. You must try harder. Less breath and more diaphragmatic speaking." And Andy *tried.* I think, Andy enjoyed . . . but what he really enjoyed most was to, sort of, listen. And most of the stuff was audited. I never thought Andy would stay as long as he did. He stayed with us for at least six months. Six or seven months. And I always felt that he would never come back. And it wasn't embarrassing. . . . It would have been embarrassing to me to read as poorly as Andy and to want to stay. He must have enjoyed it in some way.

PS: And you said that he did designs for three . . . ?

BG: He did a play called *The Days of the Bronx.*

PS: Who's that by?

BG: This is by William Larner . . . William Clifford Larner. And he did sets for that.

PS: Do you recall what they looked like?

BG: They were pictures. And if I can find them, I'll show them to you. That was the Sardi's thing. The setting was Sardi's [Restaurant].

Fred Hughes, New York, 19 December 1978

Fred Hughes has been an associate of Andy Warhol since 1967, and he is the president of Andy Warhol Enterprises.

PS: How is the Factory set up today? How are things organized?

FH: Well, you've been there. You know.

PS: Well, in your own words. [Pause] Something, say, that I haven't noticed that you think will help me understand Andy.

FH: I think, it runs like any small business or big household. There is a hierarchy of people who make decisions, but they all cooperate. And, ah, I guess, that I have, sort of, the ultimate responsibility for decisions, but it's really Andy who . . . You know? Unless he's adamant

about something, he'll tend to take my advice, or else we'll get to-gether and argue out. . . . Then, Vincent Freemont and [Bob] Col-acello have their own areas of influence. [Colacello was the editor of *Andy Warhol's Interview Magazine,* and Freemont is the manager of the daily operations of Andy Warhol Enterprises, Inc.]

PS: What is the question that you've never been asked but would like to answer?

FH: I don't like to answer questions. [Laughter] So, that's easy.

PS: Is there something that you'd like to say about Andy Warhol? When did Andy Warhol Enterprises begin, as a corporation?

FH: Actually, Enterprises . . . there were lots of . . . we kept chang-ing . . . Oh, around '68, I think, that things were consolidated, and we . . . at one point, I think, we were making . . . before I started, Andy started corporations for every little thing that he did. So, then, [he] incorporated and consolidated and things like that.

PS: Now, when I was at the directory by the elevator [I noticed that] it had several things. What are they?

FH: One is Sharks. It is a corporation to take care of one group of movies.

PS: Now, were you here when *Interview* was beginning?

FH: Ah-huh.

PS: How did that begin?

FH: Ah. Gerard Malanga was working for us, and Andy had a lot of friends because they were poets or writers, who he thought should be published, and he thought that this was something that was particularly suitable for Gerard to do. And, really, it wasn't particularly a commer-cial idea. He thought one person could do it all, which, indeed, Gerard did start it with another friend, Soren Angenou. And that's how it started.

PS: Okay. Now, when did the Factory move here to 860 Broadway?

FH: Five years ago [i.e., 1973].

PS: And was that . . . ? When I was speaking with Ronnie [Cutrone], he said [that] it was, more or less, because of space limitations at the third Factory.

FH: Well, the third Factory was that the landlord raised the rent a lot.

PS: I understand that one of Andy's new projects is a book about the '60s.

[See Andy Warhol and Pat Hackett, *POPism: The Warhol '60s* (New York and London, 1980).]

FH: Yeah.

PS: How did that come about?

FH: Ah. With his partners. They got several ideas. Besides, he had the material. It [?] was particular able to do a thing on the '60s.

PS: And why did Andy publish *The Philosophy* . . . ?

FH: The same sort of idea that evolved out of the discussion with the publishing company.

PS: And whatever happened to the Andymats?

FH: We saw that it wasn't going to be a quick, easy thing. So, we dropped it. The only way it would really work with a lot of energy, and the energy could be put in we felt, you know, one big push, and we weren't too busy with things that really do make money and keep us all going then that would have been fine, but the financing wasn't as quickly forthcoming as we first thought it would be. So, we dropped it.

PS: What are the other projects that are coming up that are on the boards?

FH: Well, we'd like to do another film—sort of in Florida. Ah. A screenplay. So, we keep talking to people about it.

PS: Something done here in New York?

FH: Then, there is Warner House—Sally Rukus put the screenplay together that we don't have, and, Andy has his photo book coming . . . [See Andy Warhol, *Andy Warhol's Exposures* (New York, 1979).]

PS: When will that be published?

FH: Hopefully, this summer.

PS: And what will that be?

FH: His snapshots that he's taken for the past two years.

PS: Great.

FH: And captions for them. And what other projects are coming up? Just the big painting exhibition for the Lonestar Foundation.

PS: And when will that be?

FH: That's the end of January. The Whitney is doing in '79 a big show of recent portraiture. [See Robert Rosenblum, *Andy Warhol: Portraits of the '70s,* exhibition catalogue (New York: Whitney Museum of American Art, 1979.)]

PS: Anything else coming up?

FH: No.

PS: I noticed while looking through the scrapbooks something about an automobile. What was that about?

FH: Bavarian Motor Works. When they had their race car in France—a sort of stock car race. They asked several artists to paint the car. So, we might do that.

PS: There has been a question that has been sometimes asked me by various people—at least 20 to 25 people—"Well, does Andy really do his own work? I've never seen him do his own work." And there are, say, the other half who say, "Always, Andy does his own work." Now, I understand . . . I think of him being a kind of [Peter Paul] Rubens, where he has such a large studio and such a large following that want his work. He designates work, and . . .

FH: Well, I don't know. You've been up here [at 860 Broadway]. You should see . . . You've seen . . . And he's done all the painting himself. The screening. You know. He has help with that, but that's . . . I mean, that's hand done, but still the screen is made mechanically in the first place. So, that's not quite so important, but he does all of his painting himself. Nobody puts the paint or mixes the paint or puts the brush to the canvas. You've seen him. Even if he's doing it with a mop.

PS: In your Wilcock interview, you said at one point . . . he asked you, "And then there's still a lot of people who misunderstand him." And you replied, "Sure. It is more elegant to be a mystery. So, he promotes a very sophisticated mystery. People read a lot of fantasies into it." Would you like to expand on that? [See John Wilcock, "Interview with Fred Hughes," in *The Autobiography and Sex Life of Andy Warhol* (New York, 1971), no page.]

FH: Well, that's it, I guess.

PS: It does for me.

FH: It's a kind of playfulness, which is nice and a kind of privacy. He's not the sort of person who constantly, you know, tried to expose his

inner thoughts or demonstrate his private self all the time, which is a ritual about our particular period, I have discovered.

PS: In what way is it a ritual?

FH: The self-awareness, the self-explanatory medium-personality. Do you know what I mean? What I'm talking about?

PS: Yeah.

FH: A magazine article or something.

PS: If you were asked, say, now or later, to write a magazine article about Andy, how would you approach it?

FH: I wouldn't do it. There are too very many qualified people, like I'm sure you are, who go through the torture of trying to do it. I'm not qualified. I'm very unverbal.

PS: In a sense, Andy is not really verbal either.

FH: Not particularly. No.

PS: But then again, you have acted as a spokesman on occasion, as when he goes to a museum or wherever.

FH: [Pause] Well, I generally try to avoid it, and there is very little reason why . . . why either Andy or myself should be spokesmen. Thank God! That doesn't seem to be the proper sales pitch in order to sell his paintings. I mean, there are many more qualified people to analyze and to speak about Andy.

PS: For instance?

FH: Art historians and museum people generally speak much better about Andy than I can.

PS: Now, I'm an art historian myself, as opposed to a journalist, and people have asked me, for instance, when I came here [to Warhol's studio] the first time—Vincent [Freemont] asked me, "What's my angle?"

FH: So, what's your angle? You mean, that's what Vincent asked you?

PS: Yeah, and I replied to him, which is absolutely true, "I have no angle. I see Andy as a kind of cultural phenomenon."

FH: Well, he really didn't mean that. He meant it *much more bluntly,* "What are you going to do with the material that you collect?" [and] "What form is it going to be published?" He was just being direct . . .

PS: It's for my dissertation.

FH: . . . When he meant "your angle."

PS: When he first said that, I thought, "Acute or obtuse?" [Laughs]

FH: I think, he didn't mean what kind of attitude are you going to strike about the whole thing. We were already told by Ivan [Karp] that you were doing something serious and art historical. So.

PS: What I am doing is going to cover from the time that Andy was at Carnegie Tech through today, and I'm going to be covering his films, his "society portraits" (as I'm calling them), his Pop Art, . . . I was talking to Fritzie Miller [Warhol's commercial art agent], and she said that another commission that Andy was asked to do was for Bufferin, and Andy did a painting of Bufferin, which you now have.

FH: I have?

PS: That's what she said.

FH: No.

PS: And I've never seen it.

FH: It's a painting of a Bufferin bottle or a Bufferin?

PS: I don't know.

FH: He did a *Listerine Bottle*. Maybe, she . . .

PS: Oh! It was *Listerine*.

FH: Yeah. Well, I don't have the painting any more. I forget who it was sold to. It's a pretty big painting.

PS: Now, it was just a bottle?

FH: Yeah. It was a pretty painting of a Listerine bottle. It's gold paint on a blue background. It's very artistic. I think that they turned it down.

PS: That's too bad. Are there any things that you think that have been mixed-up that you'd like to clarify for me? [Pause] Say, what things have been written about . . . ? [Pause] Or, has been bothering you . . . what has been written about Andy?

FH: No, because I'm sort of amused by it, by everything that is said, and very often it's enlightening. It's things that I haven't thought of. There's certainly a lot of trite things. I mean, he's been perverse. He's definitely confused issues, like this business of being a "machine" and painting, which is in his head but which has to be clarified—about

him not doing his own pictures. But, ah, I don't know. Why don't you, once you have clarified your things, then we could sit down and talk. I can say if I agree with you or not.

PS: That won't be, at least, until next fall.

FH: I'll be here. [Walks out of room.]

PS: Thank you for your time.

Ivan Karp, New York, 12 October 1978

Currently the owner of the O.K. Harris Gallery in New York, Karp has known Andy Warhol since 1961.

IK: I was working at the Leo Castelli Gallery in 1961, and I just had come to meet Roy Lichtenstein . . . And three people, I think it was, came in one afternoon, which included a very shy, strange-looking gray-haired man [Warhol], and they wanted to see drawings by Jasper Johns, who had already achieved a certain momentum in his career. [. . .] . . . after discussing what the price was. Something like 350 dollars for the drawing (a small drawing).

And this person [Warhol] expressed tremendous enthusiasm and spoke of it with such conviction and with such high spirits that I thought that I would show him a few of the other things in the gallery, and I took out this Roy Lichtenstein painting that was there maybe just the week before. And he reacted in a very stunned and almost a distressed way and saying that he himself was involved with imagery of the same type and was shocked to think that somebody else had come upon such an idea of using a cartoon-subject for a fine arts arrangement. . . . And, so, he said to me: would I not visit his studio and see what he did since I had already shown some interest in this artist, who is in the rack of the gallery? So, it was not my practice to visit an artist in his studio without seeing some evidence of the art first since we had already at that time many, many applicants at the gallery, and it was my role and personal obligation to look at everybody's work that came in. We would usually sort out the work there from the good slides, and I would visit several studios during the course of the week. But this artist simply asked me to come to his studio. Well, I was so fascinated at the idea that he might be doing the same thing as this strange man Roy Lichtenstein that I went to his studio on 89th Street and Lexington Avenue.

And there was Warhol in the setting. It was very dark; the whole house was dark, but, apparently, it was furnished with great taste: all

kinds of Victorian trappings, fine couches and all kinds of ornamental devices, which were very attractive. And it was the living room that I was ushered into. A very simple setting. It was not something that I knew or understood. It was a little bit exotic. And in the corner of this room, as I was led to it by this extremely shy man who was very odd-looking, with a very peculiar complexion and strange, gray hair, dwelled a body of paintings, maybe about 25 or 30 paintings. And there was a record playing on the record player at an incredible volume! And I remember the song that was being played. It was by Dickie Lee, called "I Saw Linda Yesterday." And during the entire time that I was there, he did not take off the record, and it played over and over again. Well, I was much caught up in the great, fresh thrust of the Rock-'n-Roll music of that time, which was at its ripest: 1961. And I didn't object to the musical style. The fact that he played it over and over again, I asked him why did he not change the record since there were other nice things to listen to, and I recommended other groups that might be interesting. And he said that he really didn't understand these records until he heard them at least a hundred times. Well, that's what he said. And it might have been a little bit pretentious of him, but, having seen a lot of his pictures there and the repetition, one begins to appreciate the mentality of work there.

He showed me a body of work, and they were largely of cartoon subject matter. And they were, as I rapidly discerned with my acute perception, of two distinct types. One was a group of cartoon characters which were expressionistically (that is, were sketchily) done. And the outlines of the figures were ideologically connected to the prevailing tradition of Abstract Expressionism—a lot of dripping and of loose painting and a lot of what you would call "action gesture." Although, there was another group of paintings that were very cartoon-like, very static and very stylized. And having learned already from the one Lichtenstein picture that I had at the gallery for about a week or so, that it might well be a legitimate thing to do an inventive pastiche of the cartoon image.

I immediately decided that to do it blandly and in a stylized way was more legitimate than to try the tradition that had preceded it. So, I said to him, "Why do you make these splashes on the picture when you can do them the other way in a very stylized and in a very flat way, without all those sketchy markings?" He said, "Well, I prefer to do them that way, but it seemed that there would be no audience interest in any work that was not expressive in this style. In other words, you can't do a painting without a drip." I said, "Maybe, it is possible to do it since this Roy Lichtenstein is doing it without drips. Maybe,

you can make a painting in modern times without a drip," I said. He said, "I would prefer to do that." And he said, "It would give me a certain amount of encouragement to hear somebody say that." So, I said, "How many people have been here?" And he said, "Nobody. I mean, like, you're the first one, basically, to see these pictures except for my few friends." And so I then inquired, like about his background and his industry. You know his biography. And, of course, I was not aware of his existence in the commercial art world, and I discovered thereafter very shortly that he was known in certain circles as an important illustrator of women's shoes for . . .

PS: I. Miller.

IK: Yeah. And, then, I realized, in having visited a place called Serendipity, which at that time was a very posh, somewhat decadent coffee shop up there in the 60s, 61st Street, that that place had been decorated with shoes by this man called "Warhol." Right? And that's what he would be famous for and that he knew a lot of people in the advertising world. But, otherwise, I had never heard of him or knew of him.

 I went back to his studio several times, and took with me, in most cases, people I knew to be emancipated [in their] collecting instinct. That is, people who had their own tastes, who were not easily put upon by art journalists, by art critics, by art historians—what we call "the independent collectors." There's a handful of these people, and there is still a handful. [Karp remarks that most art critics have "sets of principles" and "beliefs" that are upheld in reviews that are often written for other art critics, and they have reviews "embroiled in elaborate verbiage and in poetic evocation but *very rarely* in the judgment of the actual qualities of works of art."] . . . And I took each one of them ["independent collectors"] separately to Warhol's studio to get a reaction from them because I wanted my own instincts reinforced. That there was something peculiar going on here, and in each instance, one of these persons would purchase something from Warhol. They bought a painting or a picture or a drawing that he had there.

PS: Who were some of the collectors that you brought in at that time?

IK: [Karp includes: Mr. and Mrs. Burton J. Tremain, Mr. and Mrs. Morton O. Neumann, Alfred Ordover, Richard Brown Baker.] I don't think that I can clearly reconstruct who was that I brought there. There must have been eight or 10 collectors, and this represented the entire knife edge, you know, of the forward-looking collectors in America. . . . So, they bought Warhol's work at very low, outrageous

prices like 175 dollars for a picture. Two-hundred-fifty dollars. Three-hundred-fifty dollars. And, at that point, since Warhol said that he had been having a very hard time with his other work, to find a gallery for it, you know, he said that I could be his agent if I could help him find a gallery. Yeah?

I was very cooperative, as I said, and I brought [Leo] Castelli down to see it, and Castelli, of course, was also fascinated by the character and by the setting but was a little distressed to think that if we were interested in Lichtenstein, could we really be legitimately interested in Warhol?—because there might be in the fragile beginnings of an artist's career a jeopardy to one or to the other, and, if we were to commit ourselves to Lichtenstein, as we decided to do at that point, much to the chagrin and to the distress of the other artists in the gallery, that it would be a threat to the career of a new artist to have another one working just like him that obviously. So, he simply could not show Warhol.

Well, I took slides and photographs of Warhol's work to anyone of eight or 10 so-called "advanced" galleries, and they were not responsive to his work at all. So, for the first year and a half, I brought or sent clients to Warhol's studio, and I worked as his private agent and dealer, for which he would give me 10 percent or 20 percent commission if I was responsible for a particular sale. . . . He was very ethical about that and insisted that I received a fair share of any sales that I was instrumental in making for him.

And we also became friends at that point, and we went out to dinner on a regular basis. He was an immensely generous man. He always insisted on paying for fancy dinners. I never understood where he got his money from because he wasn't selling paintings, but, apparently, he was making a good living in the advertising industry.

[Karp describes one-man shows by Warhol at the Stable Gallery and by other Pop artists.]

And the type of reaction to his [Warhol's] work and to Lichtenstein's work and to [James] Rosenquist's work was not in the realm of the fine arts. That is, the critics were not responsive to it. The artists were downright hostile. The museum people were disdainful and unpleasant about this development because, essentially, it was an agreed fact that the heroic achievement of modern art in America had been the Abstract Expressionists, and everybody was paying homage to this heroic movement, in which the emancipation of America as a world-cultural power, apparently, was dependent upon the Abstract Expressionists. They were the liberating force. So, those who had a sentimental feeling about this heroism clung with all their urgency of feel-

ing to Abstract Expressionism, and any assault on its integrity was considered jeopardy to holy ground.

The resistance on the part of the establishment—critics, other dealers, museum people and even collectors—to the idea of a new ideology in the arts was seen, which was seen as a threat to the established, on-going principle which was Abstract Expressionism, was basically what could be considered an unholy assault on a very holy ground. Not that Abstract Expressionism wasn't at that point in 1960–61, full of its original vitality. It had already in some ways exhausted itself. Yet, the echo and the memory of the heroic achievement was still with everybody, and everybody wanted that it should be an on-going situation—that the European respect for American art had occurred through people like [Franz] Kline, [Mark] Rothko and [Jackson] Pollock and others, that this tradition should be sustained and maintained and that the continuous and realistic progress that American art could possibly make would be within the realm of Abstract Expressionism and that it would not occur in imagery.

And as I began in this whole digression here to say that it was *not* the fine arts society or press that reacted to the Warhol show [at the Stable Gallery in 1962] to begin with. It was the fashion press, and they picked up on it, and in their own way, maybe, with natural enthusiasm and good will, they spoiled it in some way because they talked about the commercial implications of it, and, in fact, the imagery itself was an extrapolation of known images of not only the cartoon world and of the commercial movie world and of the movie world. This was the world that was familiar to the fashion press and in which it so much admired, they saw an extension of their own involvements in the works of these Pop artists and were able to celebrate and to applaud without, what you might call, "esthetic intelligence," so that much of the fashion reaction to it was somewhat vulgar, I thought, and, yet, it was the only reaction we had at that point. [Karp describes the dismay by artists, who painted abstract works and who were represented by Leo Castelli, toward Roy Lichtenstein's first one-man show at that gallery. He discusses Sidney Janis' show the New Realists and "the fashion press" including other forms of realism within the realm of Pop Art: "A '*pop*pouri' of images of various kinds."]

Anyhow, as far as Warhol himself is concerned, in my early relationships with him, which were extremely affable and friendly. We visited studios and galleries together, and we went to dinner quite often. He was always with me a shy man, very quiet in public, and . . .

PS: How would you describe him physically at the time?

IK: He did not seem to be comfortable with himself as a physical person, and, I remember, once visiting him in his studio with Henry Geldzahler who[m] I introduced to him, that Andy came to the door, wearing a theatrical mask. And, then, I began to understand that he was very self-conscious about his complexion, which is very rough, as you know. And, then, I began to understand why the room was always dark when we were there because not only because it was romantic and, of course, it dramatized some of the features of the room—that is, a few pictures and a few pieces of furniture—but because he really didn't want *to be seen.*

During the time that I knew him, he was also a very heavy eater. He was a much heavier person than he is now. He was never fat, but he was robust. . . . He loved food.

[Karp comments that Warhol did not show him examples of his commercial art.] He never showed me *anything else* [except the Pop Art works]. . . . When I would talk to him about his work, I would always tell him what I liked, and he would always ask me about his work and about what was good in it or what was bad about it. So, we had interminable discussions about his career and about his ambitions, which were very great and very intense. In a small circle of people at that time, with those who[m] he was comfortable with, he was an easy, out-going, charming, pleasant person. Not what you would call remarkably articulate. Rarely, [he was] meditative or philosophical, you know, but always high-spirited and enthusiastic, totally caught up in the New York art scene. And always fervently admiring of the grand master: a deep and respectable homage to people like Jasper Johns and to [Robert] Rauschenberg and to other people that we mutually admired. . . . My memories of his feelings of those artists' work is the most succinct and wholesome memory that I have of him. And whenever I see him now, and it's on a rare occasion, we still have conversations about what we like in the arts or what we like in antiques or what we like in movies. And when I can be with him like that on a casual and intimate level, then he can be very sincere and very genuine. He's at his best then, I think. You know, he's a most appealing person under those circumstances, as you know.

Geldzahler approached us [at the Castelli Gallery after Warhol's two one-man shows at the Stable Gallery] if we would not consider now since Lichtenstein's career was underway and was not in jeopardy by the threat of Warhol's art, which was turning into another direction somewhat. We agreed to show Warhol, and Castelli and I agreed that it would be all right to show Warhol's art at that point. Warhol had

achieved, through his first two shows at the Stable Gallery, an enormous success, a popular success. Of course, the success is attributable to several facts. The one that I most admire, of course, is the fact that he attributed something quite significant to the fine arts culture, that his work is an important and distinctive element in the visual culture of our time at its best, but he had the advantage of the secondary audience, which is the homosexual audience, and the homosexual audience in the fine arts and in the dance and in the theatre lends a degree of fervent support that's like what you might call overwhelming. Right? And it can afford a certain artist, who has a particular propensity, an opportunity to succeed more rapidly and with greater success than an artist who's not involved this way. In fact, it's what we call "the homosexual audience." It exists! And it does impel and amplify an artist's career, sometimes before it might have happened. In other words, it can bring success more quickly. And we don't find this necessarily a despoiling element because a lot of fine artists have achieved rapid fame the way they should have from various elements in the society. [Karp comments that Warhol, Lichtenstein and James Rosenquist were considered as "outsiders" as late as 1970, by the fine arts society.] I was grieved, and I felt that there was an injustice being done in that Warhol was receiving fame for the wrong reasons, and I still believe it to be the case today when I ask people, who say Warhol's name in a hushed and religious whisper,—I say, *"Why* do you speak about Warhol like that? *What do you think he does?* Why is he famous?" They say, "Well. You know. He . . . Ah. Ah. He's all around, and he made movies." And I say, "Did you see any of the movies?" And they say, "Well, yeah. I saw a couple of them." I say, "Did you like them?" And they say, "Well, they made me feel somewhat uncomfortable, and they're sort of . . . " What we're saying here is that we had at that time (the early years of Warhol) and even up to today, unpleasantly, continuous verification of fascination and interest in him as being *not* because of his production as a fine artist, and that is continuously distressing to me. It always is. I challenge people all the time. I say, "Why do you like Warhol?" And, for the most part, the people who like him the most *don't know what he* does. They know that he makes portraits and that he goes to Studio 54 or that he gets around or that he's at every party or that he knows all the characters. Right? They know *that,* and they want to be a part of *that,* and they are mystified *by* him—by his strange name and by his strange presence and by his remarkable silence, you know, and by his fame. But when you try to [ask] *why* they think he's famous, they don't know why. If you say, "Do you understand his achievement as a

painter?" They say, "Well, he's a very good painter. Wasn't he a ter-
rific painter?" They really don't know *why* he's a "terrific" painter,
why he's considered historically significant. And this is for me con-
tinuous when meeting people.

But to go back to the development of his career . . . The *Cow*
image was my image. Warhol was intelligent enough to know at that
point that he was running out of steam. This was about 1966 then. In
1965, Warhol said that he was using up images so fast that he was
feeling exhausted of imagination. This is not his terminology. Need-
less to say, that's not how Warhol talks. But he said, "I'm running out
of *things?*" He said, "Ivan, tell me what to paint!" And he would ask
everybody that. He asked Henry [Geldzahler] that. He asked other
people that he knew. He asked, "What shall I paint? What's the sub-
ject?" I couldn't think of anything. I said, "The only thing that no one
deals with now these days is pastorals." I said, "My favorite subject
is cows." He said, "Cows!" He said, "Of course! Cows!" He said,
"New cows! Fresh cows!" I said, "What are you going to do with
them?" He said, "I'll tell you when I do it."

I went to his studio and, not at all at what I expected, I saw
wallpaper! Right? He did these rolls of cheap wallpaper! Right? He did
these rolls of cheap wallpaper of this blatant cow. And I thought that
this image was very powerful. And I thought that that particular show
was his last great show, that *Cow Wallpaper* show. And it never
achieved any success. There's nothing to sell. We sold some
wallpaper. That's what it amounted to. We sold, maybe, two or three
rolls, but the quality of the paper was so bad that you couldn't paste
it up on the wall. It was that bad. We cut out some images, and he
signed a few images. That's about what it amounted to. I think, we
still have some here [at the O.K. Harris Gallery] in the backroom,
maybe, a whole roll of *Cow Wallpaper* if anybody ever needs it. Back
there. Anyhow, that was the end of that. Well, again, he was con-
fused.

Oh! Before the *Cow Wallpaper* were the *Flowers*. The *Flowers*
was our first show [at the Castelli Gallery in 1964]. . . . And the
Flowers were all over the gallery, you know, and they were *brilliant!*
And we couldn't figure out why they were *brilliant,* and he took this
little photograph out of . . . a photograph magazine, and he got in-
volved with some legal hassle, which is really unfortunate because he
had to pay off with very valuable pictures, you know, because he for-
got to sign a release, or he forgot to pay the photographer 25 dollars
for the rights to use the photograph. Anyhow, whatever it was, he was
very innocent of doing disservice to this photographer because this

photograph was *not* what you might call a "remarkable photograph."
It was not an earthshaking photograph, but Warhol made a *remarkable*
series of paintings out of it. . . . Whatever, they were totally success-
ful, and *we sold them all!* And you could keep selling them right now!
That's it. That's one of those immortal images. You know? *He just
found it.* Right? It was a grand success.

It was after that that he came to me with that thing—"Ivan, I've
got no subjects." Right? And I suggested the *Cows,* and he did *Cow
Wallpaper.* And, then, he came again and said, "Ivan, there's nothing
left for me." He said, "I'm a popular character. I've done all sorts
of . . . but I've got no images." I said, "What's left for you? Do your-
self." Right? "Do you." That's when he did portraits of him-
self. . . . and they were moderately successful.

Anyhow, after that he realized that he had depleted himself as a
creative artist in the realm of making paintings. Although he stumbled
around a lot, he did things. . . . He started [*sic*] to make movies.
[Karp remarks that he found Warhol's early movies to be boring and
repetitious but that they had a reasonable continuity to his art, whereas
Warhol's later films were "disagreeable" and "more bizarre" and "not
a major contribution to moviemaking." By the time of Warhol's *Self-
Portrait* series, Karp mentions that he saw Warhol less and less, but
"we always talked about possibilities of the future, and so forth."] And
it was very hard at that time to establish a very good substantial price
for his work 'cause it was such a variety of things, you know. There
were prints and offset and posters and drawings and paintings of vari-
ous sizes. And some were in good condition, and some were not in
good condition, you know. And it was all kinds of things.

I remember, in fact, when I first went there [Warhol's "Factory"],
there were. . . . He had a bunch of art students hanging around be-
cause they found him very appealing and very dangerous personality
in the arts—you know: a real threat to the establishment. They really
liked hanging around. We used to get applicants at Castelli's all day
long, wanting to go down and work for Warhol, and he would receive
them all. I mean, they would all come down there. There were just
droves of students and art folk hanging around his studio all day long.

Personalities from Europe, characters, creatures, eccentrics—all
kinds of people—he received them all, and that's why that he got into
the difficulty that he did [when he was shot in 1968]. They kept traips-
ing through. He *loved* the adulation, you know.

But for the most part, he did his own work. They always said that
"Warhol has a factory, and people did the work for him." They didn't.
They stretched up the pictures often. They made constructions for his

famous *Boxes,* you know, but I always saw Warhol do his own screening of his own work. Always. When I was there.

PS: Or Gerard [Malanga].

IK: Yeah, he did most of it. Gerard Malanga. Yeah. [Karp observes that voyeurism is an essential characteristic of Warhol, and he mentions his shocked reaction to Warhol being shot in 1968. Moreover, Karp considers Warhol's present portraits as a successful formula and Warhol himself as the best portrait artist of our time.]

I'm a little distressed. My sensibilities are troubled and sometimes grieved at the kinds of happiness that Andy gets from people who are fashionable. See, I know that he is a person of greater depth than he would reveal in these situations where he says, "You know so-and-so? Oh! Aren't they simply marvelous people?" I say, "No. I don't find them that way. I find them rather vulgar." "Oh, no! Oh, when you get to know them, they're so wonderful! Look at what they did! Look at the movies they made and who they know and where they go!" And I say, "Andy, you know that you don't feel that way. Right?"

And often in testing him, he will confess that he likes them because they're famous, you know, and he still has that all-famous-they-really-are in the eyes of other people. They get an awful lot of adulation and maybe even be distressed about it and realize that they're paramount in the eyes of the multitude of people and yet not understand the *meaning* of fame. In fact, I don't either. Frankly, I don't know why he is famous at this point sometimes. He has the fame, and, yet, he pays incredible homage to other people's fame, where you could simply be reticent or discreet about it, you know. It's like he's a young teenager in that way. He needs somebody who thinks he is more famous than . . . than they are. He thinks they are more famous than he is. Right? . . . He's an observer. *He's outside of himself.* He is able to see himself and the world, and that's what you might call utter proof of high consciousness, is when you can see yourself in a situation and how you behave and be able to sort out the implications of behavior. I think, Andy is still capable of that. . . . In this questioning that he's always involved in—his simple-minded, child-like questions—is that the *meanings* of these questions will attach to it after a while, but it is possible and reasonable to speculate that he *is conscious* of the implications of them before he proposes them because he is obliged to think about himself all the time as a public person and how to deport himself in public places. He's got to think about the implications, as a sensitive person *must.* Now, if he's embarked on being

reticent with people, which he is, and to being, on-going, a shy person, then he has succeeded in doing that, and his ability to do it is remarkable, almost heroic in a way. If he can maintain the physical sameness that I knew of him, you know, as a young formative artist, then he has been able to create for himself a personality-type to function within. He can be that thing that he always was, and that's a very favorable, sensible solution for a person who has achieved fame because as a lot of people as we know, are discomforted by fame and can't deal with it. . . . I can cite the artists that I witness this happen to—they become pompous, egoistical and atrocious people because of fame. They can't deal with fame. They weren't prepared for it. They can't assimilate it. They don't know what physical or mental role to play in the face of it, and I think that Andy did establish it, as I say, in his early character—shyness, reticence—you know—the role of the observer, *as a legitimate character for himself,* and that it is quite usable in the context of his present fame. And that's what I'm trying to say about him. As I say, I don't understand it myself. I keep saying to myself, "Why Andy?" Whenever I see Andy, I say to him "Why are you famous?" You know. "Bet it sure feels good."—that kind of thing. He wants to be, yet, more famous.

I once said to him, "What do you want? You've got everything: you have crowds, hordes, young people, beautiful people, charming people, rich people, lovely people. Nobody seems to touch you." I said, "What do you want?" He says [Karp imitates Warhol's whisper], "I want more fame." So, it's there, and, I think, it's a nice instinct that he uses it and handles it well, from what I can make out.

Ivan Karp, New York, 18 October 1978

During the second interview with Karp, he makes general remarks concerning Andy Warhol's art.

IK: Warhol's *Coke* seriality, like his *S&H Stamps* and *Glass—Handle with Care,* existed visually in bludgeoning repetitivity. . . . I never asked why he painted such [Pop Art] images because he has and had instinct. . . . That Warhol searched for ideas is true. . . . He has lyrical strength in his new portraits. His series are like digressions. . . . The *Mona-Lisa* is self-conscious, and the one that Eleanor Ward has is handsome. . . . Cold, tough, alien and bland: that's the best of Pop—the cold, mechanical and technical look. . . . The Disaster Series have powerful images. And the *Race Riot.* . . . We couldn't sell that one, of course. It was too vivid. Horrible image.

PS: Why wouldn't it sell?

IK: Well, because it was an uncomfortable subject to live with. You know: people didn't want to live with [a] picture like that: it's a big picture, if you think about it. Here: it's 131 by 83 [inches]. I mean, that's a big painting to have around the house with views of a race riot. Not very comfortable to have around.

The *Electric Chairs* were the hardest to sell of all because, again, the connotation of the subject matter was totally discomforting.

The *Orange Car Disaster* was purchased, also, much later than he produced it. It's the *Car Disaster* with the people lying under the car with rather bloody faces here. All of these were sold much later on at very low prices because we couldn't find collectors for these pictures.

The *Brillo* show of '64. One of the great shows. Andy signed only a handful of them.

The *Flowers* series sold out. . . . Andy never had rigid concepts about installation except we did the *Cow* show: it was wallpaper. So, we had to put it up, but he said put the paintings close together. And we put them all up. That's all. I put them up in reasonable color sequence so that there wouldn't be too many whites in a block or too many reds [of *Flowers*]. Right? So, we just put them up there so it would look reasonably good. But they weren't composed to make a beautiful wall. They were composed to show nice pictures. Right? Which is what they were. The big ones were on the side walls, you know. It looks like an enormous . . . at the time, that [the Castelli] Gallery was very big in comparison to other galleries, but now it looks [in an installation photograph] rather intimate in comparison to the kinds of space that we have here [at the O.K. Harris Gallery].

The *Most Wanted Man* series was difficult to sell.

I went with Andy to the gallery in Toronto to that [*Brillo Box* show that] showed these things there. And Andy—his name was just filtering into Canadian culture and life—he didn't get the kind of response that he expected to get there from the crowds. It was just the young people that made any sounds of adulation: mostly art students who knew of him. And we did a number of interviews with local characters, but Andy didn't want to speak at all. It was the first time, I remember, that I did an interview with a television show with Andy. We were sitting next to each other with the interviewer. And the interviewer would ask Andy questions about his work, his art, his personality, and Andy just looked at me. And I answered all the questions, and that was the whole nature of the interview. And I think that became a basic format for all of Andy's interviews thereafter because

he never said anything. Right? And he's good at that. I mean, [he] has tremendous restraint.

PS: You and your wife [Marilyn Karp] would both answer for Andy.

IK: We what? My wife was not on that show, but during interviewing sessions. . . . I mean, if it was in a gallery space or a museum space, we were both there, me and Marilyn (who knew his works well) would answer for him. The kinds of questions that they would give us about Andy, the answer was given that we thought was appropriate answers for Andy, anyhow.

PS: And, then, Andy felt comfortable with you answering for him?

IK: Well, he seemed much relieved because he . . . I mean, he is not a very eloquent spokesman for his art or for anything. He's an interesting personality to talk with, and he can sometimes give you very succinct and sometimes very remarkable answers about the subject that you're involved in. But he's not fluent in speech. You know? He's very shy about it. And, I think, he set for himself a very good program of having other people for him, of doing that, which wouldn't be, what you might call, "a dramatic personality" to interview. No. So, during that phase anyhow, at least, he had other people speaking for him. And I . . . He doesn't appear much on talk shows these days because he doesn't talk. Right? So, he's not, what you would call "a television personality."

As far as titles . . . It was just a matter of using my own instinct about the kinds of titles that Warhol would like if he had titled them. So, they were very simple titles. Just simply descriptive titles of the subject itself. We didn't add any poetics to it, as far as that goes. . . . So, the titles are, essentially, spontaneous by me because I had to name them when they came in, and Andy never objected when I showed him the labels on the back of his pictures. I don't ever remember him objecting to a title. Ever. Or the pictures. Except [Roy] Lichtenstein [. . .] But, like Warhol, Lichtenstein never bothered to title an image. So, with Lichtenstein I did it together with him, and with Warhol, I did it alone. [Karp remarks that the subsequent title, *The All-American,* to the originally entitled *Mr. Nobody (Watson Powell)* was added later. Warhol approved only of the original title. [Karp then brings P.S. to his home and shows him his and his wife's portraits by Warhol.]

Stephen Koch, New York, 26 October 1978

Koch is the author of *Stargazer: Andy Warhol's World and His Films* (New York and Washington, D.C., 1963).

SK: [Koch comments that Warhol failed to exploit his films financially as one might expect: his income was nothing—with the possible exception of *Chelsea Girls*—from the films.]

The modus of his self-dramatization are really the result of the solutions of the strategies for dealing with almost pathological shyness and timidity.

PS: Would you include "frigidity?"

SK: [Pause] Yeah. I would say that Andy . . . I don't really know . . . some interesting things. Certainly, the manner of his presentation to the world is of someone who is cold, someone who is . . . ah. Nonetheless, that much fear has some source in patterns, whatever it may be. When in the book I quote Baudelaire's remark about the "coldness of the dandy" and "the latent fire that lies beneath the surface that might but does not wish to shine forth . . . ," and, I think, that's successfully conveyed in Andy, and, I think, it is not pure illusion. He's a man despite the coldness, and, instead of really cold people, he is not apathetic. He's extremely sensitive to other people. He is in his way very exuberant. He strikes me as less isolated and self-absorbent than many people of his generation.

The psychological portrait behind that is hard to draw, but I *do* think that he . . . Andy's involvement, I think, in a series of dodges for dealing with extreme emotion, and one of those dodges is the appearance and, in fact, . . . because the mask is the face of coldness. But it is not because I think he is a feelingless person. I think, he's an intensely disassociated one. I don't think he's feelingless.

As an epigrammatist, what he has to say is often so interesting and so penetrating, it can't come from someone who cannot understand the workings of emotion. So, I think, he is not somebody—it's quite plainly that he is not a loving person though he was apparently devoted to his mother. He is apparently a rather good uncle, too—to his nieces and nephews.

He strikes me as someone who is [Pause] . . . He is disassociated. Now, I mean, that's a very easy way out of an explanation, but, I think, it's roughly precise.

PS: What are some of the other questions that you feel that you would like to have explained about Warhol that haven't been verified?

SK: Well, there are several things that I think are . . . any number of
rather mysterious issues that are fascinating to me. One or two I can
tell you.

For example, Andy had been told by people who, I don't think,
didn't understand the film [industry] very well: that what he ought to
do is not make prints of or distribute his films so that he could save
them as . . . unique art objects, which is a certain paradoxical in terms
of Walter Benjaminesque terms—it is a certain paradoxical variant of
the mechanical reproduction of art objects, which he was making in
his graphic art works, and sculpture-objects were produced in large
numbers. But the films [Koch almost laughs] . . . were a unique copy.
I mean, I . . . but whether, in fact, he was told that . . . I asked about
that in various sources and couldn't really determine whether that was
the fact. I think that would be interesting to know.

Most important, I would say, the real one in terms of sources of
growth and something that I never determined . . . Andy came to New
York, and he was an extremely—*prolifically*—productive commercial
artist, which you know all about this. It does seem to me that at a cer-
tain point, Warhol had three or four very powerful—perhaps, not nor-
mative but very powerful—ideas about what could be done by a
graphic artist. They seem to me to be on the whole derivative of [Mar-
cel] Duchamp. They were a part . . . they came alive at the moment
that Duchamp's influence in New York was at its height. How it hap-
pened? How he made the decision to move in that direction? What
made him realize that he was on to something that would permit him
to stop doing I. [Miller shoe advertisements] . . . and, in fact, develop
a genuinely interesting idea is unclear. I don't know what psycholog-
ical forces were. . . . It was an interesting and important choice.

Andy was going to be very successful in whatever he did because
he's, I think . . . He had all the things that were necessary to be "suc-
cessful." That is, he worked inordinately hard. He thought of only the
work. He has a genuine vocation in that respect. He knows how to
never stop, which is one of the ways in which one is successful so that
it was going to do well, but a lot of things do well with various notions
of dandyism and of the Duchampian insight into perception and of his
own passivity, voyeurism and withdrawal which really end up having
a major theme, which is, as you know, of decadence. And how he was
able to exploit that for a period, producing work of very considerable
interest is . . . is an interesting line, and I don't know the answer. I
know that it happened, but I don't know why.

For me, I find his present attitude toward the films of that
period . . . I don't understand it, but I don't *quite* see why he is so pa-
tronizing toward them.

It is quite true, I think, that one problem with—and it's a critical issue; I talked about it slightly in the book [*Stargazer*]—is that Andy was infatuated with a certain kind of filmmaking: with a narrative art, with which he is genuinely ungifted. And, therefore, his films were interesting only so long as when they were rooted in a nonnarrative esthetic or one that within which the dominant esthetic was a non-narrative line, most noticeably, say, in *The Chelsea Girls* or whatever. As soon as he tried to make movies about . . . that told stories . . . the result was pretty deplorable. He couldn't do it. He just didn't know how: his sense of timing above all and a lot of factors like that. Or whether it was true that he wanted to do those things . . . I can't say. How conscious he is or how much it matters to him that he is . . . that his ideas are rather . . . that Andy has only a few ideas and that those ideas now are fully exploited. And what he is likely to do in the future, unless something remarkable happens, will be pretty repetitious and, even if not repetitious, will not likely to be very interesting on the level of his art or whatever.

I don't know how conscious he is of that or how much it matters to him. He would say to people in the early '70s that he wasn't really interested in art anymore . . . that he felt that stage of his life was over and that he would like to do other things and . . .

PS: . . . And the variant of Duchamp going "Underground."

SK: Well, yeah. I would say that . . . except it did not take the . . . It was an act of a different kind of consciousness, I would think. I would think that that is an interesting comparison, but in Duchamp's case [Pause] . . . Well, rather than attempt to explain Duchamp's motives, I think that it is the fact that Andy was aware that what he had done as an artist, it seeks to be productive. That is to say, he was going to repeat himself and that he didn't have anymore ideas. To have a few very interesting ideas is something, but, I think, he rather runs with a repertory. After that. . . . And these are also ideas of a kind that can exhaust themselves fairly easily. I think that's a problem. I mean, what are you going to do after . . . find another famous photograph? Do another one? Or another? Actually, what you end up doing is sort of sad, but it's not so surprising because you become a terribly modish, faintly silly society portraitist, doing unexhibited portraits ("John G. Smith in the style of . . . ") and that is what goes on now. It's his major source of income. It's . . . I mean, it's to me uninteresting. I'm glad that Andy is able to make a lot of money, but.

And I do say in the book [*Stargazer*] and I did believe it and I do believe it that that he was someone who unexpectingly in the 1960s

did something that briefly that was quite interesting with the idea of the portrait both in film and in the graphic work, but, I think, it's petered out rather deplorably now. I can't imagine. These things are not exhibited, and I can't imagine that they are particularly interesting.

Andy was always extremely ambitious, and that's perfectly evident. I would think that he had a fairly clear, not perhaps absolutely worked-out scenario, but a very clear idea of who and of what he wanted to be fairly early on. I'm not sure that he knew how to do it, but . . . and a piece of information that I find interesting, which I'm sure that you've heard about because it is very well known, which is that when he got to New York, he wrote Truman Capote everyday a letter, a fan letter, everyday for a year [*sic*]. And . . . why would anyone do such a thing? Capote didn't answer. They finally did get to know each other. I would think to—in 1952, which is when he arrived. . . . Right? Something like that?

PS: He arrived in 1949.

SK: Forty-nine. Better yet. It was a moment when Truman Capote was extremely visible in a way that Andy probably admired and was very interested in, and the fact that he was also, from Andy's perspective, a very cultivated figure. That is to say, a major homosexual, literary figure, who was, at the same time, glamorous in the sense that absorbed Warhol. I would think that he would try to make that connection as quickly as possible.

Charles Lisanby, New York, 11 November 1978

Lisanby, who is a set designer, was one of Andy Warhol's closest friends from the early 1950s through the mid-1960s.

CL: I have most of the books as well. I think, I have every book except *Wild Raspberries,* which I gave to a friend. A lot of these drawings are of me, and an awful lot of them. In fact, there are a number of things that are stated incorrectly—said to be someone else, but they're really of me. And many, many there were made down at my old apartment on 15th Street. [See Rainer Crone, *Andy Warhol: Das zeichnerische Werk, 1942–1975,* exhibition catalogue (Stuttgart: Wuerttembergischer Kunstverein, 1976).]

And, ah, we used to draw together every weekend. Andy was living on Lexington [Avenue]. In the 30s at that time with his mother. And we would do things like buy flowers and go down to my apartment—my apartment, even then, was filled with a lot of things, a lot of the things that are here now I had even then. Andy used to love drawing all of those things.

And the *Cat Book,* of course. . . . He did all of the *Cat Book,* I suppose, there. No, I guess, he was doing them every place. He wanted to . . . of course, he was very influenced by Ben Shahn. And Andy *always* had an original approach to anything he did. It's very, very true. In fact, that's what interested me in him. He was a most interesting person, and no matter what came up, what was mentioned, what was said, *his* understanding of that was always different from mine or anyone else I'd ever known. He was completely original, and that interested me very much.

PS: When did you first meet Andy?

CL: Well, I met Andy at a party given by another . . . designer of scenery . . . Bill Cecil [who] gave wonderful parties. . . . He [Warhol] was interested in the fact that I was working in television and because other very fine artists like Ben Shahn worked in television occasionally—they were commissioned to do title cards for *Playhouse 90* or other things like that—earlier shows than that even. And Andy wanted to do that.

Andy always wanted to do anything that was going to get him publicity. And one of these books—in one of the earlier interviews—I said that Andy was famous for being famous. That's often been quoted since then and has been attributed to other people as well, but that really is true. The *one* thing then that he wanted more than anything else was *to be famous.* I asked him once if he wanted to be a great artist, and he said, "No. I'd rather be famous." That was really his objective, and he certainly has succeeded admirably, and I for one don't see anything wrong with it.

These pictures here—*In the Bottom of My Garden.* These were done after our famous tour around the world, and in Amsterdam—as a matter of fact, we arrived in Amsterdam quite by accident; I think, we went to Amsterdam because we didn't go to Venice. I got quite ill in India, and we flew as quickly as we could to Italy because if I was going to be sick, I'd be sick in Italy. And also there were rumors . . . and we landed in Cairo . . .

PS: It was the Suez Crisis.

CL: It was the Suez Crisis. We flew over the Canal as it was happening. When we arrived in Cairo, we were taken off the plane, and there were tanks with guns aimed at the plane and everything else, and we were taken off the plane into a little room, shown a documentary or, I guess, more of a propagandistic film, which I didn't pay too much attention to. There were soldiers all over the place. Machine guns and

everything. The plane was refueled, and we were put back on the plane. We had originally expected to spend time in Egypt. We were going to go to the Valley of the Kings and everything, but I was really too ill. We had planned to go to Nepal. I think, that was the first or perhaps it was the second year that they had even allowed tourists into Nepal. We were in Calcutta when I got very, very ill. High temperature and everything else, and I didn't want to be prevented from leaving the country. I didn't know what I had. I just wanted *to get out* and get somewhere where I could get a good doctor. When we arrived in Rome, the extra was already on the street: "Suez." I got better in Rome. . . . And while we were there [in Amsterdam], we found a series of little books . . . of fairies wearing flowers as costumes, and so on. And he really based all of these drawings in this section on those. I suppose not all of them, but the whole idea was, more or less, inspired by these things. . . . *Flower Fairies of the Autumn* by Cicely Mary Barker, London and Glasgow. . . . They're children's books, and you can see where he took the things.

They're quite wonderful. In fact, this period of Andy's I really love. I really love it enormously. And much more than the later things that became famous. . . . They were so incredibly imaginative. There was not another artist who *thought* like this, who *thought* of doing these things, and he didn't do them to be strange or to be different or anything. They were spontaneous. And that's why this strange guy— so horribly dressed in chinos and dirty, falling apart shoes and no tie and everything—could walk into offices of fashion magazines and *not* be thrown out. First, someone happened to look at what he had and recognized it for what they really were, which, I think, is considerable. And he used to be *the strangest* little guy, but it didn't matter. He has such an original view on [the world]. Never in my life have I met [anyone] quite like Andy Warhol or who had that original way of seeing things to such a degree. I've known *a lot* of people, and I've worked with a lot of people who were wonderful and creative and imaginative but no one to *that* degree. It was really extraordinary, and that's why I really liked him from the very beginning. His viewpoint was *not* opposed to mine but was, sort of, *oblique* to mine in a way. I could never, never imagine. It was really extraordinary, and, I suppose, that's the reason why we became friends. I know it is.

Now, this is one of my favorite drawings. [Lisanby points to *Iris,* fig. 196 in Crone (1975).] It's really beautiful. I still have the pitcher. And this was just one Sunday when we went down to the flower market and bought some irises and came back and spent the afternoon drawing irises. . . . And it's charcoal on charcoal paper, and it's re-

ally quite large. It's not like the other things—the blotted things—
which almost had to be small. The other thing that fascinated me was
that he would just draw one line and then leave it, and when I would
draw things, I was always erasing, changing and improving. And he
never improved on anything. Rather than do that, he would draw a
new one, which is something I never thought of doing in those days.

This [fig. 200 in Crone (1975)] was done actually after our trip.
It says here, "Kyoto." But this was done *after* the trip.

This is a portrait of me. That's correct. "Happy Birthday." And
that's mine today. Actually, he gave me that on my birthday.

PS: Why did he put pears in so many things?

CL: No particular reason . . . None at all. If there was a reason, it
wouldn't be Andy's, you see . . . He used to . . . a strange
things . . . this time he was doing the I. Miller shoe ads. And it was
always fun for me to buy the [*New York*] *Times* because . . . I would
find my initials all over the place in the corners and things.

And he did some windows for Bonwit Teller's. And he just went
in and painted all over the windows and things, and one of them was
just "C.L. C.L." all over the place.

He also did for a window. It was prior to this date. . . . And I've
told someone this, and, again, it's true. He did some paintings based
on comic strips . . . and they were done for a window display.

This whole thing when he did the whole gold leaf thing. This was
also a result of our trip because in Siam or Thailand in one of the
museums there, he saw those marvelous pieces of furniture with gold
leaf, and, then, painted black, leaving areas of gold leaf showing. It
is a typical Siamese type of decoration. . . . And *that*—since he al-
ready had the black line, the blotted-line, he thought of adding the
gold leaf. In fact, he did these things, all of these things, shortly *after*
that.

PS: Did he sketch all the time?

CL: Oh, all the time. He never stopped. I have a photograph some-
where . . . an old 8mm. movie of him sketching and being surrounded
by monks or in Bali and the little children came to watch what he was
doing. I must say, we created a sensation in a few of those places be-
cause they weren't quite ready for two strange Americans, wandering
around and making drawings. We also went to Angkor Wat at that
time.

Someone must have told you, or, perhaps, it's in one of those
books *why* he developed that blotted-line look. Don't you? . . . I
know *exactly* why.

PS: Why?

CL: [. . .] And he was always striving, always yearning to become fa-
mous, to become recognized, to be noticed, and so on. And he dis-
covered somehow—someone showed him or some teacher taught him
or who knows what—because he did truly invent that, but, I must say,
he used it to a degree that no one ever else did. The blotted technique.
But *that* meant to him—those things looked to him as if they were
printed. In other words: someone saw a drawing and recognized it's
worth and printed it. And, as a matter of fact, they really are printing.
They're off-set printing. You know how he did, don't you? What he
truly did was . . .

PS: The technique?

CL: Well, he took a piece of paper and folded it, and, then, he would draw
on one side of the piece of paper. He would either do that, or he would
take a piece of paper and *attach* it to the piece of paper that the final
drawing was going to be on, with tape on top so it would be a flap
so he could fold it back, and he would draw on that with ink. And
while it was still wet, fold it back over and blot it onto the other piece
of paper. And he could only do a very short line at a time to get that
particular blotted look, but then *that* to him looked like it had been
printed. And that's *really* why he did that. . . . That was not some-
thing self-conscious. He *knew* why he was doing it. . . . He wanted
them to look that way, but, also, somehow, without ever explaining
it, I think, even to himself he *also* realized that was a different kind
of line. It really was. No one was using that in a decorative way. And
his main thrust and his own work then without thinking it out to him-
self was: he understood the value of a decorative line, a calligraphic
line, almost. And this was his "different" version of that. His own ver-
sion of that.

I was extremely interested in Japanese art at that time and in
Japanese linear design. Very. The way of using a brush to draw. And
that's why his different way of doing that interested me. And that's
why we went to Japan. And I had been fascinated by Oriental art for
a long time and wanted to know more about it, and I've been to
Europe many times then, but this was my first trip to the Orient. And,
I think, at that time, Andy had been to Pittsburgh and, I think, he had
been to Philadelphia and, of course, he had been to New York. And
that was the extent of his travel. The next thing to do is to go around
the world. [Laughter]

That's me. Now, that's attributed to someone else, but it isn't.
That is me.

PS: This is figure 206 [in Crone (1975)].

CL: Yes. It's really me. And it's *not* that way at all, even though he signed it that way. I think, he used this as a poster or something for *The Boy Book,* which never got printed. It was just on exhibit at the Bodley [Gallery].

You see, it's because the way he signed it, it's printed *that* way [head side up], but, actually, it's me lying down that way [sideways, head left]. I was lying down, taking-a-nap-picture, and that's why the eyes are closed. And I looked like that then. *A lot* of those pictures in *The Boy Book really* are me.

PS: Do you recognize any of the others as we go along? Because what I'm trying to do—I'm finding that Crone makes mistakes and others make mistakes.

CL: Yes, he does make mistakes. Someone made a very bad mistake, and, I think, it was him, and I really don't want to forgive him . . . which was not crediting me for a photograph, which I let him use. Now, you hold on to that. Ah. Let me see if I can find the book. [Lisanby walks to a bookshelf and returns.]

I have this photograph, which Andy gave to me, and—the original photograph—and . . . *this one.*

PS: Oh! The early one.

CL: And *I told him* that he could use that if he gave me credit in the book for it, and he never did. In fact, it's a small photograph that was made in an automatic machine.

PS: So, from the beginning . . .

CL: Yes. Andy was 14 then. He gave me that because he was very conscious of—when I knew him—of the way he looked, and he gave me this picture to show me that when he was a very young boy, he was extremely beautiful, as he was. Here is a little 14 year old angel. I mean, it's really cherubic.

He, at the time that I knew him, he was already having trouble with his nose, which, ah, my doctor is a very, very good friend of mine, one of my best friends, saw him and told him it was a condition that would only worsen with time, and he suggested that he do something about it. I don't really know the medical term for it, but it's the kind of thing that causes in old age a nose like W. C. Fields had, and so on, and it's sometimes associated in peoples' minds with overdrinking or that kind of thing. It really isn't at all. It's a physical condition.

So, Andy had that done. Not to change the shape of his nose be-
cause he never had a hooked nose or anything like that. And it was
an operation by a plastic surgeon, though. Something to . . . the nose
just becomes more and more bulbous, and, so, he had that done.

And he was always very conscious of his looks. . . . It wasn't
that noticeable then, but Dr. Webster said that in years to come, in
particular in middle age, would become very bulbous and very objec-
tionable. And as long as he could do something about it at the time,
which should correct it or for all time, I suppose. It was done. But this
photograph is mine, and I still have the original picture, and I'm really
very angry with Crone for *not* crediting me with that photograph be-
cause or "From the collection of . . . ," or something—I don't care
what—because this picture in his book [*Andy Warhol* (London, 1970)]
has been reproduced in other books, crediting him with it. And that
rather made me angry. . . .

The pictures of *Marilyn*. I look at them now, and I'm not sure
what I think. One day Andy had done all of these things. The
silkscreened things of *Marilyn*. And one day he called me up, and I
was very, very busy, and I hardly had the time to talk to him, and I
was living Downtown in a much smaller apartment than this, and he
said, "Oh, the Museum [of Modern Art] just bought *Marilyn Monroe*,
and they're going to be famous. And I want to give you one of them."

To tell you the truth, I didn't particularly like them. I didn't want
any. [Lisanby laughs] And he said, "I want to give you one." "Well,"
I said, "I don't have any wall space here." He said, "Just store it. One
day they're going to be worth a great deal of money." And I really in-
sisted that I wasn't going to take it, that I didn't want it. And he was
quite aware that they were going to be worth quite a deal of money.
I did keep the drawings because I loved them. I thought they were
wonderful.

PS: Now, which book were you connected directly in doing the text or
credited in doing the text?

CL: Oh, the *Cat Book* [*25 Cats Named Sam and One Blue Pussy*]. It was
so funny. There is no text. The text is the title, and I wrote the title,
which was, I don't know, an amusing thing. . . . He said, "What
should I call it?" I just said that. So, he wrote that down, which, I
think, is funny.

PS: Were you familiar with his realist drawings? One was a record cover
for C.B.S. Records.

CL: Yes. Yes. These were drawn from photographs, you know.

PS: Ah. No, I didn't.

CL: Yes. They were, but they weren't. . . . This one, for instance, obviously wasn't traced or anything. They were drawn just *looking* at photographs. And the way it is, out of the drawing, is because he was probably looking at the photograph and not at his hand while he was drawing it. Everything was almost autographic. He would just *draw* like *that* in one line, in one almost continuous line. What interested me was almost not what he did draw but what he *didn't* draw, what he left out. And that is really the secret of them.

PS: This is *There Was Snow on the Streets.* . . . Now, someone—I think, it was Nathan [Gluck]—mentioned that these are based on photographs by the photographer who knew Andy: Edward Wallowitch.

CL: Yes. Oh. Is that what they're based on? All of these things were based on photographs. Almost all of them. But it was his idea just to do just the outline like that and do it and blot it. And, then, that strange, funny, little face there.

PS: Did Andy ever mention . . . ? Now, Crone mentions Matisse was the great influence on Andy.

CL: Well, I told him that. I told him that. He's got that *slightly* wrong but almost right. What interested Andy in Matisse was not, I think, so much his work but the fact that Matisse was a very elderly man and photographed by [Henri] Cartier-Bresson. It's a wonderful photograph of him drawing doves or pigeons or something in bed. And by Cartier-Bresson. And it was either in *Vogue* or *Harper's Bazaar* at that time.

 And the fact that all Matisse had to do was tear out a little piece of paper and glue it to another piece of tissue and glue it to another piece of paper and it was considered very important and considered very valuable.

 It was *that* aspect of Matisse. It was the fact that Matisse was recognized as being so world famous and such a celebrity, and that's really what attracted Andy to Matisse and the idea that Matisse and what he was doing and everything else.

 It was really, a whole part of his psyche. It is, I think, easy enough to conclude from some of those Matisse things, where he tore little pieces of very brightly colored tissue paper out and glued them down and were just a flat color. . . . It probably in some way subconsciously influenced Andy in some of the things, but, I think, he was already doing them with those Dr. Martin's dyes. I think, it wasn't Matisse who influenced him at all. I take that back.

 It's that it did have a similar look to it. There was a sympathy more than I had mentioned.

PS: I see. What would you call it? A "sympathy" also with [Jean] Cocteau?

CL: Yes. Particularly Cocteau's lines. I think that was probably more of a conscious influence. He *knew* those drawings then, and liked them very much. They were not that easy to see in those days. But they've been reprinted so many times since, but they were around. And . . .

PS: I found out that Andy did some stuff on walls. . . . I know that he did one for a dancer in '51, and I'm told that he did a bathroom of a photographer, but I don't know who the photographer was. Ted Carey mentioned that to me.

CL: Yes. And, let's see. One night we went somewhere for dinner. I remember, it was a bad dinner at some girl I knew, who worked in television somewhere . . . like a secretary or something. I don't remember. It's very strange. Down in the Village somewhere. And we were both drawing all over her kitchen wall that night. I'm sure it's been destroyed: the painting.
 Andy once—and I never, ever forgot it—said to me . . . You see, I used to think that he was, and still do, but in those days, I thought, he was so *wonderful*. And I said, "But, Andy, you know, you can become a great artist."
 And he said, "No. I want to become Matisse."
 That's *exactly* what he said. No more, no less than that. And that's *exactly* what he meant, and it shouldn't be misunderstood, was that whatever he did—if it was tearing up pieces of *confetti* and sticking them down on other pieces of paper or whatever—but *whatever* he thought to do was to be considered important, and that's really what that meant.
 Really. That must be *clearly* understood . . . That what he meant when he said, "I want to become . . . ," when I said, "Do you want to become a famous artist?" and he said, "No. I want to be Matisse," because I felt that if [he] really had gone away from illustration and into fine arts, so-called "fine art painting," that he could be extremely successful doing that. I did not envision Pop Art. I meant really doing fine paintings or things such as Ben Shahn did. Fine things. And I felt that if he would just concentrate on that and stop worrying about drawing I. Miller shoes and things, he could do that. "No," he said. That's not what he meant to do. He *really* wanted to become famous, and he has succeeded as well as anyone who has ever succeeded in doing that, and that's fine, too. I don't put any of that down. It's fine. I think, if anybody can do what they want to do, it's great. I really do.
 An interesting thing about our trip to Amsterdam, where we

bought those little books. He bought his little books and I bought mine. And we may have bought a whole batch of them, and I took some of them, and he took the others.

I'm sorry that I and Andy are not friends as we were then because we were the closest possible of friends, and that really came about— and I'll tell you truthfully what it was. I don't know if you should say this or not, but there was a point when he became acquainted with a lot of people who were into drugs, and I didn't like these people. And it distressed me that he was *fascinated* by them, the whole thing. He was always interested in things out of the ordinary. I once told him that he better be careful or someone will murder him. Exactly. I just had uneasy feelings about all of that.

I didn't *in any way* want to be associated with any of those people. I met one or two who became very proprietary and who wanted to *take over* Andy and who wanted to cut out any of his other friends. I don't remember the names. . . . Suddenly, here was a whole new group of people, but they tried to keep other people away from Andy. He was beginning to become known then, and they wanted to be the one and only, and they would drive other people away and make it unpleasant for other people to be around. . . . Well, I didn't like it then, and, so, rather than fight it, I walked away from it. Given those circumstances, which I wish would be different, but given those circumstances, I don't regret it, you see. Andy was one of the sweetest people that I ever knew, and I felt like they were trying to use him, to become better known themselves for whatever reason. I just felt that their reasons were ulterior, and I resented that, and I didn't understand why he didn't see that. And rather than put myself in a position of, perhaps, doing the same thing, I preferred just to walk away from that, and I would see Andy after that on the street or something, and we were always extremely friendly. Then it got so that I saw him less and less because I spent less and less time here [in New York], and he was always rather vague.

I mean, he was always seeming to be preoccupied with other thoughts, even when he was sitting here talking to you. And that was just his manner. It was a manner, but, later, that vagueness and so on seemed to be caused by other reasons, and I just, I couldn't, I didn't feel like I was getting through to him. There were times that . . . he didn't quite recognize me in the same room.

PS: What kind of activities, like going to the opera or things to read and such, that he was interested in that influenced his art during the early time or . . . ?

CL: Well, we did go to the opera, and that was wonderful. And at the opera one night the, let's see, we met somebody that Andy knew. An artist named Paul Cadmus. Andy had met him. . . . New York in those days was so wonderful. And the Old Met[ropolitan Opera House] was such a wonderful place, and we did use to go there. It was wonderful.

PS: Do you remember any particular movies or . . . ?

CL: Oh, yes. It was also in those days, people were showing movies around town, sort of pornographic movies, like Cocteau. What is that called. The one about boys in prison based on a thing by Genet, actually. . . . There are no credits on it, but it was written by Genet and filmed by Cocteau. . . . One of *the* most famous works, but in those days, it couldn't be shown in regular theatres, or it would have become as famous as *Blood of a Poet* or any of those other things. . . . Well, things were going on in those days like you'd get a phone call late at night: "Oh, in an hour over in some place way over at the Bowery or somewhere, they're going to show this thing by Cocteau and Genet." And you'd jump in a cab and go running. People would come from all over the city and congregate. And that night, I think, the showing of that film was interrupted by the police or something. One night we were there, and the thing was not allowed to go on . . .

PS: *Flaming Creatures* [by Jack Smith] was shown at this time?

CL: Yes. Yes. And another film was going to be shown at a little theatre on Eighth Avenue, and Buck Henry had called me up 'cause I was working on a television show, and he was one of the *many* unknown writers working on it, and he had called up, "Oh! There's going to be a great film at this place on Eighth Avenue," and so on. And I would call up Andy, and we'd dash over there and met there, and there was a great crowd of people there in the streets, and they weren't letting us in, and the film wasn't there yet. We saw Buck, and people were climbing on top of a car and saying, "We must be allowed to see this film!" And everything. I think, it was Buck who said, "Take the theatre! Storm the theatre!" It was like the Bastille. And we all went charging into the theatre. There were police there, but there were only one or two of them, who weren't going to do anything. Anyway, we all went in, and we were sitting in the theatre, and after half an hour we realized that the film was never going to arrive. The film was not at the theatre. So, we went home.
 But, I suppose, that if I lived in New York now, there would be

a lot of things like that going on now in some other area. Those days it seemed like there was always something happening, things going on.

And, I think, one of the reasons why Andy liked me was that I was aware of everything that was going on and was participating in all of those things, and I had been around Europe eight times, and I'm told by teachers who knew me when I was a teenager, and so on, that I was rather too sophisticated really for my years, and I was formidable and frightening because of that. I think, "threatening" to a lot of older people because, I suppose, it was true, and I think *that* fascinated Andy because it was very different than his background. I really don't know why Andy liked me. I'm sure that he liked me as much as I liked him, and, when I think back on those years—they were my early years in New York, and I remember them very fondly and very happily. And I'm sorry all of that has passed. . . .

I doubt if Andy has changed very much from those days. His personality was very firmly established and held up as it change[d]. . . . I think, that vagueness was an affectation of his cover up and to give him a slight delay until he could really decide what it was that he thought about something, until he could make up his mind or something. He really thought very clearly, but he didn't express himself well at all, which, I think, was deliberate.

You know, that's James Dean. [Lisanby points to the cover of Crone (1975).] . . . From a photograph. It's true about Campbell's Soup. He used to eat Campbell's Soup all the time. His mother would cook, but she would cook rather strange things when you'd go there for dinner, but she was really a lovely lady, and she would make . . . Czechoslovakian pancakes or something with various stuffings.

He did these shoe things specifically for *Life* magazine. He knew the art editor or someone, and he did a whole series of shoe things to take to them because they told him that if they had them, they would run them in their Christmas issue or some issue. It wasn't the Christmas issue. They promised to do it. I didn't have that much faith that they would live up to their promise, but, then, they did run them.

And, then, later, some of them were run in *Vogue* or *Harper's* [*Bazaar*]. I get those two confused.

And he picked people that he admired or something. I . . . long ago, a long time ago, under the shoe, really, has, I think, not much to do with the person. I don't know what this boot has to do with James Dean. The spurs, on the other hand, I'm not so sure I don't know what it means. I knew him.

PS: James Dean?

CL: James Dean. When he was *just* getting started and when he was doing television things. I knew him *just* before he was in that play [N. Richard Nash's *See the Jaguar* (1952)] about a boy who gets locked in a cage, like an animal. And that is the one he did just before *The Immoralist* [1954] with Louis Jourdan.

PS: A question: someone told me that Andy, when he arrived in New York, would write fan letters?

CL: That's true.

PS: Did he continue writing fan letters, as you remember?

CL: Oh, yes. He wanted very much to meet Truman Capote. He had a strange feeling that he *looked* like Truman Capote, and Truman Capote was very famous at a very early age. And he wanted to do the same thing.

He wanted to meet Cecil Beaton for the same reason. Truman Capote and Cecil Beaton were friends at about that time. I knew Cecil Beaton. I worked for Cecil Beaton as an assistant on a lot of things that he did in this country, such as *Vanessa*. I was his assistant for that and for other things that he did. And *that* hasn't anything to do with it. The fact that I did know some of these people. I never knew Truman Capote at that time, but I do know that Andy wrote him fan letters. And they did get to know each other.

I used to go to all the things at the Bodley [Gallery] if I wasn't working. . . . I have the *Julie Andrews Shoe,* which Andy gave me because Julie Andrews was a friend of mine, and I'm happy to have that particular one. I think, he tried to . . . It was, really, a very deliberate kind of conscious thing he was trying to do. Something that was attractive and different. And create a "look" and be something on a magazine cover or something in printed form. I think that he succeeded. I like those gold things very much.

PS: I understand that he liked to draw feet.

CL: Yes. You see, he wrote to a lot of people letters saying that he wanted to draw their feet, and he did. You know: people who were "known," as it were. And he went around collecting drawings of their feet and that was for an exhibit . . . and I don't know if that exhibit ever took place, and I don't know where those drawings are. I have no idea where they are.

He did used to go to the automat all the time.

These little drawings of cherubs and things I really loved. He was drawing these *before* he drew the fairy thing [*In the Bottom of My*

Garden]. . . . They're quite similar in style. . . . I really love them. Once I did an Off-Broadway show—I only did one Off-Broadway show in my life—but he let me use one of his little drawings in an ad for *One of the Little Angels*.

Andy could never verbalize anthing he thought. He really could not. He could only express himself, really, graphically well. He could never tell you why he did something, *ever*. If anyone said differently, they're wrong. I would doubt if he could today, but I don't know him today.

He . . . Some of his early things, as far as his association with theatre and so on, someone was doing something, a student kind of thing, at Columbia, and because he *wanted* to design scenery or because I was designing it or because he wanted to do other things or because he wanted to become involved with theatre or because he wanted to be near famous people or something, somebody knew him and asked him to do some sets. That's when he did a thing, like stringing up a clothesline or something or just hanging newspaper over it, just taking a *New York Times* apart and hanging it over. And I wasn't there to see it, but he told me what he was going to do, and he told me it worked very well afterwards. I was probably working that night. [Lisanby looks at Crone (1975).]

No, they're trying to turn him into something that he wasn't.

PS: That's what I'm trying to ferret out because it's very difficult and because there's all sorts of misinformation.

CL: I know. Well, he *could not* express himself well. That's why he avoided situations like that. That's why he preferred to be alone with one person. He really did. One person at a time rather than groups of people. He related better to one person at a time. He would go to parties. He was certainly not averse to go to parties. He enjoyed going to parties, and he liked being out, but that was only a momentary diversion for him.

He never had a great sex drive, but he was interested in it. There's no reason why to think he wasn't interested in such things, but he had a great lack of confidence about himself physically: about his physical appearance, about his physical prowess and everything else. He made no great effort to be physical about anything. That didn't mean that he wasn't normal in all respects. He really was.

He *had* very definitely the idea that if he had an operation on his nose, which was, kind of, bulbous, then, suddenly, that would change his life.

A lot of people who have had cosmetic surgery think that it will

change their life, and it doesn't. It can't. It's not the point of it. If you need something corrected, then fine, correct it, but it's not going to suddenly make your life different.

But he *thought* that if he had his nose operated upon that he would become an Adonis and that I and other people would suddenly think that he is as physically attractive as many of the people that he admired because of their attractiveness. And when that didn't happen, I think, perhaps, that he became rather . . . he was even angry because *suddenly* now things weren't different—as if an operation could remove or rearrange something is really going to change that person.

He's lucky it didn't change him. He's still the same sweet person he ever was, and I feel, I think, he felt that my reaction to him, my attitude toward him perhaps had something to do with something physical. It never did. Ever. I liked him because he was one of the most interesting people that I had ever known at that point and because he was good and because he was sweet and gentle. I think, what I admire most in people is that they are *good* people, if they have good intentions and they try to be good to other people, and he was that kind of person to a very strong degree. And that's why I'd be surprised to see . . . And if I became well acquainted with him today and found that that had changed, I would be surprised if that had changed. I suspect, people have taken advantage of that all his life.

Something about his movie-working. I think, I may have inspired that because I used to have a movie camera. I took one, a movie camera, with me on our trip around the world. I took all kinds of pictures at the time, and he was fascinated by the things that I had that were unedited.

In fact, he thought that the "Kodak" and all the dots and everything at the beginning or at the end of the leader, in other words, was as important as anything else. He felt that *all* of that was important to the total effect of the thing, and I had one piece of film in particular in which he was *extremely* fascinated by.

It's true that those early films that he did were completely artless and that he just shot them. Nothing was done to them. He changed nothing, and he knew nothing about technique, nor did he think that it was important, and that's the important thing—that he didn't think it was important. And he did send them to the drugstore to get them developed. Really. You know. And, I think, because of that—I know, it's because of that that he started taking films, and so on. He was interested in all kinds of ways of expressing something other than through speech. That's why long quotes attributed to him, and so on, are, really, . . . I wonder about. I can never imagine him doing some of the things, as I've read about.

PS: Why is it that he began to do the comic strip paintings?

CL: He was . . . Whatever it was, it's the same thing that prompted him
 to the *Campbell Soup* and all of that. He really . . . It was his idea,
 though he never said this—and that's why I really think that he was
 truly one of the instigators of Pop Art, even though other people car-
 ried it into other directions and so on—his idea was that it was the or-
 dinary, plain everyday things in life that were important. He really
 thought that, and comic strips and melted cheese sandwiches and
 Campbell Soup really were important as far as he was concerned, and,
 I think, that's why he did comic strip paintings. Someone else saw it,
 realized that there was an original thought there that no one else had
 ever done anything with before and made something out of it, made
 a successful career out of it.
 It was Ben Shahn's line, I think, that did inspire him in doing
 those blotted things. He *saw* the similarity, and Ben Shahn things were
 printed, and they were in the Museum of Modern Art. And he
 [Warhol] wanted his things to be printed in magazines, and he wanted
 them in the Museum [of Modern Art], too. *Very much.* And that's re-
 ally why he started to do that blotted-line, which, as I have said: it
 looked like a printed thing.

PS: Did he ever meet Ben Shahn?

CL: I don't know if he ever did or not. It's possible, but I don't know.
 [Lisanby looks through Crone (1975).] See, I remember these things.
 Graphic magazine realized the value of his work very early, and he
 was always in those *Annuals*. A lot of his early ones. He was in there
 because they really *saw* something there that they didn't see anywhere
 else, stuff that was being printed in this country. I don't think, he
 sought that out. I think, they discovered him. I love this drawing of
 Count Basie. This.

PS: Did Andy like jazz, or was it more pop music?

CL: Oh. No, he . . . I don't think he *truly* cared for any of that. He
 thought that you were supposed to like jazz. You know? Holly [Neal]
 had put together a Hi-Fi for him once, and he had jazz playing. I'm
 not sure if he ever listened to it, to tell you the truth. This is a thing
 that he drew down at my house. That's *his* hand.

PS: That's number 31 [in Crone (1975)].

CL: Yes. It's a hand holding a flower.

PS: Which has six fingers, by the way.

CL: Yes. Yes. I think, I pointed that out to him. Well, that's Andy's hand, though. That's his hand, also. See, there's a certain characteristic of the thumb there. . . . The day he was drawing this, he must have made a dozen drawings like that. See, these things were drawn with a ballpoint pen [see fig. 34]. . . . I don't know who Ralph [T. Ward] is . . . Notice the little heart here. So, he was a friend. Perhaps, Andy had a crush on him at that time. He was always drawing little hearts on things if he liked someone . . .

PS: He [Warhol] doesn't like to talk about . . . In fact, I wanted to go through this book with him . . .

CL: Let me explain something to you. You see, he doesn't want to contradict anything anyone says about him that's wrong. He doesn't care.

PS: Yes.

CL: He wants people—in those days, at least . . . He wanted people to say if it was true or not. . . . I used to say, "Andy, why didn't you tell him that that wasn't true?" "It doesn't matter. It doesn't matter," he said.

PS: One of those things is when he was born.

CL: Yes. Well. That was an age thing that he had, which very many people have, who don't want to admit how old they are and would like to be a few years younger or only a few years older. . . . That's all about when he was born. [Lisanby remarks that he saw Warhol's passport and that Warhol once paid for both he and Lisanby to learn how to drive.] He used to see something, and, then, he would do his version of it. Very true.

 Going back to this Matisse drawing. Despite the similarity between that kind of a mouth and those eyes, I don't think, Andy was trying to do this. I don't think so. There were other drawings, perhaps, that Matisse had done, being printed in magazines—*Life* magazine and fashion magazines and so on—that he saw, but I don't think that he ever actually sat down and tried to do that or to copy that. It was just that was around and that he was seeing in a vague kind of way. I don't think that was deliberate. You see, I turned [Rainer] Crone onto that Matisse thing, and, I think, he went off on a tangent. I realize, knowing Andy then, that if you ask him a direct question, he will not answer it. He would rather let you go on assuming something was true that was not true rather than correct you. It was some kind of a mystique. Greta Garboesque kind of thing. He loved Garbo.

 Much more than people realized, he redrew, reinterpreted other things such as this [Jacques Stella print] and *many* of these things that

you see of his drawings were *really,* absolutely, deliberately from photographs, leaving things out.

But these things which he drew like this, almost like hand-writing, were drawn by a ballpoint pen and almost without taking the pen off the paper. And absolutely nonstop. And *never* with putting pencil outlines down first, as some kind of guide. And if the thing went off the paper, it went off the paper. If he made a mistake or something, he would throw it away and draw a new one. And he wanted to have it have that autographic quality, and he was right. I've never seen anyone work that way before at that time.

And he always found funny, amusing things like this [Jacques Stella print]. And redrew then in his style, which, of course, has nothing to do with that other than the same pose.

And he was very fascinated by sexual things, such as that [points to Jacques Stella print], and I don't know what the original artist meant by this, but his [Warhol's] idea was that it was "naughty." But it is, really, so innocent and so naive, and that is the charm of it all. It's like the Monty Python people who talk about not showing "the naughty bits."

He was always looking for something that would inspire him to do something, which, in truth, by the time that he had finished it were *so removed* from the original that no one ever would suspect.

These cat things, and he owned so many cats, and he loved to make these drawings. Even some of the cat things were drawn while looking at a book of photographs of cats that I have.

PS: I understand that he had some sort of opaque overhead projector.

CL: Yes. Yes, he had that, and also he would just take a piece of tissue paper, put it over a photograph in *Life* magazine, draw the outline only, do that.

PS: Blotted technique.

CL: . . . Fold it over, as I was telling you about, and draw on that pencil outline and blot it down, and what he created really, the artistic creation, there had nothing to do with the original photograph but that was the impetus for doing that and that's why a lot of those things have the character that they have. They are really from photographs from *Life* magazine. . . .

He really did the shoe things *originally* because of the I. Miller things that he was doing and because he was drawing shoes. I have the whole *Shoe Book,* also, and he made me a Christmas card once: a stocking and a shoe, a thing that I printed and used as a Christmas card, but he did the drawing . . .

At that time, I was doing a lot of drawings for Andy, too. I could right now sit down and do an "Andy Warhol" drawing. I really could. That you could compare to his other drawings because I did a lot of things for him, but it was his idea of how to do it, and it was force and everything else. Once, he had to have a lot of drawings for someone who designed fabrics or for someone who made fabric designs, sold fabric designs or something along that line. And we sat down and in a weekend did over a hundred of them. We were drawing everything that we could think of. We were thinking of them together, drawing things around the apartment and ice cream cones and lobsters and what all. We had been drawing everything.

And when Andy would get his books published—the reason for publishing these books was to try to attract attention to himself as an illustrator or to whatever he thought he was doing in those days: as an artist. And he would print those books in order to give out to people, to try to generate work. That was the real reason for doing it. And he would get all of his friends in to color them.

PS: The coloring parties around the round table underneath the Tiffany lamp.

CL: Yes. Yes. Exactly. That was all that was about.

Amy Vanderbilt being a famous name even then is really why he wanted to illustrate that book. He wanted very much in those days to know famous people. . . . That is me.

PS: Number 64 [in Crone (1975)].

CL: Yes. That was the flyer that was sent out. It was kind of a poster, and that's me lying down again *that* way [turns book] asleep.

PS: Ah. So, 65 and 64 [in Crone (1975)].

CL: You see, *the reason* why this neck is so narrow and all that is that that [points] is a pillow . . . And the line back here.

PS: Okay. It makes sense when I speak to people.

CL: Yeah. Yes. And you see the cleft chin. And so. It's funny. I see some of the things being printed now, and they're supposed to be other people. It's really very possible that when Andy gave them the drawings, he told them that they were . . . I don't know. [Laughs] Or, if somebody claimed that "That is me," I think, he would not have disputed it.

In between the pages [of *The Gold Book*], there are various colored sheets of tissue paper: magenta, peacock blue and colors like that.

And *that* is part of the book—that these papers were slipped in. I suspect, he may have put them in originally because sometimes ink doesn't dry too quickly on metallic paper, and, so, he simply put them in, and he also thought that it would be beautiful, and it is.

I think, you would have to say that he was, really, very influenced by Ben Shahn and that he didn't try to imitate him. He really tried to do his own kind of line, that he wanted his line to be as meaningful as Ben Shahn's line was meaningful. And, I think, he was influenced in *that* way only.

PS: What are the magazines that you remember that he traced from a lot? Was it mostly *Life*?

CL: It was mostly *Life*. . . . He was perhaps drawing from magazines that were a year old or something like that. They were still lying around somewhere.

What he would create though rarely had anything to do with the original. Perhaps not as much—certainly not as much as an Old Master making a portrait of someone, and that is, at least, a portrait of . . .

PS: Like Rubens?

CL: Yes. He wasn't "interpreting" the photographs. He was doing something of his own. . . . When he would visit somebody, he would take them a little drawing. . . . He always loved cherubs, not the conventional idea of innocence, but, as I said before, his idea of naughtiness is so innocent . . . really. Ah, butterflies. He used them a lot as a convenient symbol, I would *think,* that it is more likely to have come from [J. M.] Whistler, who used the butterfly monogram, and, I think, he liked drawing them because they were very easy to draw many different colors, and he once made a little carved eraser to make a rubber stamp out of it of butterflies and printed *lots* of them.

PS: Yes. That was a folder that he would give out.

CL: Yes. Yes. Many artists then and still today would send out mailings of drawings to try to attract attention to try to get work. That's *really* what all of those [flyers] were for, and that's why he first had things printed, and, then, he would color them so that they would attract more attention and be more attractive. From *that* came books, which were the same thing for the same reason, a little bit more impressive, a lot more impressive and attracted a lot more attention. I don't think that the butterfly "symbolized" anything. I think, it was really what I said. He did . . . He knew Gene Moore then, and Gene at that point was head of window display for Bonwit's. . . . It was later that he be-

came head . . . for Tiffany's. . . . And Andy was attracted to Tiffany's: anything that bespoke glamour and fashion or any of that, fascinated and interested him and attracted him very, very much. He, on the other hand, was . . . He affected being nondescript. It was really a reverse kind of snobbery that he was affecting. I think that he felt that he could never be physically one of the beautiful people, looking like a model or something, so he pretended not to like that kind of thing and to look the other way or something. He was *extremely* overly attracted to that kind of thing and sought it and loved to be around beautiful people, handsome people . . .

PS: In fact, he called them "beauties."

CL: Yes. Yes. . . . And, you see, he would never change anything when he did it. You remember, I said, he would redraw it.

PS: Yes.

CL: He would never change it. He would never apologize for something that didn't happen exactly as he intended. That's really the same characteristic of someone who assumes something that is incorrect, he won't correct their assumptions. He's very consistent. And I knew that at the time. He is one of the most totally consistent people that I have ever known in my life.

PS: In what other ways was he consistent?

CL: Let's come back to that later, but don't forget that. I'll have to think about that.

I remember when many of these [drawings] were done, and he would *stay up all night long,* and I would go in the next day or something and see all of this stuff that he would accumulate overnight. He would just work all night long. He worked *very* hard and very consistently all the time . . . It was that autographic handwriting . . . kind of *just* do it, and that's it. Whatever happens, that is what happens, and that is what it is supposed to be.

Later, I know that he deliberately did so many things to attract attention. I mean, all of the Pop Art scene was to become famous, to become audacious, to be deliberately outrageous. He wasn't trying to be outrageous with this. [Lisanby points to fig. 196 in Crone (1975).] I think, this is more of his true personality. The other things that he became, he became more street-wise and smarter as time went on, and he began to find ways to achieve his sole goal in life, which was to become famous, to become known. He found ways to do that, and I don't fault anyone for doing that. These drawings are to me, though,

were some of the most wonderful drawings that have been made in modern art. I really think so.

Matisse was *in a way,* perhaps, an influence. At that time, Matisse was doing that chapel, where he drew on the tiles just in black-and-white, and Andy did know that was being done at the time, but he wasn't trying to draw that way. He was trying, if anything, to draw more like Ben Shahn but not like Ben Shahn but his own way.

He was also trying to draw like those wonderful drawings of Cocteau—of the sailor dancing and those things. *Those* were much closer in influence, and, because of the sexual connotation, particularly fascinated him. Those were much more of an obvious influence.

I think, you have to say by what *they* think they're influenced by though they may be influenced by things that they are unaware of, but I don't think that they are unaware of, but I don't think that he was consciously trying to draw like Matisse. Crone picked that up *really* from what I told him by about when he said that he "wanted to be Matisse," and I explained to him [Crone] *exactly* what he meant. He [Warhol] wanted the merest scratching to be worth something, to be valuable, to be thought of as valuable because, I think, he felt that a lot of what Matisse was doing was just "nothing" but acclaimed. I really think that.

PS: Okay.

CL: I doubt if you can get him to say that, but that is really what I believe. He wanted to be photographed by Henri Cartier-Bresson and to get his picture printed in *Vogue* magazine. That's really what he wanted. He didn't want to have done the painting that Matisse had done.

PS: Crone also mentions that Andy went to the Matisse retrospective, and he doesn't footnote where he picked that up.

CL: I don't remember a Matisse retrospective. Was there one?

PS: At the Museum of Modern Art.

CL: It's very possible. It's very probable that he did, as a matter of fact. It's also very probable that I did, but I don't remember going.

Birds and birdcages. You see, one of the famous photographs by Bresson is of Matisse as a very old man with a birdcage in this little room that he lived in. . . . You can't say that he [Warhol] was unaware of Matisse.

He was aware of them. He was exposed to them, but that's not what he was trying to do himself. He was trying to do something different from that, and you can go back through *anybody's* book and get

a great mass of material like this [points to Crone (1975)] and be able to "prove" almost any claim you want to make. . . .

I was an artist, too, drawing at the same time, trying to do my own thing, but I was also designing scenery, working at C.B.S. at the time.

He called me up one day at the very *beginning* of Pop Art as a movement as a conscious movement. Andy called me up, "We're starting something." And he was over at a gallery or something. "We're going to start something."

He realized more than anyone else I knew then, I think, the value of publicity and the value of advertising, and he knew that it would be advertised and popularized and to be the next thing. And he understood that about *that* particular subject because, really, a lot of it came from what other people were saying what he was doing and finding out how to do that, too, and, suddenly, the movement suddenly sprang up, and he called me. "We're going to start something new, and we're going to call it 'Pop Art,' and you can do it, too." . . . And he was saying, "Oh, you can do that very well. You should. You should get in on this because you will make a lot of money." [Laughs]

I remember that day so well. I was so involved with a deadline or something else that I could hardly interrupt it and talk about it, and I kept on saying, "Yes, Andy. Andy, come on. I can't. I can't talk about this now." And so on. I was really rushed that day.

It wasn't where I was going. It wasn't really what I wanted to do, and, looking back on it all, the only reason, perhaps, for having done it if I had done it, then I could have become famous and made some money out of it or something. But the reason for doing something . . . So, I really don't regret not doing it. Yes, that would have been fun if that did happen, but I really did exactly what I wanted to do with my own career, and I don't regret not being a famous Pop artist, really. It's interesting.

It must be reported that he went into it with the *most deliberate* manner. He knew *exactly* what he was doing, knowing *exactly* the effect. He would try to appear artless and try to appear naive, but he *really* knew the effect that he was having. *Always.* Always.

He knew that if he made a drawing of money, that people would understand what he was doing. If he made a drawing of a hundred dollar bill, then he could sell the drawing for a hundred dollars. I mean, that was, perhaps, outrageous then, too, but he really *knew* what he was going. He did those things deliberately to outrage people, to attract attention to himself. He was able to think up all of those things because, really, as I said much earlier, he had a most original and unusual mind.

He loved to draw flowers. He loved natural things—flowers—as I do. Flowers. Butterflies. He liked feathers—things that were beautiful in nature.

And this little thing—"Do you see my little pussy?" [in *In the Bottom of My Garden*]—is, again, a "naughty" little thing. He was really very naive about girls, anyway. I'm sure he still is.

This, again. This *Iris* drawing is a favorite drawing by him that I have. It was at this time, you see. You see that that looks very Matisse, I think, but it wasn't supposed to be. It was really just drawing from some iris that we had in this pitcher, and it was about this time [ca. mid-1960s] that I told him that he could be a very famous fine artist if he just stopped doing all of his crazy things—to attract attention and to be outrageous—but just *do* this kind of thing, and that's when he said that that's not what he wanted to do.

At this time, you see, I really accused him of not being serious about any of this *Campbell Soup* business, and so on. He would never admit that. He'll never admit that to anyone. I will always be convinced he was only doing it to create an outrageous effect. It had that result. That is really the result that he wanted. It made him famous, and that's what he wanted. And whether he will admit it or not is really immaterial, and a part of his reason for *not* admitting it is that he doesn't want to betray what's done if he says he did it with an ulterior motive, I think, to him would be betraying it. But he *did* do it with an ulterior motive. And, also, there's a story that was told in those days, and it's a joke that has been often repeated since, and, I think, that means something to him, too. Tallulah Bankhead was being interviewed, and the interviewer said, "Tell me, Miss Bankhead, is it true . . . ?" and she said, "Yes," without ever hearing the question. And, I think, Andy in those days was beginning to think that whatever anyone wants to say really doesn't make any difference as long as they talk about him, and, I think, *that* was a conscious thought in his mind then, too.

PS: And the rest is more recent work.

CL: These things were all done at a time that I *really* knew him, but I wasn't involved with any of the work that he was doing here: all of these things.

PS: The *Dance Steps* . . .

CL: Yes. I knew, he was doing them, and I used to hear about them. He would go off and do them somewhere else. The kind of thing that he was drawing around me was *this* kind of thing, which I really love. [Lisanby points to fig. 196 in Crone (1975).]

PS: So, he kept that style as he was doing the Pop Art stuff?

CL: Yes. Yes.

Gerard Malanga, New York, 1 November 1978

Gerard Malanga was Andy Warhol's assistant from 1963 through the end of the 1960s.

PS: One of the questions that I've always had about his Death Series . . . that was apparently suggested by Henry Geldzahler, with whom I am going to speak with at the end of November, . . . I think, he suggested to do *129 Die In Jet!* . . .

GM: Yeah. That's the one that I know was his suggestion for that particular painting. I think that the others were an outgrowth of that initial painting, but I don't know if Henry had anything to do with other specific paintings. I think it just triggered off—inspired—the use of other violent images: the image of violence.

PS: Why do you think he decided to do images that were violent like that?

GM: Well, I guess, partly because they were shocking. I mean, they were—are—shocking images. They were unusual. They were never really done before so graphically except for certain instances by Francis Bacon. I would say they had a certain shock value to them. They were very "media." They had a very one-to-one ratio of impact.

PS: And that's what Andy wanted?

GM: Well, I don't know exactly what his needs or wants were in terms of those paintings. I don't really know. I can't pinpoint the reason behind them except that he was obviously fascinated with the idea of death. One can read into that so many different philosophical ideas, but whether they were ideas that concerned Andy, I don't really know.

PS: What do you think they were all about?

GM: Well, they were silkscreens that came from U.P.I. photos of actual images of violence, whether they were car crashes or people jumping out of windows or whatever. So, I mean, I know what they were *to begin with*. They *existed* already. All that Andy did was—which any artist, that one can hope for, to do is to transform something—what he did with those photographs, those 8 × 10 glossies, was to *transform* them in such a way without really altering their image in any specific way. If you see a U.P.I. photo, you're going to grimace, but if you see it

on a canvas with color, you might accept it. Or, it's not going to be as violent as it was in the original state.

PS: One thing that I remember in reading the criticism of the time (when they first came out) that hardly anyone talked about the sociological impact that Andy was showing: the Selma riots and the violence of that time and of today. And it always struck me as curious that on the part of the critics that they would only talk about the "hot" image and the "cool" colors in a McLuhanesque interpretation and not really deal with what he was doing.

GM: You mean that they were overlooking the possibility of Andy's projections of some kind of political statement or something like that?

PS: Or social statement or social comment. Do you think that that is possible?

GM: Well, Andy's always said . . . He said somewhere that he thought of himself as apolitical. And if you remember by reading that really good interview with Andy by Gene Swenson in '63 in *Art News* where Andy talks about capitalism and communism as really being the same thing and someday everybody will think alike—well, *that's* a very political statement to make even though he sounds very apolitical. So, I think, there was always a political undercurrent of Andy's unconscious concerns for politics or of society for that matter. I mean, Andy never came out and said, "I am a capitalist," or "I'm a communist" or something like that. He wasn't an overt follower of a certain political trend. I think, there's in a lot of his paintings an underlying statement going on—a political statement like in that terrific poster he drew of Nixon: *Vote for McGovern*. It's really a sublime piece of art.

PS: Were you there at the time of that?

GM: Not of that. I wasn't with him when he was doing that poster. I silkscreened the *Selma Riots*.

PS: What was it like? What happens when he comes to whatever image and the procedure of the silkscreening?

GM: You get a photograph. Sometimes I researched it—finding the photograph that he'll really like. We'll decide whether we want to get a silkscreen. You see, a silkscreen was made from a transparency. You make a black-and-white transparency from the "paper" image, which is to say, a photograph. So, we decide in the making of the transparency that the silkscreen is to be contrasting or not with dot patterns. Right? Like in the newspaper with photographs, it's always done with

a dot pattern. So, we could use a newspaper picture or the original glossy, which doesn't necessarily have a dot pattern. We can put the dot pattern *on it,* which is for the screen—whether it's a 100 dot screen or a 200 dot screen or a 300 dot screen (which is to say, a very fine grain). Or, we make it very contrasty, which is very black—all blacks or all whites. That, sort of, *directs* the transformation of the image onto the silkscreen. I mean, Andy was looking for a certain effect like the *Liz Taylor* portrait, which was strictly contrasts. There's no tonal value. Right? There's no grain or gray shadows. If there are gray shadows, they become immediately black. So, in the *Liz Taylor* portrait, it was the effect that was gotten which the original photograph didn't have. The original photograph had tonal values which were eliminated in that particular portrait.

PS: Did Andy ever mention to you *why* he wanted to use silkscreen?

GM: Yeah. It was easier.

PS: Easier then, say, the stamps that he tried first for the *Dollars* and the *Cokes?*

GM: Right. You see, those paintings were primitive versions of the silkscreens. It's called "serigraphy." A serigraph is like a silkscreen. In fact, it is a silkscreen except it's not made from a photograph, or, it's not a photographic silkscreen. What happened was that Andy was making drawings of, let's say, the *Coffee* or a *Postage Stamp* or a *Dollar Bill* or an early *Coke Bottle.* Those are all drawings that were made into silkscreens. In a serigraphic method, you actually cut the screen. The silkscreen has a layer that you can cut away and make holes, and that's where the paint will go through. Right? So, those were very early. They were a little painstaking. He realized that he's working with a silkscreen. Why just do it that way when he actually could have a photograph—have a silkscreen made from a photograph of the object instead of having to draw the object and then make the silkscreen of it. In other words, he could take a photograph of a Coke bottle and get a silkscreen made the same way he would do it the other way except it would be less time-involved and a lot less work. I think, it was *mostly* a matter of making things easier, which is a part of Andy's philosophy. It was always Andy's philosophy that things should be easy. So, that's where the idea of silkscreening came in for him. It was less work involved.

PS: Some people have said that what he said could be distilled, over the years, into five or 10 minutes about art itself or his ideas of art.

GM: Well, I think that one statement in the Gene Swenson interview is the summation of anything that he could say after that.

PS: Were you there at the time that Swenson was speaking with Andy?

GM: Yeah. The reason why that statement was so good is because Gene had the microphone under the table, and Andy didn't know he was being taped. So, Andy was not self-conscious when he made that statement. As with the rest of the interview, he was unaware of the fact that he was being taped. So, it was a very candid . . . but not very original idea on Gene's part, but it was very clever in terms of dealing with Andy. Andy doesn't say very much when he's being interviewed, or, he'll lie about something.

PS: Of all the times that you have ever been interviewed about Andy or anything you have ever read, what do you think is important that has never been asked or has never been written about?

GM: In terms of Andy?

PS: Yeah.

GM: I don't know. I never gave that any thought. I don't know. Do you have a question?

PS: Well, I usually ask that question because then it could lead to all sorts of different places.

GM: Yeah. I have no idea. Ah.

PS: [Begins to flip through Rainer Crone, *Andy Warhol* (New York, 1970). Subsequent references are to its illustrations.]

GM: You see, the first thing I did with Andy was a *Silver Elizabeth Taylor*.

PS: Here's one. [Crone (1970), cat. no. 93, p. 124.]

GM: Right. It was from that series. I screened that, actually, for Andy.

PS: Why would he leave one panel blank?

GM: Well, it was painted the same color as the background, and, in that case, it was silver.

PS: So, you really can't see the image?

GM: There is no image. The reason why he did that was because it doubled the value of the painting.

PS: Do you mean in the sense of money-wise?

GM: Yeah.

PS: Why did he focus on Jackie?

GM: Well, he thought, I think, that she was the most glamorous woman in the world or something like that.

PS: And he would have things like this one. No. 102 [*Red Jackie* (1963).]

GM: Yeah. I don't think he was satisfied with this particular one. So, he didn't do too many of those. But this was a part of a show we did at the Sonnabend Gallery in Paris with all these *Jackie's*. We did a lot of them.

PS: Now, I understand sometime in 1967 or 1966, he did a movie of Kennedy's assassination that was never released.

GM: Yeah. Right.

PS: And I was wondering what that was about.

GM: It was a terrible movie. I think, it is terribly boring. I can't even remember it, to tell you the truth. It was done in 1966. I played Oswald, I think.

PS: I was talking with Ronnie Cutrone . . .

GM: Yeah. He played Oswald, too. Andy had decided that he would have two Oswalds in the movie.

PS: Why would he want to do . . . ?

GM: He was experimenting. It was purely experimental. He wanted to see where it would go, and it turned out a total bore.

PS: Why—always "why"—*Jackie* at the time of the assassination?

GM: Well, I don't think that Andy was moved by those news photographs to make paintings. I guess, it was because she looked very vulnerable.

PS: And the *Mona Lisa*? Here, I think immediately of Duchamp.

GM: Yeah. I think, it was . . . I forget how that was started, but it's funny. I mean, he took a painting and made a painting of the painting, which is an archetypal situation with artists—to make a comment on art, in that sense. And it was a very easy thing to do. I mean, it's not the same to do. It was changed. It got changed because of the textureness. You know? That was purely experimental.

PS: Like *Colored Mona Lisa*? [Crone (1970), cat. no. 128.]

GM:　Yeah. This was like a throw-away painting, I think. Andy never intended that . . . I think, what had happened with this painting was what had happened a couple of times. We had a piece of scrap painting on the floor—to get the excess paint off the screen. We put the screen on top of some piece of scrap and screened over it, and, then, we cleaned the screen.

PS:　So, Andy decided to sell it? Or, it just happened to be sold?

GM:　I guess it just happened to be sold, but I don't think that Andy intended that this was going to be something that he wanted to exhibit in this particular case.

　　　And these, I screened. [*Single Elvis* (1963) and *Double Elvis* (1963). Crone (1970), cat. nos. 133, 134.]

PS:　Do you remember Andy saying anything about Elvis to you?

GM:　I think, he liked Elvis, in a sense, as a Superstar: that type of quality of personality like Troy Donahue or Marilyn Monroe. I mean, it was an easy choice, in a sense.

PS:　But at the time there were so many choices like . . . Holiday.

GM:　Yeah. But he was a big star. I mean, he was a really big . . . People *knew* what he looked like. People knew his name. Also, I think, we were showing these at the Ferus Gallery in L.A. So, Andy wanted to pick a Superstar to show at the gallery.

PS:　When I talked with Irving Blum, he said that the canvases were sent unstretched and on rolls. Do you remember that? And, then, he called up Andy and said, "Well, what do I do with these?" And Andy said, "Well, why don't you stretch them?"

GM:　I can't remember if they were rolled-up, but if Irving said that they were, then they were.

PS:　And the question that I have here is that if he was going to send paintings, say, a long distance, as opposed to stretch them and such, to just have them on a roll and send them off—it sounds to me very easy to do for Andy.

GM:　Yeah. It's a little hazardous. The paintings could start chipping. Andy was using very crude paints on a lot of these. Later on, he decided to use lacquer paints, as opposed to flat color paints. Like this. [Malanga points to *Double Elvis* (1963). Crone (1970), cat. no. 138.] I introduced the multiple image in these paintings. I deliberately moved the image over to create a jump effect, and he liked it. So, we used it. I

think, he even did one where there was three or four rapid successions. [See Crone (1970), cat. nos. 142 and 143.] It was very funny because I did these paintings, and then we went to L.A., and we were the guests of Cecil Beaton one day. And Cecil had just done a photography book, in which he used the effect! Very weird. So, this effect was being used by a photographer. And I was actually trying to duplicate a photographic effect in these paintings beyond the idea that it was a photograph to begin with—to give it some motion, and here it is, and there it was in Cecil's book, too. It was a coincidental thing. I hadn't seen Cecil's book before we did these. One of these was done on a roll of raw canvas, which is brown. The canvas was not primed. It's just raw. It looks like a potato sack.

PS: I haven't seen that one.

GM: We did a whole roll of raw canvases like that. We unrolled it to a certain point, and we kept on silkscreening. Some of them were cut up, and some of them we left on the roll.

PS: Who was helping you at the time? Now, when you first started working for Andy . . . ?

GM: It was only me and Andy.

PS: All throughout this time that you were working?

GM: Just the first two years. [i.e., 1963 and 1964.] Well, when I came to silkscreen, it was just me and Andy. And when we did the *Boxes,* Billy Linich painted the . . . We had a carpenter make these wooden boxes, and Billy Linich came to us. He was then a part of the studio, and he helped Andy paint the boxes. Let's say, the *Heinz Boxes.* He painted to get the effect of cardboard color right. So, we painted the wooden boxes to get that color. And then Andy and I silkscreened all six sides of the box with whatever the image was. Generally, for the painting it was just Andy and I. It was silkscreening.

PS: Now, Nathan [Gluck] was still working with Andy at the time.

GM: Nathan was . . . Nathan was . . . At that time, Andy was still doing some free-lance advertising—commercial work. He was illustrating something, and Nathan was hired by Andy to do the work for Andy, and Andy would get paid for it having done an illustration.

PS: And, then, you were paid to assist Andy?

GM: I was paid to assist Andy with the fine art, not the commercial art.

PS: That's what I meant.

GM: Yeah. But Nathan worked at Andy's house. He wasn't at the Factory at all.

PS: Now, was this one the fire station?

GM: Yeah. That was the fire house, and then we moved to 47th Street to a real factory. That's where the Factory got it's name. We called it "the Factory."

PS: Do you remember who coined the term, "the Factory"? Was it just . . . ?

GM: We just called it that. You know? So that stuck.

PS: And, then, you would always work with Andy there?

GM: Yeah. Well, we vacated the fire house because it was owned by the city, and it was up for sale by the Department of Real Estate, and Andy had an option to buy it, but he didn't want to. So, we went looking for a loft, and we really didn't find anything that was suitable until we found the space that used to be, I think, a hat factory. Up on 47th Street. So, we moved everything to that space.

PS: [Turns pages of Crone (1970) to p. 162.]

GM: I worked with Andy on these. These are little canvases. This was to commemorate Leo's artists [at the Leo Castelli Gallery] that he had at the gallery at the time. These were all people that Leo showed. So, Andy was asked to do these portraits.

PS: Whose idea was it to do these?

GM: I think, it was Leo's. I'm not sure. I think some of these were done on little plastic cubes, too.

PS: Page 158. [Warhol's *Self-Portrait* (1966).]

GM: This was from a photograph that somebody took, and Andy bought the photograph from the photographer. It was a Canadian photographer. I forget his name.

PS: Here's *Ethel Scull*.

GM: Yeah. I worked on that one. Those are photo-machine pictures. At the time, they had "four-for-quarters." "Four-for-quarters" they called it. These were four-for-a-quarter strips. Each one was a strip, and the screens were made of the whole thing pasted up.

PS: Would Andy be taking snapshots or what?

GM: No. Andy wasn't taking any pictures at all. He was only using other people's photographs for all of this stuff. It was only much later, I think, around 1970–71, he started utilizing Polaroid, and he started using an Instamatic. Now, he uses a Leica. But, I mean, this picture of Sidney Janis — a photo was given to Andy, and he silkscreened it, as were all of the other pictures.

PS: And these were commissioned portraits?

GM: This was commissioned by Janis or by his son. I wasn't around when the *Sidney Janis* was made [in 1967]. I took a leave of absence for about nine months. I was in Europe. I made that one. [Malanga points to *Lita Hornick* in Crone (1970), cat. no. 265.]

PS: No. 265?

GM: Yeah.

PS: That is, you silkscreened them?

GM: Yeah.

PS: Now we come to *129 Die In Jet!* Now, in '63, I noticed that at the same time the *Elvis* was . . .

GM: Yeah. But the *Elvis* was done much later than these [*Car Crashes*].

PS: I was wondering because of the overlaps.

GM: Right. Andy was experimenting. Chance. It was, really, a chance operation, and we had no idea how it would come out. And the lighter the image got, that told us that the screen had to get cleaned, as the paint would start clogging up the holes in the screen. So, there was less of an image coming through.

PS: What I find curious is that in, say, this *Car Crash* on page 188 [*White Burning Car Twice* (1963)], he would leave blanks on the canvas itself, as opposed to that other one that we were talking about earlier, where he had just a separate canvas.

GM: Right. Well, that was because this was bad mathematical calculations in terms of spacing.

PS: But did you do these . . . ?

GM: Yes.

PS: . . . on stretched canvas?

GM: No. No. No. These were all done . . . No canvas was ever stretched prior to our screening it. In some cases, it was already pre-cut. So, we

had no idea that we were going to end up with that much space underneath.

PS: So that's . . . ?

GM: That's just an arbitrary thing. I mean, Andy didn't decide ahead of time that he was going to have that much space left over. So that's what happened, actually. I mean, each painting has its own artistic decision—esthetic decision—to it. This one he may have purposely decided to leave that corner blank. [Malanga points to *White Burning Car 1* (1963) in Crone (1970), cat. no. 324.] But, as far as this part here [pointing to *White Burning Car Twice* (1963), cat. no. 323] is concerned, we didn't know that was going to happen.

You see, when you're working with a silkscreen, you don't get everything worked out *totally* in advance in what you're going to do, in terms of what you want the *effect* to be. So, everything is going to come out chancy. I mean, sometimes we'd make a mistake, and there'd be a slight space between the image here, let's say. It wouldn't be a seamless thing. And that was an accident! We missed it. Andy took all of those accidents into account, as being part of the art. You see? So. It's very easy to make a decision like that after you do it. [Laughter]

PS: What happened when the *Boxes* were shipped up to Toronto? Wasn't that the incident with the duty?

GM: I guess. That's all very vague to me now. But that sounds familiar. Anyway, the [*Electric Chair*] canvases . . . I think, 40. (I forgot how many little canvases were in the show.) Each one was in a different color, I think. That was an idea that I threw out. I said, "Maybe we should do each one in a different color." Which meant that we just painted a canvas ahead of time. The image was usually a black silkscreen on top of a colored canvas. And, I remember, Andy and I took a train up to Toronto. It was very odd, and, then, we did it coming back. I don't know *why* Andy wanted to take a train, but we did. I think, Andy wanted to take a train because he wanted to know what the experience was like.

PS: And, then, there was all sorts of trouble with the *Most Wanted Men* series.

GM: Yeah. We had to paint over some of the *Most Wanted Men* series because, it turned out, that they were no longer wanted, or, they had served their terms in prison, or, whatever. So, we had to paint over some of the images, and, then, again, the esthetic decision occurred—it was to just leave them blank and do it over.

This was a total mistake on our part. [Malanga points to *Bellevue I* (1963). Crone (1970), cat. no. 424.] We didn't know that we were going down an angle when we were silkscreening it.

PS: That's page 228.

GM: That's always been one of my favorite paintings.

PS: This one?

GM: Yeah. *The Black and White Disaster* [Crone (1970), cat. no. 427]. It's a black and yellow painting. It's a real beauty.

PS: In what way?

GM: I don't know. It's got this effect that's like . . . and I've seen it in photographs strangely enough, where it seems to capture the essence of what's taking place there: water pouring down or something like that. You know? And firemen. That went to the Pasadena Art Museum, I think. I was actually sad when the painting was sold, somehow, I just liked it around. It's got a humane quality to it: the heroic fireman saving a child.

PS: Andy always has kept some of his canvases around, apparently.

GM: Because he can't sell them probably. I don't know.

PS: Do you think that he's essentially interested in money?

GM: Yeah. Yeah. He painted money. You know. Andy always painted something that he was interested in, and Andy never really painted anything that he, perhaps, was not interested in unless it was a commission for money.

PS: Why do you think he made the, what's called, transition from being essentially an illustrator—a commercial artist—to the fine artist of his Pop Art paintings?

GM: Well, because of his interest in art and artists. Andy started collecting art while he was still an illustrator. I mean, he was buying art by people like Jane Freilicher and Jane Wilson and Larry Rivers. Until this day, he is still a collector of all kinds of things. And, somehow, by being a collector, he had an *entrée* into the art world, and then he wanted to see what he could do and he started making experiments. I mean, he took the ordinary, everyday, common object that we would see, like the Coke bottle, and he thought that that was an appropriate image of art. Just as anything else would do—a still-life. I mean, these were the images and the essentials that we were dealing with in

life. So, why not make art out of them? I think that was Andy's attitude. The *Campbell Soup Can* painting was, interestingly enough, really autobiographical. He was always eating Campbell Soup. He always had that for lunch. So, it was really, in a funny way, it is a very autobiographical painting, as one can call a painting "autobiographica."

PS: *Handle with Care—Glass.*

GM: These were actually hand-done. These weren't on screens at all.

PS: You mean, he actually painted them?

GM: Yeah.

PS: Was Andy the only one who would paint them or . . . ?

GM: These? Yeah.

PS: Would he use an opaque projector, perhaps?

GM: Yeah. He might have. I'm not sure. I think that I remember seeing an opaque projector in his apartment.

PS: Why did he do the *Silver Clouds?*

GM: They weren't meant to be clouds, actually. He wanted to do a show of clouds. I mean, it was really conceptual—a precursor of Conceptual Art. The *Big Silver Balloon* was manufactured—made, and there was a problem with it. Air started to leak out. So, we later on had smaller ones. We had them insulated with an outer lining—a clear, plastic lining—to prevent the air from escaping. They wouldn't stay up too long. They'd start to lose air and fall.
 Now these were done on plastic.

PS: *Ten Portraits of the Artists* on plexiglass.

GM: Yeah. Little plastic cubes.

PS: Why would he do that, as opposed to on canvas?

GM: Well, these were manufactured, actually. We actually didn't silkscreen them on plastic. Just something to do.

PS: Do you want to talk about the films?

GM: Yeah. We could talk about the films.

PS: I understand the idea of the studio. I think of Andy's studio as a kind of Rubens' or, even, a Walt Disney studio.

GM: Yeah. Walt Disney was always one of his . . . Andy always idolized
 Walt Disney. Andy wanted to be like Walt Disney. In other words, the
 entrepreneur or "Andy Warhol Presents . . . " Andy always wanted,
 in the end, just wanted to put his name to it, you see, which is bas-
 ically what Walt Disney did later on in his life. So, Walt Disney is a
 big hero of Andy's. In fact, when Andy and I went to California, we
 went to Disneyland. It was definitely a *must* on our itinerary.
 And Andy was always fascinated with death—that idea of, some-
 how, having his destiny—putting his name and making it all.

PS: One of the conclusions I've made since I've come to New York is that
 it's the "Signature" that's important for Andy and the "signature"
 doesn't matter. For instance, he would have his mother sign his com-
 mercial work.

GM: Yeah. Well, Andy's calligraphy derived from his mother's work. I
 mean, the calligraphy that he made famous on Madison Avenue. Com-
 mercial artists picked it up later on. It was a real script. It was, really,
 Andy's mother's calligraphy. And you know those sets. Electroset.
 You rub the letter down on a piece of paper.

PS: Yes.

GM: The company is called Electroset. Well, Andy even had his mother's
 penmanship—the script—made into Electrosets so that he would have
 instant lettering that he could rub down to make words because you
 could attach one letter to the next and do it in such a way . . .

PS: Like in the *Paint-by-Number* paintings.

GM: Well, those numbers were probably hand-painted or stenciled.

PS: Did Andy have any other "heroes," so to speak?

GM: He must have. He did. I just can't remember.

PS: How did the Exploding Plastic Inevitable come about?

GM: Ah. It came about in a round about way, actually. Jonas Mekas ap-
 proached Andy about giving him three days at the Cinémathèque to do
 something, and the immediate idea that came to mind was that we
 were considering an Edie Sedgwick retrospective. This was still being
 thought about just at the time we met the Velvets, and somehow this
 light show evolved. The Edie Sedgwick retrospective got shelved, and
 for those two or three days at the Cinemateque we did this Velvet Un-
 derground—this mixed- or multi-media type thing, and we decided to
 use the films as a backdrop instead of using gels, which Andy found

very corny. It was a very West Coast type of thing, too. And we got a couple of bookings, and, so, the thing just snow-balled. It started going on the road to colleges and various places: Rutgers University, Ann Arbor and a psychiatrists' conference.

And Andy decided to throw Nico into the act because the Velvets themselves were not very charismatic on stage, and Andy wanted a spotlight on someone. So, we put Nico in on it because she was interested in singing and had just cut a 45 in London, and she was looking for work. So, Andy threw her in on the act against the wishes of the Velvets, actually. And so they, sort of, reconciled themselves having Nico along with them, and, then, the name of the group was the Velvet Underground and Nico, to give Nico a sort of, showcase or spotlight.

The stage show was called the Exploding Plastic Inevitable, and we went into a disco on St. Mark's Place, and we also had another place on 71st Street. People would come and dance and drink, and the music would play, which was part of the show. And, then, in between sets, there was just taped music. So, it was a live act, and the movies were projected without sound as backdrops. And we'd gels in front of the spotlights, as opposed to gels on the dishes projected with a slide projector. So, it was like a moving collage of things happening behind the Velvets.

PS: Was there anything like that in New York City at that time before . . . ?

GM: There were light shows, but they were not with movies. They were of the Timothy Leary variety—psychedelic gels and dishes, thrown on the screen and an opaque projector or whatever. The movies we did use were always Andy's movies. So, it was quite different from your run-of-the-mill light show that was happening on the West Coast or Timothy Leary or . . .

PS: I'm thinking of various projects, and one that I recall seeing is *Intransit,* the magazine.

GM: Yeah. That was just something that I'd do. It had an excerpt from *a, a novel* in it.

PS: Yeah. Wasn't it called *Cock* in *Intransit?*

GM: Yeah.

PS: Who's who in the book?

GM: I'm the only real name in the book. The other names were changed. I guess, Ondine is "Ondine" in the book. That's not his real name.

PS: Who's "Drella"?

GM: "Drella" was Andy.

PS: How did that nickname come about?

GM: [Laughs] I think, Ondine gave him that name. "Drella" meaning, you know, just a sort of fairy tale name like "The Bad Guy" or something. It has that kind of association to it. The whole book is tape. Nothing was written except for those punctuations and things like that. The whole book is a taped book. The idea came about because in 1965 came the revolution in cassettes, and Phillips Norelco was the one that pioneered cassette-recorders. Phillips Norelco approached Andy with testing their product by giving him free use to it. We had to return the hardware. We kept the cassettes. They gave them to us to play around with. They gave us video cassettes, too. And we experimented with the video cassettes, but we ended up not really doing anything with it.

But out of all those experimentations, we thought, let's write a novel on tape. But the only way to write a novel on tape was just to tape somebody and then to transcribe the tapes and that would be the text. So, that's what happened. That's what was the result of working with the cassette-recorders was that novel that came out of our playing around with their toys for a couple of months.

PS: What was the origin of *Interview* magazine?

GM: Well, the origin of *Interview* magazine was that Andy just wanted to give me something to do. It was a two-forked origin. It was to give me something to do, and also we were refused press passes to the film festivals. So, we decided that in order to get press passes—in terms of legitimizing ourselves—we could start a film magazine. So, that's how *Interview* started. I'll give you a copy of one of the early issues. It's the second issue. This is what it looks like.

PS: Thank you.

GM: It was strictly a film magazine in the beginning.

PS: And, then, you edited it?

GM: I was one of the editors. And I was the founding co-editor.

PS: Who's the other one?

GM: Well, it was really Andy and me, as the only editors, but there was Paul Morrissey and John Wilcock. Paul's name was strictly figure-head, and John Wilcock was the sort of co-publisher-printer (distribution connection for Andy).

PS: Did you have much time during all of the activity—of the films, silkscreening, etc.—to do writing?

GM: I wrote all the time.

PS: Would you have a lot of time on your own?

GM: Oh, yeah. I mean, I put in my work for Andy whether I was silkscreening or making a movie, then I had all of this other time for myself. So, I was always writing and publishing. I wasn't a painter, and I wasn't another artist working for an artist. And the reason why I did work for Andy in silkscreen because I had prior knowledge in silkscreen, having done that with somebody else. It was strictly from a commercial point of view.

PS: Who were you doing it with before Andy?

GM: I was working with a man who designed ties, and we would silkscreen them on 30 yards of fabric. And, so, I had that knowledge. And Andy was just getting into working with silkscreening when I came along. So, he hired me. I was introduced to him, and he said, "Yeah. Why don't you come and work with me?" So, I did. And I had that knowledge, and it worked out fine. I mean, I knew exactly what I was doing, and I'd follow whatever line of whatever it was that Andy was trying to do.

PS: What were some of the watering holes at the time that you were working for Andy?

GM: Well, there was Max's Kansas City. That was it. That was the prime watering hole.

PS: So, Warhol at that time wasn't going to Serendipity?

GM: Yeah, he did. We went to Serendipity occasionally, but it was not a hang-out for us. We went there a few times. But all of a sudden Max's opened up, and it was the place to be, to go to.

PS: . . . Did he go to besides Max's, to poetry readings that you would take him to or to movies or what?

GM: Andy and I went out to movies together a lot, and, there was a poetry reading, we'd only go because it was, I'd tell Andy to come or I'd say, "You should hear this person." That's how Andy met Ronnie Tavel. He went to Ronnie's reading at the Cafe Metro. That's where we met Ronnie.

PS: And what were some of Andy's favorite movies?

GM: I only knew of one movie in particular that Andy and I enjoyed, and went to at least three times, was *The Carpetbaggers.*

PS: Did Andy ever tell you why he liked *The Carpetbaggers?*

GM: Oh, we liked it because it was so filled with action and Andy thought it was also a very trashy movie. But it was filled with action and we really enjoyed it.

PS: And I know that Ronnie [Tavel] would do some scripts.

GM: Yeah. Well, there was a period when Ronnie was just doing the scripts.

PS: And, then, what would be happening? Would he just ask for ideas for what you'd do next, or, did they make money at the time, or were there financial problems? Now, I'm sure, that there'd be one or two financial problems now because people would sue him for residual rights.

GM: Right. Andy never really got releases from anybody. [Laughs] It was all fun and games and we were all willing to participate, and Andy . . . and everybody wanted to be standing . . . somehow Andy had this knack: he'd put you [snaps fingers] in this movie, and he'd make you a Superstar. It was hitting on people's vanities. People wanted to be in the movies and be a Superstar. It gave them a sort of soapbox. All of a sudden, they could dial on the same level as somebody else or that kind of thing. Those movies never made any money. I think that *Chelsea Girls* and *My Hustler* were the first two films that might have started being a profit, in some sense, but a very marginal profit.

PS: Why did he turn to movies, because they didn't make a profit for him?

GM: Well, my theory is that they were a stepping stone to find a producer who would back his films in a big way, and Andy was not about to wait around for that to happen. So, he decided to do it himself in order to *attract* attention to what he was doing, wishing he would get somebody to put up money for a big, legitimate-type film. So, these "16mm two-reelers," as I would call them, were really experiments—film experiments. They were a learning process for Andy, too. I mean: Andy really didn't know how to make a movie. That's why the camera was in the wrong place. There was no cutting or anything like that. He didn't get into any of the *labor* involved.

PS: That's why he'd have someone like Buddy [Wirtschafter] to actually roll the camera for him?

GM: No. What Buddy did was . . . Andy did the camera work, whatever camera work there was to be done. It was not much. Buddy loaded the film for Andy. Andy, actually, learned how to load film, I must say, too. But, Buddy did the sound for all the films—the sound recording.

PS: Now, who had great experience at doing sound?

GM: Yeah. He did the sound in his own films.

PS: Right. Like doing Kaprow's Happening.

GM: Yeah. I'm not familiar . . . I've never seen any of Buddy's films.

PS: Ah. The reason why I ask that is because the sound track is usually unintelligible.

GM: Well, that's because they were very primitive. We were working with what has become a very obsolete 16mm camera, called a Auricon, which would enable Andy to shoot 35 minutes without changing the film. And we were working with single system, which was very inexpensive. In other words, the sound that was being recorded—went *directly* on to the film strip as it runs through the camera. So, that kind of sound quality which newsreel people would use—it was called "single system"—single system optical. It was inexpensive, but the sound quality was very poor. And the only way to get good sound quality was to shoot the film but also to do it on a tape recorder at the same time. And then when you made your print from your master original, you would *not* use the sound that was on the original but to transfer the sound from the tape on to optical 16mm track and that track would, thus, run through the machine with the visual 16mm, and the sound would be synced up. There would be a little sync sound, a little punch work that would make a "boob" sound on the film, and that's where you'd sync up your 16mm optical tape film, which came from quarter-inch tape with the visual. So, everything was in sync. . . . So, Andy had no work to do in terms of keeping anything in sync because it was automatically kept in sync because there was no editing. If you stop the camera—he had it hooked up in such a way—it was really incredible! It was the only way to do it. It was he . . . anytime you stop the camera, the tape recorder would stop, too. Now, Hollywood people for some reason don't work that way. The tape will keep on rolling, and, then, they have to edit the tape in the editing room with the film that they would be editing. But, since we were not doing any of that, we were editing in the camera by stopping and starting, even though the scene would be going on. So, we had the wires hooked up in such a way that when the camera would

be turned off, the tape recorder would go off, too. You see? And when the camera turned on, the tape recorder would go on. This was all a part of the same electric circuit. You see, when people would film in Hollywood, they never had the tape recorder connected to the camera because they were shooting, strictly, magnetic sound, as opposed to optical sound. So, there was no need for them to connect the tape recorder to the camera because they could always sync it up later in the lab. But Andy was not into doing lab work. You see, so, we had it hooked up so the tape recorder would stop when the camera would be turned off and when the camera would be turned on, the tape recorder would go on. So, it was very easy to match up. You'd bring in the quarter-inch tape and your roll of undeveloped film, and the sound was also on the film, too. We used that sound when we went double system. That was called "double system": the tape recorder and the optical. So, when the print was made from the original, we had the tape, which was converted to 16mm optical that was synced up to the punch mark on the film. And we had better sound later. But at the beginning, when we were working with Buddy, we weren't doing that. As I say, we were cutting the corners, as it were. But, Andy couldn't get away with that for too long because as much as we tried, the sound was not as good as it would be with a tape recorder.

PS: Is there anything else about the films, technical-wise, that you think is important for me to consider or keep in mind?

GM: Well, everything was a one-to-one ratio. There were no retakes. Everything was *one take,* as it were. It was *just one take.* One continuous 35-minute roll of film so there was a 35-minute one-to-one ratio *take* and that's it. There were no retakes because Andy didn't want to edit.

PS: Okay.

GM: So, the films . . . the *content* of the film, in many cases, was an extension of the form of the structure of the film.

PS: Can you think of a specific example?

GM: Yeah. *Horse* is a two-reeler. Each reel went from beginning to end without stopping the film.

PS: I just happen to have the scenario of it with me.

GM: Oh, really!?

PS: Ronnie said to me that he thinks that it's Warhol's best sound film.

GM: Yeah. I guess, it's a pretty interesting film. It's not shown like *Vinyl* was.

PS: The question that always comes up on Andy's films is, ah, voyeurism and such. That Andy would let people do whatever they wanted to do.

GM: Yeah. That's true. Andy never intruded upon what went on during the film. For a couple of reasons. One reason is that, if he did, he'd have to stop the camera. So, if something went on that Andy had *no* control over it because he already put a set of principles upon himself. He didn't want to stop the camera, and he didn't stop the camera.

PS: So, another conscious rule at the beginning would be, like, the static camera?

GM: Yeah. The static camera, no editing, no stopping of the camera to do a retake. Eventually, Andy would stop and start the camera, but he was . . . interested in the *staccato* effect of chopping up the scene, let's say. Purely abstract situation. But that had nothing to do what went on in front of the camera.

Gerard Malanga, New York, 13 December 1978

During the second interview with Gerard Malanga, Andy Warhol's former painting assistant discusses various aspects of Warhol's Pop Art.

PS: [Referring to John Wilcock's interview with Gerard Malanga in *The Autobiography and Sex Life of Andy Warhol* (New York, 1971), in which Malanga had stated that Marcel Duchamp, Gertrude Stein, television, films and John Cage most influenced Warhol, P. S. asks Malanga to expand his comments concerning John Cage.]

GM: I guess, chance methods. Every time I made a silkscreen, it was . . . He [Warhol] had a set idea; it always changed. He might have made a mistake. The image might be off-register. He might have tilted the screens slightly so that everything after that was or became tilted, without us realizing it. So, I guess, the chance method that Cage sort of utilized in his music . . . I mean, we were taking chances without knowing it. Something fantastic would come out most of the time.

PS: How specifically do you think Marcel Duchamp influenced Andy? Did Andy know Duchamp?

GM: Ideas, conceptions and ideas and the thing about taking the idea and not being afraid to put it into concrete form. I mean, actually going ahead: going from step A to step B and making it work somehow like the *Mona Lisa* or the movie *Sleep*. I mean, those are all great ideas,

but whether they really work in concrete terms, the only way to find out is to actually *do* it. We all have had great ideas, but we might not go from step A to step B with them. They just remained ideas, but Andy took a lot of these ideas and actually went ahead to *do* them, even if they sound like the most boring ideas in the world, and, somehow, they'd turn out to be very interesting—even in cases, more interesting than the idea was.

PS: Did Andy ever meet Marcel Duchamp?

GM: Oh, yeah. . . . I have met him with Andy . . . 1966 . . . Around October. We have a film that George Plimpton has a print of. Of Marcel Duchamp with an old girlfriend of mine. A three minute film. . . . It was sort of like at an opening.

PS: Did Andy ever talk about Marcel Duchamp with you?

GM: No. Not really.

PS: Did he ever mention Jean Cocteau?

GM: No. But I think that Andy would have thought that Cocteau would be very corny.

PS: Would you say there was anyone else who you would add to the list?

GM: [Pause] I think, the people around him. You know? Including myself. I mean, Andy got his ideas from those around him, actually. . . . Andy sort of *absorbed* everyone's ideas and influences. He wasn't very . . . discriminating . . . a lot of the time. Sometimes he was; sometimes he wasn't.

PS: Are you thinking of something specific?

GM: No. Not really.

PS: Andy's *a, a novel*: tell me about that.

GM: I was there for several of the tapings, and I actually gave the idea for that book.

PS: Oh. You did?

GM: Not the idea to tape Ondine but the idea of a novel or a book that was entirely composed from a cassette. Because what happened was Andy was approached at the time, which was 1965, . . . there was no cassette industry or medium. The cassette medium came on the scene in 1965, in late '65. There was no such thing as a cassette recorder or a cassette to play back until that year. What happened was Phillips

Norelco, which was among a couple of other companies that were experimenting with this new idea, approached Andy and, I think, several other people and gave them actual cassette recorders and tapes. Rather, the company gave the hardware to *Stereo* magazine, and *Stereo* magazine approached Andy. What they would get out of it was a cover story on the results of Andy's experiment not only with the cassette material but with quarter-inch video cassettes, which we also experimented with, but we never really did anything with it. So, the only thing that came out of it, really, was *a, a novel.*

PS: Do you remember anything in the making of it that I wouldn't find written anywhere?

GM: Billy Name [Linich] transcribed it. That's about all . . . A friend of Ondine's. Well, I knew Billy, too, before he came to work for Andy. I mean, he came to the Factory through Ondine, not through me. For some reason, Andy was quite taken by Billy. So, Billy became the, ah, live-in manager of the Factory. He actually lived there, kept the place clean, painted the place and was the caretaker, really. . . . The only name that wasn't changed was my name in the book, but it was only, I think, my first name that was used in the book.

PS: How did Andy get the name "Drella?"

GM: [Laughs] It's like fairy tales. It's like the "Vicious Heidi's." You know, that kind of thing. "Drella" is just sort of a homosexual, ah, . . . [pause] . . . sort of a Campy name like "The Witch": "The Wicked Witch of the North." That kind of thing, and it had an associative kind of meaning. It had nothing specifically to do with Andy. Like instead of "Here comes Andy," "Here comes Drella." That kind of thing: watch out or be on your guard.

PS: In *Intransit* . . .

GM: Yes? Where did you get that?

PS: Northwestern has a copy. [P. S. asks Malanga about poets associated with the Factory.] What do you think is the origin of Andy's use of photographic-sensitive canvas and serigraphy?

GM: What do you mean by "the use of it?" The reason why we went to silkscreening was just to make it easier.

PS: We talked about that. But in the sense of: how did he happen to get the idea for that? Some people have said that he ripped it off [Robert] Rauschenberg . . .

GM: He didn't rip it off from Rauschenberg. Rauschenberg was doing it be-
 fore Andy, but Andy was at Rauschenberg's studio one day and got
 so excited by the fact that the silkscreening was so much *easier* than
 the serigraph type of painting, so, Andy rushed out and got some
 silkscreens, which is perfectly fine. . . .

PS: I don't mean to say that in a judgmental way. I'm sorry if I said it that
 way.

GM: Yeah. He probably got that idea of silkscreening from Rauschenberg.
 I think, Andy told me himself one day that he was at Rauschenberg's
 studio and that he saw the silkscreens. I think, the silkscreens that
 Rauschenberg was destroying, in fact, that he had been using already,
 and he was very excited by the fact of the *process* . . . in other words:
 Andy was *really* looking for an ideal way of making his paintings
 without . . . with as little effort as possible. See? And the silkscreen
 allowed him to do that because he didn't have to draw anymore on the
 serigraph screen. He didn't have to cut stencils. He could eliminate all
 of that. Just send the image that he wanted copied—right on the
 silkscreen. He didn't have to copy it by hand. And the only difference
 between Rauschenberg and Andy was that—see—the silkscreen pro-
 cess was ideal for Andy because Andy could make *a lot of* the same
 paintings over and over again, but Rauschenberg only made one—one
 painting in a certain way. He may have used the screen only once, but
 he did it always in a different way for a different *context*. He did more
 collage type of material. Rauschenberg did. And, then, another thing,
 Rauschenberg always destroyed his silkscreens. I mean, in most cases,
 after they were no longer of use. Andy held on to his silkscreens. He
 really didn't destroy *them*.

PS: What context do you see, say, between Jasper Johns and Andy, if any?

GM: Let me put it this way: Jasper and Rauschenberg are the precursors to
 the Pop Art movement. They were the sort of the last gasp of, or, the
 transitional link-up between the Pop artists and the Abstract Expres-
 sionists.

PS: When I saw the Jasper Johns retrospective last year, I noticed a photo-
 mat image beneath the encaustic paint of *Three Flags,* and it's the first
 instance that I know of where the idea of a photomat was actually done
 in Pop Art.

GM: Well, Andy really took it to the extreme: the photomat image. First of
 all, he did a whole series of photomat photographs for a three page
 spread in *Harper's Bazaar*. They always have a spread on the up-com-
 ing artists or young achievers, etc., etc., and it's usually photographs

of those people. Well, what Andy did, when he was assigned the piece, was, instead of photographing the people, he put them in a photomat booth, and, so, they . . . he did the layout with the photomat pictures. That sort of dates the *Self-Portrait*. There's one *Self-Portrait* from a photomat photograph. . . . There's another *Self-Portrait* that Andy did that used a Canadian photographer's photo of him, and, then, Andy did a cover for *Time* magazine . . . of teenagers, and Marie Menken and I worked on that. . . . The one from a photomat was '64. . . . The spread in *Harper's Bazaar* was early '63.

PS: So, the *Harper's Bazaar* was the first instance of . . . ?

GM: As far as I can remember: where Andy used photomat pictures.

PS: Why did he decide, more or less, to give that up?

GM: Well, that's like . . . He didn't want to be reminded of . . . the kind of work that he was doing in the past: doing the *Harper's Bazaar* work was the last gasp, but, then, he was working with two very interesting girls [Ruth Ansell and Bea Feifler] at the time that kept on giving him assignments. Now, don't forget that Andy was . . . that Andy was not very . . . that he made money from the advertising scene, but . . .

PS: Right.

GM: . . . But he wasn't really making money from his paintings. His paintings were very *cheap* in those days, so, if he could, you know, get a really good assignment from, say, *Harper's Bazaar,* which required very little effort on his part, that was like—you know, that was like, you know, a thousand dollars in the bank, and Andy was not about to quibble about it.

PS: Since you have been interviewed so many times before about Andy, what's the question that you'd like to answer that you've never been asked?

GM: [Pause] Okay. Maybe something should be cleared up because I was accused of making some forgeries of Warhol paintings.

PS: Is this when you were in Europe?

GM: Well, I was in Europe, but the time I was being accused . . . I mean that I only found out about that when I came back to America. So, if I was in Europe, I wasn't making any paintings to begin with. . . . In fact, [. . .] uses it against me to keep me separated from Andy. I can't work on *Interview* magazine because . . .

PS: Would you like to?

GM: Well, yes! I was, actually, the co-founder of the magazine. It was my magazine to begin with. . . . But I'm not . . . I'm not the guilty party. In fact, Andy said in the Andy Warhol-Random House book, "Gerard signs all of my paintings," which is true at the time [1965]. Andy is always . . . Andy said to me at one time years ago when we were working together that one of his greatest fears was that someone could easily forge one of his paintings, which, in fact, is his *karma* because that's what, in fact, happened. Somebody was able to forge Andy's paintings. I mean, Andy's paintings are very easy to make. All you have to do is silkscreen one of his images that have already been silkscreened . . . I saw Andy the other night at a dinner party. I mean, I don't have any real animosity toward anyone at the Factory. I just feel at times that I'm being treated wrongly, as if I'm the black sheep of the family.

PS: Is there anything else that we haven't discussed about your association with the Factory?

GM: I guess that I was a catalyst at the Factory. I mean, a lot of the people who passed through the Factory doors were people who came because I was there, and there was always an exchange of ideas between Andy and some of the people that I knew that he didn't know. . . . *I was responsible* for bringing in people! Like Paul Morrissey, Ronnie Tavel, René Ricard, Allen Ginsberg, . . . and all the people who are associated with Andy at the Factory.

PS: What did Allen Ginsberg do?

GM: We did a screen test of him. We shot . . . He was in a part of *Couch.* He was there because *I* was there . . . to have him come.

Jonas Mekas, New York, 18 December 1978

Mekas has been one of the most prominent leaders of American avant-garde film, and he now manages Anthology Films Archive in New York.

PS: When did you first meet Andy Warhol?

JM: I do not remember, strange as it may seem, but I could put it this way: In 1962, '63, '64, Film Makers' Co-Operative was located at 414 Park Avenue South. It was much going, those years. It was a very busy period in New York in the Independent Film area, and the Co-Operative was the meeting ground for, ah, during that period, where the filmmakers stopped by during the day. During the evening, I was living there in the back of the Co-Op space. I gave the front of my space

to the Co-Op—the front part was the Co-Op proper during the day. In the evening, it was a sort of night co-op, and during the evenings or afternoons, whenever a filmmaker felt that he wanted to show films to a friend or some[one], he could come in and screen. There was always projectors set up. And in the evenings, practically every evening, there was some little screenings—somebody was screening—it's not a public . . . It was only that filmmakers knew and friends knew that, and this increased when we seemed to have at some films problems, censorship-wise, with public screenings. So, those films were usually screened by filmmakers and their friends at the Co-Operative.

So, it became like a filmmakers and friends (painters, poets, . . .) knew that this was where they could see—there were very few public screenings—the Underground Films, and they used to come.

And I never knew who was there, watching them. Some of them, I knew as, you know, they kept coming back. I knew the filmmakers, but I did not know the friends that they used to bring or some painters used to come and sit and watch, and I did not know. . . . I was not too deep into any art scene. . . . I knew the filmmakers and poets more than painters.

And one day, Naomi Levine, who made films but [s]he started as a painter—I said, "Why don't you come for my birthday," or something. She came to my place. "Andy Warhol is coming, too." I said, "Andy Warhol?" "You know." "I don't know Andy Warhol." "What do you mean you don't know Andy Warhol?! I met him at your place!" "You met him at my place?" "He's been there for months, watching those films." I said, "I don't know him. I wouldn't know who those people are."

So, he's been there watching those films at the Co-Op, at my place, but I did not know that that was Warhol, as I did not know many other people. So, then, I think, I met him probably at her place, and, then, I recognized him. Yes, I have seen him there. It was Warhol.

And sometime in '63, late '63. And, then, of course, he used to come to the Gramercy Arts [Theatre] on 62nd [Street], it is. And in '63, actually, he was already projecting, bringing, his films to Gramercy Arts Theatre; Co-Operative was running [it] at that time. I did the programming and the projecting most of the time.

And he brought in his early *Kiss*—reels of *Kiss* films. Those little one reelers: that's two minutes, 45 [seconds]—that's 100 feet. "One hundred f[oo]ters." And the first ones that he brought in, and, I think, the very first one was two or three *Kisses,* and, then, in each time, like each week, he brought one before the show.

And, then, there was *Jack Smith Shooting "Normal Love,"* which was later lost; it was seized by the police. That was at the St. Mark's [Theatre]. And these are the very first ones. And, then, Jill Johnson roller-skating or skating, or something like that, and with friends fooling around. And these were the very first ones. Then, there was *Sleep.*

PS: How did you happen to participate in the filming of *Empire,* when you were standing there with Henry Geldzahler and Andy and Gerard Malanga?

JM: Andy's first one-reelers, 100 footers, were [filmed] up in his studio and assisted, I think, for most of the time by Gerard Malanga and his friend, a still photographer, Billy Linich. And, then, that's how he made *Sleep* and *Tarzan Regained, [Sort Of].* Those were silent, and a few more silent films. Then in the early Spring of '64, I filmed *The Brig. The Brig* with, what's known as, "a single system camera"— Auricon camera, Auricon single-system camera, which is a camera used by newsreel men, where you can film a scene with sound on film simultaneously, magnetic or optical (and there's nobody running around with tape recorders on the side, separately). It's [the] same time you get it [the soundtrack] on film. It's called "single system." So, I filmed *The Brig* that way because it was the cheapest possible means. It cost me, like, 600 or so to film *The Brig.*

So, then, I projected it two or three days later—I developed and projected the original print with sound-on-film for the Living Theatre people, and I told Andy, and he came, and he saw it, too, and he was very impressed with the possibilities of sound and how cheap, how simple, that was. After that, he went immediately into sound, also with the Aurecon and the sound period.

But before that, he decided to shoot *Empire,* which was mostly John Palmer's idea. And since it needed long takes—it's a long film—he asked me what he should use, and I said, "Why don't you use—you know—we can use Auricon. That's the cheapest. I already had rented [one]. We can, you know, just take it." And he was interested because he wanted to get used to it because he wanted, he said, he wanted to go and use it to shoot sound films with it. You know: in the way of *The Brig.*

And since I knew how to operate it, I became the camera man for it. That's about the only thing. So, I got a camera and set it up, and, then, I said, "Where should I point it?" "Just point it there. You know." So, he came and looked at it. And, then, we ran [the camera] all night. We sat, and I don't know, what for. . . . It was Henry's office, the Rockefeller Foundation. On the fortieth floor in the Time-Life Building. And that's how that was.

PS: Did you actively participate in any subsequent Andy Warhol movies?

JM: Practically, no. I had been present watching some, you know, during the filming in Andy's studio. There were always some people present. You know, he didn't mind that. But I hadn't made any contribution or participated in any way. At least, I think so. [Mekas discusses his concept of "The Baudelairian Cinema," in reference to other filmmakers.]

PS: In conjunction with something like that—of something forbidden— writers have attributed a kind of voyeuristic quality to Andy . . .

JM: Yeah, but they say that about filmmaking and every art is voyeur[istic], that the filmmaker is a voyeur. I say, you can push that very far, but I don't think you should make a big thing out of it. I think that it's part of the imitation aspect, the imitation. . . . There's a lot of imitation in art, you see. Imitation aspect. And that: how do you imitate but by looking, staring, observing. Observation. Observation has a degree of . . . has a degree of voyeurism. Observation. Where, I guess, maybe, you could say that it has a . . . You see, I know that Stephen Koch pushed very far in that direction in his book [*Stargazer: Andy Warhol's World and His Films* (New York, 1973)]. That's his background, his interests. So, he made a big thing out of it, but, I think, he over-pushed that aspect of his films.

PS: What aspects would you emphasize in Andy's works?

JM: I don't know what I would emphasize, but I wouldn't . . . It's like this: by over-pushing the voyeurism in Warhol, you make it as if he is . . . that no other artist is concerned with it or that other art can be produced without it. I consider that it's part of every artist, filmmaker, painter is a voyeur in that aspect. It's not a negative quality, but as a working method is a part of every artist. So, that, of course, one could say that Andy maybe was . . . because he placed the camera . . . I mean, he's really less because he's not even looking through it [the viewfinder]. As the camera runs, he walks away and let's the camera be the voyeur. So, one could make a completely different point: that he is just more conscious of it than any other filmmaker—of the voyeurism, of the voyeur. Others do it unconsciously. They are caught by it, and the voyeurism manipulates them. He manipulated it. He let it be. This is the camera looking at this, picking, and he goes out . . . for coffee, or he goes to the other end of the studio and does other things. So, it's not that simple to call him "*the* voyeur." He used it, as he used everything else: objects, people. I mean, he, again, used not in a bad way, not in a negative [way] as misusing them. Just given them a chance to reveal themselves, to busy themselves with that and that and have some record of that and that and that.

The Warhol phenomenon is still very complex because it's so filled with contradictions. It's so easy to dog [put] on him that and that, but, then, immediately, you see that you have to go to the other extreme, too. It's not that simple, like many artists [and] filmmakers get involved with . . . with a large body of work. They get involved with it in a great passion, and they're almost oblivious to the world around them. They're just with that work. He's not that kind. He always maintains a distance to what he is doing, and, therefore, it's like playing a game—that distance, that conscious, is what complicates the matters. . . . He is a voyeur by conscious choice. So, there's a distance, and [it's] manipulated. . . . I still find it very complex.

PS: Would you care to talk about any of the complexities that you find in Andy for yourself in retrospect?

JM: This constant activity of . . . to keep himself busy. Now, of course, that is an obsession, but, then, maybe, at some point you don't know—and that's where the mystery is. . . . He's very conscious, and he plans to do it that way. He's with everyday . . . with the Studio 54 crowd, the Studio crowd, and all that. It's again: what is it? What is it? And what . . . one cannot say as, I think, the *Village Voice* would say, he does it for greediness. It's not that. It's not that at all. There is a big mystery for me about how conscious he is, of some of his activities and the things that he does and what he does unconsciously, and not that it matters.

PS: Did you ever discuss Andy's intentions with him in making movies or, even, in his other works or activities?

JM: I have never discussed in any, any length because he won't, but I remember a couple of times asking some very simple questions and receiving either, you know, shrugs or very simple answers, which I . . . I . . . I, of course . . . they just stayed like that and leaving only a genuine impression that it was useless to . . . to . . . to ask for reasons, motivations. And . . . Even though I would ask him in that very direct way, but anything that would lead in that direction ended right there, and I faced a blank . . . Or, you had to say something and, then, lead him into something. He would say, "Yes. Yes. Oh, yes. Yes." He wouldn't deny it.

PS: Do you think that that is Andy's paradox?

JM: And there is a "Yes. Yes," and never a "No."

PS: One of the things that I find intriguing about Andy Warhol is that the critic or the historian comes into this vacuum that there is with him

and that, if someone has a particular fixed-idea about him, Andy will let the critic or historian use that fixed-idea as a forum for the historian himself. And like . . .

JM: He won't deny because in a way . . . in a very different way, Stan Brakage when he interprets other filmmakers—a very different person, Stan Brakage, than Warhol—when he interprets—he has a lecture series published on filmmakers like Dreyer, Eisenstein—and he speaks . . . he recreates their biographies, their childhood . . . —and there was one part about me, and, then, when I read my own [biography], I realized that it's all fantasy, you know. And you have: how could you write that? I mean, "After the War, Jonas Mekas found himself in Paris, where . . . " And I never went to Paris! I went from Germany from the Camps, right here. Then, when you tell him things like this, he says, "It could be . . . " "I could be . . . " This is imaginary. You can extend. I mean, you could be . . . It could be, even . . . When Brakage deals very factually, he then goes into fantasy, and it could be that that one could be there, too. He fantasizes around it. So, of course, Andy Warhol is 10 times more open, and he would never deny it. "You mean, I could be like that?" Or: "That could mean that?" "Yes, of course. Ah. Yes. That could be." He leaves it open for you to go into that and make it up, whatever. He would never deny it.

And Brakage would even defend if somebody plants any wrong, and he could always defend and invent reasons why it could be. If that is not there. Yeah, but that could be there and that, that, that could be like that. So, Andy makes for . . . that's part of his art: to allow all those int[erpretations]. He wouldn't deny any interpretation. Ever. If some other artist or nonartist would jump at any such, if anything is wrong—they would analyze it immediately and would deny it. He will leave it. Whatever you say. So.

PS: *Film Culture* gave Andy one of the Independent Filmmakers' Awards. In retrospect, why did Andy receive it?

JM: He received an award in December '64, after *Sleep*. Why was the award given to him? Because already in '64, he had a body of work— you know—the silent [films] actually, in the early silent period. And it was . . . The work was to us very impressive. The direction to which the freshness—the originality—of the direction, which he was leading cinema—when you look at the whole history of cinema and independent film in particular of that period, you find that there is a "distress," as we termed it at that point: a return to the basics of cinema. It was very important because it had covered a lot of ground

already—hand-held cameras and painting on film—and he stopped everything dead, like beginning from scratch and forcing us to reevaluate, to see, to look at everything from the beginning. And that was, we felt, a very important contribution at that stage, which, of course, in practical terms, what he was using the long take, static camera (as I was speaking of that). That's number one, of course.

Well, using all the techniques, that were, some of them, were of [the] camera that was used unconsciously. He brought them to the open like the zoom. Okay, the zoom was used for various purposes, but he used zoom just as a zoom. Here is a zoom. Look at it. And so.

Not that—the Independent Film Awards of *Film Culture*—in other words, I am *not* necessarily . . . That work [which one] saw, but the tone changed cinema radically. You know, in that given year— within that period of cinema—here is somebody who is doing original work that is . . . inspired us, that is making us think about cinema and is making cinema more developed, which is sometimes . . . There are periods when nothing is happening. So, here, we, of course, have to point that out. And it is important. So, we were pointing.

PS: In the idea of Andy Warhol being a point in the cinema . . .

JM: More to the point, that many people did not take it seriously. They thought it was just fooling around, and we placed it in the perspective of the whole of cinema—saying that it *is* important, that it's not just playing around. [Mekas discusses Warhol's possible influences on subsequent filmmaking, including works by Michael Snow, British "Structuralists," Jacques Rivette, among others. He also suggests possible influences on Warhol, such as Jack Smith's *Flaming Creatures,* as well as unspecified films by Ron Rice and George Landos. Mekas cannot but suggest what exactly may have triggered his films.] I think, it was connected with what he was doing with the Pop . . . what he was doing in his paintings, and it was the stare. From cinema of that period, what you saw—there was very little of that. He could only . . . Influence could just be as opposition, as a reaction, which is very possible. By looking at filmmakers moving their cameras so much, and he just went and did exactly the opposite, as a reaction. . . . [Mekas looks through his filmography of Warhol.] I *reviewed,* I *looked at everything* that was. Everything at the Factory at that time. I looked at *everything:* I went there mostly on weekends when nobody was there or sometimes evenings. For hours and hours, I looked through everything, but that record—a lot is based on what I saw before and what I still saw there and made notes. Not all notes are on here. I have longer notes of some of them. . . . I was the last privileged person to see some of that work, *and it was impressive!* It

breaks *my heart:* some of the things that have disappeared. I really think that they are gone, like *The Imitation of Christ* (I think, one of the great works, and I doubt that it exists). They're in reels. I think, I have in my notes reel-by-reel notes, and there were 16 reels. There was once a screening at the Elgin Theatre. That's it. In 1970. That was a part of the Independent Film Festival that I organized.

PS: Did you ever subsequently revise your filmography?

JM: No, I have not. I mean, there was no time to double check. It's not that easy to make arrangements, and I would need this [Mekas stretches out his hands.] amount of time. . . . All filmographies are based on my filmography, even if they don't mention . . . because nobody else had access to them. Every filmography since then is based on mine.

PS: Now, Stephen Koch was also at the Factory.

JM: His is based on mine, also. . . . He didn't see much—as much as he should have or wanted. Already it was in progressed disorganization. It was just impossible for him. You see, I went there, and I ran the projector, and I was there alone. Nobody else was there. I locked the door, and I'm there all weekend sometimes, but he would not do that. He had to take what he could, when I could, just go one afternoon to Warhol's.

PS: What do you have here [Anthology Films Archive] today by Warhol?

JM: Not much. Not much. It's like this: we have legally with contract, we have *Chelsea Girls* and *Eat.* Until we check and find out and see if it—we decided not to screen it anymore: to keep it, to treat it as only as preservation. We may have the only print of it. . . .
Andy's background is different from most. Andy also worked as a commercial artist. In other words, he always wanted to *sell* his work, but [Paul] Morrissey always wanted to be in Hollywood and wanted a mass audience. So, when he had a chance to move into larger theatres, more commercial space, he took it and gravitated to it, and, then, you had to deal with a commercial [distributor]. . . . And they began approaching Warhol and Morrissey. At that time that this came up, they say, "Yes. We don't like your more-or-less earlier . . . finally, you made it. You graduated to what you should be doing." And they—it has been, you know, stated to me, really—that they preferred that Andy would keep his early work out of the market because they cannot raise money for Paul, Andy, for these new films. If the backers will see the early work, which is not commercial, . . . and they did not take it seriously. So, the only thing to do was to take it

out of distribution. So, that's what they did. They really wanted to give the *image* that they *are* capable to make commercially viable films, and that image could only be kept by keeping *non*-commercial films out of the public's eyes. . . . So, that kind of image—that he is a gallery-film-museum-filmmaker and society-filmmaker—that's out. So, that is why those films were taken out, and they're still out. . . . When he moved to Union Square, they were totally disorganized: films lay there right in the closets [and] on the floor. People were taking them. . . . *Finally*, maybe three years ago, they decided to move everything to storage out of town and [to] store them, which [is where] they are now, and it's not clear what was saved.

Ondine (Robert Olivio), New York, 16 December 1978

Ondine was one of Andy Warhol's most active "Superstars," and he was featured in *Vinyl* (1965), *Chelsea Girls* (1966) and *The Loves of Ondine* (1967), as well as in Warhol's *a, a novel* (1968).

PS: Well, the first question that I usually ask everyone is: When did you first meet Andy Warhol? But, could you tell me a little bit about what you did before you met Andy, leading up to it and when you became involved with him?

O: I was involved in the avant-garde movement as far as the '60s went because . . . as far as . . . I guess, the late '50s and the '60s. I began getting very painful feelings about my role in the world, and I had to deal with people who were simply, you know, very, very together. And that meant that I had to deal with people who were not just friends but also with people who were trying to say something. So, I was involved with the avant-garde. You know: with Freddie Herko, Nick Cernovitch, LeMonte Young, Ray Johnson, and whatever. And the whole "schmegetty"—I was involved with those people—either a love relationship with these people or involved in a kind of certain personal-social kind of relationship. My relation with Ray Johnson was very strange, and so was my relationship with almost everybody else, and I had no way of knowing, ah, of what I was dealing with in any way sh-shape-shape or form, would become the hallmark of the '60s or whatever. I mean, I wasn't dealing with what I considered "friend," and they were *always* very, very much on point. You know? What they had to say was always very together, and what I had to say was very well felt, and, so, it was one of these rela . . . —one of these things where I was just dealing with people. You know? But my friends or my acquaintances—I don't know how to put them in a way: they weren't actually friends. Ah.

Whatever my *work* meant was that the things that I was involved
with at the time was very personal with these people. You know? And
that meant: Johnson and all of those other people. You know: Herko,
whatever. And these would be the people that I grew up
with . . . these were the p-people that I know. And I (you know)
didn't go to school with them, or, I didn't have anything to do-do with
them in other ways. But that we . . . shared a common, at that point:
we shared a common, ah, heritage. You know: we had come from and
had been with and lived through and dealt with and were a part of this
scene.

At that point, it b-began to be developed by Andy Warhol. But
not because he was a part of the scene, but simply because he . . . un-
derstood it. I think, more than anybody else did, and he could put a
focus on it like nobody else could of. You know: instead of just laying
for years in . . . blackness, he threw a torch upon it. You know? And
that's, that's not the reason why I bothered with it. It was just that he
was the next person I was involved with.

PS: When did you first meet him?

O: Some . . . '61 or '62. I'm not quite sure. It's one of those years that
he was . . . I really didn't even "meet" him, as a matter of fact. I had
a . . . I was at an orgy, and he was, ah, this great presence in the back
of the room. And this orgy was run by a friend of mine, and, so, I said
to this person, "Would you please mind throwing that thing out of
here?" And that thing was thrown out of there, and when he came up
to me the next time, he said to me, "Nobody has ever thrown me out
of a party." He said, "You know? Don't you know who I am?" And
I said, "Well, I don't give a good flying fuck who you are. You just
weren't there. You weren't involved. And I just didn't want to see
anybody other . . ." The th-thing that pre-preceded . . . you see: my,
my life is not involved with these artistic movement[s]. I'm not
bothered by it. You know? I mean, the fact that I had skated down to
that party, practically on my . . . the soles of my shoes without having
shoes. And the fact that my pants would drop at, at the . . . (you
know) at, at the bat of an eyelash meant *more to me* than the f-fact that
anyone was there. I just wanted to have a good time, or, that I wanted
to be involved in some kind of orgy. Th-this was the one thing that
I didn't understand in the back of the room: it was Andy.

And he . . . and from that point on, we became, ah, *really good
friends.* You know? I mean, absolutely good friends. And he under-
stood that I understood that he understood . . . that one of these things
where (you know?), like, I mean, it was a real *quiet ploy.* You know?
We . . . we *all* understood what was going on. You know? But no-

body could talk about it. I mean, you . . . people don't talk to Andy, and they should.

PS: In what way?

O: They don't *say* things to him. They don't (you know) ask him how is he? . . . blah-blah-blah [sighs] . . . I mean, they *ask* him that, but they don't need . . . they don't want to hear what he says! They don't *listen* to him! You know? What he s-sa-says sho-should, should be li-li-list-listened, listened to! If he's in the back of a *room*, if you don't like his presence, you throw him out! If he's in the back of a room and you like his presence, you ask him to join. It's one of those things. You know?

You have to really deal with him as a human being, and very many people don't! In fact, they don't even, even think of him as a human being! I mean, I think that most of the people who have appeared in the films [by Warhol] or appeared in his films don't even consider him a part of the human race! They don't even *care* about him!

PS: Some people have described him like that.

O: B-but that's not true! That just is not true. He's a very feeling, a very caring, a very *human* person. I, I think he'll be the first to, to, to admit that. He's *totally* his own person, but you have to *deal* with him on that level. You can't really deal with him as you would with, say, a symbol.

E-everybody th-thinks of him as a symbol. He's not a symbol *at all!* He's just *that man!* He's just Andy Warhol. You know? The proof of the pudding is wh-when he was shot [in 1968]. You know? And, ah, *it was just a collapse of the entire scene!* The entire scene collapsed.

I mean, it wasn't just a question of him being shot. You know? And, ah, it was *just a collapse!* I mean, it was the fact that that kind of thing was going on. It was just *intolerable!* I mean, when I went to see him at the hospital, and he-he was beyond . . . he, ah, he couldn't even (you know) he, he couldn't even respond. He was in inten-intensive care. I couldn't even get, get to see him. I saw him three or four weeks later in his house — in his apartment — in his house on the . . . 92nd, 92nd, 92nd Street. And he was somebody that you could really say, "Well, I'll give my life for this person. If he is *touched,* ah, I'll die." You know?

He was *just* . . . you could *cling* to him in a way that you couldn't cl-cling to anybody else. He's the best. I mean, wh-what can I say?

PS: Some people have described Andy as "shy." Some people have described him as "self-contained." How do you react to something like that?

O: He's both. He's also brazen. I mean, the most brazen person I've ever met in my life was Andy Warhol.

PS: In what way?

O: Well, one evening we were out in East Hampton to do a film called *East Hampton.* (I think that was the name of the film.) It finally became a film called *The Loves of Ondine,* which fortunately [. . .]. It's a fabulous movie! I mean, it's absolutely fabulous! And he was being . . . I don't care what they say about Andy Warhol! And he was being the guest of [. . .] or someone like that, or, whatever they're called. I'm not sure. And it was this *incredible* house right, right on the dunes in East Hampton. It was an enormous red-maroon . . . and it was just centered. It was Scorpio, I think, at one time. And we, and we were, we were just sitting . . . had all come over from the house that we were living in. We were—oh!—we were inhabiting for that weekend. And we came to visit [. . .]. He sat there in a full face of make-up. He had eyebrows and eyelashes out to here. He had . . . I would say, he had, maybe, two moles—one big mole over here . . . and one mole over here. But his eyes were made-up: eyebrows, eyelashes, eye make-up . . . *completely.* The people in that house came after him. [Imitating] "Oh, Mr. Warhol, oh! . . . " He never said a word! He had a guitar at his feet. Somebody strumming a guitar. And he smiled at the women. And that's all he did. He did nothing else. I mean, nothing else. They came . . . they [. . .] *paraded* the guest list in front, in front of him. He simply . . . [whispering] he never said a word. I remember myself. I was commenting on . . . I had some kind of monkey fur. I said to him [gasping], "Oh, Mary! You are out of this . . . " I said to him, "I do not believe you! This is . . . I mean, you . . . Talk about an outrageous queen! You are the worst!" I mean, he didn't even condone their existence. So, what can I say? I mean, that's what I would say is one of the great social comments of all time. He simply didn't take notice of their being around. Although it was a party, it f-fail-fail-failed. He couldn't care less. He . . . It was astonishing. I mean, I have seen people do that but never quite like that. He did it with s-such style. I mean, I have to admit . . . [laughing] . . . it was the best style of it that I've ever seen in my life.

PS: Now, this is just a filmography, and it says, *"The Loves of Ondine.*

Ondine, Viva, Joe Dallesandro, Angelina Davis, Ivy Nicholson, Brigid Polk. Filmed August-October 1967." What about the movie . . . what should I know about it besides seeing it?

O: I think, as of all of Warhol's films, that you should s-simply see it.

PS: Okay.

O: I think, that's the most . . . I think, that's im-imperative about Warhol is seeing whatever sense that he is involved. You know? Whatever kind of sensuality that comes up. What can you say? *Complete sensualism.* Whatever he is involved in, you . . . *that's* what you do— you deal . . . if you're thinking about Warhol, you think about that. You don't think about anything else.

PS: Sensuality.

O: Well, whatever it is. If it's . . . if it's . . . if it's a film, you view it. What . . . what . . . whatever it is—he does—if he puts his mind to poetry, you would have to do whatever the poets do. Hear it at the same time. I mean, he has got that quality about what he does. The simplicity in what he does is that whatever it is he deals with, he deals with it in its frontal level. He deals with the visual as the visual. He simply doesn't . . . you know? So—ah—for my saying that you should see the film and (you know) and pre-p-p-empting you saying that you should see this on that part of . . . no way: *see* the film, and that's it. That's the *only* way to experience a Warhol film . . .

PS: Okay.

O: . . . is to simply see it. Whatever you want to intellectualize about it is your own problem. That's not . . . that's not . . . that's not . . . I mean, that doesn't have anything to do with the case. The case is the way you feel, and I'm *sure* that is *a lot* better than if somebody says— y-you *must* look at this . . . You *must* see that. You *must* see this. That has nothing to do with the reality. The reality is the visualization of it, if it is a film. You know? I don't know what else to say. His things are *very, very* simple.

PS: Yes.

O: They're *very* basic.

PS: How about the novel *a*, which is supposed to be a life . . . a day in the life of you, which I understand . . .

O: Yes.

PS: . . . is, more or less, tape-recorded over several days.

O: . . . It was. We tried to do 24 hours at one stop, and it became . . . It was just too much. I mean, Andy followed me into the toilet room when I was taking a shit. It was just impossible. It was literally impossible. It was literally like crawling up the walls. Have you ever had anyone do that to you? It's just . . .

PS: Why did he pick you instead of someone else?

O: I . . . I was simply the most interesting person that he had ever met in his life at that point, and he was quite right. I had *everything* going for me at that point. You know? I mean, I'm not at loose ends. You know? Even at this point—whatever it is—I know what's happening, and I . . . and I got the best of it. You know? I mean, as far as my world goes, it's not crummy. All right. Fine. He *knew* that. He understood that. The people who were generating out of my . . . aura . . . he got. So, this was going to make a great book. He was quite right. It is a fabulous book!

PS: I've read it.

O: It's a fabulous book, isn't it? I mean, it's a *totally* fabulous book, but . . . but how can you say that to anybody? I mean, *who's going to say that's a good book?* [Laughing] Unless you've read it and experienced it. It's just a . . . it's just another story.

PS: How did Andy get the name "Drella?"

O: That I never knew. I never understood "Drella" except I . . . I thought that was one of Debbie Cane's cats.

PS: Who's Debbie Cane?

O: Debbie Cane is Herbert Cane's daughter.

PS: And who's Herbert Cane?

O: He writes a gossip column for the *San Francisco Chronicle.*

PS: Okay.

O: And one of his c-ca-cats is called "Drella." And Debbie, who is a kind of m-minor figure in a *way,* as far as the history books go. In other words, she's quite important. She had a cat named "Drella." And "Drella" became "Drella-Drella-Drella." So, it was one of these things. And, then, the book became the fact you'd say, "Andy"— "Andrulla" or "Drella" or whatever. You know? You know that book is a group of alliterations. So, I guess, it became "Drella." I have no

way of knowing. I knew him as "Andy." You know. *I never called him "Drella." Ever.* Except, maybe, once or twice, you know, but that's not the way I knew him, who was . . .

PS: Could you tell me things—I'm not asking for gossip . . .

O: All right.

PS: . . . but your observations . . . the flavor of the times that I wouldn't find in books, or, you know what I mean. Like . . .

O: You really want . . . You really want to get the picture of it without dealing with the glamorous or whatever it was. Well, it was very— this is going to be very hard to ge-get into. You see, you deal with Jackie Curtis, Holly Woodlawn, Joe Dallesandro, Viva, Ultra Violet—all those people are after the fact. They simply weren't the kernel of the number. Ultra Violet: maybe, in a way, slid over . . . but Viva, Jackie Curtis, Holly Woodlawn, all those people came after the fact. The fame to us was important. To the people like Ivy Nicholson, Tiger Morse, ah, not even Tiger as much as . . . Brigid Polk [a.k.a. Berlin] is another story. She's always involved with her. [. . .] That's gossip. *But* Viva, J-Joe Dallesandro, Holly Woodlawn, Jackie Curtis, all these people are involved in the *second half* of the Warhol legend, and the first half of the Warhol legend is the point that makes the difference.

PS: Okay.

O: And that's the point where it's a question of *ideas.* Where Warhol was dealing with equals. He wasn't dealing with people. He wasn't dealing with people who were going to say, who were saying, "Well, I'll be like this . . . ," or, "I'll be like that . . . " He was dealing with people who were being themselves. And, so, quite frankly, *he* (whoever he was) got a play off from the other people. And this was . . . And the people who he was involved with were repercussions from the middle-fifties. They were all avant-garde. The whole number! The [Nick] Cernovitches, the [Dorothy] Podburs, the [Fred] Herkos, this and that . . . all these people. They had, literally, nowhere to go. You know? They got . . .

Warhol constructed a stage, where these people could *mirror* themselves off of him, and they did. And I'm . . . Fortunately, I was one of those people. "Unfortunately," some people might say at that point. I can't create that again. You know? Once is enough, as far as I am concerned. You don't . . . you don't get that kind of cooperation or that kind of, ah, dealing with another human being the way you did

with Warhol. It . . . For . . . Whatever Gerard Malanga was worth . . . you know? . . . he was worth *zilch*. I mean, I *hate* Gerard Malanga. He's a thorn in my flesh, but no matter what he is, you can*not deny the fact that* Gerard Malanga was there and was a part of the wall that Warhol bounced off of. The rest of them (including Viva)— they're all bouncing off an idea. They're all bouncing off an image that has been created before them. And this goes for Holly Woodlawn, Jackie Curtis, the whole group of them. They're all bouncing off this image. There was no . . . there was no contest at that point that th-th-the way had been laid. The ground had been p-paved. It was over. *We* had forged th-the way.

PS: Let's go back to the groundwork. Now, the people, who you think . . . could we go over them individually?

O: Well, I could go over Freddy Herko, who was possibly the greatest dancer. He was the Mikhail Baryshnikov of our set. He was the world's greatest dancer. Period. At that point, there was no [Rudolph] Nureyev. Nothing. This was the *total star* dealing with space and time and dealing with his audience and dealing with everything *in that little thing* called "the avant-garde." *Nowhere* to go but that simple stage that Yvonne Rainer and all those people had prepared for him. All right. But that was nowhere to go for—Freddy Her-Herko. Herko was involved in bigger things. He wanted to be *seen*. Fred Herko wanted to fly, and, in fact, he did. That's how he m-met his death. He flew. He didn't touch the ground.

PS: Something about a car . . .

O: He died. He died in flight. Yeah. And he brought, you know, this is a *terrible* commitment when you make that kind of commitment. I mean, a lot of peo-p-p-p-people think he was an asshole. He *wasn't* an asshole. He prepared himself for that moment, and Warhol was there! Warhol was able to get from Herko, and Herko was able to get from Warhol a sense of completion so that Herko could have actually died as he wanted to do all of his life. You know? . . . as we all are going to do whatever that involves. It doesn't matter.

But the thing was that Warhol had made these . . . you know? He wasn't featuring people doing things. He was allowing people to mirror himself in a way. I mean, they constantly say that Warhol is not involved with any of his . . . there is not one Warhol film that I have ever seen—even the ones that went beyond the camera—that were not perfect Warhol films. Everything that he did had a perfect Warholian flavor, whether it was *Sleep, Blow-Job*, . . . whatever it was.

They were *totally* and *completely* and *unutterably Warhol*. So, these people who were, you know, s-saying that they were bouncing off Warhol: Warhol was also bouncing off them. And it's . . . And it's . . . And it's a to-totality. I don't know how else to say it. It was a g-great sense of completion. Working with Andy Warhol was, I would say, . . . that the greatest sense of completion. Working with Andy Warhol was, I would say, . . . that the greatest sense of completion for . . . I have *never* been able in my life to . . . take my movements and my gestures and my ideas and whatever, I thought, and will-willow them . . . willow them down to 20 minutes and have everything I wanted to say and do, *totally reflected* in a piece of film. Warhol was the *only* person that gave me that cred[it] . . .

PS: Forum?

O: Forum. That stature. I mean, he allowed me to create myself, and I allowed him to create himself. It's the same kind of thing. After that's over, after *The Chelsea Girls*, I *believe*, what happen[ed] was that people started confronting.

 The Loves of Ondine is a perfect example, example of that: *everybody literally stuffed to death*. They're all sated. They had—somewhat had, you see—the dialogue go on and on and on and on. The business goes on and on, and it's not because it's a bad movie? It's just that it's too much of a good thing. You know? It doesn't work any more. You know?

PS: Which is the movie that is the 20 minute segment?

O: That's part of *The Chelsea Girls*.

PS: Okay. Now, let's go back to . . .

O: And in *that* film, not only in my segment—the culmination of my career at that point. But, quite honestly, he got from everybody involved in that film—*everything* that they could do. There are people running around *wasted* on the street now because they did it in that film. They *should be*, but they're probably dead. [Laughing] There's no way out of that film. That film is a living torture test. Yeah, you wanted to go back to something?

PS: Go back to the other people who you said were the foundation of the legend. You mentioned the dancer.

O: Well, I'm only talking about the legend as far as the theatrical things to.

PS: Okay.

O: I'm not talking about the art things.

PS: Fine. Whatever you want.

O: Yeah. The theatrical legends would be built on people like Yvonne Rainer, Bobby Schwartz, Nick Cernovitch, ah, LeMonte Young (who coached the Velvets; my second husband) and stuff like that—would assume that . . . those are the people that the legend was built, was built, on. Billy Linich (being Nick Cernovitch's ex-lover). Blah-blah-blah. It's like a soap opera. [PS laughs] It *really* is. I mean, but . . . God, you know? Totally involved. And Ray Johnson. I mean, he's had a parental kind of character, in a way.

But other people, like Gerard Malanga, Willard Maas (of course), the great and incredible Marie Menken (whether if anybody knows it or not left a stamp on everything that she . . . she did, like—complete, and she influenced Warhol greatly. She was . . . a part of the reason why she died as miserably as she did was because Warhol offended her. He didn't know he was, but he did.) But that whole *milieu* . . . Edward Albee . . . the whole number. They all came out of that. They all came out of that particular thing. They all came out of that Black Mountain [College] baby group. You know? I mean, that whole . . . I mean, I don't know how to say this, but . . . funk.

PS: The Robert Rauschenberg . . .

O: It's just a bit of funk. You know? You know? [Ray] Johnson and whatever. They're . . . it's that thing occurs and, I don't think, it occurs very often, but when it does, maybe every 10 years, it's . . . it's a little cluster of artists who get together and do this thing, and, I mean, *it was very exciting.* It was very, very . . . no one wondered about anything. We all knew what was going to happen. It was all freedom. You know? Terrific freedom. What can you do from that point on? You're strong but not strong. I don't know how to say it.

PS: Did you have anything to do with the Pop Art?

O: I had nothing to do wit-with them. I d-didn't like them. They were a tedious bore, and you couldn't step anywhere at the Factory! . . . I was involved with a group, and Billy Linich, I would say, was the spokesman f-f-for that group, where we were *totally* involved with amphetamine. Totally involved with papering the walls. We used silver foil. We were doing floral prints all over the wall, I think.

It was, you know, the expression of the '60s—was starting to come out, and, ah, when we moved up to the Factory [on 47th Street] it was simply a question of relocating ourselves from Downtown on

the Lower East Side *up* to 47th Street. And it had nothing to do with being pol-politically involved. I mean, I remember 16 hours of Bob Dylan sitting there, trying to get photo-photo-photographed, and Gerard Malanga kept putting his music on, and we kept taking it off and putting Maria Callas on. It had *nothing* to do with any kind of reality. It was just simply . . . I mean, there was no pol[itics] . . . There was no politics involved, as far as I was concerned to anything.

As far as any of the p-people on my level were concerned with it, ah, there was no politics involved *at all*. It was simply: what we wanted was *done*. Th-That's the way it happened. It has nothing to do with politics. No one had to vie for space, as far as I was concerned. When I walked in, it was done. Period. You know? And that's the way it had to be. I don't know *why*, but it was s-simply that I had, I think, . . . I had more to say, and that I wasn't really involved with the politics of it all. You know? But that's . . . *Never* have I been in my life have I been involved with pol-political struggle with Warhol. As far as vying for his attention on his time—no way.

When he was finished with me, I was finished with him. It was as simple as that. I have *never ever*—and I wouldn't because I would *assume* . . . you know? . . . knowing the man and his stature even before what I knew what his stature was. I *would never ever*. I wouldn't want to be involved with anybody who didn't want to be involved with me at that level. Period. You know? I mean, they— Gerard . . . the Gerard Malangas and whatever—they can . . . can beat their heads against the walls and that. They deserve the wall. But I *cannot deal with that*. I mean, I just never did, and I never will. I simply *can't* do that because . . . you know? I . . . Either I have to be *totally* there and feel that kind of freedom, or, else I'm not going to be there at all. And with Warhol, you could do . . . do that. I mean, you could do that and simply be that kind of person. You know?

And I wasn't, really. You see, I wasn't involved with Warhol. I simply . . . as far as it went . . . it was '68 when I told you before, when we got involved. I mean, when I realized the importance of my self on the screen. Until I saw that—*Chelsea Girls*—I had no way of knowing it had such *impact*. I couldn't really care less. Frankly, I didn't even . . . I didn't ah, . . . It was *nothing*. I have *no way* of telling you that it was *nothing* to me. I mean, *nothing* to me. I think that's one of the reasons why he appreciated me as much as he did because it didn't m-mean anything to me. It was simply *nothing*. You know? It just didn't have any effect. You know? I *couldn't care less*. You know?

PS: What were you doing when you were outside . . . ?

O: Absolutely nothing. Totally nothing. I had been doing nothing, and I was doing nothing forever. I simply didn't think I had to do anything, and I just feel that it just wasn't necessary, and I was simply right. At that point, it wasn't necessary to do a fucking thing. It just wasn't. You know?

PS: So, you'd go off to Queens, and, then, . . . ?

O: I'd do whatever I wanted. di-ne-didn't visit Queens. I didn't visit Queens for years. You know? It was just one of those . . . You know? I'd go wherever I wanted to go. I just had no . . . I had no . . . a lot of people criticized me for having no center, no location. Fine. I mean, at that point, I didn't need any. At this point . . . at this point, it's a very rough come down. At this point, I *need* a location very badly. I feel . . . You know? There's not that kind of support any more. He's just not there, which means: you just can't *be*. You know? You simply can't . . . You know? You know? . . . expand . . . you know? . . . because there's nothing there. You know? Warhol was something you could touch down on. You could *become*. You could *come* there. Even though, you know, it was a humiliating and horrible experience being involved with him in any k-kind of simple way.

PS: Why?

O: It . . . It just never worked out. It *never* did. It *never* worked out. I mean, either it was wrong (the whole point was wrong) or . . . I mean, it only works out in reflection when you think about it or works out. It didn't work out in reality in any way, sh-shape or form. It was . . . I mean, everyone was always complaining about him. "It was terrible." "He never paid anybody." "He never did this." "He never did that." Blah-blah-blah. Blah-blah-blah. It went on and on. So, you see, it was one *constant* set of frustrations. *Constantly,* I asked for money. Constantly, people asked him for money. He *NEVER* paid anyone! He *NEVER* did anything to anybody! I mean, only when he was asked to pay—when they put the *screws* to him— did he really pay! You know? It was just a series of frustrations. *Totally* involved with him was a series of frustrations and great, great plateaus. And I figured, "What the fuck?" You know? "Th-This is not going to happen again." You know? No way. This, this one, this guy—whatever it is—it wasn't even the question of being *him*. I didn't even know what it was. It was just *all* . . . all "flying around" there. It was really . . . You didn't even have to touch down at that point, but you had to in a way. I don't know how to explain it. It's a . . .

PS: Perhaps, . . . ?

O: I didn't know how to deal with it.

PS: Perhaps, you could explain by a particular incident. Or not?

O: Wish I could. There are so many incidents that were . . . Well, I *know* that I had a job as Edie Sedgwick's French maid at one point, and I *know* that my job as Edie Sedgwick's French maid was *simply* because Edie Sedgwick and I love each other so much, but that wasn't the point. The point was that Warhol was behind it in a way, supported the idea of being her French maid. He *knew* that I—somebody—had to wake her in the morning because she couldn't get awake because she was in such barbiturate trips. You know? And that *I* was the only one that could use the [front door] bell that way: BIZZ! BIZZ! BIZZ! BIZZ! And that she would eventually get up. You know? And I *never* quite knew who paid for my being the French maid although I didn't get any money for it. You know? It was a question of being supported in ways, like I was . . . You know?

PS: For meals or something like that?

O: Well, it was more than meals. It was obvious that whatever I wanted, I would get. You know? It was never a *question* of what I wanted. It was *drugs* or whatever. It was *always there.* You know? So, I would simply have to say it in a way, or, I would simply become a French maid for whatever I would . . . It didn't matter. *Those* to me . . . *Those* things were to me were really quite divine. You know? *That* was *it.*

I mean, I was *living* my life out. You know? . . . In that kind of realm, which I *just adored,* but, ah, as far as being political about it, I didn't . . . You know? I tried to actually get *involved* in *moving* Warhol from this way to that way. It was totally impossible. What Warhol wanted to do was to me s-s-sacrosanct. What Warhol wanted to do was the number. You didn't try to . . . I mean, you didn't want to get a starring role in a Warhol movie if he didn't think of you, as far as I was concerned. Period. There was no way.

Either he considered you or he didn't consider you. *Whatever* he thought was good enough for me. It was the same way of whatever. I thought of him f-f-f-for me, too. It was no problem. You know? These people have ambitions that I don't believe! The ambitiousness of the human race is just unbelievable! I mean, how *often* do you bump into a person with that kind of genius? How can you *possibly* say [Ondine imitates a wimp], "I'd like to do this or that." It's just no way. You know? *How* can they even *assume* it? You know? And it

wasn't even a question of thinking about that kind of thing. It was a question of there it was. I mean, what do you do in that kind of sit-s-s-situation? You flow—with—it. If you *don't,* you *don't.* You don't know the meaning of the word.

PS: Billy Linich's (or, Billy Name's) name keeps popping up wherever I read, and some people have said that he was very, very important.

O: He is.

PS: Could you tell me about Billy Linich? His role with Andy?

O: That is very hard to talk about. [Pauses] *It's* very hard to talk about. [Sighs] I . . . I would . . . I would assume that, ah, the names of "Warhol" and "Linich" at this point are . . . at a certain time . . . should be synonymous with each other. That's how important he is.

PS: From what time to what time?

O: From, ah, the '60s to '68 or '70, until he began to . . .

PS: Was he always the manager of what was going on?

O: He was the idea behind it, in a way.

PS: In the sense of giving Andy ideas of things to do?

O: He provided Andy with an entire stable of performers with the reason . . . for the silver . . . ah . . . He provided Andy with all the materials, and Andy dealt with the essence. Warhol dealt with it in making it a reality, and Linich used the ether—the air—to bring forth the people, ideas, . . . You know? He cul-culminated . . . All the people that we're speaking about are all, in one way or another, involved with Linich. He had a way of introducing them into the Factory.

PS: For example?

O: For example, [Willard] Maas, [Marie] Menken, [Gerard] Malanga, ah, just almost anybody that you can name. [Nick] Cernovitch, [Dorothy] Podbur, [Ray] Johnson. He had a way of, sort of, insin-sin-sinuating [i.e., stimulating] your own ideas but *not* so that it was manifest[ed], not so that *he* presented the ideas. The idea was that the idea was there so that Warhol could use it. It was a *total* wedding. Absolute. Total. A wedding. They were *that.* Created the Warhol thing. It was Linich and W-Warhol. Without a question of a doubt, it was that, even to the fact of [Henry] Geldzahler used him: Linich would leave the Factory

and become Geldzahler's man and would work on Geldzahler's space in his ap-apartment and create, you know, places in Geldzahler's apartment for . . . function[ing]. He had, you know, . . . He had a certain quality that he would pull from the ether. A kind of quality that if somebody could use that and twist it in a certain way, you could work on it. I mean, Linich is a, like, an *essential* . . . I don't know if he has ever been documented before in a certain way, but it was a certain . . . You could see it in his pictures, in his photographs. Have you ever seen the Swedish cata-cat-ca-catalogue?

PS: Yes.

O: You know that these photographs have a certain quality in them. They're not quite there. You know? You know that there are other things there, but they're not quite there. Yet, it's a certain nebula, like a chaos that exists. I mean, it's a fish-eye lens, and it's . . . They're all sort of palpitating around, and Warhol could draw from those forces and make that . . . bunch it up and make it up and make it into a thing that could be seen. You know? Linich just kept feeding him these things. Warhol kept using them. I don't know who's responsible for what. It doesn't even matter. I mean, the fact that they worked in such a perfect wedding was, you know, so eloquent. You know?

The fact that that's why there was a response when Ronald Tavel wrote a thing in . . . what? *Film Quarterly?* He wrote a thing on . . . when he put down Linich as being a "janitor!" I wrote a letter to the magazine. I said, "A letter to an unknown woman." Namely: Jack Smith. And I knew I was attacking Maria Montez and the whole Maria Montez epic right there—right there at the kernel. You know? Because you can't call Billy Linich a "janitor." He was a . . . He was a . . . He dealt in ideas but in such a way he dealt with them like he never insinuated. He never was, ah, you know, overt about his . . . He let . . . He let Warhol *see* what was happening in his life, you know? And Warhol could *draw* from it, and Warhol was the only one who could. Really and truly it was a perfect wedding. . . .

PS: Why did Billy leave?

O: The ideas became uncommercial, I guess. I have no way of knowing.

PS: What has happened to Billy since then?

O: Nobody knows. I mean, I had a very good dream about him the other . . . He was quite happy . . . He's worked his karma out so that he—flows, whatever it is. He's comfortable. I'm not worried about him any more.

PS: What was Andy for you like on a daily basis?

O: It was fun! Absolute fun every time I worked for him. I would say, it was fun. We dealt with each other up *front*. It was *fun*. He was never a *problem*. The only problem was people talking about him behind his back. That's it. Period. He was a gem. A total fun.

PS: What about Dorothy Podbur?

O: There's a picture of her. Somebody asks her, "What about the '60s?" And she says, "So what?" She couldn't care less. She couldn't be bothered.

PS: Yeah. She said to me, "Don't talk to me. Talk to Ray Johnson."

O: [Laughs] She's very humorous. Dorothy is a very humorous woman.

PS: What are the kinds of questions that you're usually asked?

O: This will probably be the last in-interview that I'll ever do. This is as far as it goes, and I'm tired of it. You know?

PS: I don't blame you.

O: *This* is not tiring. You aren't tiring at all. You've very good. I . . . I . . . I *hope* it's going to be a success. I . . . I'm looking forward to it. You know? But I will say that I . . . I think that it's over. You know? It *may* not be. But, God, if it isn't! What can I say? I just . . . I just can't c-couple myself with those people anymore. . . . I can't hack it.

Ondine (Robert Olivio), New York, 17 December 1978

In spite of Ondine's insistence that he would never be interviewed again about Andy Warhol, Ondine did agree to be interviewed again on tape.

PS: Last time we were talking, you mentioned after the tape stopped that there was to be a sequel to *a, a novel,* which was to be called *b.* Could you tell me what you mentioned before that we didn't get on tape?

O: Oh, yeah. It started: Andy and Fred Hughes picked Roger [Ondine's ex-lover] and I up in a cab in Brooklyn, and, from there, we met Candy Darling, and we stood in line to the Judy Garland funeral, when she was at Campbell's. And we waited there a couple of hours. We waited there about an hour and a half. The line was around the block, and that's where the book started. And then we went to a bar somewhere. I think, Campbell's is in the 80s. (I'm not sure where. Some-

where in the 80s.) And we went to a bar, and, instead of looking at the corpse of Judy Garland, we went to this bar, and we were met there by Mario Amaya, who was the man shot with him [Warhol], and from there we went on to Ultra Violet's apartment. And Ultra Violet and Candy and I were in the bathroom, putting on makeup or something like that. And Andy was in and out of the b-b-bathroom and all over the place. And then we went to the Russian Tea Room. And from there, we called it a day.

And then the next day, we started at the Factory, and we went to some strange place—I don't know where. And then we wound up at Beef 'n Brew or something like that. And that's where we decided it was just not feasible. It would have worked out except that there was no more interest in . . . I mean, . . . you know?

The first book was done on speed, and the second book wasn't. It just wasn't . . . I think, we got like six or seven or eight hours out of it. I'm not sure.

PS: Now, when was this done? In what year?

O: Five years after the first book was done. About 1970 because the first book was really started around 1965, and, then, by that time, it got published. It was 1968. So, you know, it was five years. And, at this point, he had an idea that every five years to do another book. So, that was that. [Ondine then discusses at length a film about Cleopatra by Viva.]

PS: You mentioned Andrea Whips Warhol and mentioned that she died . . . ?

O: Yeah. She pinned a note to her dress, and she jumped off the roof of her father's house, and the note read: "Happy Birthday Andy."

PS: And what year was that?

O: Two or three years ago. [i.e., ca. 1975–76] She thought she was Warhol, though. She would meet him in the street and scream [imitating], "They come to see meeeee! Not yooooou! Andy Warhol!" And she would go on and on, and, you know, we'd be walking down the street, and Andy would sa-sa-say to me, "What are you supposed to do with her?" I said, "She obviously needs a beating or something." You know? What could you do with her? [Imitates] "Oh, theeey cooome to see meeee!" Have you e-ever seen the David Susskind tape?

PS: No, but I've heard about it.

O: Oh, it's fabulous! She's on it, and she sings, "Curtain up! Light the lights! . . . " And she's just off of her mind, off her mind. It's a very g-g-good tape.

PS: During the commercial you leaped toward someone?

O: [. . .] I wanted to kill him, and Susskind said, said, said to me, "Oh, hold on!" I said, "And as for you, my dear . . . " I said, "Your show was a lot better when it wasn't sponsored." And they cut that. They just went right on. [. . .] All of the video stuff that he's [Warhol] done himself—and he has a lot of stuff—*Haircut* and stuff and *thousands* of hours, hours and hours of stuff like that, and he claims that it's all lost.

PS: Were you with Andy when he did *The Philosophy of Andy Warhol* (*From A to B and Back Again*)?

O: No.

PS: The reason why I ask that is because I was kind of wondering why he decided to write a book like that. I was speaking to Pat Hackett on the phone, and I said to her—I just threw out one theory—and I said, "A presupposition I could have would be that he decided to write down his *pensées,* his ideas, because he might think that other people are off-the wall." And she said, "Well, that's kind of interesting, but, no, that's not the reason." And I said, "What was it?" And she said, "I can't tell you." I said, "Okay."

O: The reason is that *a, a novel* wasn't a great success, and he wanted a great success, as in a book form. That's all. And that was the quickest way of doing it was just to do it.

PS: A pastiche . . .

O: . . . of whatever. Yeah. You know, there's nothing very . . . he didn't . . . want to set the record straight, as far as his thinking goes because, when he asked me to write the biography of him, he told me that I should *lie* about it. I just simply should make up his whole background. You know? So, I don't think that he, he, he cared, and wh-wh-what *The Philosophy of A to B and Back Again*—or whatever it is—is more-or-less him in a way, but, I think, it probably serves him in the fact that it's not pretentious. I mean, it hasn't got any pretensions about, you know, philosophically anything. That's why the word "philosophy" is so marvelous. It is because it's not really any philosophical treatise on *why* he does this, this and that except, if you look real close, and then you see the reason why he does things is for

no r-reason at all, simply because he likes it or makes money or some-
thing like that. You know? . . . At the start of *a,* Andy and I are hav-
ing a *snecken* in a restaurant called Starkee's on Lexington Avenue (in
the 50s), but who walks in but David Whitney. And the conversation
is that: who Whitney is, and what he does, why does he act the way
he does, and "don't you think he's a sn-snob?" and "I don't want to
speak to him." and this kind of thing and that kind of thing. I mean,
it's funny about that. *I think,* it's him. There is no other Whitney
who's running around.

PS: Not that I know of.

O: Yeah. And he's been running around for years. Right?

PS: Now, you were called something other than "Ondine" in the book?

O: I was just called "O."

PS: Oh. Just "O?"

O: Just "O." Yeah.

PS: Okay.

O: And that's all through the book. But, I mean, David Whitney—the
one we're talking about—he comes in, and it's really funny because
Andy says to me, "Ah! Isn't it funny? We're starting the book, and
there is David Whitney." And Andy hands me four pills immediately.
He takes them from his bottle of speed, and he said, "How many do
you want?" And I said, "Oh, I'll take them all." He said, "Oh, On-
dine!" [Laughs] He said, "How could you possibly?" I said, "You
swallow them, and, then, you have a *snecken.* And then-n-n every-
thing is all right." . . . But I managed to take a 100 milligrams right
there, and he said, "Oh! My eyeballs would be . . . you can't!" And
I said, "Oh, you have to." He said, "Well, here we go." And that's
how the book started.
 He used to *read* that book and re-read it and re-read it and re-read
it. Like, the Velvets had a . . . they were performing in town at a
gymnasium on York Avenue, and the gymnasium during the week was
only for Ukrainian graduations and Ukrainian baptisms and stuff like
that. But on weekends, it was turned into this *madhouse* with a tram-
poline and the Velvets and people dancing off balconies and going ab-
solutely be-zoo. And Andy would sit way up in the back, where some
of the spotlights were, and he would re-read the proof-sheets to the
book *in the dark* with a flashlight! *But he was always doing it,* and he
would look up fron-fron-fron-front and say, "Oh! This is so good! Oh!

This is just the best book ever! This is going to really do it!" And it didn't. If they had followed his instructions about the book, it would have done it. The title that he had f-fo-for the book was *Cock*.

PS: Right.

O: And because he was in the hospital, they thought it would get more money if they said: *a novel by Andy Warhol*. You see, Andy didn't write that book. It was 24 hours of conversations with me, but they fi-gured—Grove Press—they said, "What are you worried about?" They said, "This will pull in a lot of money. All it has to do is have the name 'Andy Warhol' on it." They didn't realize that there's still a deep resentment against him. I mean, even people who are of, like, the establishment or people who are of the avant garde, there's still a large reaction again-against him. So, so, so, if the thing has the name "Andy Warhol" on it, they're purposely not going to buy it, especially in a new field where they could put him down. Do you know what I mean?

PS: Yes, because they did that in the reviews.

O: The reviews to this day . . . they were so fabulous at first. *Newsweek* called it "a combination of *Finnegans Wake* and the *I Ching*." They said, "Wherever you pick it up, it doesn't matter where you start or where you end it, it's totally confusing; and it's so ambivalent, it can mean anything." And that was good. You know? That was good.

 And, then, there was a review in the *New York Times* that called it—the title was: "Drugs, Loquaciousness and Faggotry." And it *absolutely* put the book down, too. It was just terrible. *That* review *killed* that book. It was a long review in—what's that?—*Book Digest? Literary Supplement of the Book Digest?* — There was a "thing" about what kind of hero I was — that I was a kind of anti-hero, and a long [Jean-Paul] Sartre-type line that the prototype hero had changed in the '60s and now was becoming this anti-hero that was a perfect ac-companiment to [Marcel] Proust, or whatever. The thing was just gigantic! And they called it, they said . . . They used words like "Beckett." You know? "This is like [Samuel] Beckett." Or, " . . . like James Joyce." Or, ". . . Proust." You know? Like, whenever they have nothing to say, they whip out the old saws—Proust and . . . you know? And, you know, the more classy types say, "Henry James." You know? As if they know what Henry James is. As if anybody knows what Henry James was writing about. And not that I don't like him, but he's certainly what you would call, you know, . . . He's re-ally very "in." You know? I mean, this review just went on.

Most of the reviewers that I had me-met had obviously not read the book at all but decided it was a very important book! But we all thought it was a very important book because it was important just because there never was a book quite like that before.

PS: What were Andy's original instructions for the book that you mentioned before?

O: Just 24 hours of conversation. Just one long 24 hour period. That's why we used the speed because we were going to stay up for 24 hours. I mean, after 12 hours we were almost dead! We simply could not hit another spot. We hit every person that I've ever known. We went to every apartment that was available to us. We visited Brigid [Berlin] in the hospital. We visited Rotten Rita's apar-apartment. We went all over the place. We went to Lester Persky's residence on the East Side. You know? And we talked about . . . where I tried to take a bath and even tried to take a shit, and I couldn't because Andy was right there with the tape re-rec-recorder. I said, "Andy, please, I've got to go to the bathroom!" He said to me, "Ah-ah." He said . . . he said, "If you have to go to the bathroom, I have to go and the microphone has to be right there." I said, "Oh, please, Andy! I can never do that with anybody in the room!" He said, "You're going to have to." So, I did. You know? But, anyway, . . . So, then, we went to . . . Edie Sedgwick is in the book, and Chuck Wein is in the book. And The Sugar-Plum Fairy is in the book—Joe Campbell. And all of these people.

PS: Now, who's Joe Campbell?

O: A great love of Dorothy Dean's life. He's handsome, smart, decadent and a Southerner. He's in *My Hustler*. The most bored person in the milieu.

PS: Who are some of the other people? Like "Bobby Cool?"

O: That's Bobby Schwartz.

PS: And "Taxine" or "Taxi?"

O: Edie [Sedgwick].

PS: And "The Duchess?"

O: Brigid [Berlin]. [. . .]

PS: And, then, I have seen Peter Gidal's book on Andy. [See Peter Gidal, *Andy Warhol: Films and Paintings* (London, 1971).]

O: Oh, he's such a [. . .]. I mean, I don't believe him. Most of the stuff in it is wrong. Most of the stuff in it is a lie. I read the first couple of chapters. I couldn't believe he was saying all that. Did you know that he makes his living doing that?

PS: Who is he?

O: That's exactly wh-what I w-want to know. He talked . . . he wrote an article about sunglasses and how important they are to the modern type of hero in film. He speaks of some of the movies . . . some of the moments in *Chelsea Girls* as being "perfect" because I wear sunglasses, which has something to do that was left over from Beckett. Now really?! I mean, . . . you know? What a bunch of bullshit! That's the only word that I can use to describe it. If you have to write an article for *Art News* or *Artforum* and have to go on in that form of threadiness. I mean, that has nothing to do with anything. I mean, he gets deeply involved in the philosophical meaning of every single *word* in one of those Warhol films; and, if the Warhol films are speaking—if they're talking, it's a lot of garbage in it. Mostly garbage: blah-blah-blah-blah-blah. You know? Endless diarrhea of the mouth. I mean, endless. And he builds up these enormous castles of what it all means and what all that meant.

PS: I understand that Andy didn't care for the name of "Drella."

O: I don't think that he cared for it, but it's something that once it started no one would stop it.

PS: Who's "Oriel Dewinter Romanov?"

O: Some prostitute who broke Andy's camera when he wanted to film in her bedroom.

PS: And "The Mayor?"

O: That's Rotten Rita.

PS: And "B.N.?"

O: That's Billy Name—Billy Linich.

PS: Before you were talking about Grove Press changed some things in the format.

O: They just changed the name.

PS: Just changed the name?

O: That's all. The rest of the book was conceived and e-ex-ex-ececuted,

even with those little drawings on the top [of a page], all of that was done at the F-Factory by Billy Linich.

PS: Okay.

O: He's the one who divided it into two sections, who had it plastered up . . . I mean, he worked on this one thing.

PS: One thing that I try to ask people [about] is Andy's ideas, intentions (or, intentionality) on his part. Does that ring any bells, any associations, for you?

O: I know that when he wanted a thing done, he generally got it done no matter what it took to do it, he would do it, like: if he wanted to make a movie, he made that movie no matter what it took.
 One afternoon I was working as Edie Sed-Sedgwick's French maid, which consisted of waking her up in the morning because she was so barbiturated that she couldn't hear anybody else ring a doorbell except me. I can ring a doorbell so nervously that you could be dying, and you'd get up to answer the door. It would be so irritating, and I used to [imitates]: BUZZ! BUZZ! BUZZ! BIZZZ! BUZZ! BIZZZZZZ! And she'd go, "Ah!" And she'd scream and get up, and that's how Andy got her to work: [it] was that I would wake her up. And then I'd give her some speed, and we'd quickly go over to her grandmother's [apartment], and she'd go into her exercises. Most of the morning doing frantic yo-yoga . . . but she'd do her own yoga, where she would "split" her back and do all sorts of strange things and, then, she'd run around and say that someone had stolen her diamonds, and they'd always be, you know, in her co-cold cream jar (or something like that). And then we'd go over to her grandmother's apartment. Her grandmother lived between Park and Madison. The entrance was on Madison, somewhere on 72nd Street, and it was *16* rooms! The apartment was 16 rooms. The rooms were twice the height of this [i.e., ca. 16 feet]. Each room . . . There were servants quarters and toilets all over Persian rugs and everything. And we'd always rip-off [i.e., steal from] the old lady. We taked [*sic*] silverware and china and everything. The grandmother's . . . You could hear the grandmother's wheelchair squeaking, when she was coming down, and she'd say, "Here comes Grandma. We'll have to go down the back way." You know, Sedgwick had a lot of money. I think, they owned a town in California. They literally *own* it. So, that's how we'd get her to work.
 And Andy, if he wanted me to . . . One afternoon I was very tired, and I didn't want to do any work. It was just impossible, and he stood there. He did this [Ondine demonstrates]. He stood there.

[Imitates Warhol] "Oh, please, make a movie! Oh, please! I've got to make a . . . " And on the street corner with a man doing that—jumping up-and-down and screaming and biting his fingernails and yelling, "Oh, please! Oh, please!"—you just said, "All right. Anything. I'll do anything you want me to do, just don't act . . . act like that." That's as far as I can say about his intentions: whatever he wanted done, he got done. *He'd do anything to do it! But anything!* And he just did it.

As far as his direction, his scripts and all that kind of thing, when [Ronald] Tavel han-han-han-handed him the script of *Vinyl,* he picked out the cast, and the cast was me and Gerard [Malanga] and Tosh [Carillo] and all of these other people. With me, he wouldn't even say . . . he sa-said to me, "Do you want to look at the script?" And I said, "No, I don't even want to know that there is a script, especially if it's about S[adism]-and-M[asochism] stuff. I can't be bothered.

And Gerard tried to study his script, but Andy wouldn't let him do it. He would send him on errands, or he'd have the book blocked out, or he'd . . . he never let him study the script. So, there are bits on the film—where Gerard has his leather mask on and being tortured; on the floor is the script—and he's trying to read the pages, and he has to do this and says [Ondine imitates Malanga's halting reading of the script], "Oh! There . . . is . . . a . . . d[isc]-j[ockey] . . . Oh!, a . . . corner . . . carving . . . a . . . cross . . . in . . . an . . . old . . . lady's . . . hump! . . . Oh! . . . stop . . . this . . . flick!" The acting in it is the world's worst, but Andy wanted that. So, his intentions were never to be subverted. He had lieutenants doing whatever he wanted them to d-do, to do.

He started rumors about people; and, on one side of the hall, he'd have . . . or, he wouldn't even have it [?]. He'd have somebody put a "buzz" in somebody else's ear, "Didn't Henry Geldzahler say to you that you looked very tacky the other night? That you shouldn't go around looking like that?" And the other person would get it filtered back from one of his lieutenants. They would be appropriately like this [Ondine demonstrates] . . . as Geldzahler would walk in the room, and Andy would film it. So he got done whatever he wanted to get done by innuendo, rumor, . . . anyway!

And he operated on such a strange level, like, if you're in the film . . . like, how many times have I seen the last segment of *The Chelsea Girls?* And *to this day I don't know* what happened. I know what I did. I know what she [Angelina "Pepper" Davis] did. But when it was being filmed, I had no idea that Paul Morrissey had almost rehearsed her to the point of that. And that when she left there, she ran to the Museum of Modern Art and beat on the door—there was this

meeting at the Museum of Modern Art with Geldzahler and [Jonas] Mekas . . . and all these kind of pe-people. And she screamed, "Why did you send me in there?!"—which means Mekas sent her in there. So, *I knew none of this!* And I think that all of the people who appeared in the Warhol films—they didn't know half of the stuff that was going on around them. He had them *respond* to a certain set of circumstances. It was very good for what he did. I mean, he pulled out of those people, including myself, some of the best performances ever on screen . . . of anything. The rel-relationships between people in the film is *entirely* different. It's not like people reading a script. It's like, suddenly, you're aware of the fact when you're watching it that these are actors acting in a completely different, almost a non-coded, existence. Like, they don't know what each one is doing. No one knows how to relate to, to, to the next scene, to the next thing. It has a feeling of awkwardness, but it also has a feeling of being an uncharted kind of territory, where you never know . . . And only [Ingmar] Bergman and F-F-Federico F-F-Fellini use the same people over and over in that kind of context so that what he had was a stable of players. You know?

There was Ingrid Superstar, me, Gerard [Malanga], blah-blah, . . . all these, all these people were used films and again in his films, but in ways that . . . Like, they would really begin to dislike each other because of the dialogue, also, because of the drug-taking— an enormous amount of drug-taking—most of the people were, you know, off-the-wall with their own versions of what was ha-happening. How can you tell a person on a certain [number of] milligrams of amphetamine during the day exactly what's happening? I mean, they . . . they live in a completely mental world. So, they think that this is occurring and that is occurring, and it's not. Also, the same w-w-with Andy. I mean, I know that he's on speed most of the time, even now; but he, you know, won't admit it, and why should he? That . . . that takes care . . . care of intentions, I guess. I don't know.

PS: Now, [before the tape-recorded interview] you gave a kind of transition year, when I was speaking with Ed Burns [on the telephone], 1965 was a kind of transition year. That is, when the [. . .] types came in, as Ed Burns put it, "the Bloomingdale faggots."

O: Yeah. It's true though! They are. That's all they are. Also, you can add to it: "zombies." You know?

PS: Could you tell me more about the first time you came to Andy in the early '60s? Or, was it the late '50s? You said . . . ?

O: The early '6-'60s would be the time.

PS: Could you tell me more about that time? Free associate. Whatever.

O: It was very free. The whole thing was very free. There was never any . . . there was never any . . . like I said, he would, like . . . He would get whatever he want[ed] done . . . done, but you would not know that's what you were doing. I mean, like, supposing you make a film a day, you didn't even know about it. It was . . . It was . . . The Factory was a stop-off. You would stop up at the F-Fa-Facto-ry. . . . My usual hours at the Factory were sometime around four o'clock in the morning so that I'd get up there when nobody was there but B-Billy Linich, and we'd be playing opera all night. And, then, in the morning, you know, through various combinations of drugs and opera and stuff, we'd start filming, or we'd start doing a v-vi-vid-videotape or write a book or do this and that. It didn't interfere w-with whatever else was happening in your life, but it certainly was a major portion of it. You know? Like, every day. Maybe three times a week or, maybe, four times a week, you would g-go-go up there, and you'd just be involved with whatever he was involved in. What he . . . he was involved with more things at the same time, like he would also be painting on the side. He had actually this incredibly big space, and it was, literally, a factory because people were painting on the floors, painting on the walls, painting on this and that. They were making films in the back. They were doing recording sessions. They were doing . . . I mean, there was always someone up there auditioning or getting a screen test.

　　　　Bob Dylan sat there for 16 *hours* once for a screen test, and Andy absolutely *ignored* him—wouldn't go near him. Every time they put a Bob Dylan record on [the stereo], we'd take it off and put on Maria Callas. And he sat there, and he sat in his chair *quietly* for something like 16 hours and got more and more p[issed]-o[ff]ed. He was really angry, but Warhol was the kind of person that, if you just went up there, you were ignored—summarily ignored. Period. Unless you were a part of his group and then, anything you wanted to say (like, if your toast was wrong or if your toe hurt), it was fine. But anybody from the outside, like Montgomery Cliff or Judy Garland, he absolutely . . . If anybody was, you know, kind of a celebrity, who came in, then Andy could give "the boots" to [i.e., to throw out] he [would] put "the boots" to them immediately. He just did it. It was automatic. You know.

PS: How did he show the movies—the early movies—in the Factory? Like *Empire, Eat,* . . . and such.

O: He'd just show them.

PS: On the wall? Or, what . . . ?

O: There was a screen. You know? He pulled down the screen, or he'd get a sheet up, and we'd show them. That's all.

PS: So, the movies in the original context were like portraits on the wall?

O: They were kind of like . . . Well, because the walls were all silver, they would be . . . You would play up against the . . . you'd put them up on a screen, or you'd hang up big sheets off some of the pipes, and you'd show them on the sheets. And most of the areas in the Factory were cut off by screening. So, could show films in the back or show films in the front. All the windows were painted black. So, you couldn't see in, and you co-couldn't see out of them unless the windows were . . . were . . . were . . . were open. If you wanted to catch a bit of sunlight, you'd go up to the roof or outside. There was no way that there was any light in the place at all. It was always s-strobe light, always [an] eerie kind of light with these silverish walls. It looked like a horror show: it was [laughing] the *Big Rocky Horror Show*. It's just this . . . this enormous, you know, space, and there were lots of things going on in different compartments, all over the place.

PS: Why did Billy Linich decide to put silver all over . . . ?

O: Well, he had done it to his apartment down on the Lower East Side first, and it worked so well in that little space th-that Andy asked him to come up to 47th Street, and give up his apartment Downtown and live there. And, so, Billy being a kind of active person and with amphetamine in the picture, you know, I mean, . . . It was *nothing* but silver. The walls—they weren't just silvered, they were tin-foiled. So, it was . . . You know, with the process of the tin-foiling the walls is enormous! And tin-foiling the pipes, and the pipes are tw-twe-twenty fe-fe-feet up. The ladders are big, and pipes are hot, and you have to put tin . . . tin-foil over it. It was amazing! It was just amazing! Work never stopped there! It was amazing!

PS: Did Andy do anything that particularly pleased you?

O: *The Chelsea Girls*. That really pleased me.

PS: Did he ever do anything to shock you?

O: No. His callousness at t-times was shocking. He was *thoroughly* callous about shocking people, and *that* would shock me, but, you know,

at times, you know, he was the k-kind of person you'd say should be. You'd make a good impression on, say, photographers and people coming in from Germany just to sp-speak to him. At that point, he'd have you ask them the most *obscene* questions, and they would translate it to . . . this filthy stuff . . . and the people would . . . they would, you know, just blanch! They'd get red. The people that offended me at the Factory were not the Andy. It was [Paul] Morrissey that was offensive.

PS: Why?

O: He was so, you know, . . . he was just coming from a different . . . Nothing that Andy did was offensive because he'd . . . It wasn't intentionally meant as such. You know? He just could do whatever he wanted to. The thing that shocked me the most was when he started to leave off being his own personal representative and allowed people like Morrissey and this woman [?] who did the tours for him, to take over the control of the people around him. You see, it was a kind of betrayal because the people around him were . . . were very important to his legend in filmmaking, and they were tre-treated in a kind of cal-callous way.

PS: Why did he decide . . . ? Rather, *who* decided to have . . . to have Alan Midgette [impersonate him for a lecture tour]?

O: Oh. Andy said that he couldn't go on the tour and "would Alan please do it?" and Al-Alan went. To this day pe-people say to me that "that's not Andy Warhol; I saw him on tour, and he looked entirely different." And I said, "That was Alan Midgette." And they said, "Oh, no. The guy said [that] he was Andy Warhol." You know, they didn't . . . They didn't . . . You know, they believe . . . believe what . . . what you tell them. Really!

 The one thing that shocked me. It really wasn't a shock. I got offended by it, and it wasn't really he who offended me. It was that the Velvets appeared at a place in Rutgers. It was the Exploding Plastic Inevitable that came to Rutgers [University], and we did these shows, and I danced with them and sang with them, and we had a marvelous time. It was very great. The first show was bad [unintelligible word] because I wasn't involved with it. The second show was marvelous because you have to be able to work an audience like that. It's not just arrogance that does it. You have to be able to get to know them, and everybody on stage except me had a preconceived idea as to what the audience was g-going to take. No one wanted to offend them on their own level. You know, it's all right to offend a group, but, first, you

have to get real chummy with them. I mean, you can't just say, "Well, you're a piece of shit. You're a turd." Or, "Your uncle wears snow boots." I mean, you can't. That's not. You have to get c-close to them first. You have to show yourself as being open and all that, and the people who were involved in that first show weren't quite able to. So the second show was really good, and, at that point, I got an idea that . . . I mean, I didn't have to worry about making films or dancing, blah-blah-blah. You know? It was a dream, but nevertheless . . . So, the next thing that w-we were involved with was when we went to the Cinémathèque (when it was on 42nd Street), and the Velvets were appearing there. And Gerard Malanga came up to me and said that Andy said that I shouldn't b-be on stage because it was too crowded. Well, I was furious since I considered t-that I was responsible for the success of the first show in the first place! I th-threw a table th-through the door or something like that. I stormed off, and I wouldn't speak to Warhol for six months. And Billy Linich got us back together again, and, then, Andy said to me, "Well, why . . . ? Where have you been?" I said, "Well!" I said, "I didn't want to *come* around when you said [that] I cluttered up the stage." He said, "I never said that." I said, "Well, Gerard said it." And he said, "Gerard, come over here. Gerard, you're fired." He fired Gerard on the spot. I mean, Gerard was doing it because the show was no longer his. I had taken it over, and he was furious! So, he did *anything* to keep me off the stage, and Andy was p[issed]-o[ff]ed, too, because he realized that a part of the success that he wanted for the Velvets depended upon people like me, who could use audiences in that respect, who could [treat] an audience like that. You know? Kind of tell them the truth, offend them, joke with them, but have them . . . It's like an interplay. You've got to be able to give an audience yourself, and they have to be able to be . . . to enjoy themselves while they're being insulted or whatever. It's one of these double deals. You can't really walk in with a preconceived impression of what an audience is going to be like because they change all the time. And I know that Andy felt that if I had been with the group, it would have been a great success on the East Coast because it was a very big success out on the West Coast. But just that—[the] New York audience is different from a-any other audience in the world. You've got to literally. . . . They have *to know you* or have to know what you're doing, and it has to snowball, and I'm sure th-that he [Warhol] was very angry. I mean, he was angry enough to fire him [Malanga]. So, that was the only time that I was really mad at him . . . was at that time, and it wasn't him! It was Gerard who had lied about it.

PS: Now, when he told Gerry, "You're fired," was that only in terms of the Plastic Inevitable?

O: It was in terms of everything. G-Gerard didn't come back to the F-Factory for two years.

PS: What year was that, then?

O: 1965? '66? I'm not sure. That's why Gerard is not even around. He's not even around. He starts . . . he starts reappearing sometime around '66, as *The Chelsea Girls* is starting to be filmed. You'll see him in segments of it. And he gets back into it then. But that's . . . He was really . . . I was atrocious. You know?

PS: Could you tell me about the origin of The Exploding Plastic Inevitable, Nico and the Velvets?

O: I have no idea.

PS: But Tally [Brown] describes . . .

O: I have no idea.

PS: . . . Some of the events of St. Mark's Place.

O: Well, all right. I can go into one p-p-p-part of it.

PS: Whatever you know.

O: . . . And that is way before The Exploding Plastic I-Inevitable even g-got onto the scene, the people who were the teachers of The Plastic . . . of the Velvets—LeMonte Young and [Angus] McLeach. These people are avant garde composers and musicians, and that's the *training* or the *study* that Lou Reed and John Cale did. . . . [It] was mostly with these people. It was extremely esoteric. And I don't know, maybe, in a six months to a year period, when these people were all playing and jamming and dealing with their images, and some of them went into Rock 'n Roll and others branched out into religious music. Now, like, LeMonte is involved now with heavy religious, Indian type things. Angus is still involved with instruments and composing and all that kind of thing. But they then . . . they are the other part of the beginning [the] nucleus, of what became The Exploding Plastic Inevitable, and that's before . . . that's before even it went into . . . that's before anybody decided to be a leader of the group or a non-leader, before they had Sterling [Morrison] or Maureen [Tucker], or even before Nico came into the picture—this is when . . . this is when the thing was being formed. So, that's . . . that's as much as I know about it.

PS: Could you tell me about it?

O: That's it. That's all I know.

PS: That's it? Okay.

O: That's all I know except, see, I know all these people in different re-
lationships to me, like I knew LeMonte Young way before there's
a . . . I knew LeMonte Young in '61. '61 and the beginning of '62.
And just as I stopped b-bothering with LeMonte Young, I started tak-
ing up with Warhol and friends, and I didn't see LeMonte for a long
time because he didn't approve of speed (but he doesn't like people
who are on it b-because they make him nervous). So, the Velvets
came in, maybe, two years later, and that . . . And I didn't know any
of them even *knew* LeMonte Young until we had a dis-discussion three
[or] four years after that, somewhere in Philadelphia, when I was
locked in a room with Lou Reed, and he was playing music, and I
said, "Your chord progressions remind me so much of a musician I
used to hang around with . . . with LeMonte Young." He said,
"LeMonte?" He said, "[He] was one of my teachers." I said, "Oh, my
God! It's a small world!" That's all I know about it. I don't know any-
thing else about it.

　　　　See, I was never involved in the s-social scene. When the Velvets
would play at St. Mark's Place, or when they'd go here, here and
there, I never was involved in that. Those . . . Those occasions like
the opening of art galleries always affect me strangely. I . . . I don't
like them. You know? It just makes me . . . If there's a dinner party,
I'll go and spend the evening in the kitchen with the help because I
simply can't *bear* to be at a dinner party. I mean, it's really horrible,
especially when p-p-people have a lot of money and are being terribly
interesting in being. Oh, God! Is that dull! And the maids are always
so worried, and they're sweating. And, so, they're not having fun (and
they're so much more real). . . . And who wants to be bothered by
that thing? I hate that. That's another thing—I wasn't involved going
to art. . . . I didn't go to Max's [Kansas City] until Max's was almost
finished. I wouldn't set foot in it. I just thought, . . . [Ondine mock-
screams]. It horrified me. That social scene was the world's worst. So,
there's a lot of stuff that I don't know about. [P.S. asks Ondine's opin-
ion of Brigid Berlin, Eric Emerson and Pat Hackett; Ondine's replies
are unprintable.]

PS: Is there *anything* that you ever [have] read on Andy that sticks in your
mind as being . . . ?

O: *Stargazer* is the best. [See Stephen Koch, *Stargazer: Andy Warhol's World and His Films* (New York and Washington, D.C., 1973)].

PS: So . . . I think that, too.

O: Stephen Koch. Well, yeah. It's the best. It's the only [one work] that really . . . it's the only thing . . . it's . . . it . . . it's the only book that I've read on Warhol that has some sort of historical perspective through it and speaks, you know, knowledgeably about it. It's a good book.

PS: Now, Koch has . . .

O: Have you spoken with him?

PS: Yes.

O: He's very nice. He can be a little fussy at times, but he's nice. Do you know what I mean.

PS: Yeah. Ah. He approaches Andy [in] two ways. One is Andy ah, ah . . . taking [Charles] Baudelaire's definition of a dandy . . .

O: Ah-huh.

PS: . . . And, secondly, Marcel Duchamp.

O: Yeah. They're both ac-ac-accurate, I would assume.

PS: Do you remember anything about Andy and Marcel Duchamp? Did you ever meet Marcel Duchamp?

O: Yes.

PS: Andy talking about Marcel . . . ?

O: I remember one evening at *Conquest of the Universe*. Marcel Duchamp came backstage, with Andy Warhol and wanted to be filmed, to have pictures taken with the cast. And I said that I was busy. I couldn't be bothered. The rest of the cast could, but not me.

PS: What is *Conquest* . . . ?

O: That was a play with everybody in it: Taylor Mead and Ultra Violet and all of that. And he . . . Marcel Duchamp was *most* intrigued by it. He said [that] it was the best theatrical evening that he has ever had. He was just flipped-out over it. He *adored* it, and he wanted to come backstage and be filmed with the cast, and I said that I didn't want to.

PS: Now, who did *Conquest* . . . ?

O: John Vacaro.

PS: Okay.

O: A play by Charles Ludham.

PS: So, it was one of the Theatre of the Ridiculous productions.

O: Ah-hum.

PS: And do you remember anything else about Marcel Duchamp? Did Andy ever mention Marcel to you?

O: I remember Roger's [Ondine's ex-lover] aunt was Rose Fried of the Rose Fried Art Gallery, and she had Duchamp['s] *Boxes* and Duchamp this and that, and frequently Andy would stop and buy them. But that's all that I know. [Ondine discusses Roger.]

 If anybody ever taps into what anybody is thinking of at any given moment . . . I mean, they'll start worshiping that book *a* because that's . . . that's it. Isn't it? It's totally nonrelated in any way to anything. So, the situations are all like this: [Ondine intertwines his fingers] you know? I think that's the way it is anyway. I think that's why dreams are so . . . Why sleeping and dreaming is so wonderful, you know, because you're focused even though it seems it's *weird*. At least, one thing is surfacing that's recognizable, but with walking or with the boob tube . . . oh! oh, honey! . . . has that put a blanket on everyone's existence?! Isn't that the best thing ever created? That you can be numb. That takes away breath and life. It's really amazing! I love it. That's what I want to do—a lot of television, but no one is going to do anything with me on television. I'd be impossible to work with.

PS: Anyway, getting back to Koch's book. He talks about Marcel Duchamp with two major contexts in his approach, and the other is Baudelaire's concept of the dandy.

O: Which is . . . ? I don't know.

PS: Ah. The "painter of modern life" and being in the midst of life itself, as he is painting—being a kind of "outsider" but *in*side the society.

O: Isn't that exactly what he's doing? Even now.

PS: Do you remember . . . ?

O: I mean, especially now. *Now* he's even more of a pristine idea than he was years ago. Now, it's totally Baudelaire. Isn't it? I mean, he's *really into it.*

PS: Yes.

O: Completely. You know? Isn't that living the "art life" or what? I don't know. It's amazing. I must agree that he's quite an amazing creature.

PS: Now, can you remember the context of Koch's interview with you?

O: Well, Koch came to my house when I was living in Brooklyn, and the interview went so well that we just d-decided to spend three days with it, and we talked, and we talked, and we talked, and we talked . . .

PS: The reason why I ask that . . .

O: . . . And he said to me, "Oh, the book I was going to write . . . " He said to me, ". . . I'm going to stop. I'm going to write this new book now." And, I think, that's when he changed his feeling; and, instead of writing one of those things that people write, like the John Wilcock book, you know, with those meaningless titles: *The Sex Life and [Autobiography]*—whatever—*of Andy Warhol* . . . he really, really, wrote a book. I think, I . . . I . . . I was very frank with him. You know? And he got some insight into . . . But I don't feel as strongly about that stuff as I did. Now, you know?

PS: When I spoke with Koch, he said that he taped the interviews, but they're not available. I understand that you talked about Billy Linich, and I remember something about mysticism and occultism at the Factory. And with Andy, was there a context of mysticism and occultism?

O: The people who were around him, who were creating the life that he was living, were *definitely* involved in occultism.

PS: In what way?

O: . . . And *definitely* involved in esoteric astrology, esoteric psychiatry . . . ah . . . New World Disciples, Bob Genusha and his world . . . ah . . . saviours . . . all this kind of thing and that kind of thing. You know? They were involved in very mystical things.

PS: Was Andy?

O: Not . . . Not . . . Not really. You know? He knew it was happening, but he didn't.

PS: Someone told me that he surrounded himself with Geminis.

O: I'm one. I'm a double. I mean, . . .

PS: I'm one, a Leo.

O: So is Roger. I feel very comfortable with Leos. I mean, it shows. Right? Warhol is a Leo, too [*sic*].

PS: Yeah, and then someone said, "Well, . . . "

O: And Geminis and Pisces! The Pisces! Oh, . . . : Lou Reed, Brigid Berlin, . . . Ah. Oh. Pisces and Geminis! Oh! They're dual signs. You know? You can get a lot of work out of them, too. That whole thing. I mean, everybody got their charts done, and everybody's chart was in the right house, and we had new mystical signs with . . . We . . . we . . . we . . . we were making up new mystical signs for . . . what the new signs of the Zodiac will be when the world changed . . . and when it came, there would be the sign of the whale, the sign of the bat, and this sign and that sign. You know? It went on and on and on, and a lot of it was very true in a way. And with esoteric stuff, you have to realize that it's all very symbolic. You know?

PS: In what way?

O: It's . . . I mean, all of the teachings—all of the cult-teachings—when, like Alice A. Bailey is talking about . . . you know? . . . the new world order that's going to come and the fact that the mineral kingdom has finally exploded when the atom bomb was re-leased . . . And the thing [that] you have to remember [is] that she's speaking symbolically about it. Like, Rudolph Steiner is talking about, you know, about how to meditate, how to get into the unattainable spheres . . . It's all . . . What they're saying is very symbolical. I mean, a lot of people take this as literal. You know? Like, suppose you become very occult-oriented, you become very mysterious or very weird religious . . . or . . . [Ondine laughs] . . . some other non-sense. You know? You become this marvelous . . . you're attuned to the universe by e-eating nothing but brussel sprouts and gathering watercress at one [particular] hour of the night or something like that. [Laughter] And you wear nothing but hand-woven clothes and do no-thing but . . . and you, you know, let all your hairs on your body grow in concentric circles. Something. It was very intense. I don't know if that will ever be vogue . . . and voguish. If it had a *great* vogue in the '90s, and it had a great vogue in the '20s, but right now? Nothing could be tackier. Nothing can be tackier than to be involved in the occult.

PS: Now, when was this done?

O: In the '60s. Of all the times to be involved with the occult! Oh, God!

PS: What time in the '60s was this done at the Factory?

O: Oh, from the very inception of it to the last day—the last days of the

Factory that *I know*. I know nothing about this thing at 860 Broadway [i.e., the current address of Andy Warhol Enterprises].

PS: Some people have said to me, "I don't think [that] Andy did anything. He may have been the idea man, but he didn't actually pull the squeegee."

O: Oh, he did absolutely everything. He painted the pictures. Of course, he had people helping him, but, you know, that's such an enormous amount of work. You can't expect one man to do all those silkscreens by himself. You know? He had to have help, but he did most the stuff himself.

PS: Did Andy ever . . . ?

O: He loves to paint! You know? He's always painting, like, privately . . . when he wants to be . . . just sits around and paints. Like I said, he paints bl-blobs of color on things. He paints pinks, or he paints greens, or he paints blues, or he paints this and that, but he just likes to simply paint. It's a thing he likes to do physically, and, he does it. Is there any other way?

Robert Pincus-Witten, New York, 15 November 1978

Pincus-Witten, who was a close associate of Andy Warhol during the mid-1960s, is an art critic.

PS: So, you met Warhol in 1963–64, and you participated in *13 Most Beautiful Boys*. How was that shot?

RP: During the shooting of it, there was nothing much to do. I recall in good sort of movie version of fashion photography, during the shooting of it, that was essentially just the cartridge running out, and one is simply in front of the camera in a very neutral way. I remember, Gerry Malanga and Andy were there, and Andy would say things like, "Isn't this wonderful! Isn't he terrific! He's doing it!" As if one is really doing something wonderful by simply remaining static and unmoving before the lens, but the *hype* was very, very exciting. It's a tremendous kind of adrenaline-hype, and, of course, an extraordinary group of people in the studio at the time.

PS: What kinds of things would you talk about? As a trained art historian, what insights can you provide me about Warhol's use of iconography?

RP: For example, we would speak about the nature of iconography. Not in the sense of an art historian, or what is the history of this image in

terms of its cultural ramifications, but, "Do you think that is a good image to do?" and: "Why?" And the two rather important images associated with that phase of his career were discussed in only the largest application of the term "iconographically." One was the *Flowers,* and the other was the *Cow,* and, ah, in the degree, in the degree that the images were *done* did they appeal, not in the degree that they were smart. . . . One could do a lot of iconographic tap-dancing which has nothing to do with the *value* of the image for Andy except retrospectively today. At the time, whether or not that he knew of such, of such a cultural history was accessibility rather than the smartness and inaccessibility of an image.

PS: What did he used to say to you specifically, to your recollection?

RP: Well, another funny thing: I used to have to call him every day at four o'clock and teach him a new word. Although I don't remember any, . . . at one point, I had to sit down and think about the words, and he would—as many people do—think that I have this extraordinary . . . you know, kind of words like "iconography" and all these funny words. And, so, I would have to ring him up everyday at a certain time, and he would be by the phone, and, then, I would say the word for the day: "This is the word you're going to learn for the day. . . . " That was the kind of thing that had an ironic edge to it. Retrospectively, I suppose, there's a certain amount of truth, too. I don't recall now how long that went on, a few weeks. It's a funny memory, in any case.

PS: Did Andy talk to you much about art itself: his ideas about it?

RP: Yes. He had one motivating idea. Absolutely central. Ah. He . . . It's not because he's unexpressive. I mean, in many transcriptions . . . his tapes . . . and, sort of, publically. He was interested in the idea of glamour. Glamour fascinated him. It's ineffable. Ah. And, yet, it's the thing which is the thing that he's most striving after, obviously, because the notion of glamour [is] such a function of . . . a . . . 1930s notions of cinematographic fame. That . . . glamour is, I think, is in his mind is a function of, ah, movie star celebrity, recognizability, fan mag[azine] material. But if one had to find the key word, and he, at one point, blurted it out, you know, very much as you're doing: what *is* it, Andy, that you're after? At last, a key phrase got blurted out. He said, "I'm interested in *glamour.*" . . . It's not very . . . equal, as it were, in conversation, and, yet, one doesn't have the feeling that, by no means, that somebody . . . it's a dumb, averbal person. Maybe averbal, but it's not dumb, or he may be antiverbal, even. It's not a func-

tion of his being thick-headed. Certainly, it's now 20 years later, and, certainly, there was a cunning behind it, which is perfectly conscious. In fact, it's perfectly repellent today.

PS: Why did you use the term "cunning?"

RP: Ah. In the sense that the pose has been translated from something that was authentic to something that is merchandise. That's what I mean. He himself has become *the* packaged item: the thing that he has been merchandised, as he was, in fact, merchandised Underground Superstars, or what have you, or as he merchandised films or *Interview* magazine. He himself is merchandised as a certain type of personality. . . . It now conforms to the thing that is being processed in the media.

[Pincus-Witten characterizes Warhol's blotted-line technique as an estheticized and calligraphic application to commercial requirements and Warhol during his commercial art phase as one of the most flourishing exponents of the dilution of Picasso's linear style, even after the generation that started it had been displaced and continued it into a new iconography: I. Miller shoes.]

James Rosenquist, New York, 18 October 1978

Rosenquist is a prominent American Pop artist.

PS: When did you first meet Andy Warhol?

JR: I had been a billboard painter in Times Square until 1960, and I stopped doing that, and my last billboard was called *On the Beach.* So, I stopped painting it then, and I then . . . I . . . I scurried around trying to make some money on my own. Oh, doing whatever I thought I could do. I . . . Sss-so, I did window displays for Tiffany's or Bonwit Teller's.

PS: And that was with Gene Moore?

JR: Gene Moore and Danny Arje. And, ah, I saw . . . I saw Andy Warhol's name on some things occasionally in the commercial . . . in the commercial art world, and I would see that. I would see his name go by occasionally. I would see . . . I would see it on drawings and things then. Let's see. Ah. Then I stopped doing that . . . stopped doing that. I just . . . I just did, maybe, two sets of windows for Bonwit Teller's and some windows for Tiffany's and some things for Bloomingdale's; then, I stopped, and I began painting. That was about 1960. I had . . . I had made a living as a commercial artist, painting

billboards, and I was making a union salary. I used to paint and to design the Astor Victoria Theatre and the Mayfair Theatre and all those things. So, I got a studio and did these window displays then began painting. Then, at that time, Henry Geldzahler, Ivan Karp and Dick Belleny used to visit studios, and they would *seek* people out. [Rosenquist describes the circumstances of his earliest Pop Art works.] So, then, I had a show in February, 1962, and right in about that time I went to the [Castelli] Gallery, and Ivan [Karp] showed me a slide of a Warhol nose-job [*Before and After*], and he said, "What do you think of it?" . . .

Oh! Here's a thing I want to make clear in the interview or anything about Pop Art—is that, ah, I used to know Frank Stella about that time because he had been in the Sixteen Americans show at the [Museum of] Modern [Art], and he said . . . he saw my paintings early [on], and I had dripped a little paint down as a mistake because I had taped something up. I had painted some realistic imagery, then, another image in there, and there were a few runs [of paint drips] in there. And he [Stella] said, "You better get rid of the drips." [Laughs] Because it was, like, anti-drip esthetic because of Action Painting. [Laughs] It was that kind of feeling. Well, my paintings were done. . . . People would call a lot of people "Pop artists" for various reasons: extreme emphasis on advertising and radio commercials, . . . commercialism.

And during my billboard painting years, I thought that I painted these images so huge-like—an eye four-feet wide, spaghetti: as big as fire hoses, huge beer glasses and things—that I could use this scale to work in an area that was "numb," so to speak. Instead of being passionate about the imagery or dispassionate or nostalgic, I would use imagery that was a little bit old-fashion[ed]—that was a few years out-of-date. It was like an area to be free in. And I also knew that in French Non-Objective Painting after the war tended to get to zero in their non-objective painting, but the point was how to get below zero, and Jasper Johns seemed to show a pathway. His work had a lot of Eastern thought in it [and] other thinking that the new . . . new way to use imagery and color . . . that was very dry . . . very unusual way . . . in my case, to establish fragments of large objects in space on a picture plane so that they would appear to spill out of the canvas instead of recede like the old tradition of a picture . . . picture plane as a window. So, that's what I began doing.

So, anyway, Ivan [Karp]—showed me this slide of a Warhol nose-job painting [*Before and After*], and he said, "What do you think of this?" Oh! I just want to say . . . This is a point [that] I keep forget-

ting: Eleanor Tremaine, when she was buying [my] paintings, said, "Well, you think that you're the only one who's not dripping paintings? There's a guy in New Jersey who's making comic strip paintings." Right? So, it was Lichtenstein. Lichtenstein. Roy Lichtenstein. Ah. Then, I saw the nose-job painting. Then, there was another guy. . . . My point is that I didn't know any of the other people. I had never met them. And for 10 or 15 years after that, people said that it was [a] collusion. People said that people had cooked-up a Pop Art movement. That was totally ridiculous. The thing that did occur though is that . . . is that caused a movement or something that was called "Pop Art" was that there was a lot of energetic people at the time, I think, and that energy happens. Then, someone can say it is a "movement." So, that's basically that.

PS: Did you know Jasper [Johns] and Robert Rauschenberg when you worked at Tiffany's?

JR: Yeah, I knew them. Yeah, I knew them when I was painting billboards. I met Bob and Jasper in 1957, I think.

PS: [Questions about Rosenquist's own paintings are asked.]

Irving Sandler, New York, 11 October 1978

Sandler is a prominent art critic.

PS: As a person who is very knowledgeable in Abstract Expressionism and the New York School in general, do you want to begin with what you think the reactions of someone like Elaine De Kooning, Bill De Kooning, . . . toward Pop Art—obviously negative from what I've read?

IS: The question is complicated. Yeah, the Abstract Expressionists were against Pop Art. They considered it frivolous. They considered it anti-art. But what complicated the thing was that there was already the precedent of [Jasper] Johns. Now, Johns created a very mixed reaction. The imagery, because of its banality, was put-down. The painting . . . I've written about this particularly in my new book [*The New York School: The Second Generation* (New York, 1978)] just how the painting was looked upon as subversive because it seemed to be a parody of Abstract Expressionist brushwork. At the same time, it was admired. So, before Warhol, you have the precedent of Johns. You also have [Robert] Rauschenberg. Now, that's complicated, too, because throughout most of the '50s, Rauschenberg was sort of looked upon as an *infant terrible:* taken seriously and not quite seriously. It

was kind of easy to put him down. Maybe, not so easy. But, then, what you have in 1959 and 1960 is the emergence of [Frank] Stella. So, you not only have Johns and the mixed reaction to Johns, but you also have the emergence of Stella—and there the antipathy was very extreme.

The action for a period of time—around 1962—is taken from Stella and the emergence of a new abstract art that would later be known as Minimal [Art], while the action is taken by Pop Art—that takes all the play, all the limelight, and it's easy to hate. But underneath it all, the feeling of the greater challenge might have been coming from abstract art was there all along. You see, the very complicated response—the earliest, if not the earliest supporter of Pop Art: Henry Geldzahler—you'll notice that in a lot of time that he is supporting Pop [Art], he still is saying that, maybe, the more important art is Stella, [Ken] Noland, . . . Who else does he single out?—Well, certainly, those two.

PS: Certainly. And, of course, his on-going concern with David Smith.

IS: Yeah, but that's an older generation. I'm talking about artists who are emerging just at that time. Smith and the Abstract Expressionists and even certain artists in the second generation. Someone like Henry is very accepting and generous too . . . but it's when you make the subtle distinctions . . . I first met Henry in the circle of [Claes] Oldenburg and, then, he had a sort of very swift kind of meteoric rise. I met him again many times. I did meet him once at the Factory. I didn't go much to the Factory, of course, but Henry was there. Oh, gosh, the only thing that I remember at the time . . . [Laughs] . . . I guess, it was a great characteristic—there's nothing wrong, you know, asking Andy a question and having Henry answer it, and it seems that was the . . . the way it was going to be. Henry was, of course . . . he was then and is now utterly charming and very generous.

My close friends at the time were on 10th Street: artists at the time involved with the Tanager Gallery, particularly Philip Pearlstein and [Al] Held were probably the closest friends then and still now, and [Alex] Katz and Pearlstein were with the Tanager Gallery then, and Held was across the street at the Broder Gallery. [Sandler describes his work for the cooperative Tanager Gallery and his reviews for newspapers.]

PS: May I ask you what were your initial reactions to, first of all, what Warhol was like: his personality, your feelings when you met him, what he looked like at the time, the circumstances perhaps?

IS: Again, the—how should one put it?—the image that you have of Warhol, as other people have written about him is pretty well the image: quiet, passive, not particularly "cool." I mean, he was never unfriendly. He's still pretty much the same way, although he'll speak much more freely now and is friendlier. I didn't have any strong reactions. I wasn't in his circle. I would occasionally, as I said, go to the Factory. It's interesting. I will tell you this: that in 1962, when I reviewed for the *New York Post,* the Sidney Janis show—and, I think, that's the first show that involved Warhol that I reviewed—I don't remember it as a very positive review either.

PS: This was The New Realists show?

IS: It was The New Realists show, and it was a very long and a very serious review. I remember [that] a number of people in my circle attacking me for *even* writing the review because that in itself indicated that I was taking it too seriously. I don't know how widespread that attitude was but, I think, very widespread.

PS: Now, you mentioned that [Philip] Pearlstein was in your circle . . .

IS: No, no. I'm talking now about the Abstract Expressionists. Pearlstein had already moved out. [Alex] Katz was never really part of that, and [Al] Held, you remember, that a picture like this [Sandler points to a painting in his living room.], which is by Al Held: one of the first. It was painted in 1960. So, *already* the reaction against Abstract Expressionism has set in on the part of our painters, particularly [Frank] Stella, whose work was shown in 1959. I don't know exactly what Stella's attitude is to Warhol—probably more positive than . . .

PS: Do you think, perhaps, because Stella and Geldzahler are such good friends, as were at the time Geldzahler and Warhol? There's something that I have found strangely interesting and that is the connection between Stella and Warhol that you talked about and Barbara Rose talked about in the mid-1960s. [See Irving Sandler, "The New Cool-Art," *Art in America,* vol. 53, no. 1, Feb. 1965, pp. 99–101 and Barbara Rose, "ABC Art," *Art in America,* vol. 53, no. 5, Oct. 1965, pp. 57–69.]

IS: In "The New Cool-Art?"

PS: Yes, in "The New Cool-Art."

IS: . . . Which, actually, was a summary of articles that I did for the [*New York*] *Post* roughly a year earlier, but even in that article would have been about the first time that an attempt to pin the sensibility

down—whatever it is—and, then, later it became clear in things that Barbara Rose and I do: that compilation of statements called "Sensibility of the Sixties" that appeared in *Art in America* [vol. 55, no. 1, Jan. 1967, pp. 44–57]. Go ahead.

PS: Well, I was going to ask you . . . I thought . . . years ago when I read it that it seemed particularly apt . . .

IS: It wasn't liked at the time. I remember quite particularly, Ivan Karp being rather miffed, but I don't know why. Probably because it wasn't really meant to be favorable or . . . I don't know whether it was meant to be favorable—although that was . . .

PS: Were you and Barbara Rose conversing at the time?

IS: Yes.

PS: It seemed as if both articles appeared almost simultaneously—within a few months of each other.

IS: Barbara Rose's article was "ABC?"

PS: Yes.

IS: That one?

PS: Yes.

IS: Well, my articles had appeared earlier in the *New York Post*. Barbara might have seen them. Brian O'Doherty also wrote an article, which was called "The New Nihilism," which appeared shortly after mine.

PS: Yes.

IS: It may have picked up on ideas on what I . . . Barbara and I *talking* at the time about this? No. No. We were not . . . we knew one another. We would meet every now and then and collaborate on something, and we would sort of turn each other on [to particular artists or works?]. We did this on a variety of projects for years, but we would only see one another very occasionally, particularly when Barbara was married to Frank [Stella] because I wrote the first major review of Frank's work, and I raked it up and down. It was the worst review that I have ever written, and [it is] one that I'm not terribly proud of and one that I've completely changed my mind on, but, again, it indicated a certain . . . you see, that's what I tried to say earlier: that for some reason, as I recall it, Stella seemed far more—how shall I put it?—a threat or was taken far more seriously in a very negative way. I mean, that work was . . . you know? . . . than Warhol or any of the Pop artists were.

PS: Now, of whom are you thinking?

IS: Someone like myself who comes out of an Abstract Expressionist ambience and suddenly to run into the black pictures by Stella. To put it as strongly as I can: If what I beloved was art, as really art, then that wasn't [art]. It was something else. If that was art, then what I beloved was something else. It was that sort of attitude. But they couldn't be the same. They couldn't both be art.

With Pop Art, I don't know. It was, maybe, we weren't so heavy then. Maybe, we had two or three years to assimilate the experience of Stella. There was Johns. There was also the assimilation of Assemblage, which had taken place by 1961. And all of these things that happened.

[Sandler is asked about the difference between the paintings by Frank Stella and Ad Reinhardt. There is also a discussion concerning Ellsworth Kelly, Reinhardt, Stella, Morris Lewis and Barnett Newman.]

. . . Warhol's relation to [Barnett] Newman is rather interesting.

PS: To Barnett Newman?!

IS: Yeah.

PS: How so?

IS: What do you do with the "All-Over" [*Campbell's*] *Soup Cans*? Those are "All-Over" pictures, and the "All-Over" painter of the time was, if not [Jackson] Pollock, then [it was] Newman. They're Field Paintings.

PS: And you see Warhol in that kind of relationship with Barnett Newman?

IS: It's an interesting relationship with Barnett Newman and also with Frank Stella.

PS: Do you think [that] he would be consciously doing something like that, as opposed to his commercial art background? Or, are you suggesting a new way of looking at Warhol?

IS: No. I don't know. I think that he fit in very nicely. You know, one of the things about the Pop artists, particularly [Roy] Lichtenstein— and this was noted very early on, and, I think, it also applied to Stella although he was a little bit sloppier, maybe, in the same way that Stella was sloppy—was the relation to Hard Edge abstraction at the time, where Lichtenstein and [Ellsworth] Kelly parallels were always made. Certainly even more: [Robert] Indiana and Kelly. Well, they

were friends. You have to remember that then Indiana was considered very much a Pop artist, less [so] today. Well, still, you know, a part of that. At one point, I was one of the first to start this: to sort of try to separate hardcore Pop from other kinds. Of course, as far as I was concerned, the hardcore Pop artists were Warhol and Lichtenstein. What made them that was the absolutely deadpan quality of their work.

PS: Henry Geldzahler once said that Andy Warhol does not belong to Pop Art.

IS: Well, that's like saying that no artist belongs to a movement.

PS: That's like saying Michelangelo doesn't belong to the Renaissance.

IS: Well, he doesn't in a way. Or, Willem de Kooning once saying that he was *not* an Abstract Expressionist, and he wasn't in a sense. I mean, they were never part of a movement. Certainly, if you accept what Henry said—and I do, because at the time I knew [Tom] Wesselmann (Wesselmann had his first one-man show at the Tanager Gallery on 10th Street), and I didn't know that well, but I have the feeling that Wesselmann really didn't know the other guys. He was sort of doing his own thing somehow, and Henry [Geldzahler] reported that he moved from studio to studio and [that] the Pop artists—the so-called "Pop artists"—seemed like Lichtenstein, Warhol, Rosenquist—didn't know the existence of the other artists. If that's so, there was no movement. They did it independently, and one could say that . . .

PS: Then, Pop Art would be more retrospective?

IS: Well, it was used rather early on, not as early on as other names. What did they call them? "The Common Object painters?"

PS: "The New Realists," etc.

IS: Yeah. And, then, someone remembered that [Lawrence] Alloway allegedly coined . . .

PS: He still claims it.

IS: The only thing that I don't like about the label—that I dislike and it's misleading and it's somewhat . . . with everyone, you know: Lucy Lippard and Alloway himself had said it. . . . [It] is that it indicates a kind of *link*: English Pop and American Pop. And I'm not sure if that link really exists.

PS: I was speaking with Lawrence Alloway on Sunday, and he said that he sees no relationship whatsoever . . .

IS: None.

PS: . . . between the English and the American.

IS: I would agree with that and . . . But the fact that the name was first *used* by Alloway to not even to apply to British artists but actually to British commercial art of a kind—that always carries that quality.
 [Stella, Johns and Rauschenberg are discussed.]

PS: What was [Willem] de Kooning's reaction to Rauschenberg's *Erased De Kooning Drawing*?

IS: Well, you have to understand the circumstances of that, which are very interesting: that Rauschenberg went to de Kooning and *asked* for a drawing and told de Kooning that he was going to *erase* that drawing. And not only that, and I can't verify this, but it's a story that I *believe*: that when *faced* with this problem—because here was a young artist was proposing to *destroy* one of de Kooning's works—but faced with this problem, de Kooning then had a second problem: whether to give Rauschenberg a *good* drawing *or not*. And the story is that he chose to give him a good one. And the other thing, of course, is that Rauschenberg really completely erased it.

PS: You can still see it.

IS: Yes, you can.

PS: Yes.

IS: Which I've always found interesting. [Sandler discusses Rauschenberg's works and their relationship to de Kooning's paintings.]
 There are several confusing things about Warhol for me: the way in which, at one point, what you know is surely mechanical, not even done by Warhol. It begins to take another quality. It almost gets to look painterly—*malerisch*—in the most traditional sense of that term.
 I have the original *Brillo Box* here. The *Brillo Box* was designed by an Abstract Expressionist. His name is James Harvey. When Andy's show of the *Brillo Boxes* at the Stable Gallery, the Graham Gallery, which was Harvey's dealer, came out with a press release, saying that while Andy was selling these for 300 dollars . . . here this poor starving artist, James Harvey, had to support himself by making commercial things like *Brillo Boxes*.
 I ran into Jim on the street a few days later, and I said, "Yeah. It was rather heavy-handed—that press release." He said, "I had nothing to do with it." I said, "You know what you should have done?" I said, "While Andy was selling those things for 300 dollars or 400 dollars at the Stable Gallery, you should have been signing signed

originals at the Graham Gallery for 10 cents each." A few days later, I received a signed *Brillo Box* in the mail, and I still have it: signed by Harvey, of course. Warhol found out about it and called Harvey and offered to trade, but shortly after, before anything could happen, Harvey died. A very young man [and] a promising artist, but he died, I think, of cancer. So, the trade never took place, and I have the only *real Brillo Box*: the original.

Rupert Smith, New York, 19 December 1978

Smith is one of Andy Warhol's silkscreen printers and an associate editor of *Andy Warhol's Interview Magazine*.

PS: When did you first meet Andy?

RS: I first met Andy in 1969, when I was an art student. It was my first weekend in New York, and I met him and either Viva! or Ultra Violet at the Electric Circus. I didn't see him for about four or five years.

PS: Then what happened?

RS: I started to work with him through Leo Castelli, when they were doing the hand-painted *Flowers* series. Leo brought me in to assist on that series. I worked on that for a month or so. After about a year or two years, I approached Andy. He was in need of a printer, and I became his silkscreen head or "pinhead" or whatever.

PS: Now, you said [before the taped interview] that you had worked for de Kooning, Johns and Rauschenberg.

RS: Yeah. Just briefly though. I've worked for them all. For Johns and de Kooning, it was like liaisons — with their galleries here or bring in the stuff. You know, a "gofer" in a strange way. With Rauschenberg, it was followed [?] some of the prints. I never did any of the *Folds* silkscreens because he, really, usually had Stereo Studios do most of the silkscreens, but he had a studio here, and I knew him in Florida, too. I was involved with him in that way, but Andy has been my deepest involvement with any well-known artist, in terms of a real kind of printer-collaboration: working with him as a full time assistant, where he demands and asks a lot of your opinions on how the art should go.

PS: What was the first thing that you did for Andy?

RS: I said that already: the *Flowers* series, the hand-painted *Flowers*.

PS: Okay. And, then, what came after that?

RS: Ah. There was an interlude of a couple of years, and, then, came the *Hammer and Sickle* prints and paintings.

PS: Now, how did the idea come about for that?

RS: I'm not really positive because I came in the middle, and, I think, actually Ronnie [Cutrone] or Victor Hugo . . . I don't know. Ronnie said [that] he phoned down and bought a hammer and a sickle at a hardware store. They set them up and photographed them, and they came about like that. I don't . . . It's always, like, Andy's dual ambiguities: it's just the object, and, then again, it's the political significance tied into it. Whether or not it's intentional, the ambiguity is definitely intentional.

PS: In what way?

RS: Well, Andy always likes everything to be read in two different ways. I mean, you can take it and read it. It gives the critics something to talk about. They have to have something to do, anyway.

PS: Now, could you tell me what happens technically? A photograph is taken or whatever, say, of *Hammer and Sickle*. What happens?

RS: Let's take a portrait. That's easier.

PS: Okay.

RS: Or a personality. Let's say you're doing a *Liza Minnelli*. She comes in, made-up—whatever—Andy has a luncheon or whatever. A couple of hours or an hour of Polaroids [are] taken. They're maybe 10 or 200 taken. I think [that] with *Liza* we took about 100. It was kind of a fun day actually when those were done, but, then, after that we choose four or five (or whatever) out of those particular Polaroids.

 I make a small half-tone positive—10 by 20 inches—of all [of] them, and Andy chose one that he wants, which is then blown up. And, in this case, we used a 40-inch by 40-inch format, and, then, I make a large film positive of the half-tone of the small Polaroid— from, you know, the very original. Through steps, it's blown up to this 40-inch square positive, which is brought in, and Andy then uses it: draws from it, makes his background painting. And, then, I take the positive and make a photo-silkscreen, and it's printed directly onto the painting. It's stretched, and that's it.

PS: You said that you do this in your studio?

RS: Yeah, I do.

PS: And you do the silkscreening?

RS: Yes.

PS: On top of the . . .

RS: . . . The canvas. Most people think that it's the other way around. They always have the feeling that it's hand-colored photography, but it isn't. All the painting is underneath of it. The photograph is printed on top. Sometimes they'll print the hair stubble and the collar. The lips are generally printed for a woman, like in a red—maybe a highlight printed in, but the highlights or the lips or whatever.

PS: You mentioned [before the taped interview] the *Shadow* series, which you're currently working on.

RS: Yeah. Well, what about them?

PS: You said . . . I was speaking with Ronnie [Cutrone], and he said that he took the photograph.

RS: Yeah.

PS: Would this be the same process as . . . ?

RS: Right. He took the photograph. Somebody else—his other printer, [Alexander] Heinrici—had done a series of the *Shadows* a couple of years ago, and, then, Andy revived it recently. So, I had the small negative, which was blown back up into a very gigantic 52-inch by 76-inch positive. It's, like, a "big" piece of film: "a lot of Tri-X [film]," I always say. But, ah, . . . And the same process.
 Andy mixes the paint, and it's mopped on the canvas, and it's . . . We separate them. We cut them up and print them on top with the screen: print the screen on top of the . . . You know, the screen is made from the large positive. Its a photo-process.

PS: When I was here the other day, I saw a huge stretch of unraveled canvas.

RS: Right. That was it. Those are for the *Shadows,* and he mops them all up—paints them all up. He's using a mop for a brush. It's all kind of Abstract Expressionist kind of mark, and, then, it's . . . I cut them to the size that I want, and it's printed on top of them.

PS: How about for the *Piss* series?

RS: The *Piss* series is totally different. There's no photography involved at all. I introduced Andy to metallics. He uses them in a different way. And that we just paint the copper on; and, while it's still damp— slightly wet, Andy pisses all over them, and they turn green.

PS: I can't imagine Andy doing that in front of anyone.

RS: Oh, he doesn't. Well, he has but not often. He's a very private guy.

PS: Now, the *American Indian* series. It was just that one Indian [Russell Means] at Wounded Knee?

RS: Yeah.

PS: That was commissioned?

RS: I don't think it was, but I'm not sure because I didn't print it. I don't know.

PS: What are the other ones that you printed?

RS: Oh. *Gem* series. *Hammers and Sickles.*

PS: What is the *Gem* series?

RS: They were just jewels and gems, like diamonds . . .

PS: Oh, right.

RS: . . . And emeralds and whatever.

PS: Does Andy ask for a specific number to be pulled?

RS: No. That just depends on how we work that out. I've done lots of portraits. Hundreds of portraits. Actually, thousands. A thousand, maybe. Maybe not that many, but a lot in the past couple of years. And the *Sport Stars* series was a lot. I know that we did about 300, even though 80 were . . . I'm including all the small ones, too; but, at least, 100 gigantic ones.

PS: Did Andy do the *Mao Tse-tung* series before you worked for him?

RS: Yeah, he did. He did.

PS: I noticed the other day that there are some *Mona Lisa's* done.

RS: Right.

PS: And it's in the same kind of coloration that he's been using with the *Shadows.*

RS: They're new.

PS: This is like a new "look" or . . . ?

RS: Well, it's similar to the images that he was involved with years ago, but it's a whole different approach, I think. I don't . . . well, it's current with what he's doing now. I mean, I don't find it so eclectic that

he's, like, robbing his own work, his own series. . . . Time makes no difference in that sense.

PS: In the current issue of *Night* magazine, Victor Hugo has a brief interview, and one question that was asked him, "Did Andy ever give you any advice?" and he said, "Trace. Trace. Trace. Trace." Did Andy ever give you any advice?

RS: He has many times. It's hard to say what specifically. It's, ah, . . . Less advice than just watching him in how he deals with things. That's probably the best advice that I get from him. I mean, it's not a verbal situation in that sense. It's just how he activates and motivates everything. He's a real workhorse.

PS: Is there another question now that you're thinking about that you would like to answer?

RS: I can't think of anything. As I told you earlier, however much or however little Andy puts into his work, it always comes out him.

PS: What is . . . ? Now, could we have a typical day of you working for Andy? You wake up and eat breakfast or whatever . . .

RS: Well, let's take today [19 December 1978]. I got up about seven o'clock, went to [my] studio with five assistants because today was the day we printed all the shadows. I printed 41 *Shadows.*

PS: You have assistants yourself?

RS: Oh, yeah. I have more than he does.

PS: Now, is this subcontracted to you?

RS: Yeah. I'm not on the staff.

PS: Okay.

RS: I'm just, like, "self-employed," if you want to take it in that sense because I print for other artists, too. So, I printed for four hours, doing the big *Shadow* series . . . after that, I dealt with one of Andy's clients . . . to rephotograph some of the preliminary artwork for some of the prints, which you saw out on the floor: the *Fruit* series or *Space Fruit* series or whatever they're called. I photographed them, and I turned around and printed a couple of colors on one of the prints, and I thought that I was finished, and one of my assistants was cleaning up. I took off my paint-clothes and came up here [Warhol's studio at 860 Broadway] and dealt with him.
 We're doing his Christmas present: a painting which is duplicat-

ing *Studio 54 Complimentary Drink Invitation,* which will be turned
into paintings, which will be given to his dear best friends and good
clients, from Halston to people who buy a lot of art.

PS: How large will these paintings be?

RS: Well, they'll probably be 12 by 14 inches, but I'm getting them to-
gether. So, I can produce a painting that's around 28 or 36. by . . . I
haven't decided. It will be 28 inches or 32 inches by, like, about 30
inches. Depending [upon] who you are will depend on how big a
painting you'll get.

PS: How did the *Torso* series come about?

RS: Probably through Victor Hugo.

PS: Were you here during the photographic sessions?

RS: Oh, yeah. I did them.

PS: You did them?

RS: A lot of them.

PS: What exactly was all that about? How did it come about?

RS: I don't know how it came about exactly because I came in the middle,
in a way, of them, but I did a lot of the paintings and all of the prints
that were done of them. I mean, if you would pick some boy up that
he liked or whatever . . . "Say, Andy, I got a hot number" [i.e., a
very attractive, well-built and young homosexual]. And he'd schedule
a time, and Andy—the voyeur—would click-click-click away and see
how big his cock is [and] how wide he can spread his ass.

PS: Do you think of Andy as a kind of voyeur?

RS: Yeah, but without almost no consciousness.

PS: In what way? What do you mean?

RS: Like, there's no politics, or there's no attitude there. That's hard to say
that because there does tend to be a prevalence of attitudes of the sub-
ject matters that he picks, but a lot of times it's just that ambiguity
again, where he's not making any commitment. He's just the outsider,
photographing. It isn't . . . become voyeuristic, I don't think.

PS: When I was talking with Danny Fields, he was talking about this in
passing, and he said that Andy was a kind of ultimate voyeur: that he's
so visible, he's invisible and that he's in such a position these days
that he doesn't have to go out and "look" but people come to him.

RS: But also, I think, he's scared of that, too, because he's so vulnerable, and, in fact, that people really want to attack him: strangers or someone enamored by him. They want to get next to him and that makes him, like . . . especially after being shot. He was so scared of that—physical contact—with people. It's hard to touch him. It's really hard.

PS: You mean, other than shaking his hand?

RS: I mean, I've been in Studio 54, where there has been two humpy, well-built numbers that just jumped all over Andy, like, "I'll do anything for you, possibly." You know? And it's like he just doesn't know what to do. He's just freaked out. He'll say to me tomorrow, "Rupert, can you imagine anyone *turning them down*?" I mean, they'll always say to me, "Your place or mine?" And Andy gets freaked out. [Laughs] Which one, maybe. . . . They should beat each other up or something—leave me alone—or watch.

Ronald Tavel, New York, 8 October 1978

Tavel, a novelist and playwright, wrote filmscripts for Andy Warhol, including the *Screen Test* series (1965), *The Life of Juanita Castro* (1965), *Horse* (1965), and *Vinyl* (1965).

RT: Jack Smith once said, "Art is one large thrift shop." I later learned that he was quoting some ad. [Laughter] It's like Byron's statement, "Friendship is love without wings." And you read every word he wrote, and cannot find where he wrote that. I discovered he was quoting, someone, but we don't know who.

But that's something good to remember particularly for people interested in Pop Art: get paranoid about people stealing from their ideas. How can someone in Pop Art accuse anyone stealing!? Or . . . not participating in the large sense of recycling all art!? Some go to more extremes. I mean, it is a kind of plagiarized rearrangement of old material. You're really lifting it and rearranging it. That kind of found object kind of thing.

I'll tell you what I do in my stuff because even the quotes are put to a different purpose. They're meant to echo the source but are not being used for the purpose, but I mean, the source is obviously stood on its own feet or I wouldn't have used it. So, why should I repeat it?

PS: Where are you from originally?

RT: I'm from Brooklyn like Mae West and Walt Whitman and Marilyn Moores and Susan Hayward and Dorothy Lamour. [Laughs] There's a

rich cultural center in the country's fourth largest city. It was an independent city until the end of the nineteenth century. But I was in films before I got into theatre, at least formally. Though I started to write plays when I was fifteen, but I didn't have any of them produced until I was late in the film-writing stage.

PS: What kind of films were you making and with whom?

RT: Well, I was mostly making films with Warhol.

PS: Oh. So, we would begin right away with Warhol?

RT: Right. I didn't start with him. I started with Jack Smith, and I met him in the early sixties and knew him very well and worked briefly on *Flaming Creatures* as a prop man. [Laughs]

PS: What kind of props were you finding?

RT: Well, there was a scene: an earthquake scene, for which I had to run in back of the backdrop and move it so that it looked like everything was collapsing. I was not too good at that. I don't know what you would call that kind of person who shakes the scenery.

PS: I guess, propman. I don't know.

RT: So, I knew all those people with Ron Rice, who did the *Flower Thief,* and those are a whole community of Underground filmmakers to which, in a sense, Warhol was Johnny-Come-Lately 'cause it was . . . you know . . . he would have entered at almost the last phase of its heyday. (Of course, it's still going on.) . . .

 She's [Maria Montez] *incredibly* beautiful—an exotic beauty. That's what interested him [Jack Smith]. With long, straight, black hair. Years later I learned that it was dyed [laughing]—that she was really a blonde! Even that was a new sensibility: that a blonde should dye her hair jet black because that suited her. It was the beginning of . . . Smith used to say—its not accurate but it's very interesting sensibility—that Maria Montez was the first brunette Superstar. Like so many of his theories and ideas and statements, they're crazed, but they're very provocative and have a truth in them. They're not literally true because that's not literally true. I mean, what about Theda Bara or Rita Hayworth? It must have been . . . she certainly started in the thirties. I've seen some of them. I don't know if she was a Superstar in the thirties. And there was Clara Bow.

PS: Clara Bow.

RT: . . . is not a blonde. But his statement means something, and, I think,

what it means is the first Superstar in which the *stress* was on being
a brunette rather than it's accidental that she's such. And it suits her,
and we won't dye and lighten her hair. Here the interest is that she has
dark hair and, hence, exotic. And that's what's important. There is
another irony to that statement about Maria Montez, which is that she
was *not* a brunette. [Laughing] She was a red-head. So, you see, truth
is stretched. You're *literally* a red-head or auburn-haired, and in most
of the Technicolor films, if you see them, it's various shades of red.
It's dyed a different color slightly or tinted for each film, depending
upon who the lighting-person is, essentially. There's a fantastic light-
ing-man for the film *Ali Baba and the Forty Thieves,* and there he
needed a hair tinted very light: a strawberry blonde because he did
phenomenal things by lighting her, generally against backgrounds so
there's a series of endless—I've never seen the film in which an ac-
tress could have so many close-ups, *painful* close-ups, always the
same way which are *never* the same way, and it took me a long time
to figure out why it holds your interest so much when its really in tight
from the neck to the top of the head. There must be 28 close-ups in
the course of the 102 minutes. Why is it always interesting? And it
wasn't until I saw it at the Museum of Modern Art about six months
ago when they had a festival of her films, and I noticed that she's shot
constantly against a blank backdrop: a cardboard backdrop, actually.
And the lighting is altered radically each time so that there are green
reflections or yellow reflections or orange. And all of this is done by
keeping her in a simple gown of either white or very light pink and
turning the lights on it. And she has to do very little. Leave it to the
Technicolor people.

And this is something that would have interested filmmakers at
the time in the early sixties enormously as a study in what was the
magic of those films. How did they get so much mileage and exoti-
cism out of so little? Because even these were, contrary to what people
think, these *were* the major films at their times. They're not B films
nor were they done for children. I don't know where these misconcep-
tions came about. It's that in a cynical, decadent sensibility that we
have now, they look so innocent and childlike, but they were not.
These were the *major* releases of their time, and when they opened,
the *New York Times* carried full-page ads *for a week* before opening
day. Full-page! And they would open at the Criterion which was like
super posh. It was not Radio City Music Hall *because* they weren't
children's films. With the requisite torture sequences, and in every
single film they had blood—blood and guts—and sex and everything
else. "Scabrous" was the word that the *Times* used to use, some sand
and some sex, a totally scabious epic.

People like [Jack] Smith studied very carefully every *frame* of those films, their composition and their sets, their lighting, their color. And their cinematographers were not the best in the world by any means, but when they did something, you never forget it. And when they decide to do a *tour de force* thing in the middle of the film—the way they shoot it—can never be forgotten perhaps because it's surrounded by such static middle-shots. Most of the film, when you finally do see it, like pan or decide to swoop out, dolly out, and more up and over . . .

PS: Like a Busby Berkeley movie.

RT: Right. It's phenomenal, but it's done much more subtly than Busby Berkeley, who's doing it *in order to* dazzle you. They *never* attempted to dazzle. They were merely telling a story, and this was the best way to shoot that particular action—best to be seen overhead. These were important things in that sensibility. So, then, where Warhol comes in is that simple and ingenious esthetic that he used which is *to deny,* you know, art in that kind of sensibility. Do the opposite—*do nothing*—because these things are so elaborate and ingenious even in their subtlety. It's ingenious, say, the shooting of *White Savage* and *Ali Baba.* I'm thinking about both of those films because they're directed by Arthur Lubin, and both of them have been shown recently in New York, and I really don't remember who the cinematographer was. But we had prints of them at that time, too, in New York in the sixties, and Warhol asked to see them. And that's why I saw some of them. In fact, he even introduced me—it was in Boston, I think—at the time to *White Savage* on a program that was done on, just . . . because they sat down—like, here is a film that enormously influenced the Underground films of today. So, he introduced *White Savage.* The irony being that he really had no connection but that was the print that—it must have been CBS, I think, they were the ones (if not CBS, it was ABC) who would have had them and subsequently lost their print of *White Savage.*

But his policy would be looking at this and appreciating its loveliness, and so forth, is to do nothing. Do the opposite. And the real opposite is nothing: to move the camera, do not shoot it in color, do not have sets, do not have any change, and so forth. And he was very proud of the unmoving camera, and once actually used the phrase to me, "That's my contribution." Because when we were discussing a new film at one point, and I thought it would be suited to a moving camera, he said, "No, because that's what I *can't* do because my contribution is the static camera."

PS: So, he felt very conscious of the static camera?

RT: Yeah, he was very conscious, but that is not original with him. Remember, he is not . . .

PS: I was wondering where he would get the idea.

RT: That I can't say except when films were first invented . . . Someone did it.

PS: Edison. [. . .] So, it's the "signature of approval," so to speak.

RT: At some point . . . Well, that's more complicated. The person who substantiates. . . . If you want a definition between the innovator and the substantiator: the substantiator, maybe, is the one who really appreciated it because he can really exploit it. [Literary examples are discussed.] . . . So much of his work is dedicated in bringing back the most primitive and the original principle to simplify things. And this connected to Art Nouveau. Now, Warhol was not a specialist or didn't have a special interest in Art Nouveau, though he did in [Art] Deco. That's quite true that he was collecting privately without saying much about it—about Art Deco objects—and I didn't realize it until late in my relationship. [Tavel describes Jack Smith's interest in Art Nouveau, his own travels in North Africa and his first novel, *Street of Stairs*.] It was good to work with someone who would constantly reduce things to the minimal. And, so, the Theatre of the Ridiculous does the opposite: the greatest elaboration possible that a budget would endure—your imagination and piling things on.

 [Tavel discusses the Theatre of the Ridiculous and his plays *The Life of Lady Godiva* and *The Ovens of Anita Orange Juice*.]

PS: Now, you mentioned Jack Smith and the coterie . . .

RT: That's who I met when I came back [from North Africa]. And Irving Rosenthal. He was a kind of cultural figure of the time. He lives in San Francisco now. Ron Rice and Mario Montez and Beverly Grant and Naomi Levine and Joel Markman. He would refer to these people as his "creatures." . . . Meaning: people to be photographed or put into films, and that was their existence.

PS: How old were you when you returned from Africa?

RT: Well, my age is very vague. [Laughter]

PS: Like Warhol's?

RT: Right. [Tavel discusses his childhood, Kenneth Anger's *Scorpio Rising*.] So, [Jack] Smith would have been more influenced by him

[Anger], and it was an uneasy relationship with Warhol, who they thought of as a Johnny-Come-Lately and as a thief, and he was not. And [they were] jealous of his phenomenal publicity all the time and thought of him not as an artist but someone who had gone in publicity.

PS: How did he [Warhol] look? What was your first impression of him when you first saw him or as you remember him?

RT: It's a kind of ageless person, but it is anything but youthful. It's only when I see photos of him now—I haven't seen him in several years— that he looks *terribly* old.

The important thing to me at the time is that it [Warhol's personality] suited me. It was very distant and cold and hard, and, perhaps, there's great humanity in that distance and my need to work in an atmosphere in which people did not give—emotionally involved or violent about them because that's how work got done. And the more emotional and hysterical in a sort of way—*less* was produced . . . so, I got the most work done with Warhol because of this strange distance that could bring you, as I said, paradoxically very close.

We almost never discussed esthetics. I often said, "In all the years that I worked with him, I don't think we had more than five minutes conversation." And what I meant by that is that five minutes of *direct* conversation about art. And that was true! *We did not!* And part of that was done because we just spoke to each other silently, and that can be done by that distancing. That there was so little conscious humanity between you that there is *just* art. That I could *know* what he felt and what he wanted so that he would just tell me the title of a film and that was all, "You will do a film called *Kitchen*." That's all. By which I knew that it would be set in a kitchen and knew everything else. That it would be blindingly white and the rest. I think for one I actually asked him because we had been working so long together, and I was thinking of a plot by then, "Do you want a plot?" and he paused and thought a bit and said, "No, a situation. I do, though, want a situation."

[Tavel describes the first time that he met Warhol, in which Malanga brought Warhol to a poetry reading at the Metro Cafe. Warhol was trying to find voices for the soundtrack of *Harlot*. Tavel then describes several poets and his reactions to Happenings as well as his friendship with John Cage and Merce Cunningham, when Tavel was a young teenager.]

PS: Were you at all familiar with the books that he [Warhol] was producing—the recipe book [*Wild Raspberries*], the *Gold Book* . . . ? Were you familiar with those?

RT: No. I knew the *Shoe Book* and the advertising because sometimes
when he would become extraordinarily nervous—and I didn't know
over what; it could have been over anything, and I wasn't going to dis-
cuss it anymore than he would have discussed my life—he would
sketch and he would sketch shoes and little drawings that he used to
do for I. Miller. That kind of thing. It was interesting, and, then, I
knew he was up-tight [nervously pressured]. [Laughs] Consequently,
he never lost an opportunity to, you know, get some commercial work
in. Because as you probably know from your research, he made
money immediately when he was freelancing. There's no reason to
stop.

 [Tavel discusses *Harlot,* the *Kiss* series, *Eat* and *Empire. Harlot*
was filmed during December of 1964.]

PS: Well, what happened in *Screen Test #1*?

RT: He [Warhol] had an assistant then, called Philip Fagan, who was an
incredibly good-looking Irish boy—"Black Irish"—who hung around
him all the time, and they used to bake cake together and all this sort
of thing. . . . He was *so* beautiful: Philip. [Tavel discusses certain
rivalries among Warhol's entourage.]

 [Tavel goes back to a time just previous to *Screen Test #1,* in
which Tavel and Warhol are watching a Happening by Yvonne Rainer
at the Judson Memorial Church.] We [Tavel and Warhol] were sitting
in the center and whatnot. What was fabulous about that Happening
was everybody was waiting for it to begin, and it was over, finally,
after two hours, waiting out. That was it. Oh! And me sitting in the
middle, too: kept waiting for them to go somewhere else—to divide
themselves—the performers—from the audience, but they didn't.
During this time—and what I loved about it so much—was Warhol
walking around doing business, which is quite appropriate and sort of
the apogee of art and business that I've found so hard to explain to
people or to put on paper about his commercialism and publicity and
business. *It cannot be divided from the art.* It is turning business into
art. It was never more beautiful than in the midst of this Happening,
in which he negotiated with me. Not only negotiated with me to make
this film [*Screen Test #1*] during the Happening but to develop the
esthetic, somehow. I'd love to know whether it had incubated in his
mind before capitulating to Philip's pressure—he came up with the
idea—or whether it just occurred to him in talking to me then.
Whether he came up to me not sure what he would do, but *in some
way* this was his idea, as he expressed it, "Interview Philip now or
after the show" or something like that, or, "Tomorrow . . . " What-

ever . . . "And go home and devise an inquisition, basically. Sit and
ask him questions which will make him perform in some way before
the camera. You will not be on camera, but we'll hear you talk." Prob-
ably he said that. I don't know. Maybe, he wasn't. But, whatever
"Well do this just in-tight, you know, shot of him for 70 minutes. Two
reels in black-and-white. And the questions should be in such a way
that they will ellicit, you know, things from his face because that's
what I'm more interested in rather than in what he says in response."

In fact, now that I think of it, he did not ask me to inter-
view. . . . He *probably* didn't. I can't swear to this, " . . . to inter-
view Philip." He assumed that I knew enough about him at this point
in his life, and I did to make up enough material. So, that's what hap-
pened. We went and—if memory serves—we had to do it twice be-
cause he was very recalcitrant. He became up-tight. He wanted to be
filmed because he was so good-looking and for it to be a record of his
beauty.

And I learned so much right then and there that other filmmakers
knew and that I did not know, which is that a person genuinely beau-
tiful in real life may *not* be on the screen and vice versa: someone only
fairly good-looking may come across as a great beauty because they
express beauty, you know, and feel it and feel themselves as beautiful
and knew what to do before the camera. It was probably the secret of
Maria Montez. That it is generally assumed now that she was the most
beautiful woman of her time and people say that. And it is true that
I've spoken to three people who knew her: someone who was married
to one of her sisters, and they said that, "She was the most beautiful
woman that I ever saw." I have wondered if I would have felt that way
or if many other people would if you met her in real life, had met her,
you might have felt that it was just a good-looking woman among
many good-looking women in Hollywood. But this is one who pro-
jected beauty. That one because of the dimensions of the face and, of
course, the coloring was terribly important and also the idea behind it.
She *thought* that she was beautiful. She *enjoyed* being beautiful, and
she *said* that to the camera. And the camera said, "Yes." It agrees with
whatever you say to it.

He [Philip Fagan] couldn't. His dimensions, I think, looked cor-
rect, over and oppose to . . . (I'll speak about someone else named
Tosh Carillo, whose dimensions were wrong.) His dimensions were,
I think, that the eyes were set far apart, the nose was large enough to
become the central point, and the jaw was strong. And these are im-
portant. And the hairline is back. But he was so up-tight. He just
crawled into himself, and the more I asked him, the more up-tight he

became and less was recorded on film, and, so, I got more personal about touchy things, which became the principle for me for the next six months. I was beginning to fear my sadism after, you know. This camera is going to stop in 70 minutes. It must be done once and only once.

PS: Is this where you got some of your ideas for, say, *The Life of Juanita Castro?*

RT: Oh, yes. Many ideas were incubating like that. That film did not work, although we all learned a great deal from it. But because it didn't work, that's when Warhol said to me, showing how much [he was] re-evaluating it, "We have to have a better subject than him. So, we're going to do the same thing because I love this idea of *Screen Test,* and it has to work, and the problem here has been the subject. So, we'll get Mario Montez, who thinks of himself as a star. All of these things. He thinks he is, and he wants to be, and he is. And, then, that's how we'll pull this off, using the same technique." [Tavel describes in-fighting in Warhol's "Factory," concerning Philip Fagan.]

PS: Was that part of the fascination with youth and beauty that I seem to associate with Warhol, for some reason?

RT: Yeah. Yes, it's voyeurism. Yeah, sure. And with any visual artist should know: what is the end but beauty? Yeah. There were always many, many lovelies around: a cornucopia of lovelies hanging around. . . . [Tavel describes what happened to Philip Fagan after Fagan left the "Factory."]
 Then we did *Screen Test #2* with Mario Montez. But that was a wow! [Laughs] [Tavel describes Mario Montez as one of Jack Smith's "creatures," Montez's love for his namesake and his desire to continue her tradition (as opposed to "Yvonne de Craplos.")] You see, he [Warhol] was using an established [Underground] star at this point.

PS: I see.

RT: . . . Who Jack [Smith] had been very slow in exploiting, really. He was using him in minor roles because he thought that he had just such a great property that he has to think this over a couple of years. [Laughs] And Warhol waited for nothing. *That* must have annoyed Smith. He just took him up because the film [*Harlot*] became successful right away. It was such a nice film, and that whole technique then . . . But where is he now? He's thrown in the rug now. He lives on Long Island or Florida now, as far as I know, which is part of the symbolic collapse and decline of practically everybody and the dispersal of the [Underground] Scene.

PS: Could you, then, discuss *Screen Test #2*? That was the same idea as with Philip Fagan?

RT: Right, and the idea that I used there was to constantly . . . to defer to his understanding of himself as a star and to treat him as Miss Montez's star and to tell him constantly [Laughing] . . . that I felt, although I acknowledged his great work in the past, I felt that he had been exploited too much as a sex-symbol and wished to treat him out in "more serious material like dramas and serious tragedies," as I put it. And he goes [imitating Mario Montez]: "Oh, yes. That's fine. Yes. I'm perfectly willing." And I said, "You're relaxed?" and like that. We tried out several things.

That's where I really started getting the reputation for sadism, but what you saw on the screen was the genuine belief on his part that this was all so, his willingness to cooperate during it.

[Tavel describes a long section of the film in which Maria Montez's role in *Gypsy Wildcat* is to become more "serious" in Mario Montez's proposed role in *Notre Dame de Paris*.] And, so, he blushed and everything like that but went to it. [Laughter] He got a little uptight about it. He said, "Are you sure a holy priest of Notre Dame?" He said, "Oh! I . . . I see. It is so sacrilegious. You know? If you do it, I mean, you're really asking for it." And he just got in: "Because that person, I mean . . . you know? . . . it's personal with me. I don't care other people unless they're religious, but ya don't fool around that way." I said, "He knows his business. You must cooperate, Miss Montez, *'cause I'll stop this right now!*" So, he did. He went into a saintly thing. That's how I got him to that, but it was the saintly aspect to it. He turned her face, in profile [and said], "And think of the Fire. Oh, Lord, I take thy spirit in my hand. You'll get it." And he did it! And the soundtrack was pretty dirty, too. That was another thing that shocked people: the things that were discussed. They would get up and walk out and scream and call the police. I couldn't believe it. I haven't seen it in many years. The last time that I saw it, I broke in a cold sweat.

PS: Why was that?

RT: The extremeness of it. I couldn't believe myself. I'm not positive just what it was. It was uninhibited and sadistic.

PS: Do you think it was because of the set-up? Obviously, you were conscious of the fact that there was a camera there.

RT: And there were people there watching us film too. I think what did it: to help me speak and to help me to improvise more quickly and also

to forget, but there was like 50 people in the back of me, including photographers. That among other things, this was a publicity stunt for Warhol. And if you drank, you just forgot that, and you just focused in on him for those 70 intense minutes and got this one with just one break while they quickly processed it and put on black gloves and put it in a rubber container, and they're out in five minutes, and you are back. Just time to smoke a cigarette. And I had to do something to . . . I was very tense in those days . . . I could probably do it now without that and ignore the people, but I couldn't then.

I also didn't like . . . I had another complaint against filmmaking, which other people have felt: the exploitation of human flesh. The subject matter itself was upsetting: that you are exploited people in the most *intimate* secrets to create this art. You see, well, you can say that painters always did that, but in a way as a painter, you can choose *not* to exploit them but to tell something good about the person [of whom] you were still making a portrait of.

But if you know what to choose in film, their goodness or envy, it was just them under that pressure. It was their *worst* qualities often, having to behave under tension. You see, with a model you can still relax in a studio. There's no way to relax people in front of a [film] camera.

And I got tired of that: exploitation and playing on their dreams 'cause were paid back by fame and glory, certainly not money. And it wore me out. It seemed immoral, ultimately. I could not come to terms with it, ethically.

PS: But you think that Warhol had this idea of exploiting a person if it's Mario Montez, Philip Fagan, . . .

RT: I don't think that he cared.

PS: He didn't care if . . . ?

RT: I didn't think his areas of concern were not in ethics.

PS: So, his sensibility was somewhere else, but you at the time . . . ?

RT: No, I was concerned.

PS: You were concerned.

RT: And ethics has always been a . . . And it began to seem to me like dirty work. I didn't like it. Who was it (Kim Novak? or was it Kim Stanley?) who said . . . remember that some director said [to her], "You're just a pound of flesh. That's all you'll be for me in front of this camera." She went nuts . . . you *feel that way* when you're doing

it. My God! And it's bringing out the worst in me because: who debases himself more—the person who debases someone else? I felt humiliated in this way. I felt also part and parcel of a system that was doing something as *insane* as thinking of people as "Superstars." I couldn't live with it. And it finally gets to you, you know. Just working: all that publicity under the strain that all . . . I don't know. What is this? Is this to sell newspapers? To make critics rich while you starve to death in a tacky tenement? Everybody . . . only . . . and they called me "the exploiter," which is what was funny. Critics make their living about writing about writers. A good living off it, too.

PS: That's why you mentioned the sadism earlier?

RT: Yeah.

PS: That is what the critics were saying of you?

RT: Right. Whereas, they were even worse because they didn't have to feel the immorality of it, but they could make a sure guaranteed income, writing about it: it was the hottest thing in town.

 I didn't appreciate that. As well as being surrounded with the obvious tragedy of it all. . . . And I know that I did maintain a good degree of objectivity during that whole period because I always thought of myself as a writer, who was there taking up time until I got a break or got something else. . . . And there is something to do. So, when they threw those huge parties . . . and there were *hundreds* of people at these parties [at the Factory], and I saw Judy Garland in her last days. I mean, [. . .] and outworn and bloated and [. . .]. You looked at this and I knew [that] I was not imagining things about what they had done to these people. I saw Zachary Scott in his last days. He was one of the people in *50 Fantastics*. I saw Montgomery Clift before his death. And to look at all this tragedy of deception and confusing and use of people, which this medium had done, and this medium that I could not understand as an art form, but I could certainly understand it as a destructive influence on all involved. . . . And I do have ambiguous feelings about it because something about my childhood experience of films is very important. I guess, I'll never come to a conclusion about it.

 [Tavel comments again on Maria Montez as projecting her feelings while she is being filmed and as being taken from Hollywood by Jean Cocteau to be in unrealized projects. Tavel remarks on ethics in theatre.]

 It's *so* American. What will be more American than that phenomenon: dehumanization.

PS: Do you think that's part of Warhol's message?

RT: Inadvertently. Yes. I'm sure that's one of the things that concerns me a great deal because he thinks of himself as being inhuman. He certainly looks it. He looks more like a robot, too, or a Martian or something that's come from another planet, and he's very conscious of that and of having not what he thinks as being human feelings. And I've seen him deeply hurt many times, but what hurts him more than anything else is the inability of being hurt, which can be the greatest feeling.

PS: So, there are only two *Screen Test* movies? Was it your idea, or whose was it not to continue that series, or was it, in fact, continued and never shown?

RT: There was an idea to continue it with other people, but I forget why it was dropped. I later turned it into a stage play, which is rather different. . . . It developed into a different thing, but I based it on the two scripts, using those scripts.

　　　　But what happened at that time was—talk about exploitation—this guy [. . .] showed up. He had slashed his wrists 23 or 24 times. And Warhol thought that this would be a fascinating thing to do for a technicolor movie: get his story and ask him about it. And the camera . . . and this would be our first Technicolor film. It would focus on the slashed wrists all the time. And just use some effects, like pouring water over them for blood. And he went out and bought a bouquet of flowers.

　　　　So, we filmed it. I went and interviewed him and got the whole story of how he had attempted suicide all of these times and then, reproduced it in a script form, playing all the other characters in his life.

　　　　He consented to do this, thinking that I would change everything, which I didn't. And we did it, and he flipped out [went crazy]. He couldn't believe it. There was a basin of water on the floor, and the basin was catching the water which I would pour on him each time he went through a suicide, and at one time he picked it up . . . And he played with the flowers—his beautiful flowers. He picked it up and threw the whole basin on me. So, we stopped the camera, and Warhol said, "Do you want to just stop?" And I said, "No," like a regular trooper. "I will continue." And I did, and we continued.

　　　　And then he sued. [. . .] said, "If this is ever released, you'll all go to court." And everything like that, and he [. . .]. Consequently, the film was never shown in a theatre. That was our first Technicolor film. . . . But it's written about a lot because all of the heads of film companies at the time saw it, and those people in power

positions got to see it at private showings: a little taken aback by the extremes that everyone was going to . . . but I had to confront it in all of its nastiness.

PS: Was that the first tragic circumstance or was there a series . . . ? I tend to think there was a series of fallings-out . . .

RT: Oh, constantly.

PS: Constantly?

RT: Yeah. But in terms of tragedies, there were these people committing suicide all the time, which got through to you in the end, but I wouldn't blame it on "cinema" because it was going on in theatre, where I was working, as well as in the poetry scene, also. It was just a general phenomenon, I guess, in the arts all the time through the centuries. But it was certainly being accelerated through the use of drugs because at this time people did not appreciate the damage that the hallucinogens and amphetamine in particular were doing. More people died because of amphetamine more than the hallucinogens. Probably, a good many went permanently nuts because of acid [LSD] and what not. But the ones jumping out windows [such as Fred Herko] were largely amphetamine addicts, and everyone was an amphetamine addict at the time.

PS: How do you think Warhol was affected by this?

RT: Well, that's hard to say. When he heard that Fred Herko had jumped out the window, his famous remark was, "What a shame that we didn't run down there with a camera and film it."

You see, it's a complex statement. It's meant. It's serious. He really means it. But what it means beyond that is: anyone can decide whether this is sheer, objective detachment or whether there is a lot of pain in that, too. It's certainly expressed in a way that makes you hate him. It is hard to like anyone who had made a statement like that.

PS: It's like an autopsy doctor.

RT: It's just too . . . it's just what it is. I mean, I've never heard anyone react to a suicide like that—"What a shame we didn't have the camera down there and film it." You cannot like someone who said that, but I don't know if you can hate him either. It's beyond love and hate. It certainly made my flesh crawl, and I never tried to justify it to anyone or to justify my working with him and knowing that about him. . . . It freaked me, that statement. But you know what I mean [in that] it can also be that objectivity that is so far that it is total pain.

This artificial way of feeling good and, then, your thoughts go to what is good about it, and I became excited about . . . because I happened to see Judy Garland and Montgomery Clift in their last moments, and also it was a great scene, and that's life: a vision of the hurly-burly way of life, and tragedy is just a part of it?

That was the first thing that I saw when I went up there: he was finishing off the *Elvis Presley* series and he already, I think, had finished with the *Accidents*. He had a preoccupation with accidents and suicides, which he never spoke about.

The *Brillo Boxes*: I loved. They did so much for you and caused one to think about the beauty of the supermarket, and so forth. I used to sign these. Everyone was really important.

PS: I read that Warhol had everybody sign everything, and that his mother was a good forger of his signature.

RT: I used to forge it, too, 'cause he didn't sign anything. So, I was doing it if I was "high" [on drugs] enough. [Laughter] And sometimes I would sign it with an "X," and then when they'd say, "What's that?" I said, "Well, he can't write." [Laughter]

I think that *Horse* was the very best film that I did for him, and perhaps, the best of all his films. But why will take a lot of discussion and thinking because it's such a visual phenomenon.

There's a film called *Jail,* and you see me [in the credits] as the scriptwriter, and I did not [write the script]. It was something that was one of his policies, in a sense, inevitably. You were connected with him. "But," I said, "that's lying. If you want to give me credit, give it as an actor." "But when you're in it," [Warhol said], "in whatever way, you're directing from within," which was in our terms: writer. What makes something and you shoot it. [Imitating Warhol]: "Oh, are you directing more so than any other actor, particularly the way you're improvising? Any actor can *pull it* in a directorial direction." And, then, I finally said, "It's not what I don't want, my name as the script writer." I had enough of that garbage.

Ronald Tavel, New York, 1 November 1978

During the second interview, Tavel discusses his collaboration with Andy Warhol from the filming of *The Life of Juanita Castro* (1965), after some preliminary questions.

RT: It's something that I've felt strong about—*Couch* and whatnot— whose voyeurism . . . But he [Warhol] certainly didn't have an

PS: [. . .] He would sit there, wrapped up. You know, that's 24 hours long: *Couch.* You know about *Couch?*

PS: I spoke briefly with [Gerard] Malanga about it.

RT: That [film] was very famous in its time because people would come up [to the Factory]. You couldn't show it [in public]. It was before pornography was allowed, but it was the most famous of all the pornographic ones that he did: that one and the one he did in the toilet [a segment of *Four Stars* (1967)], which is hilarious, but *Couch* . . . People just come and fuck for 24 hours. It goes on forever. . . . See, a lot of people would come up to see it, you know, but they would, as it's said, was meant with these films and so many other films: you debauch, you walk out and have coffee and then come back and watch the movie, which everyone did—because how much could you watch these people on a couch?

But he would sit wrapped up with his legs crossed. And like a little child: just perfectly content. It wasn't a look of rapture so much as a perfect contentment that could just go on, and, I realized, could go on for hours and hours like that unless he was interrupted.

PS: [P.S. asks about the dates of the filming, and Tavel locates his calendar for 1965.]

RT: I remember them because I had a calendar—a datebook, and I saved that, otherwise I would get it mixed-up. Memory can be very faulty. I think, all of our memories are much faultier than we think, like everyone went around saying, "We made one film a week, but the calendar clearly shows it was one a month, and he was probably making . . . When I was with him, he was probably making another one without me. So, that's at least two [films per month].

Here's 1965. It says: *Screen Test [#1]*—January 23rd. *Screen Test [#2]*—February 7th. *Harlot* was in December [of 1964]. So, *Screen Test [#1]* with Philip [Fagan] was January 23rd. *Screen Test [#2]* with Mario [Montez] was February 7th. *Suicide* [or, *Screen Test #3*] was March 6th. April has nothing in it.

PS: Did you keep a journal back then?

RT: No. I remember, it was made in early April. May would have been *Vinyl. Kitchen*—that was June, and *Space* was July [of 1965].

PS: Do you remember nicknames at the Factory? I understand Andy was called "Drella." Do you remember how that came about?

RT: I just remember asking Ondine, and he said, "Well, it sounds good

that way because his real name is 'Warhola' Right? So, Drella
Warhola sounds right." And I said, "Yes, it does. No arguing with
poetry." And, so, the hangers-on—the shirt-tail people—were called
"The Drella Drellas," and they always referred to that: "Drella showed
up with The Drella Drellas." Or, that, "The Drella Drellas at this party
or that event." I don't know. It might be traced to Ondine, for all I
know, who would be the type to give everyone [Laughs] . . . and
"Drella!" There's something very ironic about "Drella" because it
sounds like "dowager." Your mother hen kind of [thing], which was
his image then. He was, sort of, to us like a clucking mother hen.

See, there's another thing about him that always impressed me:
[it] was the way "The Drella Drellas" were all incredibly young—
right?—and superficial. They would later be called "The Beautiful
Young People," but they were so younger than that. "Beautiful
people": you usually think of being thirtyish. These ["Drella Drellas"]
are in their early twenties. He would run around with them and would
feel very comfortable with them and did not feel comfortable with me.
See? It was fine if I was a part of the pack; but, when we were alone,
he felt ill at ease, as he did with anyone who was more his peer, and
he loved to spend his time with these specious types. Right? And they
didn't necessarily . . . He had a particular attraction to socialite
types—the high-falutin' descendants of the Mayflower before we got
immigration laws, but not exclusively . . . like, he took to Ingrid
Superstar. You know? So, that's a real curious trait.

PS: Now, during the '50s, he would always ask if there were any "pret-
ties" around.

RT: He liked pretties. That's for sure, but there were always beautiful boys
around, but not exclusively. It wasn't like you picture [Jean] Cocteau.
I mean, if you're nothing but . . . , you don't get through the door un-
less you were a beautiful young man. It wasn't like that.

PS: Were Cocteau's pornographic movies ever shown at the Factory?

RT: I didn't see them. I think, I saw the Genet one—*Le Chant d'Amour*—
but that you could see at a public theatre.

PS: You were going to tell me about Willard Maas.

RT: Yeah, right. He and his wife, Marie Menken, were old-type bohemian
people, and they lived in a penthouse in Brooklyn Heights, and he
taught English at Wagner College on Staten Island, and that's how
Gerard [Malanga] knew him. He was his teacher. And they were
filmmakers, too, and probably poets, and they had raised a lot of chil-

dren who since left. I never saw any children. They had a wonderful penthouse with a garden and all that, and we filmed *Bitch* there because she [Marie Menken] was to be the bitch, and it really didn't work out. We finally had to call it off, and I had to step in and start talking to her at one point, which I had not planned to do, and *that's* why there is confusion.

Some of the books say that I wrote that [script], and I didn't. But he actually asked me afterwards to take credit: Warhol [asked me to take credit] for it, and I said, "No." And he said, "But why not? You know, it's not, more or less, anything that you do for the others." But to me, it was . . . It was . . . So, it wasn't from my point of view that I didn't want a credit because I didn't like the film but because I *didn't* write it and was, in effect, just an actor briefly, even though I was using the same technique on her [Menken], as when I was directing, writing and directing—which is to grill people quickly so as to get reactions while they're . . . instead of wasting time while the film was running.

And they [Maas and Menken] were both wonderful people, and they did a film themselves on Warhol, which should be available because it's shown a lot. It's in fast-motion, showing him doing the silkscreening. And, I think, Gerard [Malanga] is in it. So, I think, it's a commentary on mass production. It's a kind of simple-minded idea.

And she was a great actress. We put her in my movie, [*The Life of*] *Juanita Castro*. She was the star, and she was incredible.

And she sat there with her beer can, and she was probably high but not drunk: one of those people who gets good and high on a beer or two. She was so wonderful because, at one point, it gave me so many ideas for my plays! [Laughs] That's the play that . . . are we up to that?

PS: That's exactly where we were going to leave off.

RT: Oh, that's where we left off? So, that was March or April?

PS: I was just looking for Jonas Mekas' filmography. [See Jonas Mekas, "The Filmography of Andy Warhol," in John Copland's, *Andy Warhol* with contributions by Calvin Tomkins and Jonas Mekas, exhibition catalogue (New York: Whitney Museum of American Art, 1971).]

RT: Oh, that's wrong. That says, "January 1965." No. I'll get . . . Who made these dates up? Do you know?

PS: Gerard [Malanga] told me that, apparently, Mekas got most of his information from Gerard.

RT: Well, he would know it wasn't that. *Suicide* was . . . so, it's April.

PS: April of '65?

RT: Yeah. It could have been right in the beginning of it. Let me think carefully. I remember walking out and leaving town on Easter vacation. [Tavel looks at his 1965 calendar.] Good Friday is the 16th, and Sunday is the 11th. I must have left the 9th. *Vinyl* was filmed on the 9th. No, wait. School vacation begins the day before Good Friday. Right? Not Palm Sunday. So, the 15th: *Vinyl* was made. That means that *The Life of Juanita Castro* or *Horse* . . . Well, I know for certain now. *Suicide* was made on March 6, 1965. So, it has to be at least two weeks after that. So, somewhere from . . .

I note that they're made on weekends, too. And people would be free. That's interesting. All of them.

So, the earliest it was made was March 27, 1965. Let me tell you a story about that. We went to a party—to a dinner—at this guy named Waldo Diaz Balart, who lived on Tomkin's Square on the north side in a townhouse, and that was a very rich section, and it's still gorgeous townhouses. And he knew Warhol. He was an exile, a Cuban exile, who had absconded with all of his funds. So, he, I think, knew what was coming up and whatnot—liquidated his assets and left Havana with *mucho dinero.*

PS: This was the time that Castro was beginning to come in?

RT: Right. Or, shortly thereafter. Whenever. He got out in a time when he could take all of his bread [i.e., money], and he was futzing around, and he was an artist, too, but I wasn't aware of that at the time. And at this time, like a few weeks before, *Life* magazine had published the diaries of Juanita Castro, in which she bad-mouthed her brother: to put down the whole revolution and everything and gave her version of it.

And there was some discussion about this at the dinner table, and Warhol said to me, "Wouldn't that be fabulous! I mean, if we did the life of Juanita Castro!" And I said, "Yes." And he said, "Why don't you get yourself, you know, *Life* magazine? Or, I'll get it." I don't remember when it was published. He might have said, "You know, talk to Waldo [Diaz Balart] about it." Or, might not have [said that], but it was the conversation of that evening of that dinner that gave me the whole attitude about it, and that was quite enough. So, I got the . . .

PS: What was the attitude?

RT: The attitude is, in a sense, the political attitude that I projected in all of my political plays, which is, one, that politics is ridiculous. So, to

take an objective and ridiculous, mocking attitude, which can become quite frightening—because this was shortly after the Missile Crisis, you know. It seemed that way, actually, but it was a few years after, but it was for most of us like yesterday. It was such a nerve-wracking experience to see it in that light, though the missiles are never mentioned in the movie or in the play. But everyone, who would come to see it, has this . . . was . . . on their minds, and *this* attitude against that background is a . . .

It would also form my esthetic about always using a woman in politics. I would not write about political situations unless the woman was the center of it. So, that's sort of interesting: to speak about the Cuban Revolution via Juanita Castro, whom most people would consider a minor figure in all of the events—but to see it through her eyes. You know, later I would do a play about Indira Gandhi and Jacqueline Kennedy and Hanoi Hannah and, finally, Anita Bryant. I'm still doing them, you know, and those glamorous, dangerous ladies in politics.

So, that was it, and it was quite interesting, and, so, I got the magazine. Either I went and bought it, or I had it, or Warhol gave it to me, or something, and read her article and wrote the play in three hours exactly, which is *still*, like, one of my most performed plays and certainly one of the best known. So, it was really a seminal work for me.

So, then, we showed up to film it, and we had a lot of lucky things. We had two sisters, Mercedes and Maria Ospina, and that was very convenient. Then, we devised this technique of my sitting there amongst all the group. It was like a huge choral group with Marie Menken. At first, I wanted . . . I actually wanted Mario Montez to play it. That seemed right and that all of the men's parts should be played by women: just in reverse, which is how we would eventually do it on the stage. But Mario would not [act in the film]. He was afraid to get involved in [Tavel imitates Mario Montez]: "Politics and religion . . . No, this is very dangerous to do these things." So, we asked some women who were around—foreign ladies who gave impressions of "European glamour"—and they said, "Well, that's very interesting. Thank you. But I'm not an actress, and I can't." And, somehow, Marie [Menken] was around, and we used her, and it was just as good.

And she was closest. She was in the foreground, and I was at the top of the heap with all of the chorus, and Waldo [Diaz Balart] was in there, too.

And I would just read the lines, and they would say them, and

[laughing] the whole interest is in the "how" they would repeat them, especially one was pidgin Spanish. And she . . . and, at first, everyone was very straight. They would just say the lines flatly or expressionly (because some of them were actors), and [laughing] she was one who first started mispronouncing the Spanish, as bad as the Spanish was that I had written. She would get it triply wrong, and everyone would start giggling but controlling themselves.

Also, Warhol had this idea. When we set up the camera, it was right dead-on straight, and, I guess, he looked through it, and he said, "You know, that's not really interesting. You people all do this, you know, screen job in this direction. Pretend the camera is here, but we will move it to the side and shoot it at an angle, but do not ever look toward it. Look . . ." And they may have placed an object where it was—"Keep looking at that."

And that gives it *so* much interest because it's so bizarre that way. And, which, you don't realize 'cause a lot of the publicity stills—I see a lot of stills of that film reproduced in books and whatnot—and they're not taken from the film. Obviously, someone was shooting, and they were shooting straight on, giving the impression that it was shot straight on, and . . .

PS: And, so, it was shot obliquely.

RT: Right. So, then, she got more outrageous, as she had another beer or two. I would give her a line. She would say, "What?" and turn around. And, then, at one point, she blew up and stood up and said, "I'm not going to say that line! Who the hell are you to use that snot-nosed 19-year-old kid? I'm 53 years old, and you're telling me what to say?! [Tavel to Menken] "I say, Marie, shut your mouth and sit down and say that line!" [Tavel imitates Menken's drunken noises.] ". . . and sit down. That was a very *stu . . . pe . . . do . . .*" "Gooseano, this revolution is not good for me."

It was so great, and, then, I would say, "Okay, now, Juanita. Please stand up and come forward to the camera for a close-up and give us your big speech." And, of course, by doing that, she walked right out of the camera [range] and gave this big harangue off camera, while all you saw was us. We're sitting there and looking bored and waiting and falling asleep because she never ended.

I think, there, at that point, I gave her the page, actually. And it was a page or two or three of this pidgin Spanish, which I had somebody do for me. . . . And I gave her that—those pages—thinking that she would pick and choose or something, but she read every single line. It went on for 20 minutes, and is, invariably, the heart of

the film and most boring to most people who watch it; but to the critics, it was the highlight. [Laughs] And, at the end, they all burst out into dance because it ran short.

But that was important in so many ways: the film for me probably more so than even Warhol. It was released right away, and [Andrew] Sarris came to review it or just came by, not even to review it. In those days, one hardly went to a . . . especially the lead [critic] of *The [Village] Voice,* you know. But what I mean by that is that it was not something that he would normally do. His job was to review Hollywood films and fine films and so forth, while [Jonas] Mekas did Underground [film reviews], and he showed up. And he reviewed whatever Hollywood film it was, and, then, at the end of this . . . concluding whatever article he wrote that "I had just seen a film by Andy Warhol called *The Life of Juanita Castro,* which I would like to write about. However, I have to think about this more, and, so, I'll probably do that next week." Which is kind of interesting. I mean, how often does a reviewer say that? And then he did, you know, the next week devote half a column to it. First, it [the review] was a Hollywood film or a foreign film. It was some big foreign film by somebody important like [Michelangelo] Antonioni, something like that, and, then, he said, "Let me turn to *The Life of Juanita Castro,* an infinitely more interesting work." And then this Antonioni or [Bernardo] Bertolucci—whatever it was that he was reviewing—[Sarris] went on from there to describe it and to give me a great deal of press, saying that, as both as actor and as scriptwriter, I did a commendable job and whatnot and finishing by saying that: "The day that Castro said that he would like to see Hollywood make a movie of the Cuban Revolution with Marlon Brando playing himself and Frank Sinatra playing Raoul, in that day that the Cuban Revolution became Camp, and Andy Warhol and Ronnie Tavel have now taken over that revolution themselves and they have made the only serious political statement on that historical event to date."

You know, that was just incredible, and we had all of these audiences and whatnot, and, in a sense, we were legitimatized: the Warhol films, thereby, became legitimatized. When a formal critic does that, then that's it.

PS: That obviously had a great impact on you and still does: the review. Did Warhol ever read reviews?

RT: Yeah, every one.

PS: Do you remember him commenting on them? [Imitating Warhol] "Oh, that's nice." Or: "That's bad." Or . . . ?

RT: He would read everything. Well, I remember, whether saying, "That was nice," but, I remember, that he said to me, "Never worry about a vicious putdown. That's a commercial review, as long as it's extreme. If they say, 'You're great,' or if they say, 'You're dreadful,' they'll flock to see it. The only bad review is the middle-of-the-road one because no one will return . . . because viciousness creates controversy."

At that time, I think, I saw him almost push that sometimes to extremes, like, almost beg for vicious . . . and almost cultivate putdown reactions to his work during this period because he couldn't really get really great ones! This "This for art . . . " as well, and he was right about it. You're interested in controversy because it is a sort of cynical attitude that one might have to[ward] the audience. They're not interested in quality in art. They're interested in an event, and controversy is an event.

So, that was that, and, as I said, probably more important to me because it gave me a genre to which I have used as recently as last year [1977] for political plays. Vary them as I might, they're still based on that idea and that attitude.

PS: Tell me about *Horse.*

RT: He hired this horse. Right? Warhol. I remember how the idea originated. It might have been that we discovered that you could just hire a horse for the day, and, I thought, it would be a pony, seen coming up the [Factory's] elevator, and in it comes. And he told me, "Write this movie for a horse. We're going to hire a horse for the whole day. So, write a Western." Or: "I thought a Western would illustrate . . ." And, so, I thought what . . . And, I think, we chose the actors in advance. Right? Oh, this is when I went and interviewed everyone. He chose four really good-looking men. Right?

PS: When I was speaking with Gerard [Malanga], I made this notation [in Mekas' filmography] that you had Hal Wickey as Tex, but, then, Dan Cassidy ended up in the movie.

RT: Yeah.

PS: Do you remember . . . ?

RT: I don't remember much about Hal, as a result. I do remember Dan.

PS: Okay.

RT: I don't remember why he told me to use Warhol. So, I went and interviewed them, and some of them like [Gregory] Battcock were really

up-tight. I think, he was teaching at the time. Larry Latrae was a runaway. Tosh [Carillo] was a bonafide sadist, and that started my interest in sadism because I never got close to one who's at least articulate, and he worked in a floral shop that specialized in funeral wreaths or had a preoccupation with trusses and [. . .]. And I went to interview him with Jack Smith, I think. Was that before . . . ? Did I see him alone? At one point, I did go with Jack Smith, and he showed us all of his things and whatnot.

PS: Chains? That kind of thing?

RT: Yeah, right. [Tavel describes the "gameroom."]

PS: Now, was it Warhol's idea for you to interview or was that going back to what you had done for the previous films—interview the people before you shot?

RT: Yeah. It was a tradition by then to do it. So, I would know . . . because they were strangers to me. So, how would I know what to write for them?

PS: And you had not known Gregory Battcock before this?

RT: No. I didn't know any of these people. [. . .] And [Carillo was] heavily into this S-and-M scene. So, one of the things that I would ask him was how he could do . . . and that's how I learned that he had "educated toes": he could pick up pencils and write with them and whatnot, and he could unzip flies with them, all of which he did in the film, from the horse.

And, let me see, Latrae . . . I don't remember much except that he was an object for the sadists. He was just a kid, and that's what his appeal was, sort of.

And, so, anyhow, we thought about it, and all we could figure—I don't know whose idea it was, but it was a general idea that what we could do with this was, since he had used already in *Juanita Castro* my saying the lines to them, we didn't want to repeat that technique. The next thing was to use idiot sheets. So, that's why these lines are very simple and rhythmic—because they had to be short enough to be written very large on [cue] cards, and Gerard [Malanga] and I would hold them up. One of us held up the name of the actor. See, they didn't know at all what the script was. That was another thing. They just came in at the appointed time, and one of us would hold up a card. It would say, "Kid," "Sheriff," "Mex," or "Tex." One would hold up that, and the other would hold up the line. And you can see how these lines would work. [Tavel points to the script of *Horse*.] They did say them one after another. You see the rhythm of them.

PS: Yes. I did read it over: "That wasn't lovely . . ."

RT: Yeah, right. "The Indian's done it." The way, that ends, and it's like
little musical sections, and, then, I had this tape of Florence Foster
Jenkins. The trio from *Faust*. The final trio. But on their corroded
sound system, you couldn't tell. It sounded like legitimate singing.
She sang it as a duet in English: "Come, angels, above . . ." [Laughs]
Anyhow, the big day came, and the elevator opened. The horse is
downstairs and the elevator comes up. [Laughs] And in comes this
enormous stallion, nervous out of its mind, out of the elevator, with
its trainer. And we all panicked, and I said to Warhol, "I mean, this
is ridiculous! Someone has made a gross error! What are we supposed
to do with that beast?!" And he said, "Well, I didn't know they'd do
that. Anyhow, it's here. So, let's make the movie."

And what we had planned then was very . . . What I saw was
something very strange that I was in . . . I was interested in a lot of
things in this script, which, I think, incidentally, is the best film that
I did for him. That's why it's a pity that it's never shown. Using as
an idea of the film, just the simplest idea to take-off a . . . not so
much a take-off on it but a *genuine* Western, showing what genuinely
went on. And they—the cowboys—had to be celibate, asexuals and
homosexuals. Why else would they spend their whole life on the
prairie? They were also in love with their horses, obviously. Horses as
sex objects. Probably screwing them. Not "probably," they were.

So, that's the theme—just in order to have something to write
about, but though what I *really* wanted to say was how easily would
a group of people under pressure be moved to sadistic acts: to
genuinely inhuman acts toward each other and perhaps the horse—
under pressure. And I had this *very* consciously in mind. Perhaps be-
cause at that time people were publishing books like *On Aggression*.
[See Konrad Lorenz, *On Aggression,* transl. by Marjorie Kerr Wilson
(New York, 1966).] And this book became very famous about it, and
lots of books about it: trying to analyze why World War II happened,
have we really evolved from beasts when actually aggressive, in which
case World War III is *inevitable*—we'll all be killed, or, is that not
so? And, so, we should not . . . All of those theories were in my
mind, but certainly that book, *On Aggression,* had suggested or held
up that idea for examination that we had evolved as aggressive, flesh-
eating beasts and [that] this is our memory and [that] this is our con-
nection with wool and leather, and so forth. It's a racial memory: this
thing that people can never explain why sadists and masochists are in-
terested in fur and leather and rubber and whatnot, and these would be
explained if that theory is true: that these are racial memories still in

the genes, or, running in packs and tearing apart beasts . . . , and so forth. Like: Marlene Dietrich in furs. So, I wanted to see.

I had this *unique* opportunity to demonstrate for myself, to experiment for myself, how quickly would people be moved to *extremely* hostile acts under pressure, inhuman acts towards their best friends (in long range) merely by telling them to do so. Two things were going on.

One, I would *tell* them to do so—"Do this"—and, two, they're under pressure of being filmed and under the pressure of this enormous stallion.

What we learned, child, you would not want to write down in a book because the answer to this question of "how quickly?" was about four minutes it took to reduce them to bestial state!

You see, they got up. They were first playing around the horse. Right? The horse was quite nervous, and the trainer was there but out of camera range and was giving it hay or sugar or whatever. It was not of much help. That horse was frightened, and they would get on it and fondle the horse for all those scenes: kissing the horse and fondling it and doing pretended sexual acts and whatnot. They had no fear under this pressure. They had no normal fear of that horse.

I became quite worried. At one point, it kicked Tosh [Carillo]. It didn't do serious damage, but it *did* damage. And he didn't feel it, as people will not under pressure (like people who have been stabbed in the back and not know it for hours).

PS: Were they probably using drugs and alcohol at this time? Because there is that sequence . . .

RT: Everyone was.

PS: Okay. So, there was a general numbness anyway besides . . .

RT: Right. They were using, actually, poppers more than anything else.

PS: What is a "popper?"

RT: Amyl nitrate that you break and sniff. It's for people with heart conditions. It's to revive the heart. It gives a quick high.

PS: Okay.

RT: Yeah. They were using that like mad, and there's always alcohol around. There's grass [marijuana] around and who knows what else. So, they're pretty stoned [drugged], but not stoned that they can't read or anything, and the pressure also sobers you up. So, it's a combination of . . . But what you saw was the *most incredible* phenomenon

occurring before your eyes. One, that they were oblivious to the danger of the horse throughout, *even* with Tosh [Carillo] getting kicked, and, two, that they went at each other to release that tension when I told them to start beating each other up on that concrete floor of the Factory! Sheer concrete! And start . . . ramming his head . . . and, I forget, who they beat up: started pounding his head on the concrete so that I had to stop them, and it took a *very* long time of screaming.

PS: Did you stop the film at that point?

RT: No. But they didn't believe me! Screaming led from one mad thing to the other. "Let's get serious!! And I'm *not* fooling!! It's not part of the film!! Stop!! Everybody stop!!" Do you know that it took almost five minutes before they actually shook their heads and came out of it!! And I said, "Quick! Switch. Do a pastoral scene." Or something else. "You're all cooking dinner." I couldn't believe it!

I was just appalled. So that's why, I think, it's such an amazing film and because it works on all these levels—because all the time that you saw all of that demonstration—the aggression theme going on—you had the Western half. And it really didn't look like a Western because of the dim lights. Even with the boom [microphone] coming down: you could see the boom. Some girl was holding it. Barbara Rubin, I think it was. And she didn't know that she was within the camera range. It doesn't spoil the effect at all. I remember Warhol saying, "Gee. It looks so real. Like a Western. Like a real Western. I don't know if I like that."

So, then, since the horse was still there, he took another 35 minute reel of just the horse's head. And when the film is shown, it was shown in the middle. They'd show, first, the reel of the four guys and, then, the horse's head and, then, the last reel. So, that was the longest film that we had done to that time. I still think, it's the most interesting and the deepest, easily the most profound thing [that] I had done for him up until then and afterwards. I'm sure in retrospect. [Tavel goes through the filmscript.]

Sometimes they didn't look. They got so involved that they forgot to look up and see who had the action or the line. So, you'd have to shout it or—I'm trying to remember—or walk to the side and whisper it, actually. [Tavel then discusses the shocked reactions to the public showing of *Horse*.]

[Tavel describes the "incredible beauty" of Edie Sedgwick, as a part of the new "look" of people from Boston. Danny Lyons and Chuck Wein enter into Warhol's entourage.] And he [Warhol] would

go around with her [Sedgwick] a great deal and be photographed, and the newspapers ate it up: . . . "With date debutante . . . social register . . . beautiful Edie Sedgwick and Andy Warhol . . ." She brought him much publicity.

PS: So, Eugene Sheppard [the society columnist of the *New York Times*] had something to say?

RT: Absolutely. So, somehow, they showed up on the set of *Vinyl* (which is the next one that I did for him), and they showed up to see it being shot. And this is a chaotic thing. This really pissed me off because I rehearsed it for a week. He [Warhol] gave me the idea behind it because Warhol gave me the [Anthony] Burgess book, *A Clockwork Orange,* and said that he had purchased the film rights from Anthony Burgess, and he wanted me to do it: to find out if it's easier to write an original script or to adapt some other material. . . . So, I took the book and read it and tried it out and found out right away [that], yes, it's much easier to adapt something than to do something original, but I only used the first half of it because I got bored and just stopped in the middle of the novel. So, then, we rehearsed it for a week, and Warhol kept sabotaging the rehearsals for his usual esthetic. . . . But when she [Sedgwick] showed up [at the shooting of the film] with her hair dyed silver, no less . . . he asked her to sit right on the set. She said, "What should I do?" He said, "Well, there's no part for you. So, just sit there." And she ended up stealing the film and becoming a star overnight . . .

It was not *her* that I had anything against but Chuck Wein, who was quite obviously watching this whole business—saw himself as Warhol's screenwriter and was in, edging me out, which is a story you hear repeated by [Gerard] Malanga.

See, Warhol's way of keeping a balance in the Factory was: when anyone was getting too powerful and getting too much attention or publicity (too many press people beginning to notice them) would bring in a competitor to keep them in line.

PS: Now comes *Kitchen.* It was filmed at Buddy Wirtschafter's.

RT: Right. That was in June [of 1965]. And there Warhol said to me, "I want several things this time. First, I want a vehicle for Edie Sedgwick. We're going to make her our Superstar. She will be the queen of the Factory, and I want it in a kitchen because I want, now, white. Completely white." And, I think, he'd seen Buddy's kitchen, and [I] thought that would be good: real white . . . brilliant white. And he said, "I want this one more involved than any of the previous

ones." So, I said, "So, you want a *plot?!*" said I in complete amazement, and, then, he said, "No, I don't want a plot, but I want a situation or situations." I said, "Okay." And, then, I brought him the script, and . . . He always used to take every script. Right? He kept a file of them. But this one he took an immediate interest in. I think he read it right there and said, "This is the best thing you've done." I don't think so, but as I film—it was *clearly* the most developed as a play. And, then, he wanted to direct it. So, we really co-directed it, and this was the first time. I mean, he sat and rehearsed it. He was very interested clearly in her, and this was a break for her.

In the meantime, Chuck Wein, *seeing this* being hit off so well, decided that he would do some sabotage work on it because it was obvious that [Edie] Sedgwick and I made a good team. So, he was taking *her* out every night and getting her stoned, so she couldn't memorize her lines and telling her that "memorizing lines was old fashioned" and "what you should do is just walk in front of the camera and improvise and say whatever you want." So, that sort of happened, but we had her sneeze when she didn't know her line so that there were scripts all over that set: in the cabinet, under the table, inside the refrigerator, every place that I could think of.

But it was chaotic! She'd skip things or go back or not find her place, and she was sneezing all over the place. . . . Also, some actor was put into it at the very last moment. Someone didn't show up. So, that made it very confusing, and, so, Warhol had to go on. I think, that was the reason that the pace was slowing so badly that he just decided to go and to take pictures of them, figuring . . . I think, it was he who was taking the pictures.

PS: This idea of the kitchen: was this supposed to be a kind of slice-of-life, out of someone was like Rice?

RT: Critics always say that: that it's a take-off of kitchen drama. They say, "Kitchen sink drama." I thought of it as an Absurdist play, which it certainly looks like in the script.

[Tavel describes his script for *Shower,* which was not used by Warhol and which was later produced Off Broadway.]

In early July or in late June [of 1965] he suggested *Space.* He said, "Do a thing on space. I have this idea, sort of, people just isolated. I want to use a moving camera. Or, if not moving, at least, different shots of, like, eight people or something. And write out the lines because she's [Edie Sedgwick] not going to memorize anything. And make it something that they have to read. We've really not done that before where they literally read."

So, I did that. I wrote the script in eight parts for eight different people. It was sometime in July [of 1965]. [Tavel describes difficulties between Gerard Malanga and Warhol, as well as another script not filmed.]

PS: Next comes *Hedy,* which [Jonas] Mekas says was filmed during November [of 1965].

RT: It wasn't November. It was February of 1966 . . . at that time the scandal broke with [. . .] shoplifting. [. . .] We decided to do a movie on that. [. . .] It's an incredibly grim film, and, *I think,* how Warhol seduced me into it was that he said, "Well, we'll really use a moving camera and many scenes and all of that. So, you won't be bored, and it will be nice." . . .

As he knew I was resistant to do any more movies, he said, "Why don't you write it out? . . . [Tavel describes difficulties with Warhol and participants in the film.] And Warhol got behind the camera, and he did the camera work, which is incredible and unbelievable. It moves constantly from the high point of action. It's very strange.

PS: As if he's deliberately trying . . . ?

RT: *Deliberately.* Yes. It's beautiful. As the script starts to build toward a climax, the camera leaves it and goes up to the ceiling and begins to examine furniture, also. As a *film,* that's an incredible thing. Again, it was shitting on the script because it was falling together marvelously. So, it was irking me beyond my hopes. . . . This was shaping into a *very* coherent, super-serious statement on Hollywood and American life and everything else. Very ingenious. So, I could not be *over* happy about this direct imposition, but I certainly appreciated it, objectively. [Tavel describes other difficulties concerning the movie.]

[Tavel describes *The Life of Lady Godiva,* his play that was produced Off Broadway, as well as another script not filmed.]

And, at the same time, I did another script: *Hanoi Hannah, Radio Star,* it was called, which is another political play on Viet Nam. I don't remember *why,* but what I *do* remember is this: that I didn't— wouldn't—come to the filming of them, that I *mailed* it. . . . And he said, "Aren't you going to help make them?" And I said, "No. I'm leaving town." It was a Sunday, and I did. I went to the [West] Coast. And what happened was they filmed them [including an adaptation of Wilder's play *Our Town,* entitled *Their Town*]. They became part of *Chelsea Girls.* [Tavel describes his subsequent plays produced Off Broadway.]

Eleanor Ward, New York, 9 November 1978

Mrs. Ward owned the Stable Gallery, where Andy Warhol had his first one-man show in New York.

PS: When did you meet Andy for the first time?

EW: I'm not certain of the year, but he was brought into the [Stable] Gallery by [Emile] de Antonio, and I immediately liked Andy as a person. There was an affinity—an instant affinity, and the gallery was, at that time, completely booked up, and I couldn't even consider looking at his work—just that there wasn't any chance to take anybody on at that time.

PS: And then what happened?

EW: Well, I'm not sure of the sequence of events were—were the following Spring or a year later, but in May or June—I think it was '62—I had to ask an artist—very prominent—to leave the gallery. Ah. He had been scheduled for an exhibition in November. And even though the gallery was completely filled with artists, and I couldn't take on any artists, and at the same time, I had a waiting list (of artists waiting to come in)—because I wouldn't allow it—so, I know that I had November and—now, when I asked this artist to leave the gallery, I knew that November was free—but this was June, and the gallery was about to close (and I spent my summers in Connecticut then), and I decided that I wasn't going to worry about it or think about it, but that the right thing would happen at the right time. And I had a lovely ice house in Connecticut outside of Old Line—a reconverted ice house: it was enchanting—lovely lawns, and I was out on the lawn one summer, a lazy summer afternoon, sunning, reading, and John [Bedencap], an old friend, an architect, was there, and I was lying there on my back, sunning, with my eyes closed, not thinking about *anything* in the world, and suddenly, a voice said, "Andy Warhol." I hadn't been thinking about artists, I hadn't been thinking about the art world. I hadn't been thinking about the gallery. Everything was utterly *remote.* I sat up and thought, "How extraordinary!" My guardian angel. I looked across at John, who was in one of those beach things, you know: sunning and I said, "John, I think I'm going to call Andy Warhol. And if I can reach him and make an appointment to look at his work, would you like to go with me?" And he said, "I'd love to." So I *immediately* went into the house, looked up Andy's number, called—this is the first time in my life that I'd ever called him. He answered the telephone, and I told him who I was. And I said, "Can

I come and look at your work?" And he said, "Wow!" [Laughter] And so we made an appointment, and John, indeed, went with me. And Andy at that time was living about 90th or 91st Street and Lexington Avenue in a blue house. His mother was alive and living with him in the same house with him at that time. And Andy showed me this collection of work, and I was absolutely stupefied. There were the *Marilyn Monroes,* there were the *Do-It-Yourself* paintings, the *Elvis Presley* pictures, the *Liz Taylor, Campbell Soup Cans.* It was an incredible collection. I was absolutely riveted. And I said, "Andy, by a miracle, I have November"—which, as you know, is the prime month of the year—and I said, "I can show you in November." And he said, "Wow!" [Laughs] So, that was it.

Earlier that year, I had been to the Museum of Modern Art, and had noticed a piece of sculpture by an artist named Robert Indiana. And I was with Campbell Wiley, who is in charge of the lending library. . . . This [Indiana] piece was in the lending library. And I said, "This is a fascinating piece of work. What gallery is he with?" He said, "He has no gallery." This was . . . I said that summer was . . . it wasn't much before that. I said, "I want to see his work. He has no gallery? I don't believe it." So Campbell said, "I can make an appointment to go down there." Which we did, and I went down, and I thought that Indiana's work was just smashing. So, he was scheduled to open the season. So that Fall of '62—I opened with Indiana, and with Andy Warhol. And if memory is correct, I think, I almost ended the season with Marisol [at] the end of May or something like that—so that Marisol was considered, more or less, with that group. Then, a very curious thing happened. A young woman from Paris, who was connected with an art gallery in Paris—persuaded Sidney Janis to have an exhibition of so-called "Pop" artists. I think by that time Lawrence Alloway had coined the phrase, and he had an exhibition—and I'm not certain of the timing of it, but I should really preface this by saying that the Indiana show sold out.

PS: Good.

EW: Mostly to museums and to top private collectors. The Warhol show sold out to collectors and to museum directors. There was one wonderful story. I can't think of their names now—they were the two, the two directors then of the Museum of Modern Art.

PS: William Seitz?

EW: Bill Seitz and . . .

PS: Mr. Soby?

EW: No. Peter . . .

PS: Peter Selz?

EW: Peter Selz. Yes. They were known as the "Bobbsey Twins."

PS: Really?

EW: Yes. And Peter Selz ran into Bill Seitz, and he said, "Have you seen the Warhol show?" And Bill said—Bill Seitz said, "Yes, I have." And Peter said, "Isn't it the most dreadful thing you've ever seen in your life?" And Bill Seitz [said], "Yes. I absolutely agree with you. I bought one." [Laughter] It caused that kind of controversy. It was wonderful. It turned out that Andy had paintings in every gallery in New York.

PS: But he never had a show.

EW: No one would give him a show.

PS: Why is that?

EW: I never understood it. He had paintings at Leo Castelli's. He had paintings at Martha Jackson. They were all up and down Madison Avenue. He had paintings that he had gone in and left.

PS: And were they being shown or just in the back?

EW: Oh, I think that they were stacked away. I don't think anybody tried to sell them. I don't even think people knew what kind of price to put on them. He never had an exhibition. He had never been reviewed. So that not one gallery had ever shown not even the slightest interest in showing his work. So, is that the end of that question?

PS: I just tend to listen — to whatever flows in your mind. One question that I have wondered about or haven't spoken to him yet — Mr. de Antonio—what exactly was he doing at that time? I understand that he was some kind of promoter for Jasper Johns and Robert Rauschenberg.

EW: Not really. I think he was enamored with their work, and he was very involved with the art world, but he never really acted as a commercial agent or a commercial promoter, to my knowledge. He had . . . I think, he taught philosophy somewhere in the Baltimore area. He came to New York, and he became deeply involved in the art world, but, I think, it had been a rebellion to what he had been doing.

PS: Could we go now to Andy's first show of November at the Stable Gallery, and I brought the [John] Coplands book to trigger your memory. How were they arranged on the walls?

EW: That's a curious question and I don't think I can answer it. The gallery—the main gallery—was a very large room. It was considerably larger than this [living room]. It was down the street at No. 33, which is a big townhouse. And that large gallery was connected with a wide hallway to a smaller room at that end—the south end of the building. So the very motives of the large hallway was hung with *Marilyns*. All different colored *Marilyns*. The large main gallery . . . I know, on the floor [we] had a *Dancestep*.

PS: Now, that was *on* the floor?

EW: On the floor.

PS: Who's decision was it to put it on the floor?

EW: Andy's. It was this high. There was a *Disaster*. These were in the small south gallery. There was a *Do-It-Yourself* painting. In the small south gallery there was an *Elvis* painting. In the main north gallery there was a *Match-Striker* this big. And somebody took a match and . . . [Laughs]

PS: Oh, no?!

EW: Yes! [Laughs] There were *Jackies*. I can't tell you the exact place. *Coca-Cola Bottles*. There was *Fragile—Glass* or *Glass—Fragile,* I think. I can't tell you the placement of things.

PS: You mentioned that the show was sold out.

EW: Yes.

PS: What was the reaction of the people and the public, in general, walking into the gallery?

EW: Well . . . [sighs], you must remember that in 1962 people weren't lining up on 59th Street and spending three days to get into the Met[ropolitan Museum of Art]. The art world was a much more closed world than today so that the people who were interested in art were, primarily, artists, art historians, museum people and collectors. They were not the mob scenes that you see at the Whitney today. Art hadn't been properly covered, you know, as a cultural phenomenon of the world. It was still the closed world of the artists, the museum people, . . . So, my gallery had a prestigious name, and I had shown a great many important people so that almost automatically . . . I would show someone, and he would be taken seriously, and so it was with Warhol.

PS: And, then, the reactions of the people who'd . . . what were the fun-

niest reactions, the most outrageous reactions to Andy—not necessarily names here—but were they the collectors, the museum people, . . .

EW: The only negative one I told you: Peter Selz. If there were other people who had negative feelings, they didn't let me know about it. There was . . . His second shows was with *Campbell Soup Boxes* and *Heinz Tomato Can Boxes* [*sic*]. Things like that. And a collector came in—a woman—and she took one look, and she ran out . . . screaming. She said that it reminded her of her mother's grocery store. [Laughter]

PS: I understand that was the reaction of many people, "Am I in the right place?"

EW: Well, you see, they wouldn't say this to me. They would say it to each other and when they'd go outside they'd say things, but when they were inside, they never said it to me. [Laughter]

PS: Now, the second show was in '64?

EW: I think so. Yeah.

PS: And who arranged, as you recall, the *Boxes* in the room? Or, how were they put into the room?

EW: Andy and I worked on it together, and Alan [Groh]—he was working on it.

PS: Do you recall the opening? Does it stand out?

EW: I think that Andy and I were both disappointed because we had visions of people walking out with *Campbell Soup Boxes* under their arms. [Laughs] We had visions of people walking down Madison Avenue carrying *Campbell Soup Boxes,* and it didn't happen. But it didn't take off the way we thought it would. We thought that night people would be grabbing things and walking off with them. We had these wonderful dreams about people walking on Madison Avenue, walking north and south, and east and west carrying *Campbell Soup Boxes.* It didn't happen.

PS: I'm sorry it didn't.

EW: It would have been fun!

PS: Yes.

EW: Yes, it would have been great.

PS: . . . Going back to about '62, to the first show, do you remember anything that Andy would say to you that you still recall?

EW: Yes.

PS: Anything in particular?

EW: Yes. "Wow!"

PS: "Wow!"?

EW: [Laughs] Yes.

PS: Okay.

EW: I think the only thing he ever said that wasn't "Wow!" was that he came in one day, in his jeans and in his sneakers, dragging a canvas— a rolled-up canvas that hadn't been framed—dragging it in and said, "Look what the cat dragged in." [Laughs]

 Somebody had given a dinner for Andy, and Andy was in the gallery. And we were both the same—it was probably the most dreadful dinner we had ever been to in our life—and we were discussing the food, the awful food, the awful furniture, the atmosphere: how just simply dreadful it was—that moment the person telephoned. So, of course, I went into what a lovely, lovely evening it was and how much I enjoyed it and be just as positive about it as I could possibly be. And I said, "Andy is here. Would you like to speak with him?" And he took the phone, and he said, "Wow! Wow! Wow!" and hung up. [Laughter] And, of course, the person who gave the dinner was overwhelmed. [Laughter] Nothing could have been greater. [Laughter] Oh, he was wonderful, just wonderful. "Wow!" [Laughter] I don't know if anybody ever told you this story. When he was in art school in Pittsburgh, his art teacher and professors were completely split down the line—50/50. Half of them thought he was a genius and half of them thought he was an absolute zero. But both groups were absolutely positive: the group who thought he was a genius, were absolutely positive that he was a genius and the other side thought that they were wrong.

PS: That is the reaction that I have had in speaking with people—with critics: they are either very for Andy or very against, and that's one of the interesting aspects of Andy because with the Pop, with the other Pop artists, there doesn't seem to be, from what I can tell, that kind

of reaction. Has there been any other artist to your recollection in the past . . . say, since past—well, in the 20th century even—that you can think of that has had that kind of reaction?

EW: No.

PS: He is rather unique.

EW: Oh, completely unique. Completely. He, ah, he's handled himself in the most extraordinary manner. . . . I sponsored a party—I did not give a party, I sponsored a party for an artist in the [Stable] Gallery. It was held in one of those wonderful garages over here—you know— in the 70s between Lexington and Park. In one of those private garages. We had a beautiful catered party. And, ah, an attendant at the door came and said Andy had not been invited because the artist for whom this party was given, I had loaned my name to—I was the sponsor to it—ah, didn't know him. But he was in my gallery. And he really didn't know Andy. And so we heard that Andy Warhol was at the door asking if he could come in. And I said, "Of course." So he came in with his entourage [laughing]—you know—and it was just wonderful. Yeah. It was just . . . you know, the way he would do a thing like that—he would do it with . . . graciousness. In other words, you wouldn't feel offended by the fact that he was crashing a party. As a matter of fact, I felt flattered. I was pleased that he had.

PS: He has immense presence.

EW: Oh, God! He certainly has.

PS: Did you ever attend any of Andy's movies?

EW: Oh, yes. I sat through *Sleep* [laughs], and I sat through the *Empire State Building,* and I sat through quite a few of them—early movies. As a matter of fact, he started making movies, movies in the compound where I lived—in the ice house where I was—when he first started making movies. [. . .]

PS: What was your reaction to the movies?

EW: Oh! . . . Boredom. I found *Sleep* awfully boring. [Laughs]

PS: Did he ever film you besides that [Fourth of July party] weekend in Connecticut?

EW: I mean, you have to be in a certain mood to respond to something like *Sleep.* In the first place, I knew the man [Alan Midgette]. He was a

poet. I forget his name. Oh. I knew him *so* well. And to see him sleeping, it was so ordinary. I didn't need that. [Laughs] You know?

PS: Did you ever ask Andy about his art?

EW: No. It never occurred to me.

PS: In looking across your living room and seeing Andy's *Mona Lisa,* which you have sideways to fit the wall, I was wondering if you acquired it after the second show? Or, what happened?

EW: No. He brought that into the gallery, and, ah, as we both said, he was extremely generous. And his prices were very, very low. And I was under the very clear understanding that he had given it to me, and, after he had left the gallery, he told me that he hadn't given it to me, and I had felt that he had given it to me. So, we resolved it by saying [that] we'll go 50-50. You know, part mine and part his. So, that's where that ended.

PS: What happened after the second show? He went to Castelli's after two shows with the Stable [Gallery]?

EW: He went to Leo Castelli's [Gallery]. While he was in the firehouse [studio], an artist (who will remain nameless) went to see his work, and Andy felt after seeing his show that he had been "influenced," in other words, "taken" things from Andy, and for that reason, Andy felt determined that he should go to the Castelli Gallery, which I thought was wise—afterward. He felt that he couldn't bout it. He felt that he couldn't bout him unless he was right in the same place with him.

PS: Okay. I have an idea of whom you're speaking of.

EW: [Laughs] You probably do. Let's not mention the name.

PS: All right. Did you have Andy's work on consignment after that?

EW: When he went to Castelli?

PS: Yes.

EW: No.

PS: Did you ever ask him why he did certain images?

EW: Oh, no! I wouldn't even dream of asking an artist that question!

PS: When I was speaking with James Rosenquist, he was comparing for me the Abstract Expressionists and the Pop artists, who apparently didn't know each other at the beginning . . .

EW: The Pop artists didn't know each other at all in the beginning. No one knew anybody. [Robert] Indiana had never heard of Warhol. Warhol had never heard of Indiana. The only reason why they heard of Marisol was because she had a show with me. The only reason why they knew of Rosenquist and Roy Lichtenstein was because they went to a show at Leo Castelli's [Gallery]. They never knew them personally.

PS: How about the influence of Jasper Johns and Robert Rauschenberg?

EW: They had no influence on the Pop artists.

PS: In what way? Because in art history books, they always say that they had immense influence.

EW: Oh, no! Not to my way of thinking.

PS: Could you explain that for me?

EW: Well, the Pop artists were all so independent, they were separate from each other, certainly. There isn't anything in Andy that would have come out of either Rauschenberg or Jasper Johns. You can say the same thing about Lichtenstein. You can say the same thing about Rosenquist. You can say the same thing about Indiana. I just completely disagree, but everyone is privileged to their own idea. And I could be wrong, but that's my feeling.

PS: Did you include Andy's earliest comic book paintings in his first show?

EW: No. I didn't see them probably, at the time.

PS: How about the *Two Dollar Bill?*

EW: I had given him my lucky two dollar bill to do a painting for the first show.

PS: Did you ever go to Serendipity?

EW: Only to eat, not to look around. Why?

PS: Well, Andy used to go there a lot. [E.W. then discusses the art scene during the early 1960s, a time for her of much excitement, as if "living in a Golden Age."]

Andy Warhol, New York, 6 November 1978

During the interview, also present were Ivan Karp (IK), Brigid Berlin (BB), Vincent Freemont and Fred Hughes.

PS: Oh, Andy, thank you for inviting me to lunch.

AW: Oh, We invited Ivan. Ivan invited you.

IK: [Karp mentions that he spoke with Ted Carey and asks Warhol "to reveal as much of you as possible" because of the "importance" of P.S.'s project.]

PS: Brigid won't talk to me. She said she's talked out.

AW: I'm talked out, too. [Warhol asks Karp about restaurants and complains about food additives. Warhol remarks that Truman Capote considers Raphael Restaurant the best in New York. Karp considers it "shockingly expensive." Warhol and Karp discuss other restaurants, and Warhol asks Karp to be the restaurant critic for *Interview*.]

PS: In your *Philosophy* book, you mention "wings." What are they?

AW: Oh, those are dimestore facial . . . anti-wrinkle devices . . .
 [Brigid Berlin interrupts Warhol to discuss the proposed lifting of her eyelids. Berlin also mentions that she is no longer taking drugs. Karp talks about his Monday poker nights and about New York restaurants and cigar shops.]

PS: Andy, you've done a lot of portraits. Of the people who've done your portrait, which one is your favorite?

AW: The one by Philip Pearlstein, done in the '40s.

IK: I didn't know Philip Pearlstein ever did your portrait. . . . You know, Andy, the "right" answer would have been your *Self-Portrait*.

PS: What was your impression of Alice Neel's portrait of you?

AW: Oh, I like Alice Neel. I thought it was wonderful.

IK: It was the only truly expressionistic style that captures [. . .]

AW: When she started it, it was so pretty, and, then, she put in these funny lines and suddenly so it was so distorted that . . .

IK: [Karp interrupts Warhol to vent his views on Alice Neel. Karp then talks about being in a wine society.]

PS: Andy, do you remember Elaine Baummann? You used to call her "The Little One." And she was telling me about how you blotted the walls of her bedroom . . .

AW: I don't remember. I really don't.

PS: Do you remember the drawings you did in a bathroom?

AW: No.

PS: Ted Carey said that you would. They were in the bathroom of a photographer.

AW: Oh. I think, it was cats in the bathroom, a children's bathroom. But they moved out, and, I think, they painted over it.

PS: Now, one thing that I've noticed is that you developed the blotted-line before you came to New York. Is that true?

AW: Yeah. I did it in high sch[ool]. . . . I did it in college.

PS: At Carnegie Tech?

AW: Yeah.

PS: Who was your favorite or most memorable teacher at Carnegie Tech?

AW: Hmm. Sam Rosenberg.

IK: Where is he now? That's the question.

AW: He's dead.

PS: How about [Robert] Lepper?

AW: Oh, yeah. He was nice. Yeah.

PS: And, I remember, that he had several different ideas—design problems—for instance, you take a . . .

AW: I don't think he ever taught me. I'm not sure. Maybe he did. I don't remember.

PS: Now, you went to Carnegie Tech at a very early age. Did you enter when you were 15?

AW: No. I was 16. But no . . . I don't think . . . Lepper . . . I may have had him. I can't remember because there were, ah, you know, two sections, and half the kids got one person and half the kids got another person. I'm not sure.

PS: Well, Philip Pearlstein remembered . . .

AW: Yeah? So what? . . . But he had gone to school before me, and he gave . . . He had Lepper, I think, before that. Maybe we did. I can't remember.

IK: That's his only claim to fame.

AW: Oh, no. [Laughs] Did he give you the interview . . . ?

PS: No, he won't do it so far . . .

AW: Oh.

PS: But you could ask him.

AW: Oh, okay. Do Dorothy [Pearlstein]. Dorothy is better.

BB: Is he in Paris?

PS: Dorothy is better?

AW: Yeah. Do his wife Dorothy. She'll do it.

PS: I was thinking of some questions about Lepper's course because in [Rainer] Crone's interpretation, he talks about various kinds of design problems: take an article of clothing and assign a personality to it. And Crone claims that this is the origin of your work since then.

IK: I can't believe a concept like that.

AW: No. No.

IK: I can't believe a concept like that. That's too theoretical and intellectual.

AW: That's true.

PS: When you first arrived in New York, I believe, you were living with Francesca Boas. Is that the first place you lived?

AW: Ah. Now, we lived in St. Mark's Place.

IK: You did!?

AW: Yeah. I was there before the hippies.

IK: Over there on First Avenue?

AW: Yeah.

IK: Oh, it was. We rented someone's apartment for the summer, and it was a six or seven story walk-up. And . . . uh . . . I bet, it wasn't a bit romantic.

AW: No. It was . . .

IK: I bet, it was horrifying.

AW: Yeah, it was. It was 1949 because we had that place just for the summer. And, then, I think, I lived with Philip [Pearlstein] for a few months, and, then I moved up to 103rd Street and Manhattan Avenue.

PS: And . . .

IK: Manhattan Avenue? Way up there?

AW: There is no Manhattan Avenue anymore. . . . They built a big project on it.

PS: Well, at that time that you were living with six or seven people. It reminded me of a kind of *My Sister Eileen* bohemia.

AW: Oh. Ah. It was just like *My Sister [Eileen]* because it was a very small apartment.

PS: And I understand that there was one large room where you had your working desk.

AW: Ah. No. That was the bedroom.

PS: The bedroom.

IK: Who told you this?

PS: Two people. Elaine . . .

AW: Elaine. Yeah.

PS: And you called her "The Little One." That's what she said. And I also talked with Marjorie Beddow.

AW: You did?! What's she doing? She was a big dancer. Is she still dancing?

PS: Well, she's now a choreographer.

AW: Where?

PS: Ah. I'm not sure.

AW: Is she beautiful still?

PS: Fantastic looking.

AW: Really? And what kinds of shows is she doing?

PS: Who was the man she was living with?

AW: Victor Reilly.

PS: Victor Reilly. He's now on Long Island, and I'm going to contact him.

AW: Oh, really? Oh.

PS: She . . . anyway right now she does industrial shows.

AW: She does? Really?

PS: She directs them and choreographs them.

AW: God! Is she married now or . . . ?

PS: She's divorced now. [. . .]

AW: She was younger than I was. She was only 14. And her girlfriend married Burgess Meredith, and she was married to Burgess Meredith for 22 years or something . . . she was on the cover of *Life* magazine.

PS: I also talked to Bob Fleischer. How was that apartment . . . ?

AW: There was a bedroom. . . . A big bedroom where I worked and another bedroom, which was also the living room. . . . No, it was the bedroom, and there was a bathroom and a kitchen and then a hallway and then another bedroom and a living room or whatever.

PS: Where was your painting of a Shanghai baby crying . . . ?

AW: Huh? No. It was a drawing, maybe. Ah.

PS: Going back to the drawings, you said you got the idea of the blot-drawings from college. How did that happen?

AW: Well, it was just that I didn't like the way I drew. I guess, we had to do an ink blot or something, and, then, I realized you can do an ink blot and do that kind of look, and, then, it would look printed somehow. Ah. And that's how, I guess, I did it.

IK: [Karp discusses wine and wine bottles.] The thing to do with Andy is to ask him questions which I can help answer because these questions . . .

AW: You know, Victor [Hugo] is such a good . . . artist. He's doing all these "come" sheets. You know, he "comes" on sheets.

IK: Yeah. What's the calligraphy like?

AW: Oh, it's just great. I was trying to get him to do *Piss Paintings* because I've been doing *Piss Paintings*.

IK: *Piss Paintings?* That's old hat.

AW: No. They're great. You haven't seen them. It's called *Oxidation*. You haven't seen them? You want to see one?

IK: No, not for a while.

PS: They're the copper ones that you showed me.

AW: Yeah.

IK: On copper plates?

AW: They could be copper plates.

IK: Oh. How could you have the audacity to use copper: to piss on copper?

AW: Yeah.

IK: It was . . . you know, with fine wines it shows everything.

AW: Oh, really?

IK: Who knows if . . . It does. It *should*. [Laughs]

PS: Would you like to talk about . . . ?

IK: No. Why don't you mix it up, instead . . .

AW: Yeah. What? What?

IK: You know it's good for him to talk about his past which he has blocked out.

PS: I'm very much interested in . . . I love your work in the '50s with all the cherubs . . .

AW: Oh.

IK: What do you mean [by] you love it?

PS: I love it! Look at it.

IK: I never saw those.

AW: Oh, you don't want to see them, Ivan. Let's . . . let's talk about some things since Ivan's here. He can help you with . . . refresh my memory . . . my friends know it better than I do.

IK: Yeah, let's talk about his life since 1960.

PS: I'm sure, you've been interviewed lots and lots and lots of times . . .

IK: Of course. He's tired.

PS: Is there any question that you . . . ?

AW: No.

PS: . . . Have not been asked . . . ?

AW: No.

PS: . . . That you think is important?

AW: No.

IK: That's a formal question. Why don't you ask him: why is he famous? Go ahead. I'll tell you the answer.

PS: What's the answer?

AW: Yeah.

PS: Andy, why are you famous?

AW: [Laughs]

IK: Because he is famous. That's the best question that a person can ask and answer.

AW: Oh, really? Is it? Is it? That's a good answer. If somebody ever asks me . . . Oh.

PS: Well, a couple of key questions . . . Now, I can understand going into commercial work and all . . . there is that time from 1959 to 1961 when you were still doing commercial work, and Nathan [Gluck] was still working with you . . . and, then, Gerard [Malanga] . . . and, then, you did the early comic book stuff that were on the 57th Street side of Bonwit's . . .

AW: Yeah.

IK: You did comic book stuff then?

AW: Yeah. That's where you saw them. You know, I showed them to you afterwards. They were at Bonwits on 57th Street.

IK: I saw them around the house?

AW: Yeah. No. Afterwards, I mean. They were . . . Yeah, we showed them to you.

IK: What did you do them for?

AW: It was a T.V. . . . or a commercial . . . yeah. It was a commercial or something.

IK: Wow! That's a terrific drawing. When was that? That's fabulous.

PS: You did a lot of early line drawings that had very political or pungent social . . .

AW: Oh. That was just because, ah . . . those were the only people that could use, ah, artists, ah, medical ads and stuff like that. They could use drawings in the news because you could get with it. I don't know.

PS: Was Ben Shahn working freelance at that time?

AW: Yeah. I think so. Yeah. For the same magazines.

PS: What do you remember about Ben Shahn?

IK: When did you work for Ben Shahn?

AW: Oh. All the same places I was.

IK: Is that true?

AW: Yeah. He actually got his big start at *Seventeen,* I think, and C.B.S.

IK: Did you communicate with him?

AW: Mmm. I can't remember. I might. I don't know now. It's hard to say if I ever met him, but I . . .

IK: Where's this drawing now?

AW: I don't know. Somebody has it. I never saw it before.

IK: It looks like a very serious piece.

AW: I know. I never saw it before. I was surprised to see it.

IK: It's someone on television.

AW: I know.

PS: Anyway, getting back to my other question about this transition time, I understand you did large canvases with this blot technique.

AW: Yeah. Nothing ever arrived. I think, I threw them away.

PS: Do you still have them anywhere?

AW: Oh. No. No. Ah. I think, I don't know. I don't know. It might have been some things from school, that I did in school.

PS: The thing there was, again, this transition time—when you were using the blotted technique on paper and doing it on canvas—then you switched to comic books, and I was kind of wondering why you would do that.

AW: No. I . . . I . . . well, when I was doing commercial work, I did a lot of straight line things—you know: without the blotted things . . .

PS: Like *Amy Vanderbilt's* . . . ?

AW: No. Everything: the shoe drawings [*sic*] and . . . everything . . . a lot of things. I don't know. Shoe illustrations and things like that with a, you know, a hard tight line, a mechanical line.

PS: And then the comic books follow that?

AW: Ah . . . Ah . . . Well . . . Umm . . . Well, for window display, and I did some . . . umm . . . some comic book things, I guess. Well, actually, I didn't know about Roy [Lichtenstein], but it all happens through Ted Carey. . . . Actually . . . Actually, I think, it was Ted who saw the things first, and, then, he told me.

IK: Did I take you to see them?

AW: No. I bought a . . . No. No. He was an old friend. He bought some Jasper Johns, and he . . . But, yeah, he bought something the week before, I think.

IK: Yes, and he brought you back there [to the Leo Castelli Gallery]. "Well," I said, "look at this thing in the racks."

AW: That was the same day?

IK: Yes. "Ooo!," you said to me, "I did something like that just recently."

AW: Oh. Oh. Yeah. Maybe. Because Ted got me, and he said that he had shown it to you first, actually. Ted knew about it.

IK: Yes. He mentions it. "Did you show those to Andy?"

AW: What?

IK: Or he said something like that.

PS: [P.S. reminds Warhol about his remark to Ted Carrey—"Oh, shit, anybody can do that. That's not art."—when they saw a Rauschenberg collage at the Museum of Modern Art's lending service. Karp protests that Warhol would never use an indecent word. Warhol asks Karp what is being shown at his gallery. Karp then discusses his own collection of Folk Art.]
When did you first become interested in Folk Art?

AW: Ah. I guess, Ted . . . Ted got me interested.

IK: Did you collect it—Folk Art?

AW: Yeah. I mean, Ted . . . You know, Ted was living in Sugartown or something like that—that was in Pennsylvania. [Warhol and Karp discuss restaurants, investing in buildings, *Interview* magazine as just breaking even, the magazine's typesetting and wines.] I think, we should have more pictures and less interviews, but people don't buy just pictures, and you have to look at something written. [Warhol talks about the weather and pollution and auction prices.]

IK: My *Brando* is unsigned . . .

AW: I didn't sign them.

PS: What I thought was interesting was that you picked *Elvis Presley* at that time in the early '60s.

AW: It was because I went to the movies with Ivan a lot. We used to see Elvis Presley movies.

IK: And also Troy Donahue. It was a fierce selection.

AW: Oh.

IK: That was a brilliant picture.

AW: Oh. He was so great. God!

PS: Did you ever meet Elvis?

AW: No, we never met him. Did we ever meet Elvis?

BB: No.

AW: No.

PS: Or Marilyn Monroe?

AW: Just a couple of times at a . . . [Warhol talks about the opening of his *Torso* series at the Ace Gallery, Los Angeles.]

PS: Did you have other assistants besides Nathan?

AW: No, just Nathan. He just worked two hours in the morning. Just three hours a day.

PS: Do you want to go through Rainer Crone's catalogue?

AW: No.

PS: Well, I was just thinking of last names, and I've heard a couple of stories about why you dropped the "a" [in Warhola].

AW: Well, the reason why I dropped the "a" is that 'cause when I was going around with a portfolio, it just happened by itself.

IK: People forgot to put it on. Right?

AW: Yeah. So, it just happened. There were other Warhols in the telephone book, and . . . ah . . .

PS: You've often given incorrect birthdates for your birthday, such as for *Who's Who* . . .

AW: Oh, I did it because I couldn't believe that they'd print it or something like that.

Holly Woodlawn, New York, 22 November 1978

Holly Woodlawn, who is one of Andy Warhol's most well-known "Superstars," has appeared in Warhol's *Trash* (1970) and *Women in Revolt* (1970–72).

PS: When did you first meet Andy?

HW: When did I first meet Andy? [Pause] The only reason why I'm taking so long thinking is because I really had . . . I had done *Trash* before I actually *knew* Andy. I worked for Paul Morrissey. Andy wasn't directing or filming *Trash,* but I had friends that knew Andy at the Factory, and, I think, the first time I knew Andy was at a screening for, I think, *Flesh* in the Factory. I met him then.

He was a quiet person, and he never said anything. Well, the one thing he did say was that I looked very glamorous. And I had known *a lot* of people who had known Andy. Candy Darling, for one person, adored him, I think. He was the George Cukor of the seventies, and, so, I was expecting a great . . . one of these loud, boisterous, very, very imposing, assuming or whatever, very big people, very big men. He was a very quiet, little, nothing, and he was always completely shocked, but I thought, he was cute. You could call it "cute," but he's not really cute . . . not attractive, I suppose. But he does look better now.

PS: What was your career like before *Trash*?

HW: I started with Jackie Curtis in Off Broadway plays, with the Theatre of the Ridiculous: Charles Ludlam and John Vacario. I was in the chorus of *A Reindeer Girl* by Jackie, and I hung-out at Max's [Kansas City]. Well, Andy and Paul Morrissey saw the show, and they asked me to be in *Trash*. So, I was plucked from the chorus to be in my first movie after my first play.

PS: Could you tell me about the back room of Max's [Kansas City]?

HW: It was fabulous! It was very *Satyricon*. There was a lot of acid being taken, and everyone would . . . I would just run around in rags. At one point, I had a purse that was a suitcase, and, you know, just the way people would dress. Oh! They were just very, very crazy. Very "up." And Mick Jagger and Bianca, . . . people would just walk in. I mean Salvador Dali and Verushka and her sisters would be at the round table. It was . . . you see, I started going there towards the end of '69 — '68, '69. I mean, Max's was in its heyday in '66, '67, '65, and, so, when I was going there, Andy very seldom went there. At one point, he would go there every night to eat.

PS: He was shot in '68, and, I'm told, his lifestyle changed after that considerably.

HW: I suppose, he didn't go out very much after that and the whole thing.

PS: And so you came to the Factory on occasion?

HW: Yes.

PS: And what was it like at the Factory?

HW: It was a huge room with a desk. It was an office — a huge office with a lot of mirrors, and nothing much was really happening there. I mean, people always thought that — stars flying in, filming, parties or whatever, but not when I was there. [Laughs]

PS: So, your first real work for Andy or Paul Morrissey was *Trash*?

HW: Yes.

PS: . . . which I've seen a couple of times, but a while ago.

HW: Yeah?

PS: How did you happen to obtain the role for *Trash*?

HW: I don't know. I guess, I fit the part. That's what they thought of me. How dare they!

PS: And what was it like?

HW: There were no auditions or anything. They just asked me if I would be in it. Actually, I was just supposed to be in one scene, and the role — the part — just grew. But, ah, that's how I got it, I think.

PS: And was there much improvisation during the . . . ?

HW: The whole thing was improvised. There was a little direction. I mean,

Paul Morrissey. But there were no clap boards and no scripts, and it wasn't like a real movie. It was not 20th Century–Fox.

PS: Could you tell me what it was like filming? How many takes were done? That kind of thing.

HW: Visually, two takes. Two takes. The pillow scene: at one point in the film, I stand up and the pillow falls out. I'm supposed to be pregnant. I'm trying to get on welfare. That took about five or six [takes]. *Most* of the scenes were done in one or two takes.

PS: How was Joe [Dallesandro] during the movie?

HW: He's fine. He was good to work with, I mean, not as an actor: he didn't have much substance, but he was a nice person. He was really nice to me. I was nervous 'cause I had never done a movie. But, ah . . .

PS: And the movie had smasho reviews.

HW: Yeah. It catapulted me to downright stardom. [Laughs]

PS: And then did *Women in Revolt* come after that?

HW: Ah-huh.

PS: Did anything happen in between?

HW: No. Just . . . Well, I did a movie called *Is There Sex after Death?* where I had just a little scene . . . for an independent company. . . . And a lot of interviews, but those were the only two movies by Andy that I worked on. In *Women in Revolt,* I worked with Andy. He did the filming on that [one]. I remember once he put the film in backwards. It was funny.

PS: Now, Jackie [Curtis] told me that Jackie insisted that Andy be behind the camera when Jackie's scenes were being shot. Did Paul [Morrissey] stay behind the camera for the rest of the movie?

HW: No. Andy was . . .

PS: Andy was behind it?

HW: Paul was there, but Andy was the one who actually turned it on.

PS: Now, it was with Candy [Darling], with you and with Jackie.

HW: . . . Jackie.

PS: Could you tell me about Candy? I know that she's dead, and I can't speak with her.

HW: What do you want to know?

PS: What you think is important.

HW: Candy was wonderful. Candy was the one, I think, who had known Andy. I knew Candy since 1963, and she was always with Andy since then, and she was always telling me how he was going to make her a Superstar. And she was very impressed by him, and she is really the one who brought me into wanting to be on stage, in the films, . . . to be a star. There was hope! Andy Warhol could turn anyone into a star.

PS: Of all the times that you have been asked about Andy, is there something that no one has ever asked you about Andy that you'd like to talk about?

HW: Hummmm. You know, it's funny, not too many people ask me about Andy. They usually ask me about Joe [Dallesandro]. . . . I don't know because I don't know Andy that well. I don't know him privately, and I myself . . . I don't know if I would want to know . . . how many times does he go to the bathroom, flush the toilet, . . .

PS: Now, there is a dark side to Andy, and if you don't want to answer the question, I can understand. But I understand that you got a very little amount of money for . . .

HW: . . . for *Trash*.

PS: Like a hundred dollars and that was it.

HW: A hundred-and-twenty-five. It was your basic contract. It wasn't even a contract. It was a release. But, then, who knew that it was going to gross nine million dollars or whatever. So, I was paid for my day's work. As I look back on it now, I wish that I were smarter and put a clause in the contract that I would have gotten a percentage, but I wasn't. So, I, you know, was for a while really bitter because, you know, he was making all that money on it, and I wasn't. And *Trash* . . . I feel that *Trash* helped him a lot. Really established him.

PS: In what way?

HW: In, well, in films. He was doing these in-sync films which did nothing—boring, dull movies, you know. The Empire State Building for eight hours? My god! And then *Trash* came out with a story that made a mark on society because it was dealing with drugs and welfare, and Andy Warhol became a great filmmaker.

PS: Did Andy ever do a picture of you?

HW: I don't think he did.

PS: Okay.

HW: I think . . . no. I would like for him to do one for my album cover.

PS: What previous to *Trash* films did you see by Andy?

HW: I saw *Flesh* with Jackie and Candy. That was a real movie, and it was nice to see them. I prefer to see a Lana Turner movie. I didn't understand *Flesh,* and I didn't understand *Chelsea Girls,* and I didn't care if I didn't understand it.

PS: What kind of directions did Andy give you in the movies you were in? Did you get directions?

HW: I probably did. It would have been "Do this . . . " or "Do that . . . "

PS: How long did it take to film *Trash*?

HW: Six days.

PS: And *Women in Revolt*?

HW: About a year. In all, about three weeks of filming days, but there were months in between.

PS: I understand that was not the original title.

HW: Yeah. I remember one of the titles: *P.I.G.S.*

PS: Have you ever read Andy's *Philosophy* book?

HW: No.

PS: The reason why I ask because in it Andy characterized the people in *Revolt* as being admirable. At the time, he said that transvestites are valuable because they do such hard work . . .

HW: Well, Andy said in an interview—about my nightclub act—that I was a good comedienne and I worked hard, but I don't live in drag, as you can see.

PS: Yes.

HW: When Andy said he admired my work, I liked that. It is my work as another character. He saw that character and put it in *Trash,* and he knows what I went through. [Before the interview continues, Woodlawn's manager shows an 8mm. film of the performer's cabaret act in London, and he gives P.S. Woodlawn's publicity portfolio, including two publicity photographs, which Woodlawn autographs.]

PS: Is there anything about Andy that I wouldn't find in books . . . when you knew him?

PS: Well, he has a rotten hair piece. . . . He likes Godiva chocolates which he used to send me on holidays. He has a filthy mind.

PS: When you were growing up, what were your favorite movies?

HW: Connie Francis in *Where the Boys Are*. That was because I was living then in Florida. I used to watch American Bandstand, and Lana Turner movies—those Bible-pagan epics like *The Prodigal*. . . . I was fifteen-and-a-half when I ran away from Florida. I suffered. I didn't speak with my parents. I met a Greek in Brooklyn, and for five-six years I was a housewife—housekeeping, and I modeled at Sak's. . . . I considered a sex change, but it was too "final." When Liz Taylor in *Cleopatra* opened in New York was when I arrived. The movie was shit, but I loved it, and I love Hollywood shit.

PS: It's said that Andy created his own Hollywood.

HW: Yes. Like Max's—it was like the Hollywood star system with Viva, . . . He had a stable of people. I was the Hedy Lamarr—sultry. Candy was the Kim Novak or another blonde type. Jackie was the Crawford type—vicious and strong type, and Joe was the Clark Gable. At that point, we were on the same level as Hollywood, if not higher.

 It's strange. When you're not a star, and you don't know these [Hollywood] people, and you're not up there and, then, all of a sudden, you are. I have known him [Warhol] since he was a star, and *I* was the one that was star-struck—but awestruck.

PS: One of the fascinations that I've had speaking with people and reading about Andy is that either you love him or you don't love him. There's no in-betweens with *anybody* whose spoken about Andy.

HW: Yeah.

PS: Why do you think so?

HW: Ah. Well, because . . . [Pause]

PS: It's a hard question, I know.

HW: It is. It is, and I know the answer. It's true because I love him now. I adore him now, but at one point I hated him. I hated him because after I was in the movie—after I was in *Trash*—and it was a success, and he made money (or, whoever made money), and it was a success. And he was still Andy Warhol, and I was still poor. So, you know,

I just got bitter about all of this. But, then, now that I think that I'm an adult, it's . . . He gave me the opportunity, the chance, to do whatever I wanted. He put me in *Trash*. *Trash* became a hit, and *he didn't know it* when he put me there. So, suddenly, overnight, I was a star, and I just didn't take advantage of it. I was too dumb, and I wasn't really serious about it. Really! At that time, I didn't want to be a star. I was having too much fun with these people, running around with Jackie and Candy and Andy Warhol. And whenever I needed money, I went up to the Factory. "Andy, I need money. Oh, God! Money! Money! Money!" And he'd give me a check. So, that's . . . so, a lot of people were his Superstars—Edie Sedgwick and . . . —who had bad endings. They just felt that he had to take care of them. I mean, he led them to believe that he would. You know?

He was that kind of thing: "'Daddy Warbucks' is going to be there." And, of course, he's not at times. He doesn't owe anything to anybody. Like it said in the [film] release—for each day that I worked, I got twenty-five bucks and nothing else. So, that's why, I'm sure, that girl shot him because she expected something. And, now, he has that thing that you naturally expected, you know, and he did not commit himself. Why should he? But he could have taken a lot better care of a few people. I mean, he could have given more breaks, done more.

Notes

Chapter 1

1. Edward Steichen's publicity photograph of Greta Garbo was first published in the October 1929 issue of *Vanity Fair* magazine. A similar pose of Garbo was used in another publicity photograph during the same year for her film *Wild Orchids*. See Frederick Sands and Sven Broman, *The Divine Garbo* (New York, 1974), p. 139.

2. Andy Warhol, *The Philosophy of Andy Warhol (From A to B and Back Again)* (New York and London, 1975), p. 68. Hereafter cited as Warhol (1975).

3. Edgar Morin, *The Stars,* trans. Richard Howard, Evergreen Profile Book 7 (New York and London, 1960), p. 44. Hereafter cited as Morin (1960).

4. Ibid.

5. Truman Capote, *Local Color* (New York, 1950), p. 14.

6. Ibid.

7. See Dianne Trimmier, "The Critical Reception of Capote's *Other Voices,*" *West Virginia University Philological Papers,* vol. 17, 1969, pp. 94–101.

8. Truman Capote, *Other Voices, Other Rooms* (New York, 1948), pp. 4f.

9. Ibid., p. 13.

10. Ibid., p. 136.

11. See chapter 2.

12. Calvin Tomkins, "Raggedy Andy," in John Coplands, *Andy Warhol* with contributions by Calvin Tomkins and Jonas Mekas, exhibition catalogue (New York: Whitney Museum of American Art, 1971), p. 8. Hereafter cited as Tomkins (1971).

13. During my tape-recorded interview with Andy Warhol, the artist indicated that this Broadway play captured the situation, living in the communal apartment. Interview with Andy Warhol, New York, 6 November 1978. In conversation with Warhol after the taped interview, he agreed again.

14. Interview with Elaine Finsilver, Hartsdale, New York, 29 October 1978.

15. Ibid.

16. Interviews with Margery Beddow, New York, 31 October 1978; Robert Fleischer, New York, 27 October 1978; and Elaine Finsilver, Hartsdale, New York, 29 October 1978.

17. Interview with Elaine Finsilver, Hartsdale, New York, 29 October 1978.

18. Interview with George Klauber, New York, 19 November 1978.

19. Morin (1960), pp. 96, 98.

20. Andy Warhol and Pat Hackett, *POPism: The Warhol '60s* (New York and London, 1980), p. 15. Hereafter cited as Warhol (1980).

21. Interview with Robert Fleischer, New York, 27 October 1978.

22. Andy Warhol, "Sunday with Mister C.: An Audio-Documentary by Andy Warhol, Starring Truman Capote," *Rolling Stone*, no. 132, 12 April 1973, p. 29.

23. See Jann Wenner, "Coda: Another Round with Mister C.," *Rolling Stone*, no. 132, 12 April 1973, p. 50.

24. There are no known reproductions of these drawings, but see Andreas Brown, *Andy Warhol: His Early Works, 1947–1959*, exhibition catalogue (New York: Gotham Book Mart Gallery, 1971), p. 10. Hereafter cited as Brown (1971).

25. Interview with Fritzie Wood, New York, 1 December 1978.

26. Interview with Stephen Koch, New York, 26 October 1978.

27. Interview with Charles Lisanby, New York, 11 November 1978. Rainer Crone bases, in part, his interpretation of Warhol's drawing style, done during the 1950s, as being derived from Matisse's drawing style because of Warhol's remark, "I want to be Matisse," to Lisanby, as quoted in Tomkins (1971), p. 10. See Rainer Crone, *Andy Warhol: Das zeichnerische Werk, 1942–1975*, exhibition catalogue (Stuttgart: Wuerttembergischer Kunstverein, 1976), pp. 74–77. Hereafter cited as Crone (1976).

28. Warhol (1975), p. 44.

29. The Pop artist has written: "I think 'aura' is something that only somebody else can see, and they only see as much of it as they want to. It's all in the other person's eyes. . . . When you just see somebody on the street, they can really have an aura. But then when they open their mouth, there goes the aura. 'Aura' must be until you open your mouth." (Ibid., p. 77).

30. Cf.: "First of all, Andy has always been ambitious. He wanted to be a star. You know, Andy is what Andy has always been—to be able to magnify and focus. He always *liked* Garboesque kind of women, and always knew a lot about them. There was a woman by the name of Cathy Linton, a model he found, and he was always pushing her. I liked her. She was always nice, you know. He was always fascinated with that Garbo-Super-Movie-Actress kind of mysteriousness." (Interview with Duane Michaels, New York, 22 September 1978. Emphasis Michaels's.)

31. Stephen Koch, *Stargazer: Andy Warhol's World and His Films* (New York and Washington, D.C., 1973), p. 89. Hereafter cited as Koch (1973).

32. Interview with Robert Fleischer, New York, 27 October 1978.

33. Warhol (1975), p. 44.

34. Interview with Daniel Arje, New York, 23 October 1978.

35. Tomkins (1971), p. 9.

36. See Brown (1971), p. 29.

37. See note 10 above.

38. Daniel J. Boorstin, *The Image: A Guide to Pseudo-Events in America,* 2nd ed. (New York, 1975), p. 48.

39. Cf.: *"The celebrity is a person who is known for his well-knownness."* Ibid., p. 57. Emphasis Boorstin's.

Chapter 2

1. Rainer Crone first documented Warhol's actual birthdate in "Das Bildnerische Werk Andy Warhols," (Ph.D. dissertation. Berlin: Frei Universitaet, 1976), p. 81. Hereafter cited as Crone (1976). The birth certification is published in Jean Stein, *Edie: An American Biography,* edited with George Plimpton (New York, 1982), p. 190. Hereafter cited as Stein (1982). Warhol has insisted that the published certificate is a forgery. See Carter Ratcliff, *Andy Warhol* (New York, 1983), pp. 11, 117. (Ironically, the Library of Congress cataloging data on p. 4 perpetuates 1928 as being Warhol's year of birth.)

2. Gerard Malanga, quoted in Stein (1982), p. 184.

3. See Crone (1976), pp. 254, 266.

4. Rainer Crone, *Andy Warhol,* trans. John William Gabriel (London, 1970), p. 12 and catalogue number 421. Hereafter cited as Crone (1970).

5. Andy Warhol, *The Philosophy of Andy Warhol (From A to B and Back Again)* (New York and London, 1975), p. 21. Hereafter cited as Warhol (1975).

6. Ibid., pp. 21f.

7. Crone (1970), catalogue number 21.

8. Robert Lepper, letter to Rainer Crone, 12 February 1974, quoted in Crone (1976), p. 235.

9. Interview with George Klauber, New York, 15 November 1978. Also see Warhol (1975), p. 22. Unfortunately, there are no known descriptions or photographs of Warhol's Pittsburgh window displays.

10. See Warhol (1975), p. 22.

11. Warhol attended a free program in art appreciation and art training at the Carnegie Institute of Pittsburgh. Interview with Jack Wilson, Glenview, 22 August 1979.

12. Philip Pearlstein, interview by Rainer Crone, New York, 14 December 1973, in Crone (1976), pp. 266f.

13. Interviews with Jack Wilson, Glenview, 22 August 1979; George Klauber, New York, 15 November 1978; and Nathan Gluck, New York, 25 October 1978.

14. Interview with Arthur Elias, New York, 28 November 1978.

15. Jack Wilson first met Warhol during their entrance qualifying exam. Wilson was, probably, the closest to Warhol during their freshman year, and he has characterized Warhol at that time as being a "shy and a struggling student because he didn't show much promise." Interview with Jack Wilson, Chicago, 7 March 1979.

16. Ibid. Warhol's infamous interviews since 1963 demonstrate, furthermore, his reluctance to converse on record about his art or his esthetic intentions. He will often use a spokesman to provide any explanations and the artist often and impulsively short-circuits interviews about himself.

17. Interview with Arthur Elias, New York, 28 November 1978. During this interview, Elias claimed not to have seen Warhol as a friend after they graduated from college. In my opinion, Elias could refer to a trip to New York City when they were still both students.

18. See Robert Lebel, *Marcel Duchamp,* trans. George Heard Hamilton (New York, 1959), pp. 35–41.

19. Interview with Joseph Groell, New York, 7 December 1978.

20. Interview with Jack Wilson, Chicago, 7 March 1979.

21. Ibid. Emphasis Wilson's.

22. Another implication of Klee's *Pedagogical Sketch Book* is that the process of reproducing an idea may be equated with the image and may be separated from its artistic means of production through expressive symbols, such as Klee's example of an arrow. By extension, the very notion of a series of such symbols may allow a succession of such a process, and such a "master sequence" (as opposed to a "masterpiece") permits the artist to command a symbiotic process within the series that is revealed only in the viewing of the entire sequence. See Paul Klee, *Pedagogical Sketch Book,* trans. Sibyl Peech (New York, 1944).

 In Warhol's Pop Art painting series, the nuances of such a process are not evident in viewing only one, or even several, such works of a particular series.

 During his senior year in college, Warhol sent a Christmas card, using the blotted-line technique, to George Klauber who still owns it. For an important project dealing with characterizing Pittsburgh's Oakland District, Warhol used the same technique. Interview with Joseph Groell, New York, 7 December 1978.

23. Robert Lepper, letter to Rainer Crone, 12 February 1974, in Crone (1976), p. 238. According to one classmate, the Carnegie Institute's *massier,* Russell Gould Twiggs, did silkscreens with inattention to proper color registration. Interview with Jack Wilson, Glenview, 22 August 1979. It is moot whether Warhol's latter use of silkscreens was in any way influenced by Twigg's prints.

24. See my "Art *in Extremis:* Andy Warhol and His Art," Ph.D. dissertation (Evanston: Northwestern University, 1982), pp. 33–48.

25. Interview with Andy Warhol, New York, 6 November 1978.

26. According to several sources, Andrew Warhola changed his name to "Warhol" sometime in the early 1950s, perhaps because of an enormous telephone bill that was in his original name or because of a misprint of his name for a commercial art work. The artist signed his name "André Warhola" during the late 1940s. Interviews with Ted Carey, New York, 16 October 1978; Tina Fredericks, New York, 1 December 1978; Nathan Gluck, New York, 25 October 1978; and Andy Warhol, New York, 6 November 1978. Also see Tomkins (1971), p. 8. For the signature "André Warhola," see Brown (1971), pp. 4f.

27. Interviews with Steve Bruce, New York, 27 October 1978; Ted Carey, New York, 16 October 1978; Robert Fleischer, New York, 27 October 1978; Alfred Carleton Walters, New York, 28 November 1978; and Fritzie Wood, New York, 1 December 1978. In my unrecorded conversations with Andy Warhol during the fall of 1978, the artist mentioned some of the objects that he collected during the 1950s. Also note Warhol (1975), p. 24.

28. Interview with Alfred Carleton Walters, New York, 28 November 1978. For several photographs of this parlor by Duane Michaels, see Brown (1971), p. 15.

29. Interviews with Robert Fleischer, New York, 27 October 1978; Joseph Giorando, New York, 30 November 1978; and Alfred Carleton Walters, New York, 28 November 1978.

30. Ibid.

31. Even during the height of Warhol's fame as a Pop artist, he continued to sketch and to blot drawings in this manner. Interviews with Charles Lisanby, New York, 11 November 1978 and with Ronald Tavel, New York, 8 October 1978.

32. Galster's description of Warhol's blotted-line technique is supplemented by others. See interviews with Seymour Berlin, New York, 27 November 1978; Ted Carey, New York, 16 October 1978; Robert Galster, New York, 25 October 1978; Nathan Gluck, New York, 17 October 1978 and 25 October 1978; and Peter Palazzo, New York, 7 November 1978.

33. Interview with Robert Galster, New York, 25 October 1978.

34. Interview with Jack Wilson, Glenview, 22 August 1979.

35. Usually, Warhol only blotted one resultant work from an original drawing, but three to four were possible. See interviews with Nathan Gluck, New York, 17 October 1978 and 25 October 1978. While still in art school, Warhol sent a blotted Christmas card, one of two known blotted works from the same drawing. Interview with George Klauber, New York, 15 November 1978.

36. Warhol's blotted-line technique has been—in my opinion, incorrectly—described as being *solely* derived from Ben Shahn's linear stylization. Peter Palazzo, who was Warhol's art director for the I. Miller shoe account during the mid-1950s, has described Warhol's blotting method as an "obvious knock-off of Ben Shahn, [who] was a lot more expensive and [who was] not available." In Palazzo's unpublished manuscript, *Pre-Warhol Warhol,* the art director wrote: "He [Warhol] originally used the technique to simulate the drawing pen method of Ben Shahn." See interview with Peter Palazzo, New York, 7 November 1978. Rainer Crone has compared and contrasted the final, printed appearance of the work of these two artists, and Crone's discussion has dwelled on the surface appearance. See Crone (1976), pp. 73–75.

 In fact, Warhol, like Shahn and David Stone Martin, worked in the graphic art department under the art director William Golden at CBS. The record slip-jacket design *"The Nation's Nightmare"* for CBS Radio was an important early work by Warhol, in terms of his career in commercial art. See Brown (1971), p. 12. For Martin's and Shahn's work for CBS, see Cipe Pineless Golden, Kurt Weihs, and Robert Strunsky, eds., *The Visual Craft of William Golden* (New York, 1962), passim.

 Warhol's relative silence concerning an "opinion" of the work of another artist, such as Ben Shahn, is indicated in my interview with Robert Galster. When I asked him if Warhol ever spoke about Ben Shahn, Galster responded:

> As a matter of fact, I don't think, we ever talked about artists or anything. I think, we talked about. . . . I don't know. Of course, Andy never talked about anything. That's one of the interesting things about Andy Warhol. My recollection of him is never hearing him say anything. You'd ask him a question, and you'd probably get the minimal answer whispered, but he was always surrounded by other people who were talking, but he didn't talk a great deal. He didn't communicate well, I would say, at all. You say, 'Did he ever talk about Ben Shahn?' And, I recall, I can't remember. I can't tell you anything. Andy never said much. (Interview with Robert Galster, New York, 25 October 1978.)

37. Ibid.

38. Interview with Bert Greene, New York, 3 December 1978.

39. According to Seymour Berlin, who was Warhol's printer during the 1950s, Warhol collected "several" graphic works by Shahn. Interview with Seymour Berlin, New York, 27 November 1978.

40. Interview with Charles Lisanby, New York, 11 November 1978. Emphasis Lisanby's.

41. Interview with Margery Beddow, New York, 31 October 1978.

42. Ibid.

43. Interview with Nathan Gluck, New York, 20 November 1978.

44. Located at 305 E. 45th Street, between First and Second Avenues, near the United Nations Building, the Loft Gallery was a part of the studio of Jack Wolfgang Beck and Vitto Giallo. Exhibits consisted of work by artists who were invited to exhibit by an informal committee. The Loft Gallery also included shows of work by Nathan Gluck and Clint Hamilton. Interview with Vitto Giallo, New York, 6 December 1978.

45. Interviews with Robert Fleischer, New York, 27 October; Vitto Giallo, New York, 6 December 1978; and Nathan Gluck, New York, 20 November 1978. There was no review of this show, and there are no known photographs of the exhibit, and no extant works from this show.

46. George Klauber owns one of these drawings consisting of two clothed males, one of whom is "mounting" the other's back. Interview with Nathan Gluck, New York, 20 November 1978. There was no review of this exhibition either. Interviews with Arthur Elias, New York, 28 November 1978; Vitto Giallo, New York, 6 December 1978; and Nathan Gluck, New York, 20 November 1978.

47. Interview with Robert Galster, New York, 25 October 1978.

48. Interview with Elaine Finsilver, Hartsdale, New York, 29 October 1978.

49. Interviews with Ted Carey, New York, 16 October 1978 and 13 November 1978; Charles Lisanby, New York, 11 November 1978; and Andy Warhol, New York, 6 November 1978.

50. Interview with Charles Lisanby, New York, 11 November 1978.

51. Interview with Robert Fleischer, New York, 27 October 1978.

52. Ibid.

53. Interview with Bert Greene, New York, 3 December 1978.

54. Interview with Vitto Giallo, New York, 6 December 1978.

55. Interview with Andy Warhol, New York, 6 November 1978.

56. Interview with Vitto Giallo, New York, 6 December 1978.

57. Interview with Alfred Carleton Walters, New York, 10 November 1978.

58. The exhibition Art for Radio was sponsored by the Radio Advertising Bureau, Inc., New York. The show was apparently seen in the bureau's headquarters, and it was not reviewed. Designed to promote the broadcasting medium during the early years of American television, the exhibit was coordinated by Jack Wolfgang Beck and was juried by Frank O'Hara, Raymond Dowden of the Cooper Union and William Atkin of Reinhold Publishing Corp. There were 20 artists who exhibited, including Ernest R. Smith, Arno Sternglass and Sheldon Cotler who won the three prizes, as well as Vitto Giallo and Warhol. See *Art for Radio*, exhibition catalogue (New York: Radio Advertising Bureau, Inc., [ca. 1956]). Special thanks to Vitto Giallo, whose extended loan of this catalogue made this discussion possible.

Rainer Crone has claimed that two works of this period were "oel/leinwand," or "oil on canvas," in his 1976 catalogue of Warhol's drawings. The first work is *Pin The Tail on the Donkey* (Collection Robert E. Adams, New York), which Crone dates 1953. This humorous and delightful three-part folding *wooden* screen was, in fact, painted by Nathan Gluck. Done ca. 1959–1960, this screen was used as a background for a table display for a children's birthday party. Interviews with Nathan Gluck, New York, 17 October 1978 and 20 November 1978; and with George Hartman and Buddy Radish, New York, 18 December 1978. Also see Crone (1976), p. 224 and fig. 127.

The second work is *Portrait of John Butler with a Dancer* (Collection John Butler, New York), which Crone dates 1952. I cannot comment on the accuracy of Crone's description of the medium, nor can I remark on the accuracy of Crone's date for the work, because I have not personally examined it. See ibid., p. 223 and fig. 122. I surmise, however, that both figures are of Butler because his distinctively heavy eyebrows are featured on the two figures. Like Warhol's *Rock & Roll*, the artist's portrait of Butler includes abstract shapes.

59. Note: "An ardent jazz and television fan, he [Stuart Davis] can watch a program of a UN debate while preparing his neat palette to begin *Rapt at Rappaport's* on the large canvas." See Dorothy Gees Seckler, "Stuart Davis Paints a Picture," *Art News*, vol. 52, no. 4, June-July-August 1953, photo caption, p. 30.

60. Interview with Alfred Carleton Walters, New York, 28 November 1978.

61. Interviews with Lawrence Alloway, New York, 9 November 1978; Ivan Karp, New York, 12 October 1978; Charles Lisanby, New York, 11 November 1978; and Alfred Carleton Walters, New York, 10 November 1978.

62. Interview with Jerry Lang, New York, 23 November 1978.

63. George Hartman, in interview with George Hartman and Buddy Radish, New York, 18 December 1978.

64. Warhol (1975), p. 24. Also note p. 26.

65. Interview with Joan Fenton, New York, 6 December 1978.

66. Ibid.

67. Interview with Geraldine Stutz, New York, 28 November 1978.

68. Peter Palazzo, *Pre-Warhol Warhol*, unpublished manuscript, as in interview with Palazzo, New York, 7 November 1978.

69. Brown (1971), p. 57.

70. Interview with Geraldine Stutz, New York, 28 November 1978.

71. Ibid.

72. Interview with Mr. and Mrs. Walter Ress, New York, 19 November 1978.

73. Interview with Peter Palazzo, New York, 7 November 1978.

74. Interview with Alfred Carleton Walters, New York, 28 November 1978.

75. Ibid.

76. Interview with Peter Palazzo, New York, 7 November 1978.

77. Interview with Robert Fleischer, New York, 27 October 1978. Emphasis Fleischer's.

78. Tomkins (1971), p. 9.

79. Interview with Bert Greene, New York, 3 December 1978.

80. Interview with Vitto Giallo, New York, 6 December 1978.

81. Interviews with Vitto Giallo, New York, 6 December 1978 and with Nathan Gluck, New York, 17 October 1978.

82. Interview with Nathan Gluck, New York, 25 October 1978.

83. Interviews with Nathan Gluck, New York, 17 October 1978 and 25 October 1978.

84. Interview with Joseph Giordano, New York, 30 November 1978.

85. E.g.: "Many times that I was there, Nathan was sitting in the corner doing 'Andy Warhol' drawings, and I always thought that it was funny that Andy was getting paid for these drawings that Nathan was doing." Interview with Robert Galster, New York, 25 October 1978.

86. Interview with George Hartman and Buddy Radish, New York, 18 December 1978.

87. Interviews with Daniel Arje, New York, 23 October 1978; Emile De Antonio, New York, 14 November 1978; Gene Moore, New York, 13 October 1978 and 30 October 1978; and James Rosenquist, New York, 18 October 1978.

88. The only known exception is Warhol's display for perfume, consisting of a boarded fence with niches for the merchandise. Interviews with Daniel Arje, New York, 23 October 1978 and with Charles Lisanby, New York, 11 November 1978. Also see Brown (1971), p. 37.

89. Interviews with Nathan Gluck, New York, 20 November 1978 and with Gene Moore, New York, 30 October 1978.

90. Interview with Gene Moore, New York, 30 October 1978.

91. Photograph courtesy of Gene Moore.

92. Interview with Daniel Arje, New York, 23 October 1978.

93. Interview with Emile De Antonio, New York, 14 November 1978.

94. Interview with Daniel Arje, New York, 23 October 1978. Emphasis Arje's.

95. Tiffany & Co., *Tiffany Table Settings* (New York, [1960]).

96. Interview with Joseph Giordano, New York, 30 November 1978.

97. Interview with Tom Lacy, New York, 30 October 1978. Emphasis Lacy's.

98. Interview with Steven Bruce, New York, 27 October 1978.

99. Interview with Alfred Carleton Walters, New York, 28 November 1978.

100. Interview with Nathan Gluck, New York, 20 November 1978.

101. Interview with Nathan Gluck, New York, 17 October 1978.

102. Interview with Suzi Frankfurt, New York, 29 November 1978.

103. Amy Vanderbilt, *Amy Vanderbilt's Complete Book of Etiquette: A Guide to Gracious Living* with drawings by Fred McCarroll, Mary Suzuki, and Andrew Warhol, 1st ed. (Garden City, N.Y., 1952).

104. Rainer Crone attributes a diagrammatic drawing of the proper way to eat a whole lobster to Warhol, but Crone offers no documentation for such an attribution. Crone implies that such a drawing is a prototype of Warhol's Pop Art *Dance Step* series, as well as Roy Lichten-

stein's 1963 Pop Art painting *Spray* II (Collection Piero Milani, Chiasso). See Crone (1976), p. 94 and Vanderbilt (1952), p. 240.

105. Amy Vanderbilt, *Amy Vanderbilt's Complete Cookbook* with drawings by Andrew Warhol (Garden City, N.Y., 1961).

106. Joseph Masheck, "Warhol as Illustrator," *Art in America,* vol. 59, no. 3, May–June 1971, pp. 54–59.

107. Ibid., p. 54.

108. See ibid., p. 59, note 2.

109. Ibid., p. 56.

110. Ibid., p. 58.

111. Ibid., p. 54.

112. Interview with Ted Carey, New York, 16 October 1978. Emphasis Carey's.

113. This work is a sample reject for Vanderbilt (1961). The drawing (Collection Ted Carey, New York) includes opaque, white correction fluid, blue pencil guide lines and Carey's proposed drawing in India ink.

114. Masheck, (1971), p. 59.

115. See interview with Geraldine Stutz, New York, 28 November 1978.

116. Interview with Seymour Berlin, New York, 27 November 1978.

117. Andy Warhol, quoted in interview with Fritzie Wood, New York, 1 December 1978.

118. Interview with Andy Warhol, New York, 6 November 1978.

119. Interview with Charles Lisanby, 11 November 1978, Emphasis Lisanby's.

120. Interview with Alfred Carleton Walters, New York, 10 November 1978. Emphasis Walters's.

121. Ibid. Emphasis Walters's.

122. Interview with Bert Greene, New York, 3 December 1978.

123. See Warhol (1975), p. 22. Warhol mentions by name the magazines *Vogue* and *Harper's Bazaar.*

124. Interview with Robert Fleischer, New York, 27 October 1978.

125. "The Camera Overseas: 136,000,000 People See This Picture of Shanghai's South Station," *Life,* vol. 13, no. 14, 4 October 1937, pp. 102f.

126. Although most commercial and illustrative artists utilize photographic source material for ideas or for preliminary references to their completed works, some of them have used, outright, photographs from *Life* and other publications. As early as 1939, one reader of *Life* wrote to that magazine's editor and complained that an illustration, which had appeared in *The Saturday Evening Post,* was based directly on a photograph published in *Life.* The editor of *Life* replied that such direct image duplication by an illustrator had been done before. See "Letters to the Editor," *Life,* vol. 7, no. 15, 9 October 1939, p. 8.

127. Interview with Jack Wilson, Chicago, 7 March 1979.

128. The use of photographs as source material by artists began as early as the discovery of the daguerreotype in 1839. For a seminal study on the use and influence of photography in the fine arts, see Aaron Scharf, *Art and Photography*, rev. ed. (Baltimore, Md., 1974).

129. E.g., Richard Hamilton, Eduardo Paolozzi and others of the Independent Group in England have utilized American mass circulation periodicals, including *Life*, as well as advertising, film stills and illustrations from science fiction serials and comic books, as pictorial source material from ca. 1942 to the present day. Interview with Lawrence Alloway, New York, 9 November 1978. Also note Frank Whitford, "Paolozzi and the Independent Group," in *Eduardo Paolozzi*, exhibition catalogue (London: The Tate Gallery, 1971), pp. 44–64.

130. Ernest W. Watson, *Forty Illustrators and How They Work* (New York, 1946), p. ix. Hereafter cited as Watson (1946). Watson's book appeared in two printings by 1947, and each chapter is, essentially, a reprinted article from a popular art magazine, *The American Artist*. According to Jack Wilson, one of Warhol's classmates subscribed to this magazine. It is possible that Warhol saw Watson's profiles either in the magazine or in book form. Interview with Jack Wilson, Glenview, 22 August 1979.

131. Watson (1946), pp. 232–37.

132. Ibid., p. 288.

133. Arthur Guptill, *Norman Rockwell, Illustrator* (New York, 1946), pp. 41–45.

134. Norman Rockwell, quoted in Guptill, *Norman Rockwell*, p. 47.

135. Interview with Alfred Carleton Walters, New York, 10 November 1978.

136. Interview with Vitto Giallo, New York, 6 December 1978.

137. Interview with Nathan Gluck, New York, 17 October 1978.

138. Interview with Charles Lisanby, New York, 11 November 1978.

139. Interviews with Nathan Gluck, New York, 17 October 1978 and with George Klauber, New York, 15 November 1978. The late Edward Wallowitch lived in Florida, and it was impossible for me to obtain Wallowitch's original photographs, which Warhol used as pictorial source material and which have never been reproduced. According to John Wallowitch, the photographer's brother Edward did experiments in the projection of slides on models and other (but unspecified) photographic tests, which Warhol watched or took part. Unrecorded conversation with John Wallowitch, fall of 1978. For photographs by Edward Wallowitch of children, that are similar to Warhol's drawings but are not the exact pictorial sources, see Rebecca Caudill, *My Appalachia* with photographs by Edward Wallowitch (New York, 1966).

140. Warhol (1975), p. 96.

141. Ibid., passim.

142. Interview with Nathan Gluck, New York, 17 October 1978.

143. Warhol (1975), p. 99.

144. Warhol (1975), p. 99. Emphasis Warhol's.

145. The 26 leaves were unbound and laid loose in folded off-white tracing paper wrapper. It was printed in an edition of ca. 100 copies. The entire book is reproduced in Brown (1971), pp. 16–19.

146. Interview with Bert Greene, New York, 3 December 1978.

147. See the photograph captioned "In work clothes Johnnie Fortune teeters on tightwire as he practices drunken clown routine. A versatile trapeze," in *Life*, vol. 32, no. 13, 31 March 1952, p. 110.

148. Curity advertisement in *Life*, vol. 32, no. 10, 19 May 1952, p. 88.

149. See the photograph captioned "F.D.R.'s Last Picture," in *Life*, vol. 35, no. 20, 16 November 1953, p. 93.

150. The subcaption of this photograph is: "Weak and tired, Franklin Roosevelt sits at his desk in the White House office on the morning of March 29. The next day he left for Warm Spring, Ga. for a needed rest. There, 13 days later, he died." (Ibid.)

151. See photograph captioned, "Tony De Spirito, King of the jockeys for 1952, lies exhausted in the dressing room after the tension of a grueling seven-race day," in *Life*, vol. 34, no. 2, 12 January 1953, p. 69.

152. See the photograph of actress Jane Cowl, in *Theatre Arts*, vol. 36, no. 9, September 1952, p. 69.

153. See the photograph of the young girl, in *Life*, vol. 32, no. 23, 9 June 1952, p. 133.

154. See the photograph of Viscount Moore, in *Life*, vol. 32, no. 2, 14 January 1952, p. 97.

155. Sixteen of the 18 unbound drawings are reproduced in Crone (1976), figs. 98–113.

156. See the photograph actress Geraldine Page, in *Life*, vol. 34, no. 9, 2 March 1953, p. 68.

157. See *Dance Magazine*, vol. 33, no. 2, February 1959, cover illustration by Andy Warhol and publicity photograph of Doris Humphrey on p. 34.

158. Interview with Bert Greene, New York, 3 December 1978.

159. Brown (1971), p. 20.

160. See illustration of medieval entertainers, in *Dance Magazine*, vol. 29, no. 11, November 1955, p. 70.

161. All of Warhol's unblotted drawings for *Love Is a Pink Cake* (1953) are reproduced in Brown (1971), pp. 24–27.

162. Interview with Alfred Carleton Walters, New York, 28 November 1978.

163. The handcolored print illustrated here is from *The Flowers Personified, Being a Translation of Grandville's "Les fleurs animées,"* trans. N. Cleveland (New York, 1847).

164. Warhol's *In the Bottom of My Garden* (1955) was printed in offset lithography by Seymour Berlin. The blotted drawings (Collection of Seymour Berlin, New York) were printed on the recto, leaving the verso blank. They were bound and handcolored by Warhol's friends and associates during the many "coloring parites," as described above. Interviews with Seymour Berlin, New York, 27 November 1978; Nathan Gluck, New York, 17 October 1978; and Charles Lisanby, New York, 11 November 1978.

165. Interview with Charles Lisanby, New York, 11 November 1978.

166. Rose Fyleman, lyricist, and Liza Lehmann, composer, *There Are Fairies at the Bottom of Our Garden*, sheet music (New York: Chappell-Harms, Inc., 1917).

167. For her account of the song, to which she added a nonchalant "Whee!" see Beatrice Lillie, *Every Other Inch a Lady* with John Philip and James Brough (Garden City, N.Y., 1972), pp. 32–35, 324.

168. See *Beatrice Lielie* [*sic*] of 1956 (Collection Mr. and Mrs. David Evins, New York), in Brown (1971), p. 50.

169. All of Warhol's illustrations for *In the Bottom of My Garden* (1956) are reproduced in Brown (1971), pp. 41–46.

170. This comparison between the illustrations by Grandville and by Warhol was first published in Crone (1976), pp. 82f. Crone's comparison omits any reference to the song by Fyleman and Lehmann, and the comparison was first suggested to Crone by Nathan Gluck. Interview with Nathan Gluck, New York, 17 October 1978 and 25 October 1978.

171. Jacques Stella, *Les jeux et plaisirs de l'enfance* (Paris, 1657).

172. See Crone (1976), pp. 80f.

173. Interview with Charles Lisanby, New York, 11 November 1978.

174. E.g., *Love Is a Pink Cake* (1953), illustration of three cherubs in *Dance Magazine*, vol. 28, no. 1, January 1954, p. 75; window display for Bonwit Teller, New York, June, 1955; *In the Bottom of My Garden* (1956); Christmas card design for Tiffany & Co., 1957; illustration of two cherubs in *Dance Magazine*, vol. 32, no. 9, September 1958, p. 34; two cupids in the accessory layout, "In the Bag," *Mademoiselle*, vol. 65, no. 11, November 1959, pp. 84f. Reproductions of all of these examples are in Brown (1971), pp. 24f., 27, 29, 37, 42–46, 57, 61, 63.

175. Warhol (1975), p. 56.

176. Ibid., p. 67.

177. Interview with Robert Fleischer, New York, 27 October 1978.

178. Interview with Joseph Giordano, New York, 30 November 1978. Also Crone (1976), p. 156 and fig. 206. Giordano met Warhol ca. 1958–59. Crone dates this drawing as being done in 1956. The date is here reassigned as ca. 1959.

179. The exhibit at the Bodley Gallery, New York, was presented from 14 February to 3 March 1956. See Brown (1971), p. 47.

180. Interview with Charles Lisanby, New York, 11 November 1978.

181. Ibid.

182. Ibid. See Jean Genet, *Querelle de Brest* with lithographs by Jean Cocteau (Paris, 1947).

183. Jean Cocteau, *Dessins* (Paris, 1923).

184. Interview with Nathan Gluck, New York, 20 November 1978.

185. Interview with Bert Greene, New York, 3 December 1978.

186. Cf.: "To Ingres, the erotic was that which is recognizable and desirable, but known to be unattainable, and therefore all the more desirable." John L. Connolly, Jr., "Ingres and the Erotic Intellect," in *Woman as Sex Object: Studies in Erotic Art, 1730–1970*, edited by Thomas B. Hess and Linda Nochlin (New York, 1972), p. 25.

187. Steven Bruce, in interview with Steven Bruce, New York, 27 October 1978.

188. Warhol's *A Gold Book* was designed by Georgie Duffee, an assistant to David Mann, who owns the Bodley Gallery, New York. All of the book's illustrations are reproduced in Brown (1971), pp. 58–60.

189. Interview with Nathan Gluck, New York, 20 November 1978 and with Charles Lisanby, New York, 11 November 1978. Unfortunately, none of Edward Wallowitch's photographs are available to compare them to Warhol's drawings.

190. Interviews with Nathan Gluck, New York, 17 October 1978 and with Jerry Lang, New York, 30 November 1978. Special thanks to Jerry Lang who allowed me to reproduce Dudley Hopler's drawing.

191. All of the illustrations of Warhol's *25 Cats* are reproduced in Brown (1971), pp. 31–33.

192. Interview with Seymour Berlin, New York, 27 November 1978. Also see Brown (1971), p. 31.

193. Interview with Nathan Gluck, New York, 17 October 1978.

194. Interview with Seymour Berlin, New York, 27 November 1978. Emphasis Berlin's.

195. Interviews with Nathan Gluck, New York, 17 October 1978 and with Charles Lisanby, New York, 11 November 1978. See Walter Chandoha, *All Kinds of Cats* (New York, 1952), p. 80.

196. Interview with Nathan Gluck, New York, 17 October 1978.

197. See Crone (1976), p. 145 and fig. 196. Crone's title is *Blumenvase*.

198. Rainer Crone, *Andy Warhol*, trans. John William Gabriel (London, 1970). Hereafter cited as Crone (1970).

199. Ibid., p. 9.

200. See Rainer Crone and Wilfried Wiegang, *Die revolutionaere Aesthetik Andy Warhols in Kunst und Film* (Frankfurt-am-Main, 1970).

201. See Crone's discussion in Crone (1976), passim.

202. See Crone (1970).

203. Interview with Bert Greene, New York, 3 December 1978.

204. Bert Greene, interview by Rainer Crone, New York, 12 December 1973, in Rainer Crone, "Das Bildnerische Werk Andy Warhols" (Ph.D. dissertation. Berlin: Frei Universitaet, 1976), p. 274. Hereafter cited as Crone-dissertation (1976).

205. Denis Vaughan, interview by Jean van den Heuvel, New York, 15 November 1973, in ibid., pp. 299f.

206. Interview with Bert Greene, New York, 3 December 1978.

207. Bert Greene, interview by Rainer Crone, New York, 12 December 1973, in Crone-dissertation (1976), p. 275.

208. Ibid., p. 276.

209. Ibid., p. 284. Also see Denis Vaughan, interview by Jean van den Heuvel, New York, 15 November 1973, in ibid., pp. 304f.

210. Interview with Fritzie Wood, New York, 1 December 1978.

211. Interviews with Arthur Elias, New York, 28 November 1978 and with George Klauber, New York, 15 November 1978 and 19 November 1978.

212. Interview with Bert Greene, New York, 3 December 1978.

213. Bert Greene, interview by Rainer Crone, New York, 12 December 1973, in Crone-dissertation (1976), p. 275.

214. Ibid., p. 287.

215. Interview with Bert Greene, New York, 3 December 1978.

216. Ibid.

217. Bert Greene, interview by Rainer Crone, New York, 12 December 1973, in Crone-dissertation (1976), p. 280.

218. Interview with Fritzie Wood, New York, 1 December 1978.

219. Interview with Bert Greene, New York, 3 December 1978.

220. Bert Greene, interview by Rainer Crone, New York, 12 December 1973, in Crone-dissertation (1976), p. 278.

221. See Crone (1976), p. 97 and fig. 46.

222. Ibid., pp. 123–25.

223. See Denis Vaughan, interview by Jean van den Heuvel, New York, 15 November 1973, in Crone-dissertation (1976), p. 300.

224. Interview with Bert Greene, New York, 3 December 1978. Also see Bert Greene, interview by Rainer Crone, New York, 12 December 1973, in Crone-dissertation (1976), pp. 279f.

225. See ibid., pp. 116–120. Also see Crone (1976), pp. 96f.

226. Crone-dissertation (1975), p. 117. Translation mine. The same passage occurs in Crone (1976), p. 96.

227. Ibid. Translation mine.

228. Eric Bentley, quoted in ibid.

229. Crone (1976), pp. 96f.

230. E.g., see Crone-dissertation (1976), pp. 144–48 ("Zu 1. Gemalte, exakt kopierte Bilder mit formalen graphischen Verfremdungseffekten").

231. Bert Greene, interview by Rainer Crone, New York, 12 December 1973, in ibid., p. 285.

232. Ibid., pp. 287f.

233. Denis Vaughan, interview by Jean van den Heuvel, New York, 15 November 1973, in ibid., pp. 305–7.

234. Interview with Bert Greene, New York, 3 December 1978.

235. Interview with Alfred Carleton Walters, New York, 28 November 1978.

236. Interview with Charles Lisanby, New York, 11 November 1978.

237. Interviews with Nathan Gluck, New York, 17 October 1978 and 20 November 1978 and with Jerry Lang, New York, 23 November 1978. Also see *"The Beast in Me,"* *Theatre World,* vol. 19, 1962–63, p. 96.

238. Interview with Jerry Lang, New York, 23 November 1978.

239. Interview with Robert Galster, New York, 25 October 1978.

240. Ibid.

Chapter 3

1. See Max Scheler, *Ressentiment*, trans. William W. Holdheim and ed. Lewis A. Coser (New York, 1961).

2. Alfred Jarry, "King Ubu," in *Modern French Theatre: The Avant-Garde, Dada, and Surrealism, an Anthology of Plays*, trans. and ed. Michael Benedikt and George E. Wellsworth (New York, 1966), pp. 1–54.

3. Roger Shattuck, *The Banquet Years: The Origins of the Avant-Garde in France, 1885 to World War I*, rev. ed. (New York, 1968), p. 207. Hereafter cited as Shattuck (1968).

4. Ibid., p. 206.

5. Alfred Jarry, as quoted in Shattuck, *The Banquet Years*, p. 241.

6. Shattuck observes that Jarry attempted to grasp rules "which govern exceptions" and which "explain the universe supplementary to this one." Pataphysics also correlates exceptions and "scarcely exceptional exceptions." Ibid.

7. Ibid., p. 239.

8. E.g., the 1920 Berlin Dada exhibition became an occasion for direct confrontations and provocations between Dadaists and the spectators, who reached the show by going through a public urinal and then were greeted by a young girl, clothed in a First Communion dress, reciting obscene verses. A hatchet was provided to destroy a sculpture by Max Ernst. For an account of this and other Dada works and exhibitions, see William S. Rubin, *Dada and Surrealist Art* (New York, n.d.).

9. Marcel Duchamp, "The Creative Act," *Art News*, vol. 56, no. 4, Summer 1957, pp. 28f. All subsequent citations are from this source. Hereafter cited as Duchamp (1957). Duchamp's lecture has been reprinted in Robert Lebel, *Marcel Duchamp*, trans. George Heard Hamilton (New York, 1959), pp. 77f. Hereafter cited as Lebel (1959). It has also appeared in Gregory Battcock, ed., *The New Art: A Critical Anthology* (New York, 1966), pp. 23–26.

10. E.g., *Bottlerack*, 1914, original lost; *Bicycle Wheel, 1913*, original lost, and *Traveler's Folding Item*, an Underwood typewriter cover, 1916, original lost. See Anne d'Harnoncourt and Kynaston McShine, eds., *Marcel Duchamp*, exhibition catalogue (New York and Philadelphia: Museum of Modern Art and Philadelphia Museum of Art, 1973), catalogue nos. 106, 94, and 117. Hereafter cited as *Marcel Duchamp* (1973).

11. I.e., Duchamp's Readymade *Fountain*, a porcelain urinal inscribed "R. MUTT/1917," 1917, original lost. See Marcel Duchamp (1973), catalogue no. 120. Duchamp submitted *Fountain* to the jury-free Independents exhibition, New York, and it was rejected. In an anonymous article published in *The Blind Man*, no. 2, May 1917, Duchamp wrote: "Whether Mr. Mutt with his own hands made the fountain or not has no importance. He CHOSE it. He took an ordinary article of life, placed it so that its useful significance disappeared under the new title and point of view—created a new thought for that object." (Reprinted in Marcel Duchamp (1973), p. 283).

12. E.g., Duchamp's *Dust Breeding*, 1920, in which several months' accumulation of dust on one of the sections of *The Large Glass* is photographed by Man Ray. See *Marcel Duchamp* (1973), pp. 293f. and catalogue nos. 138 and 145.

13. E.g., Duchamp's *Three Standard Stoppages*, 1913–14, an assemblage in which Duchamp dropped three one-meter threads and glued the fallen threads on canvases. The new

Pataphysical "measurements" were to assist in *The Large Glass*. See *Marcel Duchamp*, (1973) catalogue nos. 101 and 143.

14. The most sustained such interpretation is Arturio Schwartz, *The Complete Works of Marcel Duchamp* (New York, 1969).

15. Ambiguities are seen by most commentators. E.g., see Lawrence D. Steefel, Jr., *The Position of Duchamp's "Glass" in the Development of His Art*, Outstanding Dissertations in the Fine Arts (New York and London, 1977), p. 4.

16. E.g., "Rrose Sélavy," "R. Mutt," and "Belle Haleine." The multiplication of meanings may be associated with Duchamp's pluralization of his identity in his collection of puns, *Rrose Sélavy* (Paris, 1939).

17. In Pierre Cabanne's interview with Duchamp, the artist remarked: "The idea of 'chance,' which many people were thinking about at the time, struck me too. The intention consisted above all in forgetting the hand, since, fundamentally, even your hand is chance." (Marcel Duchamp in Pierre Cabanne, *Dialogues with Marcel Duchamp*, trans. Ron Padgett, Documents of 20th Century Art, series ed. Robert Motherwell [New York, 1971], p. 46. Hereafter cited as Duchamp [1971].) Duchamp also said to Cabanne: "Pure chance interested me as a way of going against logical reality: to put something on a canvas, on a bit of paper, to associate the idea of a perpendicular thread, a meter long falling from the height of one meter onto a horizontal plane, making its own deformation. This amused me. It's always the idea of 'amusement' which causes me to do things, . . . " (Ibid., p. 47.)

18. *Box in a Valise* (1941) is an edition of leather valises that contain miniature replicas, photographs, and color reproductions of works by Duchamp. See *Marcel Duchamp* (1973), catalogue no. 158. Duchamp has said of it: "Then, since it wasn't a matter of an enormous *oeuvre*, it was easy to make the 'Box.' And amusing. Still, it took me four years to produce the documents, between 1934 and 1940." (Duchamp, [1971], pp. 78f.)

19. Concerning his *Large Glass*, Duchamp has said: "In addition, perspective was very important. The 'Large Glass' constitutes a rehabilitation of perspective, which had then been completely ignored and disparaged. . . . The glass, being transparent, was able to give its maximum effectiveness to the rigidity of perspective. It also took away any idea of 'the hand,' of materials. I wanted to change, to have a new approach." (Ibid., pp. 38, 41f.) A significant study of Duchamp's *Large Glass* and perspective is Jean Clair, "Duchamp and the Classical Perspectives," *Artforum*, vol. 16, no. 7, March 1978, pp. 40–49.

20. The term "Pataphysical epiphenomena" is Jarry's. See Shattuck (1968), pp. 241f. On Jarry's influence on Duchamp, see Lebel (1959), pp. 8, 12, 69, and 173. When Cabanne asked Duchamp for his interpretation of *The Large Glass*, the artist replied: "I don't have any, because I made it without an idea. There were things that came along as I worked. The idea of the ensemble was purely and simply the execution, more than descriptions of each part. . . . It was a renunciation of all aesthetics, in the ordinary sense of the word . . . not just another manifesto of new painting." (Duchamp [1971], p. 42.) Concerning different interpreters of *The Large Glass*, Duchamp remarked to Cabanne: "Each of them gives his particular note to his interpretation which isn't necessarily true or false, which is interesting, but only interesting when you consider the man who wrote the interpretation, as always." (Ibid.)

21. *Being Given:* . . . is Duchamp's mixed-media assemblage done in complete secrecy when Duchamp had declared to have given up doing "art." See *Marcel Duchamp* (1973), catalogue no. 186. In my opinion, the original title is best conveyed in English as indicated here instead of the usual translation *Given:* . . . ; the mobility of the entitled, temporalizing

givens, as well as the deliberate connotation of mathematical propositions as used in French, is otherwise lost in translation. Moreover, Duchamp's *Large Glass* and *Being Given: . . .*, together with their (un)published notes, seem, in my opinion, to be structured in a "meta-actionization," a *dasein,* not in a stasis.

22. E.g., "Kinetic" or "Mobile" Readymade *(Bicycle Wheel),* Rectified Readymade *(L.H.O.O.Q.),* "Self" Readymade (Duchamp as "Rrose Sélavy") and *Unhappy Readymade* (a suspended geometry book hung on the balcony of Suzanne Duchamp's apartment). See *Marcel Duchamp* (1973), catalogue nos. 94, 131, and 130.

23. Duchamp quoted in Harriet and Sidney Janis, "Marcel Duchamp, Anti-Artist," *View,* series 5, no. 1, March 1945, p. 24. Hereafter cited as Janis (1945).

24. See note 20 above.

25. See note 9 above.

26. Duchamp has remarked: "It's always the idea of 'amusement' which causes me to do things . . . " Duchamp (1971), p. 47.

27. E.g., the verbal and visual play of suggestive puns that were printed on disks in the film *Anémic Cinéma* (1926), made in collaboration with Man Ray and Marc Allégret. See *Marcel Duchamp* (1973), catalogue no. 151. Duchamp played in international chess tournaments and was co-author of a study on an end-game problem in chess. See Marcel Duchamp and Vitaly Halberstadt, *L'Opposition at les cases conjugées sont réconciliées* (Brussels, 1932).

28. Duchamp quoted in Janis (1945), p. 24.

29. In fact, André Breton's "DUCHAMP" entry in the abridged dictionary written by the Surrealists places Duchamp in the tradition of dandyism. See A[ndré]. B[reton]., "(Marcel) DUCHAMP," *Dictionnaire abrégé de Surréalisme* (Paris, 1938), p. 10.

30. Cf. the stance of the anti-artist.

31. In 1924, Duchamp issued bonds to break the bank at Monte Carlo, but, according to the artist, "THE SYSTEM WAS TOO SLOW TO HAVE ANY PRACTICAL VALUE, . . . I SOON GAVE UP, FORTUNATELY BREAKING EVEN." See *Marcel Duchamp* (1973), catalogue no. 146.

32. Duchamp (1971), p. 16.

33. Ibid., p. 39.

34. For an overview, see John Tancock, "The Influence of Marcel Duchamp," in *Marcel Duchamp* (1973), pp. 159–78.

35. E.g., in his justification of *frottage,* Max Ernst wrote in part: "The artist is a spectator, indifferent or impassioned, at the birth of his work, and observes the phases of its developments." Max Ernst quoted in Sarane Alexandrian, *Surrealist Art,* trans. Gordon Clough (New York and Washington, D.C., 1970), p. 65.
 The American Pop artist Claes Oldenburg once remarked: "What I am interested in is that the equivalent of my fantasy exists outside of me, and that I can, by imitating the subject, make a different kind of work from what has existed before." (Claes Oldenburg, "Lichtenstein, Oldenburg, Warhol: A Discussion," *Artforum,* vol. 4, no. 6, February 1966, p. 22.)

36. Robert Rauschenberg, "Statement," in Dorothy C. Miller, ed., *Sixteen Americans,* exhibition catalogue (New York: Museum of Modern Art, 1959), p. 58. Hereafter cited as Rauschenberg (1959).

37. In retrospect, Rauschenberg has remarked to Calvin Tomkins:

> "I always thought of the white paintings as being not passive but very—well, hyper-sensitive. So that one could look at them and see how many people were in the room by the shadows cast, or what time of day it was." (Robert Rauschenberg, quoted in Calvin Tomkins, *The Bride and the Bachelors* [New York, 1965], p. 203. Hereafter cited as Tomkins [1965].)

Rauschenberg wrote from Black Mountain College to Betty Parsons a letter, postmarked 18 October 1951; in this letter the artist remarked:

> "They are large white (one white as God) canvases organized and selected with the experience of time and presented with the innocence of a virgin. Dealing with the suspense, excitement, and body of an organic silence, the restriction and freedom of absence, the plastic fullness of nothing, the point of the circle begins and ends. They are a natural response to the current pressures of the faithless and a promoter of institutional optimism. It is completely irrelevant that I am making them. *Today* is their creator." (Robert Rauschenberg, quoted in Lawrence Alloway, "Rauschenberg's Development," in *Robert Rauschenberg*, exhibition catalogue [Washington, D.C.: National Collection of Fine Arts, 1976], p. 3. Emphasis Rauschenberg's. Hereafter cited as *Robert Rauschenberg* [1976].)

38. Charles Hamm, "John Cage," *The New Grove Dictionary of Music and Musicians*, ed. Stanley Sadie, vol. 3 (London, 1980), p. 598.

39. John Cage, quoted in Tomkins (1965), p. 118.

40. Richard Schechner has commented:

> "He [John Cage] is asking us to listen to 'silence' with the same care—more care—that we listen to the 'noise' of musical instruments. Cage's piece is the coughing, the restlessness, the very heartbeats and breathing rhythms of the audience. Such performances are perceptual educations. They make us aware of our environment—both outer and inner—in new ways." (Richard Schechner, *Public Domain: Essays on the Theatre* [Indianapolis and New York, 1969], pp. 148f. Hereafter cited as Schechner [1969].)

41. In an unrecorded interview (28 January 1975) with the composer, Cage remarked to me: "I insist as an anarchist that we do our best work when we are empty-headed, or as [D.T.] Suzuki said, 'no-minded.'" That is, Cage proposes that such a method of nonintention and indeterminancy provides an equivalent process of externalization for enlightenment as does a Zen *koan*. See D. T. Suzuki, *Studies in Zen*, ed., Christman Humphreys (New York, n.d.).

42. Michael Kirby, "The New Theatre," *The Drama Review*, vol. 10, no. 2, Winter 1965, p. 29.

43. That is, placing objects (bolts, coins, etc.) among the strings of the piano and then playing a composition for the emitted "music."

44. For a documented description, see Martin Duberman, *Black Mountain: An Exploration in Community* (New York, 1972), pp. 350–58.

45. Cage has remarked: "More pertinent to our daily experience is a theatre in which . . . the activity takes place around us." Cage, quoted in Duberman, *Black Mountain*, p. 52.

46. Concerning performances which are "controlled" by chance techniques, and thus "relieving" performers of the "burden" of choosing when to do something, Richard Schechner has com-

mented that such performances are similar to methods used in many scientific experiments, in which "a controlled environment" contains "the 'natural object' under study" which "reacts in its 'own way.'" Schechner (1969), p. 148.

47. Susan Sontag, "The Esthetics of Silence," in *Styles of Radical Will* (New York, 1969), p. 9. Hereafter cited as Sontag (1969).

48. This autobiographical aspect, as it concerns Warhol, is discussed later in the chapter.

49. Sontag (1969), p. 6.

50. Interview with James Rosenquist, New York, 18 October 1979.

51. Andy Warhol and Pat Hackett, *POPism: The Warhol '60s* (New York and London, 1980), p. 3. Hereafter cited as Warhol (1980).

52. For an overview of this situation in the 1950s, see Irving Sandler, *The New York School: The Painters and Sculptors of the Fifties* (New York, 1978).

53. During my interview with James Rosenquist, the Pop artist commented that Frank Stella told him not to use drips in paintings. Interview with James Rosenquist, New York, 18 October 1978. Moreover, according to Irving Sandler, it was the emergence of Stella in the New York art world that posed "a threat to Abstract Expressionism." Interview with Irving Sandler, New York, 11 October 1978.

54. *Robert Rauschenberg* (1976), catalogue no. 52.

55. Ibid., catalogue no. 57.

56. Ibid., catalogue no. 24.

57. Robert Rauschenberg, "Robert Rauschenberg Talks to Maxine de la Falaise McKendry," *Andy Warhol's Interview Magazine,* vol. 6, no. 5, May 1976, pp. 34–36.

58. Interview with Irving Sandler, New York, 11 October 1978.

59. Rauschenberg (1959), p. 58.

60. Ibid.

61. Ibid.

62. Interview with Emile De Antonio, New York, 14 November 1978. Apparently, the museum had a supply of extra thermometers if someone took one. Also see *Marcel Duchamp* (1973), catalogue no. 141.

63. Calvin Tomkins, *Off the Wall: Robert Rauschenberg and the Art World of Our Time* (Garden City, N.Y., 1980), pp. 81f. Hereafter cited as Tomkins (1980).

64. Robert Rauschenberg, quoted in John Cage, "On Robert Rauschenberg, Artist, and His Work," *Metro,* no. 2, May 1961, p. 38, as reprinted in *Silence: Lectures and Writings* (Middleton, Conn., 1961), p. 106. Hereafter cited as Cage (1961).

65. Specifically, Cage's aleatropic method of composition is often provided by the *I Ching,* which supplies Cage with a set of fixed possibilities and with a system of relationships between coins, dice, hexagrams, etc., for the parameters of a composition.

66. Lawrence Alloway has used the term "aesthetics of heterogeneity" in reference to this aspect of Rauschenberg's Combine-paintings. See Lawrence Alloway, "Rauschenberg's Development," in *Robert Rauschenberg* (1976), p. 5.

67. Robert Rauschenberg, quoted in Gene R. Swenson, "Rauschenberg Paints a Picture," *Art News*, vol. 62, no. 2, April 1963, p. 45, cited in Alloway, "Rauschenberg's Development," p. 5.

68. Robert Rauschenberg (1976), catalogue no. 87.

69. Ibid., catalogue no. 105.

70. William C. Seitz, *The Art of Assemblage*, exhibition catalogue (New York: Museum of Modern Art, 1961), p. 87.

71. The exhibition included 34 *Merz* works by Schwitters, 13 works by Duchamp, Johns' *Book* (1957) and two Combine-paintings by Rauschenberg. Ibid., pp. 158f, 162, and 163f.

72. Concerning Rauschenberg's Combine-paintings, Brian O'Doherty has remarked: "The images were chosen not for the content they could unload on each other through juxtaposition, but for their nonspecificity. . . . Rauschenberg has introduced into the museum and its high-art ambience not just the vernacular object but something much more important, the *vernacular glance*." (Brian O'Doherty, *American Masters: The Voice and the Myth* [New York, 1973], pp. 197f. Emphasis O'Doherty's.)

73. See "Dance and Performance," in *Robert Rauschenberg* (1976), pp. 183–97.

74. See Michael Kirby, ed., *Happenings: An Illustrated Anthology* (New York, 1966), Hereafter cited as Kirby (1966).

75. Concerning his Performance Art, Rauschenberg commented to Richard Kostelanetz:

> "I don't want to be in full control. In fact, a lot of the obstacles I bring in function to make sure that I'm not in full control. I very rarely tell my people exactly what to do. What my [performance] pieces tend to be are vehicles for events of a particular nature that can embody and use the personalities and abilities of the performers." (Robert Rauschenberg, quoted in Richard Kostelanetz, *The Theatre of Mixed-Means* [New York, 1968], p. 88.)

76. Andrew Forge, *Robert Rauschenberg* (New York, 1972), p. 15. Hereafter cited as Forge (1972). See *Robert Rauschenberg* (1976), catalogue no. 89.

77. Robert Rauschenberg, quoted in Forge (1972), p. 14.

78. *Robert Rauschenberg* (1976), catalogue no. 43.

79. For a suggestive response to this Combine-painting, see Nicholas Calas, "Robert Rauschenberg," *Kulchur*, vol. 4, no. 15, Autumn 1964, p. 19.

80. *Robert Rauschenberg* (1976), catalogue no. 35.

81. Ibid., catalogue no. 25.

82. Robert Rauschenberg, statement in his offset lithograph *Autobiography* (1968), as reprinted in "Appendix," in Tomkins (1980), p. 303. Also see *Robert Rauschenberg* (1976), catalogue no. 180.

83. Lawrence Alloway, *American Pop Art*, exhibition catalogue (New York: Whitney Museum of American Art, 1974), p. 55. Hereafter cited as Alloway (1974).

84. *Robert Rauschenberg* (1976), catalogue nos. 49, 60, and 43.

85. Rauschenberg's technique entailed solvent-loosened inks that were transferred to the paper by rubbing.

86. *Robert Rauschenberg* (1976), catalogue no. 56.

87. Ibid., catalogue no. 55.

88. Parker Tyler, *Florine Stettheimer: A Life in Art* (New York, 1963), illustration caption opposite p. 154.

89. Henry Geldzahler, *American Painting in the Twentieth Century,* exhibition catalogue (New York: Metropolitan Museum of Art, 1965), p. 126.

90. Warhol (1980), pp. 15f.

91. Roberta M. Bernstein, "Things the Mind Already Knows': Jasper Johns' Paintings and Sculptures, 1954–1974" (Ph.D. dissertation. New York: Columbia University, 1975), p. 32. Hereafter cited as Bernstein (1975).

92. See note 62 above.

93. Jasper Johns, quoted in Leo Steinberg, "Jasper Johns: The First Seven Years of His Art," as reprinted in revised form in *Other Criteria* (New York, 1972), p. 31.

94. Roberta Bernstein has remarked:

> "With the *Flag,* Johns was assertively breaking away from the basic tenets of expressionism, as well as abstraction. For Abstract Expressionists—the 'gesture' painters, e.g., Pollock, de Kooning, Hofmann, Motherwell and Kline, the painting was a metaphor for the artist's subjective condition—moods, anxieties, passions; the artist's feelings, thoughts, and experiences were expressed through forms and colors. This subjectivism is an essential part of the meaning of the painting—the formal elements are intended to be vehicles of self-expression. The works of the color field painters—Still, Rothko and Newman—are not expressive in the same sense, but they too focus attention on the artist, as a kind of 'oracle' who presents a visionary experience through his art. Johns' position of detachment was to remove himself as completely as possible from the painting so it could be experienced objectively, i.e., seen for what it was as an independent object." (Bernstein [1975], pp. 15f.)

95. Michael Crichton, *Jasper Johns,* exhibition catalogue (New York: Whitney Museum of American Art, 1977), catalogue nos. 2 and 51. Hereafter cited as *Jasper Johns* (1977).

96. For instance, Moira Roth has commented that in spite of the "Aesthetic of Indifference" of Duchamp, Cage, and Cunningham, Jasper Johns' paintings before 1960 include cryptic collage material underneath the layers of encaustic paint. Roth has written:

> "More than any other artist, Johns incorporated in his early art the Cold War and the McCarthy era preoccupations and moods. This is not to imply that Johns did this consciously and single-mindedly, or that there is one simplistic reading for any particular image, but what emerges out of a collective examination of his work is a dense concentration of metaphors dealing with spying, conspiracy, secrecy and concealment, misleading information, coded messages and clues. These were the very subjects of newspaper headlines of the period, reiterated on the radio and shown on television; and these were the meat and meaning of the early work of Johns. His early work is a warehouse of Cold-War metaphors." Moira Roth, "The Aesthetic of Indifference," *Artforum,* vol. 16, no. 3, November 1977, p. 51.)

97. See Bernstein (1975), pp. 158–60.

98. Jasper Johns, quoted in Gene R. Swenson, "What Is Pop Art?: Interview with Jasper Johns," *Art News,* vol. 62, no. 10, February 1964, p. 67. Hereafter cited as Johns (1964).

99. Ibid., p. 99.

100. The context of Johns's remark:

> "I was doing at that time sculptures of small objects—flashlights and light bulbs. Then I heard a story about Willem de Kooning. He was annoyed with my dealer, Leo Castelli, for some reason, and said something like, 'That son-of-a-bitch; you could give him two beer cans and he could sell them.' I heard this and thought, 'What a sculpture—two beer cans.' It seemed to me to fit in perfectly with what I was doing, so I did them and Leo sold them." (Ibid., p. 66.)

101. Bernstein (1975), p. 97.

102. Ibid.

103. *Jasper Johns* (1977), catalogue no. 33.

104. Ibid., catalogue no. 17.

105. Ibid., catalogue no. 21.

106. Jasper Johns has remarked:

> "In terms of comment, the work probably has it, some aspect which resembles language. Publicly a work becomes not just intention, but the way it is used. If an artist makes something—or if you make chewing gum and everybody ends up using it as glue, whoever made it is given the responsibility of making glue, even if what he really intends is chewing gum. You can't control that kind of thing." (Johns [1964], p. 66.)

107. See note 9 above.

108. Interview with George Klauber, New York, 15 November 1978.

109. Alfred H. Barr, Jr., *Painting and Sculpture in the Museum of Modern Art, 1929–1967* (New York, 1977), pp. 538f. Also see "Chronology," in *Marcel Duchamp* (1973), p. 24.

110. Interviews with Arthur Elias, New York, 28 November 1978 and with Jack Wilson, Glenview, 22 August 1979.

111. Interview with Ondine (Robert Olivio), New York, 17 December 1978.

112. See Lebel (1959).

113. Interview with Nathan Gluck, New York, 17 October 1978.

114. Gabrielle Buffet-Picabia, "Magic Circles," *View*, series 5, no. 1, March 1945, pp. 14–16, 23.

115. See Janis (1945), p. 24.

116. Ibid.

117. See note 9 above.

118. Lebel (1959), p. 54.

119. Warhol (1980), pp. 42f. Warhol was in Los Angeles on the occasion of his own concurrent one-man show at the Ferus Gallery. Interview with Irving Blum, New York, 20 October 1978.

120. Compare Rauschenberg's Combine-painting *Hymnal*.

121. See Dorothy Seiberling, "The Star Had Trouble Getting Here, But, Oh Boy, What a Smile!: LISA OPENS IN D.C.," *Life*, vol. 54, no. 1, 4 January 1963, pp. 14–19.

122. Gene R. Swenson, "What is Pop Art?: Interview with Andy Warhol," *Art News*, vol. 62, no. 7, November 1963, pp. 24, 60f. Hereafter cited as Warhol-Swenson (1963).

123. Interview with Gerard Malanga, New York, 1 November 1978.

124. Leonard B. Meyer, "The End of the Renaissance?: Notes on the Radical Empiricism of the Avant-Garde," *Hudson Review*, vol. 16, no. 2, Summer 1963, pp. 169–86.

125. Warhol-Swenson (1963), p. 61.

126. Ibid.

127. Interview with Ted Carey, New York, 16 October 1978.

128. Interviews with Ted Carey, New York, 16 October 1978; Emile De Antonio, New York, 14 November 1978; Nathan Gluck, New York, 17 October 1978; and Bert Greene, New York, 3 December 1978.

129. Warhol (1980), pp. 10–13.

130. Interview with Emile De Antonio, New York, 14 November 1978.

131. See chapter 2.

132. Interview with Henry Geldzahler, New York, 17 November 1978.

133. Interview with Nathan Gluck, New York, 17 October 1978.

134. In spite of my questions to the artist, Warhol would not confirm whether both versions are or are not still in his possession.

135. Interview with Emile De Antonio, New York, 14 November 1978. Also see Warhol (1980), pp. 4–6.

136. Ibid.

137. Interviews with Irving Blum, New York, 20 October 1978; Ted Carey, New York, 16 October 1978; Leo Castelli, New York, 8 November 1978; Emile De Antonio, New York, 14 November 1978; and Ivan Karp, New York, 12 October 1978.

138. Interviews with Ted Carey, New York, 16 October 1978; Emile De Antonio, New York, 14 November 1978; Gene Moore, New York, 13 October 1978 and 30 October 1978; and James Rosenquist, New York, 18 October 1978.
 The paintings in the Bonwit Teller window display are *Advertisement* (1960), *Little King* (1960), the initial state of *Superman* (1960), the first version of *Before and After* (1960), and *Saturday's Popeye* (1960). See Rainer Crone, *Andy Warhol*, trans. John William Gabriel (London, 1970), catalogue nos. 1, 20, 15, 11, and 18. Hereafter cited as Crone (1970).

139. Ibid., catalogue nos. 15, 17, and 21.

140. Ibid., catalogue nos. 11, 4, and 7.

141. Ibid., catalogue nos. 2 and 3. Crone's catalogue does not include Warhol's first two *Coca-Cola Bottle* paintings.

142. Other sizes include 54″ × 40″ (*Water Heater*), 79″ × 45″ (*Dick Tracy*), and 40″ × 54″ (*Nancy*). Ibid., catalogue nos. 5, 21, and 17. (Dimensions are given height first, then width.)

143. Interview with Nathan Gluck, New York, 17 October 1977. Multiple images on one canvas include *Advertisement* with four different advertising sources, as well as *Little King* and

Saturday's Popeye, which include parts of the same cartoon image. Ibid., catalogue nos. 1, 20, and 18.

144. E.g., *Wigs, Dr. Scholl's Corns, Strong Arms and Broads, Make Him Want You, Batman,* and *Superman.* Ibid., catalogue nos. 6, 7, 8, 10, 11, and 15.

145. E.g., *Before and After* (first version), *Superman, Saturday's Popeye, Water Heater,* and *$199 Television.* Ibid., catalogue nos. 11, 15, 18, 5, and 4.

146. Warhol's *Superman* (Private collection) is 67″ × 52″. It was included in Warhol's exhibition at Bonwit Teller, ibid., catalogue no. 15.

147. On the technique of figuration and conventions used in comic strip art, see Pierre Couperie, et al., *A History of the Comic Strip,* trans. Eileen B. Hennessy (New York, 1968), pp. 179–241.

148. In his portraits of the 1970s, Warhol includes a similar form of visual "noise," including painterly scribbles and broad, gestural brush marks (formed by a mop).

149. Interviews with Ted Carey, New York, 16 October 1978 and with Leo Castelli, New York, 8 November 1978. In *Jasper Johns* (1977), catalogue no. 29, the owner is listed as "Private Collection." Warhol is listed as the owner in Max Kozloff, *Jasper Johns* (New York, 1969), fig. 128. Hereafter cited as Kozloff (1969).

150. See note 103 above.

151. Kozloff (1969), p. 46. Also see *Jasper Johns* (1977), catalogue nos. 9, 10, 11, 38, 43, and 44.

152. Cf. the Palmer method of penmanship, in which one exercise is a continuous hatching. Note, too, that Warhol appreciated his mother's calligraphy, and he had her sign his "signature" in his commercial art work.

153. Cf. Rauschenberg's use of *frottage,* in which the image *appears* because of the hatchings, as in *Mona Lisa* of 1958 and in his series *34 Drawings for Dante's "Inferno"* of 1959–60. See *Robert Rauschenberg* (1976), catalogue nos. 60, 77–79.

154. See note 93 above.

155. Interview with Ted Carey, New York, 16 October 1978.

156. Bernstein (1975), p. 99. Bernstein quotes Jasper Johns's remarks in Walter Hopps, "An Interview with Jasper Johns," *Artforum,* vol. 3, no. 6, March 1965, p. 36.

157. Bernstein (1975), p. 196. See *Jasper Johns* (1977), catalogue no. 114 and Bernstein (1975), fig. 65.

158. *Jasper Johns* (1977), figure on p. 57. Johns's painting was commissioned for the United States Pavilion, 1967 World's Fair, Montreal. Later, in 1971, Johns repainted the entire canvas.

159. Crone (1970), catalogue no. 17.

160. Lawrence Alloway, "Jasper Johns' Map," *The Nation,* vol. 213, 22 November 1971, pp. 541f.

161. E.g., Johns's series *White Alphabets* of 1968. See Bernstein (1975), p. 48 and fig. 77.

162. Crone (1970), catalogue nos. 433–42.

163. Warhol (1980), p. 22.

164. Jackson Pollock, quoted in Barbara Rose, *American Art Since 1900*, rev. ed. (New York and Washington, D.C., 1975), p. 212. Hereafter cited as Rose (1975).

165. Warhol-Swenson (1963), p. 24. The comparison of Pollock's and Warhol's statements was first suggested in Rose (1975), p. 212.

166. See Warhol-Swenson (1963).

167. Ibid., p. 24.

168. Andy Warhol, *The Philosophy of Andy Warhol (From A to B and Back Again)* (New York and London, 1975), pp. 21–24. Hereafter cited as Warhol (1975).

169. Ibid., p. 26.

170. Ibid.

171. Ibid.

172. Ibid.

173. Ibid. Emphasis Warhol's.

174. Warhol (1980), p. 108.

175. Warhol (1975), p. 46.

176. See note 174 above.

177. Warhol (1980), p. 198.

178. Ibid., p. 3.

179. Ibid., p. 39.

180. Ibid., p. 221. Emphasis Warhol's.

181. See note 167 above.

182. Warhol (1980), p. 134.

183. Warhol-Swenson (1963), p. 24.

184. Warhol (1975), pp. 145f.

185. Ibid., pp. 143f.

186. Andy Warhol, quoted in interview with Bert Greene, New York, 3 December 1978.

187. Duchamp has remarked: "I was interested in ideas—not merely in visual products. I wanted to put painting once again at the service of the mind. . . . This is the direction in which art should turn: to an intellectual expression, rather than to animal expression." (Marcel Duchamp, "The Great Trouble with Art in this Country . . . ," *Museum of Modern Art Bulletin*, vol. 13, nos. 4–5, 1946, pp. 19,21.)

188. Interview with Joseph Groell, New York, 7 December 1978.

189. Ibid.

190. Warhol-Swenson (1963), p. 24.

191. Lázló Moholy-Nagy, *The New Vision*, 4th rev. ed., trans. Daphne M. Hoffman, with *Abstract of an Artist*, Documents of Modern Art, series ed. Robert Motherwell (New York, 1947). *The New Vision* was written during Moholy-Nagy's association (1925–1928) with the Bauhaus; its first American edition appeared in 1930, and its second appeared in 1938.

192. Interview with Jack Wilson, Glenview, 22 August 1979.

193. Among previous introductions to the pedagogy of the Bauhaus in English are Walter Gropius, *The New Architecture* (London, 1936), and Herbert Bayer and Walter Gropius, eds., *Bauhaus, 1919–1928* (New York, 1938). Moholy-Nagy was the director of the Institute of Design, Chicago, from 1938 until his death in 1946.

194. Moholy-Nagy, *The New Vision*, p. 17. Emphasis Moholy-Nagy's.

195. Ibid.

196. Ibid., p. 20. Emphasis Moholy-Nagy's.

197. Ibid., p. 16.

198. Ibid., pp. 16f.

199. In the second part of *The New Vision,* Moholy-Nagy provides a developmental history of twentieth century "progressive" painting, as well as a proposed "final simplification" of the picture plane as a projection screen, where photography, transparent positive slides and the motion picture are considered to be among the technical pivots of his proposed pictorial evolution. Such an integration of the pictorial arts, utilizing new technologies, may be considered a theoretical prototype of Warhol's film experiments, such as split-screen projection with color filters (e.g., *Chelsea Girls* of 1966). Warhol also used several slide projectors, strobe lights and film projectors as a background for his musical group, The Velvet Underground.

200. Moholy-Nagy, *The New Vision*, p. 76.

201. Moholy-Nagy, *Abstract of an Artist*, p. 72.

202. Ibid., p. 79.

203. Ibid.

204. Ibid.

205. See Moholy-Nagy, *Abstract of an Artist*, pp. 79f.

206. The term "Multiple Art" was coined in 1955 by the artists Yaacov Agam and Jean Tinguely and by their Parisian gallery dealer Denise René. René attempted unsuccessfully to patent the term. See "Multiples Supplement," *Art and Artists*, vol. 4, no. 3, June 1969, pp. 27–65. As the term is used here, Multiple Art may include works in any medium.

207. William C. Seitz, *Claude Monet: Seasons and Moments,* exhibition catalogue (New York: Museum of Modern Art, 1960).

208. Warhol (1975), p. 144.

209. Andy Warhol, "Andy Warhol Talks about Sex, Art, Fame and Money," *Forum Magazine,* vol. 10, no. 4, January 1981, p. 21.

210. Warhol has written: "The people who have the best fame are those who have their name on stores. The people with very big stores named after them are the ones I'm really jealous of. Like Marshall Field." (Warhol [1975], pp. 77f.)

211. Ibid., pp. 25f.

212. Stephen Koch, *Stargazer: Andy Warhol's World and His Films* (New York and Washington, D.C., 1973), pp. 17–32. Hereafter cited as Koch (1973).

213. See chapter 1.

214. Andy Warhol quoted in Koch (1973), p. 121.

215. Warhol (1975), p. 54.

216. Ibid.

217. Ibid., p. 53.

218. Ibid., p. 160.

219. Andy Warhol, quoted in Gretchen Berg, "Andy Warhol: My True Story," *Los Angeles Free Press,* vol. 6, no. 11, 17 March 1967, p. 42. Hereafter cited as Warhol-Berg (1967).

220. Lynn Teresa Thorpe, "Andy Warhol: Critical Evaluation of His Images and Books" (Ph.D. dissertation. Ithaca, N.Y.: Cornell University, 1980).

221. Ibid., p. 84.

222. Warhol-Berg (1967), p. 42.

223. Ibid.

224. See my discussion concerning John Cage above.

225. John Cage, "In this Day . . . ," in Cage (1961), p. 94. Emphasis mine. Cage's remarks were first written during the fall of 1956.

226. Joanna C. Magloff, "Directions—American Painting, San Francisco Museum of Art," *Artforum,* vol. 2, no. 5, November 1963, pp. 43f.

227. Michael Fried, "New York Letter," *Art International,* vol. 6, no. 10, 20 December 1962, pp. 54–58. Hereafter cited as Fried (1962).

228. Dore Ashton, "New York Report," *Das Kunstwerk,* vol. 16, nos. 5-6, November-December 1962, pp. 68–70, 73.

229. Peter Gidal, *Andy Warhol: Films and Paintings* (London, 1971), pp. 33f and 58–60. Hereafter cited as Gidal (1971).

230. Crone (1970), and Crone and Wilfried Wiegand, *Die revolutionaere Aesthetik Andy Warhols in Kunst und Film* (Frankfurt-am-Main, 1970).

231. Thorpe (1980), p. 55. I disagree with Thorpe's use of the term "isomorphic representation" and would substitute "homomorphic representation." An isomorphism implies a one-to-one correspondence in Thorpe's post-Structuralist context, and it would be encountered only under very unusual and restrictive circumstances. A homomorphism is a "structure" that preserves the transformation, in which some of the "fine structure" (or, object's detail) is lost or rendered more coarsely grained in the silkscreen process.

232. Ibid., p. 57.

233. Ibid., pp. 58f.

234. Ibid., pp. 59f.

235. Interview with David Bourdon, New York, 16 October 1978.

236. Interview with Danny Fields, New York, 15 November 1978.

237. Interview with Andy Warhol, New York, 6 November 1978.

238. Andy Warhol, quoted in interview with Robert Pincus-Witten, New York, 15 November 1978.

239. See chapter 2.

240. Interview with Suzi Frankfurt, New York, 29 November 1978.

241. Interview with Joseph Giordano, New York, 30 November 1978.

242. The poet Charles Henri Ford, who was a friend of Gerard Malanga and Warhol, has re-marked:

> "At one point I asked Gerard [Malanga], after he'd been with him [Warhol] some time, I said, what does Andy really want? Gerard replied, glamour. And I said then, well do you think he's got it? And Gerard said, well he's getting it. That was really before the publicity explosion. Andy would say, 'Oh, I think *Harper's Bazaar* is so glamorous.'"
> (Charles Henri Ford, quoted in John Wilcock, *The Autobiography and Sex Life of Andy Warhol* [New York, 1971], n.p.) Hereafter cited as Wilcock [1971].)

243. Interview with Charles Lisanby, New York, 11 November 1978.

244. E.g., interviews with Emile De Antonio, New York, 14 November 1978; Nathan Gluck, New York, 17 October 1978; and Fritzie Wood, New York, 1 December 1978.

245. Interview with Joseph Giordano, New York, 30 November 1978.

246. Crone (1970), catalogue nos. 75 and 76.

247. Ibid., catalogue nos. 77-78a.

248. Dick Sheppard, *Elizabeth: The Life and Career of Elizabeth Taylor* (London, 1975), p. 296. Hereafter cited as Sheppard (1975).

249. Ibid., pp. 263–66.

250. Ibid., pp. 299f, 306.

251. Ibid., pp. 323–29.

252. Sheppard remarks: "On February 18 the lid blew off, and stayed off, as mounting public fascination transformed *le scandale* into the greatest single new event of 1962 throughout the world." (Ibid., p. 300.)

253. Art Buchwald, quoted in ibid., p. 307.

254. Brenda Maddox, *Who's Afraid of Elizabeth Taylor?* (New York, 1977), p. 171. Hereafter cited as Maddox (1977).

255. Ibid., p. 172. Also see Sheppard (1975), p. 324.

256. Ibid., pp. 330–34.

257. Maddox (1977), p. 175. E.g., see Hollis Alpert, "Vanitas vanitatus: *The Cleopatra Papers*," *Saturday Review*, vol. 46, no. 31, 3 August 1963, p. 64; "Can Cleo Pay It Back?" *Business Week*, no. 1762, 8 June 1963, pp. 48–50; "The Fortunes of Cleopatra," *Newsweek*, vol. 61, no. 12, 25 March 1963, pp. 63–66; Jack Hamilton, "Elizabeth Taylor Talks about Cleopatra," *Look*, vol. 27, no. 9, 7 May 1963, pp. 41–50; and Walter Wanger and Joseph Hyams, "*Cleopatra:* Trials and Tribulations of an Epic Film," *Saturday Evening Post*, vol. 236, no. 21, 1 June 1963, pp. 28–53.

258. Interview with David Bourdon, New York, 16 October 1978.

259. Warhol-Berg (1967), p. 42.

260. Warhol-Swenson (1963), p. 60.

261. As discussed, Warhol began the *Liz* series during August 1962. The Swenson "interview" appears only a year later. Taylor had, moreover, fully recovered from her illnesses by April 1963. See Sheppard (1975), p. 266f.

262. Jonas Mekas, "The Filmography of Andy Warhol," in John Coplands, *Andy Warhol* with contributions by Calvin Tomkins and Jonas Mekas, exhibition catalogue (New York: Whitney Museum of American Art, 1971), p. 146.

263. This film still, as well as that for Warhol's *Brando* (from the film *The Wild One*) appears in Richard Griffith and Arthur Mayer, *The Movies* (New York, 1957) pp. 264, 467. Whether or not Warhol used the book for pictorial sources or not is unknown. Also see note 278 below.

264. Warhol has written: "When you want to be like something, it means you really love it. When you want to be like a rock, you really love that rock. I love plastic idols." Warhol (1975), p. 53.

265. The Pop artist has remarked: "That screen magnetism is something secret—if you could only figure out what it is and how to make it, you'd have a really good product to sell." Ibid., p. 63.

266. Koch (1973), p. 5. Emphasis Koch's.

267. Warhol (1975), p. 54.

268. E.g., see Paul Bergin, "Andy Warhol: The Artist as Machine," *Art Journal,* vol. 26, no. 4, Summer 1967, pp. 359–63; Fried (1962); Gidal (1971); Ellen H. Johnson, "The Image Duplicators—Lichtenstein, Rauschenberg and Warhol," *Canadian Art,* vol. 23, no. 1, January 1966, pp. 12–19; Edward Lucie-Smith, "Pop and the Mass Audience," *Studio International,* vol. 162, August 1966, pp. 96f.; and Arnold Rockman, "Superman Comes to the Art Gallery," *Canadian Art,* vol. 21, no. 1, January-February 1964, pp. 18–22.

269. Thorpe (1980), p. 76.

270. Ibid.

271. Marxist interpreters of Warhol include Rainer Crone, Emile De Antonio, and M. Otte. See Crone (1970); interview with Emile De Antonio, New York, 14 November 1978; M. Otte, "Notizen zu Andy Warhol und Roy Lichtenstein," *Das Kunstwerk,* vol. 21, nos. 9–10, June–July 1968; pp. 54–56.

272. Crone (1970), p. 23.

273. Andy Warhol, "My Favorite Superstar: Notes on My Epic, 'Chelsea Girls,'" *Arts,* vol. 41, no. 4, February 1967, p. 26.

274. See note 226 above.

275. See Warhol (1975), pp. 3f., 158, 160.

276. Gerard Malanga, *Chic Death* (Cambridge, Mass., 1971).

277. Gerard Malanga, *My First Day with Andy Warhol,* unpublished MS, 1965.

278. Andy Warhol, interview by Michele Patterson, fall of 1980, in Michele Patterson, "The Iconography of Pop Art from a Socio-political Point-of-view" (Ph.D. dissertation. Chapel Hill, N.C.: University of North Carolina at Chapel Hill, forthcoming).

279. Interview with David Bourdon, New York, 16 October 1978.

280. Ibid.

281. Ibid. During the fall of 1978, when I regularly visited Warhol's studio, this and other sensationalist newspapers were being regularly read by Warhol and his associates.

282. Warhol (1980), p. 12.

283. Interview with Nathan Gluck, New York, 17 October 1978.

284. Crone (1970), catalogue no. 39.

285. Henry Geldzahler, quoted in Wilcock (1971), n.p.

286. Interview with Robert Fleischer, New York, 27 October 1978.

287. In chapter 2, it has been shown that Warhol traced drawings of the 1950s from photographs, which he *implicitly* makes evident only to someone who attempts to find Warhol's pictorial sources.

288. See "The Spectacle of Racial Turbulence in Birmingham: They Fight a Fire That Won't Go Out," *Life*, vol. 54, no. 20, 17 May 1963, pp. 26–36. Charles Moore's photographs that were used by Warhol appear on pages 30–31.

289. Gay Morris, "When Artists Use Photographs: Is It Fair Use, Legitimate Transformation or Rip-Off?" *Art News*, vol. 80, no. 1, January 1981, pp. 102–6. Hereafter cited as Morris (1981).

290. Crone (1970), catalogue nos. 550-600, 610, 626, and 649.

291. See Morris (1981), pp. 102—6.

292. Interview with Ronnie Cutrone, New York, 13 December 1978.

293. Crone (1970), catalogue nos. 303—30.

294. Ibid., catalogue nos. 331–86.

295. Ibid., catalogue nos. 387–407.

296. Ibid., catalogue no. 426.

297. Ibid., catalogue nos. 429–32.

298. Ibid., catalogue no. 423.

299. Ibid., catalogue nos. 102–25.

300. Interview with Ivan Karp, New York, 18 October 1978. In contrast, Karp also noted that Warhol's *Flowers* paintings were sold out entirely and would still have potential buyers.

301. E.g., see Donald Factor, "New York Group, Ferus Gallery," *Artforum*, vol. 2, no. 9, March 1964, p. 13; Barbara Rose, "ABC Art," *Art in America*, vol. 53, no. 5, October-November 1965, pp. 57–69; Irving Sandler, "The New Cool Art," *Art in America*, vol. 53, no. 1, February 1965, pp. 96–101; Ellen Wilson, "Recent American Painting, Pomona Gallery," *Artforum*, vol. 3, no. 7, April 1965, p. 10.

302. E.g., see Thorpe (1980), passim.

303. Lawrence Alloway has remarked:

 "He [Warhol] depends on the mass media to provide images of spectacular exits from the world, just as he did of its painful occupancy. Death, as Warhol depicts it in his

selected photographs, is statistically average; the car crashes are those that any of us might be in. The goldfish bowl [i.e., the popular culture and the mass media, which are "instantly" accessible] in which death and catastrophe occur includes us, the spectators." (Alloway [1974], p. 113.)

304. Crone (1970), p. 29. Emphasis Crone's.

305. Ibid.

306. Warhol-Berg (1967), p. 42.

307. Crone (1970), catalogue nos. 303, 321, 332, 408, and 426.

308. Warhol-Swenson (1963), p. 60. Also note my discussion of Warhol's desire to be a "machine" above.

309. Warhol (1975), p. 121.

310. Andy Warhol, quoted in interview with Bert Greene, New York, 3 December 1978.

311. I am paraphrasing a remark by Robert Olivio to me. Interview with Ondine (Robert Olivio), New York, 16 December 1978.

312. See my definition of Warhol's Pop Art above.

313. Warhol-Swenson (1963), p. 61.

314. During Joseph Gelmis's interview with Warhol, the artist was asked about interruptions of commercials on television, and Warhol replied:

"I like them cutting in every few minutes because it really makes everything more entertaining. I can't figure out what's happening in those shows anyway. They're so abstract. I can't understand how ordinary people like them. They don't have many plots. They don't do anything. It's just a lot of pictures, cowboys, cops, cigarettes, kids, war, all cutting in and out of each other without stopping. *Like the pictures we make.*" (Andy Warhol, quoted in Joseph Gelmis, *The Film Director as Superstar* [Garden City, N.Y., 1970], pp. 70f. Emphasis mine.)

315. See note 259 above.

316. Warhol's remark was appropriated by journalists. In *POPism*, Warhol has observed:

"In those days practically no one tape-recorded news interviews; they took notes instead. I liked that better because when it was written up, it would always be different from what I'd actually said—and a lot more fun for me to read. Like if I'd said, 'In the future everyone will be famous for fifteen minutes,' it could come out, 'In fifteen minutes everybody will be famous.'" (Warhol [1980], p. 130.)

317. Andy Warhol quoted in Berg (1967), p. 42.

318. See chapter 2, note 1.

319. Crone (1970), catalogue no. 421.

320. Warhol (1975), pp. 21f.

321. Robert Indiana, quoted in Barbaralee Diamonstein, *Inside New York's Art World* (New York, 1979), p. 153.

322. Ibid., p. 158.

323. Christopher Finch, *Pop Art: Object and Image* (London, 1968), pp. 72–87.

324. See Jim Dine, *"The Car Crash,"* in Kirby (1966), pp. 189–99.

325. See Claes Oldenburg and Emmett Williams, *Store Days* (New York, 1967).

326. Interview with James Rosenquist, New York, 18 October 1978.

327. Alloway (1974), pp. 16f.

328. Interview with Ted Carey, New York, 16 October 1978.

329. Ibid.

330. Warhol did at least two series of *Campbell Soup Cans* in 1962 and 1965. See Crone (1970), catalogue nos. 444-528. Warhol used, also, the trademark image in an unnumbered edition of prints, boxes, banners and shopping bags. See ibid., catalogue nos. 624, 625, 640, 642, 643, and 644.

331. Warhol wrote: "Working for a lot of money can throw your self-image off. When I used to do shoe drawings for the magazines I would get a certain amount for each shoe, so then I would count up my shoes to figure out how much I was going to get. I lived by the number of shoe drawings—when I counted them I knew how much money I had." (Warhol [1975], p. 85.)

332. Ibid., p. 92.

333. Interview with Gerard Malanga, New York, 13 December 1978.

334. Warhol (1975), p. 133.

335. Ibid., pp. 133f.

336. Warhol (1975), p. 135.

337. Interviews with Emile De Antonio, New York, 14 November 1978 and with Eleanor Ward, New York, 9 November 1978.

338. Interview with Alfred Carleton Walters, New York, 28 November 1978. According to Charles Lisanby, Warhol consumed Campbell's soup almost on a daily basis. Interview with Charles Lisanby, New York, 11 November 1978.

339. Warhol-Berg (1967), p. 42.

340. Crone (1970), catalogue nos. 30 and 31.

341. Interview with George Klauber, New York, 19 November 1978.

342. Interview with Andy Warhol, New York, 6 November 1978.

343. Crone (1970), catalogue nos. 159 and 160.

344. Lawrence Alloway discovered this advertisement to be Warhol's pictorial source. See Alloway (1974), fig. 94.

345. Warhol did three versions of *Before and After*. See Crone (1970), catalogue nos. 11-13.

346. Interview with Charles Lisanby, New York, 11 November 1978.

347. Ibid. Emphasis Lisanby's.

348. On the specific sense of *"ressentiment,"* as used here, see note 1 above.

349. E.g., see Warhol (1975), p. 65.

350. See Warhol (1975), p. 62.

351. Ibid., p. 63.

352. Also see Warhol (1975).

353. Ibid., p. 53.

354. Interview with Daniel Arje, New York, 23 October 1978.

355. See Bob Thomas, *Marlon: Portrait of the Rebel as an Artist* (New York, 1973), pp. 79–83. E.g., see fig. 56.

356. See Warhol (1980), passim and unpaged photographs.

357. Interview with Jackie Curtis, New York, 21 November 1978.

358. Warhol (1980), pp. 46f.

359. Ibid.

Chapter 4

1. Warhol remarked to Gretchen Berg: "I think we're a vacuum here at the Factory; it's great. I like being a vacuum; it leaves me alone to work." Andy Warhol, quoted in Gretchen Berg, "Andy Warhol: My True Story," *Los Angeles Free Press,* vol. 6, no. 11, 17 March 1967, p. 42. Hereafter cited as Warhol-Berg (1967).

2. Interviews with Tally Brown, New York, 11 November 1978; Jackie Curtis, New York, 21 November 1978; Danny Fields, New York, 15 November 1978; Ondine (Robert Olivio), New York, 17 December 1978; Ronald Tavel, New York, 8 October 1978 and 1 November 1978; Holly Woodlawn, New York, 22 November 1978.

3. Stephen Koch, *Stargazer: Andy Warhol's World and His Films* (New York and Washington, D.C., 1973). Hereafter cited as Koch (1973). Also see Charles Baudelaire, *The Painter of Modern Life and Other Essays,* ed. and trans. Jonathan Mayne (London, [1863] 1964), pp. 1–40.

4. Interview with Stephen Koch, New York, 26 October 1978.

5. W. Robert La Vine, *In a Glamorous Fashion: The Fabulous Years of Hollywood Costume Design* (New York, 1980), p. 38.

6. See Introduction.

7. During my taped interview with Warhol, most of his remarks concerned the whereabouts of former friends such as choreographer Marjorie Beddow. "Is she beautiful still?" he asked. Warhol recalled that "she was on the cover of *Life* magazine." Interview with Andy Warhol, New York, 6 November 1978.

8. Cf. Andy Warhol and Pat Hackett, *POPism: The Warhol '60s* (New York and London, 1980), p. 42. Hereafter cited as Warhol (1980).

9. Warhol-Berg (1967), p. 42. Emphasis Warhol's.

10. Warhol (1980), p. 219.

11. Stephen Koch, who frequented Warhol's studio during the later 1960s and who visited it through this period, has commented:

 "Any new guest—remember that in 1963 Warhol was entering the most conspicuous era of his fame; there were *hundreds* of guests—was put into a chair before the camera

as soon as he or she arrived. They would sit through the [film] role, their portrait being made. When Warhol wasn't there Billy Linich or [Gerard] Malanga operated the camera: it became a standard and inescapable tradition of the place." (Koch [1973], p. 45. Emphasis Koch's.)

12. Interview with Jackie Curtis, New York, 21 November 1978.

13. Ibid.

14. Ibid. Emphasis Curtis's.

15. Ibid.

16. Interview with Ivan Karp, New York, 12 October 1978.

17. See Koch (1973), pp. 3–16.

18. Interview with Gerard Malanga, New York, 1 November 1978.

19. Ibid.

20. Interviews with Ronald Tavel, New York, 8 October 1978 and 1 November 1978.

21. See *Wagner Literary Magazine* (Staten Island, N.Y.), no. 4, 1963–64, passim. Also in this issue (pp. 169f.), Henry Geldzahler has a short article on Warhol's Pop Art.

22. See Jonas Mekas, "The Filmography of Andy Warhol," in John Coplands, *Andy Warhol* with contributions by Calvin Tomkins and Jonas Mekas, exhibition catalogue (New York: Whitney Museum of American Art, 1971), pp. 147f. Hereafter cited as Mekas (1971).

23. Interview with Ronald Tavel, New York, 8 October 1978 and 1 November 1978.

24. Warhol (1980), p. 119.

25. Ibid., pp. 143–65. For a full account of the group, see Victor Bockris and Gerard Malanga, *Up-tight: The Velvet Underground Story* (New York, 1983).

26. In *POPism,* Warhol has remarked: "Nico was a new type of female superstar. Baby Jane [Holzer] and Edie [Sedgwick] were both out-going, American, social, bright, excited, chatty—whereas Nico was weird and untalkative. You'd ask her something and she'd maybe answer you five minutes later. When people described her, they used words like *memento mori* and *macabre*. She wasn't the type to get up on a table and dance, the way Edie or Jane might; in fact, she'd rather hide under the table than dance on top of it. She was mysterious and European, a real moon goddess type." (Warhol (1980), p. 146.)

27. Ibid., p. 145.

28. Ibid., p. 111.

29. See Warhol (1980), pp. 51–59.

30. Ibid., p. 55.

31. Ibid.

32. Ibid., pp. 55f.

33. Interview with Jackie Curtis, New York, 21 November 1978. Cf.: ". . . the gloomier she [Nico] could make the atmosphere around her, the more radiant she became." Warhol (1980), p. 268.

34. Interview with Gerard Malanga, New York, 1 November 1978.

35. In retrospect, Warhol has written: "Why he [Billy Linich] loved silver so much I don't know. It must have been an amphetamine thing—everything always went back to that. But it was the perfect time to think silver. Silver was the future—the astronauts wore silver suits. . . . And silver was also the past—the Silver Screen—Hollywood actresses photographed in silver sets." (Warhol [1980], pp. 64f.) Significantly, Warhol further remarked: "And maybe more than anything, silver was narcissism—mirrors were backed with silver." Ibid.

36. Warhol's film *Haircut* (1963) best conveys this atmosphere. See Koch (1973), pp. 52–58.

37. Interviews with Ronald Tavel, New York, 8 October 1978 and 1 November 1978.

38. Warhol (1980), p. 56.

39. Ibid., p. 83.

40. In an extraordinary passage of *POPism*, Warhol describes the "Factory" during the summer of 1966 and conveys just such a total absorption:

> "The air didn't really move. I would sit in a corner for hours, watching people come and go and stay, not moving myself, trying to get a complete idea, but everything stayed fragmentary; I never knew what was really happening. I'd sit there and listen to every sound: the freight elevator moving in the shaft, the sound of the grate opening and closing when people got in and went out, the steady traffic all the way downstairs on 47th Street, the projector running, a camera shutter clicking, a magazine page turning, somebody lighting a match, the colored sheets of gelatin and sheets of silver paper moving when the fan hit them, and high school typists hitting a key every couple of seconds, the scissors shearing as Paul [Morrissey] cut out E.P.I. clippings and pasted them into scrapbooks, the water running over the prints in Billy's [Linich] darkroom, the timer going off, the dryer operating, someone trying to make the toilet work, men having sex in the back room, girls closing compacts and make-up cases. The mixture of the mechanical sounds and the people sounds made everything seem unreal and if you heard a projector going while you were watching somebody, you felt that they must be a part of the movie, too." (Warhol [1980], p. 172).

41. See Warhol (1980), passim.

42. Interview with Danny Fields, New York, 15 November 1978.

43. The term "flaming creatures" was coined by the filmmaker Jack Smith and was the title of one of his Independent films. See Koch (1973), p. 5.

44. Interview with Tally Brown, New York, 11 November 1978.

45. Ibid.

46. Ibid.

47. Ibid.

48. Warhol (1980), p. 96.

49. Interview with Gordon Baldwin, New York, 18 November 1978.

50. Warhol (1980), pp. 96–98, 106f. and 154.

51. See Koch (1973), p. 65.

52. See Warhol (1980), p. 287. Also see Andy Warhol, *The Philosophy of Andy Warhol* (*From A to B and Back Again*) (New York, 1975), pp. 33–37. Hereafter cited as Warhol (1975).

53. Jean Stein, *Edie: An American Biography*, edited with George Plimpton (New York, 1982). Hereafter cited as Stein (1982).

54. Interview with Gordon Baldwin, New York, 18 November 1978.

55. Mel Juffe, quoted in Warhol (1980), p. 121. A specific case in point is the hysterical reaction of people trying to touch Warhol and Sedgwick at an opening in Philadelphia. See Stein (1982), pp. 250–55.

56. Warhol (1980), p. 127.

57. See Stein (1982), p. 193.

58. Warhol (1980), p. 124.

59. Ibid., p. 40. Emphasis Warhol's.

60. See Stein (1982), p. 204.

61. Interview with Gerard Malanga, New York, 1 November 1978.

62. Ibid.

63. See the following section on heretofore unknown Warhol films.

64. Warhol (1980), p. 42.

65. See Mekas (1971), p. 146.

66. Interview with Jonas Mekas, New York, 18 December 1978. The term means 100 feet of used film.

67. See Mekas (1971), pp. 148f.

68. Interview with Ondine (Robert Olivio), New York, 17 December 1978.

69. Interviews with Ronald Tavel, New York, 8 October 1978 and 1 November 1978.

70. See Koch (1973), pp. 17–32.

71. Warhol (1975), p. 63.

72. See Gene R. Swenson, "What is Pop Art?: Interview with Andy Warhol," *Art News*, vol. 62, no. 7, November 1963, p. 24.

73. See Warhol (1980), passim.

74. Warhol (1975), p. 53.

75. Ibid., p. 54.

76. Interview with Holly Woodlawn, New York, 22 November 1978.

77. Warhol (1980), p. 127.

78. Interview with Holly Woodlawn, New York, 22 November 1978.

79. Interview with Jackie Curtis, New York, 21 November 1978.

80. Ibid.

81. Warhol (1980), p. 265.

82. Ibid., pp. 289f. and 299f.

83. Interview with Ondine (Robert Olivio), New York, 17 December 1978. Most of his remarks concerning astrology and Warhol were, unfortunately, not tape-recorded. When I spoke to Jackie Curtis and Ondine, they both asked me what my astrological sign was and, when I replied that it was Leo, they felt that I was "akin," spiritually "right," to Warhol and, consequently, *the* person to study the artist. Curtis and Ondine, like all of the other assistants and entourage members suppose that Warhol was born during August of 1928. In fact, he was born during October of 1930. See chapter 1, note 1. Consequently, Warhol is born under the sign of Scorpio, which would have considerable astrological differences from someone born under the sign of Leo.

84. Interview with Ondine (Robert Olivio), New York, 16 December 1978. Emphasis Ondine's.

85. Warhol (1980), p. 219.

86. Ibid., p. 269.

87. Ibid., p. 75.

88. Ibid., pp. 271–75.

89. Andy Warhol quoted in Leticia Kent, "Andy Warhol: 'I Thought Everyone Was Kidding,'" *Village Voice*, vol. 13, no. 48, 12 September 1968, pp. 37f.

90. Warhol (1975), pp. 7, 10.

91. Ibid., p. 5.

92. Jean Genet, *The Thief's Journal*, translated by Bernard Frechtman (New York, 1982), p. 94.

93. Virtually all commentaries on Warhol's films begin with those made in 1963. E.g., Mekas (1971), pp. 146–56.

94. Interviews with Jack Wilson, Chicago, 7 March 1979, and Glenview, 22 August 1979.

95. Ibid.

96. Ibid.

97. Ibid.

98. Ibid.

99. See William S. Rubin, *Dada, Surrealism, and Their Heritage*, exhibition catalogue (New York: Museum of Modern Art, 1968), p. 83 and figs. 107 and 108.

100. Interviews with Jack Wilson, Chicago, 7 March 1979, and Glenview, 22 August 1979. During both interviews, I repeatedly asked Wilson what specifics the Pictorial Design students knew about the Surrealists and specifically about Surrealist art games. Wilson did not recall mention of such Surrealist collaborations, but it is possible that other students did. During the first interview, Wilson remarked:

 "You can *see* the personalities in there: Luke Macbeth chasing a little ball around with a stick and Andy Warhol, who was moving in there and working with masses of paper, pushing them around, and then . . . you can see the personalities of the people [animating the collages]." (Emphasis Wilson's.)

101. Interview with Charles Lisanby, New York, 11 November 1978. Emphasis Lisanby's.

102. "In his life and in his art," writes Stephen Koch, "'Presence' is Warhol's prime theme. . . ." See Koch (1973), p. 8.

103. My remarks concerning Warhol's films do not include those directed by Paul Morrissey (*Flesh, Trash, Women in Revolt,* etc.) but produced by Warhol. Essentially, Morrissey's films are entertaining feature-length movies with developmental plots in the manner of a Hollywood film but preserving certain "Underground" qualities (transvestites playing female roles, ribald dialogue and behaviors, etc.). See Koch (1973), passim.

104. Interview with Emile De Antonio, New York, 14 November 1978.

105. Interview with Ronald Tavel, New York, 8 October 1978.

106. Mekas also wrote a film column in *The Village Voice* entitled "Movie Journal." The collected columns describe Mekas's close involvement in the making and distribution of Independent Film in America. See Jonas Mekas, *Movie Journal: The Rise of the New American Cinema, 1959–1971* (New York, 1972). Hereafter cited as Mekas (1972).

107. "Sixth Independent Film Award," *Film Culture,* no. 33, Summer 1964, p. 1. Emphasis the editors'.

108. Interview with Jonas Mekas, New York, 18 December 1978.

109. The best introduction to the history, esthetics, and criticism of Hollywood films is, in my opinion, James Monaco, *How To Read a Film* (New York, 1977). Hereafter cited as Monaco (1977).

110. Two studies of avant-garde cinema provide a useful summary and evaluation of the content of American Independent Film previous to and concurrent with Warhol's films: Sheldon Renan, *An Introduction to the American Underground Film* (New York, 1967), and Parker Tyler, *Underground Film: A Critical History* (New York, 1970). Hereafter cited respectively as Renan (1967) and as Tyler (1970).

111. See Monaco (1977), pp. 140, 434.

112. Warhol (1975), p. 53.

113. *Henry Geldzahler* (1963) is Warhol's "first" own movie and does not appear on any filmography. On this portrait-as-film, Geldzahler has remarked:

> "I think that Andy's first attempt at a movie was an 8mm job when I lived on 84th Street and Central Park West. He just rented a little camera and came in and did a three minute movie where I was smoking a cigar, and, then, I threw the cigar in the toilet, and I brushed my teeth, and, then, I flushed the toilet. For all I know, it was never printed. He was just trying to see what it looks like through a camera." (Interview with Henry Geldzahler, New York, 17 November 1978.)

This 8mm film, which was never released, is not to be confused with the 100-minute film of Geldzahler that was filmed in 1964. See Mekas (1971), p. 148. Warhol omits reference to the 8mm film, as well as to his student films, in his own discussions of his cinematic works. E.g., see Glenn O'Brien, "Andy Warhol: Interview," *High Times,* no. 24, August 1977, pp. 20–22, 34, 42. Also see Warhol (1980), p. 29.

114. Mekas (1971), p. 146.

115. The exact number of Warhol's films between 1963 and 1968 is unknown. In Mekas (1971), 88 films are listed for these years, but Mekas's filmography is misleading because Warhol filmed dozens of separate reels alone for the *Kiss* series (1963). In fact, during the mid-1960s, it was Warhol's practice to film "portraits" of people who came to his studio, of which *Eat* (1963) and *Henry Geldzahler* (1964) are the only ones individually listed by Mekas. Ibid., pp. 147f. Also see note 12 above.

116. Andy Warhol quoted in interview with Ronald Tavel, New York, 1 November 1978. Warhol's *Hedy* (1965) similarly uses a continuous moving camera.

117. "Interview with Buddy Wirtschafter," in John Wilcock, *The Autobiography and Sex Life of Andy Warhol* (New York, 1971), n.p. Hereafter cited as Wilcock (1971).

118. Warhol (1980), p. 60. This film is also known as *The Lester Persky Story* because Persky supplied the television commercials. Ibid. Another film using multiple viewpoints is *Sleep* (1963).

119. Andy Warhol, quoted in Joseph Gelmis, *The Film Director as Superstar* (Garden City, N.Y., 1970), p. 71.

120. Ibid. Emphasis mine.

121. Interview with Ronald Tavel, New York, 8 October 1978.

122. As did Warhol's own "Superstars." See Stein (1982), pp. 164, 204–23.

123. John Palmer, paraphrased in Howard Junker, "Andy Warhol, Movie Maker," *Nation*, vol. 200, 22 February 1965, p. 206. Hereafter cited as Junker (1965).

124. This film was made during a weekend of April 1965, and not during January, as in Mekas (1971), p. 150. Interview with Ronald Tavel, New York, 1 November 1978.

125. Ibid. Emphasis Tavel's.

126. Stephen Koch has aptly observed:

> "This film is a piece of pornographic wit: *Kiss* and its fascination rest on a paradox of proximity and distance. The same paradox is at work in *Blow-Job,* but that paradoxical space of the close-up (in real life the space of the kiss, itself) is compounded by the fact that the film's real action is taking place very much out of frame. Seeing *Kiss*, the audience witnesses a nearness and a distance impossible in life. In *Blow-Job,* that space is further displaced into an imagined focus of interest, twenty inches below the frame, which the face actually on screen never for a moment lets us forget. Perversely obdurate, the frame absolutely refused to move toward the midriff, insists upon itself in a thirty-five minute close-up that must be the apotheosis of the 'reaction shot,' never to be surpassed." (Koch [1973], p. 48.)

127. Parker Tyler has compared Warhol's film to Hedy Lamarr's nude sequence in *Ecstasy* (1933), in which one entire sequence "is composed entirely of shots of Miss Lamarr's face showing supreme erotic pleasure." Tyler (1970), p. 145.

128. Warhol's "novel" is, in fact, an unedited transcript of a day in the life of the "Superstar" Ondine (Robert Olivio). See Andy Warhol, *a, a novel* (New York, 1968).

129. In Mekas (1971), *Couch* is listed as being 40 minutes long (p. 148). It is possible that the *released* version premiered at the Film-Makers' Cinémathèque on 17 April 1966, was this long. However, my discussion here refers to an original version which consisted of at least 50 reels, each lasting about 35 minutes. Interview with Ronald Tavel, New York, 1 November 1978.

130. Interview with Emile De Antonio, New York, 14 November 1978.

131. Interview with Ronald Tavel, New York, 1 November 1978.

132. Koch (1973), pp. 50f. Emphasis Koch's.

133. Mekas (1971), p. 147. The concept of *Empire* was suggested to Warhol by John Palmer.

134. Andy Warhol, quoted in Mekas (1972), p. 151.

135. E.g., Gregory Battcock, "Notes on 'Empire': A Film by Andy Warhol," *Film Culture*, no. 40, Spring 1966, pp. 39f.

136. Junker (1965), p. 207.

137. The films were released in various forms, including *13 Most Beautiful Women* (1964–65), *13 Most Beautiful Boys* (1964–65), *50 Fantastics* (1964–66), and *50 Personalities* (1964–66). See Mekas (1971), p. 149.

138. Interview with James Rosenquist, New York, 18 October 1978.

139. Interview with Danny Fields, New York, 15 November 1978.

140. Interview with Irving Blum, New York, 20 October 1978.

141. E.g., Junker (1965), p. 206.

142. Mekas (1971), pp. 146 and 149.

143. Ted Berrigan quoted in David Ehrenstein, "An Interview with Andy Warhol," *Film Culture*, no. 40, Spring 1966, p. 41. Also see Mekas (1971), p. 149.

144. Interview with Robert Pincus-Witten, New York, 15 November 1978. Emphasis Pincus-Witten's.

145. See Warhol (1980), p. 40.

146. Interview with Jonas Mekas, New York, 18 December 1978.

147. See discussion above.

148. During this period, Warhol would often go to parties, openings, etc., with a large entourage. To ensure his arrival, several limousines would be sent by potential hosts. Interview with Danny Fields, New York, 15 November 1978.

149. For example, after Warhol's rock band, the Velvet Underground, disbanded, the lead singer, Nico, sang in various New York nightclubs. In *POPism*, Warhol presents a minute portrait of Nico after she left the rock band, in which Nico is seen to be virtually *passé*. See Warhol (1980), p. 183.

150. Warhol: "Actually, I did shoot all the hours for this movie, but I faked the final film to get a better design." Andy Warhol quoted in "Pop Goes the Video Tape: An Underground Interview with Andy Warhol," *Tape Recording*, vol. 12, no. 5, September-October 1965, p. 16.

151. A film "loop" is a short piece of film that is edited end to end so as to repeat the same footage.

152. See "Interview with Buddy Wirtschafter," in Wilcock (1971), n.p. Also interview with Buddy Wirtschafter, New York, 12 October 1978.

153. See William S. Burroughs and Brian Gysin, *Le Colloque de Tanger* (Paris, 1976), especially pp. 63–72.

154. Mekas (1971), p. 165.

155. Henry Geldzahler, "Some Notes on 'Sleep,'" *Film Culture*, no. 32, Spring 1964, p. 13. The following comparison to Satie's piece was first suggested in this commentary.

156. Ellsworth J. Snyder, "Chronological Table of John Cage's Life," in Richard Kostelanetz,

John Cage, Documentary Monographs in Modern Art, ed. by Paul Cummings (New York and Washington, D.C., 1970), p. 40.

157. See Stein (1982), p. 235.

158. E.g., Renan (1967), pp. 191–95.

159. See Mekas (1971), p. 147. I disagree with Mekas who perpetuates a comment made by Warhol three years after *Eat* (1963) was made. Warhol remarks in an interview (*Bay Times,* 1 April 1966): "Well, it took him that long to eat one mushroom." If one views this film, Robert Indiana actually toys with several mushrooms and with one of Warhol's pet cats. The film was originally to be shot at the boutique-restaurant Serendipity. Unrecorded conversation with Robert Indiana, New York, fall of 1978, and interview with Steven Bruce, New York, 27 October 1978.

160. Warhol (1980), p. 180.

161. Ibid.

162. Ibid. Emphasis Warhol's.

163. Mekas (1971), p. 153.

164. Koch (1973), p. 87.

165. See Bob Cowan, "My Life and Times with 'The Chelsea Girls' by Former Projectionist Bob Cowan," *Take One,* vol. 3, no. 7, September-October 1971, p. 13. The experience of viewing this film is contingent upon the "performance" of the projectionist.

166. Andy Warhol, "My Favorite Superstar: Notes on My Epic, 'Chelsea Girls,'" *Arts,* vol. 41, no. 4, February 1967, p. 26.

167. Interview with Ronald Tavel, New York, 1 November 1978. One such sequence (*Their Town*) is a parody of Thornton Wilder's play *Our Town.*

168. Warhol (1980), p. 180.

169. Ondine has remarked:

> "Her [Marie Menken] character in *The Chelsea Girls* is also supposedly based on a script by [Ronald] Tavel. Except that she wouldn't read it. Andy said to her, 'You have to be Gerard's mother.' And that's all she had to hear, and she really tells him off in that film." (Ondine [Robert Olivio], quoted in "Ondine and Broughton—Graduate Seminar at the San Francisco Art Institute, October 2," *Canyon Cinema News,* nos. 75-76, June 1975, p. 5. Hereafter cited as Ondine [1975].)

170. That is, the "distancing effects" of the projecting (including two reels shown simultaneously, the sound track turned off, and color gels placed over the lenses of the projectors) of *Chelsea Girls* may be seen as equivalent to the brightly saturated fields of color that are the backgrounds to the images in Warhol's Disaster Series.

171. Ondine has remarked:

> ". . . the character of the Pope came from a New Years party that I was at and the hostess got rather hysterical and locked herself in the shower. Because the people were a little, ah, you know, loud. And the only way we could deal with her, they told me to go and hear her confession. And then she'd come out of the shower. Well, I really heard a confession. And that night they proclaimed me Pope." (Ondine [1975], p. 4.)

172. Interview with Ondine (Robert Olivio), New York, 16 December 1978.

173. Ondine has commented:

 "And Andy said, 'What a wonderful idea for a movie. Why don't you hear confessions?' About the film structure itself, I think it was a conglomerate effort between Billy Lennik [*sic*] and Warhol. They actually . . . I remember planning. Like their tables were full of big sheets of paper. And it would say: Reel One and it [they?] would number it, Reel 2, Reel 3 to Reel 4. And it was planned over a series of months until it got down to its present state. I'm talking about *The Chelsea Girls*." (Ondine [1975], p. 4.

174. Jean Genet, *Our Lady of the Flowers,* trans. by Bernard Frechtman (New York, 1963), p. 196.

175. Koch (1973), p. 97.

176. Interview with Ondine (Robert Olivio), New York, 17 December 1978. Emphasis Ondine's.

177. Genet (1963), p. 109.

178. Warhol (1980), p. 50.

179. Ibid., p. 109.

180. Ibid., p. 125.

181. See Koch (1973), pp. 79f.

182. Ibid., p. 83.

183. Ibid., pp. 83f.

184. Mekas (1971), p. 150. Corrections to this filmography: *Screen Test #1 (Philip Fagan)* was shot on 23 January 1965; *Screen Test #2 (Mario Montez)* was shot on 7 February 1965. *Screen Test #3* is, in fact, what Mekas entitles *Suicide,* was shot on 6 March 1965. Interview with Ronald Tavel, New York, 1 November 1978.

185. Ibid.

186. Warhol has written: "By now [1965] we were obsessed with the mystique of Hollywood, the camp of it all." Warhol (1980), p. 127.

187. In fact, *Screen Test #2* was filmed as a publicity stunt, to which the press had been invited. Interview with Ronald Tavel, New York, 8 October 1978.

188. Andy Warhol quoted in Warhol (1980).

189. Ibid.

190. Andy Warhol quoted in Warhol (1980). Emphasis mine.

191. Jack Smith, "The Memoirs of Maria Montez; Or, Wait For Me at the Bottom of the Pool," *Film Culture,* no. 31, Winter 1963–64, p. 3. Smith and his associates, including Ronald Tavel and Mario Montez, formed a cult to this actress. Interview with Ronald Tavel, New York, 8 October 1978.

192. Ibid.

193. Ibid. Emphasis Tavel's.

194. Ibid. Emphasis Tavel's.

195. Ibid.

196. Interview with Emile De Antonio, New York, 14 November 1978. *Drunk* was never released.

197. "Interview with Buddy Wirtschafter," in Wilcock (1971), n.p. In David Bourdon, "Warhol as a Filmmaker," *Art in America,* vol. 59, no. 3, May-June 1971, p. 50, the author illustrates a strobe cut in a film clip from *Four Stars* (1967). Hereafter cited as Bourdon (1971).

198. Andy Warhol, quoted in Bourdon (1971), p. 51.

199. Andy Warhol, quoted in Gelmis (1970), p. 69.

200. See note 102 above.

201. Junker (1965), p. 207.

202. *Imitation of Christ* has a running time of 105 minutes, a portion of the eight-hour segments from *Four Stars.* See Richard Whitehall, "'Imitation of Christ': Waiting through the Pain and Suffering," *Los Angeles Free Press,* 20 February 1970, p. 34.

203. Paul Morrissey has remarked:

> "My influence was that I was a movie person, not an art person. An art person would have encouraged Andy to stay with the fixed camera and the rigid structure. Andy's form was extremely stylized, and people thought the content was very frivolous. My notion was that the content is what is said by people and how they look. The emphasis now is less or very minimally on the form and all on the content. And of course modern art is completely concerned with form and the elimination of content. In that sense, Andy is completely against the grain of modern art, and more in the tradition of reactionary folk art. You can only be a child so long and be revolutionary, and Andy served his apprenticeship as a revolutionary in the art world and in the movie world. But it's pathetic to see a person not develop and not grow." (Paul Morrissey, quoted in Bourdon [1971], p. 51.

204. Paul Morrissey, quoted in F. William Howton, "Filming Andy Warhol's 'Trash': An Interview with Director Paul Morrissey," *Filmmakers Newsletter,* vol. 5, no. 8, June 1972, p. 25. Although Morrissey is referring here specifically to *Trash* (1970), the principle is the same except that Morrissey does not use the strobe cut in *Trash.* Warhol does retain the strobe cut in *Lonesome Cowboys.*

205. Koch (1973), p. 148.

206. Bourdon (1971), p. 50.

207. *Hedy* was filmed during February 1966, not during November 1965 as in Mekas (1971), p. 152. Interview with Ronald Tavel, New York, 1 November 1978.

208. Ibid.

209. Ibid. Emphasis Tavel's.

210. E.g., *Lupe* (1965), *Outer and Inner Space* (1965), *Chelsea Girls* (1966), and *Four Stars* (1966–67). See Mekas (1971), pp. 151–53.

211. See note 92 above.

212. Antonin Artaud, *The Theatre and Its Double,* trans. Mary C. Richards (New York, 1958), p. 42.

213. Warhol (1980), p. 85.

214. Andy Warhol, quoted in interview with Ronald Tavel, New York, 8 October 1978. Similarly, Warhol has written:

> "When President Kennedy was shot that fall [of 1963], I heard the news over the radio while I was alone painting in my studio. I don't think I missed a stroke. I wanted to know what was going on out there, but that was the extent of my reaction." (Warhol [1980], p. 60.)

215. Koch (1973), pp. 98–113.

216. Interview with Ronald Tavel, New York, 1 November 1978. Cf. Mekas (1971), p. 151.

217. Warhol (1980), p. 91.

218. Warhol has remarked:

> "But this made Hollywood *more* exciting to me, the idea that it was so vacant. Vacant, vacuous Hollywood was everything I ever wanted to mold my life into. Plastic. White-on-white." (Ibid., p. 40. Emphasis Warhol's.)

219. See Stein (1982), passim.

220. Interview with Ronald Tavel, New York, 1 November 1978.

221. Ibid.

222. Ibid. Cf. Mekas (1971), p. 151.

223. Interview with Ronald Tavel, New York, 1 November 1978.

224. Ibid. In this case, Warhol deliberately kept Gerard Malanga from learning his lines.

225. *Horse* was filmed during April 1965, and not during March as listed in Mekas (1971), p. 150. Interview with Ronald Tavel, New York, 1 November 1978.

226. All of the production details of *Horse* are based on my interview with Ronald Tavel, New York, 1 November 1978. Special thanks to Buddy Wirtschafter who gave me a copy of the script. The script lists Hal Wickey as "Tex," but he was unavailable during the filming.

227. Ronald Tavel, *Horse,* unpublished screenplay, 1965.

228. Interview with Ronald Tavel, New York, 1 November 1978. Emphasis Tavel's.

229. Ibid. Emphasis Tavel's.

230. Andy Warhol, quoted in Tavel interview (1 November 1978).

231. Warhol (1980), p. 180.

Chapter 5

1. *1000 Names and Where to Drop Them* (New York, 1958).

2. Andy Warhol and Pat Hackett, *POPism: The Warhol '60s* (New York and London, 1980), p. 12. Hereafter cited as Warhol (1980).

3. *1000 Names* (1958), n.p.

4. Interview with Ted Carey, New York, 16 October 1978.

5. Ibid.

6. Interview with Leo Castelli, New York, 8 November 1978. Eleanor Ward has offered a variant "scenario" to these events:

> "He [Warhol] went to Leo Castelli's [Gallery]. While he was in the firehouse [i.e., Warhol's studio in the early 1960s before the more famous "Factory" loft], an artist (who will remain nameless) went to see his work, and Andy felt after seeing his show [at the Leo Castelli Gallery] that he had been "influenced," in other words, "taken" things from Andy, and for that reason, Andy felt determined that he should go to the Castelli Gallery, which I thought was wise—afterward. He felt that he couldn't bout [sic] it. He felt that he couldn't bout him unless he was right in the same place with him." (Interview with Eleanor Ward, New York, 9 November 1978.)

7. Interview with Irving Blum, New York, 20 October 1978.

8. Interviews with Emile De Antonio, New York, 14 November with Eleanor Ward, New York, 9 November 1978.

9. See chapter 3 under the heading "Autobiographical Elements in Warhol's Pop Art and chapter 4 under the heading "Warhol's 'Superstars' and the Possibilities of 'Found' Personalities."

10. See my remarks concerning Swenson's ploy of hiding a microphone in order to "interview" Warhol in chapter 3.

11. Gene Swenson, "What is Pop Art?: Interview with Andy Warhol," *Art News*, vol. 62, no. 7, November 1963, pp. 24, 60f.

12. See chapter 4 under the heading "Warhol's 'Superstars' and the Possibilities of 'Found' Personalities."

13. E.g., see Thomas B. Hess, "Pop and Public," *Art News*, vol. 62, no. 7, November 1963, pp. 23, 59f.; Barbara Rose, "Dada Then and Now," *Art International*, vol. 7, no. 1, January 1963, pp. 22–29; Barbara Rose, "Which Twin is the Phony?" *Show*, vol. 3, no. 2, February 1963, pp. 88–90.

14. Interviews with Leo Castelli, New York, 8 November 1978 and with Ivan Karp, New York, 18 October 1978.

15. Warhol (1980), p. 113. Also see pp. 115, 149.

16. See "Pop Goes the Video Tape: An Underground Interview with Andy Warhol," *Tape Recording*, vol. 12, no. 5, September-October 1965, pp. 14–19, esp. p. 16.

17. Carolyn Betsch, "A Catalogue Raisonné of Warhol's Gestures," *Art in America*, vol. 59, no. 3, May-June 1971, p. 47 and Warhol (1980), pp. 131–33.

18. See Robert Rosenblum, "Andy Warhol: Court Painter to the '70s," in *Andy Warhol: Portraits of the '70s*, exhibition catalogue (New York: Whitney Museum of American Art, 1979), pp. 9–20. Hereafter cited as Rosenblum (1979).

19. See chapter 3 under the heading "The Death of Glamour and the Glamour of Death."

20. Rainer Crone, *Andy Warhol*, trans. by John William Gabriel (London, 1970), catalogue nos. 634–40. Hereafter cited as Crone (1970).

21. Interview with Nathan Gluck, New York, 17 October 1978.

22. Interview with Gerard Malanga, New York, 1 November 1978.

23. Interview with Eleanor Ward, New York, 9 November 1978.

24. Interview with Irving Sandler, New York, 11 October 1978. In Warhol's scrapbooks in his current studio, there is a press clipping from the *Manhattan Tribune*, 3 May 1969, concerning James Harvey as the "Father of That Brillo Box," Harvey's early death and Harvey's contemplation of suing Warhol. Also see note 27 below.

25. George Hartman, in interview with George Hartman and Buddy Radish, New York, 18 December 1978.

26. Unrecorded conversation with Leo Castelli, New York, fall of 1978.

27. Robert Cenedella, "Who's Andy Warhol? He Ain't the Father of That Brillo Box," *Manhattan Tribune*, 3 May 1969, press clipping, scrapbook of Andy Warhol, New York.

28. Interview with Ronald Tavel, New York, 8 October 1978.

29. See my discussion of Marcel Duchamp's "meta-irony" in chapter 3 under the heading "Concerning Robert Rauschenberg and Jasper Johns."

30. Ibid.

31. Ibid.

32. Warhol (1980), p. 21.

33. See Andy Warhol, *(From A to B and Back Again)* (New York, 1975), p. 179. Hereafter cited as Warhol (1975).

34. Warhol (1980), p. 134.

35. See chapter 3 under the heading "The Death of Glamour and the Glamour of Death."

36. On Warhol's Popism as being "surface" treatment of something, see Warhol (1980), p. 134.

37. Warhol (1980), p. 133. Emphasis Warhol's.

38. Ibid.

39. Interview with Charles Lisanby, New York, 11 November 1978.

40. Warhol (1980), p. 114.

41. Interview with Gerard Malanga, New York, 1 November 1978.

42. See my discussion in chapter 3 under the heading "The Death of Glamour and the Glamour of Death."

43. Warhol has remarked to Gretchen Berg: "I think we're a vacuum here at the Factory, it's great. I like being a vacuum; it leaves me alone to work." Andy Warhol, quoted in Gretchen Berg, "Andy Warhol: My True Story," *Los Angeles Free Press*, vol. 6, no. 11, 17 March 1967, p. 42. Hereafter cited as Warhol-Berg (1967). Warhol also remarked to Berg: "The interviewer should just tell me the words he wants me to say and I'll repeat them after him. I think that would be so great because I'm so empty I just can't think of anything to say." Ibid.

44. In *POPism*, Warhol described his impressions of Los Angeles and of the film community there. Significantly, he wrote: "Vacant, vacuous Hollywood was everything I ever wanted to mold my life into. Plastic. White-on-white. I wanted to live my life at the level of the script of *The Carpetbaggers*—it looked like it would be so easy to just walk into a room the way those actors did and say those wonderful plastic lines." (Warhol [1980], p. 40.) When he was asked during a recent interview if he believed in the American Dream, Warhol replied: "I don't, but I think we can make some money out of it." Andy Warhol, quoted

in Glenn O'Brien, "Andy Warhol: Interview," *High Times,* no. 24, August 1977, p. 42. Hereafter cited as O'Brien (1977).

45. In *POPism,* Warhol has remarked: "I've been quoted a lot as saying, 'I like boring things.' Well, I said it and I meant it." Warhol (1980), p. 50. In the same context, Warhol then equated boredom with emptiness: "Because the more you look at the same exact thing, the more the meaning goes away, and the better and emptier you feel." Ibid.

46. See chapter 3 under the heading "The Notion of 'Art' and the Legacy of Marcel Duchamp's Silence."

47. Andy Warhol, "The New Mary Tyler Moore," *Andy Warhol's Interview Magazine,* vol. 11, no. 4, April 1981, p. 28.

48. See Jean Lipman and Richard Marshall, *Art about Art,* exhibition catalogue (New York: Whitney Museum of American Art, 1978), p. 57 and the colorplate between pp. 32–33.

49. Lawrence Alloway, *American Pop Art,* exhibition catalogue (New York: Whitney Museum of American Art, 1974), p. 113. Hereafter cited as Alloway (1974).

50. Cf. Rauschenberg's *Mona Lisa* of 1958.

51. Warhol does use various colors when he uses *different* images of the same person, as most notably in *Ethel Scull 36 Times* of 1963.

52. In fact, Warhol continues the same procedure in his current portraits, as I observed in his studio during the fall of 1978.

53. Interviews with Irving Blum, New York, 20 October 1978; Nathan Gluck, New York, 17 October 1978; and Gerard Malanga, New York, 1 November 1978.

54. Interview with Irving Blum, New York, 20 October 1978.

55. Interview with Gerard Malanga, New York, 1 November 1978. In the interview, the painting is referred to by the title *Colored Mona Lisa,* as in Crone (1970), catalogue no. 128.

56. Interview with Ted Carey, New York, 16 October 1978.

57. Interview with Eleanor Ward, New York, 9 November 1978.

58. Interview with Ted Carey, New York, 16 October 1978.

59. See chapter 3 under the heading "The Notion of 'Art' and the Legacy of Marcel Duchamp's Silence."

60. Ibid.

61. Cf. Henri Bergson's remark: "Life cannot be recomposed; it can only be looked at and reproduced." Henri Bergson, *Laughter: An Essay on the Meaning of the Comic,* rev. ed. trans. Cloudesley Brereton and Fred Rothwell (New York, 1928), p. 167.

62. See Walter Benjamin, "The Work of Art in the Age of Mechanical Reproduction," in *Illuminations,* ed. Hannah Arendt and trans. Harry Zohn (New York, 1955), pp. 219–53. All subsequent citations by Benjamin are from this source.

63. Warhol continued to be involved with Paul Morrissey's films. According to Holly Woodlawn, Warhol did all of the camera work for *Trash* (1969–70), as well as for *Women in Revolt* (1972). Interview with Holly Woodlawn, New York, 22 November 1978.

64. See chapter 4 under the heading "Beginning Again."

65. Interviews with Stephen Koch, New York, 26 October 1978 and with Jonas Mekas, New York, 18 December 1978.

66. During my interview with Holly Woodlawn, Woodlawn mentioned that Warhol paid only $25 to the "Superstar" per working day, to the subsequent bitterness of Woodlawn when *Trash* became a financial success. Interview with Holly Woodlawn, New York, 22 November 1978.

67. Interview with Jonas Mekas, New York, 18 December 1978.

68. Interview with Suzi Frankfurt, New York, 29 November 1978.

69. Douglas W. Schwartz, "Forward," in Sidney M. Greenfield, Arnold Strickon and Robert T. Aubey, eds., *Entrepreneurs in Cultural Context* (Albuquerque, New Mexico, 1979), p. vii. Schwartz's remarks concern the characterization of entrepreneurs in general.

70. See Everett Hagan, *On the Theory of Social Change: How Economic Growth Begins* (Homewood, Ill., 1962), passim.

71. Interview with Gerard Malanga, New York, 1 November 1978. When Warhol was asked during a recent interview about the first artist to have any influence on him, Warhol replied: "It must have been Walt Disney. I cut out Walt Disney Dolls. It was actually Snow White that influenced me." Andy Warhol, quoted in O'Brien (1977), p. 21. Warhol has, however, claimed that he did not see Disney's *Snow White* until he was 45 years old. See Warhol (1975), pp. 43f. The Pop artist has claimed also that he did not actually cut up such dolls. See Warhol (1975), p. 21.

 In any case, Disney has meant something special to Warhol. During O'Brien's interview, Warhol was asked whom he thought was the world's greatest living artist. Warhol responded that he thought Walt Disney was. When O'Brien remarked that Disney had died, Warhol responded: "But I really like them all. [Robert] Rauschenberg and [Cy] Twombly and Paul Klee. Dead ones too? And I like American primitive painters. I just like everyone, every group. Grant Wood. Ray Johnson." (Andy Warhol, quoted in O'Brien [1977], p. 22.) According to Ronnie Cutrone, Warhol's choice for the most handsome "actor" is, moreover, Prince Charming in Walt Disney's animated *Snow White*. Interview with Ronnie Cutrone, New York, 13 December 1978.

72. Interview with Ronnie Cutrone, New York, 13 December 1978.

73. Ibid. Also interview with Fred Hughes, New York, 19 December 1978.

74. Interview with Ondine (Robert Olivio), New York, 17 December 1978.

75. See Warhol (1975), p. 160. Also interview Fred Hughes, New York, 19 December 1978.

76. See O'Brien (1977), p. 38. Cf. Warhol (1980), p. 214.

77. Warhol has been used as a celebrity endorser during the 1970s for Braniff Airlines, Pioneer Electronics Corporation, Air France, Puerto Rico Rums, and *U.S. News and World Report*. See Warhol (1975), p. 83.

78. Warhol (1975), p. 6.

79. Ibid., p. 50, 118, 129, 131, 132, 134, 136, 178, 199.

80. Warhol (1980), p. 124.

81. Andy Warhol, quoted in interview with Ronald Tavel, New York, 8 October 1978.

82. See the epigraph to this chapter.

83. Warhol (1980), p. 248.

84. In *POPism,* Warhol has remarked: "I gave her [Viva!] the meaningless line you always say when you don't want to give a handout—'I don't have any money.'" Ibid., p. 230.

85. Craig Unger and Sharon Churcher, "Intelligencer: Warhol to Enter Model Wars," *New York,* vol. 14, no. 20, 18 May 1981, p. 16. The authors further reported that Carmen D'Alessio would look for "fresh, new faces," as well as for established models to join the agency. Concluding the report, the authors comment: "All this could have repercussions for another Warhol venture in the over-heated modeling business. Just before conceiving Twinkies, the artist himself had signed with [the modeling agent] Zoli, who'd gushed about his great future doing endorsements." (Ibid.)

86. Warhol (1975), pp. 143f. Emphasis Warhol's. Warhol has also remarked: "Being good in business is the most fascinating kind of art." Ibid., p. 92. As has been noted, Warhol has been fascinated with money and has depicted currency, as well as has proposed to exhibit only money as a work of art. Artists have depicted (American) currency before Warhol, as summarized in Jean Lipman, "Money for Money's Sake as Art," *Art in America,* vol. 58, no. 1, January-February 1970, pp. 76–83. Hereafter cited as Lipman (1970).

 In 1969, the Whitney Museum of American Art, New York, exhibited works by Robert Morris and Les Levine. These works are close to Warhol's notion of a Business Art. Les Levine's *Profit Systems One* of 1969 consists of 500 shares of Cassette Cartridge Corporation stock and of the confirmation slip for the securities transaction. In a press release, Levine wrote: "The profit or loss of the transaction will become the word of art." See ibid., p. 82. Robert Morris's work consisted of a $50,000 loan from a collector to the museum. The museum transferred this money to the Morgan Guaranty Trust Company for a certificate of deposit at five percent interest. Morris exhibited the documents and letters of the transactions. See ibid., p. 83. Also see *Anti-Illusion: Procedures/Materials,* exhibition catalogue (New York: Whitney Museum of American Art, 1969).

 Also during 1969, Edward Kienholz exhibited *Watercolors* (1969) at the Eugenia Butler Gallery, Los Angeles. The work consists of the lettering of amounts from "For $1.00" to "For $10,000." See Lipman (1970), pp. 76–83. Whatever influence these works had on Warhol's notion of "Business Art" is unknown.

87. Ibid., p. 115.

88. Ibid., pp. 113, 149.

89. See chapter 4, the first two sections.

90. Interview with Ondine (Robert Olivio), New York, 17 December 1978.

91. Andy Warhol, *a, a novel* (New York, 1968). Hereafter cited as Warhol (1968).

92. Interview with Gerard Malanga, New York, 13 December 1978.

93. Interview with Ondine (Robert Olivio), New York, 17 December 1978.

94. Warhol (1980), p. 149.

95. Interview with Ondine (Robert Olivio), New York, 17 December 1978.

96. Ibid.

97. Ibid.

98. E.g., see Warhol (1968), pp. 19, 30, 34f., 44, 53, 56, 58, 64, 66, 69, 71, 94, 100, 138, 145, 147, 234, 236f., 253, 256, 258, 261, 282, 287, 294, 305, 316, 322, 326, 329, 342,

354, 358, 364, 372, 376, 386, 388, 390, 398, 406, 408–10, 413, 417–20, 423, 427, 429, 443, 447–49.

99. Ibid., p. 436. Emphasis Warhol's.

100. Ibid., p. 448. Emphasis Warhol's.

101. Ibid., pp. 57, 61, 258.

102. Ibid., p. 12.

103. Ibid., p. 11. Emphasis Warhol's.

104. Ibid., p. 121.

105. Ibid., p. 96.

106. Ibid., pp. 342f.

107. Ibid., p. 343.

108. Ibid., pp. 343f.

109. Warhol (1980), pp. 110, 149, 287f. Also see Warhol (1975), p. 95. During a conversation with Dorothy Dean, one of Warhol's associates and one of the participants in the taping of the concluding portion of *a, a novel,* Dean told me that the second taping session occurred in the apartment of Henry Geldzahler, who was at the time out of town. During this section of *a,* someone remarks "this *is* July 1966," which may date the second taping session. See Warhol (1968), p. 315.

110. Robert Mazzocco, "aaaaaa . . . ," *The New York Review of Books,* vol. 12, no. 8, 24 April 1969, p. 34.

111. Interview with Ondine (Robert Olivio), New York, 17 December 1978.

112. Ibid.

113. Warhol (1980), p. 288. *b* was taped during July of 1969. (Tavel interview, 1 November 1978).

114. The term "flaming creatures" was coined by filmmaker Jack Smith. See my discussion on Smith in chapter 4 under the heading "Warhol's 'Superstars' and the Possibilities of 'Found' Personalities."

115. Interview with Ondine (Robert Olivio), New York, 16 December 1978.

116. Andy Warhol, *Andy Warhol's Index (Book)* (New York, 1967). Warhol credits Stephen Shore, Paul Morrissey, Ondine, as well as Christopher Cerf, Alan Rinzler, Gerard Harrison, and Akihito Shirakawa of Random House. Photographic credits include Nat Finkelstein and Billy Name (pseud. of Linich), but throughout the book the term "Factory Foto" is used.

117. My interview with Joan Fenton, New York, 6 December 1978, indicated the opposite.

118. Lynn Teresa Thorpe, "Andy Warhol: Critical Evaluation of His Images and Books" (Ph.D. dissertation. Ithaca, N.Y.: Cornell University, 1980), p. 193. Hereafter cited as Thorpe (1980).

119. Richard Goldstein, "'Chelsea Girls,' the Underground Uplifted," *New York World Journal Tribune,* 13 November 1966, clipping in Andy Warhol's scrapbooks at the artist's studio, New York.

120. Warhol (1975), p. 63.

121. See chapter 3 under the heading "Autobiographical Elements in Warhol's Pop Art."

122. Thorpe (1980), p. 192.

123. See chapter 4 under the heading "Beginning Again."

124. Warhol (1975), pp. 5–16.

125. Emphasis mine. Warhol suggests that his persona is literally a daily "put-on."

126. See Warhol (1975), dedication page.

127. In Warhol's scrapbook #4 at his current studio, there are examples of the latter. In one clipping, the following passages were underlined: ". . . the *persona* that Warhol has hitherto presented has been that of a de-cerebrated Peter Pan, with silver stock of hair, dark glasses, and simulated babble." (p. 13); ". . . uncritical distance, expertly putting on art, criticism and the Pop scene." (p. 13) "This, of course, is the kind of Narcissism turned into a style of life, the now-familiar sixties-dandy as Mod swinger." (p. 14); and ". . . if Warhol turned loose as a kind of Narcissus in Hades." (p. 14). See Brian O'Doherty, "Narcissus in Hades," *Art and Artists,* vol. 1, no. 11, February 1967, pp. 12–15, Cf. Warhol (1975), p. 10.

128. Interview with Emile De Antonio, New York, 14 November 1978.

129. Interview with Fred Hughes, New York, 19 December 1978.

130. Interview with Ondine (Robert Olivio), New York, 17 December 1978.

131. See note 100 above.

132. See Leonard Leff, "Warhol's 'Pork,'" *Art in America,* vol. 60, no. 1, January-February 1972, pp. 112f. All of the following discussion of *Pork* is based on this review.

133. On Max's Kansas City, see chapter 4 under the heading "Warhol's Superstars."

134. Leff (1972), p. 113.

135. See "Interview with Brigid Polk," in John Wilcock, *The Autobiography and Sex Life of Andy Warhol* (New York, 1971), n.p.

136. Interview with Ronnie Cutrone, New York, 13 December 1978.

137. Andy Warhol, *Andy Warhol's Exposures* (New York, 1979), p. 19. Emphasis Warhol's. Hereafter cited as Warhol (1979).

138. Ibid.

139. Ibid., p. 48.

140. Ibid., p. 118.

141. Ibid., p. 129.

142. Ibid., p. 29.

143. See Warhol (1980), p. 292. Also interview with Gerard Malanga, New York, 1 November 1978.

144. In the first issue of the magazine, the following conversation occurs between the actress Daria Halprin and Amy Sullivan of *Interview:*

 DH: What is this interview for? What's [he] going to use it for?
 AS: Andy's putting out his paper—along the lines of *Rolling Stone,* but dealing with

film. . . . Not like *Variety*—on a smaller scale." (Amy Sullivan, "Interview with Mark Frechette and Daria Halprin," *Andy Warhol's Interview Magazine,* no. 1, 1969, p. 8.)

145. Candy Darling quoted in Bob Colacello, "At Home with: Candy Darling," *Andy Warhol's Interview Magazine,* no. 20, March 1972, p. 37. Emphasis Darling's.

146. Rose Hartman, "The World of Warhol: Inside 'Interview,'" *Alternative Media,* vol. 9, no. 4, July-August 1976, pp. 9f.

147. Ibid.

148. Mark Clements Research, Inc., *Interview Subscriber Survey* (New York, 1977). Subsequent statistics are from this source. Special thanks to Andy Warhol for a copy of this survey.

149. Advertising Rate Card for *Andy Warhol's Interview Magazine,* no. 6, 1 August 1978. Special thanks to Andy Warhol for a copy of this rate card.

150. Interview with Rupert Smith, New York, 19 December 1978.

151. See chapter 4 under the heading "Warhol's Superstars."

152. Interview with Ronnie Cutrone, New York, 13 December 1978.

153. During 1974, Warhol sold 25 such photographs from his one-man show, Andy Warhol Polaroid Portraits, at the Gotham Book Mart Gallery, New York. (Eleven of the 36 Polaroids were not for sale.) Prices ranged from $50 to $100. The Polaroids included images of actress Sylvia Miles, "Superstar" Joe Dallesandro, the filmmakers Maria Menken and Willard Maas, author Truman Capote, and interior designer Lee Radziwill. Special thanks to Andreas Brown for a copy of the price list of the uncatalogued exhibition.

154. See Warhol (1975), p. 92, and Warhol (1980), p. 232.

155. I was never allowed access to such a discussion. According to David Bourdon, the price range in 1975 was $25,000 to $50,000. "Warhol frequently asks $25,000 for a single four-foot-square painting," Bourdon remarks, "with additional panels $5,000 each." See Bourdon (1975), pp. 42, 45.

156. Exceptions to a prepaid portrait do occur. Bourdon notes that the actor Helmut Berger posed for a portrait but never agreed to pay for it. Bourdon writes:

> "Berger is nude from his blondish hair to his blonder thighs; his lean torso is turned in three-quarter profile, and he coyly holds a telephone to one ear. Undressing for Warhol's camera is one thing, but forking over the money for a portrait is quite another. Months later, the sheet of acetate is languishing on a Factory wall. Warhol stammers, 'He didn't really . . . We don't know whether . . . I haven't even started on it because I don't know whether he's going to pay for it.'" (Ibid., p. 43.)

157. The following discussion is based on interviews with Ronnie Cutrone, New York, 13 December 1978, and with Warhol's current printer Rupert Smith, New York, 19 December 1978. Details not otherwise mentioned in the interviews are based on my personal observations and on unrecorded conversations with Andy Warhol, Fred Hughes, Ronnie Cutrone, Rupert Smith, and Vincent Freemont (Warhol's manager of the studio's daily operations). Unfortunately, Freemont refused to be interviewed on tape. I was not present during Warhol's photo session with Liza Minnelli, but Warhol describes it: see Warhol (1979), pp. 186f.

158. Warhol (1980), pp. 101–6.

159. Warhol's *Liza Minnelli* (1978) is a series of at least two known panels. Halston, who designed Minnelli's costumes for *The Act,* owns the portrait panel. When I spoke with Warhol about this portrait, he was consciously vague about the circumstances of the commission. According to Rupert Smith, Halston is one of Warhol's best clients and could be the presumed customer for this portrait: such a proposed commission may explain why Minnelli wore one of Halston's gown for the portrait. Ironically, in the panel Warhol omits the dress.

160. See Robert Rosenblum, *Andy Warhol: Portraits of the '70s,* exhibition catalogue (New York: Whitney Museum of American Art, 1979), figs. 62–65. Hereafter cited as Rosenblum (1979). Also note David Bourdon's description of the uncompleted portrait of Helmut Berger in note 156 above.

161. See chapter 3 under the heading "Autobiographical Elements in Warhol's Pop Art."

162. Since 1975, Ronnie Cutrone has taken photographs for the following series: *Shadows* of 1978, *Fruit Still Life* (or, *Space Fruit*) of 1978–79, *Gems* of 1978–79, *Triangles* of 1978, *Pyramids* of 1978, *Building Blocks* of 1978–79, and *Still Life* (or, *Hammer and Sickle*) of 1975. Interview with Ronnie Cutrone, New York, 13 December 1978.

163. Warhol (1975), pp. 148f.

164. Warhol has also used Alexander Heninrici, who owns Chromacomp, Inc., as his printer. See Bourdon (1975), p. 45.

165. In some cases, Warhol only paints the "background" and omits any local color of facial features, such as *Paul Jenkins* (1979). See Rosenblum (1979), figs. 78–79.

166. E.g., *Halston* (1974), *Mick Jagger* (1976), *Ivan Karp* (1974), *Roy Lichtenstein* (1976), *Joe Macdonald* (1975), *Yves St. Laurent* (1974), and *Frederick Weisman* (1974). See Rosenblum (1979), figs. 52–53, 76–77, 82–83, 96–97, 100–101, 116–17, 130–31.

167. Even in portraits that have no local color of facial features, the "background" consists of bright, "cosmetic" colors that affect an extreme and unnatural appearance of the sitter.

168. See chapter 2 under "It Would Look Printed Somehow."

169. E.g., Charles F. Stuckey, "Andy Warhol's Printed Faces," *Art in America,* vol. 68, no. 5, May 1980, pp. 102–11, especially p. 110.

170. Interview with Ronnie Cutrone, New York, 13 December 1978.

171. Interview with Rupert Smith, New York, 19 December 1978. Also see Warhol (1975), p. 150.

172. Interview with Rupert Smith, New York, 19 December 1978. There are no known reproductions of this series at the time of writing this study.

173. Warhol (1979), p. 48.

174. Conversation with Robyn Geddes, New York, fall of 1978.

175. Warhol (1979), p. 53.

176. Cf. Warhol (1975), p. 160.

177. See Suzi Gablik, "Protagonists of Pop: Five Interviews Conducted by Suzi Gablik," *Studio International,* vol. 178, July-August 1969, pp. 9–12, especially 11f.

178. Bourdon (1975), p. 42.

179. Interview with Emile De Antonio, New York, 14 November 1978.

180. Unrecorded conversation with Gerard Malanga, New York, fall of 1978.

181. Interview with Nathan Gluck, New York, 25 October 1978. Such portraits include: *Judith Green* of 1963, *Mike and Bob Adams* of 1964, *Judy Heiman* of 1964, *Florence Barron* of 1965, *Holly Solomon* of 1966, *Lita Hornick* of 1966, *Jermayne Mac Agy* of 1968, and *Dominique de Menil* of 1969. See Crone (1970), catalogue nos. 242, 245, 246, 262, 264, 265, 281–87, 288–301.

182. See chapter 3 under "Autobiographical Elements in Warhol's Pop Art."

183. Warhol (1975), p. 45, 53, 62.

184. See my discussion of Warhol's "Cinema of Cruelty" in chapter 4 under "Towards a Cinema of 'Cruelty.'" Also note Warhol (1975), pp. 10f., 52, 62–65, 98f., 111, 163, 169, 182f.

185. Ibid., p. 70.

186. Andrew Kagan, "'Most Wanted Men': Andy Warhol and the Anti-Culture of Punk," *Arts,* vol. 53, no. 1, September 1978, pp. 119f.

187. Ibid., p. 54.

188. Ibid.

189. Warhol (1975), p. 56, 93, 112.

190. Warhol has written: "Nudity is a threat to my existence." Ibid., p. 11.

191. The Pop artist has remarked: "I never fall apart because I never fall together." Ibid., p. 81.

192. Ibid., p. 62.

193. See chapter 3 under "The Death of Glamour and the Glamour of Death."

194. Warhol (1980), pp. 134, 219, 248, 263.

Chapter 6

1. Andy Warhol, *The Philosophy of Andy Warhol (From A to B and Back Again)* (New York and London, 1975), p. 99. Emphasis Warhol's.

2. Max Kozloff, "Critical Schizophrenia, Intentionalist Method," in *Renderings: Critical Essays on a Century of Modern Art* (New York, 1969), pp. 302f.

3. Ibid., p. 304.

4. Ibid., p. 307. Kozloff is citing Philip Leider, "Saint Andy: Some Notes on an Artist Who, for a Large Section of a Younger Generation Can Do No Wrong," *Artforum,* vol. 3, no. 5, February 1965, p. 28.

5. Donald B. Kuspit, "A Phenomenological Approach to Artistic Intention," *Artforum,* vol. 12, no. 5, January 1974, p. 49.

6. Ibid.

7. Interviews with Ondine (Robert Olivio), New York, 16 December 1978 and 17 December 1978.

8. For a discussion on the installation of the *Shadow* series and its relation to other such contiguous displays of Warhol's works, see Charles F. Stuckey, "Andy Warhol's Painted Faces," *Art in America,* vol. 68, no. 5, May 1980, pp. 102–11.

9. See Gregory Battcock, "Art/Notes," *Domus,* no. 597, August 1979, p. 56.

10. Jane Bell, "Andy Warhol," *Art News,* vol. 78, no. 5, May 1979, p. 172.

11. Ibid.

12. Ibid., pp. 172, 174.

13. Ibid., p. 174. The term "push and pull" refers to Hans Hofmann's theory of pictorial tensions in Abstract Expressionism, in which the "in and out" forces that may be perceived in such abstract paintings are due to patchworks of color: such "depth" is not due to perspective nor to tonal gradations but due to color relationships. See Hans Hofmann, *Hans Hofmann* (New York, 1964).

14. Thomas McGonigle, "Andy Warhol," *Arts,* vol. 53, no. 8, April 1979, p. 18.

15. Valentin Tatransky, "Andy Warhol," *Arts,* vol. 53, no. 9, May 1979, p. 35.

16. Ibid.

17. Carrie Richey, "Andy Warhol's 'Shadows,'" *Artforum,* vol. 17, no. 8, April 1979, p. 73.

18. Ibid.

19. Ibid.

20. Thomas Lawson, "Andy Warhol/Heimer Friedrich," *Flash Art,* nos. 88–89, March-April 1979, p. 23.

21. Ibid.

22. See note 2 above.

23. McGonigle (1979), p. 18.

24. Richey (1979), p. 73.

25. See chapter 3 under "Towards a Cinema of 'Cruelty.'"

26. Interview with Ronnie Cutrone, New York, 13 December 1978.

27. Ibid.

28. Interviews with Ronnie Cutrone, New York, 13 December 1978, and with Rupert Smith, New York, 19 December 1978.

29. Andy Warhol, quoted in interview with Ronnie Cutrone, New York, 13 December 1978. Warhol's experiments in such personal and impersonal forms of Process Art are not unique at that time. Artists, such as Yves Klein, conducted similar experiments. See Allan Kaprow, *Assemblage, Environments* and *Happenings* (New York, 1965), passim. Concurrent with Warhol's personal form of Process Art was the phenomenon known as Body Art. See Willoughby Sharp, "Body Works," *Avalanche,* no. 1, Fall 1970, pp. 14–17. My point is that Warhol conducted such experiments during the early 1960s.

30. For a discussion of Warhol's use of silkscreen splotches as a part of his notion of Popism, see chapter 3 under "The Death of Glamour and the Glamour of Death."

31. In one interview, Warhol made the following remarks concerning *Still Life* (or, *Hammer and Sickle*) of 1973 and *Skull* of 1976: "We've been in Italy so much, and everybody's always asking me if I'm a communist because I've done Mao [Tse-Tung]. So now I'm doing hammers and sickles for communism and skulls for fascism." (Andy Warhol, quoted in Glenn O'Brien, "Andy Warhol: Interview," *High Times,* no. 24, August 1977, p. 22.)

32. Interview with Ronnie Cutrone, New York, 13 December 1978.

33. See chapter 5, under "Warhol's Commissioned Portraits."

34. Interview with Rupert Smith, New York, 19 December 1978.

35. Interview with Fred Hughes, New York, 19 December 1978.

36. See Battcock (1979), p. 56.

37. Andy Warhol, quoted in Gretchen Berg, "Andy Warhol: My True Story," *Los Angeles Free Press,* vol. 6, no. 11, 17 March 1967, p. 42.

38. Interview with Andy Warhol, New York, 6 November 1978.

Bibliography

Unpublished Sources

Interviews and Unrecorded Conversations

Alloway, Lawrence. Interview. New York. 9 November 1978.
Amaya, Mario. Unrecorded conversation. New York. Fall of 1978.
Arje, Daniel. Interview. New York. 23 October 1978.
Baldwin, Gordon. Interview. New York. 18 November 1978.
Battcock, Gregory. Interview. New York. 15 October 1978.
Beddow, Margery. Interview. New York. 31 October 1978.
Berlin, Brigid. Unrecorded conversation. Fall of 1978.
Berlin, Seymour. Interview. New York. 27 November 1978.
Blum, Irving. Interview. New York. 20 October 1978.
Bourdon, David. Interview. New York. 16 October 1978.
Brown, Andreas. Unrecorded conversation. New York. Fall of 1978.
Bruce, Steven. Interview. New York. 27 October 1978.
Burns, Ed. Unrecorded conversation. New York. Fall of 1978.
Carey, Ted. Interviews. New York. 16 October 1978 and 13 November 1978.
Castelli, Leo. Interview. New York. 8 November 1978.
Collacello, Bob. Unrecorded conversation. New York. Fall of 1978.
Curtis, Jackie. Interview. New York. 21 November 1978.
Cutrone, Ronnie. Interview. New York. 13 December 1978.
De Antonio, Emile. Interview. New York. 14 November 1978.
Dean, Dorothy. Unrecorded conversation. New York. Fall of 1978.
Elias, Arthur. Interview. New York. 28 November 1978.
Fenton, Joan. Interview. New York. 6 December 1978.
Fields, Danny. Interview. New York. 15 November 1978.
Finsilver, Elaine. Interview. Hartsdale, New York. 29 October 1978.
Fleischer, Robert. Interview. New York. 27 October 1978.
Ford, Ruth. Unrecorded conversation. New York. Fall of 1978.
Frankfurt, Suzi. Interview. New York. 29 November 1978.
Fredericks, Tina S. Interview. New York. 1 December 1978.
Freemont, Vincent. Unrecorded conversation. New York. Fall of 1978.
Galster, Robert. Interview. New York. 25 October 1978.
Geldzahler, Henry. Interviews. New York. 17 November 1978 and 28 November 1978.
Giallo, Vitto. Interview. New York. 6 December 1978.
Giordano, Joseph. Interview. New York. 30 November 1978.

Gluck, Nathan. Interviews. New York. 17 October 1978, 25 October 1978, and 20 November 1978.
Greene, Bert. Interview. New York. 3 December 1978.
Groah, Alan. Unrecorded conversation. New York. Fall of 1978.
Hackett, Pat. Unrecorded conversation. Fall of 1978.
Hartman, George. Interview with George Hartman and Buddy Radish. New York. 18 December 1978.
Hughes, Fred. Interview. New York. 19 December 1978.
Indiana, Robert. Unrecorded conversation. New York. Fall of 1978.
Karp, Ivan. Interviews. New York. 12 October 1978 and 18 October 1978.
Klauber, George. Interviews. New York. 15 November 1978 and 19 November 1978.
Knight, Hillary. Interview. New York. 8 November 1978.
Koch, Stephen. Interview. New York. 26 October 1978.
Kornblau, Gerard. Interview. New York. 6 November 1978.
Lacy, Tom. Interview. New York. 30 October 1978.
Lang, Jerry. Interview. New York. 23 November 1978.
Lisanby, Charles. Interview. New York. 11 November 1978.
McCarthy, Bill. Unrecorded conversation. New York. Fall of 1978.
Malanga, Gerard. Interviews. New York. 1 November 1978 and 13 December 1978.
Mann, David. Unrecorded conversation. New York. Fall of 1978.
Mekas, Jonas. Interview. New York. 18 December 1978.
Michaels, Duane. Interview. New York. 29 September 1978.
Moore, Gene. Interviews. New York. 13 October 1978 and 30 October 1978.
Neel, Alice. Interview. New York. 3 November 1978.
Ondine (Robert Olivio). Interviews. New York. 16 December 1978 and 17 December 1978.
Palazzo, Peter. Interview. New York. 7 November 1978.
Pincus-Witten, Robert. Interview. 15 November 1978.
Radish, Buddy. Interview with George Hartman and Buddy Radish. New York. 18 December 1978.
Ress, Mr. and Mrs. Walter. Interview. New York. 19 November 1978.
Ricard, Rene. Unrecorded conversation. New York. Fall of 1978.
Rosenquist, James. Interview. New York. 18 October 1978.
Rotten, Rita. Unrecorded conversation. New York. Fall of 1978.
Sandler, Irving. Interview. New York. 11 November 1978.
Silver, George. Unrecorded conversation. New York. Fall of 1978.
Smith, Rupert. Interview. New York. 19 December 1978.
Stutz, Geraldine. Interview. New York. 28 November 1978.
Tavel, Ronald. Interviews. New York. 8 October 1978 and 1 November 1978.
Ultra Violet. Unrecorded conversation. New York. Fall of 1978.
Wallowitch, John. Unrecorded conversation. New York. Fall of 1978.
Walters, Alfred Carleton. Interviews. New York. 10 November 1978 and 28 November 1978.
Ward, Eleanor. Interview. New York. 9 November 1978.
Warhol, Andy. Interview. New York. 6 November 1978.
Wilcock, John. Unrecorded conversation. New York. Fall of 1978.
Wilson, Jack. Interviews. Chicago, 7 March 1979. Glenview, 22 August 1979.
Wirtschafter, Buddy. Interview. New York. 12 October 1978.
Wood, Fritzie. Interview. New York. 1 December 1978.
Woodlawn, Holly. Interview. New York. 22 November 1978.

Dissertations and Manuscripts

Bernstein, Roberta M. "Things the Mind Already Knows: Jasper Johns' Paintings and Sculptures, 1954–1974." Ph.D. dissertation. New York: Columbia University, 1975.

Crone, Hans-Rainer. "Das Bildnerische Werk Andy Warhols." Ph.D. dissertation. Berlin: Frei Universitaet, 1976.

Malanga, Gerard. "My First Day with Andy Warhol." Manuscript. 1965.

Patterson, Michele. "The Iconography of Pop Art from a Socio-Political Point-of-View." Ph.D. dissertation. Chapel Hill, N.C.: University of North Carolina at Chapel Hill, forthcoming.

Smith, Patrick S. "Art *in Extremis:* Andy Warhol and His Art." Ph.D. dissertation. Evanston: Northwestern University, 1982.

Tavel, Ronald. "Horse." Unpublished screenplay. 1965.

Thorpe, Lynn Teresa. "Andy Warhol: Critical Evaluation of His Images and Books." Ph.D. dissertation. Ithaca, N.Y.: Cornell University, 1980.

Published Sources

Articles and Essays

Albert, Hollis. "Vanitas vanitatus: *The Cleopatra Papers,*" *Saturday Review,* vol. 46, no. 31, 3 August 1963, p. 64.

Alloway, Lawrence. "Jasper Johns' Map," *The Nation,* vol. 213, 22 November 1971, pp. 541f.

"Artist Philip Pearlstein: 'Seeing It as It Is,'" *Carnegie-Mellon Alumni News,* vol. 63, no. 1, March 1979, p. 20.

Ashton, Dore. "New York Report," *Das Kunstwerk,* vol. 16, nos. 5–6, November-December 1962, pp. 68–70, 73.

Battcock, Gregory. "Art/Notes," *Domus,* no. 597, August 1979, p. 56.

———. "Notes on 'Empire': Warhol," *Film Culture,* no. 40, Spring 1966, pp. 39f.

"The Beast in Me," *Theatre World,* vol. 19, 1962–63, p. 96.

Bell, Jane. "Andy Warhol," *Art News,* vol. 78, no. 5, May 1979, p. 172.

Berg, Gretchen. "Andy Warhol: My True Story," *Los Angeles Free Press,* vol. 6, no. 11, 17 March 1967, p. 42.

Bergin, Paul. "Andy Warhol: The Artist as Machine," *Art Journal,* vol. 26, no. 4, Summer 1967, pp. 359–63.

Betsch, Carolyn. "A Catalogue Raisonné of Warhol's Gestures," *Art in America,* vol. 59, no. 3, May-June 1971, p. 47.

Bourdon, David. "Warhol as a Filmmaker," *Art in America,* vol. 59, no. 3, May-June 1971, pp. 48–53.

Buffet-Picabia, Gabrielle. "Magic Circles," *View,* series 5, no. 1, March 1945, pp. 14–16, 23.

Calas, Nicholas. "Robert Rauschenberg," *Kulchur,* vol. 4, no. 15, Autumn 1964, pp. 16–31.

"The Camera Overseas: 136,000,000 People See This Picture of Shanghai's South Station," *Life,* vol. 13, no. 14, 4 October 1937, pp. 102f.

"Can Cleo Pay It Back?" *Business Week,* no. 1762, 8 June 1963, pp. 48–50.

Carlin, Margie. "Andy Warhol . . . Is He for Real?" *The Pittsburgh Press "Roto,"* 22 October 1972, pp. 16–18.

"Carnegie Institute of Technology," *American Art Annual* [of the American Federation of the Arts], vol. 36, part I, July 1941–June 1945, p. 273.

"Carnegie Institute of Technology," *American Art Annual* [of the American Federation of the Arts], vol. 37, part I, July 1945–June 1948, p. 288.

"Carnegie Institute Welcomes," *Carnegie Magazine,* vol. 19, no. 4, October 1945, p. 121.

Carnegie Magazine, vols. 19–22, 1945–49.

Cenedella, Robert. "Who's Andy Warhol?: He Ain't the Father of that Brillo Box," *Manhattan Tribune,* 3 May 1969.

Clair, Jean. "Duchamp and the Classical Perspectives," *Artforum,* vol. 16, no. 7, March 1978, pp. 40–49.

Colacello, Bob. "At Home with: Candy Darling," *Andy Warhol's Interview Magazine,* no. 20, March 1972, pp. 37–39.

Connolly, Jr., John L. "Ingres and the Erotic Intellect," in Hess, Thomas B., and Nochlin, Linda (eds.), *Woman as Sex Object: Studies in Erotic Art, 1730–1970* (New York, 1972), pp. 16–31.

Cowan, Bob. "My Life and Times with 'The Chelsea Girls' by Former Projectionist Bob Cowan," *Take One,* vol. 3, no. 7, September-October 1971, p. 13.

Duchamp, Marcel. "The Great Trouble with Art in this Country . . . ," *Museum of Modern Art Bulletin,* vol. 13, nos. 4–5, 1946, pp. 19–21.

Ehrenstein, David. "An Interview with Andy Warhol," *Film Culture,* no. 40, Spring 1966, p. 41.

Factor, Donald. "New York Group, Ferus Gallery," *Artforum,* vol. 2, no. 9, March 1964, p. 13.

Finkelstein, Nat. "Inside Andy Warhol," *Cavalier,* September 1966, pp. 44f, 86–88.

"The Fortunes of Cleopatra," *Newsweek,* vol. 61, no. 12, 25 March 1963, pp. 63–66.

Fried, Michael. "New York Letters," *Art International,* vol. 6, no. 10, 20 December 1962, pp. 54–58.

Geldzahler, Henry. "Some Notes on 'Sleep,'" *Film Culture,* no. 32, Spring 1964, p. 13.

Goldstein, Richard. "'Chelsea Girls,' the Underground Uplifted," *New York World Journal Tribune,* 13 November 1966.

Greene, Balcomb. "The Problem of Expression in Art," *Carnegie Magazine,* vol. 22, no. 7, February 1949, pp. 211–13.

Hamilton, Jack. "Elizabeth Taylor Talks about *Cleopatra,*" *Look,* vol. 27, no. 9, 7 May 1963, pp. 41–50.

Hamm, Charles. "John Cage," in *The New Grove Dictionary of Music and Musicians,* ed. Stanley Sadie. vol. 3, London, 1980, pp. 597–603.

Hartman, Rose. "The World of Warhol: Inside 'Interview,'" *Alternative Media,* vol. 9, no. 4, July-August 1976, pp. 9–11.

Hess, Thomas B. "Pop and Public," *Art News,* vol. 62, no. 7, November 1963, pp. 23, 59f.

"A History of Valentines," *Carnegie Magazine,* vol. 21, no. 7, February 1948, p. 215.

Hopps, Walter. "An Interview with Jasper Johns," *Artforum,* vol. 3, no. 6, March 1965, pp. 32–36.

Howton, F. William. "Filming Andy Warhol's 'Trash': An Interview with Paul Morrissey," *Filmmakers Newsletter,* vol. 5, no. 8, June 1972, pp. 24–28.

"*I Could Be Mute:* The Life and World of Former C.M.U. Faculty Member Gladys Schmitt," *Carnegie-Mellon Alumni News,* vol. 36, no. 2, June 1979, pp. 23–24.

Janis, Harriet and Sidney. "Marcel Duchamp, Anti-Artist," *View,* series 5, no. 1, March 1945, pp. 18–24, 53f.

Jensen, Claude H. "Our Local Artists, This Year," *Carnegie Magazine,* vol. 22, no. 8, March 1949, pp. 259–63.

Johnson, Ellen H. "The Image Duplicators—Lichtenstein, Rauschenberg and Warhol," *Canadian Art,* vol. 23, no. 1, January 1966, pp. 12–19.

Junker, Howard. "Andy Warhol, Movie Maker," *Nation,* vol. 200, 22 February 1965, pp. 206–8.

Kagan, Andrew. "'Most Wanted Men': Andy Warhol and the Anti-Culture of Punk," *Arts,* vol. 53, no. 1, September 1978, pp. 119–21.

Kirby, Michael. "The New Theatre," *The Drama Review,* vol. 10, no. 2, Winter 1965, pp. 23–43.

Kuspit, Donald B. "A Phenomenological Approach to Artistic Intention," *Artforum,* vol. 12, no. 5, January 1974, pp. 46–53.

Lawson, Thomas. "Andy Warhol/Heimer Friedrich," *Flash Art*, nos. 88–89, March-April 1979, p. 23.

Leff, Leonard. "Warhol's 'Pork,'" *Art in America*, vol. 60, no. 1, January-February 1972, pp. 112f.

Leider, Philip. "Saint Andy: Some Notes on an Artist Who, for a Large Section of a Younger Generation Can Do No Wrong," *Artforum*, vol. 3, no. 5, February 1965, pp. 26–28.

Lepper, Robert. "Student Project: Carnegie Tech Tests the Designer as Entrepreneur," *Industrial Design*, vol. 4, no. 2, February 1957, pp. 98–102.

"Letters to the Editor," *Life*, vol. 7, no. 15, 9 October 1939, p. 8.

Lewis, Virginia. "Again We See Paris: Lithographs by Honore Daumier, Lent by the Wiggin Collection Public Library of the City of Boston," *Carnegie Magazine*, vol. 19, no. 8, February 1946, pp. 231–34.

"Lichtenstein, Oldenburg, Warhol: A Discussion," *Artforum*, vol. 4, no. 6, February 1966, pp. 19–24.

Lipman, Jean. "Money for Money's Sake as Art," *Art in America*, vol. 58, no. 1, January-February 1970, pp. 76–83.

Lucie-Smith, Edward. "Pop and the Mass Audience," *Studio International*, vol. 162, August 1966, p. 96f.

McGonigle, Thomas. "Andy Warhol," *Arts*, vol. 53, no. 8, April 1979, p. 18.

Magloff, Joanna C. "Directions—American Painting, San Francisco Museum of Art," *Artforum*, vol. 2, no. 5, November 1963, pp. 43f.

Masheck, Joseph. "Warhol as Illustrator," *Art in America*, vol. 59, no. 3, May-June 1971, pp. 54–59.

Mazzocco, Robert. "aaaaaa . . . ," *The New York Review of Books*, vol. 12, no. 8, 24 April 1969, pp. 34–37.

Meyer, Leonard B. "The End of the Renaissance?" Notes on the Radical Empiricism of the Avant-Garde," *Hudson Review*, vol. 16, no. 2, Summer 1963, pp. 169–86.

Morris, Gay. "When Artists Use Photographs: Is It Fair Use, Legitimate Transformation or Rip-Off?" *Art News*, vol. 80, no. 1, January 1981, pp. 102–6.

"Multiples Supplement," *Art and Artists*, vol. 4, no. 3, June 1969, pp. 27–65.

O'Brien, Glenn. "Andy Warhol: Interview," *High Times*, no. 24, August 1977, pp. 20–22, 34–42.

O'Doherty, Brian. "Narcissus in Hades," *Art and Artists*, vol. 1, no. 2, February 1967, pp. 12–15.

"Ondine and Broughton—Graduate Seminar at the San Francisco Art Institute, October 2," *Canyon Cinema News*, nos. 75–76, June 1975, pp. 4–11.

Otte, M. "Notizen zu Andy Warhol und Roy Lichtenstein," *Das Kunstwerk*, vol. 21, nos. 9–10, June-July 1968, pp. 54–56.

"Pop Goes the Video Tape: An Underground Interview with Andy Warhol," *Tape Recording*, vol. 12, no. 5, September-October 1965, pp. 15–19.

Rauschenberg, Robert. "Robert Rauschenberg Talks to Maxime de la Falaise McKendry," *Andy Warhol's Interview Magazine*, vol. 6, no. 5, May 1976, pp. 34–36.

Richey, Carrie. "Andy Warhol's 'Shadows,'" *Artforum*, vol. 17, no. 8, April 1979, p. 73.

Rockman, Arnold. "Superman Comes to the Art Gallery," *Canadian Art*, vol. 21, no. 1, January-February 1964, pp. 18–22.

Rose, Barbara. "ABC Art," *Art in America*, vol. 53, no. 5, October-November 1965, pp. 57–69.

———. "Dada Then and Now," *Art International*, vol. 7, no. 1, January 1963, pp. 22–29.

———. "Which Twin is the Phony?" *Show*, vol. 3, no. 2, February 1963, pp. 88–90.

Roth, Maria. "The Aesthetic of Indifference," *Artforum*, vol. 16, no. 3, November 1977, pp. 46–53.

Russell, Virginia Ann. "A Quaint Nostalgic Charm," *Carnegie Magazine*, vol. 19, no. 9, March 1946, p. 276.

Sandler, Irving. "The New Cool Art," *Art in America,* vol. 53, no. 1, February 1965, pp. 96–101.

Seckler, Dorothy Gees. "Stuart Davis Paints a Picture," *Art News,* vol. 52, no. 4, June-July-August 1953, pp. 30–34, 73f.

Seiberling, Dorothy. "The Star Had Trouble Getting Here, But, Oh Boy, What a Smile!: LIZA OPENS IN D.C.," *Life,* vol. 54, no. 1, 4 January 1963, pp. 14–19.

Sharp, Willoughby. "Body Works," *Avalanche,* no. 1, Fall 1970, pp. 14–17.

"Sixth Independent Film Award," *Film Culture,* no. 33, Summer 1964, p. 1.

Smith, Jack. "The Memoirs of Maria Montez; Or, Wait for Me at the Bottom of the Pool," *Film Culture,* no. 31, Winter 1963–64, pp. 3f.

"*Speaking of Pictures:* CRAZY GOLDEN SLIPPERS; Famous People Inspire Fanciful Footwear," *Life,* vol. 42, no. 3, 1 January 1957, pp. 12–13.

"The Spectacle of Racial Turbulence in Birmingham: They Fight a Fire That Won't Go Out," *Life,* vol. 54, no. 20, 17 May 1963, pp. 26–36.

Stuckey, Charles F. "Andy Warhol's Printed Faces," *Art in America,* vol. 68, no. 5, May 1980, pp. 102–11.

Sullivan, Amy. "Interview with Marck Frechette and Daria Halprin," *Andy Warhol's Interview Magazine,* no. 1, 1969, p. 8.

Swenson, Gene R. "Rauschenberg Paints a Picture," *Art News,* vol. 62, no. 2, April 1963, p. 45.

———. "What is Pop Art?: Interview with Andy Warhol," *Art News,* vol. 62, no. 7, November 1963, pp. 24, 60f.

———. "What is Pop Art?: Interview with Jasper Johns," *Art News,* vol. 62, no. 10, February 1964, pp. 43–66f.

Tatransky, Valentin. "Andy Warhol," *Arts,* vol. 53, no. 9, May 1979, p. 35.

Trimmier, Dianne. "The Critical Reception of Capote's *Other Voices,*" *West Virginia University Philological Papers,* vol. 17, 1969, pp. 94–101.

Unger, Craig and Churcher, Sharon. "Intelligencer: Warhol to Enter Model Wars," *New York,* vol. 14, no. 20, 18 May 1981, p. 16.

Wagner Literary Magazines (Staten Island, N.Y.), no. 4, 1963–64.

Wanger, Walter and Hyams, Joseph. "*Cleopatra:* Trials and Tribulations of an Epic Film" *Saturday Evening Post,* vol. 236, no. 21, 1 June 1963, pp. 28–53.

Warhol, Andy. "Andy Warhol Talks About Sex, Art, Fame and Money," *Forum Magazine,* vol. 10, no. 4, January 1981, pp. 19–23.

———. "My Favorite Superstar: Notes on My Epic, 'Chelsea Girls,'" *Arts,* vol. 41, no. 4, February 1967, p. 26.

———. "The New Mary Tyler Moore," *Andy Warhol's Interview Magazine,* vol. 11, no. 4, April 1981, pp. 22–28.

———. "Sunday with Mister C.: An Audio-Documentary by Andy Warhol, Starring Truman Capote," *Rolling Stone,* no. 132, 12 April 1973, pp. 28–48.

Weintraub, Bernard. "Andy Warhola's Mother," *Esquire,* vol. 64, no. 5, November 1966, pp. 100, 158.

Wenner, Jann. "Coda: Another Round with Mister C.," *Rolling Stone,* no. 132, 12 April 1973, pp. 50–54.

Whitehall, Richard. "'Imitation of Christ': Waiting through the Pain and Suffering," *Los Angeles Free Press,* 20 February 1970, p. 34.

Wilson, Ellen. "Recent American Painting, Pamona Gallery," *Artforum,* vol. 3, no. 7, April 1965, p. 10.

Zabierek, Henry C. "Interests Transcended: The Early History of Carnegie Tech," *Western Pennsylvania Historical Magazine,* vol. 53, no. 4, October 1970, pp. 349–65.

Books

Alexandrian, Sarane. *Surrealist Art*. Translated by Gordon Clough. New York and Washington, D.C., 1970.

Andy Warhol's Interview Magazine. Advertising Rate Card. No. 6. 1 August 1978.

Artaud, Antonin. *The Theatre and Its Double*. Translated by Mary C. Richards. New York, 1958.

Barr, Jr., Alfred H. *Painting and Sculpture in the Museum of Modern Art, 1929–1967*. New York, 1977.

Battcock, Gregory, ed. *The New Art: A Critical Anthology*. New York, 1966.

Baudelaire, Charles. *The Painter of Modern Life and Other Essays*. Edited and translated by Jonathon Mayne. London, 1964.

Bayer, Herbert and Gropius, Walter, eds. *Bauhaus, 1919–1928*. New York, 1938.

Benedikt, Michael and Wellsworth, George E., eds. and trans. *Modern French Theatre: The Avant-Garde, Dada, and Surrealism, An Anthology*. New York, 1966.

Benjamin, Walter. *Illuminations*. Edited by Hannah Arendt and translated by Harry Zohn. New York, 1955.

Bergson, Henri. *Laughter: An Essay on the Meaning of the Comic*. Revised ed. Translated by Cloudesley Brereton and Fred Rothwell. New York, 1928.

Bockris, Victor and Malanga, Gerard. *Up-Tight: The Velvet Underground Story*. New York, 1983.

Boorstin, Daniel J. *The Image: A Guide to Pseudo-Events in America*. 2nd ed. New York, 1975.

Burroughs, William S. and Gysin, Brian. *Le Colloque de Tanger*. Paris, 1976.

Cabanne, Pierre. *Dialogues with Marcel Duchamp*. Translated by Ron Padgett. Documents of 20th Century Art, series ed. Robert Motherwell. New York, 1971.

Cage, John. *Silence: Lectures and Writings*. Middleton, Connecticut, 1961.

Capote, Truman. *Local Color*. New York, 1950.

———. *Other Voices, Other Rooms*. New York, 1948.

Caudill, Rebecca. *My Appalachia*. With photographs by Edward Wallowitch. New York, 1966.

Chandoha, Walter. *All Kinds of Cats*. New York, 1952.

Cocteau, Jean. *Dessins*. Paris, 1923.

Couperie, Pierre et al. *A History of the Comic Strip*. Translated by Eileen B. Hennessy. New York, 1968.

Crone, Rainer. *Andy Warhol*. Translated by John William Gabriel. London, 1970.

Crone, Rainer and Wiegang, Wilfried. *Die revolutionaere Aesthetik Andy Warhols in Kunst und Film*. Frankfurt-am-Main, 1970.

Diamonstein, Barbaralee. *Inside New York's Art World*. New York, 1979.

Dorland's Illustrated Medical Dictionary. 24th ed. Philadelphia and London, 1965.

Duchamp, Marcel and Halberstadt, Vitaly. *L'Opposition et les cases conjugées sont réconciliées*. Brussels, 1932.

Duberman, Martin. *Black Mountain: An Exploration in Community*. New York, 1972.

Engstead, John. *Star Shots: Fifty Years of One of Hollywood's Greatest Photographers*. New York, 1978.

Finch, Christopher. *Pop Art: Object and Image*. London, 1968.

Forge, Andrew. *Robert Rauschenberg*. New York, 1972.

Fyleman, Rose, lyricist; and Lehmann, Liza, composer. *There Are Fairies at the Bottom of Our Garden*. Sheet music. New York: Chappell-Harms, Inc., 1917.

Gelmis, Joseph. *The Director as Superstar*. Garden City, New York, 1970.

Genet, Jean. *Our Lady of the Flowers*. Translated by Bernard Frechtman. New York, 1963.

———. *Querelle de Brest*. With lithographs by Jean Cocteau. Paris, 1947.

———. *The Thief's Journal*. Translated by Bernard Frechtman. New York, 1982.

Gidal, Peter. *Andy Warhol: Films and Paintings*. London, 1971.

Golden, Cipe Pineless; Weihs, Kurt; and Strunsky, Robert, eds. *The Visual Craft of William Golden*. New York, 1962.

Grandville. *The Flowers Personified, Being a Translation of Grandville's "Les fleurs animées."* Translated by N. Cleveland. New York, 1947.

Greenfield, Sidney M.; Strickon, Arnold; and Aubey, Robert T., eds. *Entrepreneurs in Cultural Context*. Albuquerque, New Mexico, 1979.

Griffith, Richard and Mayer, Arthur. *The Movies*. New York, 1957.

Gropius, Walter. *The New Architecture*. London, 1936.

Guptill, Arthur. *Norman Rockwell, Illustrator*. New York, 1946.

Hagan, Everett. *On the Theory of Social Change: How Economic Growth Begins*. Homewood, Illinois, 1962.

Hofmann, Hans. *Hans Hofmann*. New York, 1964.

Kafka, Franz. *The Diaries of Franz Kafka, 1914–1923*. Edited by Max Brod and translated by Martin Greenberg. New York, 1969.

Kaprow, Allan. *Assemblage, Environments and Happenings*. New York, 1965.

Kirby, Michael, ed. *Happenings: An Illustrated Anthology*. New York, 1966.

Klee, Paul. *Pedagogical Sketch Book*. Translated by Sibyl Peech. New York, [1925] 1944.

Koch, Stephen. *Stargazer: Andy Warhol's World and His Films*. New York and Washington, D.C., 1973.

Kostelanetz, Richard. *John Cage*. Documentary Monographs in Modern Art, edited by Paul Cummings. New York and Washington, D.C., 1970.

———. *The Theatre of Mixed Means*. New York, 1968.

Kozloff, Max. *Jasper Johns*. New York, 1969.

———. *Renderings: Critical Essays on a Century of Modern Art*. New York, 1969.

LaVine, W. Robert. *In a Glamorous Fashion: The Fabulous Years of Hollywood Costume Design*. New York, 1980.

Lebel, Robert. *Marcel Duchamp*. Translated by George Heard Hamilton. New York, 1959.

Lillie, Beatrice. *Every Other Inch a Lady*. With John Philip and James Brough. Garden City, New York, 1972.

Lippard, Lucy R. *Pop Art*. New York, 1966.

Loran, Erle. *Cézanne's Composition*. Berkeley and Los Angeles, 1943.

McDonald, William F. *Federal Relief Administration and the Arts*. Columbus, Ohio, 1969.

Maddox, Brenda. *Who's Afraid of Elizabeth Taylor?* New York, 1977.

Maison, K. E. *Honoré Daumier: Catalogue Raisonné of the Paintings, Watercolors and Drawings*. 2 vols. Greenwich, Connecticut, 1968.

Malanga, Gerard. *Chic Death*. Cambridge, Massachusetts, 1971.

Mark Clements Research, Inc. *Interview Subscriber Survey*. New York, 1977.

Mayer, Ralph. *The Artist's Handbook of Materials and Techniques*. New York, 1948.

Mekas, Jonas. *Movie Journal: The Rise of the New American Cinema, 1959–1971*. New York, 1972.

Moholy-Nagy, László. *The New Vision*. 4th rev. ed. Translated by Daphne M. Hoffman. With *Abstract of an Artist*. Documents of Modern Art, series ed. Robert Motherwell. New York, 1947.

Monaco, James. *How to Read a Film*. New York, 1977.

Morin, Edgar. *The Stars*. Translated by Richard Howard. Evergreen Profile Book 7. New York and London, 1960.

O'Connor, Francis V. *Federal Support for the Visual Arts: The New Deal and Now*. Greenwich, Connecticut, 1969.

O'Doherty, Brian. *American Masters: The Voice and the Myth*. New York, 1973.

Oldenburg, Claes and Williams, Emmett. *Store Days*. New York, 1967.

Ratcliff, Carter. *Andy Warhol*. New York, 1983.

Renan, Sheldon. *An Introduction to the American Underground Film*. New York, 1967.

Rose, Barbara. *American Art Since 1900*. Rev. ed. New York and Washington, D.C., 1975.

Rubin, William S. *Dada and Surrealist Art*. New York, n.d.

Sandler, Irving. *The New York School: The Painters and Sculptors of the Fifties*. New York, 1978.

Sands, Frederick and Broman, Sven. *The Divine Garbo*. New York, 1974.

Sartre, Jean-Paul. *Saint Genet: Actor and Martyr*. Translated by Bernard Frechtman. New York, 1963.

Scharf, Aaron. *Art and Photography*. Rev. ed. Baltimore, Maryland, 1974.

Schechner, Richard. *Public Domain: Essays on the Theatre*. Indianapolis and New York, 1969.

Scheler, Max. *Ressentiment*. Translated by William W. Holdheim and edited by Lewis A. Coser. New York, 1961.

Schwartz, Arturio. *The Complete Works of Marcel Duchamp*. New York, 1969.

Shattuck, Roger. *The Banquet Years: The Origins of the Avant-Garde in France, 1885 to World War I*. Rev. ed. New York, 1968.

Sheppard, Dick. *Elizabeth: The Life and Career of Elizabeth Taylor*. London, 1975.

Sitney, P. Adams. *Visionary Film: The American Avant-Garde, 1943–1978*. Oxford, 1979.

Sontag, Susan. *Styles of Radical Will*. New York, 1969.

Steefel, Jr., Lawrence D. *The Position of Duchamp's "Glass" in the Development of His Art*. Outstanding Dissertations in the Fine Arts. New York and London, 1977.

Stein, Jean. *Edie: An American Biography*. Edited with George Plimpton. New York, 1982.

Steinberg, Leo. *Other Criteria*. New York, 1972.

Stella, Jacques. *Les jeux et plaisirs de l'enfance*. Paris, 1657.

Stites, Raymond S. *The Arts and Man*. New York and London, 1940.

Suzuki, D. T. *Studies in Zen*. Edited by Christman Humphreys. New York, n.d.

Thomas, Bob. *Marlon: Portrait of the Rebel as an Artist*. New York, 1973.

Vanderbilt, Amy. *Amy Vanderbilt's Complete Book of Etiquette: A Guide to Gracious Living*. With drawings by Fred McCarroll, Mary Suzuki, and Andrew Warhol. 1st ed. Garden City, New York, 1952.

———. *Amy Vanderbilt's Complete Cookbook*. With drawings by Andrew Warhol. Garden City, New York, 1961.

Velonis, Anthony. *The Silk-Screen Process*. Art Circular No. 6, W.P.A. Technical Series. New York: Work Projects Administration, 22 July 1941.

1000 Names and Where to Drop Them. New York, 1958.

Tiffany & Co. *Tiffany Table Settings*. New York, [1960].

Tomkins, Calvin. *The Bride and the Bachelors*. New York, 1965.

———. *Off the Wall: Robert Rauschenberg and the Art World of Our Time*. Garden City, New York, 1980.

Tyler, Parker. *Florine Stettheimer: A Life in Art*. New York, 1963.

———. *Underground Film: A Critical History*. New York, 1970.

Warhol, Andy. *a, a novel*. New York, 1968.

———. *A Gold Book*. New York, 1957.

———. *Andy Warhol's Exposures*. New York, 1979.

———. *Andy Warhol's Index (Book)*. New York, 1967.

———. *In the Bottom of My Garden*. New York, 1956.

———. *The Philosophy of Andy Warhol (From A to B and Back Again)*. New York and London, 1975.

———. *There was snow on the streets* New York, ca. 1953.

———. *25 Cats Named Sam and One Blue Pussy*. New York, ca. 1954.

Warhol, Andy and Corkie [Ralph Thomas Ward]. *a is an alphabet*. New York, 1953.

———. *Love Is a Pink Cake*. New York, 1953.

Warhol, Andy and Frankfurt, Suzi. *Wild Raspberries*. New York, 1959.

Warhol, Andy and Hackett, Pat. *POPism: The Warhol '60s*. New York and London, 1980.
Warhol, Andy and Pomeroy, Ralph. *A la Recherche du shoe perdu*. New York, ca. 1955.
Warren, Robert Penn. *All the King's Men*. New York, 1946.
Watson, Ernest W. *Forty Illustrators and How They Work*. New York, 1946.
Wilcox, John. *The Autobiography and Sex Life of Andy Warhol*. New York, 1971.

Exhibition Catalogues

Alloway, Lawrence. *American Pop Art*. New York: Whitney Museum of American Art, 1974.
Anti-Illusion: Procedures/Materials. New York: Whitney Museum of American Art, 1969.
Art for Radio. New York: Radio Advertising Bureau, Inc. ca. 1956.
Brown, Andreas. *Andy Warhol: His Early Works, 1947–1959*. New York: Gotham Book Mart Gallery, 26 May-26 June 1971.
Coplands, John. *Andy Warhol*. With contributions by Calvin Tomkins and Jonas Mekas. New York: Whitney Museum of American Art, 1971.
Crone, Rainer. *Andy Warhol: Das zeichnerische Werk, 1942–1975*. Stuttgart: Wuerttembergischer Kunstverein, 1976.
d'Harnoncourt, Anne and McShine, Kynaston, eds. *Marcel Duchamp*. New York and Philadelphia: Museum of Modern Art and Philadelphia Museum of Art, 1973.
Eduardo Paolozzi. London: The Tate Gallery, 1971.
Geldzahler, Henry. *American Painting in the Twentieth Century*. New York: Metropolitan Museum of Art, 1965.
Lipman, Jean and Marshall, Richard. *Art about Art*. New York: Whitney Museum of American Art, 1978.
Miller, Dorothy C., ed. *Sixteen Americans*. New York: Museum of Modern Art, 1959.
Paintings, Drawings, Prints and Posters by Henri de Toulouse–Lautrec, 1864–1901. Pittsburgh: Department of Fine Arts, Carnegie Institute of Pittsburgh, 6 March-20 April 1947.
Recent Drawings: U.S.A. New York: Museum of Modern Art, 1956.
Robert Rauschenberg. Washington, D.C.: National Collection of Fine Arts, 1976.
Rosenblum, Robert. *Andy Warhol: Portraits of the '70s*. New York: Whitney Museum of American Art, 1979.
Rubin, William S. *Dada, Surrealism, and Their Heritage*. New York: Museum of Modern Art, 1968.
Schuh-Werke: Aspeckte zum Menschenbild. Nuernberg: Kunsthalle, 1976.
Seitz, William C. *The Art of Assemblage*. New York: Museum of Modern Art, 1961.
———. *Claude Monet: Seasons and Moments*. New York: Museum of Modern Art, 1960.

Index